EDGAR DEGAS: The Painter as Printmaker

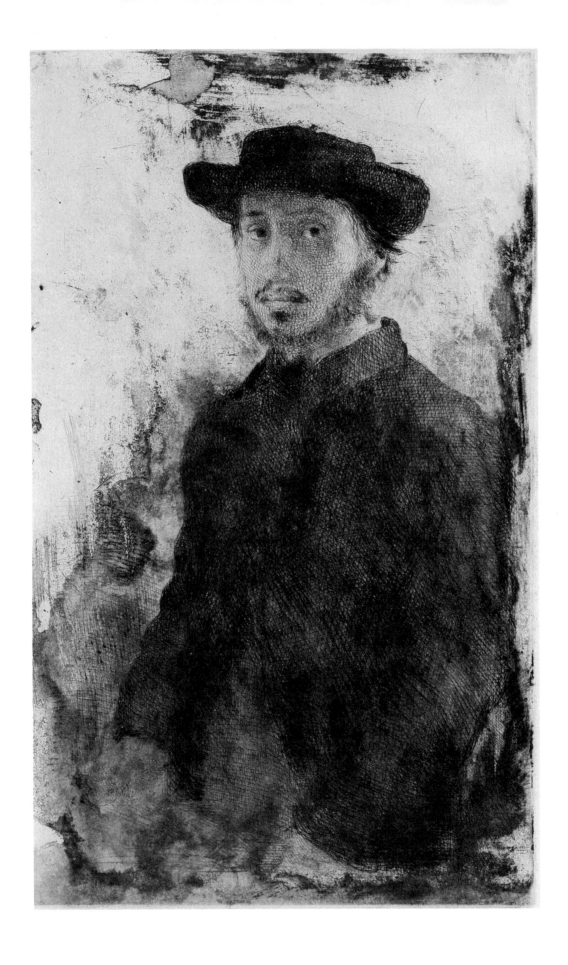

EDGAR DEGAS:

The Painter as Printmaker

Sue Welsh Reed and Barbara Stern Shapiro

with contributions by
Clifford S. Ackley
and
Roy L. Perkinson

Essay by Douglas Druick
and Peter Zegers

Museum of Fine Arts, Boston

Philadelphia Museum of Art

Arts Council of Great Britain

Frontispiece:
8. *Edgar Degas: Self-portrait,* 1857. Third state. Museum of Fine Arts, Boston

Cover illustrations (back to front, left to right):
52. *Mary Cassatt at the Louvre, the Paintings Gallery,* 1879-80.
Second state. Bibliothèque Nationale, Paris.
Fifth state. Museum of Fine Arts, Boston.
Twelfth-thirteenth state. National Gallery of Art, Washington, D.C.
Pastel over twelfth-thirteenth state. The Art Institute of Chicago.

Exhibition dates:

Museum of Fine Arts, Boston
 November 14, 1984 – January 13, 1985

Philadelphia Museum of Art
 February 17 – April 14, 1985

Arts Council of Great Britain
Hayward Gallery
 May 15 – July 7, 1985

This exhibition has been made possible by grants from the National Endowment for the Arts.

Contents

Lenders
to the Exhibition

Graphische Sammlung Albertina

The Baltimore Museum of Art

Bibliothèque Nationale, Cabinet des Estampes, Paris

Museum of Fine Arts, Boston

Boston Public Library, Print Department

Museum Boymans-van Beuningen, Rotterdam

Kupferstichkabinett, Kunsthalle, Bremen

The Trustees of the British Museum

The Brooklyn Museum

The Art Institute of Chicago

Sterling and Francine Clark Art Institute,
 Williamstown, Massachusetts

The Cleveland Museum of Art

The Royal Museum of Fine Arts, Copenhagen

Dallas Museum of Art

The Detroit Institute of Arts

Fogg Art Museum, Harvard University,
 Cambridge, Massachusetts

The Archer M. Huntington Art Gallery,
 The University of Texas at Austin

The University of Iowa Museum of Art

Kupferstichkabinett, Staatliche Kunsthalle, Karlsruhe

Library of Congress, Prints and Photographs Division

Los Angeles County Museum of Art

Mead Art Museum, Amherst College,
 Amherst, Massachusetts

The Metropolitan Museum of Art, New York

Milwaukee Art Museum

The Minneapolis Institute of Arts

National Gallery of Art, Washington, D.C.

National Gallery of Canada, Ottawa

The New York Public Library,
 Aston, Lenox and Tilden Foundations

Philadelphia Museum of Art

The Art Museum, Princeton University,
 Princeton, New Jersey

Rijksprentenkabinet, Rijksmuseum, Amsterdam

The Fine Arts Museums of San Francisco,
 Achenbach Foundation for Graphic Arts

Smith College Museum of Art, Northampton, Massachusetts

Stanford University Museum of Art

The Toledo Museum of Art

Yale University Art Gallery,
 New Haven, Connecticut

Huguette Berès, Paris

James A. Bergquist, Boston

Mr. and Mrs. O. G. Bunting

Lucien Goldschmidt, New York

Josefowitz Collection, Switzerland

E. W. Kornfeld, Bern

N. G. Stogdon

Mr. and Mrs. Eugene Victor Thaw

Mr. and Mrs. John W. Warrington

Anonymous lenders

Preface

This new catalogue raisonné of Degas's prints and the accompanying exhibition of more than 200 impressions of his etchings and lithographs celebrate the one hundred and fiftieth anniversary of the artist's birth. Both projects represent a continuing tradition of the Department of Prints, Drawings, and Photographs of the Museum of Fine Arts, Boston: exhibitions and substantial catalogues devoted to an exploration in depth of the work of master printmakers. The practice of presenting prints in variant impressions to illuminate the creative process began in 1969 with *Rembrandt: Experimental Etcher* and continued with *Albrecht Durer: Master Printmaker* (1971), *Camille Pissarro: The Impressionist Printmaker* (1973), *The Changing Image: Prints by Francisco Goya* (1974), *The Etchings of Jacques Bellange* (1975), and *Printmaking in the Age of Rembrandt* (1980). It was inevitable that Edgar Degas, one of the most significant printmakers of nineteenth-century France, should become part of this series.

An exhibition of Degas's work in all media prepared for Boston in 1974 by Barbara Shapiro dramatized the museum's longstanding commitment to the artist. During his lifetime, an oil painting *Race Horses at Longchamps* was purchased in 1903 from Degas's dealer, Durand-Ruel, followed by the gift in 1909 of a pair of landscapes in pastel over monotype. Most recently fourteen etchings and lithographs were acquired, purchases enthusiastically supported by the director and trustees of the museum.

"Degas 1879," an exhibition organized by Ronald Pickvance in 1979 for the National Gallery of Scotland in Edinburgh, included etchings shown in state sequences and provided inspiration for the present exhibition. Unfortunately, no one involved in the present project saw the pioneering 1964 exhibition of Degas's etchings organized by Paul Moses in Chicago or William Ittmann's 1967 exhibition at the Saint Louis Museum devoted to the lithographs. The accompanying catalogues, however, have proved extremely helpful to us.

Edgar Degas's status as painter, draughtsman, and sculptor is unchallenged, and his work in these media has been examined in a number of scholarly studies dating from recent years. Even his monotypes have been the topic of an influential exhibition and catalogue. His etchings and lithographs as a whole have been treated in two catalogues raisonnés by Loys Delteil (1919) and Jean Adhémar (1973). In spite of previous exhibitions and catalogues, the prints remained relatively unknown, and it was clear that there was still a great deal to be rediscovered or clarified. The quality of Degas's achievement in printmaking encouraged us to undertake an ambitious project: to locate, examine, catalogue, and discuss all of Degas's etchings and lithographs in as many states as could be found. The goal was to present a significant selection of his printed work. Sixty-six subjects have been identified as by Degas, and over 550 impressions of his prints have been located and examined. We are able to account for nearly every state previously catalogued by Delteil or Adhémar and to make a number of additions to the states described by them. In the light of recent research on Degas's work in other media and a close study of the impressions themselves, we have proposed a new chronology for the prints. We have also tried to be as specific as possible in the description of techniques used by Degas and have attempted to characterize accurately the kinds of paper on which he printed.

In 1980, at the close of a successful collaboration between the Museum of Fine Arts and the Arts Council of Great Britain on the Camille Pissarro exhibition, Joanna Drew, director of art, and Andrew Dempsey, assistant director in charge of London exhibitions, of the Arts Council expressed a desire to participate in an exhibition of Degas's prints. From the first planning phase, they have given enthusiastic support. We are equally pleased to share the exhibition with the Philadelphia Museum of Art, whose director, Anne d'Harnoncourt, and acting curator of prints, Ellen Jacobowitz, have wholeheartedly endorsed the project. The exhibition and catalogue could not have been undertaken without the full support of the director of the Museum of Fine Arts, Jan Fontein.

Once again, the National Endowment for the Arts has expressed its belief in the value of a serious examination of a major body of work in printmaking and has generously supported the research and planning aspects of the project, as well as the costs of mounting such a complex exhibition. Without their grants to support travel to study the originals and to pay for the collection of numerous photographs, neither the exhibition nor the catalogue could have been realized.

In an attempt to make this catalogue raisonné a more useful and scholarly tool, we invited Douglas Druick and Peter Zegers of the National Gallery of Canada to contribute an essay on Degas in the context of the printmaking of his time. We have mutually benefited from one another's work in the past several years and have found it enjoyable and stimulating to share information with our Canadian confrères. Roy Perkinson, paper conservator at the Museum of Fine Arts, and his assistant, Elizabeth Lunning, provided us with elegant and useful sets of paper samples at the outset of our research, so that our descriptions of papers would have a constant base. We have added the results of our findings to those of Mr. Perkinson, who has provided an essay on Degas's choice of printing papers. We are profoundly grateful to Clifford Ackley, our curator and close colleague, for his interest and involvement in this project from its beginning. Despite many other commitments, he found time to participate in the initial research, to discuss the prints, and to provide editorial comments. He also has contributed a general introductory essay to the catalogue and has supervised the design of the exhibition.

Degas's prints are rarely found in large numbers in a single collection. In the few instances in which this occurred, often as many as five of us utilized these collections intensively. We are extremely grateful for the patience and cooperation of the staff at the print rooms of The Art Institute of Chicago, the Sterling and Francine Clark Art Institute, The Metropolitan Museum of Art, and the National Gallery of Art; and at the British Museum, Royal Museum of Fine Arts, Copenhagen, Bibliothèque d'Art et d'Archéologie, Paris, and most especially the Bibliothèque Nationale, Paris.

Many collections in America contain a few prints by Degas, and nearly always ones of great interest and high quality. We are pleased to be able to represent these collections. Without exception the curators and owners of Degas prints have gone to great lengths to provide us with answers to our persistent questions. As they have shared information with us, we hope that we can share the excitement of our discoveries in the exhibition and catalogue.

We would like to express our deep gratitude to the more than fifty institutions and private lenders whose names are listed at the front of this catalogue. They have been willing to lend these rare works of art on paper for the benefit of a wider audience. Only their extraordinary cooperation has made it possible for Degas's prints to assume their rightful place within the artist's oeuvre. We are also grateful to those owners who have permitted us to describe and reproduce works in their collections in the present publication so as to make it as complete as possible.

Many individuals have generously shared their knowledge and their time with us over the past few years. We would like to thank Hélène and Jean Adhémar, Madeleine Barbin, Juliet Bareau, Judith Barter, Jacob Bean, Laure Beaumont-Maillet, Huguette Bères, James A. Bergquist, Veronika Birke, Jean Sutherland Boggs, William Bodine, Joachim Eckart von Borries, Richard Brettell, Harry Brooks, Françoise Cachin, Paule Cailac, Victor Carlson, Beverly Carter, Marjorie B. Cohn, Bruce Davis, Douglas Druick, Charles Durand-Ruel, and Adrian Eeles; also Marianne Feilchenfeldt, Rafael Fernandez, Richard S. Field, Erik Fischer, Jay Fisher, Betsy G. Fryberger, Françoise Gardey, Jane Glaubinger, Lucien Goldschmidt, Lynn Gould, Ann Havinga, and Sinclair Hitchings. We are grateful to Colta Ives, John W. Ittmann, William Ittmann, Ellen Jacobowitz, Eugenia Parry Janis, the late Harold Joachim, Robert Flynn Johnson, and Samuel Josefowitz. We are particularly indebted to Michael Kauffmann, David Kiehl, Eberhard W. Kornfeld, Fritz Koreny, August Laube, Robert M. Light, Margaret MacDonald, Suzanne McCullagh, Sara McNear, Michel Melot, Pierre Michel, Geneviève Monnier, Judith Pillsbury, Michèle and Hubert Prouté, Carol Pulin, Robert Rainwater, Theodore Reff, Bernard Reilly, John Rewald, Louise S. Richards, Andrew Robison, and Barbara Ross. Thanks are due Eckhard Schaar, Arlette Sérullaz, Mme M. Sévin, Kristin Spangenberg, Nicholas G. Stogdon, Margret Stuffmann, Christine Swenson, Marilyn Symmes, Eugene V. Thaw, Anne Thorold, David Tunick, and Ken Tyler, as well as Claire Vaudevire, Françoise Viatte, Roberta Waddell, Barry Walker, Judith Weiss, William Weston, Peter Zegers, Henri Zerner, and the late Fernando Zobel.

This publication could not have been produced without the help of many staff members at the Museum of Fine Arts, especially Carl Zahn and Margaret Jupe and their colleagues in the Department of Publications. The photography department, under Janice Sorkow and Alan Newman, made fine photographs and slides for us. Marsha Shankman, a freelance editor, calmly provided her fine editorial skills.

The exhibition was installed at the museum with the guidance of Tom Wong and Judy Downes. William Burback and Joan Hobson planned a series of lectures relevant to Degas, and Barbara Martin prepared a brochure for our museum audience. Sam Quigley answered many questions on musical instruments. The entire staff of the Department of Prints, Drawings, and Photographs has actively supported and participated in this project; we extend our special thanks to David Becker and Drew Knowlton, who covered the departmental tasks that we were forced to neglect, and especially to two interns, Heather Northway and Victoria Jennings, who assisted in many aspects of the preparation of the catalogue and exhibition. Finally, we are grateful to Eleanor Sayre, who has always encouraged her staff to pursue ambitious goals.

Sue Welsh Reed
Barbara Stern Shapiro

Edgar Degas:
The Painter as Printmaker

Clifford S. Ackley

Edgar Degas (1834-1917) is today regarded as one of the greatest painters of the nineteenth century. He was indisputably the greatest draughtsman of that century. One would assume that there was no aspect of his varied artistic production that had not been thoroughly investigated. Even his monotypes, a wholly private aspect of his artistic activity, have been explored in a ground-breaking exhibition.[1] Nevertheless, Degas's exploration of the potentialities of printmaking, his some sixty-six etchings and lithographs – also an essentially private body of work – remains relatively unknown. During the artist's lifetime only four of his original prints were published: one as an illustration in a catalogue, two as plates in a book, and one as a program for a cultural evening. Although Degas exhibited his "experiments" (*essais*) at one of the Impressionist exhibitions, in 1880, his prints were known mostly to the artists and collectors in his circle of friends until the Atelier (studio) sale after his death, in November 1918, when nearly four hundred impressions of the prints came to light.[2] Many of these etchings and lithographs, private experiments never intended for publication, existed in only a few trial impressions. Even in instances where the number of impressions of a given print was somewhat larger, many of the impressions were rare working proofs representing a particular stage (state) in the development of an image on the plate or stone.

As a result of the sale, these proofs were widely dispersed through collections public and private in Europe and America. In spite of the catalogues of Degas's prints by Loys Delteil (1919) and Jean Adhémar (1973) and the exhibition catalogues devoted to the etchings (Paul Moses, 1964) and lithographs (William Ittmann, 1967),[3] the wide distribution of rare impressions has made study of Degas's prints difficult. Many questions raised by Degas's inventive and unorthodox working procedures remain to be answered. The present exhibition and catalogue seek to better define and comprehend Degas's work in printmaking by bringing together all the authentic etchings and lithographs and as many variant states and working proofs as could be rediscovered.

Degas's printmaking activity was sporadic but covers a substantial portion of his career as an artist: it ranges in date from his first tentative trials of the etching medium made in l856, when, at twenty-two, he was still an emergent artistic personality, to the bather lithographs of 1891-92, which are stylistically part of the last phase of his work.

No one looking at Degas's first three attempts of the etching medium (cat. nos. 1-3) – extremely conservative landscapes in a classicizing style made under the direction of the print collector and family friend Prince Grégoire Soutzo – could have predicted that this young painter would become one of the most profoundly innovative and expressive printmakers of the nineteenth century.

In 1857, during a nearly three-year period of study in Italy, these timid initial efforts were followed by Degas's first etched portraits (cat. nos. 4, 5, and 8). Like virtually all his portraits in all media, they are not commissioned portraits but studies of family and friends, including his most intimate friend, himself. His first major portrait was of Joseph Tourny, a professional engraver who appears to have advised the young artist on etching technique. Tourny's portrait is strongly Rembrandt-like in aspect, evoking the etched self-portraits of the 1630s and 1640s. The reference to Rembrandt's style is most appropriate, because Tourny may also have been responsible for intensifying Degas's interest in the Dutch seventeenth-century master, whose etchings were regarded by nineteenth-century artists and connoisseurs as the very definition of what etching should be. At this time Degas made an etched copy in reverse of one of Rembrandt's portrait etchings (cat. no. 6). The psychological depth and ambiguity of his own self-portrait (cat. no. 8) is enhanced by the subtle Rembrandtian chiaroscuro that plays over his features. Degas's classical lycée education and his then ambition to be a painter of historical and literary subjects in the grand tradition are revealed in his etched illustration to a well-known passage from Dante (cat. no. 9).

After Degas's return to Paris he produced in the years 1859-62 a further group of small etched portraits that suggest in their size and format painted miniatures or daguerreotype portraits. One of these portraits, that of Mlle Wolkonska, which Degas etched in two versions (cat. nos. 11 and 12), appears from its tonal structure, pose, and setting to be based on a photograph taken in a professional studio. This use of a photograph – always free and creative rather than pedantically literal – is also to be found in Degas's portrait paintings of the time. The modern medium of photography was employed by Degas the printmaker in a variety of ways: for example, in the 1870s and 1880s he used the then outmoded daguerreotype plates as etching plates in a number of instances (see cat. nos. 32, 33, 46, and 50), and at the end of his printmaking career, in 1891-92, he may have employed photographic methods to transfer the same drawing to different lithographic stones (cat. nos. 63 and 64).

Another aspect of the 1859-62 portraits is Degas's emulation of Ingres, the great master of line in the first half

of the nineteenth century. Degas had studied for a year with a follower of Ingres, Louis Lamothe, and he worshipped Ingres throughout his life, quoting frequently to his friends the master's concise and oracular statements regarding drawing. In the course of a rare meeting during Degas's earlier years, Ingres advised him to "draw lots of lines, either from memory or from nature."[4] Later in life Degas became the proud owner of drawings by the artist he so revered. A botched and erased experimental plate from this time has revealed itself to be a direct copy of an Ingres drawing (cat. no. 13). The earlier Tourny portrait, with its intense sidelong gaze at the viewer and its delicate but firm linear structure, has distinct overtones of Ingres's portrait drawings, as does the looser, more sketch-like softground portrait of Degas's brother René made in Paris in 1861-62. Many of Degas's early portrait etchings are detached and objective in feeling, but one portrait, that of his beloved sister Marguerite (cat. no. 14), is charged with feelings of tender intimacy. The portraits of women in his family circle are among the most profoundly emotional images made by this intensely private man, whose own emotional life remains an enigma.

Degas's etchings entered a new and more contemporary phase in the years 1864-65 with his portraits of his friend the painter Edouard Manet. One of the earliest encounters of the two artists may have occurred in the galleries of the Louvre, where Manet is said to have come upon Degas working directly on the copper plate of his copy of Velázquez's *Infanta Margarita* (cat. no. 16, 1862-64). Manet was also an admirer of the art of Velázquez and had already made his own more freely interpreted etched copy of this painting. Degas remained a student of the old masters all his life, but after the early years this influence was no longer overtly evident in his work. He became, however, a "classical" realist, working as much from synthetic memory as from direct observation.

One of Degas's three etched portraits of Manet from this time, the bust-length one (cat. no. 19), is fairly conventional and formal, though a powerful characterization. The two full-length, seated portraits, however, present Manet, the painter of modern life, in a fresh, informal, and contemporary manner. It is, in particular, the version in which the elegantly turned-out Manet sits hunched sideways on a chair, his top hat abandoned on the floor, the backs of stretched canvases seen behind him, that still vividly conveys the sense of a particular moment during a studio visit.

Degas's most productive phase as a printmaker, his period of deepest engagement – which also encompassed what his friend the printmaker Desboutin jokingly dubbed Degas's "metallurgical phase" – was during the years 1876-80.[5] This was also the time of his most profound involvement in subjects taken from contemporary urban life, subjects that parallel those in the novels of realist writers of the mid-nineteenth century such as Flaubert, Zola, and the Goncourt brothers. As in the works of these writers, one of the principal themes in Degas's prints was women in society, particularly women of the laboring classes earning their living: dancers at the Paris Opéra, comic singers in outdoor cafés (café-concerts), actresses, laundresses, and prostitutes. At the other end of the social scale were the genteel visitors to the galleries of the Louvre (Mary Cassatt and her sister) or the spectator in the loge of the theater with her fan. Degas's vision of modern woman in society was not the tragic and melodramatic one of the novelists. The artist's cool objectivity and detachment, his lack of gallant idealization when portraying women has often led to accusations of misogyny. On the other hand, the image of woman remained a central preoccupation of his work to the very end.

During these years Degas also made his most innovative use of the etching media. Like his painter friends Camille Pissarro and Mary Cassatt, he sought new combinations of traditional techniques (etching, drypoint, aquatint, and softground etching) to find black and white equivalents for, rather than imitations of, the colorism and varied textures of painting. While the prints of the 1850s and 1860s had been predominantly linear in structure, Degas now began to conceive in terms of broad masses of tone and texture. Even line itself was employed in a tonal, nonlinear fashion. Unconventional tools such as a compressed carbon rod from an arc lamp or an emery pencil were used to score the plate with bundles of fine multiple drypoint lines that read as a gray tone. Multiple etched lines were apparently achieved by drawing in the etching ground with tools such as a double-pointed steel pen or a wire brush. The tonal medium of aquatint was employed both in granular form and in fluid solution. The chalk-like softground lines interweave with these other scratchy, grainy, or flowing intaglio textures. Scraping and burnishing were used either to blend these disparate media or to subtract highlights from a darker field.

Degas was preoccupied at this time with rendering not only a specific kind of contemporary setting but also the lighting characteristic of that setting, whether the slightly murky, subaqueous lights and reflections of a museum gallery (*Mary Cassatt at the Louvre: The Etruscan Gallery*, cat.

no. 51) or the dramatic patterns of light and shadow created by artificial light in an interior (*Actresses in Their Dressing Room*, cat. no. 50) or out of doors by night (*At the Café des Ambassadeurs*, cat. no. 49).

In 1877 there occurred one of the rare instances in which Degas released a completed print for public circulation. After two trials with closely related compositions (cat. nos. 22 and 23), he allowed the Society of Friends of Art of Pau to publish the third version of his etching *On Stage* (cat. no. 24) in an exhibition booklet illustrated with original etchings by participating artists. It is an indication of the growth of his reputation that no copy of this catalogue has been found from which Degas's etching has not been removed.

In the years 1879-80 Degas, with the collaboration of his friends the painters Pissarro, Cassatt, and the professional printmaker Félix Bracquemond, was making plans to publish a journal *Le Jour et la nuit* (*Day and Night*) that would involve the issuing of original etchings to subscribers. One of the prints intended for the journal, Degas's etching of *Mary Cassatt at the Louvre: The Etruscan Gallery* (cat. no. 51), appears to have been printed in a uniform edition of at least fifty impressions on Japanese paper, but the journal never appeared, and the edition was not offered for sale. The evocative title of the journal suggests not only black and white but also a sense of the momentary and passing appropriate to subjects drawn from contemporary life.

Tantalizing are the references in Degas's notebooks of this time to ideas for original prints (or illustrations) that were never executed: "For the journal – Crop a great deal – do a dancer's arms or the legs, or the back – do the shoes." Or, a more specific reference to original prints: "do in aquatint a series on *mourning* (different blacks) – black veils of heavy mourning flowing over the face – black gloves – mourning coaches, carriages of the Funerary Association – vehicles comparable to Venetian gondolas."[6] But the plans all came to nothing, perhaps because of Degas's inherent perfectionism, his difficulty in giving any of his works a final or definitive form. Mary Cassatt's mother complained bitterly in a letter about the time Mary had wasted in making prints for the nonexistent journal when she could have been better employed making paintings for exhibition and sale. She commented with disgust: "as usual with Degas when the time arrived to appear, he wasn't ready. . . . Degas never is ready for anything."[7]

About 1876 Degas began to make lithographs. He seems at first to have employed this medium in the simplest and most direct manner, drawing with crayon directly on the stone (cat. no. 26) or making a crayon drawing on lithographic transfer paper and transferring it unaltered to the stone (cat. no. 25).

Soon, however, he began to explore new approaches to making a lithograph. At this time he also was deeply engrossed in the painterly, tonal medium of monotype. To make a monotype Degas painted on the smooth, unworked surface of a printing plate with printer's ink, using brushes, rags, or his fingers. When such a plate is printed, it yields only one or two satisfactory impressions, hence the term *mono*type. Degas had been introduced to this medium by his friend the amateur artist Vicomte Lepic, who inked his etched plates in this fashion, painting with excess ink on the surface of the copper plate to evoke different moods and atmospheres. Lepic dubbed such Rembrandt-like inkings and printings of his etched plates *l'eau-forte mobile* (the fluid, or variable, etching).

Degas, who was constantly seeking new and unconventional working procedures or fresh combinations of media, conceived the idea of transferring the freshly printed, greasy monotype image to the lithographic stone. This not only made the unique monotype potentially multiple but also – perhaps more important to Degas – made it possible to realize new and unprecedented tonal and textural effects on the stone. Sometimes the monotype image was scarcely touched after transfer to the stone (cat. no. 27); in other instances it was altered after transfer by crayon work and scraping (cat. no. 30). Several separate monotypes were often transferred to the same stone, producing the effect of a sheet of studies. In some instances (cat. no. 36, for example), in which the images are differently oriented on the stone, it is likely that Degas intended that they be cut apart, perhaps to be further worked up in pastel. For Degas used not only his monotypes as a base for working up in pastel but impressions of his etchings and lithographs as well (cat. nos. 30, 31, 50, and 52). In other lithographs the various monotype transfers are oriented in the same direction on the stone: in *Mlle Bécat at the Café des Ambassadeurs: Three Motifs* (cat. no. 30) the three views of Bécat captured in various stages of her animated comic pantomime have an almost cinematic effect, as does the original sheet of drawn studies of Bécat in action in Degas's notebooks.

The rich black and white colorism that resulted from Degas's pushing of the lithographic medium to new frontiers of expressiveness may be seen in the other lithographic version of Bécat performing by night at the Ambassadeurs (cat. no. 31), in which the broad tones of monotype transfer, delicate crayon work, and incisive scraper work

combine to vividly summon up the glow of the footlights, the shimmering reflection of a chandelier in a large mirror, and the moon and streaks of fireworks seen through chestnut leaves. Degas's consciousness of the artistic potential of the medium of lithography is succinctly expressed in the statement attributed to him by Denis Rouart: "If Rembrandt had known lithography, God only knows what he would have done with it!"[8]

Degas shared one of his printed images with a limited audience once more when, in 1884, he provided a design for a lithographic program for an artistic evening to benefit the Lycée of Nantes (cat. nos. 53, 54). Characteristic of Degas's experimentation with crossbreeding of the media is the fact that the design was first worked out in softground etching and roulette on an etching plate and then transferred to a lithographic stone for the final printing of the program with its text. In the program the seemingly random montage of dancers' legs, musical instruments, and smoking steamship funnels recalls Degas's ideas for prints representing fragments from modern life that he jotted down in his notebooks at the time of the *Le Jour et la nuit* project; but these are in fact quite literal references to the varied artistic performances of the evening program and the site of the Lycée, the city of Nantes with its harbor.

The last of Degas's published prints appeared as illustrations in a privately issued book on Impressionist works in the collection of the art dealer Durand-Ruel (see cat. nos. 56 and 57, 1891-92). Degas was apparently dissatisfied with the etchings made after two of his works by a professional etcher, and he redid them, tracing over the other etcher's work to produce much bolder, less literally reproductive results.

Degas's last significant statement in printmaking was the series of closely interrelated lithographic studies of a standing bather toweling herself after her bath (cat. nos. 61-66, 1891-92). In a letter of 1891 he complained of the poor state of his eyes and then continued "I dream nevertheless of enterprises; I am hoping to do a suite of lithographs, a first series on nude women at their toilet and a second one on nude dancers. In this way one continues to the last day figuring things out. It is very fortunate that it should be so."[9] A rare lithograph drawn on a zinc plate (cat. no. 59) may be his first and only attempt at the series of lithographs of nude dancers, but the nude bathers became a major series.

The bather lithographs parallel in many respects the large drawings and pastels of bathers that the artist was preoccupied with obsessively doing and redoing from the 1880s on, frequently tracing a pose and transferring it to other sheets, then working them up in different ways. The most striking parallel in Degas's working procedures between the late lithographs and the drawings and pastels is found in three bather lithographs, in which the same image was transferred, possibly with the aid of photography, to three separate stones and then worked up in quite different ways by means of additions in lithographic crayon and subtraction by scraping (cat. nos. 63, 64, and 65).

Degas's concentration in his later years on a single figural motif that he reworked again and again may be related not only to the high standards he set himself but also to his failing eyesight. His unrelenting quest for classical perfection, even when depicting the momentary or instantaneous, is movingly expressed in a letter of 1886 to his close friend Bartholomé the sculptor: "But it is essential to do the same subject over again, ten times, a hundred times. Nothing in art must seem to be chance, not even movement."[10]

The quite sculptural late lithographs of bathers derived from observation of hired models remind us that in his prints, as in the other media he employed, Degas began his artistic career with specific portraits of family and friends, notable for their acute psychological penetration, and ended his career with studies of the bodily gestures of anonymous representatives of humanity. Conscious himself of the detached, objective nature of his later drawn studies of bathers, Degas characterized them as representing the human animal preoccupied with itself, like a cat licking itself.[11] He also spoke of observing the bathers without their betraying an awareness of being observed, as if through a keyhole.[12]

Degas's sporadic and diverse involvement with printmaking is extraordinarily difficult to sum up with broad generalizations. At every stage of his printmaking activity, from early to late, one finds prints that are primarily trials and technical experiments rather than attempts at a more resolved image. Degas would undoubtedly have been horrified at the prospect of such trial pieces being studied equally alongside his more developed prints. He believed in the alchemical secrets of the artist's laboratory and the artist's right to privacy. As he commented toward the end of his life, "Oh, literature – writers – no, what's underneath is no one's business. . . . Works of art must be left with some mystery about them."[13] Unfortunately for him, his inventive, unconventional approach to printmaking has so piqued the interest of print connoisseurs that the temptation to investigate his secrets has proved irresistible.

Many of Degas's approaches to printmaking can hardly be classified as unconventional. In a simple transfer lithograph such as "The Song of the Dog" of 1876-77 (cat. no. 25), he seems to be primarily interested in multiplying a drawing derived from a painting in gouache. On the other hand, his inventive working procedures in the 1891-92 bather lithographs are so unusual, complex, and baffling that they still defy deciphering.

One of the most fascinating aspects of Degas's printmaking is his restlessness and irresolution, his ambivalence about the "finished" image. In his prints images are sometimes quite successfully resolved (as in Manet Seated, Turned to the Right, cat. no. 18) and then partially erased, implying that the artist wished to return to the image at a later date to develop it further or rethink it; but he never did. In one notable exception to this habit, the 1857 portrait of Joseph Tourny, Degas returned to the plate a decade or so later, not to rework it, but to ink it in such a fashion that the delicate Ingres-like web of etched lines is veiled in Rembrandt-like chiaroscuro (cat. no. 5). The original etched matrix was used to produce three new and unique tonal statements of mood and atmosphere.

Degas's capacity for endless tinkering with the printed image, making small adjustments that led to broader changes of lighting and mood, is illustrated by the 1879 etching Leaving the Bath (cat. no. 42) with its twenty-two states. This patient investigation of the possible modulations of the same image is all the more striking when we realize that at no stage in the development of the plate does the small number of surviving impressions suggest that Degas considered an edition of any of these states, however well resolved. Denis Rouart, in his book on Degas's working methods, captures Degas's fascination with the variableness of printmaking: "It is clear that for Degas etching was more a means of indefinitely working, retouching and transforming a plate while keeping impressions of successive states than a means of obtaining numerous identical examples of a single state."[14]

Degas's love of difficulties, of setting himself problems, is seen in the two totally different compositions that he developed using the same figures in the same poses (reversed from plate to plate in the case of the figure of Mary Cassatt): the "Visit to the Louvre" etchings (cat. nos. 51 and 52). Although the figures of the museum goers remain the same, format, space, and lighting are totally different: The Etruscan Gallery is nearly square, while The Paintings Gallery has a radically new, long narrow format inspired by the Japanese prints that Degas collected.

Although the bold, two-dimensional graphic patterns seen in many of the developmental stages in Degas's etched plates appeal strongly to our latter-day taste for abstraction, Degas appears generally to have been working toward greater clarification of the spatial relationships. This may be observed even in the case of two prints with very unconventional or ambiguous spatial structures, such as Mary Cassatt at the Louvre: The Paintings Gallery (cat. no. 52) and Actresses in Their Dressing Rooms (cat. no. 50).

In the prints that exist in several states Degas is sometimes seen to be working toward a subtle painterly effect rather than a lively graphic one. In the other "Visit to the Louvre" etching, The Etruscan Gallery, a print for which an edition was printed but never used, Degas worked his way through early and intermediate stages characterized by sharp contrasts and strong graphic configurations to arrive at a result that is atmospheric and tonal, occupying the middle range of grays. The choice for the edition of a Japanese paper that mutes contrasts contributes further to the quiet painterly effect of the final state.

Although Degas's devastating verbal wit has been endlessly quoted and celebrated in the literature about him, little attention has been paid to the flashes of visual wit – whether sly, cruel, or comic – in the prints. The Etruscan Gallery (cat. no. 51) is a case in point. Are we to regard it as accidental that two modern, properly clad, upper bourgeois women (whom Degas knew to be spinsters) study with great solemnity an archaically smiling Etruscan couple reclining, in eternal embrace, on the lid of their sarcophagus? Or that the Etruscans are safely sealed behind glass? The image is, among other things, an amusing commentary on that strange modern institution, the art museum. A more blatant and cruel example of Degas's visual wit is the ungainly and vulnerably naked female bather lumbering out of the bath in the etching Leaving the Bath (cat. no. 42). The nineteenth-century print cataloguer Béraldi was apparently so struck by the grossness of this image that he concluded that the woman must be a prostitute (femme du quartier Pigalle).[15] Degas's robust pleasure in the lively and vulgar routines of the stars of the café-concerts is infectious in such prints as Mlle Bécat at the Café des Ambassadeurs: Three Motifs (cat. no. 30). The movements of ballet dancers are caricatured in the lithograph At the Theater: Woman with a Fan (cat. no. 37), in which the calm, dignified profile of the spectator in her loge is contrasted with the movement of the dancers on stage, who dart hectically about. Degas's interest in caricature is reflected not only in the

drawn caricatures to be found in his notebooks of all periods but also in his extensive collection of the prints of Daumier and Gavarni.

Degas's commitment to the traditions of fine printmaking is reflected in his substantial collection of prints by his contemporaries, from Delacroix to Gauguin. His feeling for the nuances of print connoisseurship is revealed in a letter to Alexis Rouart, in which he describes his pleasure in the proof impressions of Gavarni lithographs that Rouart had recently given him: "I am keeping a special box for pieces of this class and I put beside each one an ordinary print which doubles my delight in the extraordinary one."[16]

We presume that Degas had an etching press in his studio, for he sometimes pulled proofs of Pissarro's etchings for his friend, who was living in the country without access to a press. Even more interesting and surprising is the fact that he was printing color proofs of Pissarro's prints, such as the *Twilight with Haystacks* (Delteil 23, 1879), and that he corresponded with him about new methods of printing color.[17] One wonders if Degas sometimes chose himself the colors for the experimental proofs he pulled for Pissarro. He did not pursue printed color to any appreciable extent in his own work. Perhaps he felt he could always add color afterwards if he chose, with pastels. Or perhaps his declared passion for black and white was simply too great. In his later years he is said to have stated that if he had had his own way, he would have confined himself to black and white but that the world wanted color and only color![18] In 1892 he confided to his young friend Daniel Halévy, who jotted down his words: "At last I shall be able to devote myself to black and white, which is my passion."[19]

Notes

1. Eugenia Parry Janis, *Degas Monotypes* (Cambridge, Mass., 1968).

2. Atelier sale *Eaux-fortes.*

3. Full references for these catalogues are given in the Selected Bibliography.

4. Valéry, p. 35.

5. For a fuller citation of Desboutin's description of Degas's frenzied printmaking activity in 1876, see his letter to De Nittis in Mary Pittaluga and Enrico Piceni, *De Nittis* (Milan, 1963), p. 359.

6. Reff *Notebook* 30, pp. 208 and 206.

7. Mathews 1984, p. 151.

8. Rouart 1945, p. 66: "Si Rembrandt avait connu la lithographie, Dieu sait ce qu'il en aurait fait!"

9. Degas, *Letters* 1947, no. 172.

10. Ibid., no. 99.

11. Moore 1918, p. 64: "La bête humaine qui s'occupe d'elle-même; une chatte qui se lèche."

12. Ibid., p. 65: "Here is another; she is washing her feet. It is as if you looked through a keyhole."

13. Halévy, p. 109.

14. Rouart 1945, p. 66: "Il est certain que pour Degas la gravure fut plutôt un moyen de travailler, retoucher et transformer indéfiniment une planche tout en conservant des tirages des états successifs, que celui d'obtenir de nombreux exemplaires identiques d'un même état."

15. Béraldi, p. 153.

16. Degas, *Letters* 1947, no. 200.

17. This assumption is based on annotated Pissarro proofs crediting Degas as printer and on Degas's correspondence with Pissarro; see Degas, *Letters* 1947, no. 34 (1880), for his observations on experimental color printing. Moore 1918, p. 27, mentions *litho* presses when describing Degas's studio: "Great wheels belonging to lithographic presses – lithography was for a time one of Degas's avocations – suggest a printing-office." It is quite possible that one of the "lithographic" presses Moore describes was an etching press.

18. Degas, *Letters* 1947: D. Halévy, "Notes on Degas, 1891-1893," p. 243, n. 1.

19. Degas, *Letters* 1947: D. Halévy, "Notes on Degas, 1891-1893," p. 247.

Degas and the Printed Image, 1856-1914

Douglas Druick and Peter Zegers

Introduction

Degas's activity as a printmaker spans a period of some forty years that were critical in the history of printmaking. In France, that period witnessed two important "revivals" of interest in traditional print media: a revival of etching launched with considerable fanfare in the 1860s, and that took on new momentum in the 1870s; and a revival of lithography, tentatively beginning in the 1880s, but in full swing a decade later. During the same period, photography and other new technologies were spawning ever more efficient methods of reproducing images – methods increasingly used to perform functions traditionally belonging to the printmaker. As new media displaced the old as the primary means of disseminating images, the traditional media were redefined in purpose. The print ceased to be an adjunct of industry and now found its raison d'être as work of art alone. The various print "revivals" are witness to this evolution, a process that would be completed by the century's end.

Degas was one of the most important *peintres-graveurs* in a century remarkable in that domain. But his printed oeuvre is more than a brilliant testimony to the maxim that great painters make great prints. To fully appreciate the prints made by Degas, they must be viewed in conjunction with contemporary reproductions of his work. Together, these provide a fascinating indicator of Degas's interests and concerns, from the mid-1850s to the mid-1890s. They are, moreover, a barometer of changing attitudes to new and traditional forms of printmaking over that period. The artist's original prints mirrored the succession of revivals from mid-century onwards, while the various reproductions of his work reflected also the forces to which the revivals were a response.

That is not to suggest, however, that Degas approached printmaking (as did many of his contemporaries) in a spirit of reaction against the forces threatening the sanctity of traditional print media. That would have been alien to Degas: on the one hand, his natural fascination with the physical processes of image-making could not be bound by such narrow concerns; on the other, Degas's high regard for art left him somewhat indifferent to the material means of its achievement. A seeming paradox, perhaps, but as much a part of Degas's art as was his combined love for tradition and attachment to modernity.

Indeed, it is the prints, perhaps more than any other area of Degas's creativity, that most clearly reveal these diverse passions at work. There, Degas is alternately fascinated with the traditional techniques, and impatient with them; he is eager to explore the possibilities of the new mechanical and photomechanical media, and interested in wedding them to the resources of the traditional media; he is intent on making prints as works of art in themselves, and anxious to use them simply to publicize his art.

Accordingly, Degas's prints cannot be properly understood if viewed only in the context of traditional printmaking. The artist's investigations of new industrial image-making techniques and his knowledge of their application in contemporary publications profoundly influenced his approach to printmaking. To penetrate the complexities of this entails an attempt to reconstruct Degas's exposure to new media, and to convey the excitement the new techniques generated within his circle; this in turn involves charting the landmarks of a rather unfamiliar territory.

Part I:
The Early Prints, 1856-65

Degas made nineteen prints over the period 1856-65 (cat. nos. 1-19). Had he never made prints again, this body of work would be insufficient reason to accord Degas the preeminent position he holds among the nineteenth-century peintres-graveurs. For although it includes several portraits that can stand with the finest prints the century produced, the majority of this early work is tentative. That Degas himself regarded it so is suggested by his not having had any of those prints pulled in significant numbers, let alone in an edition.

On the one hand, Degas's early involvement with printmaking can be regarded as largely circumstantial, the outcome of his friendships and of his responses to new influences during these formative years. On the other hand, this body of prints attests to Degas's natural curiosity to explore new media, an enduring characteristic of his art. And if there is a certain haphazardness about this early print production, the prints nevertheless reflect many of the concerns and issues that preoccupied those who were involved with the contemporary revival of etching. In so doing, they also intimate what would be Degas's own concerns when, in the mid-1870s, he too became seriously absorbed in making prints.

Degas's First Prints: Paris and Italy

In 1856 most critics in France agreed that the essential role of printmaking was to reproduce works of art in other media, particularly works in oil. Such prints were seen as a means both of educating the public through the example of the finest works of art and of ensuring that a record remained of paintings whose inherent instability and fragility made them susceptible to change and destruction. The advent of photography had not altered this perception; photographs of paintings inevitably distorted the originals and were themselves susceptible to fading.[1]

The exalted role of the reproductive print gave it preeminence over the artist's original print. Professional printmakers invariably made up the jury for the print division of the Salon; as a result, reproductive prints predominated and reproductive printmakers carried off the honors. State commissions added to the enormous prestige of reproductive prints. While painters' commissions sometimes included copies, printmakers were commissioned to produce reproductions alone; moreover, the financial rewards they received far outstripped those that even the original prints of established artists could command.

Degas clearly valued reproductive prints as a means of disseminating works of art. His copies of the mid-1850s include drawings after reproductive prints he studied in the printroom of the Bibliothèque Nationale, where he had begun copying in 1853, and his respect for the professionals who produced such work is reflected in a contemporary notebook.[2] But Degas was also aware of printmaking's other role as a medium of original creation and of the tradition of the peintre-graveur, the artist who makes his own prints and so publicizes his compositions directly, without the involvement of a middleman. It was these peintres-graveurs that featured largely in the print collection of Degas's Rumanian friend Prince Grégoire Soutzo, an artist and amateur printmaker whom Degas admired, and who may have encouraged Degas to try his hand at printmaking and directed his first endeavors in etching.[3]

When Degas made his first etchings in Paris in 1856 (cat. nos. 1-3), it was not yet common, as it would be a decade later, for young artists to work in etching. For although the tradition of the peintre-graveur had, in the first half of the century, been continued by such artists as Géricault and Delacroix, the preferred medium had been lithography, then a recently invented technique that offered artists a more direct and simple means of reproducing their work than any of the traditional print media. By mid-century, however, lithography's attraction for the painter had been considerably diminished by the medium's employ in the production of commercial imagery; it had become tainted through its association with industry. Of the traditional media, the technically demanding process of engraving had long since entered the exclusive domain of the professional printmaker, but etching – more accessible than engraving yet less direct (and less compromised) than lithography – hitherto had enjoyed a very limited favor with painters. Older contemporaries whose etchings Degas could have known through publications or exhibitions included Delacroix, who had had a few of his etchings published in art periodicals; Théodore Chassériau, whose fifteen etched illustrations for *Othello* had been published in 1844; Charles-François Daubigny, who had been active since the mid-1840s in establishing a reputation as a painter-etcher; and the prolific Charles Jacque, whose etchings had appeared in publications since the early 1840s. Chief among the young artists who had recently taken up the medium was Félix Bracquemond, who had shown four etchings at the Universal Exhibition of 1855.

Degas would later acquire the work of some of those older painter-etchers and would count among his friends

Bracquemond, Alphonse Legros, and other young painters who began to explore etching about the same time he did; but neither group appears to have played a role in Degas's continued experimentation with etching after leaving for Italy in 1856.

The likely stimulus for Degas's printmaking during his Italian sojourn was Joseph Tourny, a copyist chiefly in watercolor who had trained as a reproductive engraver under Achille Martinet, an acknowledged master of that art. Though Tourny would soon abandon printmaking, at the time of Degas's arrival in Italy he was at work on several engravings that he would send to the Salon of 1857.[4] Aspects of that work apparently influenced Degas.

Tourny's profession as copyist involved translating one medium into another and, in prints, working from color into black and white. Degas, a fervent copyist in these formative years, was intrigued by the inherent challenge of this task; when himself copying, he sometimes translated monochrome drawings into paintings and occasionally, when making drawings after paintings, consciously used a graphic style consonant with that of the painter in question.[5] Degas's later predilection for turning his prints into pastels and using his works in color as starting points for prints can be seen to stem from this early interest.

While trained to render the work of others, Tourny like his teacher Martinet also made original portrait engravings, including the two he showed at the 1857 Salon. He was likely working on those when Degas resumed his experiments in etching, which with one exception were portraits. And while Tourny's métier was engraving, he could give Degas much practical advice regarding etching. For before touching the copper plate with the engraver's burin, Tourny, like Martinet and other professional engravers, first indicated his composition using the quicker technique of etching. As the relationship of the preliminary etching to the final engraving was much like that of the sketchy underpainting, or ébauche, to the finished canvas, the practice expressed the traditional association of etching and sketch, high finish and engraving. But the best expression of the nature of etching was the example of Rembrandt, whom the engraver Tourny apparently revered and to whom he seems to have directed Degas.[6]

Much admired, Rembrandt's prints were then the subject of a serial monograph (1853-58) by Charles Blanc that included 100 photographic reproductions of the best-known images. Although doubtless familiar with Rembrandt's prints prior to his Italian sojourn, Degas now studied them attentively; as with other contemporary painter-etchers, knowledge prompted emulation. Degas's admiration for Rembrandt's Young Man in a Velvet Cap (Bartsch 268) was first expressed in a quick notebook sketch followed by a more careful etched copy (cat. no. 6).[7] In the original portraits he etched soon thereafter, Degas paid homage to Rembrandt both in his choice of composition and in his handling of light and line. Making these etchings quickened Degas's appreciation of the work of other painter-etchers he now studied in the large print collection in the Library of Rome's Palazzo Corsini. It was here, five days after completing his portrait of a young man (cat. no. 7), that he again examined Claude's etchings, recording his admiration in considerable detail in his notebook.[8]

Degas's increased sensitivity to the beauty of original prints by the old masters did not make him unreceptive to reproductions. While he studied originals by Rembrandt, his sketch from Rembrandt's Death of the Virgin (Bartsch 99) was evidently based on a reproduction of the etching that had reversed the original composition. The part of the composition Degas copied was apparently connected with plans for a picture of "Tintoretto Painting His Dead Daughter," a subject popular in the nineteenth century that had received its most notable treatment in Léon Cogniet's painting (Salon, 1843). Degas probably did not know that picture at first hand, but he was doubtless familiar with the engraved reproduction by Tourny's teacher Martinet, exhibited at the Salon of 1855. Certainly Degas may have appreciated this and other reproductions primarily for reasons extrinsic to the medium: for information regarding the forms, composition, and theme of works that interested him. But just as clearly, Degas appreciated the intrinsic merit of the reproductive print when it rose to the level of the art it translated. The engravings after Raphael by Marcantonio that Degas copied in the mid-1850s, for example, continued to compel his admiration long after he had digested their basic information.[9]

The Return to France and New Influences

The admiration for Rembrandt, the appropriation of features of his etching style, and the particular interest in portraiture that characterized Degas's printmaking activity prior to his return to Paris in 1859 were traits shared with several of his French contemporaries who had also begun to make etchings. Working in relative isolation in Italy, Degas was nevertheless part of a commonality of interest that would soon lead to the concerted – and ultimately successful – effort to revive interest in artists' etchings in

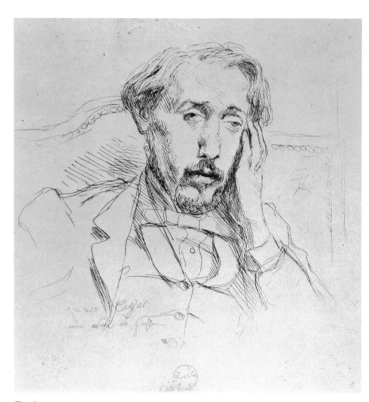

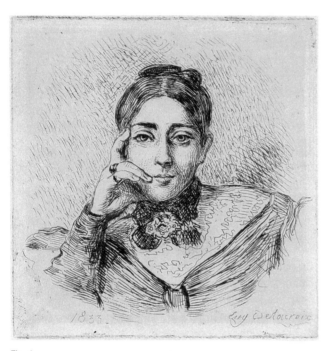

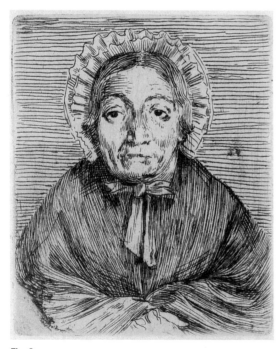

France. Once back in Paris, it was natural for Degas to continue his experimentation with etching.

The attention Degas now devoted to Delacroix's art apparently included his etchings. Degas's portrait of his sister Marguerite (cat. no. 14) suggests, both in composition and pose, a debt to Delacroix's etched portrait of Mme Frédéric Villot (Delteil 13; fig. 1), which both Degas and his friend Alexis Rouart admired and acquired for their collections.[10] But in its emphatic frontality, Degas's portrait also recalls some of Legros's contemporary prints, notably the *Head of an Old Woman* (fig. 2), which appeared in the portfolio of thirty-two of Legros's *Esquisses à l'eau-forte* published by Alfred Cadart in 1861.[11]

Degas's awareness of such current productions and his continued involvement in etching were no doubt stimulated by his friendship with James Tissot, which is documented in the latter's etched portrait of Degas done around 1860-61 (fig. 3). A melancholy pendant to Degas's own portrait of his sister, this etching is one of five Tissot made at that time, perhaps under the influence of Whistler, whom he is said to have met in 1859. Degas and Tissot may have etched together. Possibly through Tissot, Degas came into contact with Whistler, Legros, Fantin-Latour, and their friend Bracquemond.[12] Through them if not Tissot himself, Degas would also have met critic and collector Philippe Burty, then emerging as the foremost spokesman for the etching revival in France and who was

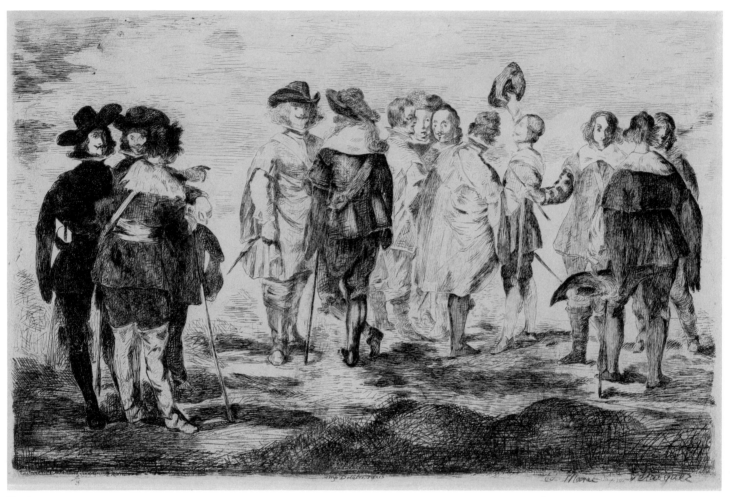

Fig. 4.
Edouard Manet after Velázquez. *Little Cavaliers*, 1860. Etching. National Gallery of Canada, Ottawa.

putting together an impressive collection of contemporary etchings, including works by Bracquemond, Legros, Whistler, and Tissot.[13] It is not surprising that the influence of etched portraits by Tissot, Bracquemond, Legros, and Whistler has been detected in Degas's roughly contemporary *Woman in a Ruffled Cap* (cat. no. 10).[14]

When Degas met Manet is unclear, and the latter's influence on his prints is not apparent until somewhat later. Degas's etched copy (cat. no. 16) after Velázquez's *Infanta Margarita* in the Louvre, purportedly the work that brought him to Manet's attention,[15] in fact suggests that he had already come into Manet's orbit. Degas was probably responding to the example of Manet's several etched translations of works thought to be by Velázquez including the *Infanta Margarita* as well as a group portrait (fig. 4) that

Degas may have acquired for himself shortly after it was completed in 1861.[16] Degas's bold handling of line in the *Infanta* appears indebted to Manet's contemporary etchings; thus both in subject and in style the print can be seen as Degas's homage – albeit an oblique one – to his more precocious contemporary.

Degas's later etched portraits of Manet (cat. nos. 17-19) firmly establish him in the Manet circle and should be seen in the context of the other portrait etchings that members of the circle made of each other. Degas's use of aquatint in the background of his bust-length portrait of Manet recalls the use of that tonal medium by both Manet and Bracquemond. Bracquemond, the technical expert of the group, may well have assisted Degas, as he had Manet, in the application of the aquatint grains.[17] But while

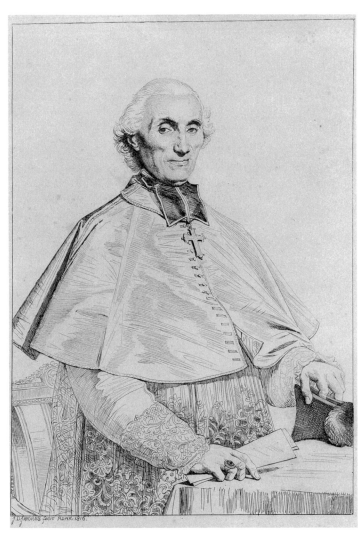

Fig. 5.
J. A. D. Ingres. *Mgr. Gabriel Cortois de Pressigny*, 1816. Etching. The Art Institute of Chicago.

his group of prints may be technically indebted to the printmaking activity of the Manet circle, the portraits also reveal a new independence on Degas's part. Stylistically they indicate a shift away from the aggressively bold idiom of his friends to a more controlled use of line, to slightly hard but elegant surfaces created by parallel hatchings that recall Degas's knowledge of early Italian engravings, Van Dyck's etched portraits, as well as Ingres's only etching, the portrait of Mgr. Gabriel Cortois de Pressigny (Delteil 1; fig. 5), which Degas could have known from Burty's collection and which he acquired for himself.[18]

Given Degas's clear involvement with the most advanced developments in French etching during the first half of the 1860s, it is initially surprising not to find his name among the founders of the Société des Aquafortistes. Announced by Philippe Burty in the August 1861 issue of the prominent *Gazette des beaux-arts* and officially constituted the following May, the Société, under the direction of its managing director and editor, publisher Alfred Cadart, represented the official launching of the etching revival. The roster of founding members is impressive: included were established etchers Jacque and Daubigny in addition to artists whom Degas admired and collected – notably Corot, Daumier, Delacroix, Gavarni, and Millet – but who were not then known as painter-etchers. Also among the founders were Manet, Bracquemond, Legros, and Fantin-Latour who, if not all friends of Degas by 1862, were certainly so by 1865, when Cadart published an updated list of the Société membership, now significantly expanded to include, among others, Degas's friend Whistler as well as Camille Pissarro.[19] If both Degas's demonstrated interest in etching and his friendship with many of those at the core of the new body would seem to have compelled his membership, so too would the extra-stylistic concerns and interests disclosed in his prints of the period.

The Precepts of the Etching Revival

In order to be properly understood, Degas's prints of this period must be seen in the context of the tenets on which the etching revival, and likewise the Société des Aquafortistes, were based. These were enunciated in the writings of the revival's advocates, a diverse group that included such talents as critics Philippe Burty and Théophile Thoré as well as writers Théophile Gautier, Charles Baudelaire, and Théodore de Banville. They stressed the essential distinction between the professional printmaker and the painter-printmaker: though the former might be an excellent technician, he was only rarely an artist. Accordingly, they emphasized the natural superiority of the painter's wholly original print over professional translations of his work as free of distortions, and enabling the artist to make "direct" contact with a larger audience. Etching was proclaimed the print medium naturally suited to the painter. Less technically rigorous than engraving, it allowed the painter to work "spontaneously," thereby permitting him to express his personality as "immediately" as in a drawn sketch; the painter's etching could indeed be regarded as

a "multiple drawing." While similar claims were advanced for lithography, it was generally held to be the popular medium for the public at large. Etching, by contrast, was pictured by Baudelaire and others as "really too *personal*, and consequently too *aristocratic*, a genre to enchant people other than those who are naturally artists." The etchings issued serially in the Société's principal publication, *Eaux-fortes modernes*, were advanced as the ideal means of putting painters into direct contact with an educated public, who received through etching "a true summary of contemporary painting."[20]

Underlying the exaltation of originality, spontaneity, and the direct revelation of personality that characterized the promotional literature of the etching revival, one detects a nostalgia for the spiritual values of the Romantic tradition which the black-and-white media had helped keep alive since the turn toward Realism. Romantic poet, novelist, and critic Théophile Gautier underlined the issues involved when he wrote, in his preface to the first volume of *Eaux-fortes modernes*, that the Société had "no other code than individualism"; it had been founded precisely because of "the need to react against positivism" and its publications were a means of combating "photography, lithography . . . lozenge and dot engraving; in a word, the regular, automatic, uninspired work that perverts the very idea itself of the artist."[21] Photography was the enemy; reproductive printmaking was suspect, insomuch as it aspired to the mechanical exactitude of the photograph.

In that context, the peintre-graveur could be regarded as the symbol of an heroic attempt to turn back the clock or at least to arrest the inevitable march of progress in the form of new image-making technologies. Applauding the young peintres-graveurs who dared "to continue the tradition of Rembrandt . . . in this age of photography [and] transfers to zinc,"[22] poet and critic Théodore de Banville identified another major technological threat: the relief printing process pioneered in the early 1850s by Firmin Gillot. *Paniconographie*, or *gillotage* as the new medium became more commonly known, involved the direct transfer of prints made in traditional ways or of specially prepared drawings to zinc plates, which were then etched so that the design stood in relief. Like wood engraving, gillotage permitted image and type-set text to be printed simultaneously. But it had two decided advantages over that medium, which had hitherto dominated the large-circulation illustrated press: the relief plates or clichés could be prepared more quickly and inexpensively by means of gillotage, since they were created by chemical action rather than by the hand of an engraver; and through the transfer of drawings or original prints, gillotage could present an artist directly, without the intrusion of a professional interpreter.

The literature commissioned or conceived to promote etching took a stridently aggressive stand against all forms of reproduction that the artist did not control directly. However, the response to both new and old reproductive media by the publishers and critics who embodied the revival was in fact less one-sided – and more positive – than that literature suggests. Something of this ambivalence can be seen in the prints of the members of the Manet circle, including those of Degas.

The Revival and Photography

Both the revival's foremost publisher, Cadart, and its most active proselytizer, Burty, appreciated the potential of photography in the realm of art reproduction. Cadart's denouncement, in one of the prospectuses for the Société, of the "deplorable tendency" of editors to increasingly consider photography as "the best means of popularizing works of art" was clearly a position adopted in support of his new venture.[23] Nevertheless, Cadart himself had published photographs of paintings and drawings beginning in 1859; and when in 1861 he took on the photographer Félix Chevalier as his partner, Cadart increased this publishing activity, abandoning it only with the formation of the Société.

Philippe Burty had, on occasion, praised Cadart's photographic productions. In fact, he was of the express opinion that photographs of works of art, since more impartial than reproductive prints, had succeeded in becoming the "indispensable references for those who collect an artist's works." Moreover, he cherished the hope that through photography good reproductions of works of art might be popularized inexpensively and he was critical of the French for failing to encourage the enterprise more vigorously. Prescient, he recognized that the change might come about by a fruitful marriage of photography with the traditional print media, whereby relief, planographic, or intaglio printing surfaces could be prepared from photographic negatives.[24]

The impact of photography was increasingly being felt in the practice of the traditional print media. Since its invention, the photograph had been relied upon by printmakers working for the vast industry that supplied the public with printed images. But what had first served as an

aid was quickly assuming the role of master. The painter-etchers of the revival were characterized as "determined to oppose with all their might the invasion of photography and to defend, whatever the cost, the ancient, hallowed territory of the old masters."[25] Yet in fact they showed interest in employing photography in their printmaking. Degas's apparent use of a photograph as the model for his etched portraits of *Mlle Wolkonska* (cat. nos. 11 and 12) was by no means unique within the Manet circle; Bracquemond had etched several portraits after photographs and Manet's own roughly comtemporary etching of Edgar Allan Poe was based on a daguerreotype. This use of new reproductive media in the service of old is also evident in Manet's employment of photographs of his paintings to make tracings, which he used in the preparation of prints based on the paintings.[26] That the photograph and the original print could co-exist and interact is further suggested in one of Degas's contemporary notebooks. There we find a reference to the photographer Disdéri along with a sketch possibly based on one of his portraits; an impression of Degas's etching *Greek Landscape* (cat. no. 1) with a portrait photograph pasted onto the same page; and a landscape photograph glued down beside a tracing of a landscape print.[27]

Other juxtapositions in the same notebook are intriguing: an original landscape etching (cat. no. 2) with Degas's tracing of a professionally made wood engraving after the drawing of another artist; Degas's etched reproduction after Ingres (cat. no. 13) near a sketch for a history painting; subtly shaded copies based on originals and on reproductive prints beside wholly original drawings.[28] They suggest that the lines between drawing and print, and between reproductive and original print were less strictly drawn than the publicly advanced positions would suggest.

The Reproduction versus the Original

Within the context of the etching revival, the reproductive print was regarded with an ambivalence not dissimilar from that with which the movement's promoters viewed photography. But unlike photography, the reproductive print—and especially engravings—received criticism from two quarters: from those favorable to photography, for not being sufficiently "faithful" to the originals, and from the revival's advocates for being primarily concerned with exactitude. The latter habitually cited the reproductive print as the antithesis of the direct expression evident in productions of the painter-etchers. Yet, like photography,

reproductive prints claimed the attention of both Cadart and Burty.

After the Société's formation, Cadart continued his earlier practice of publishing reproductive prints, which he advertised along with the Société's publications. As for Burty, he repeatedly warned against the threat photography posed to reproductive printmaking (and particularly to the "essentially national" art of engraving) and advocated ways of keeping the grand tradition alive. The professional printmaker, wrote Burty, should exploit the advantage he held over the camera lens: the ability to translate rather than merely reflect, to "get under the skin" of the painter and so act as both interpreter and critic. Yet that reasoning managed to bring Burty full circle to the conclusion that since only a painter could fully penetrate the thought of another painter, the best reproductive printmaker was necessarily the peintre-graveur.[29]

Degas's respect for the art of the reproductive print, suggested by the fact that he owned several, was clearly expressed more than a decade later. When Bracquemond received a state commission to do an etched copy of Delacroix's *Boissy d'Anglas at the Convention* (1831), Degas concluded a congratulatory note with the phrase "Vive le premier métier."[30] But that he did make a distinction between the professional's reproductive print and the artist's original print emerges clearly in a letter written to Pissarro in the late 1870s, at the time they were making prints together and experimenting with new techniques. Relaying Bracquemond's advice about the laying-in of aquatint grains, Degas observed that to create an even tone "is very difficult, if one is to believe Maître Bracquemond. But since we only want to make original artistic prints, it's perhaps easy enough."[31] Here we find Degas implicitly subscribing to his friend Comte Lepic's view that "true artists, for whom etching is not a métier but an art, are not bound by narrow technical processes"; that imperfection, "lack of finish and of definition" are the hallmarks of "true etching, the work of an artist."[32] These were the qualities that characterized Degas's etched copy after Velázquez (cat. no. 16), a translation whose boldness, like Manet's of the same subject, threatened to upset "the correct balance between respect for the master's work and interpretative liberty" that Burty had prescribed as the reproductive printmaker's ideal.[33]

While Degas thus had a healthy respect for métier, it did not restrict his own approach to making prints, even when copying the old masters. His second state of the *Infanta Margarita* is not as concerned with "finish"

as many of his drawn copies. While technical questions influenced him, they did so only insofar as they served his graphic purposes. Degas, like most of his friends, saw printmaking as essentially an extension of drawing.

The Print as Drawing:
Traditional and New Media

At the time of the Société's founding in 1862, photography and the new mechanical printing processes had not yet been sufficiently perfected to displace the established print media in their traditional role as vehicles for disseminating visual information. The Société's primary aim, in accord with that tradition, was to promote the work of contemporary painters by multiplying images of their work. Cadart's marketing strategy relied primarily on the notion of the print as a multiplied image, and he sought to take as many impressions from an etched plate as it would yield (and the market warranted) and to sell them inexpensively. In order to increase the printing life of copper etching plates, Cadart and his printer Auguste Delâtre had recourse to the new technology of electroplating the copper with a thin coating of steel–the process known as steel-facing.[34] Cadart's enterprise, essentially commercial, thus relied on volume. As a result, despite care taken in choosing papers and in printing, the contents of the volumes of *Eaux-fortes modernes* satisfied only the Société's basic aims of dissemination; often heavily and uniformly inked and somewhat lifeless, they are printed images rather than fine prints. And it was not primarily as original prints that they were treated in the literature that promoted them.

"Every etching is an original drawing," wrote Gautier in his preface to the first volume of *Eaux-fortes modernes*, suggesting at once the ease with which etching could be used and the expressive handling it naturally permitted. Banville carried this idea a step further stating, "[an etching] is not a print, *but a drawing of which one can have several copies.*"[35] This characterization of etching, as distinct from other print media and identical with drawing, was a key strategy used in promoting the etching revival. Its aim was two-fold: to portray etching as ideally suited to artists who wish to disseminate their work but were reluctant to become involved in mastering complicated techniques; and to suggest to the public that in acquiring artists' etchings, it obtained as much "original" art as in the unique painting or drawing. Its effect, however, led in two quite different directions, both of which can be seen as antithetical to the aims of Cadart and the Société.

On the one hand, the identification of etching with drawing (made with appeal to the example of Rembrandt) was a potent force that led artists like Lepic to a view of etching quite at odds with the Société's. He valued the differences rather than the similarities between any two impressions of the same print, and so concluded that exact repeatability was anti-artistic and that the intrinsic "merit" of an impression was a function of its uniqueness.[36] The most obvious means to ensure uniqueness was to print ink from the surface of the plate as well as from the permanently etched lines, a practice the English described as "surface" or "artistic" painting and that Lepic pursued to obsessive lengths in the technique he called "eau-forte mobile."

Both that attitude and that practice were controversial since, as detractors noted, if left to a printer, the extensive manipulation of ink on the plate's surface introduced a degree of unwanted interpretation of the artist's work; and even if printed by the artist himself, the practice subverted the basic *raison d'être* of the print medium.[37] Yet a number of the young painter-etchers were intrigued by the painterly possibilities of surface painting. Degas was no exception, as testify the richly inked, Rembrandtesque impressions he pulled in the mid-1860s of the portrait of Tourny that he had etched some years earlier (cat. no. 5).

On the other hand, the association of etching with drawing led to quite different attitudes, equally opposed to the Société's official view of etching. For the persistent identification of etching as drawing, coupled with a denigration of the professional printmaker's "métier," suggested that rather than a special medium with its own rules and aesthetics, etching was merely a passive vehicle to be exploited in the production of "multiple drawings." Certainly many realized, as did Baudelaire, that etching is "very complicated despite its apparent simplicity"; nor was Fantin the only member of the Manet circle to recognize that while etching may be drawing, facility in drawing does not make an etcher.[38] Yet with the emphasis on the end result rather than on the means employed, it was natural that the orthodoxy of one's means should become a secondary consideration.

Something of this attitude is reflected in Degas's portrait of his brother René (cat. no. 15). A softground etching, it was prepared by drawing with a pencil on a thin piece of paper placed on top of a copper plate covered with soft etching ground. The main virtue of that medium, as Burty's English counterpart P.G. Hamerton pointed out,

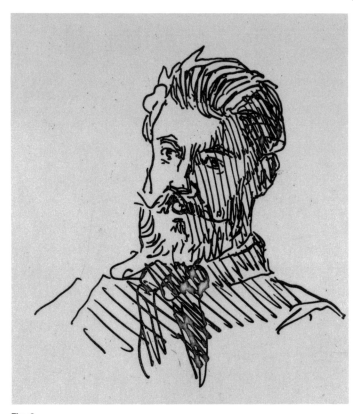

Fig. 6.
Edouard Manet. *Félix Bracquemond*, 1865. Etching. National Gallery of Canada, Ottawa.

was that the result "strongly resembles a pencil drawing"; its principal attraction was the fact that in its preparation "you do not trouble yourself about etching in any way whatever, but think only of your pencil drawing."[39] Degas may have been assisted in this experiment by Bracquemond, whose involvement in new processes for printing drawings may actually have motivated it.[40]

Bracquemond was working on a technique that was to drawings in pen and ink what softground was to pencil drawings. Baptized the "procédé à la plume" or "pen process," it permitted an artist to make an etching by drawing directly onto the surface of a copper plate with pen and ink. To those who saw the relation of etching to drawing as "analogous to the printing house and press, which multiply the written thought,"[41] this new technique held promise. Beginning in 1862-63, Braquemond made five prints in this way and Manet, under his guidance, did one (fig. 6).[42] But while related to the traditional softground technique and acknowledged as yielding "almost perfect imitations of pen drawings," the procédé à la plume displeased traditionalists like Hamerton for whom the art of etching was more than mere drawing.[43]

Technically the pen process had much in common with the new commercial relief techniques used in printing drawings, notably those patented by Comte and Vial. Since Braquemond had made prints in both these commercial techniques, this relationship is not surprising.[44] But the similarity does reveal that peintres-graveurs like Bracquemond and his friends, far from being repelled by the new relief etching techniques as the current literature stated, were in fact intrigued by their potential.

In the years leading up to the founding of the Société, gillotage had a revolutionary impact on the illustrated press. It was also used more and more to reproduce the prints of artists, including those of the future founding members.[45] Gillot's process was rapidly improved upon: increasingly, plates were made from drawings prepared with special ink on a special transfer paper, and experiments with transferring images photographically rather than directly were ongoing. It was only two years after the appearance of *Eaux-fortes modernes* that the Société was challenged on its own ground by *L'Autographe au Salon*, Louis Rousseau's publication devoted to reproducing works shown at the Salon. While the basic concept of that publication was not new, the idea of using gillotage to reproduce drawings made by exhibiting artists after their own works was a significant departure over the practice of employing reproductive printmakers. Rousseau also asked that artists provide him not with finished drawings but with "sketches," the more intimate revelation of the artist's personality. In short, Rousseau's publishing aims were quite similar to those of Cadart, but with two important differences: the artists' drawings were printed in an edition of 18,000, an enormous run for the time, by comparison with which the Société's distribution was modest indeed. Secondly, while Rousseau occasionally made use of artists' prints in preparing plates, the majority were made from drawings transferred directly, or when necessary photographically, to zinc plates. Accordingly, contributors, including Manet, Bracquemond, and other Société members, were truly free to ignore technical considerations, which was not the case with etching.

The Printed Image, Publicity, and Degas's Career

Degas's absence from the pages of *L'Autographe au Salon* in 1864 and 1865 is simply explained. The year 1865 would have been the first in which he met the basic qualification for inclusion: at the age of thirty, he showed at the Salon for the very first time with his historical picture *The Misfortunes of the City of Orléans* (Musée d'Orsay, Paris). He was unknown, a debutant, and it is unlikely that Rousseau would have invited his participation. But it is also unlikely that Degas would have sought inclusion any more than he would have wanted membership in the Société des Aquafortistes.

First and foremost, the Société had been founded in 1862 with the aim to publicize contemporary developments in art; etching, while promoted for its unique qualities, was also prominently treated as a convenient and appropriate means to that end. It was that association of etching with contemporary art and the emphasis given to the publicity possible through the etching medium that had attracted many founding members who, like Fantin-Latour, had previously shown little interest in printmaking. For Fantin as well as Manet, Legros, Bracquemond, and others in that circle had all had their work exhibited, and were intent on keeping themselves in the public eye. Degas, by contrast, was still working privately.

By 1865 Degas began to turn from his private, intensive study of traditional art to take a place in and to derive subject matter from the contemporary world about him. That year was a watershed in Degas's development: he showed at the Salon with the last of his historical compositions; the same year he completed one of his first pictures with a distinctly "modern" look, *The Woman with Chrysanthemums* (Metropolitan Museum, New York). Yet at precisely the moment Degas became a more public artist, he stopped making prints. Was there a connection between those two events?

Possibly Degas saw his printmaking to date as tentative and experimental, a relatively minor aspect of a personal apprenticeship that was now drawing to an end. This view is strengthened by the fact that Degas had used reproductive prints in the study of the old masters, had himself employed etching to copy and pay homage to the masters, and had in his original prints confined himself almost exclusively to the "traditional" genre of portraiture (albeit, as in his studies of Manet, "modern" portraiture). However, that etching could lend itself to the subject

Fig. 7.
Amand Gautier. *Work*, 1864. Etching. National Gallery of Canada, Ottawa.

matter that had begun to interest Degas was evident. Only recently Cadart had published an etching by Courbet's friend Amand Gautier dealing with the theme of work in the person of the laundress (fig. 7),[46] a subject Degas would treat in painting and, later, in etching (see cat. no. 48). Moreover, gillotage, then regarded by some of Degas's associates as the natural extension of etching, had just recently spawned an illustrated press devoted to the theme of contemporary life, a press whose imagery we know influenced Manet and the Impressionists, Degas included.

But Degas was just finding his way and was not yet ready to put etching, let alone gillotage, in the service of his new interests. The time of experimentation was past; consolidation lay ahead. When Degas later resumed printmaking, it was to continue experimentation, but in the service of publicizing his art.

Notes to Part I

We are indebted to a number of people who have assisted us in various ways in the preparation of this essay: to Claude Lupien and Charles Hupé for help with photography; to Carry-Anne Calay and Anne Mayheux for sharing their technical knowledge of printmaking; to Madeleine Barbin, Jean Sutherland Boggs, Antony Griffiths, Maija Vilcins, Suzanne Folds McCullagh, and Janine Bailly-Herzberg for assisting us with the research; to Sue Welsh Reed and Barbara Stern Shapiro for their patience and support; and to Marsha Shankman for her editorial advice. Finally, we are particularly grateful to Edward Tingley, whose suggestions and assistance at every stage in the manuscript's preparation were invaluable.

1. Until the development of panchromatic film at the end of the century, photographic emulsions responded only to the shorter wavelengths of light toward the violet end of the color spectrum. Early film was insensitive to yellows, oranges, and reds, which were recorded as unnaturally dim. The concern about fading permeates the early literature on photography.

2. Degas registered as a copyist at the Cabinet des Estampes on 9 April 1853. For his early copies after prints, see Reff 1963 and 1964. An entry concerning a projected trip made in a notebook Degas used between June and September 1855 includes a reference to François Trichot-Garneri of Chalon-sur-Saône and the large lithographic reproduction he had made in 1838 after Ingres's *Martyrdom of Saint Symphorien*; it would seem Degas wished to meet the lithographer; see Reff *Notebook* 3, p. 96.

3. Degas's admiration for Soutzo is attested to in Reff *Notebook* 6, pp. 42-43, 65. The literature has traditionally – and erroneously – identified the Soutzo in question as Prince Nicolas; in fact it was Prince Grégoire Soutzo (1815-69), his cousin (not, as often stated, his father). We are indebted to Michael Pantazzi, Associate Curator of Paintings at the National Gallery of Canada and a distant relation of the Soutzos, for having brought this to our attention. Grégoire Soutzo's collection included 143 prints by Adrien van Ostade as well as engravings by Dürer and etchings by Claude Lorrain and Rembrandt.

4. References to Tourny appear in Reff *Notebook* 2, pp. 6, 86. Lemoisne implies that Degas and Tourny knew each other from the Ecole des Beaux-Arts, though clearly Tourny was no longer a student there in the mid-1850s; see Lemoisne 1946-49, vol. 1, pp. 14-15. At the 1857 Salon, Tourny showed two portrait engravings, three portrait watercolors, and a watercolor after Titian; thereafter he showed only watercolors.

5. See, for example, his pen and wash drawing after Poussin's *Triumph of Flora* (Louvre, Paris), Atelier sale IV, 80c; color reproduction in Adriani 1984, no. 37.

6. Reff 1964, p. 251.

7. One of Charles Jacque's first etchings was a copy after Rembrandt, as were two of Delacroix's earliest etchings (Delteil 9, 10) and one of Bracquemond's of 1849 (Béraldi 229). Degas's sketch after Rembrandt is on p. 13 of Reff *Notebook* 10.

8. Reff *Notebook* 10, pp. 50-52. The importance of this print collection is underlined in Karl Baedeker, *Italy: Handbook for Travellers. Part 2: Central Italy and Rome* (Coblenz/London/Paris, 1869), p. 227.

9. The partial copy after Rembrandt appears in Reff *Notebook* 8, p. 86; on the recto and verso of the same page are compositional studies of the Tintoretto subject. In 1886 Henri Béraldi reported that Degas looked at Marcantonio engravings "pour sa satisfaction personelle" (Béraldi, vol. 5, p. 154).

10. In the Atelier sale Estampes, Degas's impression (state unknown) was sold as lot 107. Loys Delteil mentions Rouart as having owned a second state (Delteil 13).

11. See Bailly-Herzberg 1972, vol. 2, pp. 135, 137, n. 28. Degas owned one of the prints from the publication (*The Death of St. Francis*, no. 56 in Harold J. Wright, "Catalogue of Alphonse Legros's Prints," MS, Wright Archives, University of Glasgow), as well as other etchings by Legros of the same period; see Atelier sale Estampes, nos. 216-22. The *Head of an Old Woman* is Wright 11.

12. The portrait is inscribed in the plate, lower left, "James Tissot / mon ami de Gas." See Michael Wentworth, *James Tissot: Catalogue Raisonné of his Prints* (Minneapolis Institute of Arts, 1978), no. 5. Wentworth suggests that Degas and Tissot met shortly after Tissot's arrival in Paris in 1856, either in Lamothe's studio or through Elie Delaunay, Whistler, Manet, or Fantin (ibid., and no. 1). It is unlikely that Lamothe's studio was the place of their meeting; Tissot was there in 1858, when Degas was in Italy. Whistler is said to have met Tissot while copying in the Luxembourg in 1859 (E.R. Pennell and Joseph Pennell, *The Life of James McNeill Whistler* [London, 1902], vol. 1, p. 73).

13. See *Catalogue of the First Portion of the Important Collection of Modern Etchings, Engravings and Lithographs the Property of Monsieur Philippe Burty of Paris*, a four-day sale beginning 27 April 1876, London. In addition to extensive holdings of the early prints of Legros, Bracquemond, and Whistler, Burty's collection included an impression of both states of Tissot's etching *Louise*, 1861 (Wentworth 3); their rarity suggests that Burty acquired them directly from the artist.

14. See Wentworth, no. 1, and Moses 1964, no. 10.

15. Loys Delteil, no. 12, says Manet met Degas in the Louvre about 1860, while the latter was copying the *Infanta* directly onto the copper plate, and that he admired a directness of procedure Manet himself would not dare. But the current thinking is that Manet himself first began to etch in 1861, and that his own copy after the *Infanta* dates to the period 1862-64 (see New York, *Manet* 1983, nos. 15-18; see also cat. no. 16). The basic credibility of the meeting as described by Delteil is undermined by the fact that Degas indeed made a preliminary sketch before drawing his copy of the *Infanta* onto the plate (see Reff 1964, p. 252 and n. 36).

16. The majority of the sixty-eight impressions of Manet's prints in Degas's collection were acquired from the sale of Philippe Burty's collection in 1891 (see New York, *Manet* 1983, no. 15, "Provenance").

17. Juliet Bareau has noted (New York, *Manet* 1983, no. 18, "Provenance") that Bracquemond, by way of helping his friends with their plates, "acquired many proofs in rare states, amassing a fine collection" – hence his collection of important Manets. Delteil indicated that Bracquemond's son and heir, Pierre, owned an impression of each of the two portraits by Degas of Manet seated and two impressions of the bust-length Manet.

18. Lot 519 in Burty's sale in 1876 and lot 200 in the Atelier sale Estampes.

19. See Bailly-Herzberg 1972, vol. 1, p. 43. The list of 1865 included 99 names that had not appeared in that of 1862; only 13 names appearing on the first list do not reappear in 1865; see also pp. 132, 175, nn. 54-55.

20. These quotations, taken from a number of sources, are cited in Bailly-Herzberg 1972, vol. 1; the Baudelaire quotation comes from "Peintres et aquafortistes," *Le Boulevard*, 14 Sept. 1862, trans. Jonathan Mayne, in *Baudelaire: Art in Paris 1845-1862* (London and New York, 1970), pp.

221-22. (Unless otherwise stated, all translations from the French are by the authors.)

21. Théophile Gautier, "Un Mot sur l'eau-forte," in Bailly-Herzberg 1972, vol. 1, p. 267; this preface is dated August 1863. On the subject of the etching revival and renascent Romanticism, see Pierre Georgel, "Le Romantisme des années 1860," *Revue de l'art*, 20 (1973), pp. 8-64.

22. Théodore de Banville, "La Société des Aquafortistes," *L'Union des arts*, 1 Oct. 1864, p. 1, reprinted in Bailly-Herzberg 1972, vol. 1, p. 129.

23. Bailly-Herzberg 1972, vol. 1, p. 50.

24. Philippe Burty, "Exposition de la Société française de photographie," *Gazette des beaux-arts* [hereafter abbreviated *GBA*], 15 May 1859, p. 220; "Revue photographique," *GBA*, Aug. 1860, p. 253; "La Photographie en 1861," *GBA*, Sept. 1861, p. 245; "La Gravure, la lithographie et la photographie au Salon de 1865," *GBA*, July 1865, pp. 93-95.

25. Jules Janin, "L'Eau-forte, le soleil, et le crayon," preface to the second year's volume of *Eaux-fortes modernes* (1864), in Bailly-Herzberg 1972, vol. 1, p. 268.

26. By 1861, Bracquemond had published or exhibited three etched portraits. See Jean-Paul Bouillon, "Les Portraits à l'eau-forte de Félix Bracquemond et leurs sources photographiques," *Nouvelles de l'estampe*, 38 (March-April 1978), pp. 4-10. On Manet's *Poe* see New York, *Manet* 1983, no. 60; on his tracing of photographs, see Juliet Wilson, *Manet: Dessins, aquarelles, eaux-fortes, lithographies, correspondance* (Paris, 1978), no. 6.

27. Reff *Notebook* 18, pp. 100, 105.

28. Ibid., pp. 37, 102, 127, 131.

29. Philippe Burty, "La Gravure et la lithographie à l'exposition de 1861," *GBA*, Aug. 1861, pp. 173-74; "Salon de 1863: La Gravure et la lithographie," *GBA*, Aug. 1863, p. 148; "La Gravure, la lithographie et la photographie au Salon de 1865," pp. 82-86.

30. See Atelier sale Estampes, lots 1-3, 12, 13, 59, 205-10. Degas's letter to Bracquemond is published in Degas, *Lettres* 1945, no. 22. The letter dates to late 1879 or early 1880 (Bracquemond's receipt of the commission was announced in the *Chronique des arts*, 31 Jan. 1880).

31. Degas, *Lettres* 1945, no. 25. This letter dates to the late summer or early fall of 1879.

32. Le Comte Lepic, "Comment je devins graveur à l'eau-forte" in Raoul de Saint Arroman, *La Gravure à l'eau-forte* (Paris, 1876), pp. 93, 106, 108-9.

33. Burty, "La Gravure et la lithographie à l'exposition de 1861," p. 175.

34. On Cadart's use of steel-facing, see Bailly-Herzberg 1972, vol. 1, p. 45; on his marketing practices, see vol. 2, p. 110.

35. Gautier, p. 266; Banville, p. 129.

36. Lepic, pp. 99, 104.

37. See Eugenia Parry Janis, "Setting the Tone – The Revival of Etching, the Importance of Ink," in C. Ives, S. Reed, D. Kiehl, and B. Shapiro, *The Painterly Print: Monotypes from the Seventeenth to the Twentieth Century* (New York, 1980), pp. 9-28.

38. Baudelaire, "Peintres et aquafortistes," p. 220; Douglas Druick and Michel Hoog, *Fantin-Latour* (Ottawa, 1983), nos. 40, 43.

39. Philip Gilbert Hamerton, *Etching and Etchers* (London, 1868), pp. 339-40.

40. Bracquemond was as technically proficient in the technique of soft-ground as he was in aquatint; see Jean-Paul Bouillon, "Félix Bracquemond, les années d'apprentissage (1849-1859): La Genèse d'un réalisme positiviste," *Nouvelles de l'estampe*, 48 (Nov.-Dec. 1979), p. 19.

41. W. Bürger (pseud. of Théophile Thoré), "Société des aquafortistes; Préface, troisième année," in Bailly-Herzberg 1972, vol. 1, p. 271.

42. On the "procédé à la plume," see Jean-Paul Bouillon, "Bracquemond, Rops, Manet et le procédé à la plume," *Nouvelles de l'estampe*, 14 (March-April 1974), pp. 3-11.

43. Hamerton, p. 230. The relationship between softground and the pen process was clear to contemporaries like Maxime Lalanne who, in his influential *Traité de la gravure à l'eau-forte* (Paris, 1866), pp. 77ff., grouped under the rubric "théories diverses" softground, the procédé à la plume, and drypoint – the "drawing" processes.

44. For the "procédé Comte," see C. Motteroz, *Essai sur les gravures chimiques en relief* (Paris, 1871), pp. 43-45; A-M. Villon, *Nouveau Manuel complet du graveur en creux et en relief* (Paris, 1894), vol. 2, pp. 102-3. For the Vial process, see Alfred de Lostalot, *Les Procédés modernes de la gravure* (Paris, 1883), pp. 119-20. Bracquemond's essay on the Vial process is catalogued under Béraldi 173; the print he made with the procédé Comte, under Béraldi 272. The information that Béraldi published on Bracquemond's prints was provided directly by the artist, and so is particularly trustworthy (Bouillon, "Bracquemond, Rops, Manet . . . ," pp. 4 and 8, n. 7).

45. The etchings Bracquemond made for transfer to gillotage plates were commissioned for *Le Musée français-anglais*, the first major periodical to be illustrated by gillotages made from etchings and lithographs; on this subject, see Béraldi's entry for Bracquemond's *Ville indienne*, 1857 (Béraldi 156).

46. The print, *Work*, was one of two dealing with the theme of labor that were printed on the same sheet (the other was *Man Sawing Wood*). They were published as no. 134 of *Eaux-fortes modernes* in the fascicle of 1 November 1864. Gautier's name appears in Reff *Notebook* 24, p. 112 and Reff *Notebook* 31, p. 94. Bailly-Herzberg 1972, vol. 1, p. 137, suggests that Degas might have met Gautier at Cadart's atelier, although it is not certain that Degas went there at that time.

Part II:
The Peintre-Graveur as Peintre-Entrepreneur, 1875-80

In the second half of the 1870s, Degas took up printmaking again and over a five-year period produced a body of truly remarkable etchings and lithographs that earned him his reputation as a peintre-graveur. Degas was now an artist in full possession of his powers and his prints reflect this. Yet given both the intensity of his involvement in printmaking and the quality of the results, it is puzzling that only two of the prints from the period were pulled in an edition (cat. nos. 24 and 51). The "final" states of both lithographs and etchings (despite the almost baffling number of transitional states for some of the etchings) were pulled in very small numbers.

The rarity of Degas's prints has led to certain assumptions about his attitude toward printmaking, about the role of prints in Degas's oeuvre. In the most searching study of Degas's prints to date, Michel Melot offered a number of provocative conclusions. For instance, that the prints made by Degas and Pissarro during this period were a private affair, neither motivated by potential sales nor created for the purpose of disseminating and publicizing their work. Against a background of both social and technological change, Melot characterizes the etchings of Degas and Pissarro as actually subverting the traditional nature of the print as the matrix for a multiple image. Their concern with technical experimentation, involvement in the actual printing of their plates, failure to pull as many impressions as a plate could yield, and interest in the variety rather than in the even repetition that a single printing surface could guarantee are seen as a reaction against industrialization. In their emphasis on both the hand-crafted origin of the print and the uniqueness of any single impression, Degas and Pissarro were removing the print from the realm of the image-making industry, changing it from a vehicle for the "popularization" of art into something private and precious, like a drawing. Their monotypes epitomize such an attitude. It was that emphasis on "l'art pour l'art" that ultimately attracted the bourgeois collector to prints and that determined an attitude to prints and a print market that took final form in the 1890s and continues to this day.[1]

The problem with such a characterization of Degas's print work is that it understates the complexity of the work's origins and of Degas's intentions. Degas's rekindled interest in making prints reflects several varied and recent changes in his life and career: his shift from follower to leader within the avant-garde; a new outgoingness manifested in his friendships, in his interest in group participation; a fascination with contemporary life ranging from the sordid to the scientific, the theatrical to the technical; and, finally, a new need to promote his art. While on the one hand Degas's exploration of tonal techniques in his intaglio prints links him to a group of printmakers who, in the spirit of the etching revival, were seeking to disassociate printmaking from industry, on the other, Degas's transfer lithographs and notebooks attest to a fascination with the latest industrial techniques and their commercial applications.

Degas's interest in a wide variety of both "artistic" and "industrial" processes could perhaps be viewed as no more than symptomatic of his interest in the physical process of image-making, were it not for the inalterable fact of his plans to launch an illustrated periodical. In that enterprise, we indeed find Degas conceiving of printmaking with regard to both market and publicity. Moreover, far from seeking to distinguish the "original print" from the industrially "printed image," Degas sought to explore simultaneously the resources of traditional and new printing media so as to wed art with industry. The rarity of his prints is a function of both the scale of this ambition and Degas's own tendency to find conception and preparation often more compelling than realization.

Degas's Return To Printmaking

Prints had featured in the first Impressionist exhibition of 1874, in the entries of Félix Bracquemond, Comte Lepic, and Henri Rouart, all of whom exhibited largely due to their friendship with Degas.[2] But Degas's return to printmaking early in 1875 had less to do with these friendships than with his association with painter-printmaker Marcellin Desboutin. The impecunious Desboutin was then actively involved with producing and promoting his drypoints or "esquisses sur métal" as he called them, a term which underlined their association with drawing.[3] Degas and Giuseppe de Nittis, the Italian painter whose inclusion in the 1874 Impressionist exhibition Degas had also negotiated, were then Desboutin's two closest friends and Degas undoubtedly took part with them in the gatherings at Cadart's print establishment early in 1875.[4] It was likely there, in the atmosphere of camaraderie reflected in Degas's portrait of their colleague the etcher Alphonse Hirsch, that Degas made his two experiments in drypoint (cat. nos. 20 and 21).

It is difficult, however, to see these efforts as inaugurating the concentrated activity that would begin in 1876 and carry on, albeit intermittently, until 1880. Two letters sent to De Nittis and his wife in London in July 1876, from

the columnist Jules Claretie and from Desboutin, are more instructive: each contains news of Degas that reveals the intensity of his interest in printmaking and each suggests in different ways the reasons for that interest. On 4 July Claretie wrote: "I bumped into Degas yesterday. Just back from Naples he was going to the Gare de l'Est to meet his brother returning from I don't know where. He spoke to me about a new method of printmaking that he has found."[5] Desboutin, writing two weeks later, went into greater detail about Degas's current passion:

Degas . . . is no longer a friend, a man, an artist! He's a zinc or copper plate *blackened with printer's ink, and plate and man are flattened together by his printing press whose mechanism has swallowed him completely! The man's crazes are out of this world. He now is in the metallurgic phase of reproducing his drawings with a roller and is running all over Paris, in the heat wave – trying to find the legion of specialists who will realize his obsession. He is a real poem! He talks only of metallurgists, lead casters, lithographers, planishers!*

The letter continued with an account of an exhibition then at Durand-Ruel's:

You have certainly heard that Durand-Ruel has held a black-and-white exhibition here on the model of the London one. It goes without saying that I have shown the complete series of my drypoints there, including several works . . . which I have made since the [second Impressionist exhibition in April]. I hope with that to interest at least a few collectors. . . . I was excited to see . . . the most recent works by Legros and Tissot. The latter's drypoints, especially, have been an enormous success in the art world.[6]

Claretie's mention of Degas's brother recalls the recent deterioration in Degas's finances. His father had died in 1874, leaving the bank he had run with enormous claims against it, a situation complicated by the bank's large outstanding loan to Degas's brother René. Formerly well off, Degas had begun to feel the pinch and had already been forced to find less expensive quarters. Repayment of the loan was crucial to satisfying the creditors, and to discuss the problem René had traveled to Paris from New Orleans that summer. By July, Degas was doubtless aware that other financial commitments would keep René from any immediate payment, so that both Degas and his brother Achille would have to "live . . . on a bare subsistence" in order to honor their promises.[7] For the first time in his life, the selling as well as the making

of art had become a necessary consideration. But there was another problem. The general economic depression that had followed the crash of 1873 (and which had no doubt contributed to the problems at Auguste Degas's bank) was beginning to affect Durand-Ruel: by 1877 he was in financial difficulties and unable to help the artists he worked with, Degas included.[8] Printmaking may now have appeared to Degas á potential means to extricate himself from his financial troubles. His conversations with industrial printers on the one hand and the black and white exhibition on the other indicated the two different paths Degas explored to realize this potential.

The Fine-Art Print and the Printed Image

Durand-Ruel's "Exposition des ouvrages exécutés en Noir et Blanc" (1-31 July 1876) was as Desboutin and several critics noted indeed modeled on an English example, the Black and White exhibitions held at the Dudley Gallery in London. The first of these, in 1872, had developed from the awareness that works in black and white never showed well when seen amidst color, and, more fundamentally, that both the revival of etching and the burgeoning illustrated periodical press had served to generate public interest in those media. The exhibition aimed to acquaint the public with both pure and applied aspects of contemporary draughtsmanship, with the result that both types hung together, original beside reproductive prints, drawings made for the illustrated press beside drawings made as ends in themselves. Both the first and the second exhibition (in 1874) were such a success that the Black and White exhibition became an annual event, reviewed in the French as well as the English press. As a showcase, it served to make etching in particular both more fashionable and more remunerative.

Those of Degas's friends to participate at Durand-Ruel's included – with Desboutin – Fantin, Legros, Lepic, Tissot, and Manet. Manet received praise from Henri Guérard in the specialized weekly *Paris à l'eau-forte* as "one of the rare artists who understand the splendid effects to be obtained from that marvelous 'black and white' scale." Desboutin's drypoints also received favorable notice, as they had when shown earlier that year at the second Impressionist exhibition. And the prints by Tissot and Legros were, as Desboutin had indicated, widely admired.[9]

All this may have given Degas cause for reflection. He had recently seen his own work disseminated through

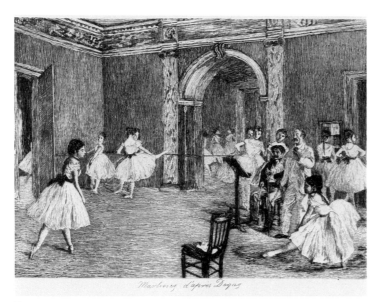

Fig. 8.
Martinez after Degas. *The Dance Foyer at the Opéra.* From *La Galerie Durand-Ruel,* 1873, pl. CXIII. Etching. National Gallery of Canada, Ottawa.

etching: in 1873, shortly after Durand-Ruel became his dealer, two of Degas's pictures appeared in etched reproductions (fig. 8) in the serial publication *La Galerie Durand-Ruel: Recueil d'estampes gravées à l'eau-forte.* There Degas found his work advertised along with that of his peers Manet, Monet, Sisley, Pissarro, and Fantin, and in the company of such luminaries as Millet, Corot, and Delacroix in a publication which, like Cadart's periodical *Eaux-fortes modernes,* sought to present the development of contemporary art in what claimed to be a "profession of artistic faith" appealing "directly" to the public.[10] Possibly Degas's work was again publicized through the etchings at the Noir et Blanc exhibition, where Durand-Ruel included twelve of the prints from his *Galerie* publication.[11] The examples of Tissot, Legros, and Manet might now also have persuaded Degas that exposure through prints was advantageous.

Tissot and Legros were artists whom Degas respected and whose participation he had tried to enlist in the first Impressionist exhibition. Only recently he had been involved in readying Legros's entries – all prints – for the second exhibition.[12] In addition to critical attention, the etchings and drypoints of these men brought them impressive financial rewards.[13] Manet's recent efforts to publicize his work through prints had been considerable. But while etchings comprised Manet's entries at the Noir

et Blanc exhibition, only one of his many recent print projects had been done in that medium. In the quest to disseminate his work in print, Manet had turned to less "artistic" media such as lithography and wood engraving as well as to the recently developed medium of transfer lithography and the related industrial process of gillotage.[14]

Degas's disclosure to Claretie that he had found a "new method of printmaking" could refer to monotype or one of the intaglio tonal techniques as well as to any of the new industrial processes that Desboutin's letter indicated he was pursuing.[15] Degas was clearly interested in both the traditional printmaking techniques and the new industrial ones. Two of his prints published early in 1877 attest to this and to the way in which these interests were linked. In January 1877 an etching by Degas related to his entry for the salon of the Société des Amis des Arts de Pau (cat. no. 24) appeared in the attractively printed accompanying catalogue. Also included were prints by Desboutin, Charles Jacque, and Norbert Goeneutte who reproduced their own submissions. Three months later, a drawing by Degas after one of his works in the third Impressionist exhibition was reproduced by means of gillotage in *L'Impressionniste* (fig. 9), George Rivière's short-lived art journal published in support of the Impressionists to coincide with their exhibition. Renoir, Sisley, and Caillebotte also had drawings reproduced there.[16]

Fig. 9.
Edgar Degas. *Dancer at the Bar.* From *L'Impressionniste,* 14 April 1877. Relief process: Devaux. National Gallery of Canada, Ottawa.

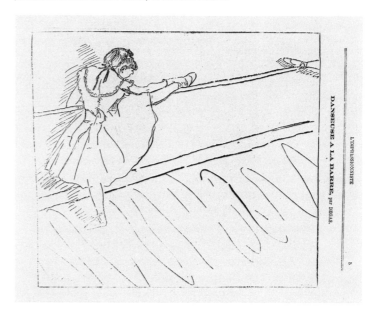

Degas's aim in both was the same: to promote his art in print and to promote the Impressionist cause – a purpose less evident in the Pau catalogue but apparent to reviewer Louis Gonse, who "without malice" noted that "most of the small etchings illustrating the volume belong to the most resolute Impressionist school." The difference between the print in Rivière's journal and the Pau print is that one is an inexpensively, rather poorly realized image whose only status is that of a reproduction; the other, as Gonse pointed out, is one of eleven "original etchings" that had been "elegantly printed on handsome Holland paper" in a publication he called "a real connoisseur's piece."[17] While the differences between the two publications were apparent, their two methods of image reproduction were in 1877 perceived as less categorically distinct, and more theoretically compatible, than they would be later. Thus it was not as strange as it may now appear for Degas to explore two directions simultaneously: the one leading to an ever increasing emphasis on the print as a precious, hand-produced object, the other to the printed image as conceived in the burgeoning industry of the illustrated press.

Cuisine: New Techniques of the Art of Printmaking

Degas returned to printmaking in 1875, the year of the death of Alfred Cadart, pioneer publisher of the etching revival of the 1860s. While Cadart's publishing ventures were carried on by his widow, that activity merely sustained the revival of interest in original prints. The revival had now entered a second phase, characterized by new attitudes (implicit in Gonse's review of the Pau catalogue) as well as by new approaches (of which Degas's contribution to that catalogue is characteristic). Increasingly, the focus of concern was not the ability of the printing surface to yield multiples, but rather interest in the many recipes for creating this surface – "cuisine" – and a preoccupation with the richness of the individual impression – "la belle épreuve."

Probably the single most important force in this change of emphasis was Richard Lesclide whose illustrated periodical *Paris à l'eau-forte* (founded 1873) published prints by a new generation of etchers. In 1873 Armand Guillaumin's etchings were featured extensively and prints by Dr. Gachet began to appear under the pseudonym Van Ryssel; in 1874 Henri Somm was a contributor and both Félix Buhot and Henri Guérard began to be fea-

tured regularly; 1876 brought Norbert Goeneutte and Jean-Louis Forain as contributors. Degas was acquainted with all these men, and he was familiar with their prints when he seriously resumed printmaking in 1876.[18] In the etchings Degas made over the next four years, we find both the influence of their technical experimentation and their attitude to etching as reflected in the pages of *Paris à l'eau-forte*.

While the contributors to *Paris à l'eau-forte* furthered the notion of the print as drawing in etchings remarkable for their bold sketchiness, it was their exploration of ways to print tone that marked a new stage in the etching revival. Part of that preoccupation was manifested in their interest in special inkings, and in the radically different effects to be achieved through the method of surface printing that had been explored in the latter half of the 1860s and that now, in 1876, Lepic baptized "eau-forte mobile," as his own invention. The technique had actually long been known to Guérard[19] and both he and evidently Dr. Gachet had taken the method to its logical conclusion by the end of 1875, when Richard Lesclide published an account of his recent visit to Guérard, "one of the most indefatigable and original explorers" of etching techniques:

We entered his studio unexpectedly and found him busy covering a copper plate with a layer of black printer's ink. This pastime surprised us all the more since the plate didn't bear the slightest trace of drawing. . . . But Guérard's answer was simple: I am trying out a new method of printmaking, printmaking with a muslin rag [gravure à la mousseline]. And as soon as his plate was evenly blackened he grabbed several oily and dirty rags, some rolled in balls, others folded in points, and worked them over the copper plate. After a good half hour, the plate was beginning to shine here and there; lighter areas were appearing, as well as gradations of light and shade; heavy pillars were beginning to emerge in the dark, supporting the arches of an imposing crypt; rays of light were filtering through the small windows, rising only to die slowly in the gloom. At last, when the artist judged his work ready, he took the plate . . . and put it through the press, covered with a sheet of paper . . . I anxiously awaited the outcome of this operation. Triumphantly the proof emerged from its felt covering. It was a marvellously tormented image of a cavern.

This description is the first known account of the art of the monotype. Provocatively, Lesclide closed it by stating: "This reproductive process is accessible to anyone, and

yields deep tonalities and effects that combine the vigor of etching with the nuances of fine lithographs. It can only be put to proper use by the Impressionist school, which is so nicely gaining ground lately."[20] The indisputable superiority of Degas's talent in the medium of monotype is not evidence of his having pioneered it. Lesclide clearly believed he was describing a new process. Without evidence to the contrary, it would seem that Degas's and Lepic's involvement with monotype came on the heels of the experiments of Guérard and Dr. Gachet and virtually in response to Lesclide's invitation.[21]

In the realm of the tonal intaglio techniques, Degas clearly followed the lead of Gachet, Guérard, and Buhot. As early as 1874, Gachet was using fine aquatint in conjunction with brush and stop-out varnish – as in *Chateau Fort* (fig. 10) – in a manner that recalls Degas's later use of the same media in such prints as *A Café-Concert Singer*, *Two Dancers in the Studio*, and *On Stage III* (cat. nos. 23, 32, and 33). Lesclide encouraged this search for "delicate and fascinating" tonal effects, praising Guérard's and Buhot's "ingenious experiments in biting, obtained by new processes" which included both regular and liquid aquatint, stop-out, sulphur tint, liftground, and open biting. Buhot's evocative *Twilight* (fig. 11) demonstrated how these processes could be used to suggest remarkably subtle qualities of light and reflection. "It belongs," declared Lesclide, "to the best of the Impressionist school, and brings to mind certain first states of roughed-out plates. However, on second glance the impression is complete."[22]

Lesclide's frequent use of the term "Impressionist" to characterize the etchings of Guillaumin, Gachet, Guérard, Buhot, and Norbert Goeneutte reflects his personal enthusiasm for the work of Manet and the Impressionists and his desire to demonstrate how particularly suited were the various tonal techniques to their aims. Degas's notebooks of the period – which contain recipes for sulphur tint and aquatint as well as ideas for the descriptive uses they could serve – and also the etchings themselves show how much Degas shared Lesclide's interest in the potential of such techniques.[23] The question of whether the subtle effects obtained through such technical cuisine could be sustained over a large edition was not at issue; the focus on the print as a means of dissemination had been replaced by a concern for the "belle épreuve."

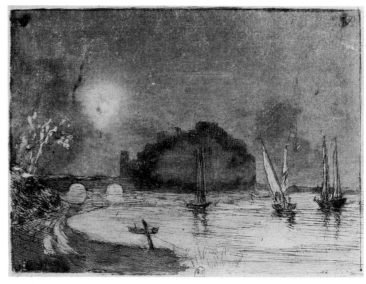

Fig. 10.
Dr. Paul Gachet (pseud. Van Ryssel). *Chateau Fort*, 1874. Etching and aquatint. Bibliothèque Nationale, Cabinet des Estampes, Paris.

Fig. 11.
Félix Buhot. *Twilight*. From *Paris à l'eau-forte*, 19 March 1876. Etching, drypoint, and aquatint. Bibliothèque Nationale, Cabinet des Estampes, Paris.

The Print as Art Object

The climate had changed since the 1860s, when the artist's direct involvement in printmaking was the prominent issue. As the new industrial reproductive techniques improved and began taking over the role of dissemination from the traditional media, proponents of the latter laid increasing emphasis on the degree to which a printed impression realized the full potential of the printing surface. The concept of the "belle épreuve," first advanced by Philippe Burty in his preface to Cadart's album *L'Eau-forte en 1875*, was an important factor in this redefinition of the aims of the original print. There Burty discussed the crucial elements in the creation of a beautiful impression of an etching: the biting of the plate, the ink chosen for the printing, the actual inking of the plate, the papers used in printing, the size of the paper relative to the print, even the manner of drying an impression.

Most important was his discussion of the essential question of how many "belles épreuves" a plate could yield. The answer was few. Using Rembrandt as an example, Burty pointed out that over the course of repeated printings a plate wore down and lost its original "bloom"; impressions from a worn plate failed to translate the artist's original idea. Rarity, even if initially circumstantial, was regarded as a value in its own right. Burty's concept of the "belle épreuve" was embraced by the administration of *Paris à l'eau-forte* where the essay was reprinted.[24] Lesclide, recognizing the qualitative differences between impressions printed on the mechanically driven press and those pulled by artists on the hand press, used the latter in printing "éditions de luxe" of limited number (usually 100), often destroying the plates thereafter. The publishing of limited editions, while of longstanding bibliophilic tradition, had only recently been introduced into the print market and was just now becoming a regular feature of it. It was a practice that was bound to be commercially exploited, and would be decried by many who saw in it only the aim to make artificially "elitist" a medium that in origin had been the most democratic art form, and with the new technique of steel-facing could be even more so.[25] Yet it was also true that some prints could yield only a limited number of good impressions and that steel-facing as practiced in the nineteenth century often entailed a coarsening of the image. This was especially true of the work of those who, like Degas, sought delicate tonal effects using unorthodox techniques.

Were Degas's etchings of the period 1876-80 conceived in the spirit of the "belle épreuve"? Yes, to the extent that they display his fascination with *cuisine*, that he printed them on his own press and sometimes experimented with different inks and inkings. But his disregard for the papers used in printing suggests a difference in intention that sets him apart from *cuisiniers* like Félix Buhot, for whom the materials and the process seemed to count as much as the product. Degas's overriding concern was with the end result, the image. Moreover, his simultaneous fascination with transfer lithography and other of the new industrial transfer techniques is indicative of a desire to find a way round the problem of rarity inherent in some of the techniques he used – to serve his *cuisine* to a larger audience.

Degas and the New Industrial Techniques

A connection between Degas's interest in techniques more associated with industry than with art and the recent activity of Manet can be inferred from two addresses in Degas's notebooks. The first is that of Alphonse-Alfred Prunaire, a wood engraver who had worked with Manet in 1873-74 cutting woodblocks for publication after drawings Manet specially made for that purpose. The second is that of Lefman who specialized in the gillotage process and had made a reputation as one of the first to effect transfers photographically, thus preserving the artist's original design, lost in the direct-transfer process. Lefman had worked with Manet in 1874 and again in 1875 as printer of the "drawings" illustrating *Le Corbeau*; he would do so again early in 1877. Some and perhaps all of Manet's work printed by Lefman may be relief prints rather than the lithographs they have been thought to be.[26]

In Degas's quest for information regarding new industrial techniques for "reproducing" drawings, he doubtless sought the advice of two other friends: Charles Tillot and Louis Amédée Mante. The former was a painter who showed with the Impressionists in 1876, the latter a bassist in the orchestra of the Paris Opéra. Both were also photographers. Tillot, as a member of the Société Française de Photographie, would have been able to supply Degas with the latest information on the processes submitted to and reviewed by that body and published in their bulletin. One of these had recently been Mante's process for preparing relief zinc plates using photography, apparently a variation on Lefman's process.[27] Further evidence of Degas's fascination with such processes is recorded in the notebooks where we find both the names of Gillot himself and of Lucas, who like Mante and many others

was currently working on the application of photography to the relief processes.[28] Degas's interest was part of a general climate of enthusiasm characterized by the belief that "the chemical printmaking processes and photogravure . . . [were] bound to enlarge the field of all the pictorial arts, putting within reach of the greatest number of people works that [had hitherto] . . . served the artistic education of the few."[29]

Prints made by artists in these new relief media, since technically related to those in the traditional media and often presented like etchings or lithographs, appeared to contemporaries like Burty to be "neither fish nor fowl."[30] Degas, on the other hand, was fascinated by the idea of producing hybrids by straddling the traditional and the new media. As both his notes and his work attest, that is the potential Degas saw in the various processes involving direct transfer, of which transfer lithography was the most obvious.

Transfer Lithography

Lithography, which had come on the scene early in the nineteenth century as the latest in quick, inexpensive image-making technology had, by 1870, been displaced by gillotage as the primary vehicle for the dissemination of popular imagery. But at the same time, the perfection of the transfer technique that was the original basis for gillotage had given lithography new potential. Transfer lithography - involving drawing with special ink or crayon on specially coated paper and then transferring the drawing to the lithographic stone, which is prepared and printed like a regular lithograph - dates back to the beginnings of lithography. But it had remained imperfect. It took the advent of gillotage, which relied on the same process, to stimulate improvement in the materials and techniques employed.

The attractions of transfer lithography were two-fold: it required no special technical knowledge and the composition, reversed when transferred to the stone, printed in the same direction as drawn, unlike all traditional print media. The view that transfer lithography was thus an ideal means of "reproducing" artist's drawings was fostered by lithographer Alfred Robaut, who in 1872 persuaded his friend Corot to try his hand in the medium. The following year, Robaut published twelve of these transfer lithographs as *Douze croquis et dessins originaux*. This title underlines the aesthetic of lithography, which was advanced in Robaut's preface as a medium for spontaneous drawing (fig. 12). Robaut regarded lithography primarily

Fig. 12.
J. B. Camille Corot. *The Meeting at the Grove*. From *Douze Croquis et dessins originaux sur papier autographique* (1872). Transfer lithograph. The Art Institute of Chicago.

as a means to multiply drawings rather than as a medium to be exploited for its own graphic resources.

The Corot publication sparked in Degas's friends a new interest in lithography, a prelude to its full-blown "revival" in the 1890s. Bracquemond made two transfer lithographs in 1873; 1874 is the date traditionally assigned to Pissarro's twelve experimental crayon and pen transfer lithographs, and the year Manet made his first "autographies" (as transfer lithographs were often called); in 1875 Legros made a portrait of Champfleury using the method; and the following year Fantin-Latour, who had begun work with the stone in 1873, made the first of his many transfer lithographs.[31]

Degas, like Fantin a friend of Robaut, was familiar with these works, some of which he owned, and influenced by this new attitude to lithography. Though he

made one lithograph entirely on the stone (cat. no. 26), it is something of an anomaly. As both his notes on sources of lithographic materials and his practice suggest, in the 1870s Degas thought of lithography less as a traditional printmaking medium than as a vehicle for the multiplication of drawings, an adjunct to the new image-making methods.[32]

Transfers and Tracings

Degas produced *The Song of the Dog* by making a drawing that was transferred to a lithographic stone; then, without any rework on the stone by the artist, the lithograph was printed. But Degas's drawing could as easily have been used to prepare a gillotage, by either directly or photographically transferring the drawing to a zinc plate, as

was the case with *Dancer at the Bar* (fig. 9), the drawing Degas prepared for *L'Impressionniste*. That drawing could equally have been prepared to make a transfer lithograph rather than a gillotage. The potential interchangeability is not all that the two images have in common. Both were based on earlier works and in preparing each Degas used a photograph of its antecedent. When the gouache (fig. 13) on which the *Song of the Dog* lithograph is based is photographically reduced to the same scale as the print (fig. 14), what the eye suspects is borne out. Degas proceeded by laying the thin, transparent transfer paper over a photograph of his gouache and tracing the contours of the major forms: the singer and the column behind her (the contours of the column are so straight they appear to have been ruled). That done, Degas deviated from the original in sim-

Fig. 13.
Edgar Degas. *The Song of the Dog*, 1875-77. Gouache and pastel over monotype. Photo Sotheby Parke Bernet, New York.

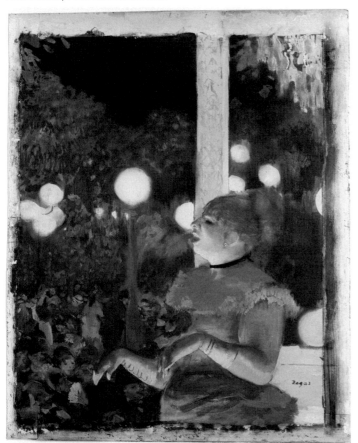

Fig. 14.
Edgar Degas. *The Song of the Dog*, 1875-77. Transfer lithograph and superimposed outline of gouache. National Gallery of Canada, Ottawa.

plifying the composition and the value structure, and by extending the composition vertically. Apparently tracing paper and a photograph were also employed in drawing the *Dancer at the Bar*.

This reliance on tracing was a natural extension of Degas's student practice of tracing reproductions and reflects as well his knowledge and emulation of Ingres, who made extensive use of tracing in preparing his own compositions. Moreover by the 1870s it was common-place for painters to have their works photographed and Degas was not alone in using such photographs as the basis for tracings used in preparing prints and reproductions.[33] His use of photographs became increasingly sophisticated, the results more independent of their sources. Thus a photograph of his pastel *The Ballet* (fig. 15) served as the germ for Degas's lithograph *Woman with a Fan* (cat. no. 37): Degas traced the photograph to establish the profile and fan of the figure in shadow, which became the principal figure of his new composition (fig. 16). He then took the thin transfer paper with the faintly indicated composition on it, placed it on top of a piece of laid paper with a distinct surface texture, and continued working; the underlying paper texture was picked up, as in a rubbing, and accounts for the particular laid-chain pattern discernible in the tonal areas of the print.

More ingenious still was Degas's use of photographs in preparing the two *Mary Cassatt at the Louvre* prints (cat. nos. 51, 52). Both compositions ultimately derive from a pastel dealing with the same theme (fig. 17). Degas had this photographed, with prints made in various sizes. Using photographs of different dimensions to trace out-lines of the standing and the seated figures, Degas was able to bring them into the different relative proportions his new compositions demanded. This can be confirmed in figure 18, which shows an outline of the pastel superim-posed over a reversed detail from the *Etruscan Gallery* at right, and a detail of the *Paintings Gallery* at left. Each is here reduced to a different degree to show the coinci-dence of outline and to demonstrate the direct relationship between the pastel, the tracings, and the final prints. It was perhaps this practice of creating new compositions out of old, working from one medium into another, that suggested to Degas the idea of "piggybacking" media.

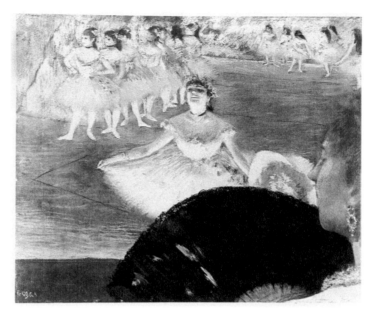

Fig. 15.
Edgar Degas. *The Ballet*, 1878. Pastel. Rhode Island School of Design.

Fig. 16.
Edgar Degas. *At the Theater: Woman with a Fan*, 1878-80. Transfer lithograph and superimposed outline of pastel. National Gallery of Canada, Ottawa.

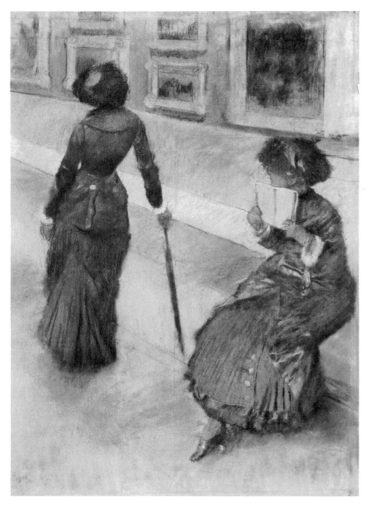

Fig. 17.
Edgar Degas. *At the Louvre*, 1879-80. Pastel. Photo Sotheby Parke Bernet, New York.

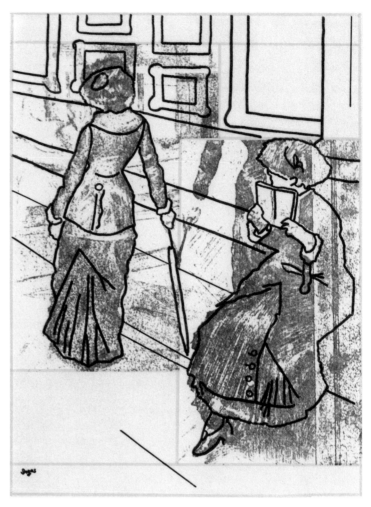

Fig. 18.
Edgar Degas. Composite of *Mary Cassatt at the Louvre: The Paintings Gallery* and *The Etruscan Gallery* (see cat. nos. 52 and 51); reversed images and superimposed outline of several pieces of paper here indicated by the gray lines. National Gallery of Canada, Ottawa.

Multiple to Unique and Unique to Multiple

As photographs of works in other media could be serviceable to printmaking, so prints could aid in non-print work. Degas used his etchings, lithographs, and even more frequently monotypes as the basis for pastels, sometimes with significant compositional changes and enlargements (see cat. nos. 25a, 30, 31, 50, and 52).[34] On occasion the evolutionary process went full circle, as in the *Song of the Dog.* The gouache whose photograph served in the preparation of the lithograph had itself started out as a monotype on paper; Degas worked this over with gouache and pastel, successively enlarging the support to keep apace with his expanding compositional intention (see fig. 19).

On still other occasions, the print used as the basis for a pastel had originally been conceived as a work in another medium, as was the case in *Mlle Bécat at the Café des Ambassadeurs* (see cat. no. 30): first a monotype, it was transferred to the stone, reworked and printed, and then heightened with pastel.

Such acts of transformation are characteristic of Degas's art: he was more concerned with realizing his goal than with the so-called "integrity" of the media he used in the process. This is particularly true of his printmaking, where we quite clearly see evidence of a remarkable willingness to experiment with creating "hybrids" that allowed him to exploit the different advan-

tages of the media involved. The monotypes that Degas transferred to the lithographic stone are a case in point and reveal an aspect of Degas's aims in printmaking hitherto unexplored in the literature.

Given Degas's interest in exploring different media, some astonishment has been expressed that he did not show interest in cliché-verre.[35] In fact the similarity in preparation and appearance between Corot's several clichés-verre, drawn on a glass plate covered with printer's ink or oil paint, and the "dark-field" monotypes of Degas is remarkable enough to suggest that Degas was already aware of the former.[36] In view of his fascination with the most current techniques of reproducing drawings, one may assume that Degas ignored cliché-verre because it had been made technologically obsolete by the new transfer processes. With the monotype, Degas could achieve effects comparable to those achieved in cliché-verre; the result was not a multiple, but by transferring the monotypes to stone Degas invested the medium with even that capacity. This piggybacking of a medium on lithography, practiced early in the century, had recently become more viable with the development of new techniques. In 1873 etcher Rodolphe Bresdin had the printer Lemercier pull editions of seven of his etchings that had been transferred to the stone. Two years later Robaut's brother-in-law Charles Desavary had even had several of Corot's clichés-verre reproduced by means of photolithography.[37]

Also suggestive of Degas's ambition to pluralize the monotype using current industrial techniques is the resemblance between his "light-field" monotypes of the latter half of the 1870s and Bracquemond's experimental "essai de procédé" (fig. 20), which dates from the same period. Bracquemond's print, a continuation of his earlier interest in the *procédé à la plume*, was evidently prepared by first painting his design on the plate with brush and printer's ink, the same method followed by Degas in preparing the "light-field" monotypes. Although it is not clear by what process Bracquemond transformed this drawing into an intaglio printing surface, there were several industrial processes then current in which the artist began by drawing on copper with "encres grasses" (greasy printing inks).[38] Indeed, Degas's designation of the monotypes he exhibited at the 1877 Impressionist exhibition as "dessins faits à l'encre grasse et imprimés" (drawings made with printer's ink and printed) indicates how he saw them and intended them to be seen. Degas chose terminology that implicitly associated his prints with the printing industry, with processes such as that explored by Bracquemond as

Fig. 19.
Edgar Degas. *The Song of the Dog*, 1875-77. A: Original paper support and monotype platemark; B and C: Extended paper support and superimposed outline of gouache. National Gallery of Canada, Ottawa.

well as the many new processes for converting photographic negatives into "impressions aux encres grasses" that were appearing in the trade literature. The notation in one of Degas's contemporary notebooks of the name and address of Théophile Geymet, among the foremost practitioners of these new processes, reinforces this connection. Finally, the ambitions implicit in the way in which Degas designated his monotypes in 1877 become manifest in his plans to illustrate an edition of Ludovic Halévy's *Famille Cardinal* using reproductions of his monotypes, to be made, it seems, by means of the photogravure process of another preeminent industrial printer, Dujardin.[39]

The emphasis on transfer media in Degas's notebooks of the period (particularly the appearance there of two recipes for making relief or intaglio plates by directly transferring to zinc or silver plates impressions of prints

pulled at an earlier date) evidence an interest in extending the life not only of monotypes, but of prints in other media as well, including delicately etched plates that could not themselves yield large editions.[40] With such recipes in mind, Degas could see in a single impression the potential for a large future edition. Thus the original printing matrix could be exploited simply for the graphic effects it permitted; the number of impressions pulled from that matrix did not matter. Degas's transfer of some of his monotypes to the stone can be seen as a sort of trial run for more ambitious undertakings; the lists of recipes and industrial printers that feature in the notebooks, as Degas's homework for such projects.

Fig. 20.
Félix Bracquemond. *Essai de procédé (Landscape with Tree)*, about 1875. Unidentified intaglio process. Private collection.

Plans for an Illustrated Periodical

By the time the fourth Impressionist exhibition closed in Paris on 11 May 1879, Degas's plans for launching an illustrated periodical were well advanced. Degas had recruited Mary Cassatt, Pissarro, and a somewhat reluctant Bracquemond to provide illustrations; Ludovic Halévy had offered to write for the periodical; and Caillebotte had promised to "guarantee" for the undertaking. When Degas wrote to Bracquemond on 13 May he was considering a "programme" he could present to the backers, probably alluding to both Caillebotte and the banker Ernst May. Apparently Degas was also addressing the practical question of how to illustrate his projected publication. For in the same letter he informed Bracquemond that, accompanied by Prunaire, he had visited "a certain Geoffroy, a famous phototypist [phototypeur] . . . a curious man, an inventor with eye trouble." And when he wrote again shortly thereafter, Degas reported that an enthusiastic Pissarro had already sent him "some experiments in softground etching" from Pontoise. We can speculate that Degas envisioned the use of conventional methods as well as the new industrial processes of printmaking in his undertaking.[41]

The planned publication was seen by Degas as a means to "make the most of our gains" from the financially successful Impressionist exhibition of 1879.[42] Yet by the time the fifth Impressionist exhibition opened the following April, the publication had still not appeared. For that, Mary Cassatt's mother held Degas responsible; writing a week after the opening of the exhibition, she explained:

Degas who is the leader undertook to get up a journal of etchings and got them all to work for it so that Mary had no time for painting and as usual with Degas when the time arrived to appear, he wasn't ready – so that "Le jour et la nuit" (the name of the publication) which might have been a great success has not yet appeared – Degas never is ready for anything – This time he has thrown away an excellent chance for all of them.[43]

The 1880 exhibition did indeed contain prints made with a view to the publication, including one by Pissarro designated as "forming part of the first issue of the publication 'Le Jour et la nuit.'" It never appeared. At the year's end, Pissarro informed critic Théodore Duret that he and his friends had "abruptly ceased" making prints.[44]

Why had the idea of an illustrated publication been so appealing to Degas and his friends; what were its con-

tents to have been; how was it to have been produced; and why was it finally abandoned? The answers to these questions are in fact suggested by its proposed title – *Le Jour et la nuit*.

Le Jour et la nuit: Publicity and the Press

The founding charter of the Impressionist group, published several months before its first exhibition in 1874, had listed among the group's aims "the publication, as soon as possible, of a periodical exclusively concerned with the arts."[45] But to date, the only attempt to realize that aim had been *L'Impressionniste*, appearing briefly in 1877 to combat the attacks of those hostile to the group. The author of a column that appeared regularly in *Le Moniteur universel* was one of those critical of the Impressionists. He called into question the purported visual "truth" of Impressionist pictures and dismissed their claim "to play the same role in painting as the naturalists do in literature." The author was anonymous, but his column was entitled "Le Jour et la nuit."[46] That two years later Degas chose the same title for his own publication may not have been coincidence. The 1877 review was neither the fiercest nor the most important of those critical of the Impressionists and had indeed contained words of praise for Degas's "remarkable series of dancers." But while the review may have been forgettable, the column's title, through its various associations, made it both memorable and particularly suited to Degas's various aims. One of those aims was to publicize his projected periodical and to take advantage of the favorable reception the Impressionists' work had received at the 1879 exhibition. And it was undoubtedly recent publishing activity both within and beyond the Impressionists' circle that had suggested an illustrated periodical as an appropriate means.

Rivière's promotion of the group in *L'Impressionniste* had been followed, early in 1878, by Théodore Duret's plans for a brochure in the group's defence, to be illustrated with etchings promised by both Renoir and Pissarro.[47] Although his *Peintres impressionnistes* did appear in May 1878, it did not include the etchings; the only illustration was a photo-gillotage of a Renoir drawing. But it was the events of 1879 that were doubtless crucial in deciding Degas's project. To begin with, Edmond Duranty became a contributing editor that year to *Les Beaux-Arts illustrés* (founded 1876). A close friend of Degas, who painted and exhibited his portrait in the same year (The Burrell Collection, Glasgow Art Gallery), Duranty had three years before defended the Impressionists – and extolled

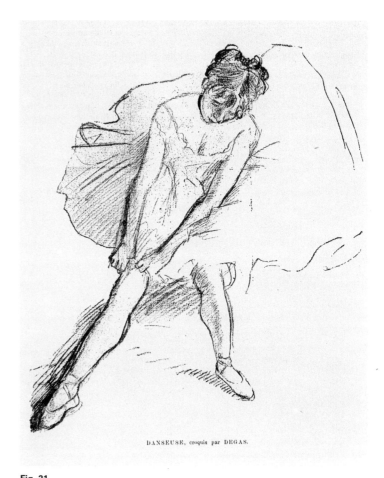

DANSEUSE, croquis par DEGAS.

Fig. 21.
Edgar Degas. *Dancer*. From *La Vie moderne*, 29 May 1879. Relief process: Gillot. National Gallery of Canada, Ottawa.

the genius of Degas – in a small brochure entitled *La Nouvelle Peinture*. Duranty took advantage of his new position to publicize the group's work at the time of their fourth exhibition, now focusing on the printed image rather than the written word. Duranty solicited graphics for reproduction, with the result that drawings by Degas, Cassatt, and Forain, as well as Pissarro's etched portrait of Cézanne (Delteil 13), were featured in the pages of this periodical in the weeks following the exhibition's opening.[48]

A second vehicle for the promotion of the Impressionists' work made its first appearance on the same day that exhibition opened. Published by Georges Charpentier under the title *La Vie moderne*, this new illustrated periodical grew out of the important literary and artistic salon held by Mme Charpentier. Degas was not a stranger to her gatherings, which included authors of the Charpentier sta-

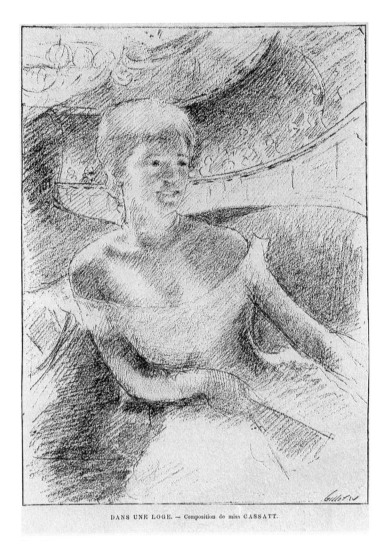

DANS UNE LOGE. — Composition de miss CASSATT.

Fig. 22.
Mary Cassatt. *In the Opera Box*. From *La Vie moderne*, 9 August 1879. Relief process: Gillot. National Gallery of Canada, Ottawa.

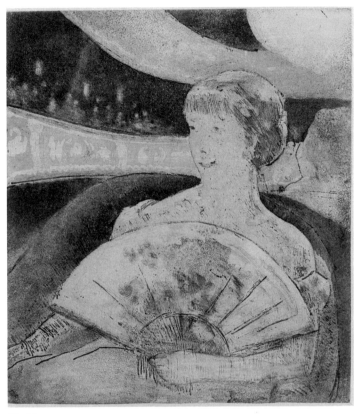

Fig. 23.
Mary Cassatt. *In the Opera Box* (No. 3), 1879-80. Softground etching and aquatint. The Art Institute of Chicago. Gift of Gaylord Donnelley and the Print and Drawing Club Fund.

ble (Daudet, Flaubert, Goncourt, Huysmans, and Zola), conservative painters such as Henner and Carolus Duran, and also Manet, De Nittis, Renoir, and others of the Impressionist circle. Also, he knew the periodical's director and editor, Emile Bergerat, a close friend of Bracquemond. These associations may have played a role in Bergerat's decision to include two drawings each by both Degas and Mary Cassatt (figs. 21, 22) in issues of *La Vie moderne*, following an issue containing a review of the Impressionist exhibition particularly deferential to Degas and encouraging of Cassatt.[49]

Although Degas undoubtedly appreciated this publicity as did Cassatt, *La Vie moderne* was not their ideal vehicle. As editor, Bergerat set as much if not more store on such "great modern masters" as Henner, Meissonier, and Bonnat; the Impressionists were in a sense compromised by this attention to an art unsympathetic to theirs.[50] Yet aspects of the appearance of their work in *La Vie moderne* do suggest their own publishing ambitions. Cassatt's drawings were based on (and promoted) paintings shown in the Impressionist exhibition; some of the prints she (fig. 23), Pissarro (fig. 24), and Raffaëlli (fig. 25) would subsequently prepare for *Le Jour et la nuit* were also dependent on paintings.[51] Though the drawings of dancers Degas supplied Bergerat did not publicize works in other media, the context in which they were published is equally suggestive of his aims. One of the drawings (fig. 21) accompanied a classic example of Ludovic Halévy's writ-

ings on the world of the backstage, a piece entitled "Notes prises pendant un examen de pantomine." However fortuitous the combination may have been, it foretokens both the collaboration Degas had in mind for his periodical and the nature of its contents. The other drawing was published in conjunction with a review of the Exposition de Dessins de Maîtres Anciens at the Ecole des Beaux-Arts. This grouping suggests the relationship, implicit in its title, between *Le Jour et la nuit* and the growing interest in the art of "black and white."

Le Jour et la nuit: Black and White

The black and white media had recently received vigorous promotion in Paris. The exhibition of old master drawings, the first of its kind in France, aimed to further the growing interest in media hitherto overshadowed by painting. No sooner had that exhibition closed than *La Vie moderne* opened another on its premises of selected drawings and illustrations (the categories were distinct) that had been reproduced in its pages, including works by Forain and Renoir. In the realm of prints, similar attention to the importance of "black and white" had emerged the preceding year from the large retrospective of Daumier's work held at Durand-Ruel's gallery. On that occasion, Duranty declared Daumier-the-lithographer more important than Daumier-the-painter, ranking him as a draughtsman with Michelangelo, Rubens, and Rembrandt.[52]

Degas shared Duranty's high opinion of Daumier and the Durand-Ruel exhibition served to fire his interest in his lithographs (1800 of which he eventually owned), and to suggest the potential potency of a medium usually dismissed as "minor." The following year, Degas's interest in "black and white" was doubtless stimulated further by the many old master drawings in the exhibition organized by his friend Charles Ephrussi. And the show at *La Vie moderne* would have underscored the dual potential the new processes had built into the graphic media: works that served as reproductions could also be appreciated and marketed as works of art.

Pissarro too had recently become aware of the new status of black-and-white media; he had taken up printmaking again in 1878, sending a third state of his large drypoint *Woman Emptying a Wheelbarrow* (Delteil 31) to the 1878 Dudley Gallery Black and White Exhibition. The asking price for the print reveals Pissarro's belief in both its merit and the attraction prints now held for a buying public.[53] That interest is reflected in the title "Le Jour et la nuit," metaphorically black and white. The choice of such a

title situates the undertaking within the broad context of the black-and-white movement in France – a movement, in fact, with ideological overtones.

Black and White and the Applied Arts

The 1879 exhibition of old master drawings had, like Durand-Ruel's Noir et Blanc exhibition three years earlier, been modeled on an English example. In the climate of patriotic concern for the health and future of France that had developed since the defeat of 1870, such dependency was considered ominous: just as the country's military strength had proved vulnerable, so might her supremacy in the arts and sciences, a threat to her position as an exporting nation. The best defense against foreign encroachment was, it was now advanced, to educate the public. The Ecole des Beaux-Arts exhibition was in fact conceived to this end. So too were the two illustrated periodicals that Degas and his circle were involved with. *Les Beaux-Arts illustrés* had first sounded the charge in the statement of intent in its first issue: "In the fine arts, to which this weekly review is devoted . . . we see the means to form taste, to improve it and thereby to preserve in the industrial areas in contact with art that superiority which other nations still acknowledge in us while struggling to take it away from us."[54]

The 1878 Universal Exhibition held in Paris exacerbated the fears of those concerned with the vitality of the relationship between French art and industry. These included the habitués of Mme Charpentier's salon. *La Vie moderne* was born of the determination to "assist in the reconstruction of the French homeland and pursue vigorously the fight against all the bad habits that affect it, especially that which blinds it to the progress realized by other nations." Such progress included the illustrated press, and *La Vie moderne* sought to reclaim for Paris the preeminence in that domain that was now London's. But it also aimed to address the major underlying problem – the perception of art and industry as mutually exclusive – by insisting that masters of the applied arts, such as ceramists, were of the same "intellectual family" as painters and sculptors.[55]

Degas's own interest in the applied arts was then particularly keen. Among the list of works he drew up in planning his contribution to the 1879 Impressionist exhibition, we find a "Portrait on a lampshade," and while that novelty was not among his entries (and apparently never executed), his works there did include several painted fans and the "essai de décoration" on the same list.[56] This last

work may be connected with Degas's project for "Portraits in a frieze for the decoration of an apartment" (see cat. no. 40, fig. 1) which, in turn, is related to his contemporary prints: the figure of Ellen Andrée at right appears in reverse in the small etching of 1879 (cat. no. 40) and the poses of the remaining two figures recall the two *Mary Cassatt at the Louvre* compositions (cat. nos. 51, 52).

There are other points of similarity between Degas's "applied art" objects and his contemporary prints. The rather abstract compositions as well as the caricatural quality of the figures on the fans are also evident in certain etchings (cat. no. 39), lithographs (cat. no. 37), and monotypes. These qualities are also characteristic of the ceramics that Degas decorated at that time (fig. 26).[57]

Degas's interest in ceramics may have been fostered by Pissarro, who had recently resumed his involvement in ceramic decoration.[58] But a more important stimulus was Bracquemond, who since 1872 had been head of an atelier in Auteuil that produced designs for the decoration of porcelain manufactured at Limoges by Charles Haviland. At the 1879 Impressionist exhibition, Bracquemond's wife Marie had exhibited a faience dish as well as cartoons for large tile murals. The cartoons impressed Degas and may have encouraged his single painted tile.[59] More important for him, however, was the printmaking activity at Auteuil. A primary aspect of Bracquemond's job was to oversee the printing of designs as etchings and lithographs, which were then sent to Limoges where, by transfer, they were used to decorate porcelain. Bracquemond had made numerous prints for dinner services, and some were included in the Impressionist exhibition of 1880. It was in the experimental atmosphere of the Auteuil atelier that Degas made at least one print - the transfer lithograph *Dancers in the Wings* (cat. no. 38) which he inscribed with the "H & Cº" mark sometimes imprinted in the Haviland ceramics. That lithograph, which could have been transferred to a variety of ceramic forms, suggests that Degas may have toyed with producing prints for use in ceramic decoration (the plates and the tile he had decorated were painted by hand and, apparently, not fired). Certainly, the atelier's use of printmaking as an adjunct of the industrial arts could have reinforced some of Degas's own notions about the use of prints.

Le Jour et la nuit: Bridging Art and Industry

In planning how to realize his illustrated periodical, *La Vie moderne* would have been Degas's obvious model. This periodical's stated aim was to bring art to the industry of

Fig 26.
Edgar Degas. *Café-Concert Singer*, about 1875-80. Oil paint on ceramic tile. Photo Paul Rosenberg & Co., New York.

printed with patterns that could produce a uniform gray tone.[62] *La Vie moderne* was the first periodical to make extensive use of this new drawing medium. The cover illustration of the second issue featured a drawing by Renoir made on scraperboard (fig. 27) that demonstrated the medium's ability to convey "painterly" effects.

The printing industry's search for a satisfactory means of reproducing tone paralleled the printmakers' current preoccupation with achieving tonal effects. These two concerns naturally overlapped: Renoir's drawing was made on a scraperboard that received its embossed pat-

Fig. 27.
Auguste Renoir. *Léon Riesner*. From *La Vie moderne*, 17 April 1879. Relief process: Gillot. National Gallery of Canada, Ottawa.

the illustrated press; to that end it employed artists as well as professional illustrators to print their work on high quality paper using the most up-to-date refinements of the Gillot process. Never before had gillotage yielded such fine results and *La Vie moderne* claimed to have effected "a revolution in the illustrated press."[60]

Degas, like Goncourt and others associated with the Charpentier salon, doubtless kept abreast of the activity at *La Vie moderne*, and was aware of Bergerat's ambition to produce gillotage images of unsurpassed quality. But it is unlikely that Degas fully shared the editor's enthusiasm for the print quality of the images in *La Vie moderne*. Degas's own drawings reproduced there had suffered a loss of subtlety and clarity in their translation to the printed page. Mary Cassatt's more tonally developed work (fig. 22) had reproduced even less satisfactorily.[61]

Those reproductions point up the major flaw in gillotage in the late 1870s: despite improvements, the medium could not yet effectively reproduce halftones. Charles Gillot then developed the so-called "papier procédé" or scraperboard, thick papers or cards, coated with barium oxide, which were embossed and sometimes

Fig. 28.
Félix Bracquemond. *Le Chemin des Coutures à Sèvres,* about 1876-79. Etching and aquatint. National Gallery of Canada, Ottawa.

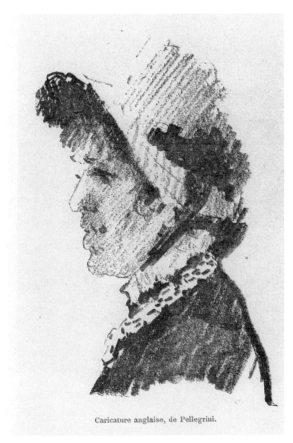

Caricature anglaise, de Pellegrini.

Fig. 29.
C. Pellegrini. *English Caricature.* From *La Vie moderne,* 3 July 1879. Relief process: Gillot. National Gallery of Canada, Ottawa.

tern by being sent through the press against an evenly grained aquatint plate. With scraperboard just coming into use, it quite naturally appeared that traditional aquatint might be an alternative means to the same end. Thus Bracquemond, working with Gillot's competitor the firm of Yves et Barret, attempted to transfer his print *Le Chemin des Coutures à Sèvres* (fig. 28) to a zinc plate and make a gillotage; this experiment "to see how the aquatint would come out" was successful. *Le Chemin des Coutures* is also one of the few prints in which Bracquemond used the technique of liquid aquatint that he explained to Degas, who in turn described it to Pissarro in the letter that marks the high point of the collaboration towards *Le Jour et la nuit*.[63] And more likely than not, Degas's ideas to employ both new and traditional media in his periodical can be related to Bracquemond's experiment. Degas's note instructing Bracquemond to "Go to Gillot without me, I am too busy"[64] may refer to plans to make gillotages from the aquatints he and his associates were then making.

Mrs. Cassatt referred to *Le Jour èt la nuit* as a "journal of etchings," a rather vague and untraditional format that the subsequent literature has not much clarified. The evidence indicates that Degas was neither contemplating a serial publication of etchings on the model of Cadart's *Eaux-fortes modernes* nor a combination of in-text gillotage illustrations with *hors texte* etchings, the formula used by the *Gazette des beaux-arts* and *L'Art* (founded 1875), to which Bracquemond had contributed etchings shown at the 1879 Impressionist exhibition. For the prints Degas and his fellow contributors were making simply would not allow for the large editions both types of publication involved. The editions of the few prints pulled in readiness for the first issue of *Le Jour et la nuit* were limited to fifty impressions. Yet Degas's aim was a "monthly review" – a periodical that reached a significantly larger audience than an edition of fifty prints implies.[65] The only indication from Degas himself as to how he conceived the publication is found in his prediction to Pissarro: "With our issues [livraisons] *before letters* we will cover our expenses. That's what several print collectors have told me."[66]

In view of Degas's interest in print techniques, we can hypothesize that *Le Jour et la nuit* was in fact to have been illustrated by gillotages made from original prints to be supplied by the contributors. The planned *mise-en-page* may have resembled that of *La Vie moderne* and it is easy to imagine Degas's small images of the café-concert and contemporary Parisians (cat. nos. 27, 28, 35) as conceived

to serve as tailpieces and in-text vignettes like those Bergerat requested of Manet, Forain, and other of Degas's acquaintances for *La Vie moderne* (fig. 29).[67] Degas's idea of "issues *before letters*" was probably a plan to produce the original prints from which the gillotages were made in a small edition for subscription at a higher cost by interested collectors.

In physical production, *Le Jour et la nuit* was to marry traditional and up-to-date printing techniques; in its marketing, it was conceived both as an illustrated periodical for a large audience and as a vehicle for the sale of original prints to the few.

Le Jour et la nuit: Modern Life

The "Jour et la nuit" column in the *Moniteur universel* reported all of the important and unimportant material that was the stuff of contemporary life, all that is encompassed by the rubric "faits divers" (the title actually adopted by the column in 1879). It kept its readership up-to-date with the goings-on of the aristocracy, the wealthy bourgeoisie, and the demi-monde; with art exhibitions, concerts, the latest realist novel by Goncourt, as well as with more popular forms of entertainment; with great deeds, crimes, and suicides; with religious issues as well as with the latest applications of electric lighting; and with the weather.

The prints that Degas and his colleagues made for a publication of the same name indicate remarkably similar aims. Those shown at the 1880 Impressionist exhibition reflect the diverse aspects of modern life that were to have made the publication's content: Cassatt's image of the night life of the well-heeled and fashionable (fig. 23); Degas's picture of the intellectual pursuits of the comfortable urban bourgeoise (cat. no. 51), Pissarro's scenes of man and nature (fig. 24), and Raffaëlli's portrayal of the dispossessed (fig. 25). Although the literature on *Le Jour et la nuit* specifies that only one print by each artist was conceived for the publication, we must in fact view all of the contemporary prints by Cassatt, Pissarro, and Degas as part of the undertaking. Thus to the foregoing list, we must add Cassatt's various depictions of bourgeois domestic life, Pissarro's rural scenes of the industrious peasantry and of weather effects (most notably in his *Rain Effect*; Delteil 24), and Degas's images of the backstage and onstage life of performers and of popular entertainment. But while the subject matter of that body of work mirrors the "faits divers," it is not its direct reflection; it transcends its banality.

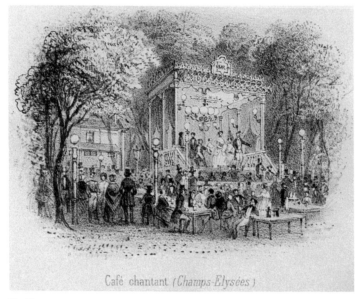

Fig. 30.
Ch. Rivière. *Café-Chantant (Champs-Elysées)*. From *Subjects for the Young Artist*, 1854, pl. 17. Lithograph. Bibliothèque Nationale, Cabinet des Estampes, Paris.

Fig. 31.
G. Droz. *Sketch of a Café-Concert on the rue Madame*, 1857. Lithograph. Bibliothèque Nationale, Cabinet des Estampes, Paris.

This is particularly evident in Degas's treatment of the café-concert. When Degas first began to employ this subject in the mid-1870s, the café-concert was a well-established form of Parisian entertainment. As early as 1854, instruction books for young artists had proposed it as a mode of urban entertainment from which to draw inspiration (fig. 30). Degas had displayed an early interest in the genre in a pen-and-wash drawing of a public dance hall; in its subject, choice of medium, and handling, it is indebted to the work of Constantin Guys.[68] But while considered appropriate subject matter for an "illustrator" like Guys, the café-concert was generally deemed unworthy of the serious artist's attention. It was in popular prints that the image of the café-concert was perpetuated in the 1850s and 1860s as a place of more or less innocent entertainments (fig. 31).

The popularity of the café-concert grew, with the result that what had begun as a simple form of entertainment had become an elaborate spectacle to be enjoyed in the suburbs as well as at the more fashionable locations in the city. Chief among these was the Champs-Elysées, where side by side were found the Alcazar and the Ambassadeurs, providing entertainment out-of-doors from spring to fall. The Ambassadeurs (fig. 32) was considered "the most beautiful, the most attractive, the most entertaining of its kind and consequently the most frequented by the the pleasure-seeking crowd." This was "a diversified public representing every class of the Parisian population, from the purest snob to the lowliest store clerk" (fig. 33), all of whom gathered "in order to breathe an air more or less pure and to listen to airs more or less impure."[69]

The entry in Edmond de Goncourt's journal for 6 August 1876 provides us with a vivid picture of the magnetism of the Ambassadeurs and its neighbor:

I dine at my young cousin's, with her brother. Dessert is not yet finished and there is already a frenzy, an impatience, a craze to go where? You can guess it! To a café-concert on the Champs-Elysées. Note that my cousin is a little girl from faubourg Saint-Germain and her brother a specimen of the fashionables of the clubs. There is a crowd, a crush. . . . At last, after enough diplomacy to get us front row seats at the Opéra on a first night, there we are, all three of us, right at the back of the big drum. . . . And all that to hear . . . "Have you seen that handsome boy?" An enthusiam, an electricity, a solidarity of the public joining in the refrain as if it were a patriotic anthem.[70]

The images of the café-concert and other urban and rural entertainments found in popular lithographs and the illustrated press clearly influenced the Impressionists' choice of both subject matter and compositional treatment; Degas's notebook sketches, prints, and paintings of the 1870s attest to that indebtedness.[71] But Degas's printed images also reflect the degree to which he transcended his sources: for whether topographical, comic, or satiric, the popular views of the café-concert are, almost without exception, banal and lifeless in comparison to Degas's. Degas transformed the popular pictorial tradition by imbuing it with an intellectual rigor shaped by keen observation. His realism had a distinctly scientific bias, enabling him to realize visually the same qualities as Zola had in his "naturalistic" novels. This he did by bringing his interest in contemporary science to bear on the subject matter and the very fabric of the prints he made for his publication.

Le Jour et la nuit: Modern Ideas

In part Degas's concept of modernity involved conveying modern ideas through modern subject matter. The ideas "for the journal" that Degas entered in his notebook in May 1879 reveal his current fascination with capturing the expressive face, the characteristic movement, the suggestive object:

Do all kinds of objects in use, placed, associated in such a way that they take on the life of the man or woman, corsets that have just been taken off, for example, and which still retain as it were, the shape of the body, etc. etc.

Series on instruments and instrumentalists, their shapes, the twisting of a violinist's hands and arms and neck, for example. The swelling and hollowing cheeks of a bassoonist, and oboist, etc.[72]

Degas's concern with thus conveying "modern feelings" dates back to the late 1860s, when both his notebooks and his work attested to an interest in theories of physiognomic expression.[73] A decade later, the exhibitions devoted to Daumier and the drawings of the old masters, Degas's close association with Duranty, and his interest in contemporary scientific findings all served to strengthen his fascination with physiognomy.

Duranty considered the "truth" with which facial expressions and gestures were rendered as critical to the success of a work of art. He compared Daumier's knowledge of physiognomy to Holbein's and praised his "way of summing up figures or objects in a few lines that translate

Fig. 32.
S.T. after A. Normand. *The Café-Concert des Ambassadeurs, on the Champs-Elysées*. From
L'Illustration, 29 May 1875. Wood engraving. National Library of Canada, Ottawa.

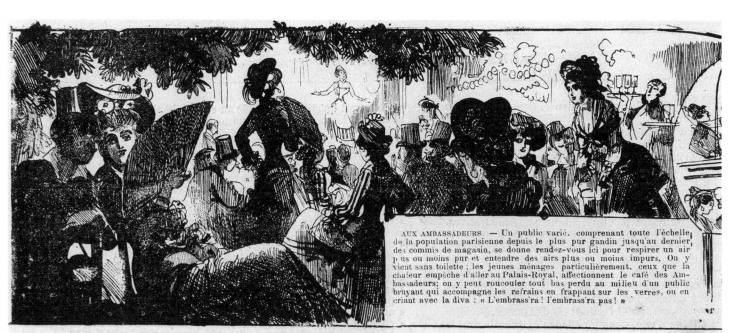

AUX AMBASSADEURS — Un public varié, comprenant toute l'échelle
de la population parisienne depuis le plus pur gandin jusqu'au dernier
des commis de magasin, se donne rendez-vous ici pour respirer un air
plus ou moins pur et entendre des airs plus ou moins impurs. On y
vient sans toilette ; les jeunes ménages particulièrement, ceux que la
chaleur empêche d'aller au Palais-Royal, affectionnent le café des Am-
bassadeurs; on y peut roucouler tout bas perdu au milieu d'un public
bruyant qui accompagne les refrains en frappant sur les verres, ou en
criant avec la diva : « L'embrass'ra ! l'embrass'ra pas ! »

Fig. 33.
Roby (pseud. Albert Robida). *On the Champs-Elysées, Evening – "Ombres chinoises et
bienheureuses": At Les Ambassadeurs and l'Alcazar*. From *La Vie parisienne*, 1 July 1876.
Relief process: Yves & Barret. National Gallery of Canada, Ottawa.

their characteristics." These gifts, abundantly displayed in the lithographs, made Daumier a preeminent "historian of our habits, of our appearance and of our race" carrying on the eighteenth-century tradition of the "school of observation" that included "the Moreaus, the Cochins, the Saint-Aubins."[74]

Degas's admiration for Daumier's lithographs is directly felt in his choice and his compositional treatment of certain subjects beginning in the late 1860s and continuing to the early 1880s. And by the late 1870s, Degas had also begun to assemble a collection of lithographs by Gavarni, finally larger than his collection of Daumier.[75] Degas's interest in these acknowledged masters of physiognomy and expressive gesture was the same as that which led him to read *La Nature*, a weekly "review of the sciences and of their applications to the arts and to industry" that included articles on phrenology.[76] Clearly he was fascinated by subject matter whose modernity went beyond its visual surface.

Degas manages to infuse his depictions of Mlle Bécat at the Ambassadeurs (cat. nos. 30, 31) with the unique vitality that had made her a celebrity. "You do not draw a word," Duranty quoted Daumier as saying, "you draw a gesture, an expression"; and like Daumier's lithographs, Degas's have no need of an explanatory text to convey their meaning. Degas searched for the synthetic gesture that could at once convey the "*intention of suppressed feelings* or movements *just about to happen*" that Duranty found exemplified in figures like the angry vendor in Gabriel Metsu's *Amsterdam Vegetable Market* (fig. 34). Mlle Bécat's pose (fig. 35) is similarly "popular" and expressively rich, but it reads differently. Crouched and leaning forward, her hands askew and placed on her thighs, she is at once vulnerable and self-possessed, playfully offering herself to her audience while teasingly keeping her distance. We sense the musical accompaniment in the jaunty rhythm of her posture which, while it conveys the spirit of the performance, also anticipates its end. Degas has realized "a picture that really *moves* and *speaks*, in the truest meaning of both words."[77]

Degas's images of the café-concert also reflect his current fascination with the theme of evening illuminated by artificial light, one of the ideas included in his list for his projected journal. That subject too evidences Degas's interest in "la science moderne," where the rapid developments of new lighting systems – gaslight and especially electric light – during the last years of the 1870s "preoccupied . . . the scholarly world and the general public," who

Fig. 34.
Z. de Mare after Gabriel Metsu. *The Vegetable Market, Amsterdam* (detail). From *Gazette des beaux-arts*, January 1877. Relief process: Gillot. National Gallery of Canada, Ottawa.

Fig. 35.
Edgar Degas. *Mlle Bécat at the Café des Ambassadeurs: Three Motifs*, 1877-78. Transfer lithograph. Museum of Fine Arts, Boston.

were kept up-to-date by articles in reviews like the *Beaux-Arts illustrés* and *La Vie moderne* as well as in such specialized periodicals as *La Nature*.[78] The perfected "electric lamp" invented by Paul Jablochkoff in 1877 was almost immediately used to light some of the main avenues, monuments, and department stores of Paris; in 1879 both the exhibition of old master drawings at the Ecole des Beaux-Arts and the Salon were illuminated by Jablochkoff & Co., with whom Degas was in contact regarding the lighting of the Impressionist exhibition that year.[79] But electricity did not immediately render gas obsolete. New gaslights installed on the rue du Quatre-Septembre in 1879 were compared favorably with the electric lighting installed the previous year on the nearby avenue de l'Opéra. And it was not until 1882 that "Jablochkoff's harsh light" replaced the "garlands of opaque glass gaslights" which, against the night sky, seemed to Jules Claretie "strings of artificial pearls in a jewel-case of silk velvet."[80] These and other effects of natural and artificial, direct and reflected light are as much the subject of Degas's *Mlle Bécat* as is the performance itself.

This interest in a modernity rooted in contemporary technology is also indicated by a notebook entry Degas made at the time he began to think seriously of launching a publication. An address on the rue Montmartre with the note "Bellet d'Arros / crayon voltaïque,"[81] is a reference to the latest invention permitting "the reproduction of a drawing in a more or less unlimited number of copies." Reported in the issue of *La Nature* that appeared two days after the opening of the 1879 Impressionist exhibition, the creation of MM. Bellet and Hallez d'Arros (fig. 36) consisted of a "pencil" that emitted a continuous series of electric sparks strong enough to pierce paper. By drawing with this "electric pencil" on a sheet of paper placed on a metal plate, an artist could make a design consisting of a series of small perforations. As the article pointed out, this in turn could be used as a stencil either to print a limited number of "drawings" directly or, for a large edition, to make lithographs or gillotages by transferring the design to a lithographic stone or a zinc plate; "finally," the author promised, "it is also possible to succeed in reproducing etchings, as we have seen in fine examples,"[82] although the method was not explained.

Intrigued with the most current methods of image reproduction, Degas would naturally have been attracted to this new device. Whether he actually visited the inventor and tried the "electric pencil" to make etchings or gillotages is unknown. And while none of the etchings

Fig. 36.
The New Electric Pencil of MM. Bellet & Hallez d'Arros. From *La Nature*, 12 April 1879. Wood engraving. National Gallery of Canada, Ottawa.

exhibit signs of its use, some do reflect Degas's fascination with "modern" tools. Late in 1879, Degas began to use as a drawing instrument in printmaking the "crayon de charbon" or carbon rod used in electric arc lamps (see for example cat. nos. 39, 40, and 42), also commonly known as "crayon voltaïque."[83] Though Degas appreciated the "attractive grays" he could obtain by scratching the plate with this instrument, its association with the new technology was probably equally attractive to him. The prints made with carbon arc rods are yet another example of Degas's desire to connect old and new, to infuse tradition with modernity, both in the actual production of his images as well as in their content. It is particularly appropriate that with the carbon rod prints the two concerns merge: the rod from electric lamps was employed to make images that explored the effects of gaslights.

The Project Abandoned

The reasons *Le Jour et la nuit* never materialized were probably several. To begin with, other illustrated publications had followed the lead of *La Vie moderne*. Shortly after its appearance, F.G. Dumas had launched his widely praised *Catalogue illustré du Salon*, which employed reproductions of drawings made by artists after their Salon paintings. Its success had immediately led to the publication of a deluxe edition that contained, in addition to gillotages, original etchings and literary contributions.[84] In

conception, this deluxe edition was probably close in several respects to the projected *Le Jour et la nuit*.

So too was *L'Art de la mode*, the periodical started in 1880 by the early collector of Impressionist painting and occasional critic Ernest Hoschédé. Hailed as an exemplar of the "new artistic press," it listed among its promised contributors writers Goncourt and Halévy and artists such as De Nittis who specialized in depicting modern life.[85] In its focus – fashion as a reflection of society – and in its general tone, *L'Art de la mode* had affiliations with the planned *Le Jour et la nuit*. Even the decision to include plates "printed in color," as well as the method of printing them, was related to Degas's idea in the summer of 1879 to make color prints using woodblocks and stencils, printing color over "line drawings" made with etching or softground.[86]

These developments may have caused Degas and his friends to reconsider the wisdom of their plans. For while neither *La Vie moderne* nor subsequent illustrated publications duplicated Degas's intention, all drew on some of the same ideas, called on some of the same resources, and competed for part of the same market. To ensure regular publication, at the proper standard, and at a cost to compete with other periodicals was clearly no easy task. By the fall of 1879, faced with the necessity of "earning a living," Degas discovered it was "impossible" for him to devote himself entirely to the journal: "always articles to fabricate" he wrote Rouart, "the last is a monochrome fan for Mr. Beugniet. I think only of prints and make none."[87] As 1880 progressed, he came to see this dilemma as insurmountable. To master printmaking would simply take more time than Degas or Pissarro could afford. They abandoned *Le Jour et la nuit* and "quite suddenly" stopped making prints.[88]

Early in 1881, Degas, through Pissarro, was invited to exhibit prints at the first London exhibition of a newly formed society of painter-etchers that included Legros and Tissot; his response was that he was "absolutely against" exhibiting his work there. Perhaps Degas, like Pissarro, had now come to regard his prints as "primitive experiments" that he feared the organizers would find too "imperfect" to hang, or that if accepted would not represent him well.[89] It is also possible that he was simply disenchanted for the moment with printmaking, and since no longer making prints saw no reason to advertise himself as a printmaker.

Whatever the exact reasons for Degas's disinclination to exhibit prints in London, it is clear that he was often more interested in exploring an idea than in its realization; and he distinctly disliked being under the obligation to produce for the market. And though their saleability was probably among the reasons Degas had been drawn to prints, it is questionable whether financial reward would have secured his ongoing interest in them. After all, Degas had begun making fans in the late 1870s for similar reasons, but came to resent fulfilling what commissions he did receive in the same way he resented producing small pastels for business.[90] Degas came to view these as "articles of trade" rather than works of art, and himself as a "fabricator" rather than an artist. From this, we can conclude that while the prospect of making money through prints excited Degas, and while he was clearly intrigued by the different processes he essayed, his involvement in printmaking – as in making fans – was bound to be short-lived. Had he been successful in marketing them, he would have come to see them as "articles" tainted by their direct association with commerce. Since it ultimately became apparent that prints were not a way out of his financial dilemma, Degas dropped printmaking as too time-consuming.

The general financial crisis of the late 1870s that had directly affected the fortunes of the Impressionists began to abate in 1880. Durand-Ruel, who had been unable to actively support the group during that period, now began to buy and to sell their work. Degas turned his attention from the "industrial" art projects – from prints, fans, ceramics, decorative experiments – to paintings and pastels. When he next became involved in printmaking, the circumstances would once again be different.

Notes to Part II

1. See Michel Melot "L'Estampe impressioniste et la réduction au dessin," *Nouvelles de l'estampe*, no. 19 (Jan.-Feb. 1975), pp. 11-15, 56; and "La Pratique d'un artiste: Pissarro graveur en 1880," *Histoire et critique des arts*, June 1977, pp. 14-38.

2. Bracquemond's entries (cat. nos. 23-28) were, with the exception of one drawing, all etchings, including original and reproductive work; Lepic's entries, cat. nos. 74-80, comprised four watercolors and three etchings; Rouart's entries (cat. nos. 157-58) were both etchings. On the circumstances that determined the composition of the first Impressionist exhibition, see Rewald 1973, pp. 309ff.

3. See a letter from Desboutin to Giuseppe de Nittis and his wife in London, 13 April 1876 (Mary Pittaluga, *De Nittis* [Milan, 1963], p. 354).

4. In the letter to De Nittis (ibid.), Desboutin expressed his wish "de reprendre nos séances chez Cadart" as soon as De Nittis returned to Paris. In his letter to Mme de Nittis of 18 May 1875, Desboutin described Degas as his "seule consolation" in Paris (Pittaluga, p. 355).

5. Jules Claretie to De Nittis, 4 July 1876 (Pittaluga, p. 339).

6. Letter from Dijon, 17 July 1876 (ibid., p. 359).

7. On Degas's financial problems, see John Rewald, "Degas and His Family in New Orleans," *Gazette des beaux-arts* (hereafter cited as *GBA*), July-Dec. 1946, pp. 106-26. The words are Achille's, in a letter to his uncle Michel Musson dated 31 August 1876, where René is mentioned as just having left Paris for New Orleans.

8. Melot, "La Pratique d'un artiste," pp. 19, 21; Gerstein 1982, pp. 108-9.

9. Henri Guérard, "La Semaine," *Paris à l'eau-forte*, 30 July 1876, pp. 95-97 and 20 Aug., pp. 123-24. Guérard was favorable to Tissot but critical of Legros's dependence on Renaissance models. Louis Decamps featured Legros in his review ("Expositions d'oeuvres d'art exécutées en noir et en blanc," *L'Art*, no. 6 [1876], p. 198) whereas Alfred de Lostalot promoted Tissot ("Exposition de dessins et gravures: Noir et blanc," *Les Beaux-Arts illustrés*, 17 July 1876, pp. 71-72).

10. Preface by Armand Silvestre to *Galerie Durand-Ruel* (Paris, London, and Brussels, 1873), pp. 5-6. *Avant la course* (Lemoisne 317), etched by Laguillermie, appeared in the 5th issue as plate 45; *Foyer de la danse à l'Opéra* (Lemoisne 298), etched by Martinez, appeared in the 12th issue as plate 113.

11. The twelve unspecified prints appeared as cat. nos. 227-36.

12. Letter from Degas to Philippe Burty, 1876 (Degas, *Lettres* 1945, p. 37).

13. Legros's etched *Portrait of Carlyle* (second Impressionist exhibition) had been priced at the preceding Dudley Gallery Black and White exhibition (no. 247) at £10 (roughly 200 francs). This and the prices asked by Tissot for his prints compared very favorably with those realized by the Impressionist pictures sold at the first Vente Hoschédé (13 January 1875).

14. For the prints involved, see Juliet Wilson, *Edouard Manet: Das graphische Werk* (Ingelheim am Rhein, 1977), nos. 69, 75, 79, 83, 89, 90, 105.

15. Eugenia Janis interprets Degas's disclosure to Claretie as relating to the technique of monotype (Janis, no. 52).

16. On *L'Impressionniste*, see Rewald 1973, p. 394. Degas's drawing, which appeared in issue no. 2 of 14 April 1877, reproduces the pastel (Lemoisne 421) that is evidently the one listed as no. 41 in the catalogue of the third Impressionist exhibition.

17. L[ouis] G[onse], *La Chronique des arts*, 28 Jan. 1877, pp. 34-35.

18. Guillaumin showed at the first Impressionist exhibition in 1874; he was particularly close to Degas's good friend Pissarro, through whom Degas would have known of the printmaking activities at Auvers by Pissarro, Guillaumin, Dr. Gachet, and Cézanne during the summer and autumn of 1873 (see Paul Gachet, *Cézanne à Auvers: Cézanne graveur* [Paris, 1952]). Forain had evidently entered Degas's orbit, frequenting in his company the Café de la Nouvelle-Athènes; he made his first contributions to *Paris à l'eau-forte* in the fall of 1876 (Rewald 1973, p. 399). Guérard also frequented the Nouvelle-Athènes (ibid.); he was a friend of Degas's friends Desboutin and Manet, for whom he supplanted Bracquemond as an assistant in printmaking. Norbert Goeneutte had been a friend of Desboutin since 1873, and like Degas contributed an etching to the catalogue of the 1877 Salon of the Société des Amis des Arts de Pau. Félix Buhot was both a friend of Somm and, more important in the context of Degas, of Philippe Burty as early as 1874-75.

19. Le Comte Lepic, "Comment je devins graveur à l'eau-forte," in Raoul de Saint Arroman, *La Gravure à l'eau-forte* (Paris, 1876), p. 115. See, for example, Guérard's eau-forte mobile *Moulin à Montmartre*, signed and dated 1870 (Claude Bertin, "Henri Guérard [1846-97]: L'Oeuvre gravé." Mémoire de l'Ecole du Louvre, 1975, no. 228).

20. Richard Lesclide, "Eaux-fortes de la semaine," *Paris à l'eau-forte*, 28 Nov. 1875, pp. 92-93. The method he describes – that of drawing lights out of darks – has been termed the "dark-field" manner (Janis 1967, I and II).

21. There are two monotypes by Guérard in the collection of the Bibliothèque Nationale, Paris: an *Intérieur auvergnat* (which could, in fact, be the print Lesclide saw made) and a *Soleil couchant* (Bertin, nos. 123, 280). The two monotypes by Dr. Gachet in the same collection are similarly "dark-field" monotypes like those Degas first made; both are assigned to 1875 in the manuscript catalogue prepared by the artist's son Paul Gachet. While a heightened impression of what is thought to be Degas's first monotype, *La Répétition de Ballet* (Lemoisne 365), is said to have been sold to Mrs. Louisine Havemeyer in 1875, the bill of sale cited in substantiation of the date (Janis 1967, I and II, pp. 22, 72) appears not to exist. One could, then, date Degas's first monotype to late 1875 or early 1876.

22. Lesclide, "La Semaine," *Paris à l'eau-forte*, 2 April 1876; 9 Jan. 1876, p. 1, and 19 March 1876, p. 82. For details on Buhot's techniques, see Colles Baxter and Jay Fisher, *Félix Buhot, peintre-graveur* (Baltimore, 1983), especially pp. 39-52.

23. Lesclide published Manet's illustrations to Charles Cros's *Le Fleuve* and to Mallarmé's translation of Poe's *The Raven*. Manet's work was also warmly reviewed on several occasions in the pages of *Paris à l'eau-forte*. The first exhibition of the Impressionists in 1874 received a sympathetic review by C. de Malte in the 19 April 1874 issue of the periodical (pp. 12-13). A recipe for sulphur tint appears on p. 54 of Reff *Notebook* 26 and for aquatint on p. 22 of Reff *Notebook* 30, where ideas on the subjects to be carried out in aquatint appear on pp. 204-6.

24. *Paris à l'eau-forte*, 20 Dec. 1874, pp. 9-11.

25. Burty's English counterpart P. G. Hamerton, for example, was opposed to print connoisseurship that laid emphasis on the rare, and he welcomed steel-facing as enabling "immense editions" and thus bringing to an end "the days of rare proofs"; he did not believe that steel-facing a plate affected the quality of the resulting impressions (Philip Gilbert Hamerton, *Etching and Etchers* [London, 1868], pp. xii, 30-31). French etcher A. P. Martial noted that without steel-facing, an etching on copper

could yield at most between 500 and 600 impressions if the plate was well bitten, and between 100 and 200 impressions if not; with steel-facing, thousands of impressions could be pulled (*Nouveau Traité de la gravure à l'eau-forte pour les peintres et les dessinateurs* [Paris, 1873], p. 55).

26. Prunaire's name and address are entered in a hand other than Degas's on p. 2 of Reff *Notebook* 26. Degas owned both states of Manet's two wood engravings (Atelier sale Estampes, nos. 288-89). Lefman, whose name and address appear on p. 1 of Reff *Notebook* 27, specialized in "heliogravure en relief pour la typographie." See *Bulletin de la Société française de photographie*, 16 (April 1870), pp. 99-100; and C. Motteroz, *Essai sur les gravures chimiques en relief* (Paris, 1871), pp. 57, 64. Lefman had printed *Le Café* in 1874; and, in 1877, *Au paradis*, Manet's contribution to the *Revue de la semaine*. In the poster advertising *Le Corbeau* as well as in the review in *Paris à l'eau-forte*, 16 May 1875, pp. 14-15, Manet's illustrations were referred to as "dessins" rather than as lithographs. (See New York, *Manet* 1983, nos. 85, 86, 89, 105.)

27. On Mante's process, see Motteroz, p. 49; the *Bulletin de la Société française de photographie*, 18, no. 2 (1872), p. 33; and Jacqueline Millet, "La Famille Mante, une trichomie, Degas, L'Opéra," *GBA*, Oct. 1979, pp. 105-12. On Tillot's experiments with stereoscopic imagery, see "Compte-rendu sommaire de l'exposition ouverte par la Société au palais de l'industrie en 1870," *Bulletin de la Société française de photographie*, 17, no. 4 (1871), p. 105. Tillot's role in providing Degas with information is suggested by Degas's entry on p. 49 of Reff *Notebook* 26: "Harrison 11 rue des Petites Couronnes, Asnières, photographe, ami de Tillot." Harrison's name appears under Asnières, in the "Liste générale des principaux photographes" of C. Fabre's annual *Aide-mémoire de photographie* (Paris, 1876-) for 1877, 1878, 1879, and 1880, pp. 100, 182, 183, and 184 respectively.

28. Gillot's name appears on p. 49 of Reff *Notebook* 26, where it is recorded in the context of "heliogravure," or photomechanical printing. Lucas, whose name appears on p. 56 of the same *Notebook*, filed on 16 October 1876 a patent application for "Heliochalcographie, ou nouvelle application des procédés photographiques, uniquement à l'usage des graveurs sur métaux" (Fabre, *Aide-mémoire . . . 1878*, p. 178).

29. Motteroz, p. 48.

30. Burty, "La Gravure au Salon de 1870," *GBA*, Aug. 1870, p. 142.

31. Bracquemond's transfer lithographs are catalogued by Béraldi as nos. 755, 756. Pissarro's transfer lithographs are catalogued by Delteil. Degas's collection included Legros's portrait of Champfleury (Harold J. Wright, "Catalogue of Alphonse Legros's Prints," MS, Wright Archives, University of Glasgow, no. 35), possibly one of the two lithographs by the artist in the 1876 Impressionist exhibition (under no. 83). He also owned a dedicated impression of Fantin's *Le Musicien* (1877; no. 13 in Germain Hédiard, *Fantin-Latour: Catalogue de l'oeuvre lithographique du maître* [Paris, 1906]). For these, see Atelier sale Estampes, nos. 121, 218 bis. Page 6 of Reff *Notebook* 26 includes a reference to Robaut, who had given Fantin a trial proof of one of Corot's lithographs from the 1872 publication (Douglas Druick and Michel Hoog, *Fantin-Latour* [Ottawa, 1983], no. 74).

32. J. Audouin, whom Degas cites on p. 67 of Reff *Notebook* 26 regarding "talc-encres lithographiques," "encre à report," and "papiers de chine à report," advertised himself in photographic publications as specializing in "fournitures générales pour la photographie," including "papiers et articles spéciaux, Bristols, produits chimiques, etc. Papiers à toutes prépa-

rations pour les procédés inaltérables." In the Bottin (Paris directory) for the years 1875-78 inclusive, Audouin is similarly listed under the rubric "fournitures générales pour la photographie" and is not cross-referenced under any of the categories dealing with either lithography specifically or printing ink in general. Similarly, G. Guilleminot, listed on the same page of Degas's notebook as Audouin, was as Degas indicated a "fabricant de produits chimiques" including "papiers photographiques." He is listed in the Bottin for 1875 under both "Photographie" and "Produits chimiques." In October 1876 Lucas, whom Degas mentions on p. 56 of Reff *Notebook* 26 for "encre lithographique," entered an application for "Heliochalcographie, ou nouvelle application des procédés photographiques, uniquement à l'usage des graveurs sur métaux" (Fabre, *Aide-mémoire . . . 1878*, p. 178). Others named in conjunction with lithography in Degas's notebooks include Moret (Reff *Notebook* 24, p. 103), probably the Moret who first appears in the Bottin of 1877 as specializing in "encres de toutes sortes"; given the date of this first appearance, the usage of *Notebook* 24, dated by Reff 1868-73, should probably be extended to 1877. Auguste Vanhymbeeck, whose name is noted on p. 13 of *Notebook* 21 (according to Reff, 1865-68) for "encre lithographique" and on p. 67 of Reff *Notebook* 26 (1875-77) for transfer ink, was listed in the Bottin for the years 1875-80 under both "encre lithographique" as well as "encres d'imprimerie"; as Reff has pointed out, the address entered in *Notebook* 21 ceased to be correct after 1867 (from 1875 on, Vanhymbeeck was located on the rue de Rivoli). The Meyer whose name appears on p. 103 of *Notebook* 24, with that of Moret, could be either the Meyer listed in the index of C. Fabre's *Aide-mémoire de photographie pour 1876* (Toulouse, 1875), p. 105, under the rubric "fournisseurs d'articles photographiques" or, more likely, Isidore Meyer, who appears in the Bottin in 1875-77 under "Imprimeurs-lithographes" and "impressions commerciales et administratives," and whose "imprimerie lithographique et papeterie" was on the rue Richelieu.

33. Caillebotte and Sisley apparently worked in the same manner in preparing the drawings after their paintings for *L'Impressionniste*. L. Marais, whose name and address appear on pp. 16 and 98 of Reff *Notebook* 27, may have provided the photographs from which the drawings in that publication were prepared. Marais advertised in the third and fourth numbers of *L'Impressionniste* (21 April 1877, p. 8; 28 April 1877, p. 8): "L. Marais / photographe-éditeur / spécialité de reproductions/de/ tableaux et objets d'art." He is among Parisian photographers listed in Fabre's *Aide-mémoire de photographie* for the years 1876-79.

34. We know that on one occasion Degas actually heightened a photograph with color. No. 105 of the Atelier sale Estampes is described as *Buste de Femme*, 1873, "photographie retouchée aux crayons de couleurs." Around 1873 Manet, too, heightened a photograph of his *Le Chemin de fer* (New York, *Manet* 1983, no. 134).

35. Melot 1974, no. 43, p. 22. A cliché-verre was made by drawing through an opaque coating on a glass plate that was then simply laid on photo-sensitive paper and exposed to light. The paper was then developed as a photograph.

36. The similar appearance of *clichés-verre* and monotypes was noted by Germain Hédiard in "Les 'Procédés sur verre,' " *GBA*, 1903, p. 410. Procedurally, both are essentially subtractive processes that entail a removal of medium by a variety of implements (brushes, sticks, rags). The major difference between the two is that in the monotype the drawn-out areas on the plate print as white on a dark background (hence the term "dark-field") while in the *cliché-verre* they print as dark on a light background, since the plate functions as a negative.

37. Dirk van Gelder, *Rodolphe Bresdin* (The Hague, 1976), vol. 1, pp. 173-82; Michel Melot, *L'Oeuvre gravée de Boudin, Corot, Daubigny, Dupré, Jongkind, Millet, Theodore Rousseau* (Paris, 1978), Corot nos. 48, 74, 83, 93.

38. Not described by Béraldi, the print is reproduced and discussed in Melot 1974, no. 166. The process patented by Firmin Didot frères is discussed by Motteroz, p. 46. The related technique of galvanography, invented in 1840, is discussed in *Reproductive Arts* (Boston: Museum of Fine Arts, 1892), p. 35.

39. Geymet's name and address appear on page 5 of Reff *Notebook* 26. On the rue Neuve Saint-Augustin, Geymet ran "ateliers d'impression aux encres grasses pour les arts et l'industrie sur tout cliché photographique" (Fabre, *Aide-Mémoire . . . 1877*, p. 161). He also published several books on photography and its application to lithography and other industries over the period 1868-75. On the project to publish the Famille Cardinal monotypes see Janis, pp. xxi-xxii and checklist no. 223; Cachin, pp. 87-88 and no. 69. Both Janis and Cachin indicate Dujardin as the technician to have carried out the photomechanical reductions of the monotypes. Two photomechanical reproductions of the composition *In the Corridor* (Janis checklist no. 223; Cachin no. 69) exist: one formerly in the collection of Mme Le Garrec, Paris, and another in the Bibliothèque Doucet. The latter bears no indication that it was produced by Dujardin, who, with Amand Durand, ranked among the foremost photo-engravers of the period.

40. Pages 58 and 60 of Reff *Notebook* 26 (1875-77) contain skeletally outlined procedures for making relief or intaglio plates from existing impressions of prints that seem closely related to the *procédé Vial* as described by Alfred de Lostalot in *Les Procédés modernes de la gravure* (Paris, 1883), pp. 119-20. Reff *Notebook* 26, p. 60: "On a zinc plate transfer a print impregnated with copper sulphate. After submerging it in a bath of diluted nitric acid one obtains an intaglio plate. Idem in a bath of diluted hydrochloric acid a relief plate – 7 to 8 minutes for the 2 operations." Reff *Notebook* 26, p. 58: "On a daguerreotype silver plate lay a print impregnated (but blotted) with gold toning (gold chloride) – put through the press, there results a damascened negative plate. If one wants an intaglio plate, bite lightly with nitric acid (10 per 100)." Lostalot, p. 119, states: "The methods devised by Mr. Vial, in 1863, rest upon: 1 the precipitations of metals, 2 the affinity of acids for certain metals to the exclusion of others."

 The one discrepancy between the recipes recorded by Degas and Lostalot's description of the Vial process is in the use of nitric acid, which Degas records as producing an intaglio plate and Lostalot a relief plate. This discrepancy may reflect an error on Degas's part.

41. Letters to Bracquemond, 13 May 1879 and late spring/early summer 1879 (Degas, *Lettres* 1945, nos. 18 and 19. See also Ludovic Halévy, notebook entry for 16 May 1879, *Revue des deux mondes*, 15 Dec. 1937), p. 826. Georges Rivière states that both May and Caillebotte were to be partial backers; *M. Degas, bourgeois de Paris* (Paris, 1935), p. 75. Degas was involved with May at that time, acting as intermediary in the banker's purchase of a watercolor from Bracquemond (see letter no. 19 to Bracquemond).

42. Letter to Bracquemond, 13 May 1879 (Degas, *Lettres* 1945, no. 18).

43. Letter of 9 April 1880, cited in Frederick A. Sweet, *Miss Mary Cassatt: Impressionist from Pennsylvania* (Norman, Oklahoma, 1966), pp. 52-53.

44. Letter to Duret, 23 December 1880, in Pissarro *Correspondance* 1980, no. 83. Henri Béraldi, in his entry for the print by Raffaëlli that was to have been included in the first issue of *Le Jour et la nuit* (*Le Chiffonnier éreinté*; Béraldi 1), noted that "the first number of the publication never appeared" (Béraldi, vol. 11, p. 57). There is no evidence to suggest otherwise, though in 1913 Achille Segard asserted that "one number of *Le Jour et la nuit* appeared"; *Mary Cassatt: Un Peintre des enfants et des mères* (Paris, 1913), p. 99. Many writers have since propagated Segard's error.

45. *Chronique des arts*, 17 Jan. 1874, p. 19.

46. "Le Jour et la nuit," *Le Moniteur universel*, 8 April 1877.

47. On plans for *Les Peintres impressionnistes*, see the exchange of letters between Pissarro and Duret (Pissarro *Correspondance* 1980, p. 112 and notes).

48. Degas's drawing was a *Study of a Dancer* (coll. Mr. and Mrs. Alexander Lewyt, New York; reproduced in Adriani 1984, no. 95) for the figure at right of the pastel *Danseuses au repos* (Lemoisne 343). Cassatt's drawing reproduced her *Femme lisant*, no. 52 in the catalogue of the 1879 Impressionist exhibition. Both were reproduced in *Les Beaux-Arts illustrés*, no. 10 (1879), p. 84. Pissarro's etching (unrelated to any of his entries in the exhibition) and Forain's drawing were reproduced, together with a drawing by Heilbuth, in issue no. 12, p. 96.

49. Degas had met Bergerat in 1870, during the siege of Paris (Reff 1976, p. 329, n. 67). The review of the 1879 Impressionist exhibition appeared in the 24 April 1879 issue of *La Vie moderne* (p. 38). Cassatt's drawings appeared in the issues of 1 May (p. 54) and 9 August (p. 238), and Degas's drawings in the issues of 8 May (p. 79, *Danseuse [Melina Darde, Seated]*) and 29 May (p. 115, *Danseuse [assise, rajustant son maillot]*).

50. In Bergerat's lengthy list published in December 1879 of important artists and illustrators whose work had been reproduced in *La Vie moderne*, the names of Degas, Cassatt, and Renoir failed to appear.

51. Cassatt's etching *In the Opera Box* (fig. 23), no. 25 in the 1880 Impressionist exhibition, is identified as her contribution to the first issue of *Le Jour et la nuit* (see Segard, p. 99). It is closely related to the drawing of the same title published in *La Vie moderne* (fig. 22) that reproduced, in turn, the painting shown at the 1879 Impressionist exhibition as no. 49 "Femme dans une loge" *(Lydia in a Loge;* Philadelphia Museum of Art). Pissarro's *Wooded Landscape at L'Hermitage, Pontoise* (Delteil 16; fig. 24), no. 139 in the 1880 Impressionist exhibition, is based on his painting of the same title dated 1879 (see Arts Council, *Camille Pissarro* [London, 1981], no. 161). Raffaëlli's *Chiffonnier éreinté* (fig. 25), indicated by Henri Béraldi as his contribution to the first issue of *Le Jour et la nuit* (see note 44 above), was shown as no. 167 at the 1880 Impressionist exhibition, where it was specified as being after a composition of the same title (undoubtedly the watercolor of that title, no. 158 in the same exhibition).

52. Charles Ephrussi and Gustave Dreyfus, introduction to the catalogue *Dessins des maîtres anciens* (Paris, 1879), pp. iii-vii; Emile Bergerat, "Notre Exposition: Les Dessins de *La Vie moderne*," *La Vie moderne*, 17 July 1879, p. 239; Edmond Duranty, "Daumier," *GBA*, May and June 1878, pp. 429-43, 527-44.

53. The print is listed under no. 273 in the catalogue of the sixth Black and White Exhibition, Dudley Gallery, London, June 1878. It was priced at £5, approximately 100 francs. At the Paris sale of Ernest Hoschédé's collection, also in June 1878 (admittedly a disastrous affair for Pissarro), the highest price brought by any of his nine canvases sold was 100 francs.

54. G. Decaux, *Les Beaux-Arts illustrés*, 22 May 1876, p. 8.

55. Emile Bergerat, "Notre programme," *La Vie moderne*, 10 April 1879, pp. 2-3.

56. Reff *Notebook* 31, pp. 67, 68.

57. On the stylistic relationship between the fans, prints, and ceramics, see Gerstein 1982, pp. 112, 114.

58. Pissarro had begun experiments with ceramic decoration in 1876 and resumed them in 1878 (Pissarro *Correspondance* 1980, pp. 36-37, 118-19).

59. Letters to Bracquemond, early 1879 and 13 May 1879 (Degas, *Lettres* 1945, nos. 16 and 18). On Bracquemond's activity at Auteuil, see J. and L. d'Albis and Jean-Paul Bouillon, *La Céramique impressionniste* (Paris, 1974).

60. *La Vie moderne*, 10 April 1879, pp. 2-3; 4 Oct. 1879, pp. 402-4; 11 Oct. 1879, p. 428. In the first few years of its existence, *La Vie moderne* was printed both in a regular edition and in a special edition on china paper.

61. In the letter from Mary Cassatt's father to her brother, of 1 September 1879, he indicated that the reproduction had failed to do "justice" to her painting (Sweet, p. 46).

62. These embossed and printed patterns were mostly systems of lines, simulations of fabric textures, or aquatint grain. By drawing with crayon or brush, pen and ink, the artist could create darker tones; by scraping he could break up the printed pattern, thus optically creating a range of lighter gray tones, or remove the pattern altogether to create white highlights.

63. Letter to Pissarro, summer 1879 (Degas, *Lettres* 1945, no. 25). The information on Bracquemond's experiment comes from Béraldi 208. Béraldi assigns no date to the *Chemin des Coutures à Sèvres*, but implies a date of about 1873 by the order in which he catalogues it. We believe the print is of a later date, between 1876 (the date of the other print in which Bracquemond specified using "aquatinte en liqueur," *Fernand* [Béraldi 42]) and 1879.

64. Letter to Bracquemond (Degas, *Lettres* 1945, no. 15). Degas's reference to Bracquemond's "list of entries" permits dating the letter to the period prior to either the Impressionist exhibition of 1879 or that of 1880.

65. Degas referred to *Le Jour et la nuit* as a "revue mensuelle" in a letter to Bracquemond of 30 December 1903 (Degas, *Lettres* 1945, no. 233). Raffaëlli's *Chiffonnier éreinté* (Béraldi 1) was pulled in an edition of fifty (Béraldi, vol. 11, p. 57). Pissarro's *Wooded Landscape at L'Hermitage, Pontoise* (Delteil 16), also destined for *Le Jour et la nuit*, was similarly printed by Salmon in an edition of fifty. For Degas, see cat. no. 51.

66. Letter to Pissarro, fall 1879/winter 1880 (Degas, *Lettres* 1945, no. 26).

67. For the letters from Bergerat to Manet, see Jean Adhémar, "Manet et l'estampe," *Nouvelles de l'estampe*, 7 (1964), pp. 233-34.

68. Reff *Notebook* 18, p. 18.

69. "Le Café-Concert des Ambassadeurs," *L'Illustration*, 29 May 1875, p. 360; "Aux Champs-Elysées le soir," *La Vie parisienne*, 1 July 1876, p. 378.

70. Edmond de Goncourt, *Journal: Mémoires de la vie littéraire* (Paris, 1956), vol. 2, p. 1143.

71. For the latest discussion of this relationship, see Joel Isaacson, "Impressionism and Journalistic Illustration," *Arts Magazine*, June 1982, pp. 95-115.

72. Reff *Notebook* 30, p. 208, translated in Edinburgh, *Degas* 1979, pp. 76-77.

73. Reff 1976, pp. 213ff.

74. Edmond Duranty, "Promenades au Louvre: Remarques sur le geste dans quelques tableaux," *GBA*, Jan. 1877, pp. 15-57; "Daumier," pp. 432, 440, 532, 538; "Les Français du dix-huitième siècle dessinés par eux-mêmes: Encore à propos de l'exposition des dessins de maîtres anciens," *La Vie moderne*, 22 May 1879, p. 102.

75. For Degas and Daumier, see Reff 1976, pp. 70ff. Degas mentions his collection of Gavarni lithographs in a letter to Alexis Rouart (Degas, *Lettres* 1945, no. 155; and Reff *Notebook* 35, p. 108).

76. A reference to this periodical appears in Reff *Notebook* 31, p. 81: "*Journal: la Nature* / Victor Masson (année 1878)." Articles on phrenology appeared in the issues of 19 July and 23 August 1879 and of 17 January 1880.

77. All quotations are from Duranty, "Promenades au Louvre."

78. See Pierre Giffard, "La Science moderne," *La Vie moderne*, 29 May 1879, pp. 125-27; Henry Vivarez, "Chronique scientifique: La Lumière électrique et l'art," *La Vie moderne*, 27 Dec. 1879, pp. 605-6; "La Lumière électrique," *Les Beaux-Arts illustrés*, no. 41 (1879), p. 327; and articles on electric lighting in the issues of *La Nature* of 28 April and 7 July 1877, 15 June and 14 Dec. 1878, 30 Aug. and 29 Nov. 1879, and 8 May 1880.

79. See the letter from Degas to Bracquemond, Degas, *Lettres* 1945, no. 17. (Degas's reference to the cartoons of Bracquemond's wife, Marie, dates the letter prior to the 1879 Impressionist exhibition.)

80. Jules Claretie, *La Vie à Paris* (Paris, 1881), p. 137; "Histoire anecdotique de la semaine," *La Vie moderne*, 20 May 1882.

81. Reff *Notebook* 31, p. 9.

82. C. M. Gariel, "Le Crayon voltaïque," *La Nature*, 12 April 1879, pp. 289-91.

83. See the entry for "crayon" in Pierre Larousse, *Grand Dictionnaire universel du XIXe siècle* (Paris, [1891]), p. 938. Under the subheading *"Crayon voltaïque ou crayon à lumière"* is the description: "Bâtonnet de charbon pour les lampes électriques à l'arc voltaïque."

84. F. G. Dumas, *Salon de 1879: Catalogue illustré, contenant cent douze fac-similés d'après les dessins originaux des artistes* (Paris, 1879). The English precedents were two publications edited by Henry Blackburn: *Academy Notes*, first published in 1875, and *Grosvenor Notes*, first published in 1878. The deluxe edition, entitled *Le Salon illustré*, contained sixteen original prints, including a drypoint by Desboutin. It was reviewed by Edmond Duranty in *Les Beaux-Arts illustrés*, 6 (Jan. 1880), p. 47.

85. "Actualités," *La Vie moderne*, 21 Aug. 1880, p. 544.

86. See letter to Pissarro, summer 1879 (Degas, *Lettres* 1945, no. 25).

87. Letters to Bracquemond and Henri Rouart, fall 1879 (ibid., nos. 22 and 32).

88. Letter from Pissarro to Duret, 23 December 1880 (Pissarro *Correspondance* 1980, no. 83).

89. See letters from Pissarro to his niece Esther, 7 January 1881, and the letters from Duret to Pissarro and Pissarro to Duret of 14 January and 17 January 1881 (ibid., no. 84; no. 85 and n. 1).

90. Gerstein 1982, pp. 108-9.

Part III:
Prints and Reproductions, 1884-1914

After his burst of activity in the 1870s, Degas made only three etchings and a small body of lithographs before abandoning printmaking forever in the early 1890s. But as his reputation grew over the last thirty-five years of his life, so too did the number of prints made after his work. Most often these were done with his consent and participation, and they far outnumber his original prints of the period.

Though small in number, Degas's own prints, especially the lithographs, are important for their intrinsic value, for the light they shed on the artist's contemporary preoccupations and practice and, in a broader context, as examples of a major movement in printmaking during the last fifteen years of the century. Similarly, the reproductions reveal Degas's changing idea of how his work should be reproduced, as well as the attitudes to both traditional and new means of reproduction. Finally, when viewed together, both types of print point up the artist's continued ambivalence toward the role of the original print just when it was being defined in the terms still current today. It was at that moment too that Degas came to be erroneously viewed as exemplifying an attitude to printmaking that emphasized rarity. In fact, this was only a circumstantial aspect of his print work.

Changes in Attitudes

The 1880s saw the expanded use of more perfected photomechanical processes developed in the two previous decades. The illustrated press, now dominated by photogillotage, grew steadily in response to demand, with new publications appearing regularly. Some of those who supplied this burgeoning press with drawings won a large following, like Degas's friend Forain; and Degas was not alone in collecting their "published drawings," as an earlier generation had collected the lithographs of Daumier in Le Charivari.[1]

Increasingly, painters availed themselves of the developing technology to publicize their work at the expense of the traditional print media. Manet, for example, had all but abandoned printmaking when, following his success at the 1882 Salon, he made an etching for publication after Jeanne, one of his two submissions. Dissatisfied, he had the plate destroyed and submitted instead the etching's preparatory drawing. A color reproduction of Jeanne (made from a trichromatic photograph taken by Charles Cros) that appeared on the cover of Hoschédé's booklet on the Salon exemplified the latest technology that seemed to interest Manet rather more than etching.[2] Publishers now promoted photomechanical reproductions as "original drawings." La Vie moderne, for example, in announcing its subscribers' premiums, made no qualitative distinction between an original drypoint by Desboutin and reproductions of drawings produced by gillotage or by Dujardin's photo-intaglio process of heliogravure.[3]

The distinction between the handcrafted original, reproductive prints, and the photomechanical reproduction thus came to be increasingly blurred in the public's mind in the early 1880s. For many it was the image and not how it was produced that mattered; whether a print came directly from an artist's hand was not seen to affect its desirability. But while in the previous decade there had been a general enthusiasm for the new printing processes, a reaction against them was now growing in some quarters. Vincent van Gogh, writing to his brother Theo in 1882, rationalized his interest in trying to "make some lithographs . . . simply by drawing on the stone itself," explaining: "For much as I like those drawings . . . in Vie moderne, still there is always something mechanical in them, something of a photograph or photogravure. . . . I mean that an ordinary etching, an ordinary wood engraving, or an ordinary lithograph has a charm of originality which cannot be replaced by anything mechanical."[4]

Pissarro expressed similar sentiments independently and more vehemently two years later, when discussing drawings on scraperboard with his son Lucien, who was then beginning to work with the medium. Gillotage represented to Pissarro "all that is least artistic"; though when put in the service of a Degas the results might not be bad, this did not change the basic fact that because it was "mechanical" the process was inherently "anti-artistic."[5]

This aesthetic aversion was matched by certain critics' concern for the ultimate fate of the traditional media, given the general confusion of the relative merits of images printed from plates prepared photomechanically or by the hand of the printmaker. The early fears of the threat posed to the traditional graphic media by photography seemed now to have come true: "for the time being," wrote Salon reviewer Jean Alboize in 1886, "it is photography wearing the mask of photogravure or heliogravure that is parading triumphantly in the windows of print dealers and print publishers. It has banished lithography and it is about to banish intaglio prints as well." Yet while many critics despaired that the continued existence of the traditional media was in the balance, Alboize viewed the situation optimistically: in replacing the traditional media in the industry of image-making, photography had in fact freed the printmaker to pursue "l'art pour l'art." Thus lithogra-

phy, no longer shackled to an industry that had outgrown it, could now enter "the realm of pure art" wherein it could regain the integrity it had lost.[6]

This renewed appreciation for the virtues of traditional media – now clearly displaced in some of their traditional functions – was colored by feelings of nationalism. This was particularly evident in the growing interest in lithography. As early as 1878, Martinet, reporting on the printing section of the Universal Exhibition, had warned, "it is not . . . to be concealed that strenuous efforts are now needed to maintain the preeminence of French lithography, since other countries . . . are working very hard and making noticeable progress."[7] In the early 1880s, French critics adopted an increasingly proprietary attitude towards lithography, insisting on the medium's inherent "Frenchness" despite its German origins. The founding in 1884 of the Société des Artistes Lithographes Français to "perpetuate the art of lithography" was widely regarded as a healthy response to the "mission of saving for France one of its national artistic manifestations."[8]

A concerted effort to revive the art of lithography was underway. Yet, for the moment, it was the professional printmakers who were the focus of this promotion because of the lack of painter-lithographers and the nature of the Société membership. Of its thirty-four founding members, all but one – Odilon Redon – specialized in reproductive printmaking. And though in 1885 the number of *sociétaires* swelled to eighty, only three of the new members, John Lewis Brown, Fantin-Latour, and poster designer Jules Chéret, used lithography to make original creations.

Degas and the Professional Printmakers

Degas was now an artist with a rapidly growing reputation: his work in the Impressionist exhibition of 1880 had increased his standing among the critics; when in 1884 he showed two racetrack pictures at the gallery of Georges Petit, the reviewer for *Le Voltaire* reported that his "sincerity" in rendering nature "has assured him a special position in the esteem of connoisseurs"; and in 1886, at the time of the last Impressionist exhibition, Roger Marx wrote, "No reputation has a more solid foundation than Mr. Degas's and the collectors seek his work all the more eagerly since the artist has very high standards and produces very little."[9] By 1888, his success with critics and collectors as well as his reluctance to part with works all suggested the appropriateness of a portfolio of reproductions of his work. These were consigned to a reproductive printmaker, the lithographer George William Thornley.

A student of the celebrated reproductive lithographer Achille Sirouy, Thornley had first distinguished himself in 1881 when, at age twenty-four, he had prepared an album of twenty-five "color drawings" after Boucher. Based on prints by Bonnet, Demarteau, and others after Boucher, these color lithographs were the best reproductions of drawings in that medium to date; reviewers recommended them to both collectors and artists.[10] Thornley then consolidated his reputation with a series of reproductions after paintings by Puvis de Chavannes, lithographs that appeared in the Salons of 1884, 1885, and 1888.

But it was his fifteen monochrome lithographs after paintings and pastels by Degas that marked a new level of achievement both for the lithographer and for his art. These prints, unlike those after Boucher, were not conceived of as "facsimiles." But while Thornley did not seek to imitate the surfaces of the works he reproduced, he did try to capture the artist's "touch," that personal quality usually lost by the printmaker when translating a painter's syntax into that of his own medium. As with his lithographs after Puvis, Thornley attempted to interpret Degas's paintings and pastels in terms of the artist's style of drawing, thus accommodating the translation of works in color into monochrome. Thornley's remarkable ability to convey the spirit of the artist he translated is evident in his lithograph after Degas's gouache *The Song of the Dog*, on which Degas himself had based his lithograph of 1876-77 (see cat. no. 25).

Though it was not until 1889 that the portfolio was published by Boussod and Valadon, four of the lithographs were shown in April 1888 at the firm's gallery on the boulevard Montmartre, where Theo van Gogh was director. There they attracted the attention of Félix Fénéon, cofounder of the avant-garde *Revue indépendante* and art critic, an admirer of the Impressionists and already a defender of Seurat and Neo-Impressionism. Fénéon was struck by the way the lithographs, "through their sparse and essential eloquence, evoke the originals" and noted that "other Thornley-Degas's will follow, to which we shall devote more space."[11] This reference to "Thornley-Degas" was tacit acknowledgment that the lithographs were indeed the result of a close collaborative effort. Degas apparently selected the works to be reproduced, and his scrutiny of the quality of each translation is attested to in the letter he wrote Thornley shortly after the first lithographs had gone on view at Boussod and Valadon, and Degas had left Paris for Cauterets. Degas scolded the

lithographer for having rushed his recent work in order to complete it prior to his wedding and honeymoon:

A few days after your flight, they brought me trial proofs from [the printer] Becquet (women trying on hats [Lemoisne 729]). I told them to stop the printing and informed them I would go to the press. It was impossible for me to go there, or to return to Rouart [who owned the pastel] with your drawing on transfer paper. I wanted to make a few alterations on the drawing; and I hardly regret not having made them as you were not there. I shall return to Paris about 15 September and we shall finish with all that. You were in too much of a rush, my dear Mr. Thornley. Art requires more leisure than that. But I now see the reason for your impatience. [12]

Under that rigorous discipline, Thornley brought the art of reproduction to new heights, as Fénéon recognized when more of the lithographs were exhibited in September: "The sagacity he displays here is truly disconcerting: it is Mr. Degas's very spirit, at its most intimate, that he has imprinted on these plates. In order to achieve this secondary reality, he has freely treated his text, and has found remarkable equivalences when it would have been a disservice to translate the idiom of painting too literally." [13] Such enthusiasm on the part of a major figure within the contemporary avant-garde is less surprising than it may now appear. Reproduction was still considered an art and its brilliant exponents were widely admired, as the Thornley portfolio testifies.

The idea to publish a portfolio of reproductions might have been suggested to Degas by Henri Rouart, who then owned eleven of the fifteen works Thornley interpreted, or by Michel Manzi, a friend of Degas and a collector of his work who was in charge of Boussod and Valadon's workshop in the rue Forest, where the firm's lucrative photomechanical reproductions were printed. [14] Possibly Degas himself specified lithography. Several weeks before Becquet legally registered Thornley's lithographs, four less inspired reproductions after works still in Degas's possession (fig. 37) had been deposited by the printer Lemercier at the Bibliothèque Nationale. [15] But these reproductions were probably undertaken after Degas had begun working with Thornley early in 1888 and may even be the fruit of that first endeavor. Thus Theo van Gogh emerges as the probable moving force for the Thornley project. He actively promoted the reproductions in Paris and saw that they were included, along with a drawing by Degas, in the Black and White exhibition organized in the summer of 1888 by the Nederlandsche Etsclub in Amsterdam, where they attracted considerable attention. [16] Moreover, his involvement in selecting the medium and the interpreter and in committing Boussod and Valadon to publish the Degas reproductions is suggested by his participation in a comparable publishing venture soon thereafter.

Late in 1889, Theo wrote to his brother Vincent to tell him that he had "seen a score of very fine lithographs after Monticelli's pictures done by a certain Lauzet"; those monochrome lithographs, each printed in a different tone (as had been Thornley's reproductions), provoked Theo to concede "the man who made them is a true artist." Auguste Lauzet, then twenty-four, was a member of the Société des Artistes Lithographes Français, as was Thornley, and like his slightly older associate approached lithographic reproduction in terms of what Fénéon had called "equivalences." Theo's appreciation of Lauzet's work led him to exchange one of Vincent's St. Remy drawings for one of Lauzet's lithographs and finally to support their publication. Although the lithographer had originally undertaken to publish the prints himself, through subscription, the album of twenty lithographs was finally published by Boussod and Valadon in June of 1890. [17]

Lauzet was to translate Degas's work the following year in two prints after his pictures (see cat. nos. 56, 57) for inclusion in *L'Art impressionniste d'après la collection privée de M. Durand-Ruel.* The text for that book was written by Georges Lecomte, who had earlier contributed to *L'Art dans les deux mondes,* the periodical promoting the Impressionists that Durand-Ruel published between November 1890 and May 1891. The periodical had featured reproductions of Impressionist pictures, achieved by the photomechanical process patented by Michalet. But the mediocre results it produced were apparently a source of discontent. Pissarro described Degas as "furious" with Durand-Ruel's periodical, which featured reproductions of his drawings in the issue of 20 December 1890. The book redressed that problem using, as Pissarro had advocated for the periodical, etching as reproductive method. [18] But a new problem was created in the selection of printmaker. Lauzet's reputation as a distinguished translator of paintings rested only on his abilities as a lithographer; he was a less gifted etcher, as Degas learned. [19] Discontented with Lauzet's rendering of his pictures, Degas now carried out the threat made earlier to Thornley: he redid the two etchings himself, though not before many copies with Lauzet's effort had been issued (see cat. no. 56).

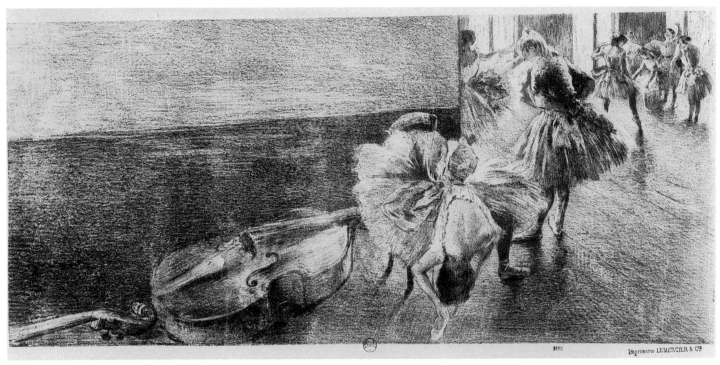

Fig. 37.
Anonymous after Degas. *Dancers in the Rehearsal Room with a Double Bass*,
1889. Transfer lithograph. Bibliothèque Nationale, Cabinet des Estampes, Paris.

Degas's concern for the quality of his work in print, demonstrated in his involvement with both the Thornley and Lauzet commissions, certainly reveals his appreciation of the unique qualities of the reproductive print and is of course a natural expression of the exacting standards he applied to all his work. It is also a reflection of his own revived interest in making prints.

New Emphasis on the Original Print

While reproductive printmaking was first to benefit from a reaction to the growing dominance of photography, it was the original print that sustained the most profound and lasting effects. The etching revival continued into the 1880s, propelled by its redirection in the previous decade. Of the group that had been involved in *Le Jour et la nuit*, Bracquemond remained an active proponent of etching; Pissarro took up the medium again in 1883; Cassatt was making prints by 1884;[20] and in the same year Degas created the etching used as a program for the alumni of the Lycée of Nantes (cat. nos. 53, 54), a work in which the inclusion of smokestacks, parts of instruments, and cropped fragments of the human form stems directly from

Degas's earlier ideas for the projected journal (see cat. nos. 51 and 53-54). General interest in painters' prints was sustained by exhibitions devoted to the art of black and white media, including that organized in 1881 on the premises of the periodical *L'Art* and the series of Expositions Internationales de Blanc et Noir held in Paris from 1885. In addition to the market such exhibitions encouraged, there were the commissions for prints for publication in art periodicals and to illustrate books of prose and poetry. Degas's etching of a *Dancer Putting on Her Shoe* (cat. no. 55) exemplifies the latter, having been made in 1888, probably at Mallarmé's request, to illustrate a projected edition of the poet's *Tiroir de laque*.[21]

But this activity could not disguise the fact that much of the original vitality of the revival was on the wane. A number of promising talents of the 1870s, such as Forain and Raffaëlli, had abandoned etching for the new reproductive media they found more convenient or more remunerative. Moreover, the general perception of the original print was confused by the marketing of photomechanical reproductions as originals on the one hand and the promotion of the handcrafted "original" reproductive print on the

other. It was to address those problems that in 1888 Brac-quemond and five other printmakers founded the Société de l'Estampe Originale, which immediately published the first (and only) issue of *L'Estampe originale*. More important than the ten original prints by founding members included in the album was its preface by critic Roger Marx, which advanced two significant concepts: that the artist's original print had a unique value not shared by the reproductive print and that etching was not the sole medium suitable for original prints.[22]

This emphasis on originality in all of the print media was particularly timely with regard to lithography. Although Degas and his friends had made lithographs in the 1870s, their experiments had not altered the general perception of that medium as unworthy of the artist's attention. The change in attitude had begun in the 1880s, largely as the result of Fantin-Latour, whose continued production and exhibition of lithographs had made him the contemporary symbol of the *peintre-lithographe*. When in 1886 Adolphe Jullien's biography of Richard Wagner was published with fourteen *hors texte* lithographs by Fantin, critics hailed the work as the most important event in the history of lithography since Delacroix's illustrations for *Faust* and *Hamlet* and proclaimed that an "unexpected renaissance" of lithography was underway.[23]

Painters Come to Lithography

The new interest in lithography was shared by other artists of Degas's acquaintance. In the early 1880s, Brown began to make lithographs in black and white and in color, which he showed at the Salon. The color prints, in particular, interested his friends. When in 1888 Mallarmé asked for prints to illustrate *Le Tiroir de laque*, John Lewis Brown, though an accomplished etcher, was asked to provide a color lithograph for the cover. His work also fascinated Berthe Morisot, who decided her contribution to that publication would be a color lithograph too; Brown was to instruct her in the unfamiliar medium, and Degas, who owned several of Brown's lithographs, himself offered to assist in her preparations.[24]

It was Degas's renewed involvement with printmaking that probably influenced his decision to participate in the Exposition de Peintres-Graveurs that took place at Durand-Ruel's gallery early in 1889; and it was his recent experience with amateur and professional lithographers that may have influenced his choice to be represented there only by lithographs done in the 1870s rather than by his more recent etchings. The exhibition was organized to demonstrate the principles that had informed the short-lived *L'Estampe originale*: to display printmaking as an extension of the painter's art, several artists were represented by drawings, pastels, or oil sketches in addition to prints; to highlight the differences that separated the original print from any form of reproduction, reproductive prints were forbidden. Phillipe Burty, in the catalogue's preface, described the "photographic processes" as no more than a means of "popularizing information." By contrast artists' original prints, though in the past used "to make their genius known throughout the world," transcended this basic purpose. He characterized the peintres-graveurs participating in the exhibition as committed to the belief "that final states can be appreciated only through choice proofs either pulled by the artist as *bons à tirer* . . . or printed under his direct supervision." Their intent was "to create an audience of amateurs who seek only the *belle épreuve* for their portfolios, a select public exclusively devoted to original and honest painting [*sic*]."[25]

This notion of the "belle épreuve" was not new, but given the great strides in photomechanical reproduction, the climate was now more receptive to equating desirability with exclusivity. The exhibition of peintres-graveurs in 1889 marked the beginning of the print revival of the 1890s, a revival in which the belle épreuve was a conceptual leitmotif as well as an important strategy for a burgeoning market for original prints in which lithography was paramount. In this respect Degas's entries in this, the first of a series of exhibitions, were prophetic. The master catalogue of the exhibition, now in the archives of Durand-Ruel, contains manuscript notations regarding the rarity of the prints exhibited and their prices, information passed on to interested collectors. Of Degas's two entries, it was noted that one existed in six impressions and the other in only three.[26] These were priced according to their rarity: 100 francs for the less unique of the two, 200 francs for the other. These prices, while not as elevated as sums asked for the rarest impressions of etchings by Tissot, Guérard, or Albert Besnard, were nevertheless high: most of the twenty-two etchings shown by Pissarro were priced at 20 francs, the most expensive at 50. But more striking still is the fact that these prices were being asked not for etchings but for lithographs. It would still be several years before lithography achieved the same status as etching in the market or among painters. Of the twenty-six artists in the French section of the peintres-graveurs exhibition, only Degas, Brown, Fantin-Latour, Odilon Redon, and Jules Chéret showed lithographs; and those by Fantin, then the

only widely known and admired peintre-lithographe, were priced at a mere forty francs each.

Whether the high prices for Degas's lithographs were set by Degas or Durand-Ruel, they can be partially explained by Degas's growing reputation not only as a painter but also as a printmaker. In 1886, Henri Béraldi had devoted two pages in the fifth volume of his *Graveurs du XIXe siècle* to the man he described as a recognized leader of the " 'intransigent' school . . . who tries his hand at intransigent printmaking." He cited Degas's work in etching and transfer lithography, described his monotype technique, discussed the subject matter of the prints, and drew attention to Degas's habit (practiced only the previous year; see, for example, cat. nos. 31, 52) of using prints as the initial foundation for pastels. Given the lack of exposure Degas's prints had had to date, along with Béraldi's conservatism, it is remarkable to find Degas treated at such length and so favorably in this encyclopedic "guide for the collector of modern prints."[27]

Degas's two entries in the peintres-graveurs exhibition drew favorable attention. The *Revue des beaux-arts* called them "most interesting" and *Le Chat noir* extolled them as "two marvels"; Fénéon called *Nude Woman at the Door of Her Room* (cat. no. 36) "a small lithograph whose brutal artistic pungency is dizzying." Thus Degas came quite suddenly to be seen as an exponent of lithography, his name even mentioned in the same breath as Fantin-Latour and Chéret.[28] It was in the interest of those concerned with the revival of lithography to conscript Degas in the service of their cause.

Degas and the Lithography Revival

When Béraldi reviewed the state of printmaking in 1889, he was able to report that the peintres-graveurs exhibition that year had "provoked a unanimous campaign in favor of original printmaking in the press." However, the position of lithography was precarious. While a "revival" of the medium was "in the air," it would be realized only when painters would take lithography "into their own hands in order to once again make it compelling."[29] The call to artists to take up lithography was echoed by other critics similarly interested in promoting a revival of that medium. This had, in fact, already begun to happen.

Both Gauguin and Emile Bernard had made portfolios of lithographs on zinc that were included in the June 1889 Synthetist exhibition held at the Café Volpini. The same year Degas's friend Raffaëlli and the young Henri Rivière (soon to be, if not already, an intimate) were among the

artists who produced lithographic programs for the 1889-90 season of the Théâtre Libre. By 1890, a trend was in the making. Early in that year Van Gogh, who less than two years previously had dismissed as unprofitable Gauguin's idea to undertake a periodical publication of lithographs, now wrote his brother Theo, "I think I . . . should start lithographing"; among those who did were Eugène Carrière, Maximillien Luce, and Berthe Morisot; the last made a four-color lithograph and spent the summer on a planned portfolio of color lithographs of her daughter Julie.[30]

But such activity remained sporadic, a symptom of a new climate of interest rather than a testimony to a full-scale revival. To that end, the Société des Artistes Lithographes Français and other supporters of lithography believed the proper means to be an exhibition that would bring "the [lithographic] masterpieces of our predecessors as well as of our contemporaries to the attention of the general public" and would, in giving the medium new exposure, encourage painters to work in it.[31] This idea was realized in the form of the Exposition Générale de la Lithographie held at the Ecole des Beaux-Arts in the spring of 1891. The exhibition included almost 1,000 lithographs, many lent by members of an organizing committee that included Béraldi, Bracquemond, Fantin-Latour, and Degas's close friend Alexis Rouart.

Degas, who had contributed to neither the second nor third annual peintres-graveurs exhibitions, had not intended to be represented in this retrospective; unlike Mary Cassatt, he had not given Rouart, one of the major lenders to the exhibition, permission to include any of the lithographs by Degas he owned. Degas was therefore furious when he discovered that another member of the organizing committee, Aglaüs Bouvenne, had included an impression of the program made for the Lycée de Nantes (see cat. no. 54). In a scathing letter to Bouvenne, Degas called into question the way in which Bouvenne had procured his impression of the print, while deploring his lack of manners in not asking consent, and he showed extreme displeasure at being represented in this major review of lithography with a single, minor work.[32]

Bouvenne's breach of etiquette is, if not commendable, certainly understandable. The organizing committee aimed to make the lithography exhibition as representative as possible of the history of French lithography, and particularly of the eminent peintres-lithographes. Although Degas had shown no prints since 1889, the lengthy entry devoted to him in the second supplement to Larousse's

Grand Dictionnaire universel had included a dozen lines dealing with his prints. About the same time, the *Revue indépendante* began to run advertisements for their deluxe edition in which subscribers were promised frontispiece prints by, among others, Degas.[33] Like it or not, Degas's reputation as a printmaker was growing apace with his reputation as an artist, and his prints were a drawing card. It was in the interest of the revival to include even a minor work by Degas. The strategy worked – even on Degas himself. For despite his anger at being an unwilling participant, Degas was apparently prompted by the 1891 lithography exhibition to renew his involvement in the medium.

The Return to Lithography

Four days after the opening of the Exposition Générale de la Lithographie, Degas dined at the house of Ludovic Halévy, where after dinner he "chatted with Jacques [Emile] Blanche; they talked about lithography, technical processes. . . . Degas said that he greatly admired Delacroix's lithographs,"[35] many of which were included in that exhibition. This discussion certainly reflected Degas's interests of the moment. Five days earlier, on 25 April, Pissarro had reported: "[Degas] is making lithographs, Mayer would like to have them, it's an important venture." Salvator Mayer, a dealer on the rue Lafitte specializing in eighteenth- and nineteenth-century prints, was friendly with both Degas and Forain. Forain had begun making lithographs that Mayer apparently handled and it seems Degas hoped to establish a similar arrangement.[36] But whether he had actually begun making lithographs, as Pissarro noted, or simply had come to a decision to do so is uncertain. For in early July, Degas informed his friend the painter Evariste de Valernes that he was "planning to do a suite of lithographs, a first series of nude women at their toilette, and a second series of nude dancers."[37] Had he not yet made any of the bather lithographs (cat. nos. 61-66) or the single one of dancers (cat. no. 59), then Pissarro could have referred only to the *Maid Combing Hair* (cat. no. 60).

The immediate stimulus for Degas's renewed interest in lithography would seem to have been the 1891 lithography exhibition. But a secondary influence probably came from his friends. Early in April 1891, Degas discovered two of Pissarro's etched plates while cleaning his studio; testimony of a collaborative effort he remembered fondly, they may have rekindled that "passion" to "devote myself to black and white" that he confessed to the Halévys several months later.[38] Not long after Degas had returned the plates, Pissarro and Cassatt, disgruntled with Durand-Ruel, talked of breaking away from the dealer and exhibiting together, "probably . . . with Degas."[39] Degas's plans to do lithographs may have been stimulated as well by the example of his close friend Forain; his decision to do them in series was possibly influenced by his knowledge that Pissarro and Cassatt envisioned working on a print "series" together and that Morisot had, the previous summer, planned to realize a set of lithographs on a single subject.[40]

Degas realized only one of the two projected series: that of the bathers. In both the treatment of the subject and the medium, he revealed a unique ability to synthesize a variety of interests in a single printed image.

Subject Matter

Degas's late lithographs can be seen as deriving from his interest in the theme of women "bathing, washing, drying themselves, combing their hair or having their hair combed" that had recently found expression in pastels, a number of which he had shown, with the foregoing description, at the eighth and last Impressionist exhibition in 1886. Degas's decision to treat the subject of the bather in lithographs followed closely on the heels of the exhibition of Mary Cassatt's color aquatints in April 1891 at Durand-Ruel's. Several of her series of ten prints featured various aspects of women at their toilette. One of these, the *Woman Bathing* (fig. 38), particularly attracted Degas's admiration for the splendid economy with which Cassatt had rendered the back of the bending figure, a focus of interest in Degas's subsequent lithographs. Degas equally admired the Japanese woodcuts that were the source of Cassatt's inspiration. He himself owned several such prints, was familiar with many more in the collections of friends such as Manzi, and had visited the major exhibition of Japanese prints held in 1890 at the Ecole des Beaux-Arts, which had been the direct impetus for Cassatt's printmaking.[41] But while Degas was drawn to the theme of the toilette as depicted in Japanese woodcuts and while the poses of the bathers in his lithographs have been related to certain of them, his prints do not exhibit their concern with linear stylization.

The combination of subject and medium recalls the tradition of erotic lithographs (the so-called "lithographies libres") that had been a staple feature of the print market from the 1820s to the 1850s. These prints varied in their degree of sexual explicitness, but Mathieu Barathier's *The Bath* (fig. 39) of 1832 is typical of the class. Such prints

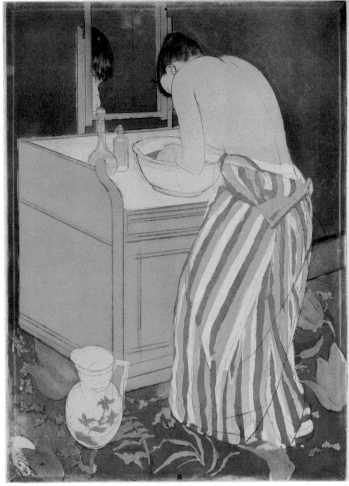

Fig. 38.
Mary Cassatt. *Woman Bathing (The Toilette)*, 1891. Drypoint, softground etching, and aquatint, printed in color. The Art Institute of Chicago.

particularly noticeable in the illustrations published in *Le Courrier français* (founded in 1883). There the theme of the bath, for example, was treated in a way that bluntly insisted on its prosaic function in the life of prostitutes, no longer portrayed as exotic playthings for the wealthy but as daughters of the people, at work. Forain was a leading exponent of this "brutal" vision, in drawings Degas admired (fig. 40).

In the late 1870s, Degas had dealt with the theme of prostitution in his monotypes and possibly in his etching dealing with the bath (cat. no. 42), which featured a "woman of the quartier Pigalle," as Béraldi recognized her in 1886. While Degas recorded many of the props of the deluxe brothel or, as in the etching, the well-appointed apartment of a prostitute, his images (unlike those in the illustrated press) were not spectator-oriented.[43] "Hitherto,"

Fig. 39.
Mathieu Barathier. *The Bath*, 1832. Lithograph. Bibliothèque Nationale, Cabinet des Estampes, Paris.

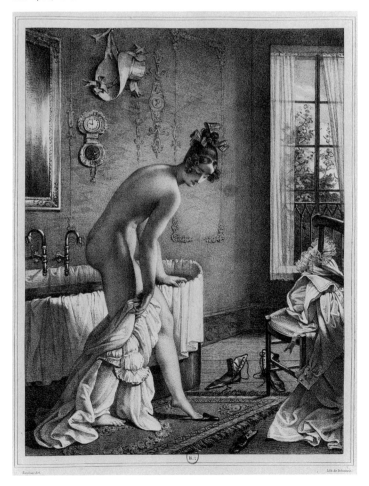

were often published simultaneously in Paris, London, New York, and other large urban centers, where such imagery found a ready market. Here we are presented not with the nude of traditional art, but rather a naked contemporary woman whose sexual accessibility is underlined by the way in which she is presented for the viewer's delectation. The genre did not die when lithography was replaced by gillotage as the primary vehicle for popular imagery; rather it migrated to the illustrated press that gillotage spawned.

Foremost in this context was *La Vie parisienne*, which, beginning in 1863, published images of women designed to titillate an audience of affluent urban males and a rural and foreign readership eager to glimpse the pleasures of the wicked capital. In the late 1870s a more licentious illustrated press came into being, a "pornographic press" whose origins were traced to the joint influences of *La Vie parisienne* and the realist novel, exemplified by writers such as Goncourt and Zola.[42] The most striking change in the erotic imagery of the illustrated press in the 1880s was, as Béraldi noted, that whereas before "prettiness and licentiousness were the fashion, now it is only ugliness and brutality." The new emphasis is

Fig. 40.
Jean-Louis Forain. *The Bell's Ringing! If It's the Englishman from Yesterday, Mother, You'll Leave!* from *Le Courrier français*, 30 March 1890. Relief process: Decaux. National Gallery of Canada, Ottawa.

Fig. 41.
Eugène Fichel. *The Bath*, 1891. Woodburytype of oil painting. Bibliothèque Nationale, Cabinet des Estampes, Paris.

George Moore quoted Degas as having observed, "the nude has always been represented in poses which presuppose an audience, but these women of mine are . . . unconcerned by any other interests than those involved in their physical condition. . . . It is as if you looked through a key-hole."[44] In the emphasis on the sheer physicality of the awkward bodies, the slightly caricatural quality of the figures, and the tinge of cynical humor, Degas's prints prefigured the direction the illustrated press would take in the 1880s. And when in 1886 Degas showed his series of pastels of women at their toilette, they were perceived in the context of the so-called "grande épidémie de pornographie"; like the drawings in the illustrated press,

they were considered vulgar, brutal, and cynical depictions of a debased feminine ideal.[45]

George Moore defended Degas's "cynicism" as a tactic for "rendering the nude an artistic possibility" by "infusing new life into a worn-out theme." In fact, when in 1891 Degas undertook to do lithographs, the attention devoted by painters and public alike to the theme of the nude was such that *Le Nu au Salon*, a special annual publication launched with great success in 1888, was about to make its third consecutive appearance. Moreover, other painters might as easily have made the observation attributed to Degas: "Two centuries ago I would have painted Susannah at the bath. Today, I paint only women

in their tubs.''[46] Artists like Gervex and Fichel (fig. 41) treated the theme of the bath quite differently from the draughtsmen for the illustrated press: feeding on the public's hypocrisy, they regaled the viewer with the charms of their contemporary beauties who, like the Venus of Botticelli, rise from the water to receive the ministrations of protective attendants. The veil of decency these allusions seek to throw over bodies blatantly displayed as articles of pleasure speaks of duplicity quite foreign to the cynicism that informs some of Forain's printed images and also Degas's earlier etching where, tongue in cheek, he employed the same reference to the grand tradition.

Although two of Degas's lithographs of 1891-92 feature the attendant found in the print of 1879-80, his pictorial concerns were now different. The furnishings that in the earlier print set the stage are inconsequential in the bather lithographs (cat. nos. 65, 66). Degas sometimes did indicate the tufted chaise longue and the partially curtained bed with large pillow, but most of the narrative details became obscured as Degas, moving from state to state, refined the image to its essence: the figure. Degas may have regarded his prints as in the tradition of an old master like Boucher, three of whose series of drawings of a nude model viewed from behind (fig. 42) were in the collections of acquaintances.[47] In those drawings Degas could have seen evidence of the advice he gave to his friend

Bartholomé in 1886: ''the same subject must be done over and over, ten times, a hundred times. Nothing in art must appear to be chance, not even movement.'' This was the advice he increasingly followed himself, as in the many drawings that relate to the lithographs (fig. 43).[48] The study of a single movement was probably to have been the essential subject of his proposed lithographic series of bathers. While that series was not realized as a publication, its many extant states gives us an indication of how Degas conceived of the proposed publication and why Degas saw lithography as an appropriate vehicle.

Degas's Lithographs

Beginning in the 1880s, those promoting lithography as a medium for painters borrowed a concept that had been successfully employed for promoting etching in the 1860s: they emphasized that lithography was an extension of drawing, requiring little or no technical knowledge. When in 1886, etcher Félix Buhot first raised the question of whether etching or lithography was better suited to the artist's ''improvisation,'' he concluded that lithography had the advantage, since it demanded ''the fewest unsuccessful trials and preparatory studies.'' As he pointed out, the idea that a lithograph is no more than ''a crayon drawing in which the stone is substituted for paper'' had indeed been carried to a logical conclusion with the development

Fig. 42.
François Boucher. *Studies of Academic Nudes Seen from the Back*. Four drawings in different media.

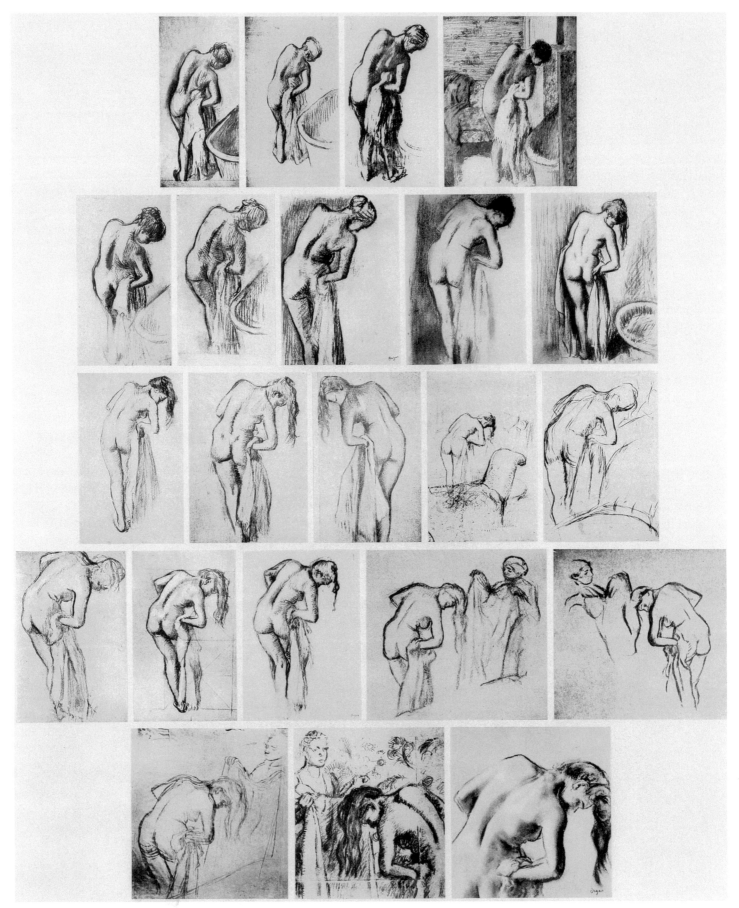

Fig. 43.
Edgar Degas. *After the Bath*. Twenty-two drawings of various dimensions in a variety of media.

of improved transfer papers that obviated work on the stone altogether.[49] Henceforth, until the century's end, the publishers, printers, artists, and critics seeking a revival of artistic lithography would advance that view of the medium, which transfer paper had served to emphasize. This redefinition of lithographs was often apparent in their actual printing. While technical treatises stressed that for best results lithographs should be printed on a smooth-surfaced, slightly absorbent paper, there was increasing tendency to use a laid paper with a distinctly textured surface, of the type used in chalk and charcoal drawings, to assume the "look" of a drawing.

Degas was aware of these developments. He had in fact made most of his lithographs in the 1870s using the transfer method; and his approach to the medium and his use of transfer paper occasionally anticipated certain developments of the 1890s. Certainly Degas had treated several of these earlier lithographs – notably the *Song of the Dog* (cat. no. 25) – as straightforward drawings. Like Fantin, Degas had early used the thin transparent *papier végétal* developed in the 1870s by the firm of Lemercier; the way in which he used it (cat. no. 37; see Part II) indicates his recognition that, as treatises of the 1890s would point out, by drawing over a textured surface, textural effects could be obtained. Degas was also aware of the mechanically patterned transfer papers that printers now began to recommend and that Whistler had been using since 1888 in prints like *Chelsea Rags*, an impression of which Degas owned.[50] The pronounced pattern evident in Whistler's print (fig. 44) can be detected in certain areas of Degas's bathers (fig. 45), indicating that he used a comparable transfer paper. And finally, the current desire to see the lithograph as a drawing is reflected both in Degas's lithograph *Three Dancers* (cat. no. 59), where the character of the printed line resembles that of graphite, and in his decision to print a number of impressions of the bathers on a laid paper with a pronounced texture (cat. no. 61IV). But for all that, Degas's lithographs – and notably the bathers – are not typical of the approach to lithography then fostered by the proponents of its revival.

While the general movement in lithography was toward increasingly simplified procedures, such as those Degas himself employed in the 1870s, his current methods were experimental and rather complex. This is particularly apparent in his elaboration of the composition *After the Bath*, which though catalogued as three prints (cat. nos. 63, 64, 65) is essentially a single image developed over nine states. Degas worked on it closely with Manzi,

Fig. 44.
James Abbott McNeill Whistler. *Chelsea Rags*, 1888. From *Albemarle*, January 1892. Transfer lithograph. National Gallery of Canada, Ottawa.

who doubtless put all his technical expertise at the artist's disposal. Yet although there is some documentary evidence as to *how* they proceeded (see cat. no. 63), it is difficult to comprehend *why* these procedures were adopted and to explain some of the physical characteristics of prints. Why, for example, did Degas begin by drawing on transparent celluloid? Had he planned to transfer his composition directly to the stone, transfer paper would have been more appropriate; if the intent was (as a note on the drawing on celluloid that was in Manzi's collection suggests) to employ a photographic process, then would not a drawing on paper have sufficed?[51] Possibly the idea was to take advantage of the clear material to make a contact negative from the image on celluloid (a sort of positive negative); making a negative that way would ensure that more of the "information" in the drawing was recorded than would be by photographing a drawing on paper. But if the idea was to use the negative to transfer the image to the lithographic stone, that does not explain why the transfer was so incomplete, requiring extensive

Fig. 44.
Detail.

rework on the stone (see cat. no. 63); by that date, photo-lithography could be expected to yield near perfect results. There seem as many unanswerable questions surrounding the transfer Degas made after the initial image was on the stone (see cat. nos 64, 65). Similarly mysterious is the fact that in the large version of *After the Bath* (cat. no. 66), the reticulated texture associated with mechanically patterned transfer paper appears not in the first state, as might be expected, but in the second. Since Degas had not yet transferred the image to a second stone, one can account for the texture by positing that he may have developed the image by drawing on a blank sheet of transfer paper, whereby the crayon work was then transferred to the stone.

In short, one suspects that working with Manzi (probably at the studio on the rue Forest), Degas became so involved with experimenting with various technical possibilities that he lost sight of his publishing objective.[52] The process and not the product captivated him. And yet if at each stage of his elaboration of the small bather turned to the right (cat. nos. 63, 64, 65) Degas had pulled an edition, he could have produced a portfolio on the theme of the bather that was both a graphic tour de force as well as a fascinating insight into a central preoccupation of his late work.

Jacques Emile Blanche remembers Degas's having advised him: "Make a drawing. Start it all over again, trace it. Start and trace it again."[53] Degas himself did that increasingly in the 1890s. Often he would work a drawing to a certain point and then, rather than carry it further on the original sheet, he would trace the drawing and continue work on the fresh support; sometimes he would work the

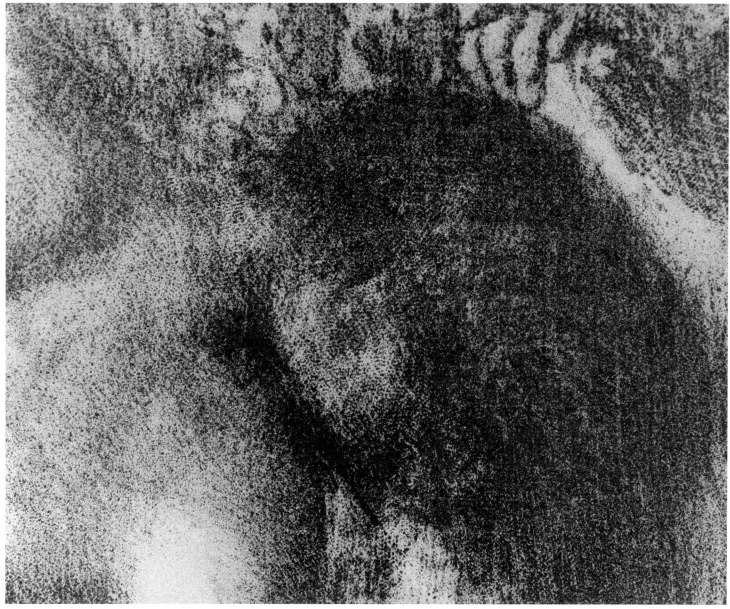

Fig. 45.
Edgar Degas. *After the Bath (large version)* (cat. no. 66 V; detail), 1891-92. Transfer
lithograph. National Gallery of Canada, Ottawa.

tracing with pastel, then abandon it, retrace it, and con-
tinue work on the new sheet. As Denis Rouart, Vollard,
and others pointed out, a consequence of this habit of
"improving his work by corrections on tracing paper" was
the progressive enlargement of the image. Since Degas
traced outside of the original lines, the image "grew" with
each successive tracing.[54] This was the fate of the small
bather, as Degas moved from state to state, refining,
developing, and transferring his image to different printing
surfaces (fig. 46).

Degas brought to lithography a technical inventive-
ness that had not seen its equal. The results are hybrids of
a sort, the products of work done on the stone and also
transferred to the stone, directly and probably photographi-
cally. But while the lithographs reveal Degas's willingness
to explore to the limit a variety of technical possibilities,
they also betray a certain impatience with the media. They
are "messy" prints in the sense that the artist took little
trouble to cover traces of earlier work as he successively
modified his initial conception, working towards a satisfac-
tory image. And while the portfolio was not realized,
Degas does indeed appear to have been satisfied with
some of the results. He apparently had small editions
pulled of the first and second states of *After the Bath III*
(cat. no. 65) and possibly authorized the edition of the final
state of the large version (cat. no. 66 V; see also cat. no.
61 IV and VI).

Yet these lithographs of 1891-92 mark the end of
Degas's career as a printmaker. Just as the lithography
revival was hitting its stride and the medium attracting
ever more artists, young and old, Degas turned his back on
it.

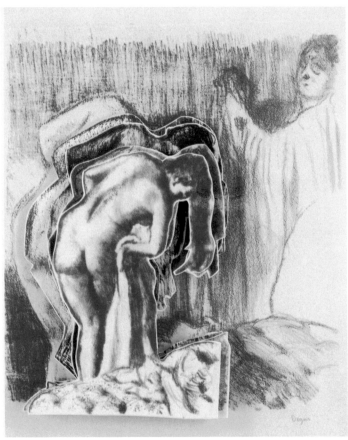

Fig. 46.
Edgar Degas. *After the Bath I, II, III*. Details from selected states, superimposed (cat. nos. 63 II, 64 I, 64 IV, 64 V, 65 I). National Gallery of Canada, Ottawa.

New Types of Prints

The end of Degas's career as a printmaker in the classic sense did not spell the end of his involvement with the making of multiples. While other artists, tempted by the new market for original prints, made lithographs and etchings, Degas now became a passionate photographer. Between 1894 and the century's end he made almost as many photographic prints as he had made etchings and lithographs over the preceding forty years.[55]

Degas's interest in photography, at its most intense during the period 1894-95, may have prompted his involvement with Manzi in the publication of a portfolio of reproductions, *Vingt dessins fac-similés de Degas*. Each portfolio, signed by Degas himself, was pulled in an edition of 100 and published in 1898 after several years of preparation.[56] The care in the preparation is evident in the product: it is a remarkable testimony to the brilliant results

photomechanical processes were now capable of yielding in the hands of a master technician like Manzi working closely with an artist as demanding as Degas. Exhibited in the spring of 1898 at the gallery of Boussod, Manzi, Joyant, and Co. (formerly Boussod and Valadon), these photomechanical reproductions attracted as much attention as had Thornley's lithographic reproductions at Boussod and Valadon a decade earlier. André Mellerio, a guiding force in the print revival of the 1890s, recognized the complexity of the processes used and the intelligence with which they were employed, and he applauded the "perfect" results. Mellerio also noted that Degas's works, even to the least of his drawings, now commanded "fabulous" sums and he welcomed "a publication . . . that will help to perpetuate and further propagate that which is the essence, the very marrow, of this artist."[57]

Mellerio's review underlines several recent developments. By so warmly praising photomechanical reproductions, however good, in the midst of an acknowledged print revival, Mellerio indicated two changes in attitude regarding the relationship of new processes to traditional printmaking. It was clear that the original print had become so firmly established in its own right that it had nothing to fear from such processes; on the other hand, the handcrafted reproductive print had finally succumbed. Only the previous year Mellerio had himself sounded the deathknell of the professional printmaker's art when he wrote that the utility of reproductive printmaking was fundamentally reduced in an age of perfected processes.[58] Having lost its raison d'être, the handcrafted reproductive print as a viable and vital art form would not survive the decade; the future belonged to the original print and the photomechanical reproduction.

A second major development underscored by Mellerio's review is the emergence of Degas as a modern master and a natural candidate to have his works reproduced by the new, and once again lauded, industrial printing processes. Thus, when in 1898 Roger Marx launched *Les Maîtres de dessin*, a serial publication of drawings by old and modern masters designed to "lead collectors and the public to a sound notion of Beauty," it was not surprising to find Degas featured in the first issue.[59]

During the last years of the nineteenth century and in the years leading up to his death in 1917, Degas found his work reproduced with increasing frequency. Often he was unable to control the quality of the reproductions, many of which he probably never knew about. But that he did so when he could is rather touchingly testified by Vollard's

publication in 1914 of ninety-eight reproductions "signed by Degas."[60] The artist reviewed each photograph to be used in the publication, noting his approval by a signature in the lower right margin beneath the photograph. This awkward signature of a near sightless old man is reproduced along with the signatures on the works themselves in the last printed testament to Degas's genius within his lifetime.

Notes to Part III

1. Walter Sickert recalled that in the apartment Degas lived in from 1890 to 1912 on the rue Victor Massé, he had a mahogany table in the ante-room used solely to accommodate the piles of Forain's drawings from the illustrated press ("Degas," *Burlington Magazine*, Nov. 1917, p. 184).

2. See New York, *Manet* 1983, no. 214.

3. *La Vie moderne*, 4 Dec. 1880, p. 771; 29 July 1882, p. 467.

4. Letter to Theo, November or December 1882 (*The Complete Letters of Vincent van Gogh* [Greenwich, Conn., 1959], vol. 1, p. 483).

5. Pissarro *Correspondance* 1980, letter no. 212.

6. Jean Alboize, "Salon de 1886: La Gravure," *L'Artiste*, July 1886, p. 52.

7. Emile Martinet, *Exposition universelle internationale de 1878 à Paris. Rapport sur l'imprimerie et la librairie* (Paris, 1880), p. 73.

8. Joseph de Gayda, "La Lithographie et la Société des lithographes français," *L'Artiste*, Nov. 1885, p. 377.

9. Pierre Larousse, *Grand Dictionnaire universel du XIXe siècle* (Paris [1891]), pp. 1006-7.

10. *Fac-similés par G. W. Thornley de vingt-cinq dessins en couleur d'après François Boucher* (Paris, 1881). Reviewed in "Beaux-Arts," *Le Livre*, 10 Feb. 1882, p. 102.

11. Félix Fénéon, "Calendrier d'avril: Expositions: VII. Aux vitrines dans la rue – chez Van Gogh," *La Revue indépendante*, May 1888, p. 382. Because the album of fifteen prints was not registered with the *dépot légal* at the Bibliothèque Nationale until April 1889, it was not officially published until that time.

12. Letter to Thornley, 28 April 1888 (Degas, *Lettres* 1945, no. 121).

13. Félix Fénéon, "Calendrier de septembre: Les Expositions. Chez M. Van Gogh," *La Revue indépendante*, Oct. 1888, p. 139.

14. The works reproduced from the Rouart collection were Lemoisne 324, 380, 406, 408, 537, 545, 570, 573, 644, 715, 729; the remaining four works were Lemoisne 757, 847, 876, 891. Degas knew Manzi by 1886, the date the latter inscribed on the impression of his etched portrait of Degas in the Cabinet des Estampes, Bibliothèque Nationale, Paris. A brief account of Manzi's career and association with Degas is contained in the introduction to the sale catalogue *Collection Manzi: Tableaux, pastels, aquarelles, dessins par . . .*, Première vente, 13-14 March 1919. See also Degas, *Lettres* 1945, p. 136, n. l.

15. Lemercier registered four lithographs after Degas in the *dépot légal* on 19 February 1889. Strangely, in the register only the printer's name appears; both the spaces for the reproductive printmaker's name and the name of the originator of the composition were left blank. The other prints were after Lemoisne 890 and two other compositions Degas subsequently altered.

16. Both the drawing and the four Thornley lithographs were listed in the catalogue as having been loaned by Boussod, Valadon et Cie, Paris. On Theo's involvement see also Pissarro's letter to Lucien, 4 September 1888 (Pissarro, *Lettres* 1950, p. 175).

17. See letters from Theo van Gogh to Vincent, 8 and 22 December 1889, 22 January 1890, 13 June 1890 (*The Complete Letters*, vol. 3, pp. 558, 559, 562, 573).

18. For brief descriptions of the book and the periodical see Rewald 1973, p. 610. See also Pissarro's letters to Lucien, 23 December 1890 and 2 January 1891 (Pissarro, *Lettres* 1950, pp. 198-99).

19. None of the articles prompted by Lauzet's untimely death in 1898 mentions his etched work, while all pay homage to his gifts as a lithographer.

20. On Cassatt, see Frederick A. Sweet, *Miss Mary Cassatt: Impressionist from Pennsylvania* (Norman, Oklahoma, 1966), p. 95; on Pissarro see Pissarro *Correspondance* 1980, p. 146, n. 6.

21. For this project see Janine Bailly-Herzberg, "Les Estampes de Berthe Morisot," *Gazette des beaux-arts* (hereafter cited as *GBA*), 93 (1979), pp. 215-27.

22. Roger Marx, "Préface," *Premier album publié par les artistes membres de la Société de l'Estampe Originale* (Paris, 1888).

23. Paul Leroi, "Salon de 1886," *L'Art*, 41 (1886), pp. 30-40. See also Douglas Druick and Michel Hoog, *Fantin-Latour* (Ottawa, 1983), pp. 275ff.

24. Bailly-Herzberg, "Les Estampes de Berthe Morisot," p. 216. Degas owned more than six lithographs by Brown (Atelier sale Estampes, lot. no. 14).

25. Philippe Burty, preface to the catalogue of the *Exposition de graveurs* (Paris, 1889).

26. Degas's entries, cat. nos. 104, 105, were each simply listed as "lithographie."

27. Béraldi, vol. 5, pp. 153-54.

28. "Les Expositions: Les Peintres-Graveurs," *La Revue des beaux-arts*, 15 Feb. 1889, p. 39; H[enri]S[omm], "L'Exposition des peintres-graveurs," *Le Chat noir*, 23 Feb. 1889, p. 1284; Félix Fénéon, "Les Peintres-Graveurs," *Le Cravache*, 2 Feb. 1889; A[lfred] de L[ostalot], "Concours et expositions: Exposition des peintres-graveurs," *La Chronique des arts*, 26 Jan. 1889.

29. Béraldi, vol. 9, pp. 255-71.

30. *The Complete Letters*, vol. 3, pp. 73, 242. Bailly-Herzberg, "Les Estampes de Berthe Morisot," pp. 217-18, 225.

31. Minutes of the meeting of the Société des Artistes Lithographes Français, 2 December 1888.

32. Letter to Aglaüs Bouvenne, spring 1891 (Degas, *Lettres* 1945, no. 160). One can infer Degas's decline of Rouart's request from this letter. Degas's lithograph appeared in the catalogue of the exhibition as no. 956: "Programme pour les anciens Elèves du Lycée de Nantes, 1884 (Collection Bouvenne)."

33. The advertisements for the deluxe edition of the *Revue indépendante* began to appear in the July 1890 issue of the regular edition and appeared sporadically until December 1890. No print by Degas was published. Possibly that intended for publication was the print (cat. no. 54) Degas had made for Mallarmé, who was closely associated with the review.

34. Henri Béraldi, "Exposition de la lithographie," *GBA*, June 1891, p. 486. Other artists Béraldi mentioned in this context included Cassatt, Raffaëlli, and, incorrectly, Redon.

35. Entry in Daniel Halévy's journal for 30 April 1891 (Halévy, p. 57).

36. Letter to Lucien, 25 April 1891 (Pissarro, *Lettres* 1950, p. 255). We would like to thank Janine Bailly-Herzberg for dispelling the confusion caused by the discrepancy between the French and English editions of the letters (the French edition has Degas doing the lithographs; the English edition Pissarro), and for alerting us that the name is Mayer rather than Meyer, as it appears in both published editions. This will be rectified in her forthcoming volumes (II and III) of Pissarro letters. For Degas's friendship with Mayer and information on the dealer, see Degas's letter to Madame Mayer, April 1896 (Degas, *Lettres* 1945, p. 210 and n. 1). One of Forain's earliest lithographs depicts Mayer in the window of his rue Lafitte gallery (Marcel Guérin, *Forain lithographe* [Paris, 1910], cat. no. 6).

37. Letter to De Valernes, 6 July 1891 (Degas, *Lettres* 1945, p. 183). Note that in the English edition of the letters the date is given as 6 December 1891, without explanation for the change.

38. Entry in Daniel Halévy's journal for 14 February 1892 (Degas, *Lettres* 1945, Appendice III, p. 273). Pissarro reported the finding of the plates in a letter to Lucien of 8 April 1891 (Pissarro, *Lettres* 1950, p. 230, where this letter is mistakenly run together with that of 3 April, an error corrected in the English edition).

39. Pissarro, *Lettres* 1950, p. 255.

40. Pissarro discusses the series project in letters to Lucien of 3 April and 23 June 1891 (Pissarro, *Lettres* 1950, pp. 228, 255).

41. Achille Segard, *Mary Cassatt: Un Peintre des enfants et des mères* (Paris, 1913), p. 104. On the relationship between Degas and Japanese art see Colta Feller Ives, *The Great Wave: The Influence of Japanese Woodcuts on French Prints* (New York, 1974), pp. 34-44; Gabriel Weisberg et al., *Japonisme: Japanese Influence on French Art 1854-1910* (Cleveland, 1975); Theodore Reff, "Degas, Lautrec and Japanese Art," *Japonisme in Art: An International Symposium* (Tokyo, 1980), pp. 189-213.

42. For a synopsis of these changes see Béraldi's entry on *Le Courrier français* in vol. 9, pp. 89-92. See also Henri Grignet, "La Presse pornographique," *Le Livre*, 10 Nov. 1880, pp. 287-89.

43. Béraldi entry on Degas, ibid. On the theme of prostitution in Degas see Eunice Lipton, "Degas's Bathers: The Case for Realism," *Arts Magazine*, May 1980, pp. 94-97; and Hollis Clayson, "Avant-Garde and Pompier Images of 19th-Century French Prostitution: The Matter of Modernism, Modernity and Social Ideology," *Modernism and Modernity: The Vancouver Conference Papers* (Halifax, 1983), pp. 43-64.

44. George Moore, "Degas: The Painter of Modern Life," *The Magazine of Art*, 13 (1890), p. 425.

45. J. K. Huysmans, *L'Art moderne – Certains* (Paris, 1975), pp. 293-97.

46. Moore, pp. 425-26; Armand Silvestre, *Le Nu au Salon* (Paris, 1888-94).

47. The drawings are, from left to right, nos. 444, 445, 448, and 447 in A. Ananoff, *L'Oeuvre dessiné de François Boucher*, vol. 1 (Paris, 1966). Edmond de Goncourt owned nos. 444 and 445 (no. 444 had also been shown in the 1879 Exposition de Dessins des Maîtres Anciens at the Ecole des Beaux-Arts and was reproduced by means of gillotage as a full-page supplement in *La Vie moderne*, 5 June 1879); no. 448 was owned by Degas's friend Henri Michel Lévy, who appears in a painting by Degas of about 1878 (Lemoisne 326, Gulbenkian Foundation, Lisbon); no. 447 was in the collection Péreire, Paris.

48. Letter to Bartholomé, 17 January 1886 (Degas, *Lettres* 1945, p. 119). The studies of the bather in fig. 43 are, from top to bottom and from left to right: Atelier sale II, no. 320; II, no. 296; II, no. 258; I, no. 172; II, no. 169; III, no. 194; II, no. 222; National Museum of Belgrade; Parke Bernet, N.Y., 1949, Sale 1052, no. 88; Atelier sale II, no. 316; III, no. 327; III, no. 262; III, no. 384; IV, no. 266a; IV, no. 158; II, no. 321; II, no. 318; III, no. 177; IV, no. 356; III, no. 334-2; II, no. 310; Lemoisne 856.

49. "Pointe Sèche" (pseud. of Félix Buhot), "Gravure et lithographie," *Le Journal des arts*, 23 April 1885, p. 1.

50. Atelier sale Estampes, lot 323.

51. Celluloid, invented in the United States in 1869, had been introduced to France in the mid-1870s; in 1879 it was applied to the manufacture of typographic *clichés* or plates. In 1882 the *Bulletin de la Société française de photographie* announced the use of celluloid "comme support pour l'impression aux encres grasses" (p. 36). Degas would have learned of the use of celluloid in the printing industry through his acquaintance with printers like Manzi, or through scientific reviews like *La Nature*, where it was discussed in the issue of May 1880 (p. 383).

52. Around this time Degas wrote a letter to Bartholomé from the rue Forest atelier and in another to Manzi informed the printer he had been to the rue Forest to see him, but had not found him in (Degas, *Lettres* 1945, pp. 146, 148).

53. Jacques Emile Blanche, "Notes sur la peinture moderne," *Revue de Paris*, 1913, in R. H. Ives Gammell, *The Shop-Talk of Edgar Degas* (Boston, 1961), p. 22.

54. Ambroise Vollard, *Recollections of a Picture Dealer*, trans. V. M. Macdonald (New York, 1978), pp. 235-46; Denis Rouart, *Degas: A la recherche de sa technique* (Paris, 1945), pp. 67-68.

55. See Antoine Terrasse, *Degas et la photographie* (Paris, 1983).

56. The blindstamp on each of the twenty prints indicates a copyright of 1897; judging from their complexity, one must assume they were begun in 1896, also the date of the last works to be reproduced in the portfolio (which spanned the years 1861-96).

57. André Mellerio, "Expositions: Un Album de 20 reproductions d'après des dessins de M. Degas," *L'Estampe et l'affiche*, March-April 1898, pp. 81-82.

58. André Mellerio, "Deux Expositions de lithographie," *L'Estampe et l'affiche*, 1 (1897), pp. 219-20.

59. See *L'Art moderne*, 19 (1899), p. 163.

60. *Quatre-vingt-dix-huit reproductions signées par Degas (peintures, pastels, dessins et estampes)* (Paris, 1914). While it is sometimes said that this book was printed only in 1918 when it was taken over by Bernheim-Jeune et Cie., it was in fact first published in 1914 as the *dépôt légal* copy in the Bibliothèque Nationale, Paris, attests.

Catalogue

Use of the Catalogue

The catalogue entries describe and illustrate all Degas's etchings and lithographs in as many states as it was possible to assemble. They expand and correct the definitive work published in 1919 by Loys Delteil. His catalogue raisonné, which has served as a fundamental guide, was subsequently revised in part by the exhibition catalogues of Paul Moses (etchings, 1964) and William Ittmann (lithographs, 1967). Further information was provided by Jean Adhémar in his catalogue raisonné of 1973.

The catalogue entries are in chronological order as established by the authors. One catalogue number is given for each of the sixty-six etchings and lithographs, with the states for every print expressed in roman numerals.

Works related to the prints have letters (a, b, etc.) appended to the number. Titles assigned to the prints by the authors are in English; French titles according to Delteil appear in the Concordance. Dimensions are given in millimeters (mm.); height precedes width. Measurements are given for plate and stonemarks (or image) and for sheet size.

Whenever possible, illustrations are actual size.

All works illustrated throughout the catalogue are by Degas unless otherwise indicated.

For fuller information on technical terms, see the Glossary. More complete information on former collections (Coll.) is given in "Collectors of Degas's Prints." Papers and watermarks are described in "Degas's Printing Papers." Canceled impressions are discussed in "Degas's Copper Plates."

The following abbreviations are used for frequently cited references:

Adhémar: Adhémar, Jean, and Cachin, Françoise. *Degas: The Complete Etchings, Lithographs and Monotypes*. Translated from the 1973 French edition by Jane Brenton. New York, 1974.

Delteil: Delteil, Loys. *Edgar Degas. Le Peintre-Graveur illustré*, vol. 9. Paris, 1919.

Janis: Janis, Eugenia Parry. *Degas Monotypes*. Cambridge, Mass., 1968.

Lemoisne: Lemoisne, Paul André. *Degas et son oeuvre*. 4 vols. Paris, 1946-49.

Reff *The Notebooks of Edgar Degas*. 2 vols. Oxford, 1976.
Notebook: (Refers to Reff's order of the extant Degas notebooks.)

Other bibliographic references appearing in short form are given in full in the Selected Bibliography.

A census of owners of Degas prints has been compiled based on the impressions known to the authors. The owners, cited in the entries by place or name, can be readily identified by referring to the list of lenders to the exhibition. Abbreviations for collections not cited by place or name or for those who are not lenders to the exhibition are as follows:

AIC: The Art Institute of Chicago
Artemis: Artemis Group, London
BAA: Bibliothèque d'Art et d'Archéologie, Fondation Doucet, Paris
BM: The British Museum
BN: Bibliothèque Nationale, Cabinet des Estampes
BPL: Boston Public Library, Print Department
Frankfurt: Städelsches Kunstinstitut, Frankfurt am Main
LACM: Los Angeles County Museum of Art
LC: Library of Congress, Prints and Photographs Division
MFA: Museum of Fine Arts, Boston
MMA: The Metropolitan Museum of Art
MOMA: Museum of Modern Art, New York
NGA: National Gallery of Art, Washington, D.C.
NGC: National Gallery of Canada, Ottawa
NYPL: The New York Public Library, Astor, Lenox and Tilden Foundations
Prouté: Archives Paul Prouté S.A.
PMA: Philadelphia Museum of Art
R. M. Light: R. M. Light, Inc., Santa Barbara, California
SF: The Fine Arts Museums of San Francisco, Achenbach Foundation for Graphic Arts
N. Simon: Norton Simon Museum
Texas: The Archer M. Huntington Art Gallery, The University of Texas at Austin
Tunick: David Tunick, Inc., New York
Wesleyan: Davison Art Center, Wesleyan University, Middletown, Connecticut

1

Greek Landscape or *The Anchorage* 1856

Etching. One state
Delteil 10 (undated); Adhémar 1 (1856)
80 x 66 mm. platemark
Cream, moderately thick, moderately textured, wove paper
209 x 208 mm. sheet
Atelier stamp
E. W. Kornfeld, Bern

The tentative quality of this etching suggests that it was Degas's first print. It is executed with simple technical means: short hesitant strokes, little modeling with parallel lines, and no crosshatching; it was bitten only once in an acid bath.

This impression was found in Degas's studio after his death. Another impression was pasted in a notebook used by Degas between 1859 and 1864 (Reff *Notebook* 18, p. 105). (These are the only two uncanceled impressions located.) At that time Degas's notebooks served both as sketchbooks and as albums in which he grouped similar visual ideas or observations, recording his interests and activities of the moment. The items are rarely dated, and the notebooks were used randomly. It is therefore not a contradiction that his first print is found in a notebook used at a later time. Between pages 89 and 107 there are a number of landscape subjects: drawings, one photograph, and some six tracings of sites in Greece from small wood-engraved illustrations to Homer's *Iliad* and *Odyssey* from editions published in London in 1853.[1] Degas included this etching and three impressions of *Mountain Landscape* (cat. no. 2) as part of a conscious grouping of Greek landscapes.

According to Loys Delteil, the *Greek Landscape* was executed at the suggestion of Prince Grégoire Soutzo, who was visiting Degas's father and who apparently provided the artist with his first lessons in etching. Soutzo, a Rumanian landscape artist living in Paris and a collector friend of Degas's father, was an amateur printmaker. In one of his notebooks Degas made a drawing after a landscape by Soutzo, inscribing and dating it 15 February 1856 (Reff *Notebook* 6, p. 42). In the same notebook between February and April 1856 Degas copied Greek antiquities – architecture, sculpture, and small objects – from book illustrations (Reff *Notebook* 6, passim).

The style of this etching is far less evolved than that of the *Portrait of a Young Man* (cat. no. 7), signed and dated in the plate 8 Nov. 1857; Degas's association with Soutzo in the early months of 1856 as well as his interest in Greek antiquities and illustration of Greek sites further support a date early in 1856 for the execution of this print.

Note

1. *The Iliad*, 2 vols., and *The Odyssey*, 1 vol., translated by Alexander Pope with notes by T. A. Buckley and illustrated with "Flaxman's Designs and other engravings," London: Ingram, Cooke, and Co., 1853.

1

2

Mountain Landscape 1856

Etching and drypoint. Three states
Not in Delteil; Adhémar 2 (1856)
132 x 91 mm. platemark (first state)
115 x 91 mm. platemark (second and third states)

I first state

Etching touched with graphite and pen and brown ink
Gray-white, thin, smooth, oriental paper
139 x 108 mm. sheet
Bibliothèque Nationale, Paris
Not in exhibition

II second state

Gray-white, thin, smooth, oriental paper
115 x 96 mm. sheet
Bibliothèque Nationale, Paris
Exhibited in Philadelphia

III third state

Gray-white, thin, smooth, oriental paper
124 x 102 mm. sheet
Bibliothèque Nationale, Paris
Exhibited in Boston

All four known impressions of this print are in the Bibliothèque
Nationale, three of them pasted onto the recto and verso of the
same notebook sheet (Reff *Notebook* 18, pp. 101-102).

 This small etching again reflects Degas's interest in Greek
landscapes, and it was probably executed soon after his first
attempt at etching (cat. no. 1). The forms and shapes of the trees
and bushes relate closely to those in his first print. The jagged
contours of the mountain and the manner in which its planes are
suggested by hatching recollect those wood-engraved illustrations
in *The Iliad* (London, 1853) studied and traced by Degas (figs. 1
and 2).

 The impression of the first state, here illustrated, is unevenly
printed with proposed additions added by hand in graphite and pen
and brown ink, primarily to enlarge the tree at left and to indicate a
church steeple in the middle distance, as well as to shade the
mountain.

 In the second state, the artist has completed the profile of
and shaded the low hill at far right. The plate was cut down, and
an accidental vertical line appears in the sky.

 The third state reflects in etching most, if not all, of the
additions made by hand on the first state impression. The tree at
left has been enlarged, a small tree appears at the far right, the
steeple is indicated, and a seated figure watches over a flock of
sheep. Degas has added personal touches that alter the initial
effect of a spare classical landscape.

 The image is more freely drawn, was etched in more than
one bite, and has fine drypoint touches throughout. In the third
state Degas achieved a broader range of tonalities and greater
sense of space than in his first print, the *Greek Landscape*.

2 first state

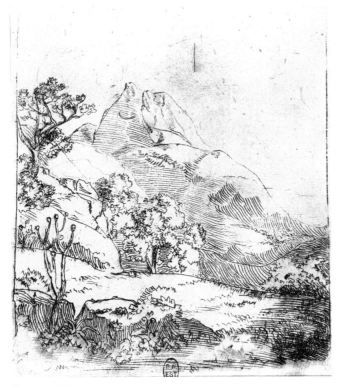

2 second state

2. Fig. 1.
Temple of Theseus. Pen and brown ink on tracing paper. After wood engraving in fig. 2.

ATHENS—TEMPLE OF THESEUS.

2. Fig. 2.
Unknown Artist, *Temple of Theseus*. Wood engraving from Homer, *The Iliad* (London, 1853), vol. 2, p. 130.

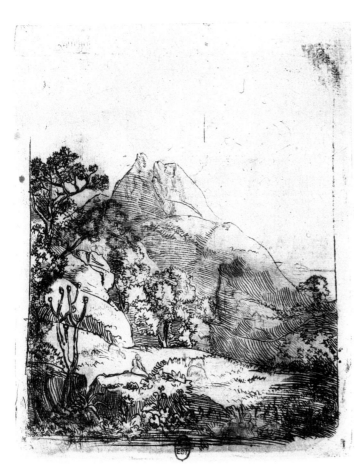

2 third state

3

The Sportsman Mounting His Horse 1856

Etching. Five states
Delteil 9 (undated); Adhémar 3 (about 1856)
83 x 75 mm. platemark, irregular

I first state

Gray-white, thin, smooth, oriental paper
102 x 78-82 mm. sheet, irregular
E. W. Kornfeld, Bern

II second state

Gray-white, thin, smooth, oriental paper
100 x 82 mm. sheet, irregular
Coll.: Rouart
Bibliothèque Nationale, Paris
Exhibited in London

II second state

Gray-white, thin, smooth, oriental paper
95 x 80 mm. sheet
*Sterling and Francine Clark Art Institute, Williamstown,
Massachusetts*
Exhibited in Boston and Philadelphia
Not illustrated

III third state

Not located

IV fourth state

Not located

V fifth state

Not located

V fifth state, from the canceled plate

Cream, moderately thick, moderately textured, wove paper
325 x 245 mm. sheet
*The Metropolitan Museum of Art. The Elisha Whittlesey Collection,
The Elisha Whittlesey Fund, 1967*

The small format and the character of the linework in this print relate to the first two landscape etchings. However, the use of a variety of hatchings to create subtle tonalities and to suggest atmosphere reveals a greater facility with the etching needle. Perhaps the most advanced aspect of this print is the depiction of a cloudy sky, ignored or only schematically suggested in the two previous etchings. Degas also introduced a more contemporary subject matter, two top-hatted riders and their horses.

In the first state Degas sketched in the entire composition, including the shading in the sky. This impression, with the striations on its surface, appears to have been hand-rubbed rather than run through the press (see also cat. no. 15). Two impressions of the first state are in the Kornfeld collection.

In the second state Degas added hatching and crosshatching to model the horses, the undergrowth, and the clouds above. The coat of the sportsman in the foreground is not shaded. The sketch-like quality of the first state has been superseded and the tonal range increased. Impressions have been located at BN (Rouart) and Clark.

Delteil cites three further states with additions to the foreground plants and the introduction of two trees in the right middleground. No impressions of these states have been located.

This impression of the fifth state, which was printed after Degas's death, is from a plate that was canceled by three strong diagonal lines. Degas had already begun to obliterate the horse in the foreground; the area is partly burnished and marred by a series of vertical scratches. Here Degas initiated a practice often seen in his later prints, in which he left a plate partially erased and unresolved.

3 first state

4

René-Hilaire De Gas, Grandfather of the Artist
1856-57

Etching and drypoint. One state
Delteil 2 (1856); Adhémar 6 (1856)
128 x 108 mm. platemark
Off-white, moderately thick, moderately textured, laid paper
280 x 230 mm. sheet
Watermark: fragment of ARCHES
Library of Congress, Washington, D.C.

Although the subject of this etching is frequently identified as Degas's father, Auguste De Gas, recent studies have persuasively argued that it is a portrait of the artist's grandfather, René-Hilaire De Gas (1770-1858). From July 1856 to April 1859 Degas lived in Italy, where he stayed with his grandfather in Naples, visited members of the family in Florence, and worked in Rome. He was in Naples between July and October 1856 and from August to November 1857. One impression of this print (Bibliothèque d'Art et d'Archéologie, Paris) from the collection of Philippe Burty is inscribed in pencil *Degas/Naples/1857*. Another in the Bibliothèque Nationale from the Alexis Rouart collection is inscribed *Degas Naples 1856*. Degas completed and dated an oil portrait of René-Hilaire (Lemoisne 27) in 1857 at Capodimonte. Three pencil drawings in preparation for this portrait are found in a notebook used in Naples in 1856 (Reff *Notebook* 4, pp. 21-23). One of these drawings, that on page 22 of the notebook, shows the sitter wearing eyeglasses with his head slightly bowed to the left, reading a book (fig. 1). This slight sketch bears a distinct resemblance to the etched portrait in reverse, and it seems to be the most convincing visual evidence for the identification of the sitter in the print.[1] Degas employed the same pose as he had for the etching in a small, unfinished oil (Lemoisne 33, Louvre). He used it again as one of his pictures within pictures in the oil painting of *The Bellelli Family*, 1859-60 (Lemoisne 79, Louvre), in which a framed drawing of the sitter appears. In these two works the subject faces in the same direction as in the etching; the print may have served as the initial study for both. The red chalk drawing of René-Hilaire depicted in the painting apparently never existed.[2]

Both in subject matter and in etching technique this print relates more closely to the etched portraits Degas made in Rome in the winter of 1857 under the guidance of Joseph Tourny (see cat. no. 6) than to the landscapes made in early 1856 with Soutzo in Paris. However, all the impressions examined exhibit scratches and damage to the surface of the plate, suggesting that a passage of time had elapsed between the etching of the plate and its printing. The drypoint caricature profile at the upper left of the print, in a different medium and style, was also probably added at this later time.[3]

The sketch-like quality and unfinished effect of the print is self-evident. Although the line of the jaw is more deeply crosshatched and etched, the image is not as sensitively drawn nor as evenly bitten as other portraits of this period; see, for example, the Tourny portrait (cat. no. 5) and the *Self-portrait* (cat. no. 8). Both the roughened condition of the plate and the relatively faint impressions make it difficult to say whether the plate was

3 second state

3 fifth state

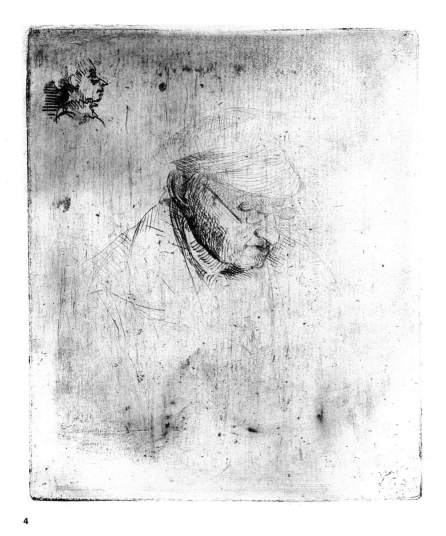

4. Fig. 1.
René-Hilaire De Gas. Pencil drawing from a notebook (Reff *Notebook* 4, p. 22). Bibliothèque Nationale, Paris.

4

executed before or after other well-documented prints of Rome done in 1857.

Seven impressions have been found: AIC, BAA (Burty),[4] BN (Rouart), Josefowitz (Roger Marx), LC, NGA, and San Francisco (with pale Atelier and Succession stamps, although no impressions were listed in the Atelier sale catalogues).

Notes

1. An interesting point made in the Chicago, *Degas* 1984 exhibition catalogue, no. 3, is that for many years no one, including his children and heirs, questioned the identity of the sitter as Auguste De Gas.

2. For further information about the Bellelli family portrait, see Finsen 1983.

3. In technique the profile relates to the broad drypoint lines used in *The Infanta Margarita* (cat. no. 16). For drawings in a similar spirit see Reff *Notebook* 4, pp. 29-31, after Hogarth and dated to 1859-60; also *Notebook* 18, between pp. 187 and 203, dated to 1859-64.

4. Noted on the sheet in pencil is "M. Brandon, père du peintre Brandon (Portrait du Grand'père)." Edouard Brandon was a history painter and friend of Edgar Degas who worked in Rome during 1856-63 and exhibited in the first Impressionist exhibition of 1874. The significance of this inscription is not known.

5

The Engraver Joseph Tourny 1857

Etching. One state
Delteil 4 (Rome, 1856); Adhémar 7 and 8 (Rome, winter 1857)
230 x 144 mm. platemark

First printing (Rome, 1857)
Gray-white, thin, smooth paper mounted on cream, moderately
thick, moderately textured, wove paper
388 x 270 mm. sheet. Lower right in graphite: *Rome 1856*
Coll.: Atelier; Lockhart
*The Art Museum, Princeton University. Gift of James H.
Lockhart, Jr.*

Second printing, with plate scratches and slight corrosion (Paris,
after 1859)
Off-white, medium to moderately thick, rough, laid paper
246 x 165 mm. sheet
*Museum of Fine Arts, Boston. Katherine Eliot Bullard Fund in
memory of Francis Bullard and proceeds from sale of duplicate
prints*

Third printing, with additional scratch and increased corrosion
Off-white, medium weight, moderately textured, laid paper
420 x 315 mm. sheet
Watermark: fragment of *ARCHES* in capital script letters
Signed lower right in graphite: *Degas*
*Fogg Art Museum, Harvard University. Gift of Meta and Paul J.
Sachs*

Third printing, with monotype inking (Paris, mid-1860s)
Cream, medium weight, slightly textured, laid paper
432 x 295 mm. sheet
Watermark: Arches countermark
E. W. Kornfeld, Bern

Third printing, with monotype inking (Paris, mid-1860s)
Cream, medium weight, moderately textured, laid paper
480 x 310-315 mm. sheet
Watermark: Arches countermark
Kupferstichkabinett, Staatliche Kunsthalle, Karlsruhe
Exhibited in Boston and Philadelphia

Third printing, with monotype inking (Paris, mid-1860s)
Off-white, moderately thick, moderately textured, laid paper
534 x 363 mm. sheet
Watermark: D. & C. Blauw (in block letters)
Coll.: Guérin
The Metropolitan Museum of Art. Harris Brisbane Dick Fund, 1927

Fourth printing, with corrosion partly cleaned and additional
scratches
Off-white, moderately thick, moderately textured, laid paper
315 x 225 mm. sheet
Watermark: Arches countermark
Coll.: H. O. Havemeyer
*The Metropolitan Museum of Art. Bequest of Mrs. H. O.
Havemeyer, 1929*

Fifth printing, with corrosion cleaned and additional scratches
Cream to buff, moderately thick, moderately textured, laid paper
363 x 275 mm. sheet
Watermark: fragment of Arches countermark
Atelier stamp
Library of Congress. Pennell Fund, 1944

Sixth printing, with plate polished to remove scratches
Red-brown ink on cream, moderately thick, smooth, Japanese
vellum
320 x 250 mm. sheet
Inscribed in ink (not in Degas's hand): *Portrait du graveur
Tourny executé à Rome en / 1856 par / Degas*
Museum of Fine Arts, Boston. Bequest of W. G. Russell Allen

Sixth printing
Black ink on cream, moderately thick, smooth, Japanese vellum
324 x 236 mm. sheet
*Philadelphia Museum of Art. Joseph E. Temple and Edgar Viguers
Seeler Funds*

The subject of this etching, Joseph Gabriel Tourny (1817-1880),
was a painter in watercolor and a printmaker who won two Prix de
Rome competitions for engraving. It would appear from inscrip-
tions in his notebooks that Degas knew Tourny as early as 1854,[1]
but did not make the etched portrait of him until 1857, when
Tourny was in residence in Rome. Degas also used Tourny's fea-
tures for those of Dante in his painting of *Dante and Virgil*
(Lemoisne 34, by 1858) and in studies for it (see cat. no. 9). It is
generally accepted that Degas executed his Roman etchings in
consultation with or under the tutelage of Tourny.

There is only one state of this print, but it is apparent that
several printings were made over a period of years. The plate
acquired accidental scratches and an area of corrosion during the
course of its use, and it is now possible to propose a printing
sequence based on the progression of these marks. It is clear that
the plate was lightly bitten initially and does not appear to have
had the lines reworked at any time.

First printing.
This example is one of two that was almost certainly printed in
Rome at the time of its execution. These two early impressions
(Princeton/Atelier and NGA/Atelier) do not exhibit any of the
scratches that appear subsequently.

Degas had originally drawn on the plate a three-quarter-
length portrait, recalling a format utilized by Ingres for single male
sitters. In the course of working on the plate he changed the
proportions of the composition by drawing a horizontal line and
proceeded to develop more fully a half-length image, reminiscent
of prints by Rembrandt. He also drew a remarque of two monastic
heads in profile at the bottom of the plate. The head of Tourny and
one of the lower profiles are meticulously modeled with fine cross-
hatching. Each of these early impressions has been purposefully
inked and wiped clean in the middle zone so that only the half-
length portrait is emphasized. The present impression was lightly

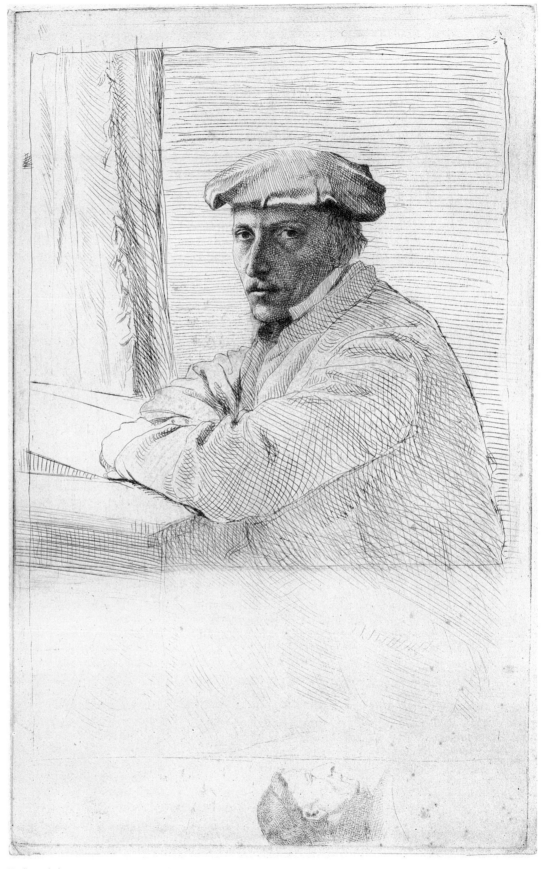

5 first printing

touched by Degas in black chalk to shade the coat, cravat, and right side of the face. This suggests that Degas thought of working further on the plate but never did so.

Second printing, with plate scratches and slight corrosion.
At some later time, after Degas first returned to Paris in 1859, he must have printed again from the plate, which had acquired a slight disfiguration in the middle zone, possibly owing to a mildly corrosive action on the plate surface. Three noticeable scratches appear on the plate: a hooked vertical above Tourny's cap, a long curved vertical through the elbow of his left sleeve, and a fine vertical scratch that passes through the unworked area of this sleeve. A curved vertical line that runs across the forehead of the right-hand profile was not as long-lasting as the other scratches. Two impressions record the plate in this condition: BN (given to Alexis Rouart by Degas, who apparently approved of the impression) and MFA.

Third printing, with additional scratch and increased corrosion.
It is very possible that once again Degas put the plate aside and that the area which was originally corroded became more vulnerable to further action. Three impressions besides the Fogg example are signed by Degas (BAA/Burty, Detroit, and NGA) and show an area that holds ink and prints in a manner to suggest the attachment to the plate of a powdered or granular substance, probably the incrusted product of corrosion. A short, curved, horizontal scratch between cheek and curtain appears at this stage. The quality of the impression of the half-length portrait remains very high.

Third printing, with monotype inking.
Close study of the three monotype-inked impressions reveals that the condition of the plate with regard to scratches was the same as that described in the preceding impression. Also noticeable in these specially inked impressions is a spot of corrosion in the lower right corner that appeared only on the National Gallery of Art impression of the previous second printing.

Various factors suggest that Degas made these three, monotype-inked impressions in the mid-1860s. At least two of his contemporaries, Adolphe Appian (1818-1898) and Degas's friend Ludovic Lepic (1839-1889), altered the appearance of their etchings by manipulating ink on the surface of the plate. Before 1866 Appian made variant inkings that he referred to as "without engraving or biting" ("sans gravure ni morsure"), and Lepic practiced his "eau-forte mobile" as early as the 1860s.[1] The Paris printer Auguste Delâtre was promoting the use of surface tone in etchings for the publications of the Société des Aquafortistes between 1862 and 1867. Furthermore, the Arches papers with the MB countermark found in this printing came into use after 1860-61 and are the same as those employed for some impressions of the Manet portraits datable to 1865 (cat. nos. 17, 18, 19).

Degas's primary interest during the 1860s was portraiture, and it seems reasonable to assume that he printed the plate at this time in the spirit of the Société artists, in contrast to his efforts a decade later, when he worked in the pure monotype medium. The most important aspect of these uniquely inked impressions of the Tourny plate is that they are the earliest examples of Degas's painterly use of plate tone.

Compared with the other two variants, the use of ink in the Kornfeld impression is conservative and essentially adds local color to the figure and its setting. The etched work is clearly discernible beneath the transparent ink, which has been employed primarily to suggest a shadowy atmosphere.

The Karlsruhe impression displays a bolder use of ink tone. Degas left ink on the beret and jacket and added a vertical streak in the background. He carefully wiped clean the right side of the face and left sleeve, although he still remained true to the contours of the etched image.

The Metropolitan Museum's impression offers a distinct change in composition through the use of ink. Degas added a strong vertical at right in the background and altered the configuration of the curtain. He wiped the plate in a bold manner, with less regard for the etched definition of the image. There are numerous fingerprints throughout that attest to the artist's uninhibited application of ink on the surface of the plate. Of the three monotype-inked impressions, this is the most baroque in concept and relates closely to Rembrandt's etched *Self-Portrait Drawing at a Window* (Bartsch 22).

In all three variant inkings there are short white lines at the bottom edge of the darkened image. These were probably caused by the edge of a card held against the plate while the lower portion was wiped clean.

Although it has been generally accepted that these monotype-inked impressions were the last to be made and have always been related to Degas's pure monotypes of the mid-1870s, it is interesting to note that at least six clean-wiped impressions were subsequently printed by Degas. We are persuaded that Degas executed the variant inked impressions in the mid-1860s; nevertheless, attention should be called to the pamphlet *La nouvelle peinture,* by Edmond Duranty, first published 12 April 1876 and based on Degas's artistic ideas and principles. It includes a brief but significant paragraph that describes new printmaking techniques presumably embraced by Degas. "Here is [the artist] who takes up a drypoint tool and uses it as a pencil, attacking directly on the plate, tracing the work with a single stroke; here he is who tosses unexpected accents into the etching by using a burin; here he is who varies each etched plate, lightening it, making it mysterious, literally painting it by an ingenious manipulation of the ink at the moment of taking the impression."[2]

Duranty's brochure was issued for the second Impressionist exhibition at the Galeries Durand-Ruel and preceded the period of active enthusiasm for new printmaking techniques that took place in the summer of 1876.[3] It is very possible that Duranty wrote his comments based on work he saw in Degas's studio that had been executed at an earlier time.

Fourth printing, with corrosion partly cleaned and additional scratches.
The Metropolitan Museum impression is the only one located that exhibits in the middle zone partly erased traces of pitted corrosion

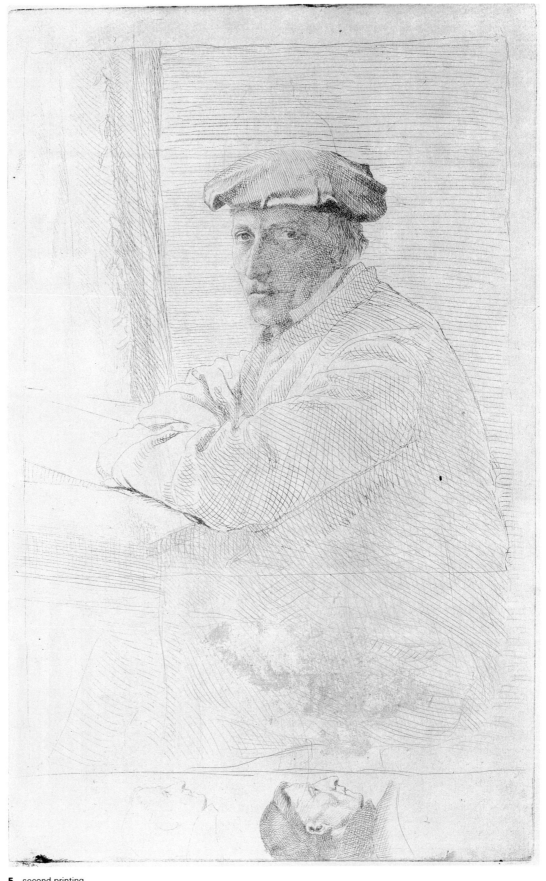

5 second printing

and a new strong diagonal scratch. The scratch remains visible throughout subsequent printings. Also new are many fine, curved wiping scratches in the upper background. The plate was wiped clean of its pale surface tone of ink in the areas of corrosion and along the margins. This impression bears random flecks of ink on the surface of the sheet and was probably printed to check the progress of cleaning the corrosion.

Fifth printing, with additional scratches and corrosion cleaned. While no great extent of time may have elapsed since the previous printing, the plate now exhibits two strong accidental marks that will remain throughout: short but deep vertical strokes across the uppermost white fold at the shoulder and below the elbow, across the horizontal dividing line. More faint scratches appear in the background. All traces of the corrosion in the middle zone have been erased, but the diagonal scratch remains. The Arches papers of some impressions of this printing are the same as those used in the third and fourth. Impressions of the fifth printing may be found in AIC (Atelier), Cincinnati (Atelier), Copenhagen (Eddy, Whittemore), East Berlin (acquired in 1914), LC (Atelier).

Sixth printing, plate polished to remove any shallow scratches. At a later time the plate appears to have been skillfully polished and carefully printed to provide impressions of high quality. It seems probable that a printer other than Degas executed this last printing of the plate during the artist's lifetime.[4] The work appears to have been done at Degas's bidding, however, for on the impression at the Metropolitan Museum, Mrs. H. O. Havemeyer noted that it was given to her by Mary Cassatt in 1889. Three known impressions, two of which are in black ink (MMA and PMA) and one in red-brown ink (MFA), were printed on Japanese vellum paper unlike that used for any previous printings of this plate.

Red-brown ink was favored occasionally for other impressions printed during Degas's lifetime, three of which were also on Japanese vellum (see cat. nos. 12, 15, 19, 24). These impressions were well printed, and with the use of the reddish ink it was possible to achieve rich coloristic effects.

Notes

1. Melot 1974, pp. 34, 107.

2. Edmond Duranty, *La nouvelle peinture* (1876; 2nd ed., Paris, 1946), p. 48. "La voilà qui reprend la pointe sèche et s'en sert comme d'un crayon, abordant directement la plaque et traçant l'oeuvre d'un seul coup; la voilà qui jette des accents inattendus dans l'eau-forte en employant le burin; la voilà qui varie chaque planche à l'eau-forte, l'éclaircit, l'*emmystérise*, la peint littéralement par un ingénieux maniément de l'encre au moment de l'impression."

3. See also a letter regarding Degas's printmaking activities from Desboutin to De Nittis, 15 July 1876, as cited in Melot 1974, p. 78.

4. Adhémar, p. 260, no. 7, suggests that these impressions were printed by Michel Manzi (1849-1915), a contemporary of Degas (see cat. no. 63).

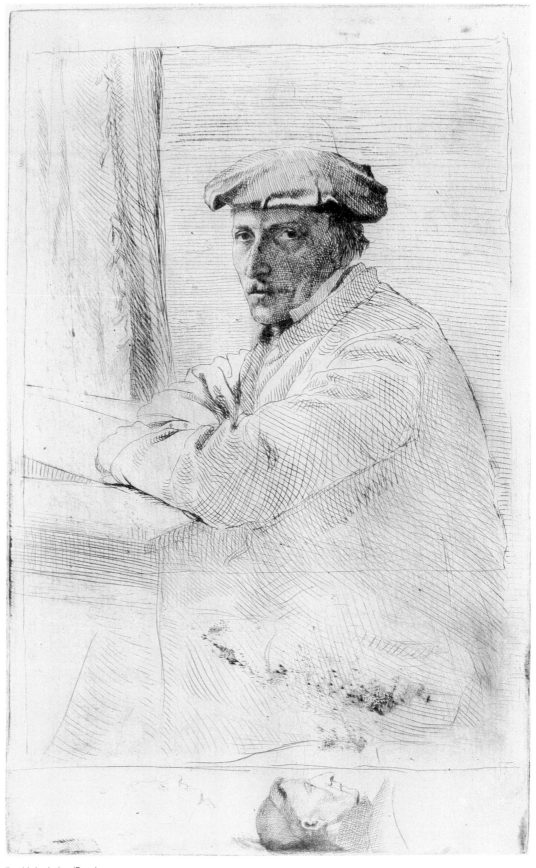

5 third printing (Fogg)

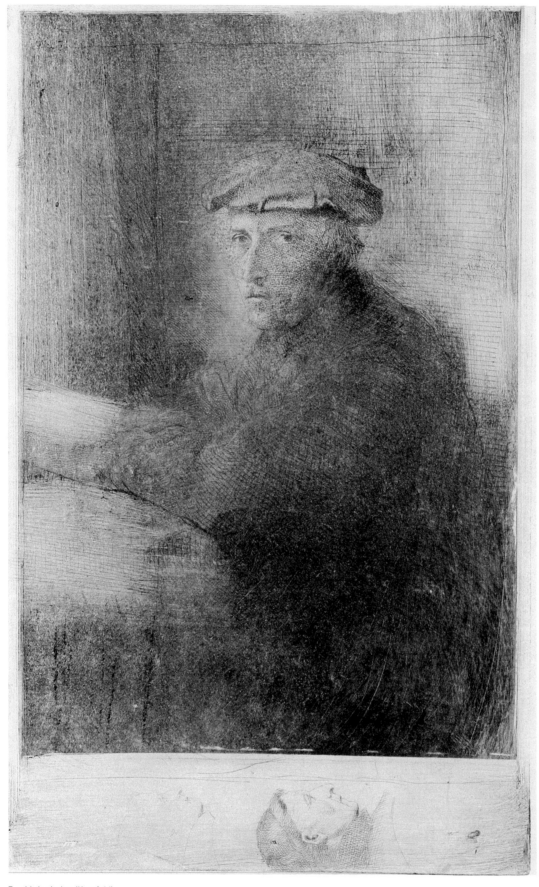

5 third printing (Kornfeld)

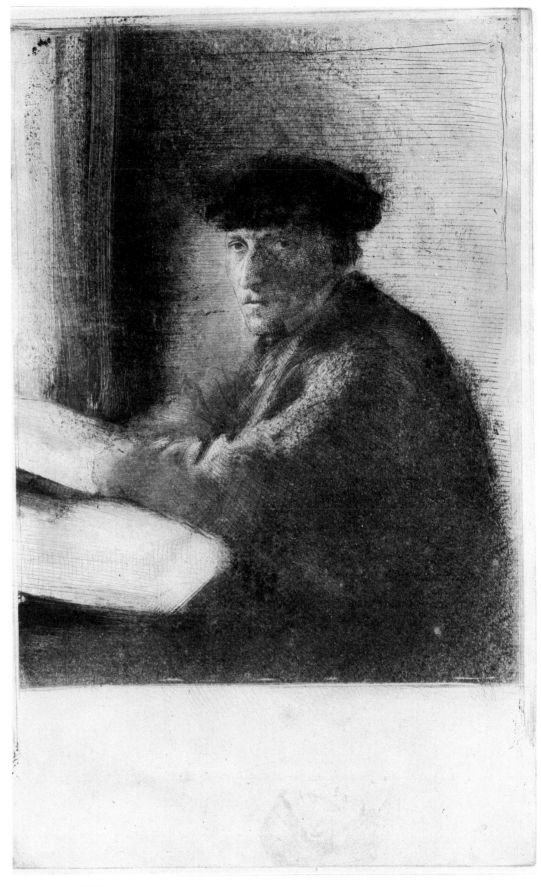

5 third printing (Karlsruhe)

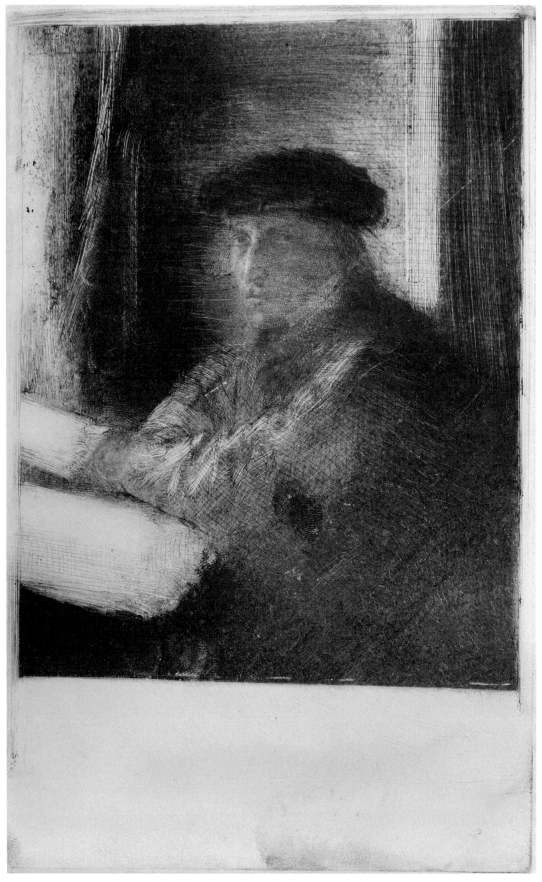

5 third printing (Metropolitan)

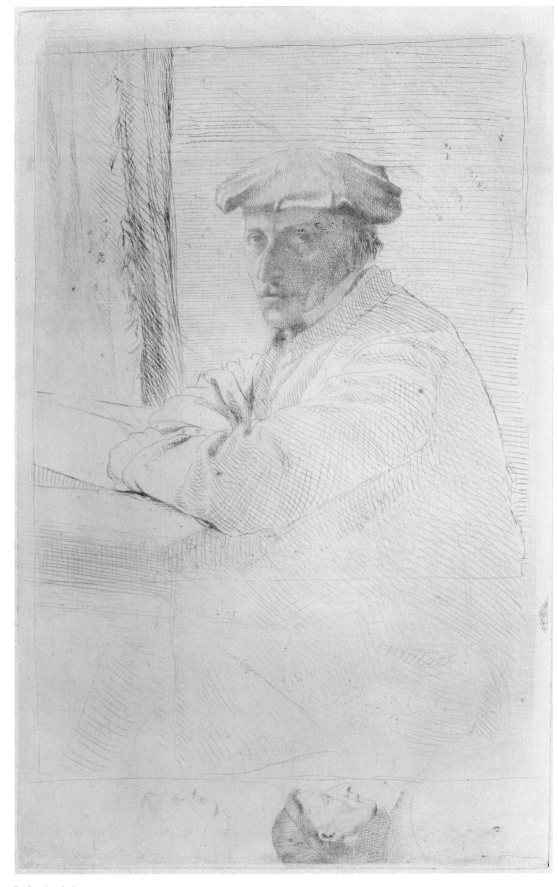

5 fourth printing

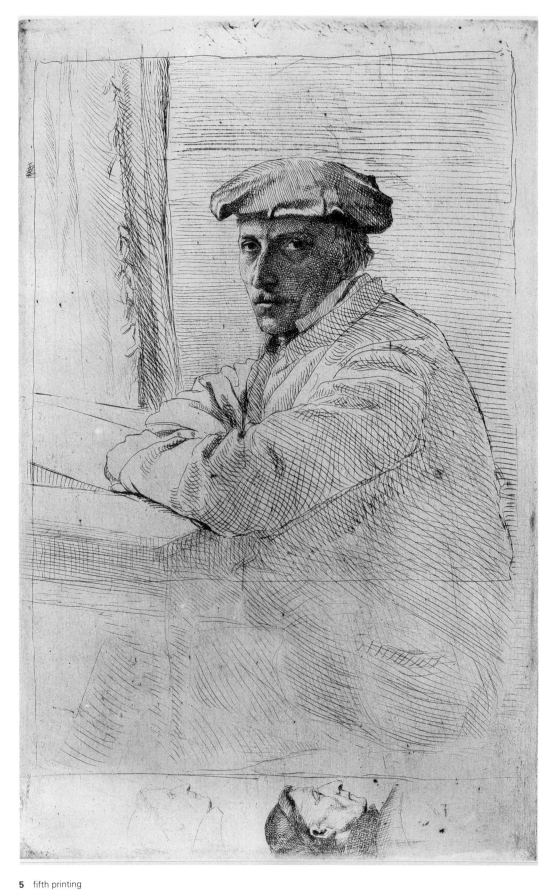

5 fifth printing

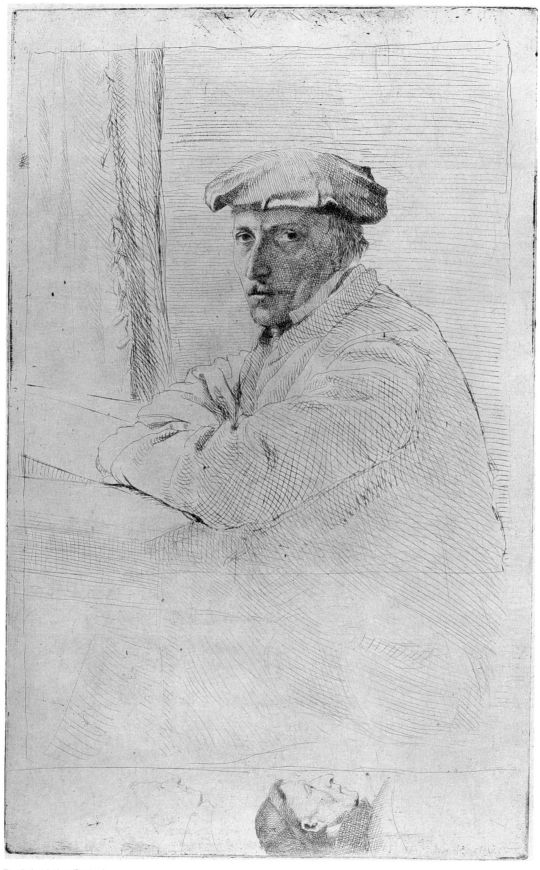

5 sixth printing (Boston)

6

Young Man, Seated, in a Velvet Beret,
after Rembrandt 1857

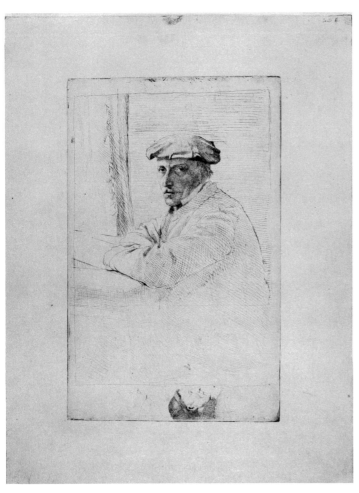

5 sixth printing (Philadelphia)

Etching. One state
Delteil 13 (about 1860); Adhémar 11 (about 1857)
119 x 95 mm. platemark
Off-white, medium weight, moderately textured, laid paper
165 x 123 mm. sheet
Museum of Fine Arts, Boston. Lee M. Friedman Fund

6a

Rembrandt van Rijn, Dutch 1606-1669
Young Man in a Velvet Cap
Etching, second state
Bartsch 268; Hind 151
97 x 84 mm. platemark
Laid paper
Signed and dated 1637
Museum of Fine Arts, Boston. Gift of Mrs. Edward Jackson Holmes

This close copy documents Degas's enthusiasm for Rembrandt's etchings, which became evident during his first stay in Rome in 1857-58. It is clear that the work of the seventeenth-century master etcher influenced Degas's portraits made in Rome, especially those of the French engraver Joseph Tourny and an unidentified young man (cat. nos. 6 and 7). In all likelihood, Tourny drew Degas's attention to the old master etchings.

Between April 1853, when he registered as a reader at the Cabinet des Estampes, and 1861, when he returned to Paris after prolonged stays in Italy, Degas had copied hundreds of paintings, drawings, and prints by earlier masters. Among these were sketches after four etchings by Rembrandt that included *Young Man in a Velvet Cap* (Bartsch 268; Reff *Notebook* 10, p. 13).[1] The paper of this notebook bears Italian watermarks, and Reff dates its usage to Rome and Naples in 1857 (Reff *Notebooks*, vol. 1, p. 64). Furthermore, this faint study was apparently made before Degas traveled to Naples, where he arrived 1 August 1857.

The art critic Charles Blanc described the appeal of this small Rembrandt etching for French etchers of the nineteenth century: "I have often had occasion to peruse the work of Rembrandt with artists, whether introducing them to my collection, or looking with them at the reserves of the print room, and I must say that the *Young Man*...is one of the pieces which has always struck them the most."[2] Although Degas's plate was larger than Rembrandt's, he drew the figure on the same scale and wiped the plate, leaving a pale tone of ink that conforms in size and format, though in reverse, to the Rembrandt print.

Degas captured with sensitive accuracy the expression of the sitter's face, although he was less interested in achieving Rembrandt's tonal range and textural finish. He used stop-out on the beret, the hair, and probably on the left profile of the young man's face. These lightly bitten areas that hold little ink and print gray were never worked on further in this clearly experimental plate. It is apparent that Degas responded to the expressiveness of Rembrandt's portrait, but technically the print is unresolved.

There is an obvious relationship both to the Tourny etching, in which Degas depicted his friend from the same angle and wearing a similar soft cap, and to the *Portrait of a Young Man* (cat no. 7), which is decidedly Rembrandtesque.

Eight impressions of Degas's etched copy after Rembrandt have been located, including one printed on the same sheet with a very faint impression of Jenny Delavalette (cat. no. 13): Bergquist (Atelier), BN, Josefowitz, Kornfeld (Atelier and two others), MFA, MMA (Beurdeley). Two of these (Kornfeld, Bergquist) show wavy patterns of corrosion that suggest a later printing, but both bear the Atelier stamp. The canceled plate exhibits the same configuration of pitting and corrosion.

Notes

1. The other drawings are after *The Death of the Virgin* (Bartsch 99; Reff *Notebook* 8, p. 86, illus.); *Jacob and Laban* (Bartsch 118); Reff 1964, p. 258; four illustrations for *Piedra Gloriosa IV* (Bartsch 36; Reff 1964, p. 258).

2. ''J'ai eu souvent occasion de parcourir l'oeuvre de Rembrandt avec des artistes, soit en leur faisant les honneurs de ma collection, soit en regardant avec eux les réserves du Cabinet des estampes, et je dois dire que le *Jeune homme assis et réfléchissant* [Blanc's title for Bartsch 268] est une des pièces qui les ont toujours le plus frappés.'' Charles Blanc, *L'Oeuvre complet de Rembrandt* (Paris, 1861), vol. 2, p. 227; also quoted by Ten Doesschate Chu 1974, p. 76.

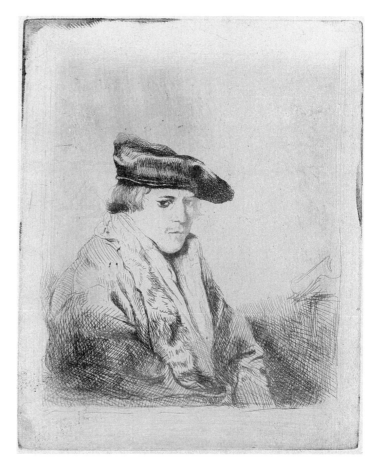

6

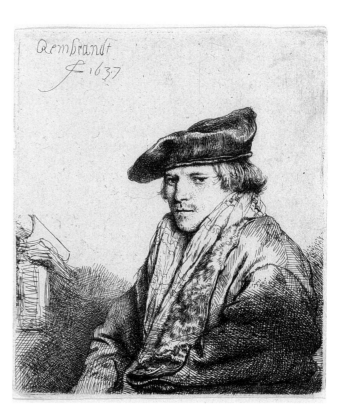

6a

7

Portrait of a Young Man 8 Nov. 1857

Etching. One state
Delteil 5 (1857); Adhémar 10 (1857)
127 x 104 mm. platemark
Signed and dated in plate, lower left: *8 Nov 57 / E. Degas f.*
Impression touched with brush and gray wash
Cream, medium weight, moderately textured, wove paper
223 x 147 mm. sheet
Bibliothèque Nationale, Paris
Exhibited in Philadelphia

There are only two impressions of this etching recorded, both
listed as self-portraits in the Atelier sale.[1] The unretouched impres-
sion, formerly in the Fèvre and Guérin collections, has not been
located but is illustrated here (fig. 1).

Although this etching was cited by Delteil as a self-portrait,
the features of the sitter do not resemble those of Degas. The
young man may have been an artist friend depicted close to the
time when Degas and Tourny were working in Rome. There is a
tantalizing reference in a notebook Degas used in Tivoli in Nov-
ember 1857 to "Luigi Cerissi / bel homme / que j'ai rencontré / au
dessus de / Tivoli et / qui voulait / venir à Rome" (Reff *Notebook*
10, p. 155). The same notebook contains recipes for Rembrandt's
etching ground and for stop-out varnish (p. 24), a list of etchings by
Claude Lorrain seen by Degas at the Galerie Corsini in Rome, 13
November 1857 (p. 50), and notes on the sunset and nightfall at
Tivoli, 10 November 1857 (p. 46).

This portrait and that of Joseph Tourny share a similarity of
pose and treatment. There is a correspondence in the finely
crosshatched modeling of the heads and in the test patches of
linework at the edges of the images. The young man's loose-fitting
smock, however, is far more fully shaded and developed than that
of Tourny.

The dating of this plate, unique in Degas's oeuvre, the rare
signature, and the contrast of the dark figure against an unworked
background are strongly reminiscent of the work of Rembrandt
(see also cat. no. 5). In this impression the entire image has been
painted over with a gray wash that was used to indicate a land-
scape background with a row of trees. This modern handling of
the print is not in keeping with Degas's initial imitation of the
Dutch master, and it is probable that he made these additions in
wash at a later date.

Note

1. Atelier sale *Eaux-fortes*, nos. 1 and 2; no. 1 catalogued as a first state.

7

7. Fig. 1.
Portrait of a Young Man. Etching dated 8 Nov. 1857. Formerly Fèvre and Guérin
collections.

8

Edgar Degas: Self-portrait 1857

Etching and drypoint. Four states
Delteil 1 (1855 - five states); Adhémar 13 (1857)
230 x 144 mm. platemark

8a

Self-portrait
Drawing in black crayon touched with white chalk
White wove paper
291 x 232 mm. sheet
The Metropolitan Museum of Art. Bequest of Walter C. Baker, 1971
Exhibited in Boston

I first state

Grayish-white, medium weight, smooth, wove paper
272 x 178 mm. sheet
Signed lower left in black chalk: Degas
Coll.: Marcel Guérin, who purchased it from Ambroise Vollard in 1910
The Metropolitan Museum of Art. Gift of Mr. and Mrs. Richard J. Bernhard, 1972

II second state

White, medium weight, smooth, wove paper
263 x 172 mm. sheet (irregular)
Coll.: Beurdeley
The Metropolitan Museum of Art. Jacob H. Schiff Fund, 1922

III third state

Cream, moderately thick, rough, laid paper
462 x 310 mm. sheet
Watermark: D & C Blauw
Coll.: Viau
Museum of Fine Arts, Boston. Katherine Eliot Bullard Fund in memory of Francis Bullard and proceeds from sale of duplicate prints

IV fourth state

Off-white, moderately thick, rough, wove paper
370 x 278 mm. sheet
Watermark: fragment of Arches countermark
Coll.: Atelier; James H. Lockhart, Jr.
Los Angeles County Museum of Art. Purchased with Funds Provided by the Garrett Corporation, 1981

Copper plate (canceled)

Los Angeles County Museum of Art. Museum Purchase with County Funds, 1960

In the 1850s Degas frequently used himself as a model for portrait drawings and oil paintings.[1] This etching, his only self-portrait in a print medium, follows very closely, in reverse, a drawing that may have served as the model.[2] Degas stands, facing three-quarters front, holding drawing tools in his left hand. He wears a broad-brimmed, soft hat that throws his face into shadow. Both the shaded face and his general appearance are close to the painting in oil on paper mounted on canvas now at the Clark Art Institute and dated 1857-58.

The drawing is unusual in Degas's oeuvre, though not unique, in its finished rendering and fully expressed tonality. The face and clothing are worked in densely hatched and crosshatched strokes of the crayon to shade and model the forms. Other drawings executed in Italy around 1856-57 exhibit this characteristic chiaroscuro, which is unlike the linear economy of Ingres observed in many other early Degas drawings.[3] To a certain degree, the pose and lighting of the drawing evoke Degas's Rembrandtesque portrait prints of Joseph Tourny (cat. no. 5) and of a young man (cat. no. 7).[4]

It is almost certain that Degas executed his etched self-portrait in Rome during 1857. Two impressions of the fourth state are signed by the artist but incorrectly inscribed in another hand: "Florence 1857" (BAA and private collection, Germany).

Through successive stages of biting the plate, Degas attempted to build up the darks gradually, using layers of cross-hatching to achieve the chiaroscuro effects of the model drawing. He encountered technical problems in the biting of the plate in the third state, where the ground was permeated by the acid and large areas of the figure and the background were roughened by accidental biting. In this state the artist compensated for the condition of the plate by wiping it so as to leave varying amounts of surface ink. These variations and the care with which he printed the plate in the third state make it aesthetically pleasing in its expressive Rembrandtesque light and shade. Subsequently, Degas cleaned much of the accidental biting from the background and strengthened his features with a few drypoint lines. Evidently the etched portrait was satisfying to Degas, who willingly offered it to friends. His other self-portraits, both paintings and drawings, were kept in his studio until after his death, but this print was reproduced as early as 1912 in Lemoisne's monograph on the artist.[5]

The first state is executed in lightly etched, crosshatched lines, and the features of the face are not yet distinctly defined; nevertheless the self-confidence of the twenty-three-year-old artist is clearly established. This can be accounted for by the subtle shift in direction of the eyes. In the drawing the sitter looks to one side, while in the print he gazes directly at the viewer. The overall effect is light and delicate. There are two known impressions of this state: BN (Fèvre) and MMA (Guérin).

Degas experienced some difficulties in rebiting the plate for the second state to achieve darker lines and to further develop the hat and hair. Accidental biting is visible as a halo around the image, especially at the lower left of the print, where a fabric texture can be detected. Nevertheless, the figure has taken on a greater con-

trast and substance due in part to an experimental but intentional bitten tone on the coat, hands, and sheet of paper. There are three known impressions of this state: MMA (Beurdeley), BN (Rouart), and NGC (Soutzo).

Additional etched linework on the face, hat, and coat, as well as bitten tone, whether accidental or intentional, make the third state more dramatic and powerful. Some impressions are inked with greater amounts of surface tone that mask the linear elements of the image and provide a dark, shadowy background. It is important to note that information on the watermark MB (Arches countermark) suggests that impressions of the third state on this paper were printed after 1860-61. The letters MB indicate a new partnership that formed at the Arches paper mill at this time. (See essay "Degas's Printing Papers.") These printings may have been concurrent with the third printing of *The Engraver Joseph Tourny* (cat. no. 5), including two of the monotype inkings. Seven impressions of this state have been located: AIC (Rouart), BAA (Burty), Clark, Kimbell (Bartholomé), MFA (Viau), N.G. Stogdon; another, not examined, formerly coll. Eugène Mayer, New York.

Although Delteil has described the fourth state as one with the background cleaned but with no further work on the plate, no impression has been located. The example cited by Delteil and reproduced by Arsène Alexandre in 1918 is in fact the fifth state. An impression sold from the collection of Mlle Fèvre (12 June 1934, Galerie Jean Charpentier, no. 7) appears from the illustration also to have the retouches of the last state.

In our fourth state (Delteil's fifth) Degas strengthened his features, adding small strokes to the corners of the left eye, the left nostril, and to the line of the mouth. Although it has been suggested that this last retouching may be by another hand, there is no visual evidence for this since the work is consistent with Degas's style. Furthermore, three impressions of this state are signed in Degas's hand (BAA, Prouté, and private collection, Germany), and two bear the studio stamp (LCMA, NGA).

The copper plate for this print was acquired by the Los Angeles County Museum of Art (1960) after the printing made by Lacourière in Paris for the Frank Perls Gallery (1959). (See the essay "Degas's Canceled Plates.") This heavy copper plate (with rounded corners and smooth edges), the kind traditionally used by professional etchers, attests to the seriousness of Degas's self-portrait undertaking. It is in distinct contrast to the variety of roughly cut or reused plates that he often employed for making prints.

Notes

1. Lemoisne and Guérin 1931.

2. The early history of this drawing is not known. It was first published in 1948 both in the catalogue of a Degas exhibition at the Ny Carlsberg Glyptotek, Copenhagen, lent from a private collection, and in René Huyghe, *Le Dessin français au XIXe siècle* (Lausanne, 1948), pp. 89 and 175, listed as private collection, Paris. For subsequent exhibition and bibliographic references see Claus Virch, *Master Drawings in the Collection of Walter C. Baker* (New York, 1962), no. 103. Some authorities today do not agree with the attribution of this drawing to Degas.

3. See, for example, the degree of modeling in *Italian Head* and the regularity of hatching and shading in *Adelchi Morbilli*, Boggs 1966, nos. 6 and 21 respectively.

4. Ten Doesschate Chu 1974, pp. 76-77, cites the resemblance of these prints and of the self-portrait to Rembrandt with respect to their exaggerated *contre-jour* effect and their psychologically expressive chiaroscuro.

5. Lemoisne 1912, facing p. 18.

8a drawing

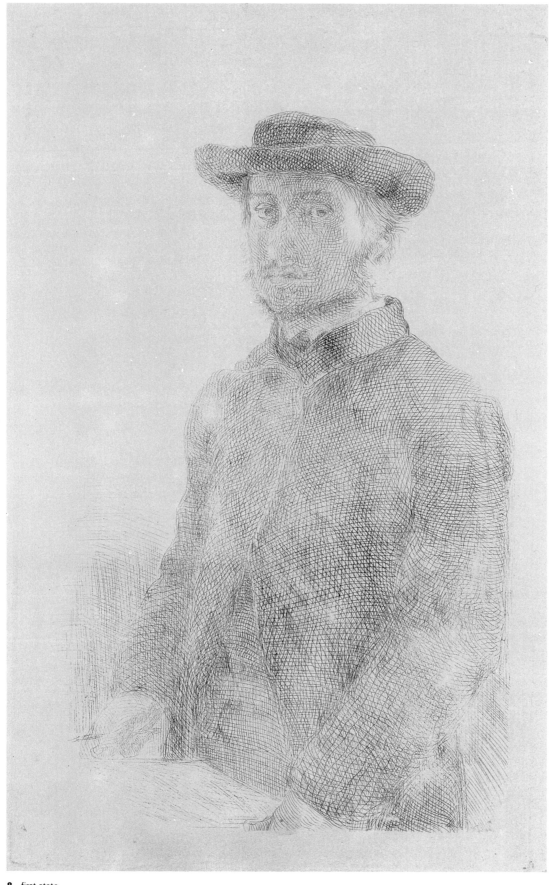

8 first state

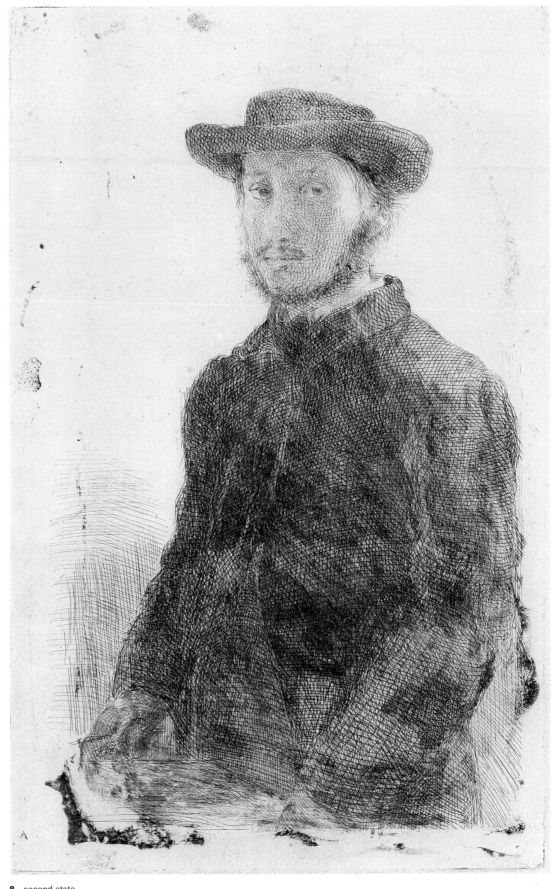

8 second state

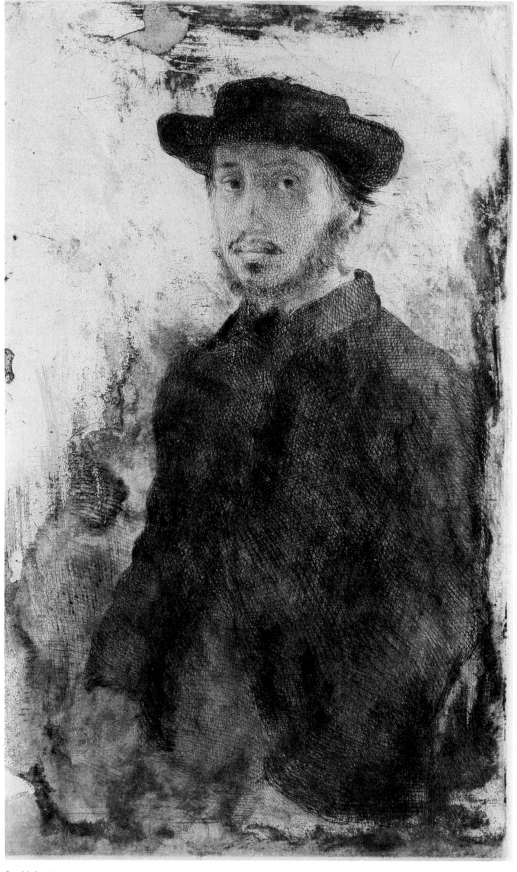

8 third state

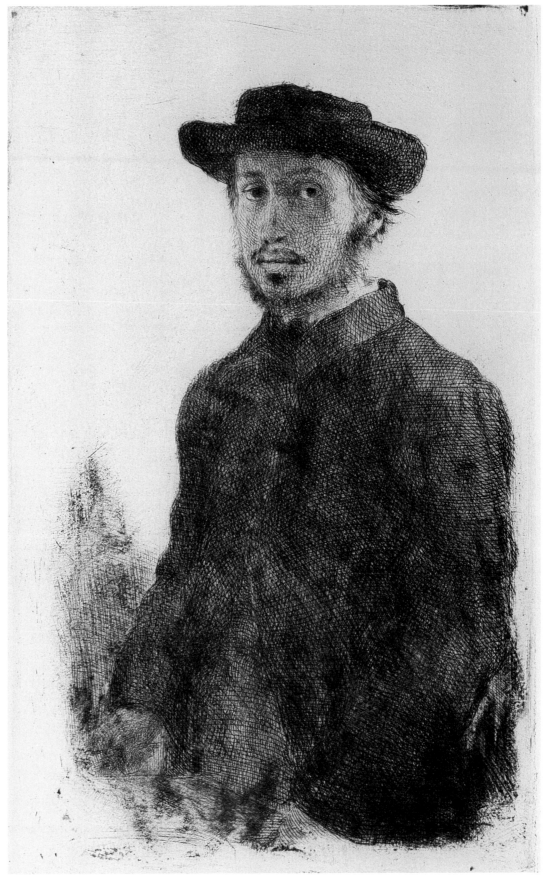

8 fourth state

9

Dante and Virgil 1857

Etching and drypoint. Three states
Delteil 11 (1860?); Adhémar 9 (Rome, winter 1857)
118 x 86 mm. platemark

I first state

Off-white, medium weight, smooth, wove paper
238 x 180 mm. sheet
E. W. Kornfeld, Bern

II second state

Off-white, medium weight, smooth, wove paper
235 x 179 mm. sheet
Coll.: Rouart; A. E. McVitty (in pencil)
The Metropolitan Museum of Art. Gift of Mrs. Imrie de Vegh, 1949

III third state

Off-white, medium weight, smooth, wove paper
239 x 175 mm. sheet
Coll.: Edward C. Crossett
Mead Art Museum, Amherst College. Gift of Edward C. Crossett '05

Between 1856 and 1858, Degas executed in Italy a number of drawings and two paintings that illustrated an episode from Dante's *Inferno*. This etching of the two poets Dante and Virgil at the Gates of Hell dates from the same period. At least one notebook, Reff *Notebook* 11, contains several small sketches of this subject. The two figures in the etching have sometimes been identified as Dante and Beatrice, a subject that Degas also depicted; however, the setting of the print at the Gates of Hell, confirmed by the inscription below the image taken from Dante's *Inferno*, points to the identification of the figure at the left, who wears a crown of laurel, as the Latin poet Virgil.

The figure of Virgil and the configuration of his drapery relate more closely to an oil sketch (Lemoisne 35, St. Louis) than to the finished painting (Lemoisne 34). The figure of Dante in the etching resembles that of the finished painting, in which Dante bears the features of Joseph Tourny taken from an oil study dated *Rome 1857* (Lemoisne 26).

The etching sets the pale figures before a dark background. Degas made the effort to reverse the image in the process of transferring it to the plate so that it prints in the same direction as the paintings.

In the two known impressions of the first state (Kornfeld and BN/Fèvre) Degas has drawn the entire composition in fine, scratchy, crosshatched lines, similar to those in his copy after Rembrandt (cat. no. 6).

In the second state he has re-etched the plate, adding fine lines to the ground to indicate cracks around the stone portal as well as in the rock above to suggest the carved inscription described in the passage from Dante's *Inferno* 3. 1. 9, "Per me si va nella città dolente . . . /Lasciate ogni speranza voi ch'entrate."[1] The words themselves have been etched in the lower margin. A

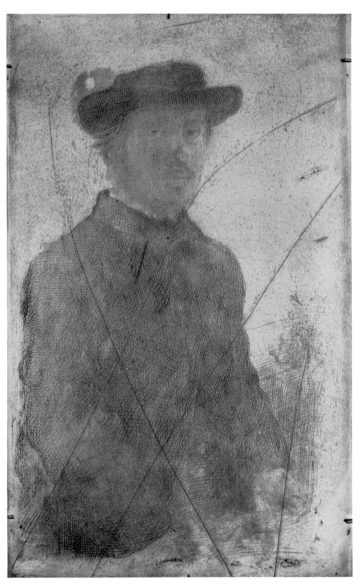

8 copper plate (canceled)

9 first state

9 second state

small patch of foul-biting at the lower left occurred when the plate was re-etched. This is the only known impression of the second state.

To Adhémar's two states a third can now be added, recognizable by further work such as the crosshatched shading on the ground on both sides of the figures and further oblique lines to the right of the doorway. Only this one impression with the additional work is known. It also shows a thin film of ink left on the plate except for the figure of Virgil, which is wiped clean.

Note

1. Degas included one of the most famous of quotations: "Through me is the way to the doleful city. . . /Abandon hope all ye who enter."

9 third state

10

Woman in a Ruffled Cap 1859-60

Etching. Two states
Delteil 6 (1859); Adhémar 12 (1859-60)
120 x 87 mm. platemark

I first state

Off-white, medium weight, moderately textured, wove paper
115 x 85 mm. sheet (cut within platemark)
National Gallery of Art. Rosenwald Collection, 1952

II second state

Cream, medium weight, moderately textured, wove paper
192 x 131 mm. (irregular)
Bibliothèque Nationale, Paris
Exhibited in London

Delteil has convincingly noted the relationship of this print to a charcoal drawing of a woman sewing, inscribed by Degas "26 August 1859 Paris ED" (fig. 1). The large eyes and slightly pursed mouth, as well as the thick, waved hair and ruffled cap of the unidentified sitter are common to both drawing and etching.

The print is executed with a shadowed background of fine, crosshatched lines from which the image projects in a manner similar to the etching *Dante and Virgil* (cat. no. 9). The overall style and choice of subject, however, anticipate the portrait of Degas's sister Marguerite (cat. no. 14). If one accepts the close relationship to the dated drawing, this etched portrait of a woman may be the first print Degas made after his return to Paris from Italy in April 1859. Until that time the male portraits had been executed in the manner of Rembrandt, whereas this study of a woman is mindful of Degas's French contemporaries.

The first state clearly establishes the sensitive expression of the sitter. In a second impression (BN, fig. 2), Degas has darkened the background and dress with chalk and has added faint lines to the face as well as a notation in the upper right margin: "la paupière un peu plus haut / un peu plus de...[illegible]."[1]

In the second state the face remains unchanged, although Degas has darkened the background with additional hatching, clearly focusing attention on the delicately rendered head. He disregarded the shaded effect of the touched impression and left the unworked gown indicated in a summary manner. Only one impression of this state has been located. Delteil cites four impressions in the Atelier sale, nos. 4-7, three first states and one second. These prints were identified there as *Dame agée (la Mère de l'Artiste?)* and were probably withdrawn from the sale along with other portraits of family members at their request.

Note

1. A note in black chalk: "to raise the eyelid" and added in pencil on another line: "a little more."

10. Fig. 1.
Woman Seated in an Armchair Sewing. Charcoal drawing dated 26 August 1859. Musée du Louvre. Photo: Documentation photographique de la Réunion des musées nationaux.

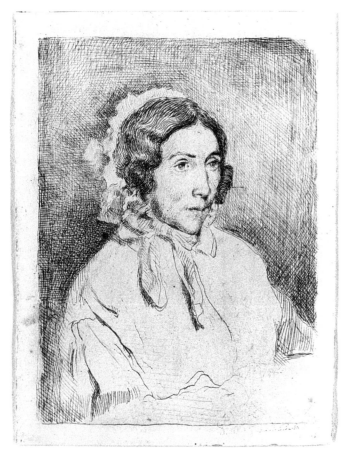

10 first state

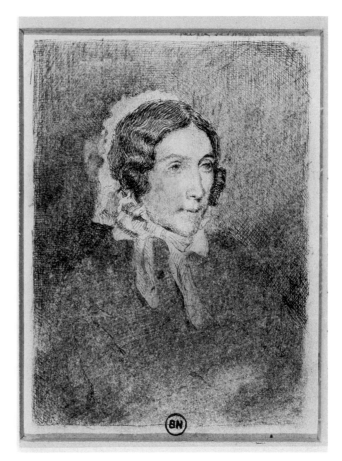

10. Fig. 2.
Woman in a Ruffled Cap. Etching, second state, touched with black chalk. Bibliothèque Nationale, Paris.

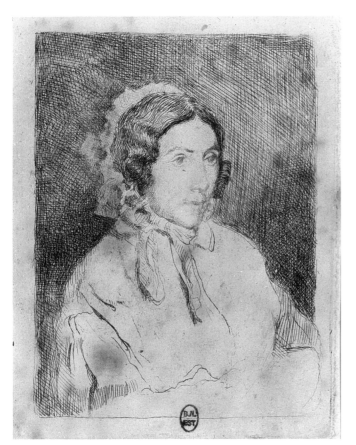

10 second state

11

Mlle Nathalie Wolkonska, first plate 1860-61

Etching. One state
Delteil 7 (1860); Adhémar 14 (about 1861)
119 x 87 mm. platemark
Cream, medium weight, moderately textured, oriental paper
320 x 213 mm. sheet (irregular)
Atelier stamp
Bibliothèque Nationale, Paris
Exhibited in London

This is the first of two plates Degas etched of the same young girl. There are only two known impressions, both of which exhibit the same light scratches across the sitter's face. It is possible that the plate was put aside or mislaid, causing Degas to re-etch a similar image on a second plate (cat. no. 12).

The identity of the sitter is still problematic. (See Adhémar 14 for a reference in an 1860 directory to a Wolkonski family with a Paris address.) The etching was probably made in Paris in 1860-61 while Degas was completing his major portrait painting of *The Bellelli Family* (Lemoisne 79). The figural type, face, and costume of the sitter bear a general resemblance to Giovanna Bellelli, Degas's young cousin seen at left in the painting, suggesting a similar date of execution.

The static, formal pose, the studio-like setting, and the sharp contrast in tonal values indicate that a photograph may have served as a model for the etching. Marcel Guérin classifies both Wolkonska plates as "after daguerreotypes."[1] Around 1861 Degas painted a portrait of *La Princesse de Metternich* (Lemoisne 89, National Gallery, London) after a *carte-de-visite* by Disderi,[2] whose small photographic visiting cards were highly popular in Paris by 1861. The photograph shows the princess and her husband full-length against a plain background, whereas Degas's painted portrait depicts a half-length, single figure seen against flowered wallpaper. His etching of Wolkonska shows a compositional and stylistic correspondence to this painting and includes a background of flowers executed in delicate tracery. The only other known impression of this print is in the Albertina (Guérin).

Notes

1. Guérin, *Additions*, nos. 7 and 8.

2. Terrasse 1983, nos. 3 and 4.

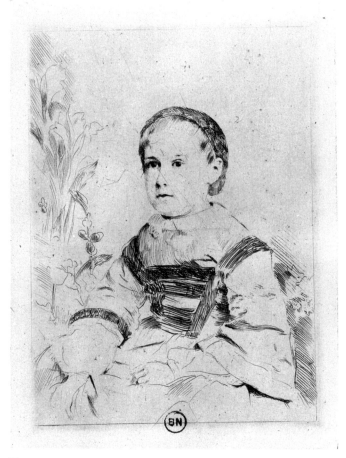

11

12

Mlle Nathalie Wolkonska, second plate 1860-61

Etching. Two states
Delteil 8 (1860); Adhémar 15 (about 1861)
120 x 88 mm. platemark

I first state

Off-white, moderately thick, smooth, wove paper
360 x 255 mm. sheet
Coll.: A. Rouart
*Sterling and Francine Clark Art Institute, Williamstown,
Massachusetts*

II second state

Cream, moderately thick, smooth, oriental paper
307 x 214 mm. sheet
Atelier stamp
*Museum of Fine Arts, Boston. Katherine Eliot Bullard Fund in
memory of Francis Bullard and proceeds from the sale of duplicate
prints*

II second state

White, thick, moderately textured, wove paper
250 x 175 mm. sheet
Coll.: Beurdeley
Library of Congress. Pennell Fund Purchase, 1950
Not illustrated

This is the second plate of the young Mlle Wolkonska, executed
with more detail on the dress and in the background. Degas
essentially repeated the composition of the first plate, although he
handled the description of the dress and its ornamental bands in a
slightly different manner.

 In the second state additional etched lines darken the sitter's
hair and her dress, and there is extensive work in the background
where Degas has included a somewhat ambiguous arrangement
of flowers that appear to be studio props rather than a patterned
wallpaper.

 Only one impression of the first state has been located
(Clark/Rouart) and nine of the second state (AIC, Artemis, Balti-
more, BAA in red-brown ink on Japanese vellum, BN, Copenha-
gen, LC, MFA, private collection, Germany). These appear on a
range of paper types from thick, almost blotter-like white paper to
thin oriental-type papers. Some impressions have been cleanly
printed. Others retain a film of ink within the printed border lines,
but with the margins wiped clean, in the manner of Auguste
Delâtre, the influential French artist-printer and contemporary of
Degas. The Boston Museum's impression exemplifies this method
of inking.

 The pearly reflective surface of some of these printing
papers evokes the silvered surface of a daguerreotype plate. The
fine impression from the Library of Congress, in which the plate
deeply impressed a very thick sheet of paper, almost suggests a
framed daguerreotype.

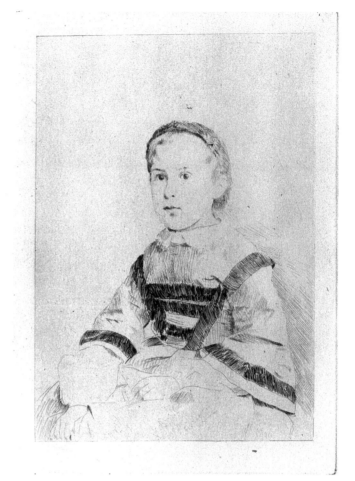

12 first state

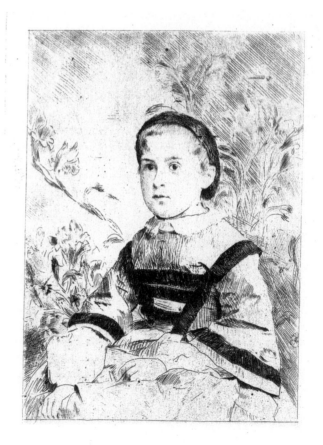

12 second state

13

Portrait of Jenny Delavalette,
after Ingres about 1860-61

Softground etching. One state
Not in Delteil; Adhémar 22 (1861-63)
112 x 60 mm. platemark
White, medium weight, slightly textured, wove paper
310 x 222 mm. sheet
Colls.: Atelier; Succession Ed. Degas
Bibliothèque Nationale, Paris. Gift of E. Béjot, 1931
Exhibited in Boston

This softground etching after a drawing by Ingres, probably
Degas's first attempt in this medium, was a technical failure. The
consistency of the ground did not permit the lines to bite properly,
and the protective coating broke down in the acid bath, causing
the deeply pitted foul-biting. The only three impressions known
show the obliterating scratches that indicate Degas's immediate
dissatisfaction with the plate, although he would later reuse it for
his portrait of *Alphonse Hirsch* (cat. no. 21). This impression, the
most carefully printed of the three, has a tone of ink on the plate,
perhaps to compensate for the weakness of the image.

A second impression (fig. 1) was pasted in one of Degas's
notebooks (Reff *Notebook* 18, p. 37), used in Paris and Normandy
between 1859 and 1864. It was not run through a press (as was
the impression here exhibited) but was printed by hand-rubbing.
The impression lacks a completely impressed platemark; the
image is only partially transferred, and there are noticeable broad
rubbing strokes (see also cat. no. 15). A third impression (Korn-
feld), very pale in appearance and illegible, was printed casually on
the same sheet with the *Young Man in a Velvet Beret,* after
Rembrandt (cat.no.6); perhaps these were test impressions made
at a later time to determine the condition of the plates with reuse
in mind.

Despite the obvious imperfections of Degas's small etching,
the Ingres-like character of the image encouraged the authors to
refer to Ingres literature for a pictorial source. The hitherto anony-
mous sitter had, in fact, been identified as Jenny Delavalette by
Hans Naef, who fully documented the Ingres drawing of 1817 (fig.
2), the source for the Degas print.[1] Degas may have had access to
the original drawing or may have known a lithograph after it by
Jean-Eugène Doneaud, probably made about 1860. According to
Naef, the drawing was exhibited at the major Ingres exhibition at
the Ecole des Beaux-Arts in 1867. It could very well have been
known to Degas earlier, just as it was to Doneaud.

Notes

1. In his documentation, Mr. Naef has cited the Degas etching. Hans Naef,
Die Bildniszeichnungen von. J.A.D. Ingres (Bern, 1977-), vol. 2, p. 227, and
vol. 4, no. 203. Until now, the identification of the sitter and the connection
with Ingres have not appeared in the Degas print literature.

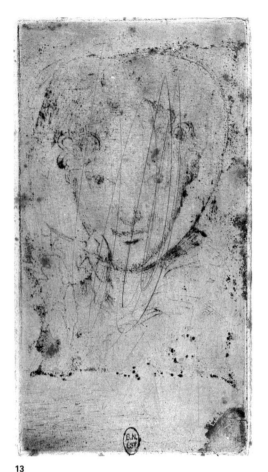

13

13. Fig. 1.
Jenny Delavalette. Softground etching, pasted into a notebook (Reff *Notebook* 18,
p. 13). Bibliothèque Nationale, Paris.

14

Marguerite De Gas, the Artist's Sister 1860-62

13. Fig. 2.
J.A.D. Ingres, *Jenny Delavalette*, 1817. Graphite drawing (Naef 203). Private collection.

Etching and drypoint. Six states
Delteil 17 (1856); Adhémar 23 (about 1862-65)
116 x 88 mm. platemark

I first state

Grayish white, thin, smooth, oriental paper
121 x 91 mm. sheet
Coll.: Atelier; Succession Ed. Degas; Guérin
Private collection
Not in exhibition

II second state

An impression of the second state from the Manzi, Fèvre, and Guérin collections has not been located.
(Illustrated from Delteil)

IIa heliogravure of the second state

138 x 104 mm. platemark
Dark brown ink on cream, medium weight, moderately smooth, laid paper
342 x 265 mm. sheet (irregular)
Watermark: PORTFOLIO and MBM
Coll.: Atelier; Succession Ed. Degas; Mlle Fèvre (inscribed in pencil *Fèvre 21*)
Huguette Berès, Paris

III third state

Grayish white, thin, smooth, oriental paper
125 x 115 mm. sheet
Coll.: Rouart
Bibliothèque Nationale, Paris
Exhibited in Boston

IV fourth state

Grayish white, thin, smooth, oriental paper
130 x 105 mm. sheet
Coll.: Eddy; Hartshorne
National Gallery of Art. Rosenwald Collection, 1946

V fifth state

Grayish white, thin, smooth, oriental paper
125 x 110 mm. sheet (irregular)
Coll.: David-Weill
Museum of Fine Arts, Boston. Katherine E. Bullard Fund in memory of Francis Bullard

VI sixth state

Off-white, moderately thick, slightly textured, wove paper
174 x 122 mm. sheet
Coll.: Atelier; Succession Ed. Degas; in pencil, verso:
Mlle Fèvre n 1
Huguette Berès, Paris

Marguerite De Gas was the artist's younger sister, born in 1842. In 1865 she married an architect, Henri Fèvre, and moved to Buenos Aires, where she died in 1895. She bore five children. A daughter, Mlle Jeanne Fèvre, retained a number of works by Degas, many of which were sold at the Galerie Jean Charpentier, 12 June 1934.

Although this etching has been dated as late as 1865, it bears a closer relationship in style and technique to the Rembrandtesque prints of 1857 and to the *Woman in a Ruffled Cap* of 1859-60 (cat.no.10) than to the three etched portraits of Edouard Manet, 1864-65 (cat. nos. 17-19), which are executed in a more modern manner.

The contemplative pose, the overall use of delicate line, and the darkened crosshatched background are common to the portraits of both women. *Marguerite* demonstrates a greater facility with the etching needle and especially with the drypoint tool, which is used judiciously to define and enhance the features. In the most successful impressions of this print Degas achieved a remarkable tonal balance between the sitter's pale face and costume and the dark background and fur muff. He explored textures further in this print and used to advantage the grainy areas on the plate that were probably caused by accidental biting. *Marguerite* exhibits sophisticated use of the etching and drypoint medium and represents Degas's most creative design in a print thus far.

"The pose of the head resting on the hand is a traditional one used to indicate melancholic meditation."[1] At least three visual sources for this touching gesture have been suggested, two by Rembrandt and one by Eugène Delacroix.[2] This distinctive pose was also used by Degas in his painted portrait of his older sister, Thérèse Morbilli, with her husband (Lemoisne 164, Museum of Fine Arts, Boston). Delacroix's small etching of *Madame Frédéric Villot*, 1833 (Delteil 13) depicts the wife of his close friend in a bust-length portrait with one hand to her cheek (fig. 1). Degas owned an impression of this rare print (Atelier sale, 6-7 Nov. 1918, no. 107). It is not known when he acquired it; however, he must have been familiar with the print before an impression entered the Bibliothèque Nationale collection in 1863, the year of Delacroix's death. Two other impressions were sold in 1864, and the plate itself was acquired by the printmaker Félix Bracquemond, a friend of Degas's.[3]

Rembrandt's charming silverpoint drawing of 1633 (Benesch 427, Berlin Kupferstichkabinett) portrays his bride, Saskia, in a straw hat, in a similar pose, hand to cheek (fig. 2).[4] It could only have been known to Degas as a reproduction, possibly J. F. Bolt's facsimile engraving of 1811.[5]

Degas's etching bears the strongest resemblance in mood, drawing style, and technique to Rembrandt's etching *Head of a Woman* (Hind 153, first state; fig. 3, second state). Not only the pose but also the character of the line and the modeling of the face with short, fine strokes are strikingly similar in both prints. Rembrandt's etching was reproduced in facsimile in Charles Blanc, *L'Oeuvre complet de Rembrandt* (Paris, 1861), vol. 2 , opposite p. 214. The publication of this book was a manifestation of the popularity of Rembrandt for French artists of the mid-nineteenth cen-

14 first state

14 second state

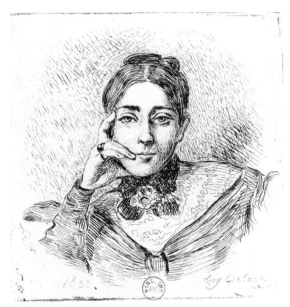

14. Fig. 1.
Eugène Delacroix, *Mme Frédéric Villot*, 1833. Etching. Bibliothèque Nationale, Paris.

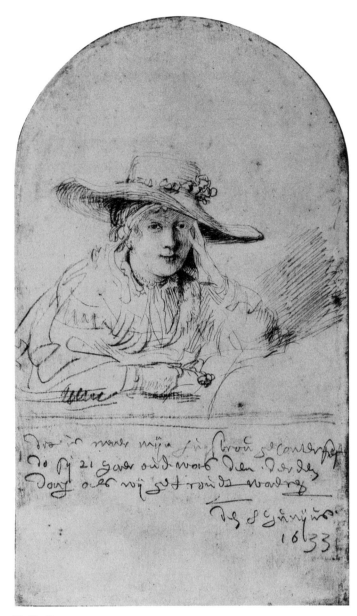

14. Fig. 2.
Rembrandt van Rijn, *Portrait of Saskia*, 1633. Silverpoint drawing. Kupferstichkabinett, Staatliche Museen, Berlin.

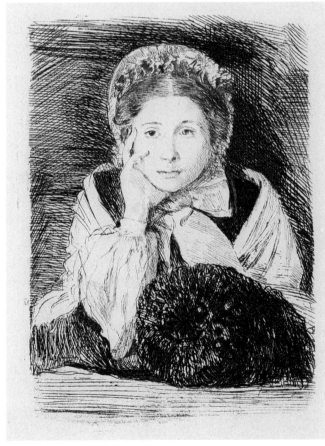

14 heliogravure of the second state

tury. Part of this phenomenon was the so-called etching revival supported by the publisher Alfred Cadart and the printer Auguste Delâtre.

Unlike his contemporaries, who exaggerated Rembrandt's etching and inking procedures, Degas absorbed the essential qualities of the Rembrandt etching and presented the sitter in his own style. In the portrait of Marguerite he moved beyond the direct copy of Rembrandt's *Young Man* (cat. no. 6) but still paid homage to the seventeenth-century master.

The first state establishes the dark and light areas of the figure and background but does not describe the face or costume in detail. The coarse etched lines do not hold ink well and take on the appearance of lines drawn in pen and ink. The only known impression is here illustrated.

The work in the second state (not located, illustrated in Delteil) is essentially complete, and a reproduction of this state in heliogravure of the same image size but of larger plate dimensions

records the additional modeling and facial detail. The retouching by hand necessitated by the photomechanical process may have altered the overall appearance in comparison with the original second state. This impression of the heliogravure was found in Degas's studio after his death, confirming that he approved of it during his lifetime and that it was not a posthumous reproduction. Two heliogravure reproductions, both printed in brown ink, are known: Berès (Atelier) and BAA.

In the following state sequence (III–V), there are no major compositional changes; however, very fine, subtle touches in drypoint differentiate the successive states, each known in a single impression.

In the third state, the hair and background have been darkened by etched lines, and an accidental, granular bitten tone is visible throughout. There is additional drypoint work on the features, hat, and hair. This unique impression (BN), not fully inked, was probably taken to record the work in drypoint.

In the fourth state, Degas carefully burnished the accidental tone from the face, making it lighter, and added fresh touches of drypoint to the bonnet and to the sitter's left nostril. He delicately painted the white of the sitter's right eye with pigment. This unique impression (NGA), like that of the third state, seems to be a trial proof.

In the fifth state, more fully inked and printed, Degas has sensitively redrawn the features in drypoint. The correction to the finger that touches the sitter's cheek and the dark drypoint on the palm of her hand create an expressive and sculptural effect. Further drypoint touches may be detected on the dress and bonnet. Degas's small adjustments to facial features here are similar in nature to Rembrandt's; both artists struggled to achieve the finest nuances of a sitter's character. Only the Boston Museum impression of this state is known.

In the final state (here sixth, formerly fourth), the evidence of overall foul-biting and pitting suggests that Degas reapplied the ground and etched the plate once again. He then found it necessary to eliminate the resulting acid accidents and in the process almost completely erased the work on the bonnet, hair, face, and hand, leaving pronounced vertical scratches on the plate. The plate is at present deeply pitted; in 1919 Delteil noted that it was severely corroded. A second impression of this state has been found (private collection); it was more generously inked, thereby compensating for the abrasions and foul-biting.

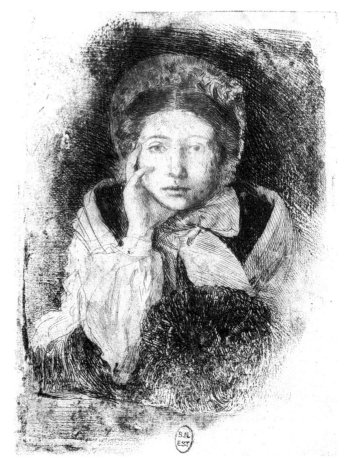

14 third state

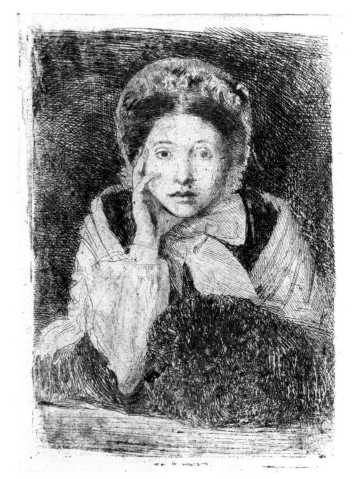

14 fourth state

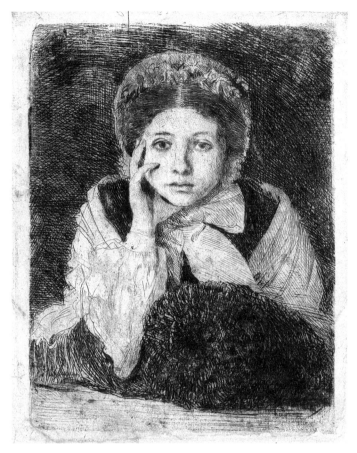

14 fifth state

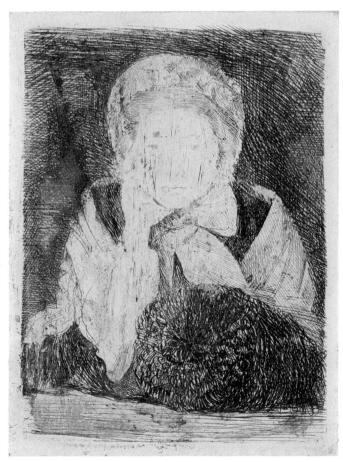

14 sixth state

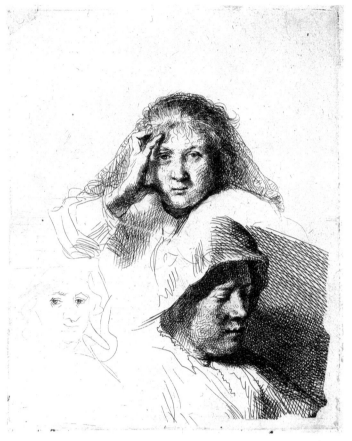

14. Fig. 3.
Rembrandt van Rijn, *Three Heads of Women*. Etching. Museum of Fine Arts, Boston.

Notes

1. Ten Doesschate Chu 1974, p. 65, n. 2, observes that the pose of Delacroix's *Madame Frédéric Villot* and that of Rembrandt's *Head of a Woman* (Hind 153) was also used by Degas in his portrait of Marguerite. C. G. Boerner, Düsseldorf, *Neue Lagerliste*, no. 58, 1971, lot 4, notes the similarity between Degas's depiction of Marguerite and Rembrandt's silverpoint drawing of Saskia.

2. Folke Nordstrom as cited in Ten Doesschate Chu 1974, p. 65.

3. We are grateful to Carol Solomon Kiefer for providing this information about Delacroix's print.

4. Otto Benesch, *The Drawings of Rembrandt* (London, 1954), vol. 2, no. 427, fig. 483.

5. Documented in Alfred von Wurzbach, *Nierderländisches Künstler-Lexikon* (Leipzig and Vienna, 1906), vol. 1.

15

René De Gas, the Artist's Brother 1861-62

Softground etching. One state
Delteil 3 (1857); Adhémar 21 (about 1861-62)
86 x 72 mm. platemark
Gray-white, medium weight, smooth, wove paper
125 x 96 mm. sheet
Coll.: Mlle Fèvre
Sterling and Francine Clark Art Institute, Williamstown,
Massachusetts

15a
Printed in red-brown ink on cream to buff, moderately thick,
smooth, Japanese vellum
327 x 238 mm. sheet
Rijksprentenkabinet, Rijksmuseum, Amsterdam

Although this etching is sometimes dated a few years earlier, a
date of around 1861-62 seems more appropriate considering the
adolescent appearance of the sitter. René De Gas was born in
1845 and left for New Orleans in 1865. In this print he is certainly
represented as a young man of sixteen or seventeen years of age.

Degas has successfully mastered a straightforward use of
the softground technique, achieving the appearance of a graphite
pencil drawing. In the same manner as his first softground attempt
(cat.no.13) Degas printed impressions of René De Gas by hand-
rubbing, as in the Clark Art Institute example. The Rijksmuseum's
impression in red-brown ink was printed in a press and shows all
the work drawn on the plate by Degas. For comments on the use
of red-brown ink, see cat. no. 5.

This small, informal portrait of René resembles certain stud-
ies of heads by Ingres. As in those drawings, Degas has concen-
trated on the facial features, with an emphasis on the large eyes,
and has noted the specific arrangement of the hair (here some-
what careless), while only summarily indicating the clothing.

Eight impressions of this print have been located: AIC
(Rouart) and Clark (Fèvre) were hand-rubbed printings; the others
are Amsterdam, BAA (Burty), BN, Huntington Library, private col-
lection, Paris, private collection, U.S. (Atelier).

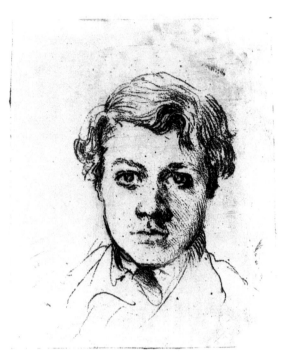

15

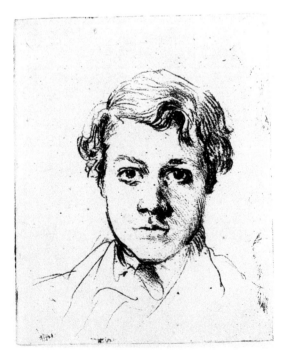

15a

16

The Infanta Margarita, after Velázquez 1862-64

Etching and drypoint. Two states
Delteil 12 (about 1860); Adhémar 16 (about 1861-62)
170 x 120 mm. platemark

I first state

White, medium weight, slightly textured, wove paper
275 x 180 mm. sheet
Coll.: Rouart
Bibliothèque Nationale, Paris
Exhibited in Philadelphia

II second state

Cream, medium weight, smooth, wove paper
180 x 150 mm. sheet (torn within lower platemark)
Atelier sale
E. W. Kornfeld, Bern

At various times between 1853 and 1868 Degas was registered to copy paintings at the Louvre. He was listed in September 1861 and in January 1862.[1]

This etching reproduces in reverse a painting of the Infanta Margarita in the Louvre, now attributed to the Velázquez workshop.[2] (Delteil incorrectly referred to this portrait as *L'Infante Isabelle.*) There is also an incomplete pencil copy in a notebook, used in Italy and Paris during 1858-60, that records Degas's early interest in the painting (Reff *Notebook* 13, p. 112, illus.).

Both Degas and Edouard Manet made etchings after this seventeenth-century Spanish painting at about the same time. The two prints, similar in format, share an interest in a "pen-and-ink" style of etched lines. Manet's etching, which faces in the same direction as the oil, probably depended on a watercolor copy that served as an intermediary step.[3] Degas's etching, in reverse, has moved far away from the earlier drawn fragment. There may be some truth in Delteil's anecdote that Manet first met Degas in the Louvre and expressed surprise when he saw the artist drawing directly on the copper plate.

In the only known impression of the first state, the entire composition was lightly etched, and all the dark accents were executed in drypoint. Degas may have taken the lightly bitten plate back to the Louvre, where he completed the extensive drypoint additions that so successfully imitate the tonalities of the painting (see cat. no. 5 for Duranty's note on Degas's use of the drypoint needle).

Manet's freely rendered etching is more abstract and individualistic than Degas's, which reflects a direct response to the painterly qualities of the original. In following the model, Degas's small print combines both creative liveliness and precision. (For an illustration of both images, see Dunlop 1979, p. 54.)

In the second state Degas burnished and scraped away parts of the composition, leaving the plate incomplete and essentially unresolved, a practice he repeated often in his prints (see cat. nos. 14, 17, 18, 22, 48). This is the only known impression of the second state, which shows, in spite of its erasures, additional drypoint work on the chair, the background below the Infanta's left arm, and her skirt at lower left.

The drypoint tool used for the horizontal parallel strokes on the chair in this print appears to be the same as that used for the profile sketch in the upper left of Degas's portrait of his grandfather (cat. no. 4), for it produces a similar broad and soft quality of line.

Notes

1. Reff 1963, pp. 241-51; Reff 1964, pp. 250-59.

2. José Lopez-Rey, *Velázquez: A Catalogue Raisonné of His Oeuvre* (London, 1963), no. 398.

3. Jean Harris, *Edouard Manet: Graphic Works* (New York, 1970), no. 14.

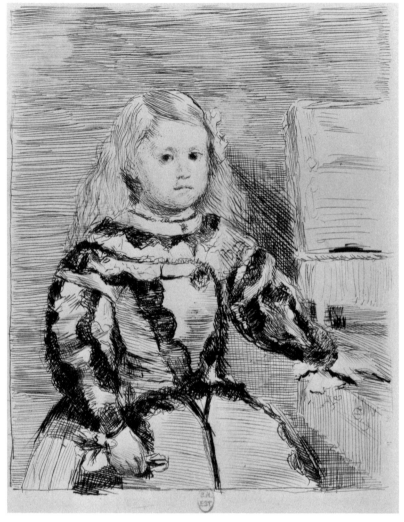

16 first state

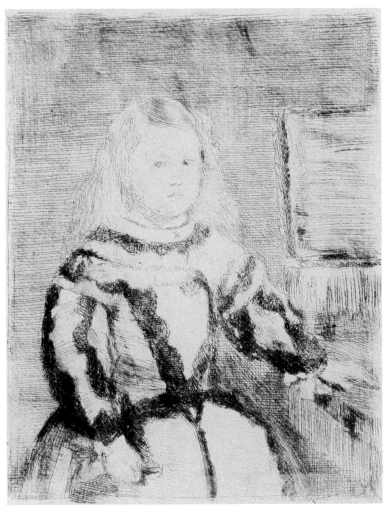

16 second state

17

Manet Seated, Turned to the Left 1864-65

Etching. Two states
Delteil 15 (1864); Adhémar 18 (about 1861)
171 x 120 mm. platemark

17a

Drawing for *Manet Seated, Turned to the Left*
Black chalk
Buff, moderately thick, wove paper
330 x 232 mm. sheet
Degas signature stamp
The Metropolitan Museum of Art. Rogers Fund, 1919
Exhibited in Boston

I first state

White, medium weight, smooth, wove paper
310 x 220 mm. sheet
Coll.: A. E. McVitty
National Gallery of Art. Rosenwald Collection, 1950

II second state

Cream, moderately thick, moderately rough, laid paper
360 x 270 mm. sheet
Watermark: ARCHES
Coll.: Atelier; Wiggin
Boston Public Library. Wiggin Collection

Edouard Manet's paintings of modern life, exhibited in the Salon des Refusés of 1863, established influential new directions for French art and for Degas. The change of style seen in Degas's portraits of Manet executed about the same time reflects this influence and pays homage to its creator. Manet's physical appearance did not change substantially in the decade of the 1860s,[1] and it seems likely that the three etched portraits (cat. nos. 17, 18, 19) were all made around 1864-65, after Manet's new work had become firmly established and readily accessible to Degas. Certainly, Manet's personal stylishness was attractive to Degas, and his worldly vision served as an inspiration. Manet's effect on Degas's artistic development is well documented.

Two of Degas's etched portraits of Manet rely closely on drawings of the artist seated in his or in Degas's studio (see cat. no. 18); the third etching shows an affinity to another drawing (see cat. no. 19). (For a fourth portrait see the Appendix.) Degas's comfortable relationship with Manet may have induced him to show his friend in relaxed, informal poses. Indeed, these etchings represent a distinct change in style from Degas's earlier prints because of their strong sense of contemporary life.

Although the drawing for *Manet Seated, Turned to the Left* was too large in scale to be employed in the direct transfer to the plate, it was closely followed in pose, costume, unworked background, and especially in the treatment of the head. The etching needle replicates the pencil strokes that define the hair and beard.

Degas added further shading to the clothing to indicate Manet's characteristic street dress of dark jacket and coat and pale trousers. The regularity of the etched work and the strong reliance on the drawing suggest that this print is the first of the three etched portraits of Manet.

In the first state the composition was completely established. All three known impressions were printed with plate tone left within the etched border and clean-wiped margins, in the manner of Auguste Delâtre. Three impressions of this first state have been located: BAA (Burty), Copenhagen (Atelier), NGA.

In the second state Degas scraped and burnished the plate, nearly obliterating the coat, probably in preparation for a reworking that never took place. Six impressions of this state were in the Atelier sale; none appear to have been given by Degas to his contemporaries. The authors have located six impressions: Albertina (Atelier), BAA, BPL (Atelier), Carnegie Institute, Kornfeld, Wesleyan (Atelier). As there is essentially only one resolved state of this print executed in line etching of one bite, Degas must have abandoned this plate and renewed his efforts on a second one.

Note

1. For some contemporary portraits of Manet, see those made by Fantin-Latour in 1864, 1865, 1867, and 1870; reproduced in Douglas Druick and Michel Hoog, *Fantin-Latour*, exhibition catalogue (Paris, 1982). See also a photograph by Nadar in 1865; reproduced in New York, *Manet* 1983, frontispiece.

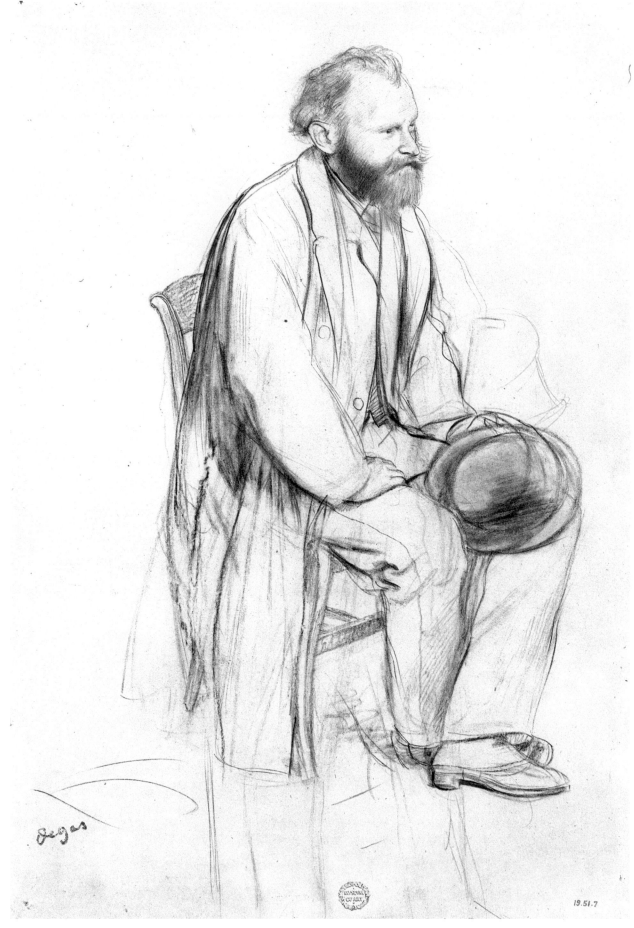

Degas

19.51.7

17a

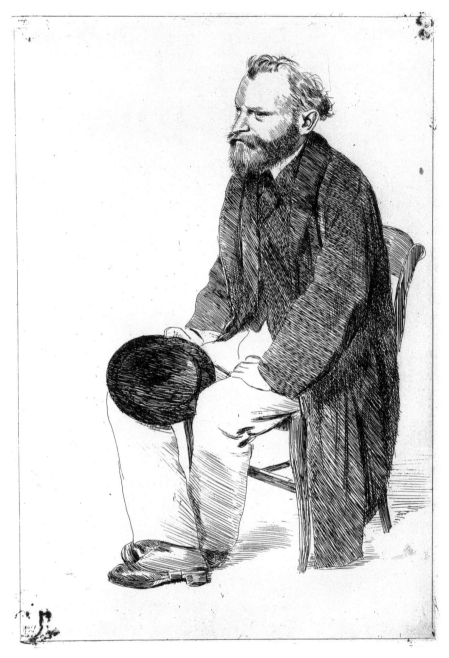

17 first state

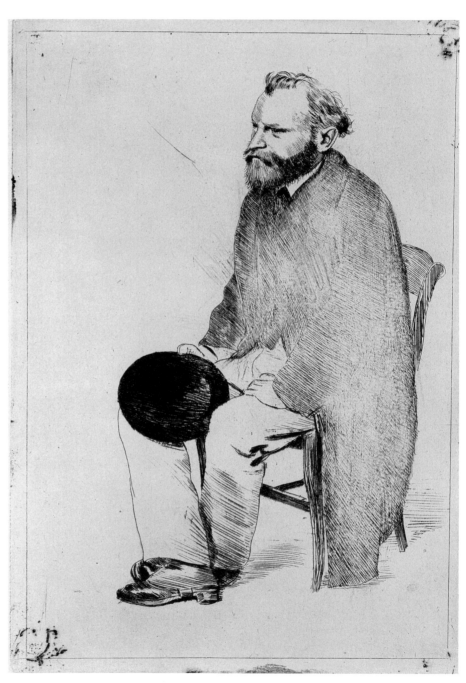

17 second state

18

Manet Seated, Turned to the Right 1864-65

Etching and drypoint. Four states
Delteil 16 (1864); Adhémar 19 (about 1861)
195 x 130 mm. platemark

I first state

White, moderately thick, smooth, wove paper
298 x 218 mm. sheet
Atelier stamp
Museum of Fine Arts, Boston. Bequest of W. G. Russell Allen

II second state

White, thick, smooth, wove paper
314 x 226 mm. sheet
Coll.: Atelier; H. Whittemore
*The Detroit Institute of Arts. Founders Society Purchase, General
Membership Fund*

III third state

Off-white, moderately thick, smooth, wove paper
315 x 225 mm. sheet
Atelier stamp
The Art Institute of Chicago. Charles F. Glore Collection

IV fourth state

White, thick, slightly textured, wove paper
250 x 173 mm. sheet
Atelier stamp
The Baltimore Museum of Art. Blanche Adler Fund

In this, the most fully rendered of the Manet portrait etchings,
Degas has captured the insouciance of his artist friend, who infor-
mally sits sideways on a small chair. Manet is posed before a large
canvas with stretchers that form a rectilinear backdrop and quite
specifically indicate a studio setting. Degas's satisfaction with this
print is evident from the number of impressions printed. Delteil
listed seventeen, of which fourteen have been located.

There is a preliminary drawing for *Manet Seated, Turned to
the Right* (fig. 1) composed of four separate images, from which
Degas extracted at will to produce his etching, in reverse. The
vitality of the drawing, created in part by the artistic placement of
each motif, is similarly achieved in this masterful etching.

Degas made frequent reference to the pencil drawing as he
worked on the plate through the first three states. He depicted
Manet's figure in the same pose, while the etched lines of the
head follow the configurations of those of the larger head on the
drawing sheet. The top hat resting on the floor in the print was
also taken from the drawing and added in the second state.
Whereas the earlier etching of Manet (cat. no. 17) nearly replicated
the drawn portrait (cat. no 17a), this etching represents a synthesis
of its drawing source.

In the first state, the figure and the background canvas are
drawn in their entirety. Delicate linework around the eyes gives a

distinct character to the face, while long parallel strokes and judi-
cious accent lines enrich the jacket. The free handling of the shad-
ing in this etching is in contrast to that in *Manet Seated, Turned to
the Left* (cat. no. 17), where the changing directions of the regular-
ized hatching create the effect of flat patches that differentiate the
parts of his garments.

The unconventional pose and the contemporary setting mark
a departure within Degas's oeuvre from his earlier and more tradi-
tional prints in the manner of the old masters. Manet's influence is
further detected both in the style of execution and in the inking
techniques, which Manet himself had learned from the printer
Auguste Delâtre and the publisher Alfred Cadart. The obvious and
even plate tone within the etched border line is a device most
noticeably employed in the original prints of the Société des
Aquafortistes.

At least five impressions are known of the first state: BAA,
BN (Rouart), MFA (Atelier), MMA, and NGC (Eddy).

In the second state Degas has altered the balance of the
image by adding in drypoint a top hat, derived from the drawing, in
the lower left corner. There are now horizontal drypoint lines to
shade the stretcher and the floor and a few delicate lines on the
sitter's face. Dark drypoint lines accent Manet's right shoulder,
trouser leg, and the leg of the chair. Two impressions are known,
both bearing Atelier stamps: Detroit and East Berlin.

In the third state the hat is more fully defined and more
closely resembles its model in the drawing. There are two impres-
sions: AIC (Atelier) and Prouté (Atelier).

The fourth state represents Degas's unfulfilled intention to
rework the plate, as in other instances (see cat. nos. 14, 16, 17).
He has scraped and burnished and nearly obliterated a large part of
the image, including the head and background. In contrast to the
previous portrait of Manet (cat. no. 17), he has left the body and
clothing intact.

Despite the incomplete appearance of the fourth state, there
are at least five impressions known. One of these, rather more
cosmetically inked, was owned by the artist's friend Alexis Rouart,
to whom Degas usually gave fine impressions of his prints. Five
impressions of this unresolved state are known: Albertina,
Amherst (Atelier), BAA, Baltimore (Atelier), Clark (Rouart).

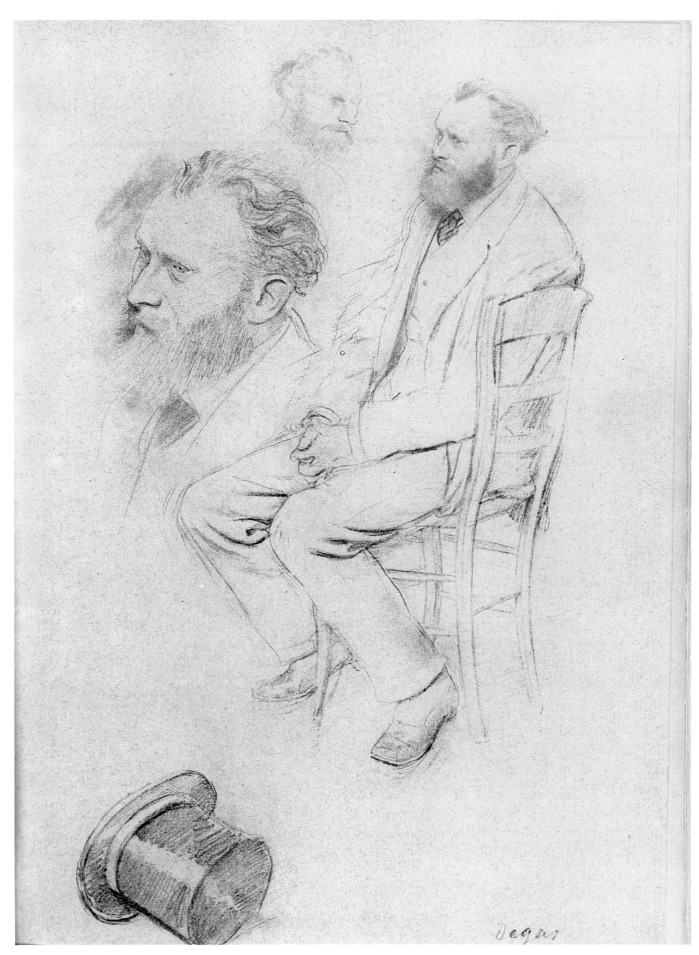

18. Fig. 1.
Manet Seated, about 1862-64. Black chalk. Formerly collection Rouart. Private collection, Paris.

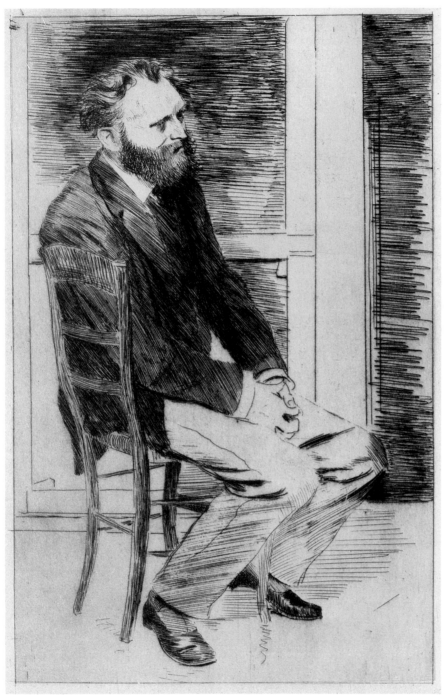

18 first state

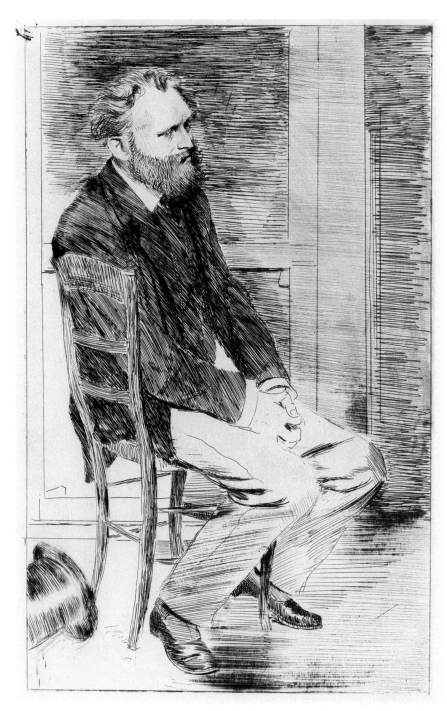

18 second state

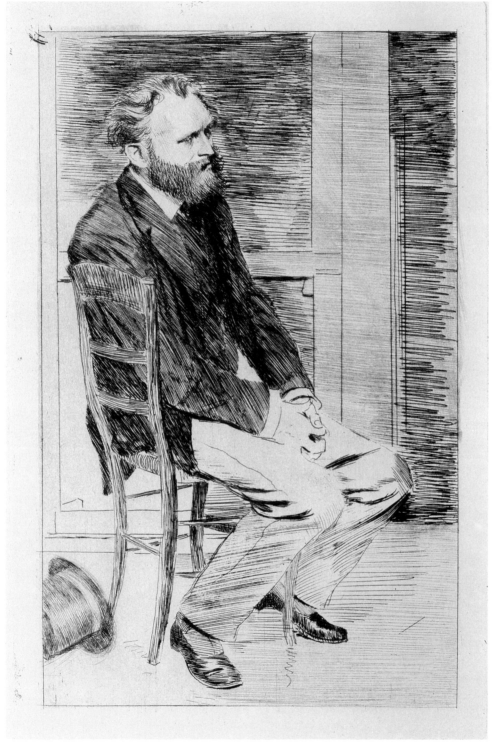

18 third state

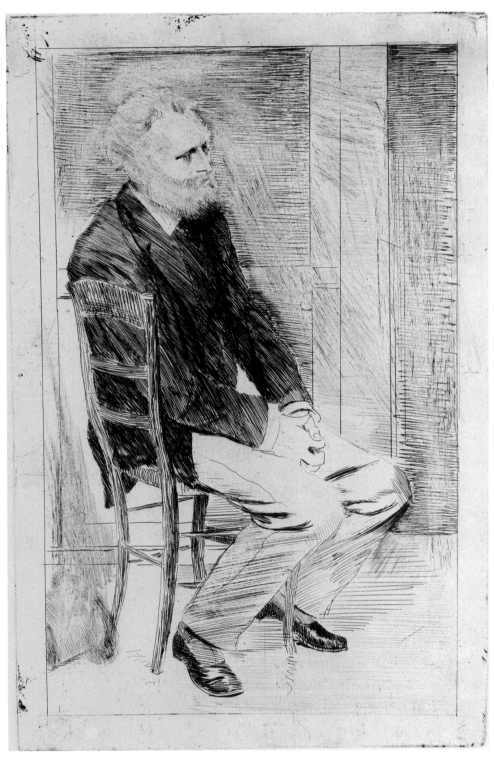

18 fourth state

Edouard Manet, Bust-Length Portrait 1864-65

Etching, drypoint, and aquatint. Four states
Delteil 14 (five states, 1864); Adhémar 17 (about 1861)
130 x 105 mm. platemark

I first state

Off-white, moderately thick, smooth, wove paper
313 x 225 mm. sheet
Coll.: Rouart
*The Art Institute of Chicago. Joseph Brooks Fair Collection
1932.1295*

II second state

Off-white, moderately thick, smooth, wove paper
315 x 225 mm. sheet
Coll.: Bracquemond (*Bd* in pencil on verso); R. R. Coll. (in pencil on verso)
*Philadelphia Museum of Art. Joseph E. Temple and Edgar Viguers
Seeler Funds*

III third state

Off-white, moderately thick, moderately textured, laid paper
282 x 203 mm. sheet
Coll.: A. E. McVitty
The Metropolitan Museum of Art. Gift of Mrs. Imrie de Vegh, 1949

IV fourth state

Cream, thick, rough, laid paper
360 x 270 mm. sheet
Watermark: fragment of Arches countermark
*Museum of Fine Arts, Boston. Katherine Eliot Bullard Fund in
memory of Francis Bullard and proceeds from the sale of duplicate
prints*

IV fourth state

Printed in red-brown ink
White, thick, smooth, wove paper
250 x 170 mm. sheet
Inscribed in pencil, lower right: *Degas*
National Gallery of Art. Rosenwald Collection, 1951
Not illustrated

The angle of the head and eye-level point of view in this bust-length portrait of Manet most closely resemble those in a drawing of Manet seated (fig. 1). In both print and drawing, Degas has depicted a somewhat pugnacious Manet, gazing from hooded eyes, with a prominent brow, jutting jaw, and strong neck muscles.

Degas's print reveals a powerful characterization of Manet when compared with the routine academic study made by Félix Bracquemond found in the frontispiece of Zola's biography of Manet (Paris, 1867). Although the bust-length pose is a conventional one, Degas's increased technical facility and expertise and the use of aquatint suggest that this was the last of the three etched portraits of Manet to be executed.

In the first state Degas described Manet's face with careful attention to the personality of the sitter; he used a variety of etched lines: light parallel strokes to model and shade and bold cursive lines to indicate Manet's tousled hair and wiry beard. The clothing is summarily sketched. There are four known impressions of this state: AIC (Rouart), BAA (Burty), Copenhagen (Atelier), and Prouté (Beurdeley).

In the second state Degas added fine drypoint lines to the forehead near the hairline, to the earlobe, and on the beard. This impression is the only one known and belonged to Pierre Bracquemond, son of the artist friend of Degas, Félix Bracquemond. The impressions shown here of first and second states have been inked and wiped so that the margins of the plate are clean, but a tone of ink remains within the etched border line.

For the third state, Degas applied a new ground to the plate and etched parallel, diagonal lines to cover the jacket, vest, and tie. The background is shaded with a series of horizontal strokes. This new work causes the head to take on a lighter coloration and more leonine aspect that is in keeping with Manet's physical appearance. In addition to this impression (MMA), one other has been located in a private collection, Germany, and is inscribed in pencil: *Degas 1868*. Both impressions are clean wiped and carry no plate tone. The speckled appearance of the collar is evidence of foul-biting resulting from the re-etching of this plate.

In the fourth state an aquatint grain has been applied to enrich the dark background and coat; there is no further work to the head. This is the first instance where Degas used the aquatint technique, and it is tempting to suggest that Félix Bracquemond assisted him in its skillful application. Six impressions of this state have been located, although Delteil knew of seven: BAA, BN, Cincinnati (Atelier), Kornfeld (Atelier), MFA (possibly Rouart), and NGA (red-brown ink, probably Viau). The MFA and Cincinnati impressions were printed on a machine-made Arches paper more commonly used at the end of the century.[1] This fact suggests that at least some, and perhaps all, impressions of the fourth state were printed several decades after the plate was begun. (For further discussion, see the essay "Degas's Printing Papers.")

There are a few examples of Degas's etchings in red-brown ink (see also cat. nos. 5, 15, and 24). These impressions clearly record the condition of the plate; any rough areas along the plate edge or any surface scratches retained ink and printed. In this instance, the red-brown ink evokes Manet's well-known ruddy coloring.

Delteil's fifth state is characterized by a scratch on the sitter's temple; he noted that one impression was sold at the Atelier sale, although it was not listed in the catalogue. We agree with Paul Moses that this accident does not constitute an additional state. We have not located an impression made in Degas's lifetime that shows the scratch.

19 first state

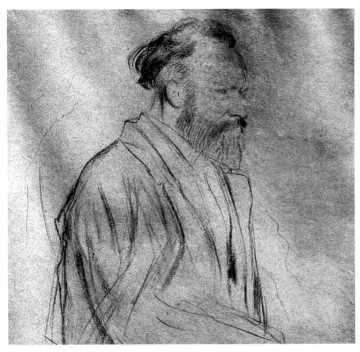

19. Fig. 1.
Manet Seated, about 1862-64. (Detail.) Black chalk on faded pink paper. The Metropolitan Museum of Art. Rogers Fund, 1919.

Note

1. There is a possibility that Degas's etching of *Edouard Manet, Bust-Length Portrait* could have been considered as an illustration for a book or periodical. Two of Camille Pissarro's etchings, *Shepherdess at a River Bank* (Delteil 93) and *The Haymakers* (Delteil 94), were printed on the same paper in an edition of 100 before they appeared respectively in the *Gazette des beaux-arts* (spring 1904) and in Théodore Duret, *Histoire des peintres impressionistes* (Paris, 1906).

19 second state

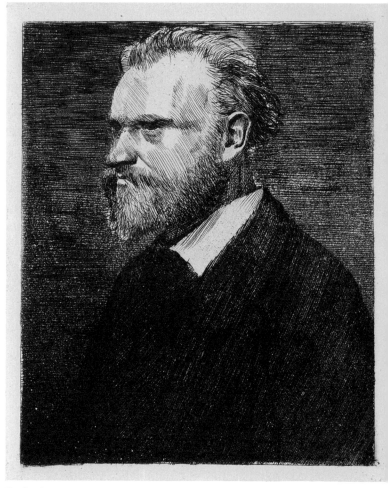

19 third state

19 fourth state

20

A Dancer 1875

Drypoint. One state
Delteil 18 (about 1875); Adhémar 38 (about 1878)
100 x 138 mm. platemark
Cream, moderately thin, smooth, wove paper
142 x 199 mm. sheet (mounted down)
Atelier sale (stamp not visible)
Bibliothèque Nationale, Paris
Exhibited in Boston

For this experiment in traditional drypoint Degas used a plate in poor condition, scratched and showing evidence of foul-biting. Only one impression is extant.

The drawing of the image is awkward, and Degas has shown less than expert control with the drypoint needle. One can propose that this plate was used like a sketch page for a quick notation, either an on-site observation or a drawing from memory. The plate may have been a preliminary trial before Degas executed more skillfully the portrait of Alphonse Hirsch (cat. no. 21). For the latter he reused a previously worked plate (cat. no. 13), and he probably did so for this dancer, although no print of similar size has been identified.

The somewhat static and academic qualities of the drypoint echo numerous drawing studies for ballet class paintings of the early to mid-1870s. The pose of the dancer, with her arms held behind her skirt, shows a correspondence to that of the foreground figure in the painting *The Dance Class* (Lemoisne 397, Harry Payne Bingham, New York), probably executed in 1874-75.

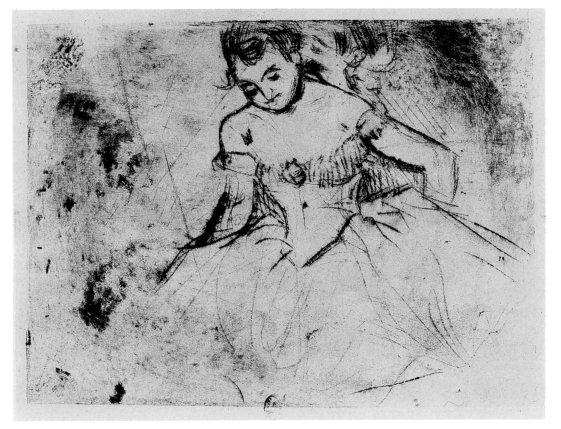

20

21

Alphonse Hirsch 1875

Drypoint and aquatint. Two states
Delteil 19 (1875); Adhémar 24 (20 February 1875)
112 x 60 mm. platemark

I first state

Cream, medium weight, slightly textured, laid paper
Inscribed in ink by Philippe Burty, recto: *le peintre Alphonse Hirsch, fév. 75 par De Gas*
Bibliothèque d'Art et d'Archéologie (Fondation Doucet)
Not in exhibition

II second state

Off-white, medium weight, slightly textured, laid paper (blank sheet from a book)
240 x 185 mm. sheet
Watermark: portion of large oval containing image, perhaps a vat and a paper press
Museum of Fine Arts, Boston. The Frederick Brown Fund

21a

Restrike impression, 1959
Printed in brown ink on buff, moderately thick, moderately rough, laid paper
195 x 145 mm. sheet
Circular stamp in black on verso: Printed by Arthur Flory 1959
Museum of Fine Arts, Boston. Gift of the Print Council of America

Alphonse Hirsch (1843-1884) was a painter and etcher who acted mainly as an agent for collectors.[1] His studio overlooked the railroad station Saint-Lazare, and his close relationship with contemporary artists is attested to by the appearance of his young daughter as a model for Edouard Manet in his major painting *The Railroad*, 1872-73 (National Gallery of Art, Washington).[2] Tradition has it that Degas, Hirsch, Marcellin Desboutin (1823-1902), and Giuseppe de Nittis (1846-1884) gathered on 20 February 1875 to fulfill a friendly commitment to execute portraits of each other in drypoint, the medium favored by Desboutin.[3] They were perhaps encouraged by the collector Philippe Burty, who inscribed some of the resulting impressions with the date (see those by De Nittis, Desboutin, and Degas at the BAA). There are no known portraits by Hirsch that can be connected with this project, but drypoint heads of Degas by Desboutin and De Nittis are executed in a sketch-like style similar to that of Hirsch by Degas.[4] This is the last print in which Degas dealt with portraiture in a traditional manner.

Degas must have considered the enterprise in a very offhand fashion since he clearly reused an imperfect, previously etched plate on which he had portrayed Jenny Delavalette (cat. no. 13). The earlier image is faintly visible underlying the new drypoint head, which Degas placed upside down on the plate. The pitted foul-biting from the first image appears across Hirsch's forehead.

There is only one impression known of the first state. The drypoint burr is strong and retains a great deal of ink. An accidental drypoint stroke is visible across the upper part of the sitter's forehead.

In the second state a distinct aquatint grain, added to the plate some time after the execution of the initial image, describes a jacket and cravat. In this impression the drypoint burr is less pronounced, but it still retains considerable ink. Traces of Jenny Delavalette's ruffled collar appear in softground to the left of Hirsch's neck, and the ink has been partially wiped out of the drypoint scratch on the forehead. Impressions of this state are found in the MFA and NGA.[5]

In 1956, when the plate was in the hands of the Swiss dealer Gérald Cramer, Geneva, four impressions were pulled by the painter Jean-François Liegme. One was retained by Cramer, and three were given to Lessing J. Rosenwald when he purchased the copper plate in 1959.[6] The plate was illustrated in Cramer's catalogue no. 10, 1959, lot 44, before steel-facing and with the pitting across the forehead clearly visible. Rosenwald had the plate reprinted and offered impressions for sale to members of the Print Council of America. The prospectus and order form describe this edition:

In 1959 Mr. Lessing J. Rosenwald acquired the plate and decided to print a limited edition which would be made available to collectors and institutions. The result . . . may be considered a third restrike state of the portrait. The edition was printed by Mr. Arthur Flory. . . . Before the printing the accidental pitting which marred the forehead in the earlier states was removed. . . . The plate was then steel faced to preserve it. Experiments to determine a satisfactory tone and consistency of ink resulted in a mixture of Weber etching inks consisting of black warmed by Van Dyck brown, a little burnt Sienna, and a bit of plate oil. Five hundred proofs, each hand-wiped, were then pulled, using a standard etching press. They were printed on 7¾ x 5¾ inch sheets of handmade Dard Hunter paper which was once owned by the late James McBey. . . .

Each impression of this edition bears on the reverse side the imprint of its authenticity: a circular stamp one-half inch in diameter with the text "Printed by Arthur Flory 1959."

Notes

1. The only print by Hirsch catalogued by the Bibliothèque Nationale is a copy of Goya's etching *Love and Death* from the *Caprichos*.

2. Reff, *Manet* 1982, no. 10.

3. Melot 1974, pp. 99-105.

4. Melot 1974, nos. 214, 226, illus.

5. An unusual impression in the Art Institute of Chicago, printed in blue ink on oatmeal, laid paper, does not have the fine drypoint scratches or the pitting across the forehead of Hirsch.

6. Information obtained from the Print Council of America prospectus and the National Gallery of Art records.

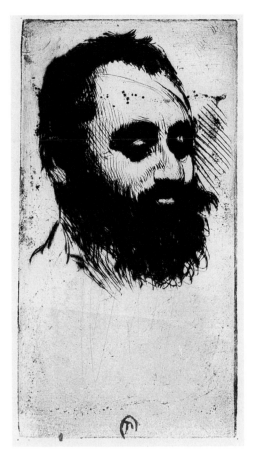

21 first state

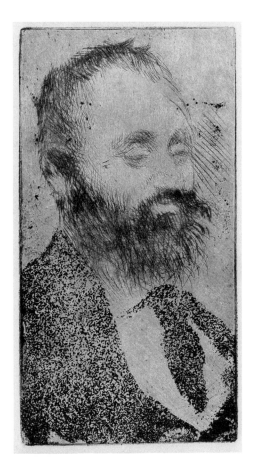

21a

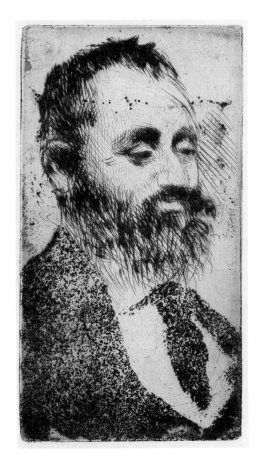

21 second state

On Stage I 1876

Softground etching and drypoint. Five states
Delteil 33 (1877); Adhémar 27 (1877)
120 x 160 mm. platemark
Signed in the plate, lower right: *Degas*

22a

M. Gouffé Playing the Double Bass about 1869
Graphite
Off-white, thin, smooth, wove paper
188 x 120 mm. sheet
Coll: Mme Dihau; Marcel Guérin; Daniel Guérin
Mr. and Mrs. Eugene Victor Thaw
Exhibited in Boston

I first state

Off-white, medium weight, smooth, wove paper
160 x 245 mm. sheet
Atelier stamp
National Gallery of Art. Rosenwald Collection, 1943

II second state

Buff, moderately thick, moderately textured, laid paper
185 x 219 mm. sheet
Coll.: Rouart
Bibliothèque Nationale, Paris
Not in exhibition

III third state

Cream, moderately thick, rough, laid paper
267 x 352 mm. sheet (irregular)
Watermark: fragment of letters
Atelier stamp
Department of Prints and Drawings, The Royal Museum of Fine Arts, Copenhagen

IV fourth state

Off-white, moderately thick, slightly textured, wove paper
159 x 244 mm. sheet
Coll.: Rouart
Josefowitz Collection, Switzerland

V fifth state

Cream, medium weight, laid paper
159 x 183 mm. sheet
Atelier stamp
E. W. Kornfeld, Bern

Degas had served in the infantry during the Franco-Prussian War and remained outside of Paris throughout the unsettling events of the Paris Commune of 1871. On his return, he again attended the Paris Opéra, for which he had regularly held a ticket from the time he was twenty years old. By the summer of 1872 he received permission to visit the practice rooms where the classes for the young ballet dancers were held. As early as 1869 Degas had depicted members of the opera orchestra playing for a ballet performance with a glimpse of the stage beyond the pit. One painting, *The Orchestra of the Opéra* (Lemoisne 186, Louvre), executed about 1870, before the war, reflects Degas's continuing interest in portraiture of specific individuals and also indicates his growing preoccupation with the theater. The painting served as a repertoire of motifs for several works of 1876-77, including the three prints entitled *On Stage* (cat. nos. 22-24) as well as a pastel over monotype, *Ballet at the Paris Opéra* (see cat. no. 24, fig. 1). This last picture was probably one of the two works Degas contributed in 1877 to an exhibition organized by the Friends of Art of the city of Pau (Basses-Pyrénées). He also executed an etching to serve as an illustration to the catalogue. On the rare occasion that Degas prepared a print for a wide audience, he went through an elaborate procedure of making preliminary drawings and trying state sequences before he was satisfied with the finished print (see also cat. nos. 51, 53, 54). We believe this version, *On Stage I*, subsequently rejected along with *On Stage II*, preceded the published print and was part of the preparatory process.

This print is less successful than *On Stage III* in the spatial relationship of the orchestra to the stage. Here Degas focused on the heads in the foreground without adequately separating the orchestra pit from the stage floor at right. He addressed himself to remedying this defect throughout the development of the print, primarily scraping to achieve a spatial resolution. After obliterating much of the image in the final state, he abandoned the plate. Although Degas began with a professionally beveled plate and had etched his signature in the image, very few impressions of *On Stage I* are known. In our view, this plate was not a sequel to *On Stage III* (cat. no. 24).

A drawing that served as a study for both the painting, *The Orchestra of the Opéra*, and *On Stage I* represents the double bass player M. Gouffé, a prominent member of the orchestra at the Paris Opéra. The drawing is on a sheet that was certainly part of a notebook of the same size (187 x 120 mm.), which included other sketches for the painting. Notebook 25 was used in Paris and Normandy between 1869 and 1872. Reff has observed that before numbering, one sheet between pages 34 and 35 had been removed.[1] This must be the Thaw drawing, which is torn along the left side and has the same rounded corners. It was originally followed by a study of Gouffé's chair with color notes, now page 35. In his customary manner, Degas used both the earlier drawing and the painting as sources when he prepared the *On Stage* prints in 1876.

It is difficult to understand Delteil's state sequence and to accept his notations on the states of the impressions in the Atelier sale. He accounted for nine impressions, not identical in sequence and provenance to the nine at present located.

The first state of *On Stage I* was executed in softground etching only. The artist drew over the plate densely to achieve considerable tone. An area of the stage at left was scraped to lighten it. The space between the double bass player's head and

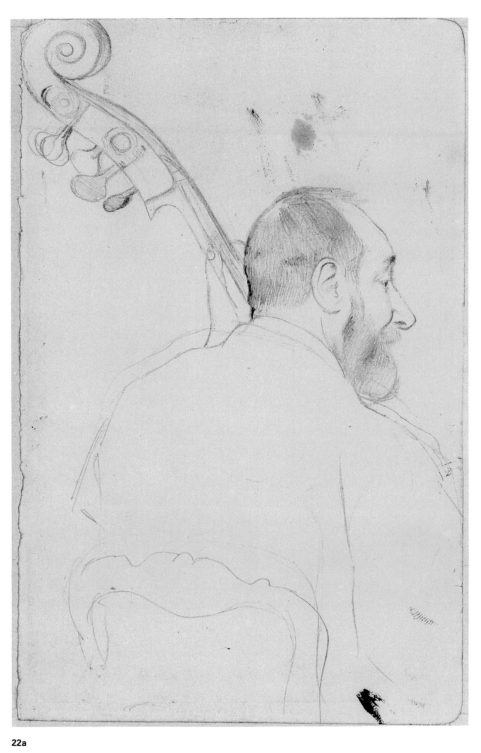

22a

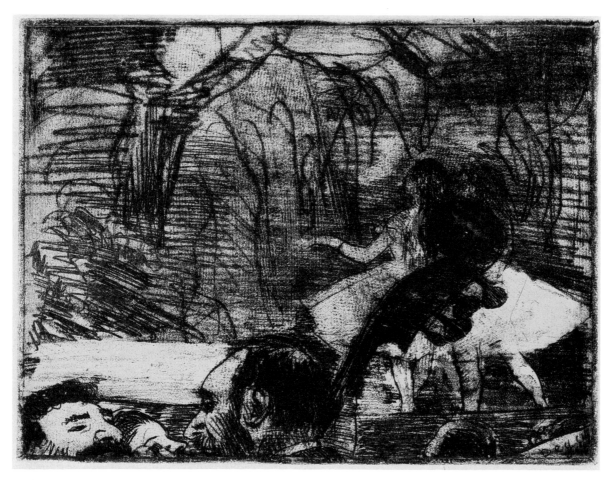

22 first state

the skirt of the dancer as well as the floor of the stage at right are dark. The image is completely described in the first state. Three impressions have been located: BM (Beurdeley), Kornfeld (Atelier, maculature), and NGA (Atelier).

In the second state there is evidence of burnishing on the stage floor that borders the orchestra pit at right and on the skirts and legs of the two dancers. This burnishing makes the pegs of the double bass more prominent. Oblique drypoint lines shade the neck of the instrument while horizontal lines of drypoint darken the space between the legs of the dancers and appear on the skirt at right. Only one impression of this state has been found: BN (Rouart).

The only known impression of the third state (Copenhagen, Atelier) exhibits additional drypoint lines that create crosshatching on the top of the double bass and define its contour more clearly. A few fine drypoint strokes are visible on the face of the musician at the far left. Degas scraped to lighten a small portion of the

stage between the dancer's skirt and M. Gouffé's head; he redefined the contours of the head in drypoint.

Two impressions of the fourth state show evidence of further work on the plate. The area above Gouffé's head is now white, and an indistinct patch to the right of the double bass indicates another head. Additional fine drypoint hatching shades the face of the man at the far left, and drypoint lines lengthen the hair of the left dancer. The following impressions have been located: Dr. and Mrs. Martin L. Gecht, Chicago (Atelier), and Josefowitz (Rouart).

The fifth, and nearly erased, state shows drypoint lines between Gouffé and the dancers that make the additional head more visible. Two impressions are known: BAA (apparently signed by the artist) and Kornfeld (Atelier).

Note

1. In Reff's introduction to *Notebook* 25, he describes the condition of the notebook. The faint, printed blue lines of squaring noted by Reff have apparently faded from this sheet.

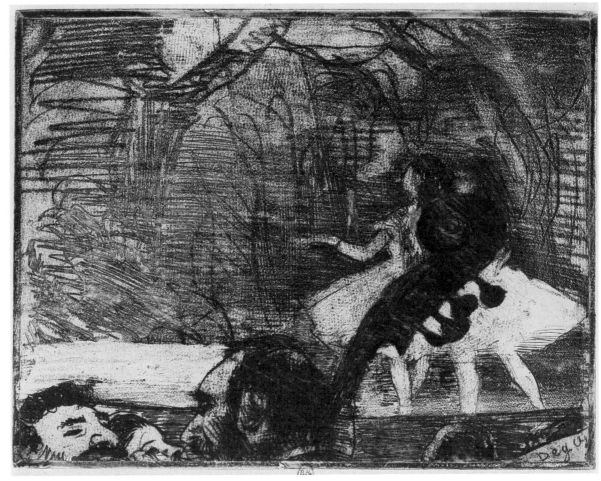

22 second state

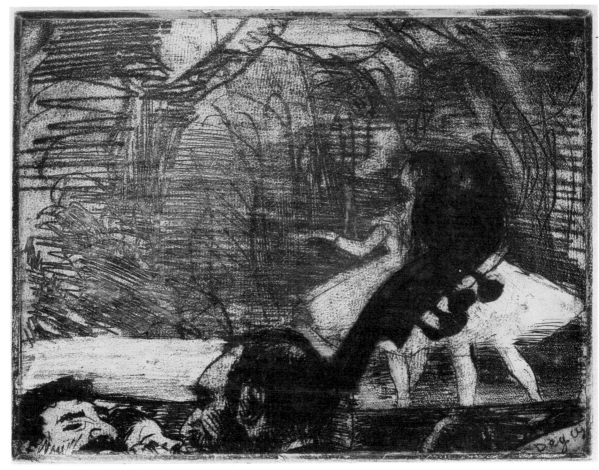

22 third state

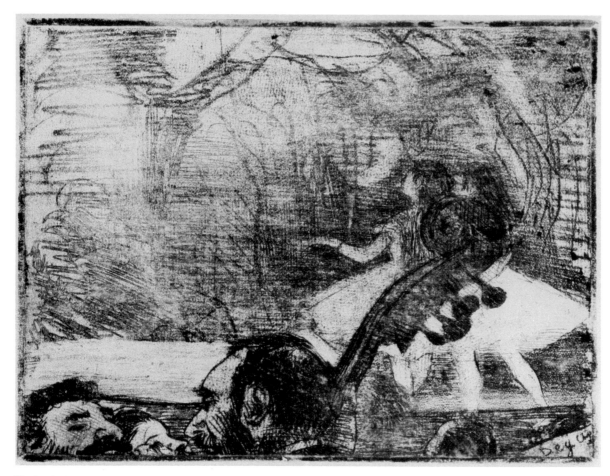

22 fourth state

22 fifth state

23

On Stage II 1876

Aquatint over softground
Delteil 31 (1877); Adhémar 25 (about 1877)
80 x 120 mm. platemark
Signed in the plate upper left: *Degas*
Cream, moderately thick, moderately textured, laid paper
178 x 264 mm. sheet
Watermark: fragment of a crowned shield
Atelier stamp
Museum of Fine Arts, Boston, Katherine E. Bullard Fund in memory of Francis Bullard and proceeds from sale of duplicate prints

The composition and subject matter of this experimental plate, *On Stage II*, are closely related to those of the published version (cat. no. 24). The small, professionally beveled plate of no. 23 shows softground indications of the heads of orchestra members, a double bass at the far left, and generalized shapes of dancers on the stage. These faint outlines are almost completely covered by a fine-grained aquatint, stopped out and bitten at least twice. The two primary dancers appear white, the two in the background, the stage set, and the musicians' heads gray, and the remainder of the stage space very black. The aquatint was unevenly applied at the upper right.

Although our eyes today admire the richness of this murky, almost abstract image, Degas printed only one impression and obviously considered it a technical failure. We have discovered that, at a later date, the artist cleaned and polished the plate, leaving slight traces of this ballet image, and reused it to execute a drypoint, *The Little Dressing Room* (cat. no. 41). The signature that is obscured by aquatint in the upper left corner of *On Stage II* is visible in the second print.

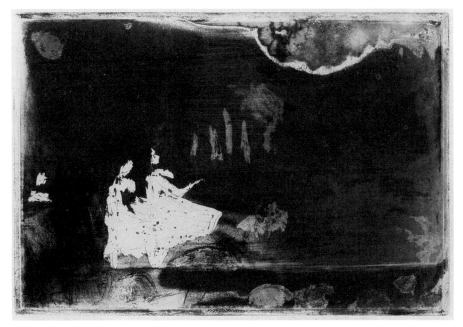

23

On Stage III 1876-77

Softground etching, drypoint, and roulette. Five states
Delteil 32 (1877); Adhémar 26 (1877)
99 x 127 mm. platemark
Signed in the plate, lower left: *Degas*

I first state

Cream, moderately thick, moderately textured, laid paper
153 x 240 mm. sheet
Atelier stamp
E. W. Kornfeld, Bern

II second state

Cream, moderately thick, moderately textured, laid paper
155 x 238 mm. sheet
Atelier stamp
*Fogg Art Museum, Harvard University. Anonymous loan in honor
of Jakob Rosenberg*

III third state

Off-white, moderately thick, smooth, laid paper
128 x 156 mm. sheet
*Sterling and Francine Clark Art Institute, Williamstown,
Massachusetts*

IV fourth state

White, very thick, smooth, wove paper
173 x 250 mm. sheet
Atelier stamp
The Metropolitan Museum of Art. Rogers Fund, 1921

IV fourth state

Printed in red-brown ink on cream to buff, moderately thick,
smooth, Japanese vellum
145 x 171 mm. sheet
Philadelphia Museum of Art. John D. McIlhenny Fund
Not illustrated

V fifth state

Cream, moderately thick, moderately textured, laid paper
126 x 178 mm. sheet
Coll.: Barrion; Beurdeley
N. G. Stogdon

On Stage III represents Degas's third and successful attempt to
produce an illustration for the catalogue of an exhibition sponsored
by Les Amis des Arts de Pau. Impressions of the fifth and final
state of *On Stage III* are more plentiful than most of Degas's
prints, for they were published in the catalogue, which contained
original etchings by artists participating in the exhibition. In a
review, Louis Gonse commented that the small catalogue was
elegantly printed on beautiful Holland paper with a red and black
title page and contained eleven original etchings by Degas,

Desboutin, Goeneutte, Charles Jacque, Lapostolet, Teyssonnières,
and others after their paintings. Gonse characterized the majority
of the etched illustrations as belonging to "the most resolute
school of Impressionism."[1] Two copies of this catalogue have
been located and examined. In the copy at the Bibliothèque
Nationale there are no prints, and the page measurement is 190 x
127 mm. The copy in the Frick Art Reference Library contains ten
prints (etchings or drypoints) interspersed throughout the text but
does not include Degas's etching, which was apparently removed.
The page measurement of the Frick copy (which is in a library
binding) is 216 x 133 mm. The ten prints are small, approximately
75 x 100 mm., and are on cream, laid paper; two bear fragments
of the same watermark noted on two impressions of Degas's *On
Stage III.* Impressions in the Baltimore Museum and British
Museum bear evidence of stitching marks and were undoubtedly
removed from copies of the pamphlet. Approximately 150 mem-
bers belonged to Les Amis des Arts de Pau, and this may suggest
the limit of the edition, the size of which is otherwise unknown.

In the section of the Pau catalogue devoted to watercolors,
drawings, and prints, Degas is listed as showing two works. One
of them, *Un Ballet à l'Opéra* (no. 486, cited as a pastel), was not
for sale and was probably the picture of the same title now in the
collection of the Art Institute of Chicago (fig. 1). It was formerly
owned by Albert Hecht, a banker friend of Degas who had also
acquired the painting of a similar subject, entitled *Robert le Diable,*
signed and dated 1872 (Lemoisne 294, Metropolitan Museum).
Only recently was it discovered that the Chicago pastel had been
drawn over a monotype.[2]

There is a decided relationship between the Chicago *Ballet
at the Paris Opéra* and the print *On Stage III,* even though the print
is in reverse, of a different format, and a simpler version with
fewer figures. Both works have airy stage sets of leafy foliage,
dancers posed in similar movements, and two double basses dom-
inating one side. In the two compositions the heads of the orches-
tra players are cropped in similar fashion, while the same uplifted
face enlivens the foreground. It is likely that Degas produced a
print for distribution to reflect a work that was part of the exhibi-
tion. Although the practice of making etched reproductions of
paintings and pastels was common at the time, Degas's print was
not a slavish copy but a creative variant. (For a similar example of a
print after an existing work, see cat. no. 51.)

A work known only from an illustration in the Atelier sale
catalogue is a preliminary stage of the print (fig. 2).[3] It is difficult to
determine whether this image is a first state of the softground
etching or the verso of a drawing used for transfer with the rem-
nants of the ground adhering to it. The medium is given as pen
(*plume*), which might describe the brown color of the softground;
moreover, there are lines on the area where the prominent white
oval peg of the double bass appears in the print. These could be
lines drawn in but stopped out before the plate was bitten. This
work is signed *Degas,* as is the first state. (See cat. no. 51 for a
preparatory drawing with softground on the verso.)

The first state is executed entirely in softground etching,
drawn with both pointed and broad-tipped tools. The dark borders

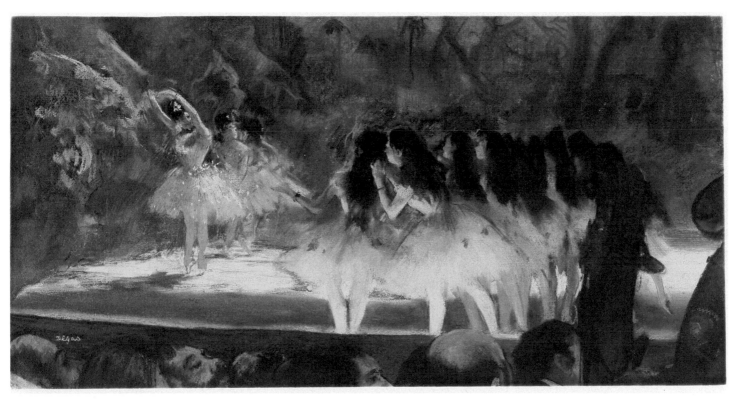

24. Fig. 1.
Ballet at the Paris Opéra, 1877. Pastel over monotype. The Art Institute of Chicago.
Bequest of Mary L. Block, 1981.

24 first state

of the print are caused by the sharp edges of the unbeveled plate that hold the ink. Two impressions of the first state have been located: BN (Rouart) and Kornfeld (Atelier).

In the second state there is additional softground work in the scenery and stage at right. Drypoint lines surround and emphasize the figures of the dancers. Two impressions are known: Fogg Museum loan (Atelier) and Kornfeld (Atelier).

In the third state extensive work executed with the roulette further darkens the plate in the area of the orchestra pit, on the stage, and on the scenery behind the dancers. The edges of the plate still retain ink. Two impressions are known: BN (Rouart) and Clark. In subsequent states there is no additional work on the image; the only changes are to the edges of the plate.

Delteil's descriptions of the following states are difficult to follow. He maintains that the edges of the plate are first cleaned (fourth state) and then beveled with the corners lightly rounded (fifth state). The manner in which the plate edges are wiped and the type of paper used make the differentiation between fourth and fifth states difficult to determine.

The Metropolitan Museum's impression of the fourth state (with the Atelier stamp) can serve as a model for comparison. In this impression, printed on a thick, blotter-like paper, the strong plate edges have been noticeably beveled, and the plate is wiped so that some ink is left on the edges. The Philadelphia impression printed in red-brown also demonstrates this method of wiping. An impression in the Boston Museum on thin japan paper bears a signature that appears to be Degas's in a hand characteristic of his later years.

The fifth state represents the way the image was printed for the catalogue of the Pau exhibition. The plate was beveled, and the edges wiped clean, in keeping with a professional style of printing.[4] Impressions of the fairly common fifth state are found on cream, laid paper. Two bear watermarks: BAS (Amsterdam and R. M. Light); one impression has a watermark of script letters with scrolls (Yale). These watermarks also appear on the papers of some of the etchings by other artists in the copy of the Pau catalogue belonging to the Frick Library. Not all impressions of this state were bound in the catalogue, as evidenced by the impression acquired by A. Beurdeley from the Barrion sale in 1904 and those owned by Amsterdam (Atelier) and R. M. Light (Atelier). These three and those at Baltimore, BAA, the British Museum, and San Francisco are representative examples of this state.

24. Fig. 2.
On Stage III, 1876-77. Pencil study or pre-first state. Present location unknown.

Notes

1. *La Chronique des arts*, 27 Jan. 1877, pp. 34-35: "La plupart des petites eaux-fortes qui illustrent le volume appartiennent à l'école impressioniste la plus délibérée."

2. Lemoisne 513; Chicago, *Degas* 1984, no. 31.

3. Sale IV, no. 137b, p. 131, 10 x 13 cm., first cited by Moses 1964, no. 23.

4. Two of the prints in the catalogue by other artists bear the etched inscription *Imp. Cadart*, which suggests that they may have been printed at the Paris workshop founded by Alfred Cadart. A collector's stamp *E.M.* appears on the BAA impression of the fifth state. Lugt identified this collector as Ed. Marthelot, a printer for the firm of Cadart and Luquet.

24 second state

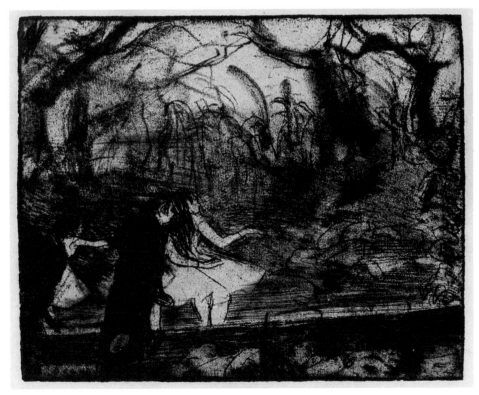

24 third state

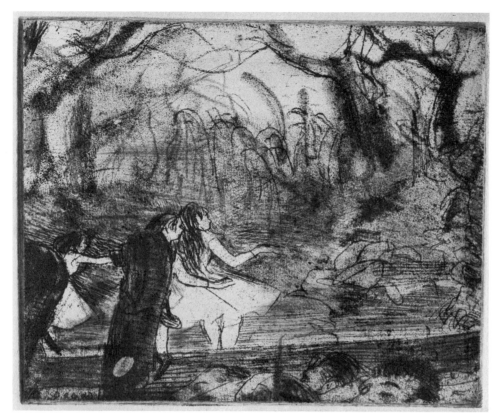

24 fourth state

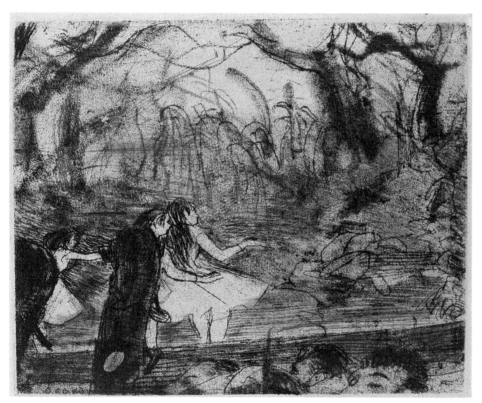

24 fifth state

25a

The Café-Concert 1877

Pastel over monotype
Lemoisne 404; exhibited in 1877 Impressionist exhibition
242 x 445 mm. sheet
Signed lower left: *Degas*
Corcoran Gallery of Art, Washington. William A. Clark Collection
Exhibited in Boston

In the mid-1870s Degas turned to the depiction of Parisian nightlife and produced a series of images of the café-concert, a form of entertainment first introduced in the 1840s that had become particularly successful during the Exposition of 1867 (fig. 1). In fine weather these entertainments took place out-of-doors. Two of the most popular establishments were the Ambassadeurs and the Alcazar d'Eté, identical neoclassical kiosks or bandstand-like structures set among the trees of the Champs-Elysées. The performers, usually women, sat on the raised platform in a semicircle known as the *corbeille* (basket). When the singer's turn came to present her act, she stood forward on the small stage, below which the musicians played. The stage was lighted by chandeliers and footlights; gas globes singly or in clusters surrounded the building and lighted the area where the audience, composed mainly of the working or middle class, sat at tables or strolled among the trees.[1]

There were visual precedents for the depiction of the café-concert in illustrated magazines and newspapers, specifically in the lithographs of Daumier, who in one memorable image of 1852 had shown the audience's reaction to a singer's performance.[2] Contemporary accounts document that these popular pastimes also appealed to upper-class observers such as Degas and his friends. Réné De Gas reluctantly accompanied his brother one evening and wrote to his wife in 1872: "After dinner I went with Edgar to the Champs-Elysées, and from there, to a café-concert to hear songs by idiots, such as the song of the journeyman bricklayer and other absurd stupidities."[3] Degas's enthusiasm, however, did not wane, for as late as 1883 he wrote to Henri Lerolle urging him to go hear the singer Thérésa and mentioning her vulgarity.[4]

By 1876 Degas had begun to explore the visual richness of the café-concert.[5] A series of monotypes and prints reveals his interest in the dramatic effects of artificial light. He viewed the performers singly and in groups, from various angles. He showed them from the front of the stage, including musicians and members of the audience, and from the side, where the singer alone was glimpsed from the back. He used the round gaslight globes as ornamental motifs, placing them suspended in the dark or reflected in a mirror behind the performer. Particularly in black and white prints, he could capture the dramatic contrasts of light and dark inherent in these nighttime scenes.

In the third Impressionist exhibition of April 1877, Degas exhibited two small pastel-over-monotype representations of the café-concert: *The Café-Concert* (Corcoran Gallery, Washington) and *Aux Ambassadeurs* (Musée des Beaux-Arts, Lyon). Both depict a group of female performers on stage with musicians and spectators before them. The Lyon pastel over monotype (Lemoisne 405; fig. 2) is a vertical image, full of detailed informa-

25a. Fig. 1.
Coste, after Morin. *A Café-Concert on the Champs-Elysées, Paris*, 1867. Wood engraving from *Paris Guide* (1867), p. 997.

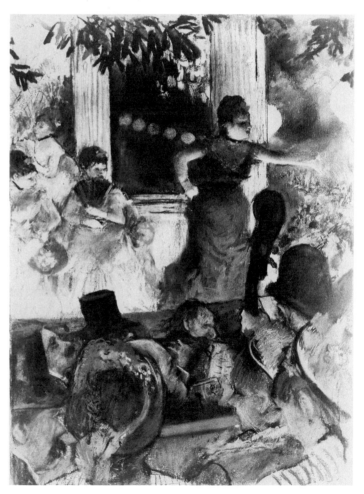

25a. Fig. 2.
Aux Ambassadeurs, 1877. Pastel over monotype. Musée des Beaux-Arts, Lyon.

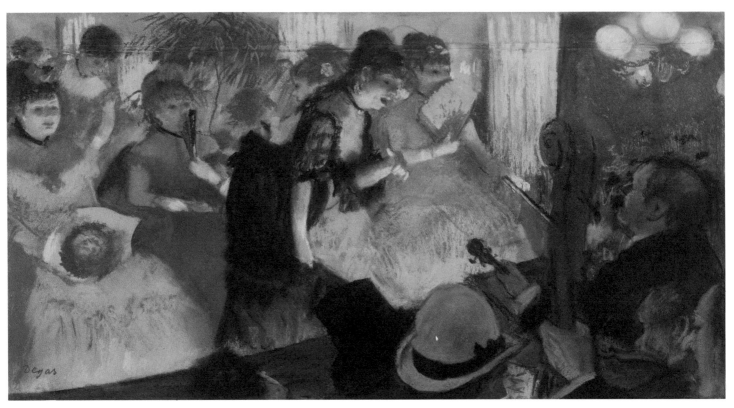

25a

tion on the café architecture. The Corcoran *Café-Concert* (Lemoisne 404) is a cropped, horizontal composition that emphasizes the on-stage activity. The neck of a double bass seen in front of the singers is used as a compositional device just as in Degas's contemporary prints of ballet scenes (cat. nos. 22-24).

In a review of the 1877 exhibition Emile Zola expressed his appreciation of these works, full of "astounding life, the 'divas' straining forward over the smoky lamps, lips apart."[6]

These two colorful pastels over monotype present the architectural setting of the café Ambassadeurs with its distinctive fluted columns, lively participants, and variety of artificial lighting. They help to clarify the more cryptic and often fragmentary images of the black and white monotypes and prints.

Notes

1. For much of this information we are indebted to the article by Michael Shapiro, "Degas and the Siamese Twins of the Café-Concert: The Ambassadeurs and the Alcazar d'Eté," *Gazette des beaux-arts* 95 (April 1980), pp. 153-64 (hereafter cited as M. Shapiro 1980).

2. Delteil 2231; reproduced in Reff, *Manet* 1982, p. 90.

3. "Après diner je vais avec Edgar aux Champs-Elysées, de là au Café-chantant entendre des chansons d'idiots, telles que la chanson du compagnon maçon et autres bêtises absurdes"; M. Shapiro 1980, p. 153.

4. Degas, *Letters* 1947, no. 57.

5. See also the many sketches of café-concert entertainers in Reff *Notebooks* 28 and 29.

6. As cited in Isaacson 1980, p. 92.

25

"The Song of the Dog" 1876-77

Crayon lithograph (from transfer paper). One state
Delteil 48 (about 1876); Adhémar 41 (about 1877-78)
355 x 230 mm. image
Gray-white, medium weight, smooth, laid paper
370 x 266 mm. sheet
Museum of Fine Arts, Boston. Gift of W. G. Russell Allen

25b

Georges-William Thornley (born 1857)
"The Song of the Dog" 1888 (?)
Crayon lithograph (from transfer paper) after Degas
Mounted china paper (244 x 200 mm.); mount 569 x 389 mm.
Printed by Becquet. Published in *Quinze lithographies d'après Degas* (Paris: Boussod and Valadon, n.d.)
National Gallery of Canada, Ottawa

By 1870 Thérésa (born Emma Valadon, 1837-1913) was the "reigning queen" of the café-concert.[1] She was given a lasting identification as a performer by Degas, who showed her in the act of singing a song about a dog, with her arms held in a paw-like gesture. The lithograph *"The Song of the Dog"* is one of a group of studies Degas made of Thérésa performing; he drew her several times in this unique pose and made a caricature of her face as well.[2]

A fully developed gouache and pastel over monotype (fig. 1) definitely served as the source for the lithograph.[3] Louisine Havemeyer, the former owner of this colorful picture, wrote in her memoirs a perceptive description of the singer and her role in the café-concert:

A woman stands upon the stage singing a popular song: "La Chanson du Chien." Look at her and observe the common type. You feel at once that she has crowded herself into the uncomfortable gown, that her gloves are a strange annoyance to her. There is nothing elegant about her pose. Her hands suggest the movement of a dog, and the gesture is done as only Degas could do it, with a flash of the pencil. The lines of the mouth as she bawls out the vulgar song, her exultant exaggeration, showing she is conscious of her power over her audience, all this and much more shows clearly what a café-chantant is, what part it plays in Parisian life, the kind of creature it is that furnishes the amusement; and although you do not see them distinctly, you know immediately the class of pleasure seekers who are entertained by such a performance. Degas, the keen, subtle philosopher, reveals the café-chantant as it is from its heart and core, from cause to effect.[4]

Degas shows Thérésa plump and glossy, in her mature years, not as the slender, dark, curly-haired young woman she was in the 1860s.

The lithograph was made in crayon on paper and then transferred to the stone. Evidence of this process appears in the creases in the paper that are seen in the finished print. Except that the background has been extended at the top, the composition of the lithograph follows almost exactly that of the gouache over monotype. It has recently been observed that to execute this print Degas must have traced over a photograph that reduced this gouache, a method used by Manet to make prints as early as 1874.[5]

In the print Degas followed the gouache closely both in his depiction of the singer, who wears a black ribbon at her neck, long gloves, and a corsage of flowers, and in the ornamentation of the column behind her. However, in the lithograph the setting was more loosely rendered. Sketchy crayon strokes shade the background, where unsupported globes of light float freely. Degas employed a limited range of tonalities and used the unworked patches on the face and figure to imply the dramatic glow of the footlights. The close reliance on a finished work suggests that this was Degas's first lithograph.

Delteil knew of four impressions of *"The Song of the Dog"*; the authors have located six: Amherst (Atelier), BN, MFA, private collection, Stogdon (Atelier), and Warrington (Rouart).

Degas is known to have taken an active part in the making of reproductive prints after his paintings. For instance, he was committed to the work of the lithographer Georges-William Thornley, with whom he corresponded. In an undated letter to Thornley, Degas indicated his desire to make some changes to a drawing on transfer paper by Thornley.[6] Around 1888 Thornley had made by means of lithography a reduced version of the gouache over monotype *"Song of the Dog."* It was one of fifteen lithographs executed by Thornley after works by Degas that were published as a portfolio and praised by Degas's contemporaries.[7]

In comparison with Degas's lithograph, Thornley's is a more literal translation. He has attempted to duplicate the subtle modeling of the figure in the gouache, whereas Degas, in his print, has merely implied it. Thornley's sensitivity to the model and his skillful use of the lithographic crayon combine to make this a reproductive print of considerable visual interest.[8]

Notes

1. M. Shapiro 1980, p. 158.

2. A study in graphite, Boggs 1966, no. 81, illus.; two pencil sketches and a caricature of Thérésa's face appear in Reff *Notebook* 28, p. 11.

3. The gouache, Lemoisne 380, private collection, U.S.A.; Sotheby Parke-Bernet, New York, May 18, 1983, lot 12, illus. (color).

4. Louisine W. Havemeyer, *Sixteen to Sixty: Memoirs of a Collector* (New York, 1961), pp. 245-46.

5. New York, *Manet* 1983, no. 8. See the essay by D. Druick and P. Zegers in this catalogue for further information on Degas's use of photographic reductions.

6. Degas, *Letters* 1947, no. 133. This letter, placed among those from 1890, most certainly dates to 1888.

7. Specifically by Félix Fénéon in *La Revue indépendante*, Oct. 1888, as cited by Melot 1974, p. 175; Melot also gives interesting and valid information on Degas's working relationship with Thornley.

8. It is possible that in his enthusiasm for the Thornley project, Degas prepared his own lithographic interpretation at the same time, a decade later than the accepted date of execution in the later 1870s.

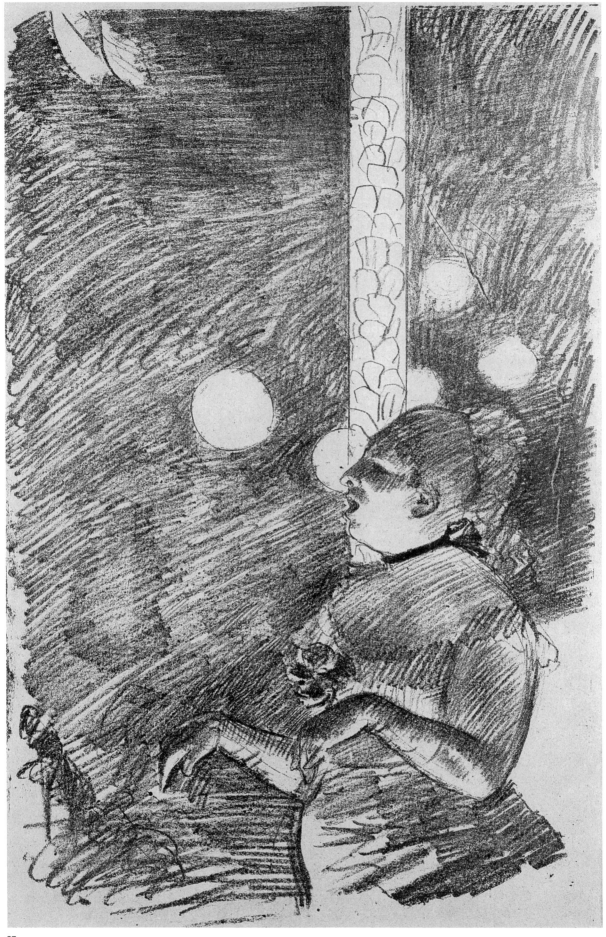

25

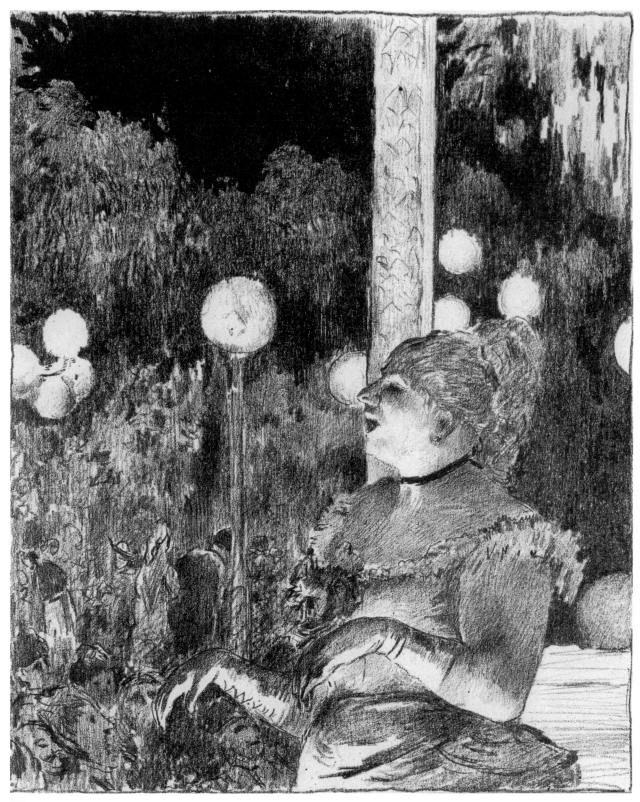

25b

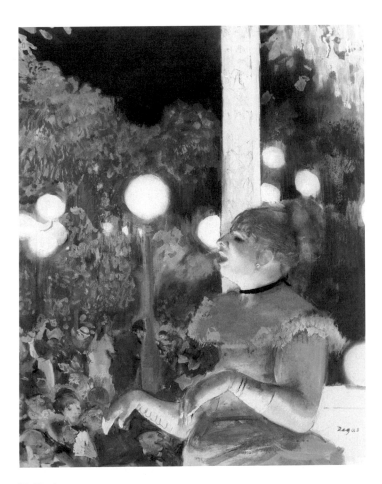

25. Fig. 1.
At the Café-Concert: "The Song of the Dog," 1876-77. Gouache and pastel over monotype. Private collection. Photo: Sotheby Parke-Bernet.

26

Singer at a Café-Concert 1876-77

Crayon lithograph on stone. Two states
Delteil 53 (about 1875); Adhémar 33 (about 1878)
250/255 x 190/192 mm. border lines

I first state

White, medium, smooth, wove paper
348 x 257 mm. sheet
Signed in pencil lower right: *Degas*; below, an erased inscription:
à M. Delo[rière?]
Coll.: Barrion; Beurdeley
Museum of Fine Arts, Boston. Bequest of W. G. Russell Allen

II second state

Gray-white, medium weight, smooth, oriental paper
336 x 272 mm. sheet
Atelier stamp
Boston Public Library. Wiggin Collection

Degas has chosen not to be specific in his depiction of this café-concert performer and shows her from the back with a lost profile. It has been suggested, however, that the slim figure of the singer represented is that of Mlle Bécat, who usually wore a wreath of flowers in her hair.[1] (See cat. nos. 30 and 31.)

Degas has taken an unusual vantage point behind the performer, who stands on a raised platform. Both the striped awning with its supporting brace and the fluted column reinforce the pose of the singer, who gesticulates toward an unseen audience. The blank white area in the foreground is clarified by Toulouse-Lautrec's color lithograph *Aux Ambassadeurs*, 1894 (Delteil 68; fig. 1), in which a singer is cut off from view by a latticework partition. The striped awning also appears in Degas's aquatint *At the Café des Ambassadeurs* (cat. no. 49).

Unlike the transfer lithograph "*The Song of the Dog*" (cat. no. 25), this subject was drawn directly on a lithographic stone. Using sharpened crayons, the artist created a range of gray tonalities punctuated by the dark accent of the distinctive black ribbon tied at the singer's neck. The conservative handling of the medium and the delicate, transparent effect of this print suggest that it may well be Degas's first attempt on stone. He did not repeat the procedure, for every other lithograph clearly exhibits, or at least suggests, the use of some transfer method.

Fourteen impressions of the first state have been located, of which four were signed by Degas: AIC (signed), Amsterdam (signed), BM (Atelier), BN, E. Berlin (Roger Marx), Josefowitz (Atelier), Kornfeld, MFA (signed, Barrion, Beurdeley), MOMA (Atelier), private collection, Germany (Atelier), Prouté (signed), St. Louis, N. Simon, N.G. Stogdon. The relatively large number suggests that he may have intended to offer them to friends.

After printing the first state, Degas created a second state by filling in the unworked lower area with a mass of dark shading and shapes to suggest foliage. Some of this crayon work has been scraped away to lighten portions and to create white patches.

26. Fig. 1.
Henri de Toulouse-Lautrec. *Aux Ambassadeurs*, 1894. Color lithograph. Private collection.

These additions neither enhance the composition nor clarify the setting. Only one impression is known of this dramatic but unresolved experiment: BPL (Atelier).

Note

1. Chicago, *Degas* 1984, cat. no. 60.

26 second state

26 first state

27

Four Heads of Women 1876-77

Lithograph, transferred from four monotypes. One state
Delteil 54 (about 1878); Adhémar 44 (about 1877-79)
Images, clockwise from upper left: 80 x 68 mm.; 80 x 73 mm.;
80 x 73 mm.; 82 x 60 mm.
Off-white, thick, smooth, wove paper
358 x 275 mm. sheet
Atelier stamp
The Art Institute of Chicago. Clarence Buckingham Collection
1952.236

27a

Bust of a Woman in a Striped Bodice: Ellen Andrée
Monotype
Janis 59 (about 1878); Cachin 38 (about 1880)
82 x 70 mm. plate
Off-white, laid paper
165 x 109 mm. sheet
Atelier stamp
Private collection
Not in exhibition

27a

The lithograph comprises four unrelated images of women created
by the transfer of four separate monotype impressions. One can
clearly read the characteristic textures and brushstrokes of the
original monotype images. Unlike the Mlle Bécat lithograph (cat.
no. 30), *Four Heads of Women* displays only a minimum of addi-
tional crayon work on the stone and a small amount of scratching
to lighten the opaque areas. The one monotype that still exists for
the lithograph, a young woman in a striped bodice, has yielded up
most of its ink in the transfer process. In the lithograph the two
stripes on the right side of the bodice were added to the stone in
crayon.

 A number of small monotype portraits of women, close in
plate size (approximately 82 x 70 mm.), distinctly relate in subject
matter to cat. no. 27. Delteil lists twenty-three in the Atelier sale
(see Cachin 11-13 and 37-46), including the fresh and distinctive
profile monotype from the Art Institute of Chicago (fig. 1), for
which there is no existing lithograph. Since the Chicago monotype
was never used for transfer, one can still observe the full range of
minute brushstrokes and fingerprints similar to those transferred in
this lithograph.

 The grouping of four images on the sheet recalls the assem-
bling of photographic *portrait-cartes* on an album page. Adhémar
has tentatively identified three of the portraits: the woman at the
upper left as Thérésa (see cat. no. 25); the singer at the lower
right as Mme Faure "of the stern profile who sang 'The Fireman's
Sister,' " and that at the upper right as Ellen Andrée.[1] The hat
worn here by Ellen Andrée is indeed similar to the one she wears
in Degas's painting *L'Absinthe* (Lemoisne 393, Musée d'Orsay),
which dates firmly from 1876. There she is seated next to Marcel-
lin Desboutin, who is smoking a pipe. Desboutin was similarly
depicted by Degas in a monotype that was also transferred to a
lithographic stone (cat. no. 28).

27. Fig. 1.
Café Singer. Monotype. The Art Institute of Chicago. Potter Palmer Collection, 1963.

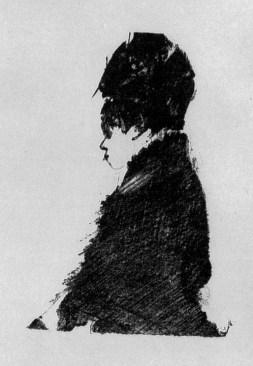

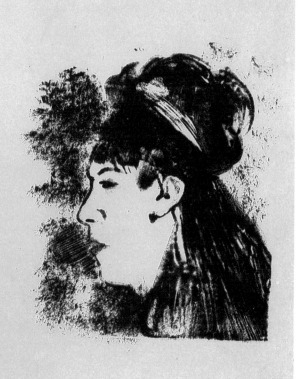

27

Three Subjects: *The Toilette, Marcellin Desboutin, The Café-Concert* 1876-77

In one session Degas must have painted and printed a number of monotype images of women, almost certainly using the same small plate. He took four fresh monotype impressions and assembled them on a single lithographic stone. Under pressure the greasy ink of the monotype sheets was transferred to the stone, which could be treated, inked, and printed like a conventional lithograph. The lithographic images stop abruptly, replicating exactly the plate edges of the monotypes. Despite the several procedures involved, the lithograph has maintained the freshness and immediacy inherent in the monotypes. Degas's interest in the café-concert apparently coincided with a flurry of monotype and printmaking activity. His artist friend Marcellin Desboutin wrote a letter, dated 17 July 1876, to Mme Giuseppe de Nittis, describing Degas's frenetic pursuit of plates, ink, and supplies throughout Paris. Desboutin likens him to a "plate of zinc or copper blackened with printer's ink . . . he is in the metallurgic phase for the reproduction of his drawing with a roller and runs all over Paris . . . his conversation only turns on metallurgists, lead-workers, lithographers, planishers."[2]

One can only speculate why Degas transferred monotypes to a lithographic stone. It seems to have been one of his many innovative explorations of printmaking techniques, unique to him in his time. Whether he considered cutting the sheet into four separate parts is not certain. All the recorded impressions retain the four images on a single sheet. Delteil knew six impressions, of which four have been located: AIC (Atelier), BAA, BN (Rouart), E. Berlin (Roger Marx). (For the cutting of multiple images from a single lithographed sheet, see cat. nos. 28, 35, and 36.)

Notes

1. Adhémar, no. 44.

2. See Janis 1968, cat. 52, for an English translation. For the entire letter reproduced in French, see Mary Pittaluga and Enrico Piceni, *De Nittis* (Milan, 1963), pp. 358-59.

Lithograph, transferred from three monotypes. Two states
Delteil 55 (about 1878); Adhémar 46 (about 1876-78)
Images clockwise from left: 164 x 117 mm.; 82 x 71 mm.; 82 x 72 mm.

I first state

Off-white, medium weight, smooth, wove paper
269 x 344 mm. sheet
Atelier stamp
N. G. Stogdon

II second state

Off-white, medium weight, smooth, wove paper
268 x 345 mm. sheet
Atelier stamp
Mead Art Museum, Amherst College. Gift of Edward C. Crossett 1951.951

28a

Marcellin Desboutin (Man with a Pipe)
Monotype in black ink; slight touches of brown chalk
Janis 52; Cachin 35
80 x 71 mm. platemark
Cream, medium weight, slightly textured, laid paper
181 x 163 mm. sheet
Atelier stamp
Bibliothèque Nationale, Paris
Exhibited in Boston

This lithograph was probably made in the same year as *Four Heads of Women* (cat. no. 27) and, like that print, is composed of images executed first as monotypes and then transferred to the stone. The monotype of *Marcellin Desboutin* relates closely to his portrait in *L'Absinthe,* a painting completed by September 1876. It should also be seen in comparison with the double portrait Degas painted of Desboutin and Lepic in which the two artist friends were depicted with their printmaking and monotype tools (Lemoisne 395, Musée d'Orsay). Although this is the only monotype located for the three subjects of the lithograph, it is clear that the same transfer process was used for all the images.

The small café-concert singer seen from the back, against a dark sky punctuated by exploding fireworks, certainly derives from a monotype. It concentrates in a small format all the effects of artificial light so attractive to Degas (see also cat. no. 31).

The bather, also from a monotype, is related in subject matter and dimensions to one in the Bibliothèque Nationale (Janis 176, Cachin 133; see cat. no. 42, fig. 4) and may be part of a sequence depicting a young woman with her maid performing a bath ritual. Another monotype heightened with pastel of a similar subject was exhibited in the third Impressionist exhibition in April 1877 (Lemoisne 422, Louvre; Janis 175; see cat. no. 42, fig. 2) and further supports the dating of the lithograph to 1876-77. It is

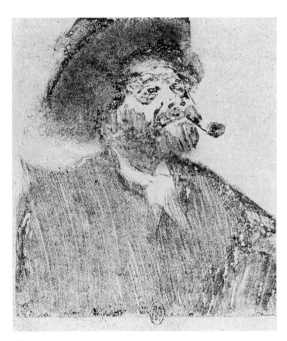

28a

Degas's first print of a nude bather, a subject he was to return to more extensively in lithography in the 1890s (see cat. nos. 61-66).

The rarity of this lithograph as well as the disparity of its subjects attest to its experimental nature. Degas almost certainly considered these monotype-lithographs as personal experiments in printmaking that could only be executed privately in his studio. In his own inventive way he used monotype transfers to obtain broad painterly tones. Such effects were not achieved by his contemporaries until the early 1890s, when Camille Pissarro and Toulouse-Lautrec worked directly with brush and tusche on prepared zinc plates or lithographic stones.[1]

In the first state the three subjects are completely established, each a combination of monotype transfer and crayon work on the stone. For *The Toilette* the monotype image was reworked extensively with fine lines of scraping and with strokes of crayon. Untouched monotype is visible in the patterned chaise at the upper left, whereas pure crayon work appears on the wallpaper at the far right and on the maid's apron. In the lithographic transfer from the monotype of *Marcellin Desboutin*, Degas has made a few small but thoughtful changes. He enlarged the top of the hat and scraped delicately to refine the features, hair, and beard and to lighten the cravat. The most noticeable addition is the smoke rising from Desboutin's pipe. *The Café-Concert* exhibits reworking of the transferred monotype image, with some scraping away and crayon additions throughout the image. Both of these lithographic images remain the same in the second state.

This impression of the first state is apparently unique in its completeness. The other two impressions of *The Toilette* in the first state were cut and given by Degas to friends: Alfred Beurdeley (the impression now at the BPL) and Alexis H. Rouart (at the BN).

In the second state of *The Toilette* Degas has scraped to remove the water from the bathtub, to lighten the solid dark areas of the bather's hair and the maid's dress, and to create a more transparent effect at the upper left. He also erased much of the modeling on the bather's legs and removed from her buttocks the traces of his fingerprints that were transferred from the monotype and visible in the first state.

The only known impression of the right half of the sheet is in the BN and inscribed in pen *Degas* by Ludovic Halévy, the original owner. Its measurements and paper type indicate that it is probably the other half of *The Toilette*, now in the BPL. Halévy was a novelist, librettist, and close friend of Degas. In the late 1870s or early 1880s Degas made monotype illustrations for his novella *La Famille Cardinal*.

Note

1. See Pissarro's *Bathers*, 1894 (Delteil 160), and works by Toulouse-Lautrec, beginning in 1891.

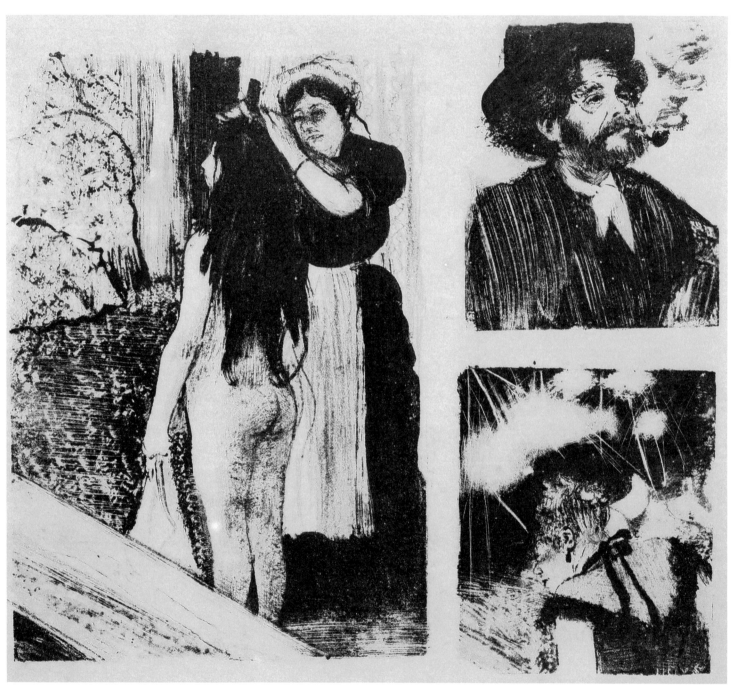

28 first state

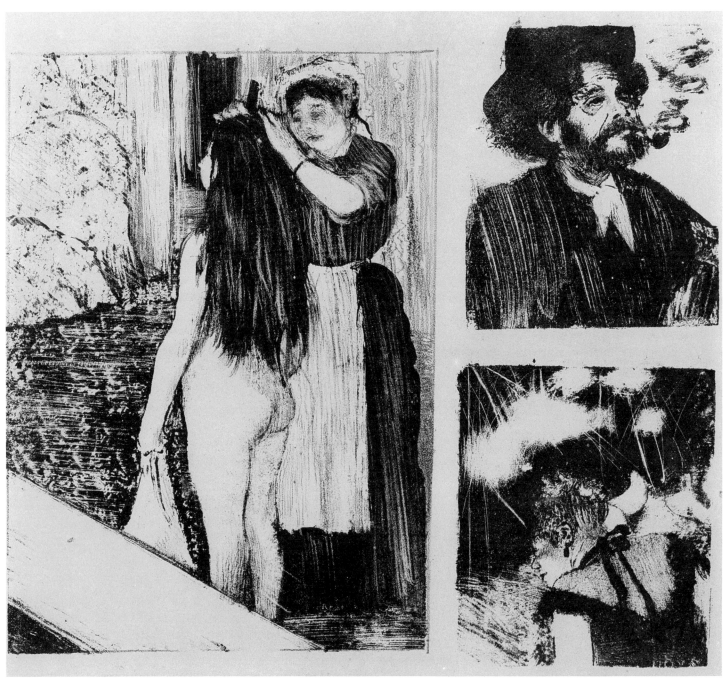

28 second state

29

Profile of a Singer about 1877-78

Drypoint and aquatint. Three states
Delteil 24 (about 1875); Adhémar 49 (about 1878)
68 x 86 mm. platemark

I· first state

Cream, moderately thick, moderately textured, laid paper
132 x 199 mm. sheet
Atelier stamp
Lucien Goldschmidt, New York

II second state

Cream, laid paper
202 x 177 mm. sheet
Atelier stamp
E. W. Kornfeld, Bern

III third state

Buff, moderately thick, moderately textured, laid paper
155 x 238 mm. sheet
Watermark: fragment of ARCHES
Atelier stamp
Rijksprentenkabinet, Rijksmuseum, Amsterdam

Degas has isolated a small vignette of a café-concert singer, placing her, in the final state, in an outdoor and nocturnal setting brilliantly illuminated by four gas globes, one glimpsed in part beneath her chin. Her eyes are in shadow, and the lower part of her face reflects the glow of the unseen footlights.

There is a decided visual correspondence between *Profile of a Singer* and several small monotypes in black and white, one of which (Janis checklist 45) shows the prominent gaslights and another that exhibits a similar effect of cropping (Janis checklist 247). Furthermore, there is a relationship in the medium of cat. no. 29 to that of the large etching of a similar performance, *At the Café des Ambassadeurs* (cat. no. 49). The irregular shape and rough edges of this small plate suggest that it was a technical experiment.

In this unique impression of the first state Degas sketched in drypoint the profile of a woman who wears a dark ribbon around her neck. He placed the head in the lower corner, purposefully cropped by the edge of the plate. The remainder of the copper plate is unevenly bitten, with three lightened areas that may have been left intentionally. There are numerous, accidental, fine scratches throughout the image, confirming Degas's indifference to using a plate in poor condition; this is perhaps the back of a used plate.

The most important additions in the second state are the carefully traced drypoint outlines that contain the light areas of the previous state and denote gas globes. There are further drypoint strokes drawn in the woman's hair, indicating a bun. Only two impressions of this state are known: Clark and Kornfeld (Atelier).

In the third and final state the most dramatic addition is a rich aquatint that transforms the somewhat uneven gray background into a deep black. A lighter tone of aquatint partially colors the singer's face. There is further drypoint work that enriches her hair and shades the upper part of her cheek. Degas burnished the lights to accentuate the effect of a nighttime illumination. The pert, gamine-like profile is a facial type frequently encountered in Degas's work. Two impressions of this state are known: Amsterdam (Atelier) and BN (Rouart).

29 first state

29 second state

30

Mlle Bécat at the Café des Ambassadeurs:
Three Motifs 1877-78

Lithograph transferred from three monotypes
Delteil 50 (about 1875); Adhémar 43 (about 1877)
Images clockwise from top: 125 x 213 mm.; 161 x 116 mm.;
162 x 121 mm.
Off-white, medium weight, smooth, wove paper
352 x 272 mm. sheet
Museum of Fine Arts, Boston. Gift of George Peabody Gardner,
1927

30a

Mlle Bécat
Monotype, touched with pencil
Janis 32; Cachin 4
150 x 215 mm. plate
Gray-white, wove paper, tipped onto white mount
152 x 226 mm. sheet
Verso: partial drawing of figure
Atelier stamp on the mount
Department of Prints and Drawings, The Royal Museum of Fine
Arts, Copenhagen

30b

Mlle Bécat
Monotype
(Not in Janis or Cachin)
159 x 119 mm. plate
Cream, medium weight, moderately textured, laid paper
180 x 130 mm. sheet
Watermark: fragment of FRERES
National Gallery of Art. Rosenwald Collection, 1943

30c

Mlle Bécat
Pastel over lithograph
Lemoisne 372
124 x 219 mm. (sight)
Signed upper left: *Degas*
Colls.: Zacharie Zakarian; Marcel Guérin
Private collection, New York

Degas's concept of arranging three small compositions of the same subject on one stone is unusual; he must have found his source of inspiration in photography, which can record movements in sequence. By changing his vantage point, Degas has given an accurate description of Mlle Bécat's well-known, energetic, and exaggerated singing style, called the *style épileptique.*

The performer is identified as Emélie Bécat, who was born in Marseilles and began her professional singing career in the summer of 1875 at the Café des Ambassadeurs. She later moved to the matching structure on the Champs-Elysées, the Alcazar d'Eté, where she popularized at least five songs over three or four years. A photographic *portrait-carte* and a music sheet cover

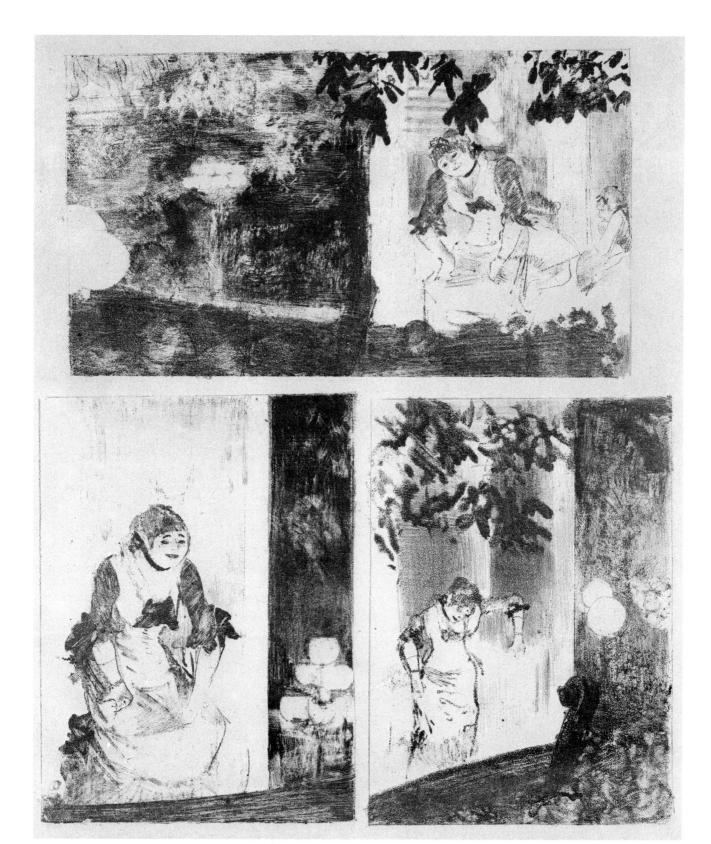

30

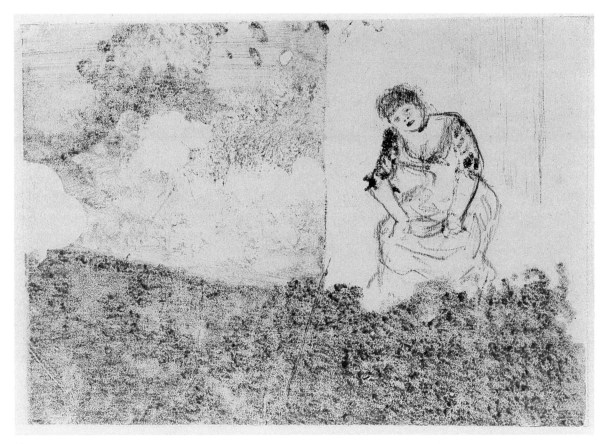

30a

record her pleasant features and the garland of flowers she typically wore in her hair.[1]

Degas took fresh impressions of lightly brushed monotypes and, while the ink was still wet, placed the sheets face down onto a lithographic stone, transferring under pressure the inked images to its surface. In addition, Degas worked directly on the stone with crayon, tusche, and scrapers to complete the compositions and to broaden the tonal range from the white gas globes to the dark overhanging leafy boughs. The existence of two of the monotypes offers an opportunity to identify the extensive work added on the stone and to study the clues that reveal the lithograph's origins in a monotype base. Note especially the figure of Mlle Bécat in the lower left lithographic image, where the traces of pure monotype are most readily discerned.[2] Because the two monotypes have given up most of their ink to the stone, they are pale and mottled in appearance. Some creases, such as those in the dark portion of the top image, are common to both the monotype and the lithograph and occurred in the transfer process. Degas made a point of touching up the monotype figure on the Copenhagen sheet with pencil strokes in order to refurbish the very pale image that remained. No monotype has been located for the third image at the lower right; the traces of monotype are obscured by the extensive crayon work.

One can only speculate whether Degas intended to cut the sheet into separate images. There is one impression of the top subject, touched with pastel, which was given by Degas to his artist friend Zacharie Zacharian, a still-life painter. Whereas the changes made between the monotype and the lithograph are compositional, here the image has been enlivened with color. For a fuller revision of a lithograph with pastel see cat. no. 31.

The full sheet has been located in seven impressions: AIC (signed), BAA (Roger Marx), Baltimore (Beurdeley), BN (Rouart), Kornfeld (Atelier), MFA, and N.G. Stogdon (Atelier).

Notes

1. See M. Shapiro 1980, pp. 156-57.

2. This monotype, which we have identified as by Degas, was formerly catalogued as a copy by Jean-Louis Forain after Delteil 50; Alicia Craig Faxon, *Jean-Louis Forain: A Catalogue Raisonné of the Prints* (New York, 1982), no. 176, illus. It had been acquired by Lessing J. Rosenwald in a group of works by Forain.

30b

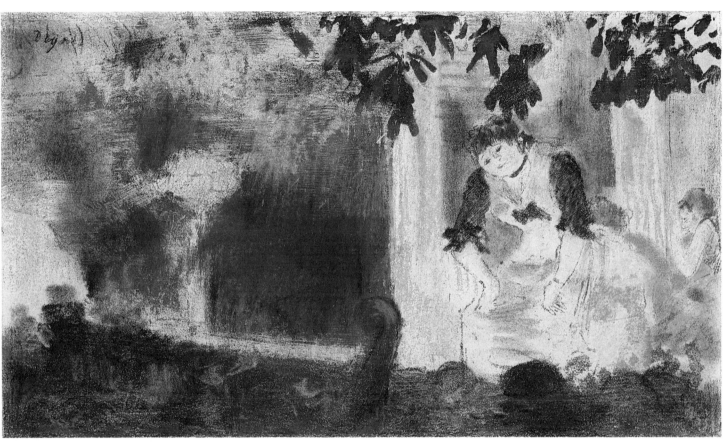

30c

31

Mlle Bécat at the Café des Ambassadeurs

1877-78

Lithograph. One state
Delteil 49 (about 1876); Adhémar 42 (about 1877)
204 x 194 mm. image
Cream, medium weight, smooth, wove paper
344 x 274 mm. sheet
Signed in black chalk: *Degas*
Museum of Fine Arts, Boston. Bequest of W. G. Russell Allen

31a

Buff-tan, moderately thin, smooth, wove paper
350 x 273 mm. sheet
Coll.: Rouart
Bibliothèque Nationale, Paris
Exhibited in Boston

31b

Pastel over lithograph
230 x 200 mm. sheet
Signed lower right: *Degas / 85*
Coll.: Mr. and Mrs. Walter Sickert (by May 1891); Mr. Fisher
Unwin (1898); Mrs. Ralph King, Cleveland
Mr. and Mrs. Eugene Victor Thaw, New York
Exhibited in Boston

This is one of the most striking and best-known prints executed by Degas and dramatically displays the technical expertise he had acquired in the medium of lithography. It exhibits every form of natural and artificial lighting that could manifest itself in a nocturnal scene: a large gas lamppost, a cluster of gas globes, and a string of lights, seen at the right, are reflected, along with a prominent hanging chandelier, in the mirror at left behind the performer. In the dark sky, the moon shines through the trees of the Champs-Elysées, while fireworks send down streamers of light. Even a small patch of light is glimpsed in the orchestra pit. Moreover, Degas's characteristic use of reflected footlights is clearly implied in the figure of the singer, who is brightly lit from below.

Mlle Emélie Bécat, the star performer at the Café des Ambassadeurs and the Alcazar d'Eté, was permanently recorded by Degas in four lithographic images of which this is the most fully developed (see also cat. nos. 26 and 30). Here, in the slim figure with uplifted, wide-flung arms, Degas has captured the personality of the singer. Her individualized figure remains a strong focal presence within the enveloping and contrasting patterns of the outdoor setting.

Although there are several pages of sketchbook studies of Bécat's distinctive gestures, there is no evidence that a particular drawing served as a direct study or was transferred to the stone.[1] Likewise, no specific monotype has been located that might have acted as the initial stage for the lithograph. However, the close relationship of cat. no. 31 in subject matter and handling of the medium to the lithograph *Mlle Bécat . . . Three Motifs* (cat. no. 30), in which monotypes formed the basis, persuades the authors that in this example a transferred monotype almost certainly underlies Degas's extensive work in crayon on the stone.

He achieved a broad tonal range that encompasses the reserved whites of the gaslights, the pale grays of the performer's dress, and the black hats in the foreground. Degas used sharp tools to scrape and scratch into the stone, to lighten crayoned areas such as the columns, or to draw the chandelier and fire-works. He attained brilliant effects by means of his proficient and varied use of lithographic techniques, both additive and subtractive.

A unique impression at the Bibliothèque Nationale that is less opaque in the lower right section of the image exhibits the freshly crayoned appearance that characterizes an early impression. Here, against a partially mottled background, may be seen the necks of two double basses, one with a distinct highlight. Long, dark vertical streaks of ink accidentally mar the right half of the image. In subsequent impressions the image fills in somewhat with ink, especially in the lower right quadrant, which becomes dark and undifferentiated except for the box-like lights and a few fine, white strokes. The fifteen impressions located were printed on paper of inferior quality, originally off-white, that has a tendency to darken to a warm beige: AIC (Atelier), BAA (signed), BN (Rouart), Brooklyn (Atelier), Copenhagen (Atelier), East Berlin (Roger Marx), Kornfeld (Atelier and Viau), LC (Atelier), MFA, MOMA, MMA (Atelier), NGA (Atelier), NGC, private collection, Detroit (Atelier), and N.G. Stogdon (Atelier). The relatively large number of impressions testifies to Degas's apparent satisfaction with the print; nevertheless, the fact that most of the impressions were found in his studio after his death signifies that only a handful were sold or given away to friends.

This lithograph can be associated with the two dramatic pastels over monotype shown in the third Impressionist exhibition of 1877. With regard to subject matter, point of view, and composition, a date earlier than 1877 cannot be justified (see cat. no. 25a and fig. 2).

Nearly a decade later, Degas chose to rework an impression of cat. no. 31 with brilliant pastels. It is one of several examples dated 1885 where he used a print as the base for this type of transformation (see also cat. no. 49, fig. 1 and cat. no. 52). In May 1891 Lucien Pissarro wrote to his father, Camille: "[Walter] Sickert, a young man who knows Degas, invited me to lunch. I went to his house. He has the little Degas lithograph retouched with pastels, that we saw . . . some time ago."[2]

In customary fashion Degas added strips of paper to the right and bottom edges of a trimmed impression, enabling him to enlarge the composition. The additional slender column at right echoes the two existing vertical elements. The prominent foreground figures dramatically alter the proportional balance and cause the performer on stage to appear farther away from the viewing audience. In this instance, Degas chose light green for the structure and background foliage and pink for the performer's dress and the gaslights, while somber earth tones describe the three women spectators, whose blue-tinged faces reflect the artificial light of the nocturnal setting. Bright pink and blue touches give credence to the aerial fireworks display.

In a novel of 1869, in a picturesque account of a visit to a

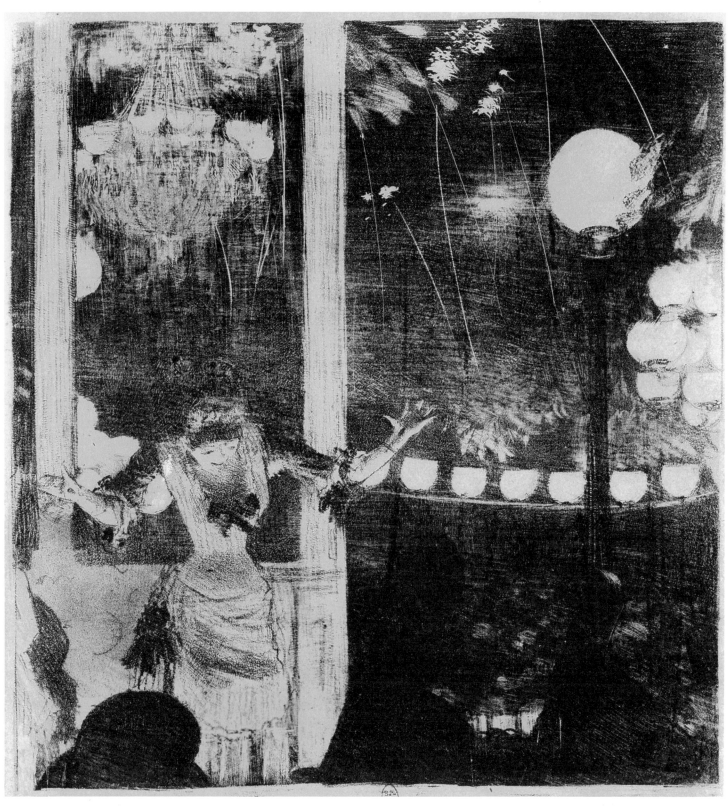

31

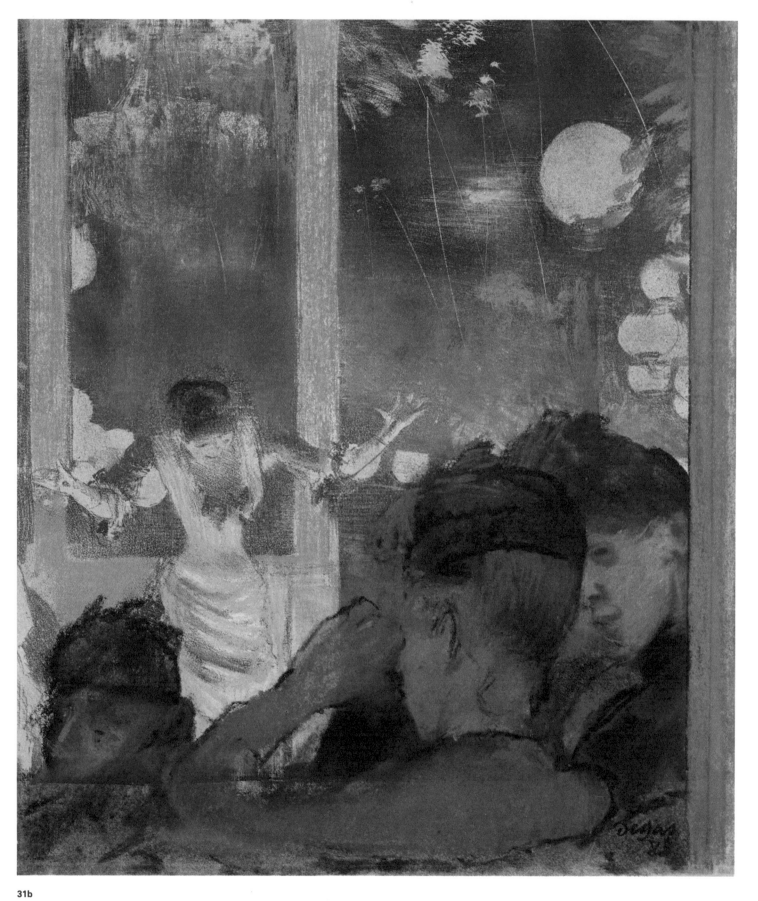

31b

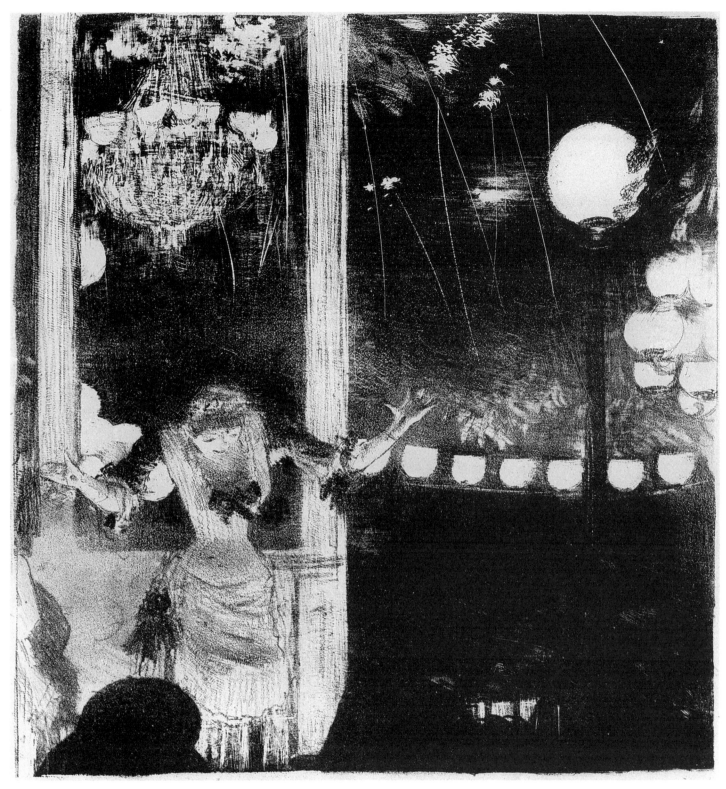

31a

dance garden, Gustave Flaubert characterized the climax of the evening: ''Squibs went off; catherine wheels began to revolve, the emerald gleam of Bengal lights illuminated the whole garden for a moment; and at the final rocket the crowd gave a great sigh.''[3]

Notes

1. Reff *Notebook* 27, p. 92; *Notebook* 29, pp. 13 and 15; and *Notebook* 27, p. 89, where the gas globes are sketched.

2. As quoted in Artemis Group 1983, no. 26. Lucien Pissarro's original

letter (in the Ashmolean Museum, Oxford) reads as follows: ''Il a la petite lithographie de Degas retouché[e] au pastel que n[ou]s avons vu[e] dans le temps chez Water-Clozet.'' This was an amusing wordplay on the name Closet, as confirmed by a letter from Degas to Durand-Ruel, dated by Guérin to 1885 (?): ''Tomorrow, Saturday, I should be much obliged if you could send me a little money. I can scarcely continue to draw any from little Closet in the rue de Chateaudun. I have already delivered several drawings to him and I must wait until he sells them'' (translated from Degas, *Lettres* 1945, no. 79).

3. *Sentimental Education*, trans. Anthony Goldsmith (London, 1966), p. 69.

32

A Café-Concert Singer 1877-78

Aquatint, drypoint, and scraping. One state
Delteil 21 (about 1875); Adhémar 29 (about 1877-78)
160 x 117 mm. platemark
White, thick, smooth, wove paper
Coll.: Rouart
*Bibliothèque Nationale, Paris. Gift of M. and Mme Henri Rouart in
memory of their father Alexis Rouart*
Exhibited in London

32a

Off-white, medium weight, slightly textured, laid paper (blank
sheet from a book)
236 x 184 mm. sheet
Watermark: *Côte d'or* in script
E. W. Kornfeld, Bern
Exhibited in Boston and Philadelphia
Not illustrated

A reference in one of Degas's notebooks dated as being in use
between 1875 and 1877 makes it clear that the artist was certainly
aware of daguerreotype plates and their potential as a matrix for
etching.[1] This print as well as *Two Dancers* (cat. no. 33) and *The
Laundresses* (cat. no. 48) were executed on plates of the same
size that bear the name "Schneider . . . Berlin" in a corner of the
print. These words, stamped into the plate, were inked and printed
in reverse on the paper and must have referred to Fr. Schneider,
the maker of silvered copper daguerreotype plates who estab-
lished his own manufactory at 9 Linkstrasse, Berlin, in 1847. It is
probable that these plates had first been used for photographic
images. For these three prints Degas utilized half-plates of approxi-
mately 118 x 160 mm. in size. Two other prints also reveal the use
of daguerreotype plates: *Woman Seated in Bonnet and Shawl* (cat.
no. 46) and *Actresses in Their Dressing Rooms* (cat. no. 50), the
latter a full-size plate of 160 x 215 mm. In the absence of a
platemaker's name, the evidence of crimped corners identifies
daguerreotype plates. The corners, which were scored, bent, and
unfolded as part of the polishing process, provide firm evidence
that these prints (as well as a number of monotypes) were made
from daguerreotype plates.[2]

In this image a café-concert singer is obviously performing in
an outdoor setting; hence the traditional title of *Behind the Safety
Curtain* no longer seems valid. The visual vocabulary of Degas's
other café-concert prints makes clear that the pale disk at right is
to be read as a gaslight globe and the large area at left as a
reflection of light in a grand mirror. For two lithographs of a similar
subject and viewpoint, see cat. nos. 25 and 26.

Like a mezzotint, this print was essentially created by scrap-
ing a pale image from a darkened plate. A fine-grained, liquid
aquatint was applied, stopped out in part to create white areas for
the globe and its reflection, and bitten for a short time. Degas
scraped the plate to extract from the pale gray-toned background
the vertical column and the white highlights of the figure, which he
further clarified with fine drypoint lines.

There are four impressions known of this experimental aqua-
tint: Albertina, BM, BN (Rouart) and Kornfeld. This last impression
is printed on a blank page from the same book as cat. no. 21 II
(MFA), suggesting a contemporaneous printing.

Notes

1. Reff *Notebook* 26, pp. 58 and 56, used in reverse order:
p. 58: "Sur une plaque argentée (de daguerre[otypie]) . . . si l'on veut une
taille douce, mordre légèrement à l'acide nitrique" (On a silvered
daguerre[otype] plate . . . if one wishes an etching, bite lightly with nitric
acid); p. 56: Degas gave measurements in centimeters for large and small
daguerreotype plates: "33c - 27c / 17c - 22c (gr[ande] daguerre[otypie])
12-1/2 - 16-1/2 (pet[ite] daguer[reotypie])."

2. Buerger and B. Shapiro 1981, pp. 103-06.

32

33

Two Dancers in a Rehearsal Room 1877-78

Aquatint, drypoint, and scraping. One state
Delteil 22 (about 1876); Adhémar 37 (about 1876-77)
157 x 116 mm. plate
Buff, medium weight, moderately textured, laid paper
300 x 214 mm. sheet
Watermark: fragment of ARCHES
Atelier stamp
Private collection

This plate is similar in its experimental nature and its technique to
A Café-Concert Singer (cat. no. 32) but reveals the use of a more
complex process. An aquatint grain was applied to the plate and
stopped out for at least three intervals during biting. It produced a
narrow range of gray tonalities that broadly describe two dancers
in a practice room with a tall window. The configuration at the
upper right suggests the use of liquid aquatint that pooled and
protected more completely where it thickened. Degas then
scraped the aquatint to define in negative white lines the dancers,
floor, and curtained window. He added positive drypoint lines to
complete the image. The sketch-like nature of the figures and the
repositioning of the standing dancer's torso suggest that Degas
was experimenting with a composition prepared directly on the
plate. The "negative" effect created by the white linework further
displays Degas's unconventional printmaking technique and his
interest in photography.

 Like *A Café-Concert Singer*, this print is also executed on a
daguerreotype plate and bears the same manufacturer's name:
"Schneider . . . Berlin."

 Delteil knew of eight impressions of the print, including five
in the hands of collectors. At present six have been located: J.
Bergquist, BM, BN (Rouart), Clark (Beurdeley), MMA (Atelier), and
private collection (Atelier).

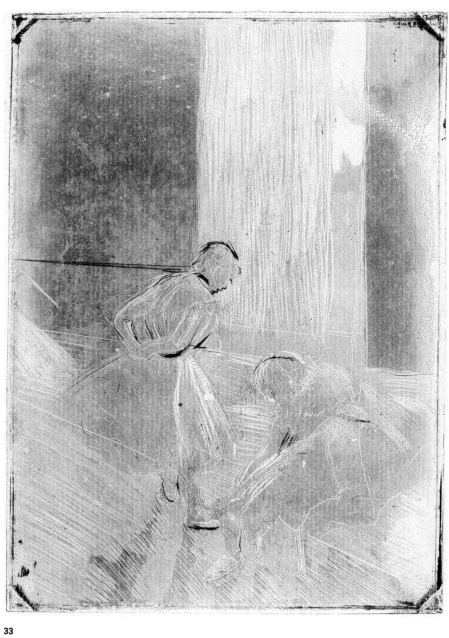

33

34

A Singer 1877-78

Softground etching and aquatint. Three states
Delteil 25 (undated); Adhémar 39 (about 1878)
160 x 120 mm. platemark

I first state

Off-white, moderately thick, smooth, wove paper
Atelier stamp
Graphische Sammlung Albertina, Vienna
Exhibited in Boston

I first state

Off-white, moderately thick, moderately textured, wove paper
246 x 161 mm. sheet
Atelier stamp
E. W. Kornfeld, Bern
Exhibited in Philadelphia and London
Not illustrated

II second state

Buff, medium weight, slightly textured, laid paper
310 x 225 mm. sheet
Coll.: Rouart
Bibliothèque Nationale, Paris
Exhibited in London

II second state

Off-white, medium weight, moderately textured, laid paper
350 x 260 mm. sheet
Watermark: Large crowned shield
Coll.: Atelier; McVitty
Philadelphia Museum of Art. Joseph E. Temple Fund
Exhibited in Boston and Philadelphia
Not illustrated

III third state

White, thick, moderately textured, wove paper
258 x 175 mm. sheet
Coll.: Rouart
E. W. Kornfeld, Bern

In Delteil's catalogue raisonné of Degas's prints, he cited a pencil drawing in reverse (Atelier sale IV, 137c) that may indeed be the sheet used in the softground transfer process (fig. 1). It has nearly the same dimensions (16 x 11 cm.) as the print and clarifies its composition. One standing singer performs while another awaits her turn, seated in an upholstered armchair. The pastel over monotype *Aux Ambassadeurs* (cat no. 25a, fig. 2), shown in the third Impressionist exhibition of 1877, similarly depicts this seating arrangement, so characteristic of the café-concerts.

In the first state, lines of softground etching sketchily indicate the head and skirt of a standing woman whose torso is barely detected. A dark patch at the upper right of the print represents a fragment of the same dark area seen in the pencil drawing. The two impressions listed in the Atelier sale are Albertina and Kornfeld.

In the second state, additional lines of softground define the torso and arms of the singer. A pale tone of liquid aquatint covers the plate except where Degas stopped out the figure to silhouette it against the gray background. Two impressions were found: BN (Rouart) and PMA (Atelier).

In the third state, Degas has once again drawn and bitten softground lines that indicate the armchair and skirt of a second, seated woman. Her arm is defined with another application of aquatint that completes the prominent vertical band behind her. The dark, textured patches on the plate appear to have been accidentally bitten where the softground improperly lifted in part. Three impressions are known: Kornfeld (two, Rouart and Atelier) and St. Louis (Atelier).

The reliance on tonal areas to define the image is closely related to the methods Degas used to make monotypes of café-concert singers (see Cachin 5, 6, and 10), and one wonders if this print was an attempt to replicate the effect of a monotype on a plate from which multiple impressions could be taken. The seven impressions known of this print are all relatively pale and indeterminate.

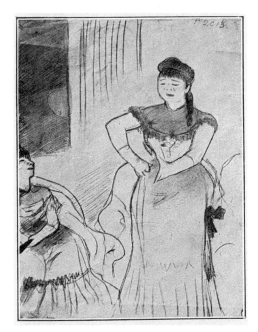

34. Fig. 1.
Café-Concert Singers. Pencil. Present location unknown.

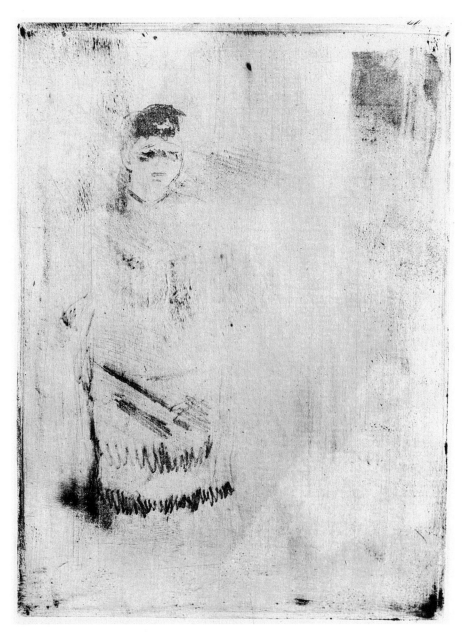

34 first state

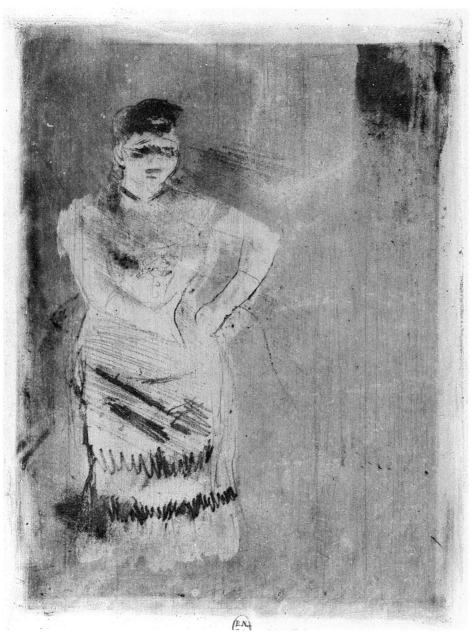

34 second state

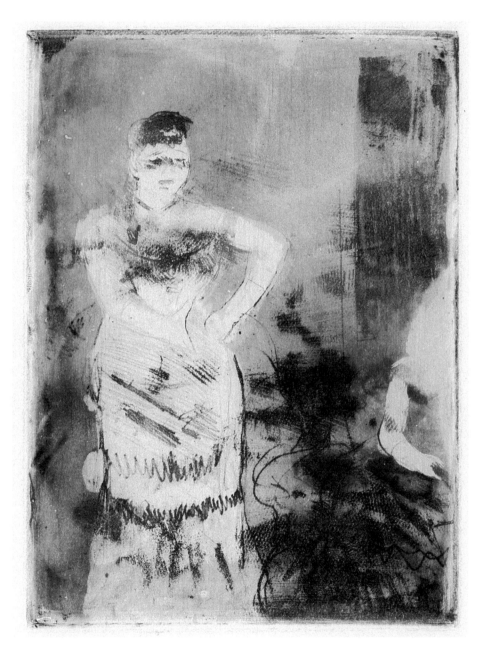

34 third state

35

Two Performers at a Café-Concert and

Morning Frolic 1877-79

Lithograph, transferred from two monotypes. One state
Delteil 51 and 52 (not dated); as monotypes: Cachin 5 and 121;
Janis checklist 33, 34, and 94
162 x 120 mm. left image; 120 x 162 mm. right image
Off-white, medium weight, moderately thick, wove paper
245 x 320 mm. sheet
Atelier stamp
E. W. Kornfeld, Bern

These two images, printed from one stone on a single sheet, are
lithographs transferred from monotypes. In both the Atelier sale
(*Eaux-fortes*, no. 138) and his catalogue raisonné, Delteil listed this
impression as a lithograph and noted one impression of only the
right-hand subject, *Morning Frolic* (no. 139). Both these sheets
have been recently examined. Since there was no further work on
the stone, either in crayon or with the scraper, the lithographs,
especially in reproduction, resemble monotypes. Subsequent to
Delteil's catalogue these rare lithographs have been erroneously
cited as monotypes.

There is an extant monotype for the café-concert subject. It
was included in the Atelier sale (*Eaux-fortes*, no. 194), where
Delteil definitely related it to the lithograph: "Divette de café-
concert. Variante de la lithographie cataloguée sous le no. 138."
This monotype, with its clearly impressed platemark, was used for
the transfer to the stone (fig. 1).[1] There is another image of the
same subject, reworked with pastels and signed by Degas, which

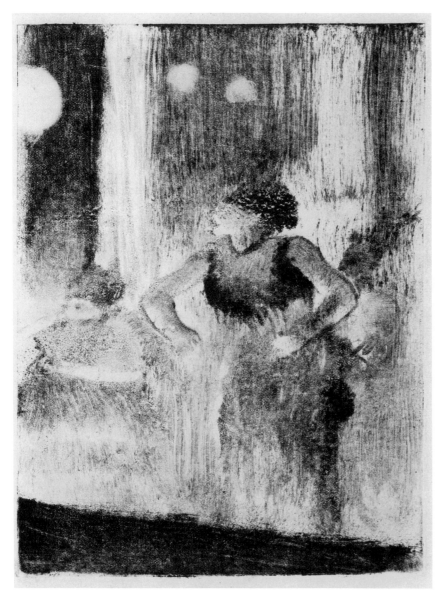

35. Fig. 1.
Two Performers at a Café-Concert. Monotype. Present location unknown.

has been called a pastel over monotype. Some authorities, including the present authors, believe it is pastel over an impression of the lithograph (fig. 2).[2] In both the black and white lithograph and the pastel the singer's features are defined and the configuration and transparent inking of the front of the stage are the same.

The second subject on the sheet –a mildly erotic nude – is unique in Degas's lithographic oeuvre but appears frequently in the monotype medium, usually associated with more explicit brothel subjects. See, for example, the nudes in the series *Repos sur le lit* (Janis checklist 92-98), as well as those in *Maisons closes* (Janis checklist 72-75), where they lie on sofas with uplifted legs.

The two unrelated images are placed on the paper in different directions, indicating that Degas planned to cut the sheet after printing (see also cat. no. 36). One impression with both images is here catalogued (Kornfeld/Atelier). The right half of another impression is in a private collection, England (Atelier), and we suggest that the left half of that sheet may be the lithograph heightened with pastel.

Notes

1. The monotype is that illustrated as Cachin 5. Its present location is unknown to us; it is not in the Kornfeld collection. This monotype was examined and discussed by Janis 1967, pt. 1, p. 29, fig. 53, and pt. 2, p. 76, n. 25. Janis 1968, checklist no. 33, incorrectly reproduces an impression of the lithograph instead of the monotype.

2. Lafond 1918-19, vol. 2, color plate facing p. 38. First exhibited, Paris, *Degas* 1924, no. 213 (Coll. Georges Viau), as lithograph heightened with pastel; Lemoisne 458 as pastel over lithograph; Janis 1967, pt. 1, fig. 52, as monotype under pastel, second impression; and Janis 1968, checklist no. 34, as pastel over monotype.

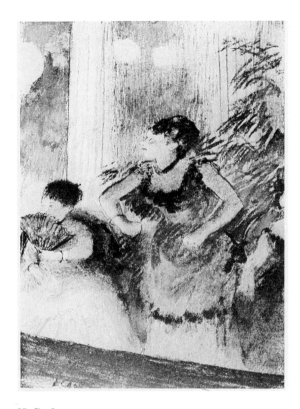

35. Fig. 2.
Two Performers at a Café-Concert. Pastel over lithograph. Present location unknown.

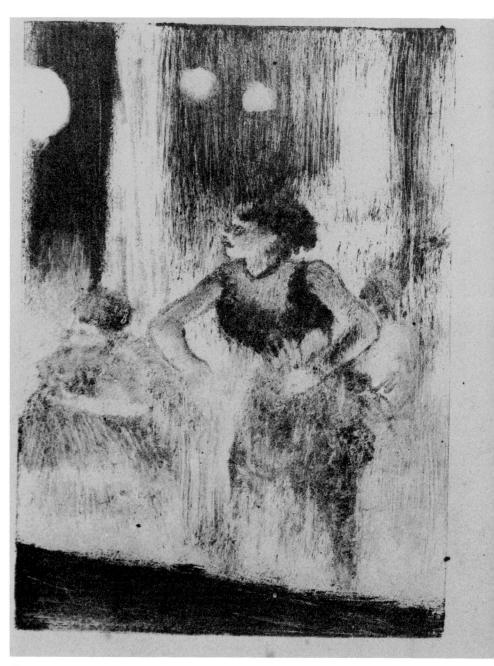

35

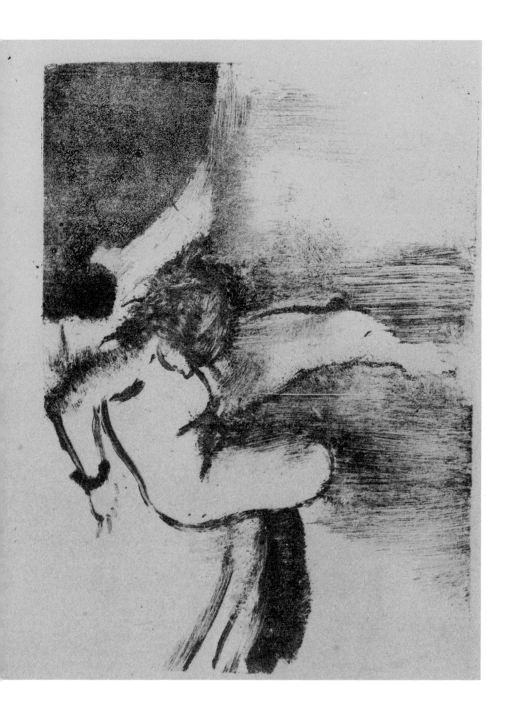

36

At the Cirque Fernando and *Nude Woman at the Door of Her Room* 1879

Lithograph, transferred from two monotypes. One state
Delteil 46 (as *Au Cirque Medrano*) and 47 (not dated); Adhémar 45 (1876-79)
119 x 160 mm. left image; 161 x 119 mm. right image
Gray-white, chine collé (276 x 167 mm.) mounted on white, wove paper
360 x 273 mm. sheet
Atelier stamp
Rijksprentenkabinet, Rijksmuseum, Amsterdam

36a

At the Cirque Fernando (left subject)
Lithograph
White, thick, smooth, wove paper
157 x 243 mm. sheet
Coll.: Roger Marx
Museum of Fine Arts, Boston. Katherine E. Bullard Fund in memory of Francis Bullard and proceeds from sale of duplicate prints
Not illustrated

36b

Nude Woman at the Door of Her Room
Monotype
Janis 42; Cachin 128
161 x 118 mm. platemark
Buff, medium weight, moderately textured, laid paper
142 x 235 mm. sheet
Watermark: fragment of ARCHES
Coll.: Atelier; Guérin
Museum of Fine Arts, Boston. Katherine E. Bullard Fund in memory of Francis Bullard

The Cirque Fernando opened in Paris in 1877 and in 1898 changed its name to the Cirque Medrano. Degas made a number of studies of Miss Lala, a trapeze performer at the circus, in early 1879 and exhibited his oil painting of her in the fourth Impressionist exhibition of the same year. This lithograph of a man with his performing dogs is the artist's only other circus composition and most certainly is from the same date.

Degas used fresh impressions of monotypes to transfer his designs to a single lithographic stone (see cat. no. 30). In this instance, the two subjects are completely unrelated (see cat. no. 35). The monotype for the circus subject is neither recorded nor located. However, the exact same size of the circus image and the nude woman, the legibility of the plate edge, the manipulatiom of the ink and its distinctive textures – all suggest that a monotype also acted as the first step in the execution of the Cirque Fernando lithograph. The monotype for the right side, the nude in her bedroom, was originally acquired by Marcel Guérin from the Atelier sale (*Eaux-fortes*, no. 215). Also in the 1919 sale were two full sheets with both subjects (now Amsterdam and Kornfeld). Degas had given a third full sheet to Alexis Rouart (now AIC), as well as the left side, touched with pastels (BAA). Roger Marx owned both

the right side (BAA) and the left side (MFA). Another example of the right side only is in the BN. These account for five full printings of the stone. Obviously, Degas intended the sheet to be cut after printing.

The monotype of the *Nude Woman at the Door of Her Room* is executed broadly. The sheet has given up much of its ink to the lithographic stone. Degas used a crayon and scraper extensively to make the generalized forms of the monotype more specific and detailed in the print. He scraped the floor, including the cast-aside shoes and the small bedside rug; the headboard also becomes more clarified. With crayon he drew in the bed linens, the edge of a tufted chaise, and a heap of clothing at the right. The figure, now long-haired, with her right arm visible, is delicately delineated down to the tiny bracelet on her wrist. Behind her Degas defined a slightly open panel door. The anonymous, uncertain figure of the monotype now assumes an attentive, expectant attitude. In subject, in the intimate quality of the image, and in the gesture of the nude reaching out to an open door, this lithograph relates to the drypoint of *The Little Dressing Room* (cat. no. 41). Although both prints are more reticent and ambiguous, lacking explicitly provocative poses and gestures, they evoke the monotypes of the brothel subjects.

In his review of the Peintres-Graveurs exhibition of 1889, Félix Fénéon wrote: "Mr. Degas nonchalantly exhibits a small lithograph whose savage artistry is astounding. Her long hair falling down her back, the nude woman, aching all over or half asleep leaves her room. And everything – the woman disappearing, the unmade bed, the downy easy-chair – bear the mysterious imprint of Degas."[1]

The circus scene with its emphasis on the forceful curve of the ring anticipates the depictions of the same subject by Toulouse-Lautrec a decade later. In a sketchy manner Degas merely implies the audience in the background and suggests the sense of extended space by using the witty device of a dog's tail disappearing at the lower left. He took one impression of this lithograph (BAA) and further enlivened it with colorful touches of pastel: red and blue on the man's costume, red on the railing, and ocher on the ground, which covers the dog's tail. Degas drew a head on the dog at left. This colored impression is signed, as are most of the prints reworked with pastel.

Note

1. Druick and Zegers 1981, p. 25. The original French reads as follows: "M. Degas expose négligemment une petite lithographie dont la sauvage saveur d'art étourdit. La chevelure sur le dos, une femme nue, courbaturée ou mal éveillée, émigre de sa chambre. Et n'importe quoi, la femme disparaissante, le lit découvert, le pelucheux crapaud, porte la mystérieuse marque de Degas"; Félix Fénéon, *Oeuvres* (Paris, 1948), p. 165.

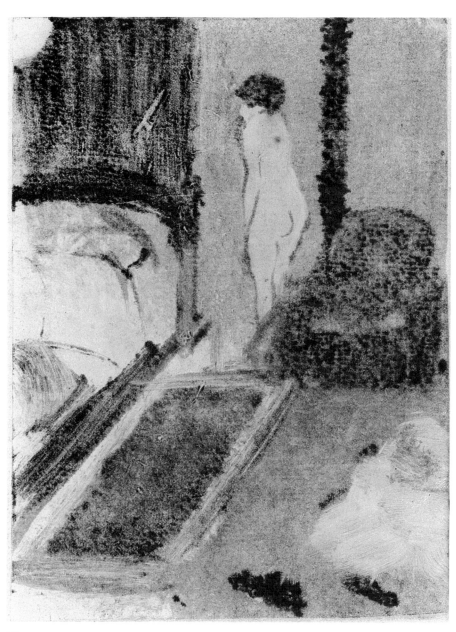

36b

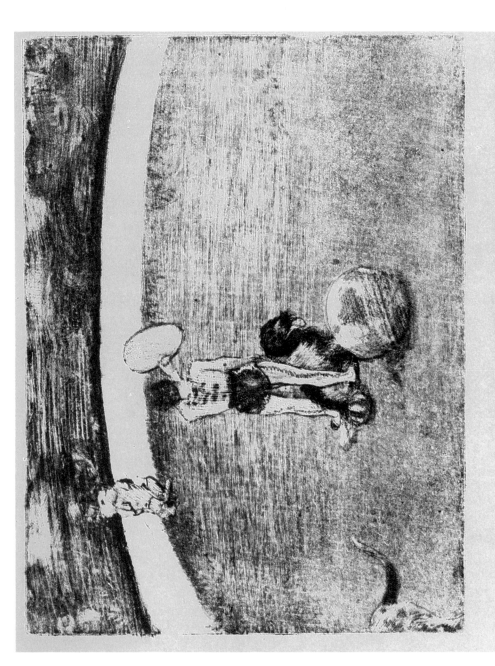

36

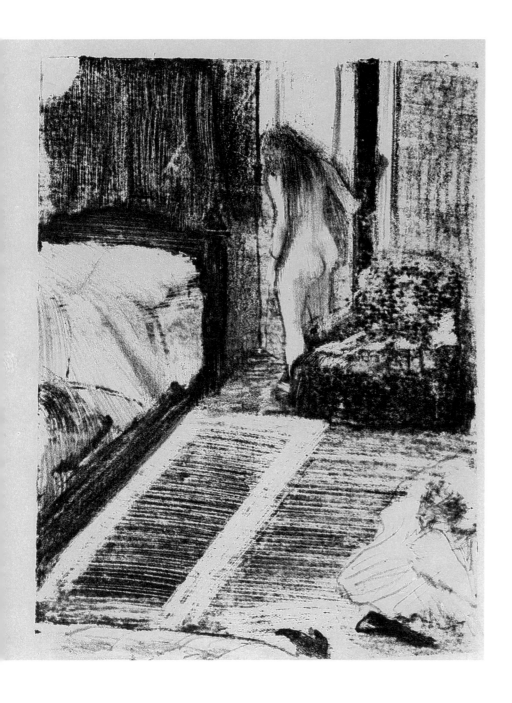

37

At the Theater: Woman with a Fan 1878-80

Crayon lithograph from transfer paper. One state
Delteil 56 (about 1880); Adhémar 34 (about 1878-79)
232 x 200 mm. image
Off-white, medium weight, smooth, wove paper
350 x 270 mm. sheet
Museum of Fine Arts, Boston. Bequest of W. G. Russell Allen

In the conception of the subject and the style in which the dancers are drawn this transfer lithograph appears closest to Degas's fan paintings of 1878 onward. As in the fan designs, he depicts small, lively figures of dancers who dart with exaggerated animation across the stage. The large fan in the foreground of the lithograph, beyond which the dancers are perceived, operates visually in the same fashion as the stage flat in the drypoint of *Two Dancers in the Wings* (cat. no. 39).

Degas has composed this subject asymmetrically along one side of the sheet, using the oversize open fan to establish a sense of balance. There is a contrast in drawing style between the weightless, summarily indicated dancers and the more carefully rendered spectator who anchors the composition.

There are related pastels of theater subjects where a boldly placed figure in the foreground corner, holding a fan, observes dancers on the stage (Lemoisne 577; 828, Philadelphia Museum of Art; and 829). Whereas the pastels are more firmly structured and the dancers are depicted as part of a formal ballet production, the dancers in the lithograph convey a sense of uncontrolled vitality.

The distinctive profile of the woman who dominates the foreground of the lithograph is directly related to the figure in a pastel over monotype of horizonal format, also dating from about 1878-80 (fig. 1; Lemoisne 476, Museum of Art, Rhode Island School of Design).[1]

Degas depended on this finished work when he drew the image on transfer paper, probably with the aid of a photograph.[2] The transfer process enabled him to produce a lithograph in which the theater goer faces in the same direction as in all the pastel variants. In the print Degas simplified her earring but made the fan more decorative.

Three impressions of this print have been located: BN (Rouart), East Berlin (Roger Marx), and MFA. Delteil also mentions impressions owned by Beurdeley and Bracquemond and one in the Atelier sale.

Notes

1. Johnson 1981, pp. 28-31. See also Browse 1949, fig. 106.

2. For further discussion of Degas's use of photographs, see the essay "Degas and the Printed Image."

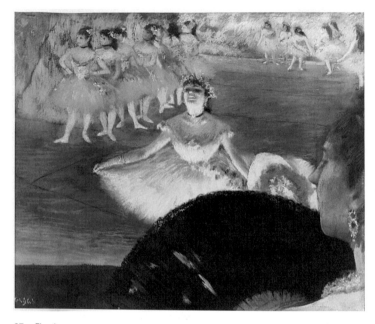

37. Fig. 1.
Dancer with a Bouquet, 1877-80. Gouache and pastel over monotype. Museum of Art, Rhode Island School of Design. Gift of Mrs. Murray S. Danforth.

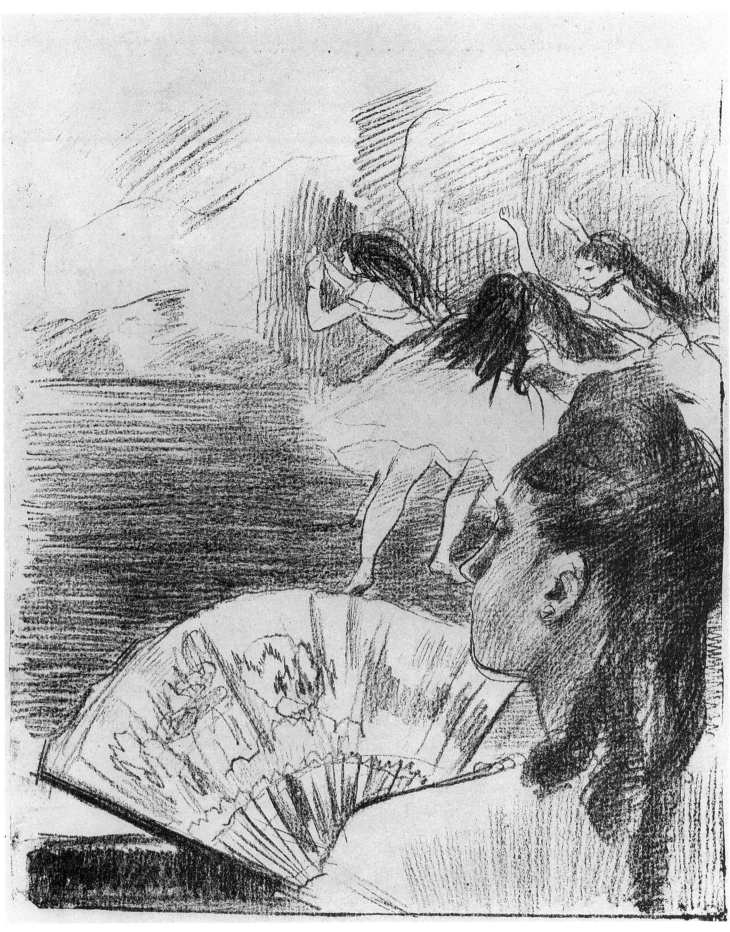

Degas
Auteuil
H et C°

38

38

In the Wings 1878-80

39

Two Dancers in the Wings 1879-80

Crayon lithograph (from transfer paper). One state
Delteil 59 (about 1885); Adhémar 35 (about 1879-80)
243 x 170 mm. image
On the stone, lower left: *Degas/Auteuil/H et Co*
Cream, wove paper
356 x 253 mm. sheet

Signed in pencil, lower right: *Degas*
Coll.: Barrion; Beurdeley; Marcel Mirault (M.M)
Mr. and Mrs. John W. Warrington
Exhibited in Boston and Philadelphia

Off-white, thin, smooth, wove paper
402 x 300 mm. sheet
Coll.: Rouart
Bibliothèque Nationale, Paris
Exhibited in London
Not illustrated

It was probably upon the invitation of Félix Bracquemond that Degas visited the ceramics factory at Auteuil, opened by Charles Haviland in 1873 for the purpose of creating decorative ceramic pieces in the Impressionist and Japanese styles. Bracquemond was the artistic director of the studio for a decade beginning in 1872. The Auteuil workshop presented its first products in the important Exposition Universelle of 1878. It was probably soon thereafter that Degas prepared this lithograph, indicating on the stone his location, *Auteuil*, and the familiar trademark, *H et Co.*

The print was of great interest to the artists working at the factory. One potter decorated a vase with a pair of dancers in poses similar to those in the lithograph. Also included on the vase is a gentleman dressed in a dark suit who observes the scene as in the print.[1] Given the flourishing activity of the Auteuil workshop in 1878-79, as well as the stylistic relationship of the lithograph to the drypoint of *Two Dancers in the Wings* (cat. no. 39) and to the aquatint of *Dancers in the Wings* (cat. no. 47), a date of 1878-80 can be proposed for this print.

Despite the quick, sketch-like appearance of cat. no. 38, Degas has taken pains to make fine corrections and adjustments throughout the image. For the most part the composition was drawn on transfer paper. Some work at the far right was added directly on the stone: note the line of division in the long hair of the dancer. A number of areas, including the dancers' arms and costumes, were scraped with a fine tool.

At least eight impressions were known to Delteil, of which five have been located: Albertina, BN (Rouart), Copenhagen (Atelier), Frankfurt (Atelier), Warrington (Barrion, Beurdeley).

Note

1. J. and L. D'Albis, "La Céramique impressioniste," *L'Oeil*, no. 223 (Feb. 1974), p. 48, figs. 4 and 5.

Drypoint. Two states
Delteil 23 (about 1875); Adhémar 36 (1878-79)
112 x 100 mm. platemark

I first state

Cream, medium weight, moderately textured, laid paper
178 x 115 mm. sheet
Watermark: crowned shield with lion and fragment of ORIGINAL/
BASTED MILL/KENT
Atelier stamp
E. W. Kornfeld, Bern

II second state

Cream, medium weight, moderately textured, laid paper
296 x 212 mm. sheet
Watermark: fragment of ARCHES
Atelier stamp
N. G. Stogdon

In 1879-80, during a period of prolific intaglio printmaking, Degas experimented with a number of innovative techniques. To achieve a variety of tonal effects with drypoint he employed unconventional tools, such as emery pencils and the carbon rod from an arc lamp (formerly termed *crayon électrique*), to scratch or incise the plate. This print and cat. nos. 40 and 41 are small experiments; for a full discussion of the tools, see cat. no. 42.

The close relationship of this drypoint in theme and treatment to the aquatint *Dancers in the Wings* (cat. no. 47) and the lithograph *In the Wings* (cat. no. 38), as well as to a number of fans representing dancers, indicates a date for its execution around 1879. With the broad, tonal lines of the carbon rod Degas has suggested the movement of dancers within a stage set. The work seems effortless when compared with the multiple states of the aquatint of the same subject.

In the first state the carbon rod appears to test the technique, especially the maneuverability of the tool. Without the sketchy indication of the dancer, the image would read as a variety of scribbled lines. The Kornfeld impression from the Atelier sale is unique.

The second state presents a spirited image that resembles a number of Degas's decorative fan-shaped paintings (see, for example, Lemoisne 564; fig. 1). The same abruptly cropped dancers who are interspersed among prominent stage flats appear in both media.[1] In the second state, new work with the carbon rod completes and unifies the experimental patches to create a stage flat. Degas also used a pointed tool to denote a second dancer at right and to refine the dancer at the center. These drypoint tools did not achieve profound blacks; the print has an overall gray appearance. Five impressions of this state have been located: Albertina (Roger Marx), BAA, BN (Rouart), Copenhagen (Atelier), N. G. Stogdon (Atelier).

Note

1. Lillian Browse has compared this print with a rectangular design on a fan in oil paint on silk; Browse 1949, pl. 7 and pp. 332-33.

39 first state

39. Fig. 1.
Dancers, 1878-79. Fan painting. Present location unknown.

39 second state

The Actress Ellen Andrée 1879

Drypoint. Three states
Delteil 20 (undated); Adhémar 52 (about 1879)
113 x 79 mm. platemark

I first state

Cream, medium weight, moderately textured, laid paper
184 x 140 mm. sheet (irregular)
Coll.: Rouart
Department of Prints and Drawings, The Royal Museum of Fine Arts, Copenhagen

II second state

White, medium weight, moderately textured, laid paper
178 x 128 mm. sheet (irregular)
Atelier stamp
The Metropolitan Museum of Art. Gift of Mrs. Imrie de Vegh, 1949

III third state

Buff, moderately thick, moderately textured, laid paper
219 x 158 mm. sheet
Watermark: fragment of ARCHES
Coll.: Rouart
Museum of Fine Arts, Boston. Katherine E. Bullard Fund in memory of Francis Bullard and proceeds from sale of duplicate prints

Ellen Andrée was an actress who frequently served as a model for Degas, Manet, and Renoir. Her theater performances were enjoyed by Degas, and her talents as a pantomime artist were praised by Renoir.[1] Although her birth date is unknown, she had died by 1895.[2] Degas was acquainted with Ellen Andrée from the late 1860s, and she posed for his painting *L'Absinthe* (Lemoisne 393), completed by 1876, where she appeared as a world-weary café habituée. Degas depicted her in the same guise, wearing a striped bodice and jaunty hat, in the small monotype transferred to the lithographic stone of *Four Heads of Women* (cat. no. 27).

In a dramatic change of character, she posed as a museum visitor carrying a guidebook for two large charcoal and pastel drawings on gray paper. Her pert figure is clearly identifiable at the right in the *Project for Portraits in a Frieze* (fig 1; Lemoisne 532, private collection, Germany; shown at the sixth Impressionist exhibition in 1881), and she is also seen from front and back in *Two Studies of Ellen Andrée* (Boggs 1966, no. 87, illus.). Both these drawings are associated with the major pastel portraying Mary Cassatt and her sister, Lydia, in a painting gallery of the Louvre (Lemoisne 581; see cat. no. 51, fig. 1). All three works were probably executed around 1879.

This small experimental drypoint image of Ellen Andrée follows closely, though on a greatly reduced scale and in reverse, the woman at right in the drawing *Project for a Frieze*, cited above. Even within this small format, Degas has placed the isolated figure on the page in a way that reveals his constant, underlying sense of design. Using drypoint tools, including the carbon rod, he has

40 first state

imitated the tonalities of the drawing, although in the print he has introduced a new floral pattern on the skirt.

Arsène Alexandre's appreciative description of the print, though often quoted, is worth noting again:

I do not wish to leave the etchings without mentioning a very small print to which it would be a shame not to give attention. It is a young woman, standing, in a jacket and a "Niniche" hat, her nose in the air, her hair in a mess. In several scribbles, Degas has evoked no more, no less than the charming Ellen Andrée who, by her urchin-like grace, her heady and light Parisian touch, illuminated the small group of Halévy, Degas, Meilhac, Renoir and tutti quanti. It is only a little nothing, but a perfect, exquisite nothing.[3]

This portrait, delicately handled in drypoint, is fully characterized in the first state. Degas used the carbon rod (or perhaps an emery pencil) to describe the ribbed texture of the jacket and the folds of the skirt, as he did for the costumes in *Mary Cassatt at the Louvre: The Etruscan Gallery* (cat. no. 51). He employed a sharp point to create the delicate flecks in the patterned skirt. The fragility of the drypoint burr and the variations in wiping the plate create differences within the small number of impressions known.

This unique impression of the first state (formerly Rouart collection) was first described by Adhémar.

In the only known impression of the second state (from the Atelier sale), there are fine lines of hatching added to the lapel of the jacket and to the brim of the hat, which has a few additional strokes suggesting an ornament. This impression has a soft, blurred effect due to the uneven wiping of the plate that pulled ink out of some of the lines.

In the third state Degas has suggested a setting for the figure of Ellen Andrée by inserting fine, horizontal lines below and to the left. These scratches cover the faint flecks that appeared at left in the first two states. In at least three impressions of this state a thin film of ink was left on the plate, perhaps to suggest atmosphere. Seven impressions have been located: AIC (Atelier), BAA (Burty), BN, Goldschmidt (Atelier), MFA (Rouart), NGA (Atelier), and Smith (Atelier).

Notes

1. Dunlop 1979, p. 163.

2. Boggs 1962, p. 108.

3. Alexandre 1918, p. 14.

40 second state

40. Fig. 1.
Project for Portraits in a Frieze. Charcoal and pastel on gray paper. Private collection.

40 third state

41

The Little Dressing Room 1879-80

Drypoint. Five states
Delteil 34 (about 1880); Adhémar 48 (about 1879-80)
119 x 79 mm. platemark
Signed in the plate, lower left, vertically: *Degas*

I first state

Cream, moderately thick, moderately textured, laid paper
297 x 219 mm. sheet
Watermark: fragment of ARCHES
Atelier stamp
Josefowitz Collection, Switzerland

II second state

Cream, medium weight, smooth, laid paper
178 x 111 mm. sheet
Watermark: fragment of ORIGINAL/ BASTED MILL/ KENT
Atelier stamp
E. W. Kornfeld, Bern

III third state

Cream, medium weight, slightly textured, laid paper
170 x 113 mm. sheet
Coll.: Rouart
Bibliothèque Nationale, Paris
Exhibited in Philadelphia

IV fourth state

Gray-tan, thin, smooth, oriental paper
205 x 150 mm. sheet
Coll.: Rouart
The Art Institute of Chicago. Print Department Purchase Fund 1955.1100

V fifth state

Cream-buff, moderately thick, moderately textured, laid paper
300 x 215 mm. sheet
Watermark: fragment of ARCHES
The Art Institute of Chicago. William McCallin McKee Fund 1951.123

For this print Degas reused a beveled plate from which he had originally printed a unique impression of the aquatint *On Stage II* (cat no. 23). For another plate twice used, see cat. nos. 13 and 21. Degas polished the plate, almost entirely obliterating the horizontal image, and turned it to create this vertical subject, *The Little Dressing Room*. Vestiges of the original design remain, including the drypoint signature that now can be perceived running vertically along the lower left edge.

 Although it was customary for Degas to express his brothel scenes in the medium of monotype, in this rare instance he has executed a small drypoint in which a bather is transformed through progressive states of the print into a prostitute.[1] In the first state,

41 first state

the sketchily indicated nude figure in an unspecific setting reaches into a washbasin; she could be any young woman at her ablutions. By the fifth state, the shapely woman, ornamented with bracelet and neckband, stands by the open door of her highly decorated room. Her hand, now moved to the side of the washstand, extends as if to welcome the visit of a client. There is a decided change in presentation and content. Much of the spirit of the print has been captured by Richard Brettell, who relates it to the mono-type series on brothels in its sense of anticipation and implied movement.[2] *The Little Dressing Room* could also stand as an illus-tration to a text; a number of popular novels whose subjects pertained to prostitutes were published at that time.[3]

 In subject and in the sketch-like use of the drypoint medium, this print resembles *Leaving the Bath* (cat. no. 42), here dated 1879. In both prints Degas employed the carbon rod to establish the composition in tones of gray. He subsequently reworked the plates with fresh drypoint lines that had rich burr and were of greater strength and duration.

40 second state

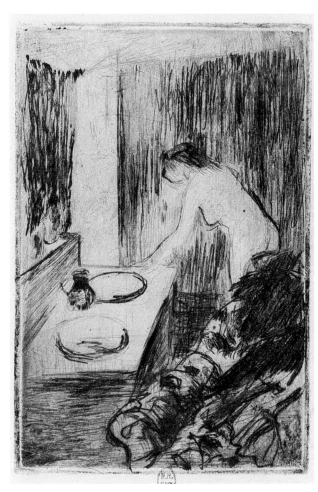

41 third state

The entire composition in the first state is sketched in bundles of lightly scratched drypoint lines, giving the image an overall gray tonality. The woman's left arm reaches into the basin on the washstand, where a second basin and a pitcher are lightly indicated. A bottle rests on the shelf above. The walls are shaded with vertical strokes, and the arched back of a small chair is visible beside the figure. There are two known impressions of this first state: Josefowitz (Atelier) and private collection, Germany (Roger Marx).

In the second state the woman's arm has been redrawn and moved from the basin. There is strong new drypoint work that defines the contours of the upholstered armchair in the foreground and adds ambiguous scratches to its back and seat. Zigzag lines ornament the walls. Two impressions were located: Albertina (Atelier) and Kornfeld (Atelier).

In the third state there is considerable additional work in crisp drypoint with burr that describes the woman's contours, the basins, pitcher, and shelf. The walls are shaded with strong verti-

cal strokes, and horizontal lines to the left of the figure suggest the floor. The armchair is now covered with an ornamental pattern, and new work suggests items of clothing laid on the chair. Impressions of this state are BAA and BN (Rouart).

The fourth state reveals the addition of most of the finishing touches: the woman now wears black ribbon bands around her neck and wrist. A line of demarcation separates her hand from the washstand. A small, dark form, probably representing a sponge, is added to the near left corner of the counter; and two bottles stand on the shelf. The curved-back chair behind the woman is redrawn; the top of a door is strengthened, and the walls have an additional decorative pattern. This impression is unique: Chicago (Rouart).

In the fifth state the walls are completely covered with meandering lines, and the front of the washstand is darkened with vertical strokes. Four impressions of this final state are known: AIC, BAA, BM, East Berlin (Atelier). Although Delteil indicates six impressions of this print, eleven have been located.

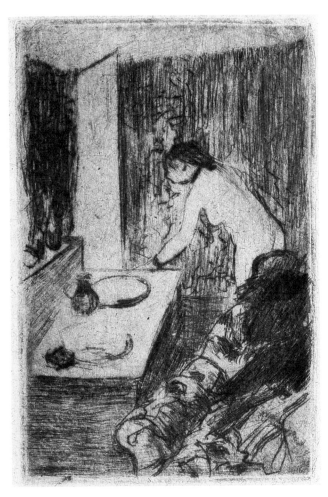 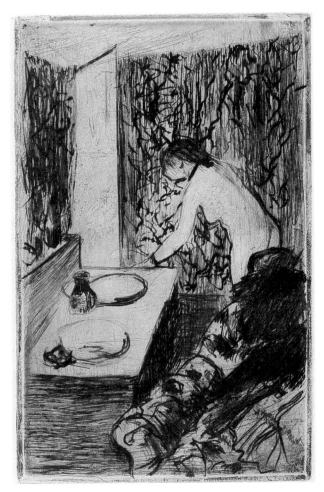

41 fourth state

41 fifth state

Notes

1. For brothel monotypes featuring the act of washing and bath accessories, see Cachin 124 and 129. A lithograph, *Morning Frolic* (cat. no. 35), can also be interpreted as a brothel scene.

2. Chicago, *Degas* 1984, pp. 120-21, nos. 55 and 56.

3. Adhémar and Cachin, p. 83, cite the following novels published during the period 1876-80: *Marthe, histoire d'une fille,* by J. K. Huysmans; *La Fille Elisa* by Edmond de Goncourt; *La Maison Tellier* by Guy de Maupassant (of which the 1934 edition, published by Ambroise Vollard, included reproductions of Degas's brothel monotypes); and finally, the well-known *Nana* by Emile Zola.

42

Leaving the Bath 1879-80

Drypoint and aquatint. Twenty-two states
Delteil 39 (about 1882); Adhémar 49 (about 1879-80)
127 x 127 mm. platemark

I first state

White, medium weight, moderately textured, laid paper
177 x 224 mm. sheet
Watermark: emblem and ORIGINAL/BASTED MILL/KENT
Atelier stamp
*The Art Institute of Chicago. Albert Roullier Memorial Collection
1928.232*

II second state

Cream, medium weight, smooth, laid paper
177 x 222 mm. sheet
Watermark: coat of arms with elephant and lion rampant and
ORIGINAL/OXFORD MILL
Atelier stamp
*The Fine Arts Museums of San Francisco. Achenbach Foundation
for Graphic Arts purchase, 1972*

III third state

Cream, moderately thick, moderately textured, laid paper
215 x 295 mm. sheet
Atelier stamp
*The Art Institute of Chicago. Clarence Buckingham Collection
1962.82*

IV fourth state

Staatliche Museen zu Berlin, DDR
Not in exhibition

V fifth state

White, medium weight, smooth, laid paper
175 x 200 mm. sheet
Watermark: coat of arms and ORIGINAL/OXFORD MILL
Coll.: Rouart
Anonymous loan

VI sixth state

Coll.: Atelier; Robert Hartshorne
Mr. and Mrs. John W. Warrington
Not in exhibition

VII seventh state

Cream, medium weight, moderately textured, laid paper
297 x 215 mm. sheet
The National Gallery of Canada, Ottawa

VIII eighth state

Cream, medium weight, moderately textured, laid paper
295-300 x 213 mm. sheet (irregular)
Coll.: Loys Delteil
Bibliothèque Nationale, Paris. Gift of Mme Delteil, 1928
Not in exhibition

IX ninth state

Buff, medium weight, moderately textured, laid paper
297 x 216 mm. sheet
Watermark: numeral 2
Atelier stamp
Museum of Fine Arts, Boston. Horatio G. Curtis Fund

X tenth state

Off-white, medium weight, smooth, laid paper
177 x 225 mm. sheet
Watermark: coat of arms and ORIGINAL/BASTED MILL/KENT
Atelier stamp
Rijksprentenkabinet, Rijksmuseum, Amsterdam

XI eleventh state

Off-white, laid, Japanese paper
227 x 165 mm. sheet
*The Archer M. Huntington Art Gallery, University of Texas at Aus-
tin. The Archer M. Huntington Museum Fund, 1982*

XII twelfth state

Cream, medium weight, moderately textured, laid paper
308 x 208 mm. sheet
Atelier stamp
The Metropolitan Museum of Art. Rogers Fund, 1921

XIII thirteenth state

Buff, medium weight, smooth, wove paper
211 x 175 mm. sheet
Atelier stamp
*Smith College Museum of Art, Northampton, Massachussetts. Gift
of Selma Erving '27, 1972*

XIV fourteenth state

Buff, moderately thick, moderately textured, laid paper
233 x 178 mm. sheet
Watermark: fragment of BLACONS
Atelier stamp
*Sterling and Francine Clark Art Institute, Williamstown,
Massachussetts*

XV fifteenth state

Buff, medium weight, smooth, laid paper
236 x 180 mm. sheet (irregular)

Watermark: fragment of BLACONS
Atelier stamp
The Metropolitan Museum of Art. Harris Brisbane Dick Fund, Rogers Fund, The Elisha Whittelsey Collection, The Elisha Whittelsey Fund, 1972, by exchange

XVI sixteenth state

Cream, medium weight, moderately textured, laid paper
232 x 180 mm. sheet
Watermark: fragment of BLACONS
Atelier stamp
Sterling and Francine Clark Art Institute, Williamstown, Massachussetts

XVII seventeenth state

Cream, moderately smooth, wove paper
235 x 178 mm. sheet
Atelier stamp
Collection John Talleur
Not in exhibition

XVIII eighteenth state

Buff, medium weight, moderately textured, wove paper
235 x 182 mm. sheet
Josefowitz Collection, Switzerland

XIX nineteenth state

Buff, medium weight, smooth, laid paper
Atelier stamp
Department of Prints and Drawings, The Royal Museum of Fine Arts, Copenhagen

XX twentieth state

Cream, medium weight, moderately textured, laid paper
270 x 170 mm. sheet
Watermark: fragment of FRERES
Atelier stamp
National Gallery of Art. Rosenwald Collection, 1950

XXI twenty-first state

Buff, medium weight, moderately smooth, wove paper
230 x 180 mm. sheet
Atelier stamp
National Gallery of Art. Rosenwald Collection, 1950

XXII twenty-second state

Cream, moderately thick, moderately textured, laid paper
276 x 298 mm. sheet
Watermark: fragment of Arches countermark
E. W. Kornfeld, Bern

42a

Impression from canceled plate
Cream, smooth, Japanese vellum
National Gallery of Canada, Ottawa
Not in exhibition

In Delteil's catalogue raisonné of 1919 he lists seventeen states of *Leaving the Bath*. This print had been broadly categorized in the Atelier sale of the previous year under three large groups: without plants, with small plants, and with large plants. Delteil catalogued the states drawing upon the forty-three impressions in the Atelier sale and the six impressions in collections known to him. Both Moses and Adhémar proposed that there were many more intermediate states. From our present knowledge of thirty-three impressions, of which twenty-two states and eleven duplicates are here catalogued, it seems unlikely that many new states are still to be discovered. Because Delteil's descriptions are unclear, however, a new sequence of states is hereby proposed.

The date of execution for *Leaving the Bath*, 1879-80, accords with Degas's renewed printmaking activity and his use of innovative methods that centered on the projected journal of prints, *Le Jour et la nuit*. (For a discussion of this project, see cat. no. 51.) Degas's enthusiasm for new tools is evident in a letter he wrote to Alexis Rouart, erroneously dated by Guérin to 1882 and generally associated with this print:

My dear friend,

It was only yesterday that I had this little attempt with carbon crayon printed. You see what a pretty gray it is. One should have emery pencils. Do give me an idea how to make them myself. I could not talk about it with your brother on Friday. Thank you for the stone you gave me. It scratches copper in a most delightful manner. Is it a conglomerate like Denis Poulot makes? With the magnifying glass I read Delanoue the Elder.

On what could I use it as an etching needle?

No time to do some really serious experiments. Always articles to fabricate. The last is a monochrome fan for Mr. Beugniet. I think only of printmaking and do none.[1]

Degas's letter refers to the dealer in paintings M. Beugniet, for whom the artist was preparing a fan. This fan has been located, but its exact date of execution is still elusive; nevertheless, it is well documented that Degas's efforts to produce saleable fans took place around 1878-80, culminating in a display of five examples in the fourth Impressionist exhibition of 1879.[2]

Guérin reported an anecdote told him by Alexis Rouart and first published by Delteil in 1919. Degas spent the night at Rouart's home because of an ice storm and on the following morning asked for a copper plate, on which he sketched the first state of this print, using a carbon rod (*crayon de charbon*). Indeed, Rouart owned impressions of two very early states of *Leaving the Bath*. Moreover, there is firm evidence that the weather in late 1879 was abnormally cold and icy.[3]

In his letter Degas mentioned abrasive tools such as emery pencils, a stone that "scratches copper in a most delightful man-

ner," and a carbon rod with a "pretty gray" effect. The carbon rod, often referred to as a *crayon électrique*, is properly described as a "crayon fait en charbon de cornue et utilisé dans l'industrie électrique."[4] The "crayon" is a carbon rod used in both nineteenth- and twentieth-century arc lamps, not a pencil employing electric current.[5]

The effects that Degas achieved with various unorthodox drypoint tools in the early states of *Leaving the Bath* closely resemble the work in Camille Pissarro's *Woman Emptying a Wheelbarrow* (Delteil 31; fig. 1). In the fourth state of Pissarro's print, which had been completely reworked with a gray tone, the artist signed and dated the plate *1880* and inscribed at least two impressions: *manière grise* (gray manner).

One can assume that Degas, who owned eight impressions of various states of Pissarro's drypoint, shared his expertise with his friend and that the carbon rod and emery stone were used by both artists. Since an impression of the third state of *Woman Emptying a Wheelbarrow* had already been exhibited in London in 1878,[6] we propose that Pissarro, with Degas's assistance, began about two years later to revise an old plate, using innovative techniques. In later states of both *Leaving the Bath* and *Woman Emptying a Wheelbarrow*, aquatint is superimposed on the weakened drypoint work.

The relationship of Degas's print to three monotypes of the same subject (figs. 2, 3, and 4), two reworked with pastel, is striking. All have similar figural poses and interior settings with patterned walls. In the two pastels over monotype (figs. 2 and 3), the presence of an upholstered armchair in the left foreground makes it easier to decipher the same object in the early states of the drypoint. The Louvre work was shown in the third Impressionist exhibition of 1877, and Degas must have had these monotypes in mind when he made his small print from memory.

There was evidently no intention to publish the print since only a few impressions, at most, of each state document the frequently minute changes; yet these numerous states testify to Degas's characteristic persistence in working out a problem to its satisfactory conclusion or, on the other hand, to his practice of leaving a composition ultimately unresolved.

There is a natural orchestration of work on the plate that falls into several phases. In the first eight states Degas assembled and described the basic elements of the composition, using a variety of drypoint hatchings. This work culminates in the ninth state, when a bold pattern is introduced to the walls and upholstered armchair, similar to that seen in the pastels over monotype illustrated here.

From the tenth state on, aquatint provided dark tones that remained constant in the lower right quarter of the print. Beginning with the fourteenth state Degas's manipulation of aquatint, especially on the body of the bather, altered the light and suggested an intimate nocturnal scene. In the twenty-first state, when the aquatint had either worn or been removed, he tried by other means to cast the bather's figure into shadow. In following the development of this print, one experiences the evolution of a sequence in time with its inherent changes of light. The cycle concludes with the

42. Fig. 1.
Camille Pissarro. *Woman Emptying a Wheelbarrow*, 1880. Drypoint, fourth state. The Art Institute of Chicago. Albert H. Wolf Fund and Joseph B. Fair Fund.

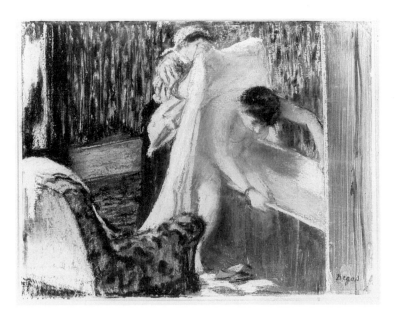

42. Fig. 2.
Woman Leaving the Bath, 1877. Pastel over monotype. Musée du Louvre, Cabinet des Dessins, Caillebotte Bequest. Photo: Documentation photographique de la Réunion des musées nationaux.

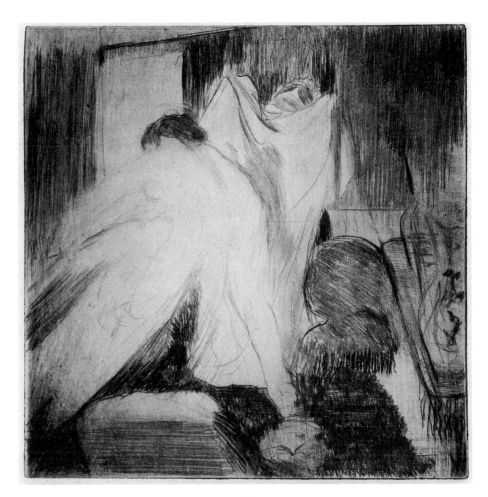

42 first state

42 second state

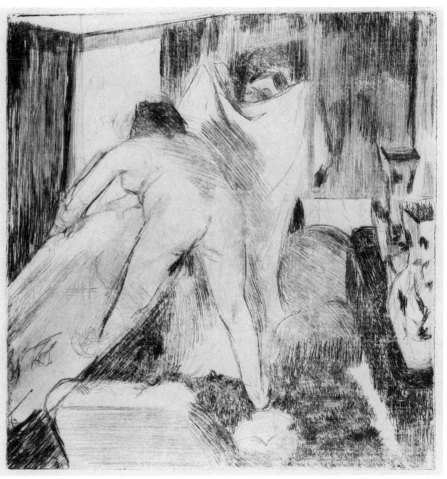

twenty-second state, which approaches the first in its daytime tonality and sense of incompleteness.

In the first state the composition is fully suggested and executed completely in drypoint with both pointed and broad tools. The bather is not entirely outlined, and the left side of the bathtub is only summarily indicated. The left and right walls are shaded with vertical strokes, and only the head of the maid appears above the large bath towel she holds. The mantel is outlined and lightly shaded, and two vases are vaguely indicated. The rug has a tufted texture. There are two impressions of this state: AIC (Atelier) and Albertina.

In the second state burnishing and drypoint additions occur. The bather's head is altered in shape, and her back shaded. A few scribbled lines in the tub suggest water. More shading on the wall at left defines the ceiling, and burnishing suggests a frame on the wall above the maid. There is additional diagonal shading on the lower and upper part of the towel. The mantel is darkened and has a fringe, and the two vases are patterned. The San Francisco impression (Atelier) is unique.

Again, in the third state there is drypoint and burnishing. The bather's hair is reworked, and her hands better defined. Horizontal and oblique lines cover the interior of the tub. The picture on the wall is more distinct. Fine flicks model the bases and surrounds of both vases; this work is retained throughout the remaining states. Three impressions are known: AIC (Atelier), East Berlin, private collection, Paris (Rouart).

A very few additions in drypoint are made in the fourth state, which is recorded in two unevenly printed impressions. The door and the dado at right are shaded with vertical lines, while two long folds appear on the right of the towel. Two impressions were located: East Berlin (acquired 1919) and LC.

In the fifth state drypoint shades the bather's left leg, and the tub water is indicated with long diagonal lines. Short diagonals pattern both walls. The maid's face is abruptly cast into shadow, and the upper right fold of the towel is altered in shape. The only known impression in a private collection was formerly Rouart's.

In a lightly printed impression of the sixth state, pale, fine-grained aquatint describes the water in the tub and adds tone to the mantel and rug. The rim of the tub near the bather's hands and a few branches that emerge from the vases were drawn in drypoint. One impression exists: Warrington (Atelier).

In the seventh state a few drypoint strokes suggest a pattern on the top of the armchair. The rug is crosshatched with drypoint rich in burr. The only impression of this state, in the National Gallery of Canada, is inscribed as having belonged to Camille Pissarro.

There are a number of changes executed in fine drypoint lines in the eighth state. A lock of hair falls on the bather's back, while a horizontal line between her arms defines the panel of the door. Fine patches reinforce the pattern on the top of the armchair, and additional scribbles decorate the walls. There is new hatching on the picture, and additional tufts are on the carpet. The Bibliothèque Nationale impression, once belonging to Loys Delteil, is the only one located.

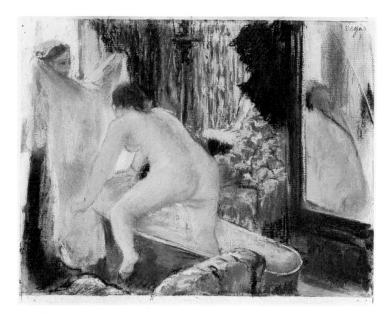

42. Fig. 3.
Woman Getting out of the Bath, about 1877. Pastel over monotype. Norton Simon Inc. Foundation, Los Angeles.

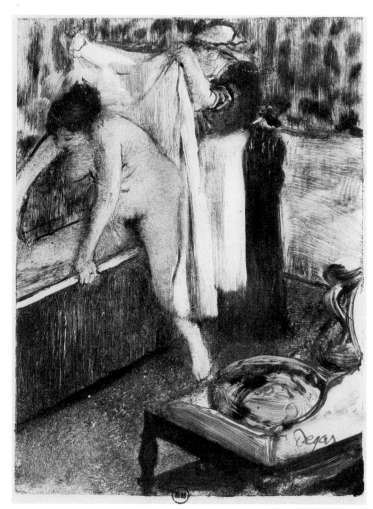

42. Fig. 4.
Woman Getting out of the Bath, about 1877. Monotype. Bibliothèque Nationale, Paris.

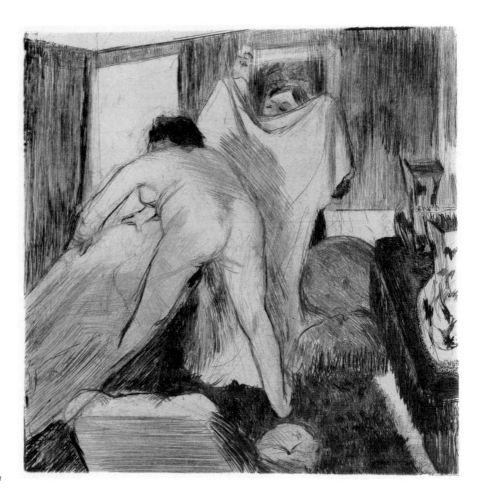

42 third state

42 fourth state

The ninth state shows a number of major revisions executed in drypoint. The bather's contours were redrawn, with an indented waist; her right shoulder and lower back were shaded. The armchair and walls bear a bold, large pattern of dark scribbles on a light ground. The towel, whose upper fold is now a deep vee, has begun to change into a robe, and an area of burnishing and drypoint that will be developed into a sleeve masks the top of the small chair. There is fresh work on the mantel, vases, and branches, but the drypoint burr is no longer present on the rug. Two impressions record this state: British Museum and MFA (Atelier).

A second application of aquatint, deeply bitten and carefully stopped out, appears in the tenth state and is used to describe water in the tub. Accidental pitting occurred here as well as on the bather's legs and her robe. There is also aquatint on the walls, the small chair, the mantel, and the rug, which exhibits a serpentine pattern. One impression is known: Amsterdam (Atelier).

In the eleventh state most of the aquatint has been burnished from the tub and walls. The water is now represented by long, oblique drypoint lines, and the wall pattern is created by bold drypoint scratches. The bather's lock of hair is redrawn, and her hands are more distinctly outlined. Additional drypoint sets off the robe's emerging sleeve and shades the small chair with vertical strokes. The branches are extended farther to the left. Two impressions have been located: University of Texas, Austin, and Artemis Group 1983 (Atelier).

Four known impressions record the twelfth state, which is one of the most resolved and satisfying of the series. Considerable drypoint work refines the image. The bather's right contour is redrawn, and the water in the tub curves around her leg. Her shadow is cast on the robe, whose sleeve has a diagonal fold. A short, nearly vertical, accidental scratch appears on the back of the armchair. This state is represented in the BAA, Kornfeld (two, both Atelier), and MMA (Atelier).

In the thirteenth state burnishing reduced the shaded area of water. The small fringed chair is better defined with hatching, and horizontal lines appear on the rug. The near corner of the mantel is clearly formed. Two impressions are known: Smith College (Atelier) and Tunick 1977 (Atelier).

New work in aquatint created major tonal changes in the fourteenth state. Most noticeably it covers the bather, darkens the outside of the tub, revises the shape of the mantel, and fills in the light areas of the rug. The pattern on the armchair and the vases is now expressed in aquatint. Judicious touches of aquatint and drypoint describe new folds in the robe. Vertical drypoint lines shade the tub's interior. One impression is in the Clark Art Institute.

In the fifteenth state Degas began to lighten the overall tonality with burnishing and made small amendments in drypoint. Burnishing models the bather's body, and her backbone begins to be visible. There is new drypoint shading on the wall above her arm, on the door, the frame, and most noticeably on the right side of the robe. The topmost horizontal panel of the door is redrawn. The edge of the mantel is defined by burnishing, and a teacup and long rectangular shape, probably representing a hairbrush or comb,

appear on top of the mantel. The vases have been burnished, and new drypoint strokes added to a rim and the branches. One impression is in the MMA (Atelier).

In the sixteenth state Degas more completely defined the bather's backbone with burnishing and made further drypoint additions. A strong line defines the far rim of the tub; vertical lines further shade its interior, the walls, and the formerly white dado at right. Lines with burr have been added to the maid's hair, the small chair, and the tub. The corner of the mantel with its deep edge is clearly shaped; the saucer is dark; the branches are taller. There is one impression of this state in the Clark Art Institute.

In the seventeenth state there is additional drypoint work. Vertical and horizontal hatching appears throughout: inside the tub between the bather's hands, on the wall at left, on the door, and around the head of the maid. Hatching is used to darken and model the robe more forcefully. A few curved lines simulate water in the tub, and horizontal lines shade the hearth. The plants are taller and thicker. One impression is known: Talleur (Atelier).

In the eighteenth state burnishing makes more apparent the backbone of the bather's heavy body. There are also drypoint additions. Many curved lines represent water in the tub. Diagonal hatching occurs in the tub as well as on the wall above. Fresh drypoint elaborates the decorative design throughout the background. The defining line of the right side of the tub is more pronounced. One impression is in the Josefowitz collection.

In the nineteenth state the image is sharpened by drypoint and burnishing. Vertical lines define the left corner of the room, shade the right side of the door, and appear on the tub between the bather's hands. A deep vee-shaped fold models the upper part of the robe. Burnishing lightens the teacup and saucer. One impression is in Copenhagen (Atelier).

In the twentieth state most of the drypoint burr present in the previous states has been scraped away; overall the print exhibits lighter tonality except for the areas of strong aquatint. The pattern on the rug is more noticeable. One impression is in the NGA (Atelier).

In the twenty-first state Degas dramatically changed the coloration and spatial relationships of the image by means of extensive revisions in drypoint. With a sharp point he drastically altered the shape of the bather, whose figure is now wide and bulky. With a broad tool, perhaps an emery pencil, he entirely shaded the bather, the left sides of the tub and the door, and the robe, creating an overall gray tone. The plants are enlarged, and the rug has a well-defined, sharp edge. One impression with printing defects records this state: NGA (Atelier).

In the twenty-second and final state Degas burnished much of the drypoint tone from the previous state, leaving the composition unresolved. The shading has been removed from the bather, the tub, the door, and the towel. Some of the bather's contour lines were burnished, and these attempts at erasure are especially visible along her upper arm. Long, oblique lines shade the hearth. Two impressions of this final state are known: Kornfeld, and private collection, Chicago (Atelier).

Impressions from the canceled plate are pale but resemble

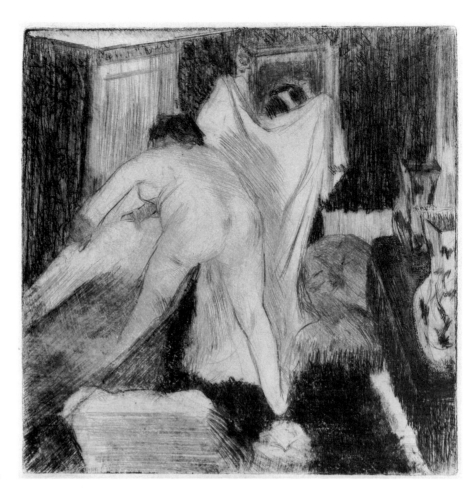

42 fifth state

42 sixth state

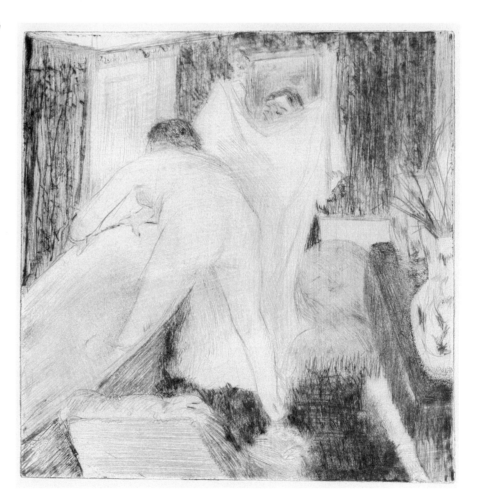

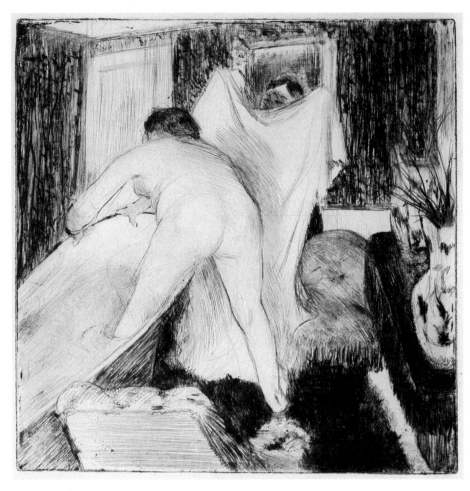

42 seventh state

the twenty-second state in terms of the stage of development. These document the fact that Degas never returned to experiment further with this plate.

Notes

1. Degas, *Letters* 1947, no. 41; Degas, *Lettres* 1945, no. 32:
Mon cher ami,
Je n'ai fait tirer qu'hier ce petit essai avec le crayon de charbon. Vous voyez comme c'est d'un joli gris. Il faudrait des crayons à l'émeri. Donnez-moi donc une idée pour en faire moi-même. Je n'ai pas pu Vendredi en causer avec votre frère. Merci de la pierre qu vous m'avez envoyée. Elle raye le cuivre d'une facon délicieuse. Est-ce un aggloméré comme en fait Denis Poulot? Avec la loupe, j'ai lu Delanoue aîné.
Sur quoi pourrai-je l'user en pointe?
Pas le temps de faire des essais un peu sérieux. Toujours des articles à confectionner. Le dernier est un éventail en camaïeu pour Mr. Beugniet. Je ne pense qu'à la gravure et n'en fais pas.

2. Gerstein 1982, p. 109.

3. We are grateful to Douglas Druick and Peter Zegers for bringing to our attention documentary evidence of these weather conditions; see *La Nature*: *Revue des sciences*, 15 Nov. 1879, and 20 Dec. 1879, which mentions the record cold spell beginning in October.

4. Rouart 1945, p. 65.

5. *La Nature,* a scientific journal designed for a general audience, contained many articles that traced the progress made in the development of electric lighting. Illustrations show the various ways the carbon rod was employed. See, in particular, 30 Nov. 1878, and other articles for the years 1878-79.

6. Druick has pointed out that an impression of the third state of Pissarro's print was shown at the sixth Black and White Exhibition, Dudley Gallery, in 1878, entitled *Paysanne renversant une brouette remplie de fumier.*

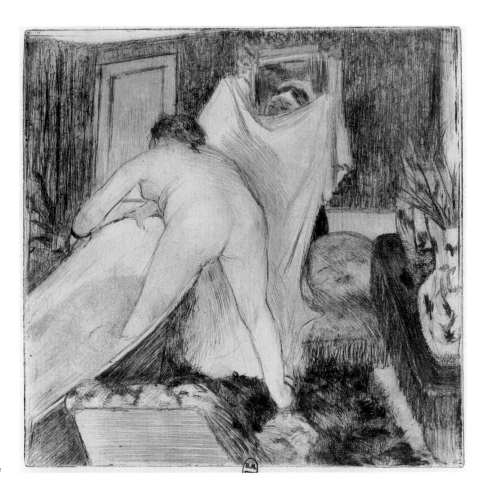

42 eighth state

42 ninth state

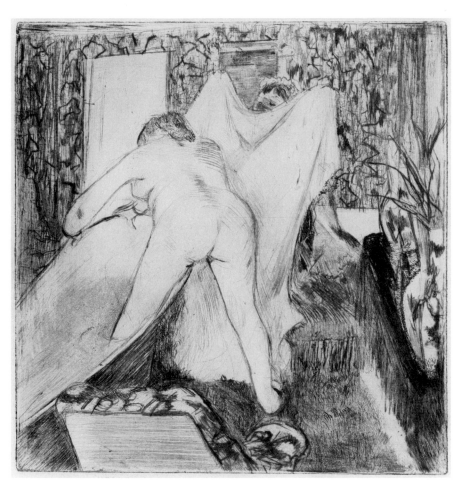

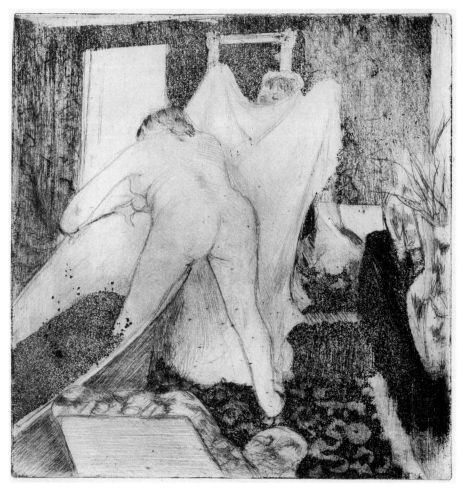

42 tenth state

42 eleventh state

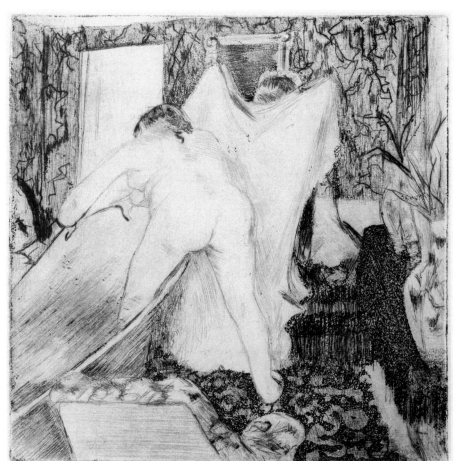

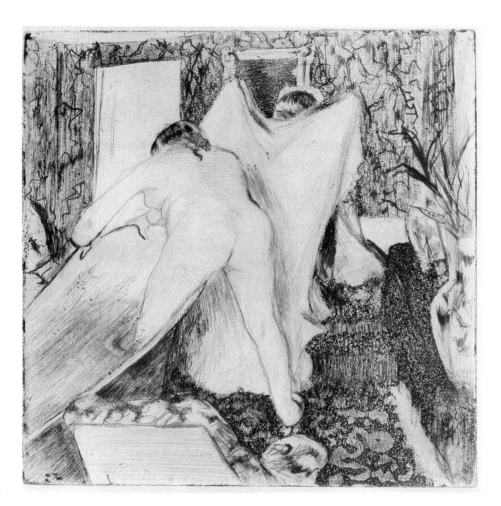

42 twelfth state

42 thirteenth state

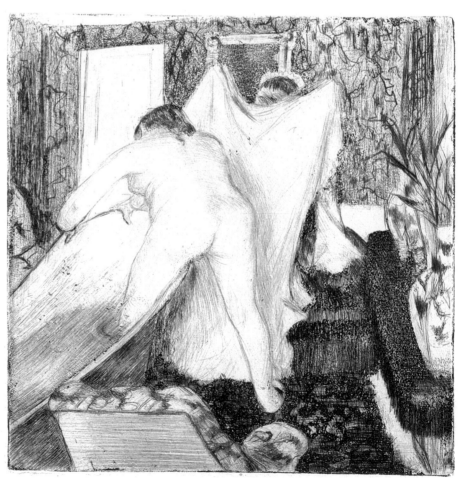

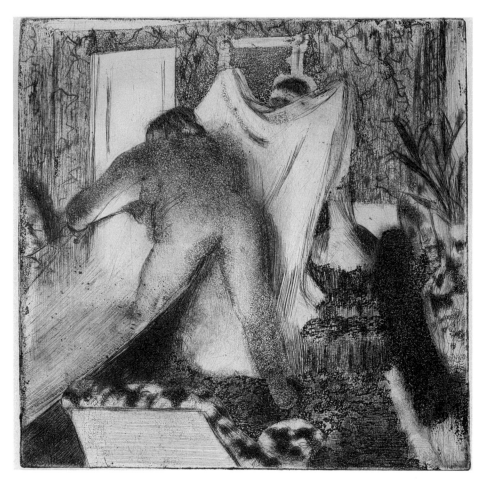

42 fourteenth state

42 fifteenth state

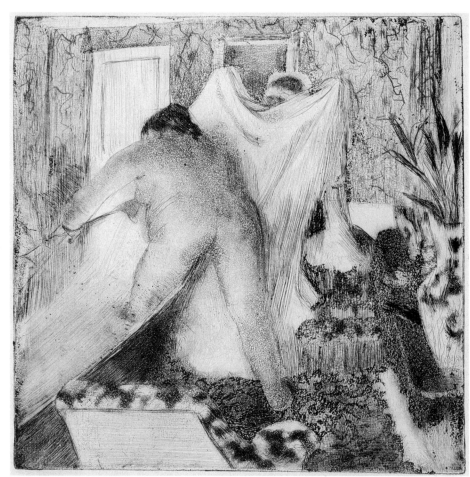

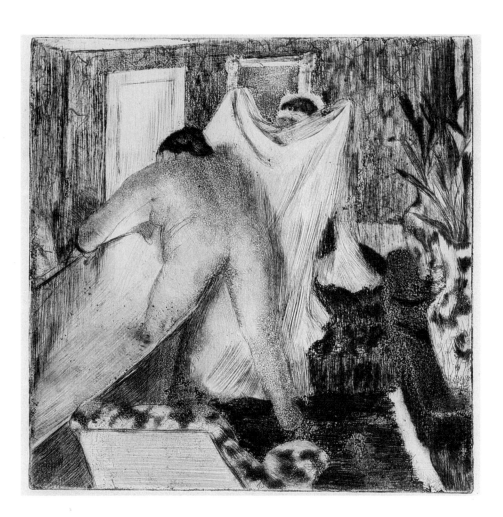

42 sixteenth state

42 seventeenth state

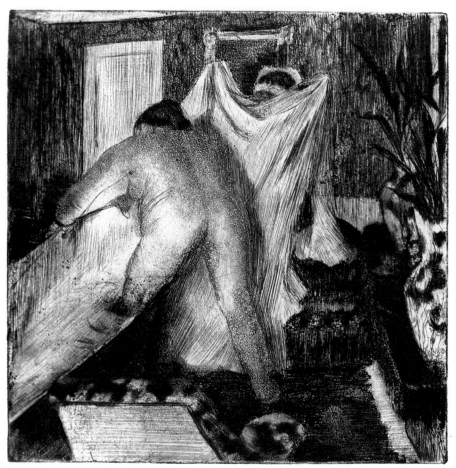

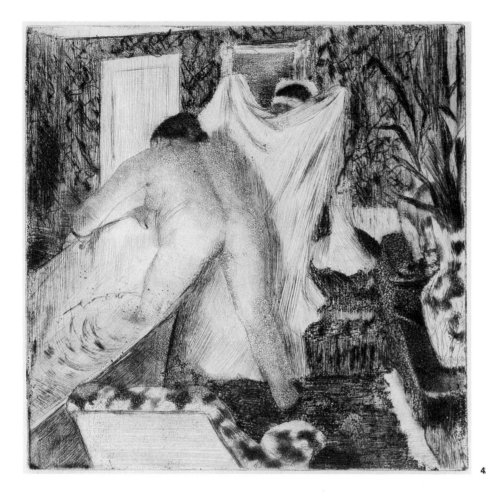

42 eighteenth state

42 nineteenth state

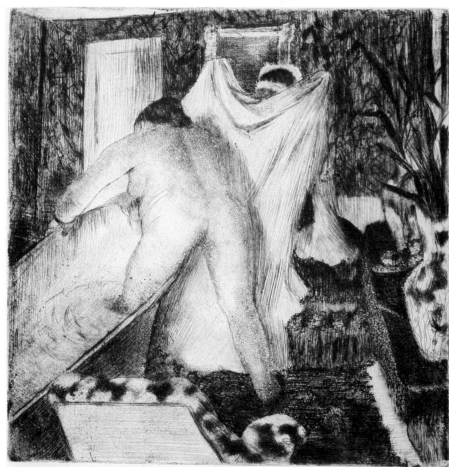

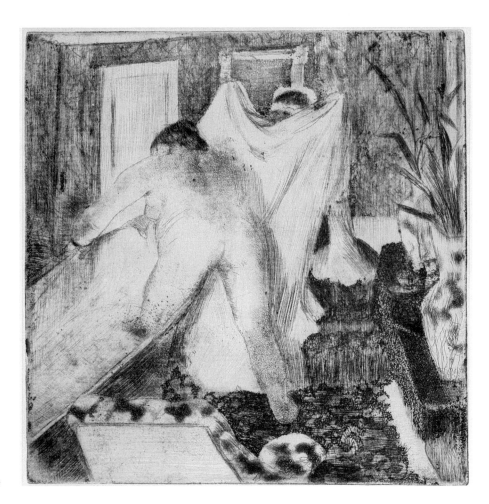

42 twentieth state

42 twenty-first state

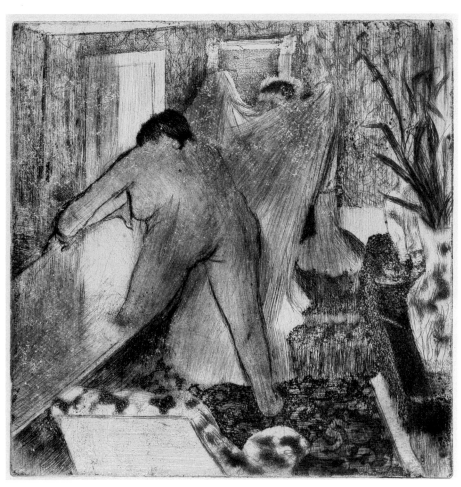

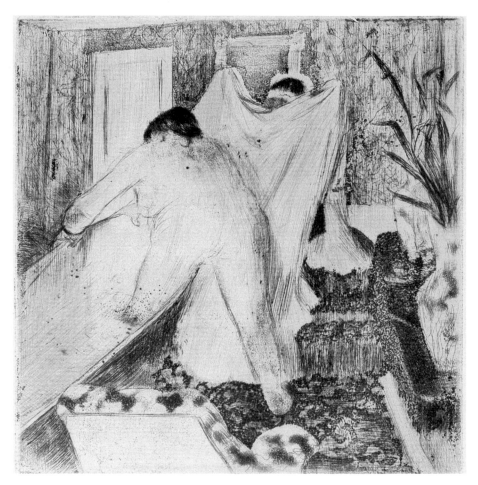

 42 twenty-second state

 42a impression from canceled plate

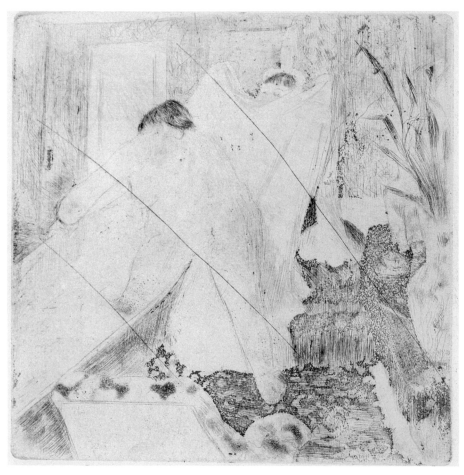

43

Head of a Woman in Profile 1879

Softground etching, aquatint, and drypoint. One state
Delteil 42 (not dated); Adhémar 50 (about 1878-79)
115 x 113 mm. platemark
Cream, medium weight, moderately textured, laid paper
193 x 260 mm. sheet
Watermark: partial shield with cursive letters: *VGZ*
Inscribed in pencil lower part of sheet: *essaie de grain liquide*
épreuve unique par M. Degas/Mary Cassatt
The Metropolitan Museum of Art. Bequest of Mrs. H. O.
Havemeyer 1929

This unique print belonged to Mary Cassatt, who, late in life,
inscribed it: "unique impression [of an] experiment with liquid
aquatint." She also mentioned the print in a letter to Louisine
Havemeyer, March 22, 1920: "Before leaving Paris I sold to the
DR's [Durand-Ruel] all I had left of my drypoints & a lot of pastel
drawings, & amongst them one unique etching of Degas, un essai
wet grain which Braque [Bracquemond] had got him to try."[1]

It seems very likely that the plate was executed in 1879-80,
when Degas, Cassatt, and Pissarro, as well as Bracquemond, were
focusing on a proposed journal of original prints (see cat. no. 51).
During this time Degas corresponded with Pissarro about the use
of liquid aquatint in combination with softground etching:

This is the method. Take a very smooth plate (it is essential, you
understand). Degrease it thoroughly with whiting. Previously you

will have dissolved resin in very concentrated alcohol. This liquid,
poured after the manner of photographers when they pour collo-
dion onto their glass plates (take care, as they do, to drain the
plate well by inclining it), this liquid then evaporates and leaves the
plate covered with a coating, more or less thick, of small particles
of resin. In allowing it to bite you obtain a grainy texture, deeper or
less deep, according as to whether you allowed it to bite more or
less. To obtain equal tints this is necessary; to get less regular
effects you can obtain them with a stump or with your finger or
any other pressure on the paper which covers the softground.[2]

Indeed, this print, in which the brim and crown of the hat are
shaded with softground lines, serves as an excellent illustration of
the printmaking techniques described in Degas's letter. The profile
is lightly sketched in drypoint, which acts as a boundary for the
stopping out of the aquatint tones. The abstract patterning of this
enigmatic image, surely considered unfinished in its day, appeals
to our twentieth-century sensibilities.

The relatively simple and straightforward use of liquid aqua-
tint in this experimental print helps one to better understand the
complex technique seen in *Actresses in Their Dressing Rooms*
(cat. no. 50).

Notes

1. Included in Mathews 1984, p. 332.

2. Degas, *Letters* 1945, no. 25. Translation by the authors.

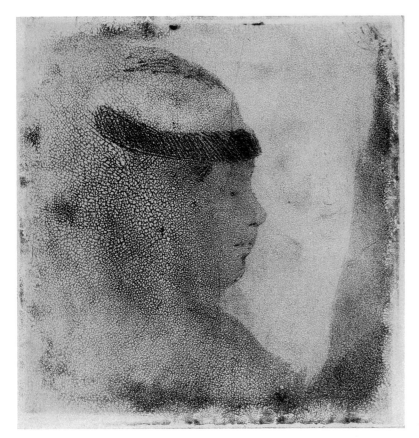

43

44

Head and Shoulders of a Young Woman
in Profile I about 1879

Softground etching. One state
Delteil 45 (not dated); Adhémar 5 (about 1856)
82 x 72 mm. platemark
Oriental paper
276 x 208 mm. sheet
Atelier stamp
E. W. Kornfeld, Bern

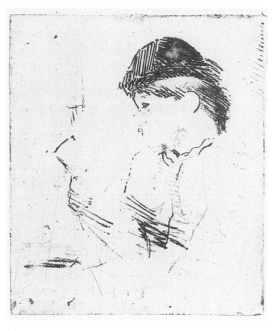

44

45

Head and Shoulders of a Young Woman
in Profile II about 1879

Softground etching. One state
Delteil 44 (not dated); Adhémar 4 (about 1856)
82 x 71 mm. platemark
Oriental paper
288 x 218 mm. sheet
Atelier stamp
E. W. Kornfeld, Bern

These two small experimental prints have caused much confusion with regard to both title and technique. In the Atelier sale (1918) and in his catalogue raisonné, Delteil titled his no. 45 *Buste de femme* but called no. 44 *Les Amourex (The Lovers)*, evidently seeing a second head in the pattern of the foul-biting. He described the medium as "crayon électrique," which was corrected in 1945 by Denis Rouart to "etching." The titles were retained by Adhémar with minor changes.

From our examination it appears that Degas made an incomplete drawing in softground on the recto of the plate (cat. no. 44, Delteil 45) and proceeded to repeat the single image on the verso of the same plate (cat. no. 45, Delteil 44), which exhibits amorphous areas of foul-biting. The small, roughened irregularity in the center of the plate edge at the top of the first version and the bottom of the second is evidence that both images were printed from the recto and verso of the same plate.

The subject matter of these two prints and the manner in which the softground hatching is handled correspond to the *Head of a Woman in Profile* (cat. no. 43) and suggest a similar date.

Although it appears to be accidental, the area of foul-biting does not intrude upon the figure and may have been an experimental attempt on Degas's part to create a bitten tone.

These single impressions were sold in the Atelier sale and are unique.

45

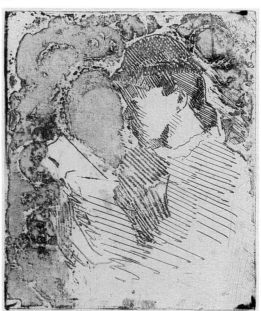

46

Seated Woman in Bonnet and Shawl about 1879

Aquatint, drypoint, and etching. One state, from canceled plate
Delteil 43 (not dated); Adhémar 51 (about 1879)
160 x 118 mm. platemark
Cream, moderately thick, slightly textured, wove paper
320 x 247 mm. sheet
The Baltimore Museum of Art. Blanche Adler Memorial Fund

This unfinished print is a study of a seated woman wearing an off-the-face bonnet and a shawl or cape. The blank rectangles behind her probably represent two paintings hanging on the wall. The subject very likely relates to the pair of prints of Mary Cassatt

visiting the Louvre that evolved from an elaborate sequence of preparatory studies (see cat. nos. 51 and 52). The image was executed on a daguerreotype plate of standard measurements and with crimped corners (see cat. no. 32). It was lightly sketched in drypoint, and areas of the wall and skirt were defined broadly with an aquatint tone. On the floor at the lower right appear etched brush-like strokes similar to those found in *The Laundresses* and *At the Café des Ambassadeurs* (cat. nos. 48 and 49).

The only impressions of this print known to any cataloguer are from the canceled plate.

46

47

Dancers in the Wings 1879-80

Etching, aquatint, and drypoint. Eight states
Delteil 26 (about 1876); Adhémar 28 (about 1877)
140 x 103 mm. platemark

I first state

Cream, moderately thick, moderately textured, laid paper
267 x 165 mm. sheet
Watermark: fragment of DAMBRICOURT
Atelier stamp
Josefowitz Collection, Switzerland

II second state

Cream, medium weight, smooth, laid paper
205 x 175 mm. sheet (irregular)
Watermark: rectangle containing a caduceus and EB
Atelier stamp
E. W. Kornfeld, Bern

III third state

Cream-buff, medium weight, moderately textured, laid paper
270 x 202 mm. sheet
Watermark: PA/A.SA
Atelier stamp
Museum of Fine Arts, Boston. Lee M. Friedman Fund

IV fourth state

Buff, medium weight, moderately textured, wove paper
238 x 196 mm. sheet
Atelier stamp
Philadelphia Museum of Art. Joseph E. Temple Fund

V fifth state

Not located

VI sixth state

White, smooth, wove paper
220 x 132 mm. sheet
Atelier stamp
Anonymous loan

VII seventh state

Gray-white, moderately thin, moderately textured, oriental paper
245 x 170 mm. sheet
Coll.: Beurdeley
Sterling and Francine Clark Art Institute, Williamstown, Massachusetts

VIII eighth state

Cream, medium weight, moderately textured, laid paper
370 x 273 mm. sheet
Watermark: fragment of ARCHES
Atelier stamp
Museum of Fine Arts, Boston. Lee M. Friedman Fund

In this innovative print Degas achieved a variety of tones and patterns ranging from thin tracery to coarse aquatint. As he developed the composition, he moved from a relatively flat, abstract space to an illusionistic stage setting occupied by petite, sharply delineated dancers in profile. The early states resemble Degas's fan paintings of 1878-80, where the small-scale dancers appear and disappear among the enveloping flats. The highly finished final state corresponds in style and conception to paintings and pastels of the same period; see, in particular, the pastel and gouache over monotype *Ballet Dancers* (Lemoisne 491, National Gallery of Art, Washington), in which the asymmetrical composition and the scale and figural type of the long-haired young dancers are remarkably similar to those in the print. (Both works are reproduced in Chicago, *Degas* 1984, no. 43.) In another, less finished, pastel of a dancer on stage (fig. 1), the configuration and back lighting of the scenery correspond to the stage design in the etching.

Because of the ambiguous depiction of the dancers in the middle ground, Guérin's suggestions about an intermediate state between III and IV are unclear. We have preferred to retain Delteil's eight states.

In the first state a relatively even grain of aquatint covers much of the plate except where it is stopped out to indicate a single, circular spot of light. One stage flat at the left is indicated with etched lines created with a multipronged tool, probably a metal brush. There are three dancers lightly sketched in drypoint; the figure at left is pale because it was stopped out and therefore protected from the aquatint tone. This is the only known impression of the first state: Josefowitz (Atelier).

In the second state a heavier grain of aquatint extends up the right side of the image and sets off the dancers, defining their skirts. One horizontal drypoint line indicates where the skirt falls on the foremost dancer's leg, and small amendments of drypoint and burnishing were made to the two dancers at center. This is the only known impression: Kornfeld (Atelier).

The third state exhibits additional etched lines throughout the background: horizontal lines suggest the floor bounded by a stage flat at lower right. More lines clarify the figures of the three dancers; long hair is added to the central figure, and a fourth head is indicated to her left. Only one impression of this state is known: MFA (Atelier).

The fourth state shows extensive reworking with etched lines and burnishing. The head and shoulders of a new figure are added at the far left, bringing the total number of dancers to five. They are glimpsed behind large, clearly delineated stage flats, one of which, in the foreground, covers the foremost dancer's hand. These additions, combined with the horizontal lines added at right

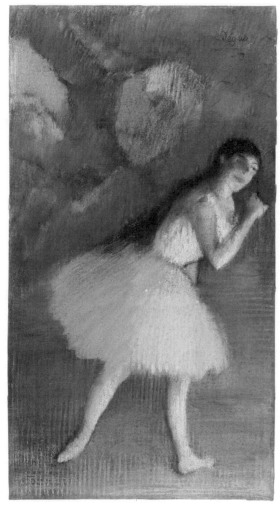

47. Fig. 1.
Dancer on Stage. Pastel. On loan to Museum of Fine Arts, Boston.

in the previous state, suggest a more convincing stage space. The heads of the dancers in the middle ground have been repositioned and do not read very clearly. There are three impressions known: East Berlin (Atelier), NGA (Atelier), and PMA (Atelier).

According to Delteil, the fifth state has erasures on the stage flats at left and right and strong retouches on the hair of three of the dancers that create dominant black spots. No impression corresponding to this description has been located.

In the sixth state Degas boldly burnished the image throughout; the general appearance of the print is light in tonality. Only four dancers are visible. Degas has erased one head in the middle ground while clearly defining the features in profile of another dancer, who wears a bow in her hair. The second circular light at right has been burnished to enlarge its area. One impression is known: private collection (Atelier).

In the seventh state a fifth dancer reappears in the middle ground, turned to the left and visible above the two other dancers, whose heads have been modified somewhat. The two dancers closer to the foreground are also altered; the hair of the one at the far left now hangs below her shoulders and completely masks the features of her companion. There is more etched work on the stage set. This Clark Art Institute impression from the Beurdeley collection is printed with a film of ink except for the more cleanly wiped central orb of light and the dancer farthest to the right. Three other impressions are lightly printed: AIC (Atelier); Kornfeld auction, 1984, no. 240; and an impression reworked with pastel,

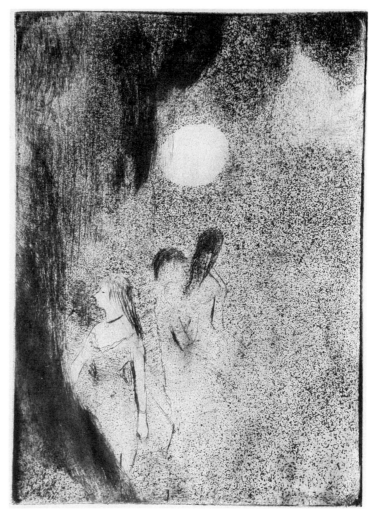

47 first state

probably at a later date (Sotheby Parke Bernet, New York, May 9, 1979, lot 114, illus. [color], incorrectly listed as fifth state).

The eighth state exhibits a long diagonal that divides the upper portion of the stage flat at left. The lower part of this flat is enlarged to cover all but the face and arm of the central dancer. A new tracery of lines appears in the two light areas of the background. There are small, subtle, etched additions to the dancers' figures, and in the clean-wiped impressions of this state a pale, granular tone shades parts of their bodies. At least ten impressions of this last state have been located: Baltimore, Basel (Atelier), BAA, BN (Rouart), LC, MFA (Atelier), NGA, SF (Atelier), private collection, Germany, and private collection, Chicago (Atelier).

145

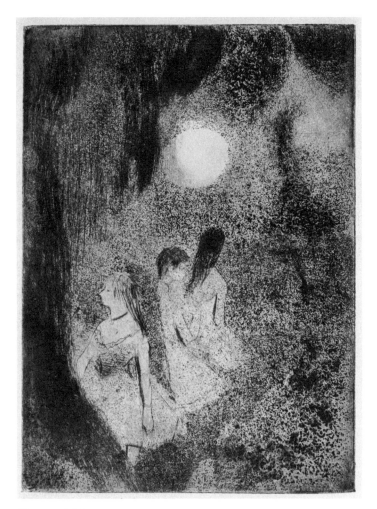

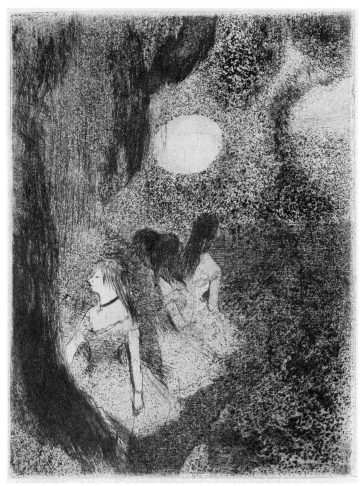

47 second state

47 third state

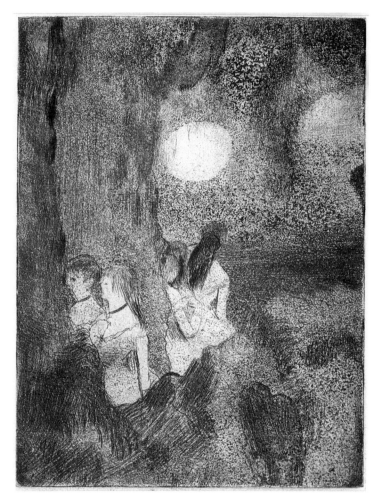

47 fourth state

47 sixth state

47 seventh state

47 eighth state

148

48

The Laundresses 1879-80

Etching and aquatint. Four states
Delteil 37 (about 1880); Adhémar 32 (about 1879)
118 x 160 mm. platemark

I first state

Off-white, medium weight, moderately textured, laid paper
214 x 300 mm. sheet
Watermark: fragment of ARCHES
Atelier stamp
The Minneapolis Institute of Arts. Gift of Mrs. E. Bates McKee,
1975

II second state

Cream, medium weight, moderately textured, laid paper
214/217 x 300/303 mm. sheet
Atelier stamp
Department of Prints and Drawings, The Royal Museum of Fine
Arts, Copenhagen

III third state

Reproduced from Atelier sale III, no. 92
Not located

IV fourth state

Cream, medium weight, moderately textured, laid paper
192 x 241 mm. sheet
Watermark: fragment of ARCHES
The Brooklyn Museum

Although the subject matter is unique in Degas's print oeuvre, *The Laundresses* firmly relates to other etchings of this period (cat. nos. 49 and 50) in its inventive exploration of space and in the use of experimental techniques with painterly effects. The setting of a laundry – with ironing counter, tall windows, linen hanging to dry, and a special stove for heating irons – may be more clearly seen in a pastel in the Burrell Collection, Glasgow Art Gallery (Lemoisne 776). The etching was executed on a daguerreotype plate without the typical crimped corners but bearing the name "Schneider . . . Berlin" on the lower right side. Degas seems to have begun another composition on this plate before executing *The Laundresses*. Numerous light scratches already existed around the standing figure, and a light aquatint grain initially covered the plate. The aquatint was stopped out in the upper right and center, and a pervasive crisscross pattern of white lines was burnished.

In the first state Degas drew the cramped interior of a ground level laundry by etching lines with multipronged tools, including a wire brush and what must have been a double-pointed steel pen.[1] As noted in Chicago, *Degas* 1984, no. 57, there is a correspondence in figural style and technique between this print and Camille Pissarro's etchings of this period, especially *Rain Effect* (fig. 1), an impression of which was owned by Degas (Delteil 24, sixth state). One impression of the fourth state of

48. Fig. 1.
Camille Pissarro. *Rain Effect*, 1879. Etching, drypoint, and aquatint, sixth state. Bowdoin College Museum of Art.

Pissarro's print was inscribed: "Imprimé par E. Degas . . . reprise au pinceau métallique" (printed by E. Degas . . . reworked with a metal brush). Indeed, the use of a wire brush in *Rain Effect* is confirmed in a review by Félix Fénéon, who reported some of Pissarro's methods as described to him by the artist.[2] In Degas's first state the brush-like etched lines block out a composition that is superimposed over an ambiguous aquatint pattern. Four impressions of this state are known: Albertina (Roger Marx), BM (Gift of Charles Ricketts, 1919), Kornfeld (Atelier), and Minneapolis (Atelier).

The second state exhibits more etched linework throughout, clarifying the interior space as well as suggesting the hanging linen that masks the edge of the original aquatint area. Degas differentiated between the verticals of the doorway and the dominant black stovepipe. The dumpy figures of the women, the chair, cat, and mountainous bundle of laundry at right were further shaded. The bowl is now larger and touches the edge of the ironing counter. Two impressions are known: Copenhagen (Atelier) and private collection, Germany (Gerstenberg).

In the third state Degas erased the bowl almost entirely. He redrew the slipper of the standing laundress so that it drops off her heel. In the foreground the handle of the iron that is being warmed on the stove reads clearly. An application of aquatint darkens the stovepipe and appears in small patches at the left of the woman who approaches outside the door. The only unretouched impression known is here illustrated from the Atelier sale. An impression reworked with pastel and belonging to Mme Gérard was exhibited in the Galerie Georges Petit "Exposition Degas . . . ," Paris, 12 April-2 May, 1924, no. 207. It was cited as Delteil's third state.

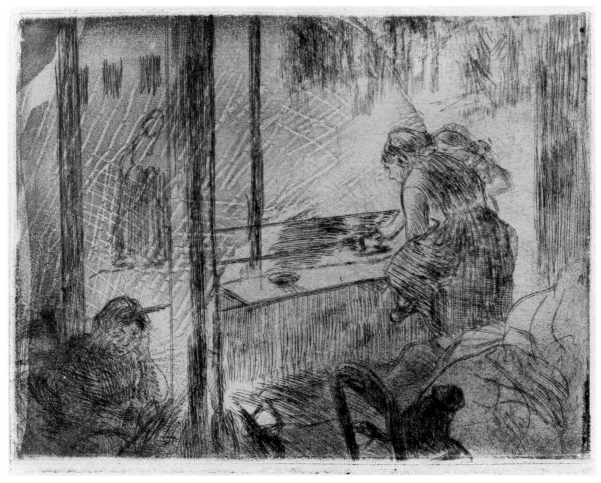

48 first state

The fourth state exhibits considerable scraping of the image, especially on the seated laundress, the chair, cat, stovepipe, and wall to the left of the doorway; the curious aquatint shape at the upper left was removed. The spatial ambiguities in this print are not unlike those found in *Actresses in Their Dressing Rooms* (cat. no. 50). The plate was left in this technically and compositionally unresolved condition. Nevertheless, eight impressions of this state are known, two of which were given by Degas to friends: AIC, BAA (signed), BN (Rouart), Brooklyn, Clark (signed), Josefowitz (Atelier), NGA (H. Lerolle), N. Simon (Atelier).

Notes

1. Double-pointed steel pens were manufactured in the nineteenth century for use by accountants.

2. Félix Fénéon, "Exposition de la Revue Indépendante" (Jan. 1888.), in *Oeuvres* (Paris, 1948), p. 119.

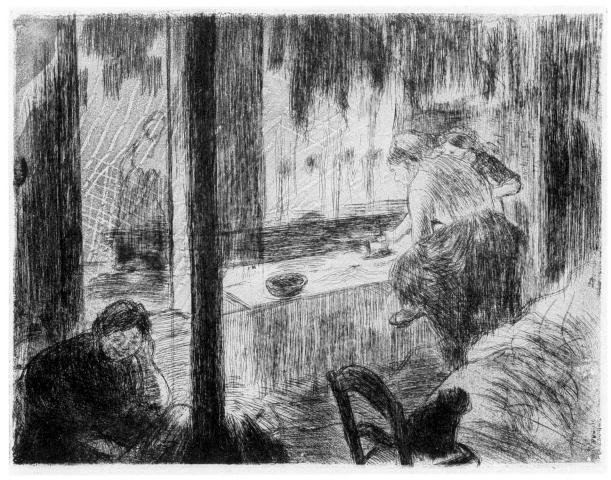

48 second state

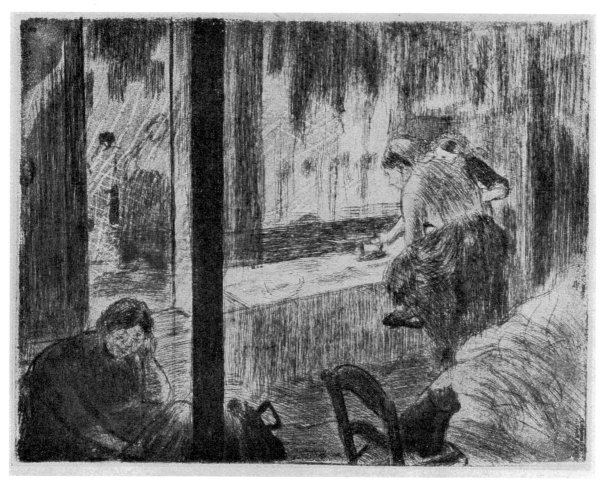

48 third state

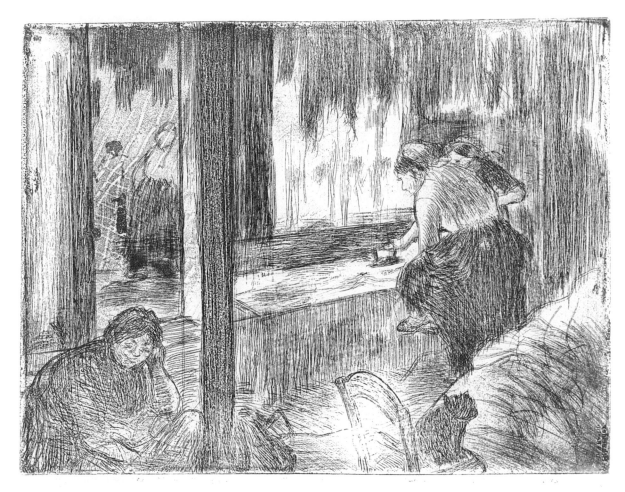

48 fourth state

49

At the Café des Ambassadeurs 1879-80

Etching, softground, drypoint, and aquatint. Five states
Delteil 27 (about 1875); Adhémar 30 (about 1877)
266 x 296 mm. platemark

I first state

Moderately thick, moderately textured, laid paper
285 x 325 mm. sheet (irregular)
Graphische Sammlung, Albertina, 1924
Exhibited in Boston

II second state

Cream, moderately thick, moderately textured, laid paper
318 x 343 mm. sheet
Watermark: VAN GELDER
Atelier stamp
Private collection
Exhibited in Boston and Philadelphia

III third state

Buff, moderately thick, moderately textured, laid paper
470 x 315 mm. sheet
Coll.: Rouart
Sterling and Francine Clark Art Institute, Williamstown, Massachusetts

IV fourth state

Cream, moderately thick, rough, laid paper
356 x 378 mm. sheet
Atelier stamp
Graphische Sammlung, Albertina, 1924
Exhibited in Boston

V fifth state

White, thick, smooth, wove paper
313 x 449 mm. sheet (irregular)
National Gallery of Canada, Ottawa

This painterly and very theatrical print is Degas's largest etching
and expands the view presented in the lithograph *Singer at a Café-
Concert* (cat. no. 26). In both prints Degas included distinctive
architectural elements and chose an unusual vantage point behind
the performers on the outdoor stage. As noted by Janis, it is in a
roughly worked and difficult-to-read monotype that this composi-
tion first appears (fig. 1).[1]

An impression of the third state of the etching, reworked
with pastels by Degas in 1885, aids in understanding the forms in
the print and the monotype. The vertical shape rising prominently
in the foreground plane and colored brown in the pastel (fig. 2) can
be clearly identified as a tree trunk. Although a lush covering of
pastels is generally found in Degas's reworked monotypes, the
fine, horizontal lines visible in the unworked area at the upper left
confirm that the etching served as the base for this pastel. (For

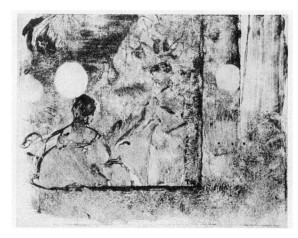

49. Fig. 1.
Café-concert. Monotype. Saarbrucken Museum.

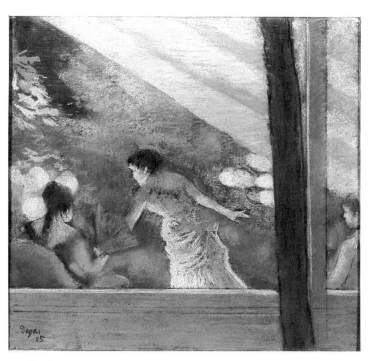

49. Fig. 2.
At the Café des Ambassadeurs, 1879-80. Etching reworked with pastel. Signed and
dated 1885. Musée du Louvre, Cabinet des Dessins, Camondo Bequest, 1911. Photo:
Documentation photographique de la Réunion des musées nationaux.

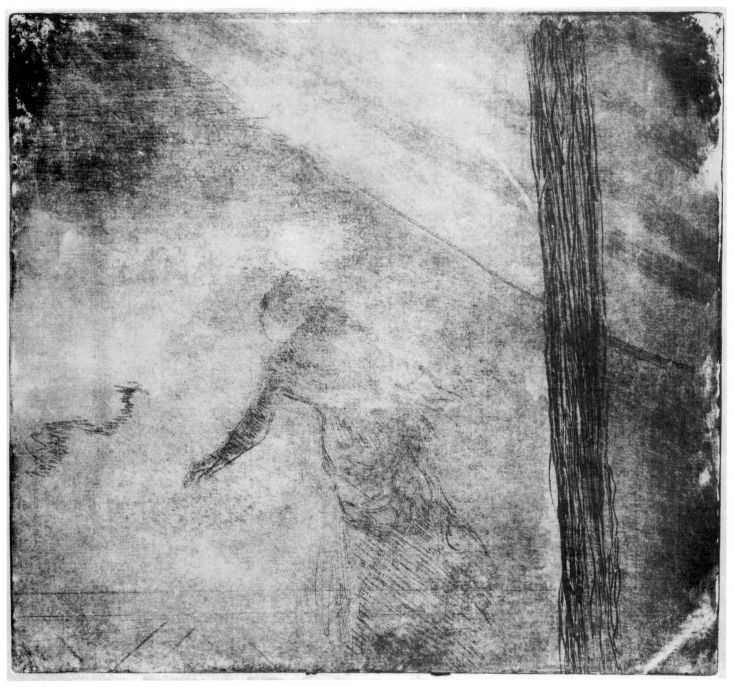

49 first state

similar reworkings of other prints, see cat. nos. 30, 31, 50, 51.)

Guérin was correct in suggesting that there are five rather than three states of this print (see also the five states described in Galerie Marcel Guiot's catalogue of the A. H. Rouart sale, 1936, preceding lot 125). The first and fourth states are each known in only one impression (both in the Albertina) and were probably those described in the Atelier sale as a maculature and a semi-erased proof.

The unique first state is unevenly inked but indicates the main elements of the setting: awning, tree trunk, and latticework railing, behind which is glimpsed the back of a single performer. Once again Toulouse-Lautrec's lithograph *Aux Ambassadeurs* (cat. no. 26, fig. 1) of 1894, helps with the reading of the image. Degas probably applied a relatively soft etching ground through which he drew with a variety of implements. He used a broad point to describe the bark of the tree, a stiff brush to make the stripes on the awning, and a double-pointed pen to depict the figure (see also cat. no. 48). A pale bitten tone covers the plate in an uneven fashion and may have been achieved by means of softground or fine-grained aquatint. This Albertina impression was perhaps the one described in the Atelier sale (no. 68) as a maculature of the first state, although it does not bear a stamp.

Much of the existing work in the first state is more readily legible in the second. A new bitten tone, most likely a fine-grained aquatint, extends evenly over the plate except where it is stopped out to describe four gas globes and the pale awning above. New short drypoint hatchings shade a vertical architectural support at the right of the tree trunk and the top of the railing in the foreground. This unique impression from a private collection appeared in the Atelier sale (no. 68) as a first state.

In the third state Degas made a number of additions to the plate that are clarified by a study of the pastel over etching. He added a second performer at the left, seated in an armchair, holding a fan. He has hinted at a third figure, blocked by the tree trunk, who also waits her turn and holds in her lap a paper-wrapped bouquet of flowers. The contour of the tree trunk has been extended. The balustrade and the wall at right are now totally darkened, as are the hair and dress of the performer. The background is covered with bundles of etched lines that give the appearance of freely painted brushstrokes; the gas globes are neatly outlined. The overall result of these additions is an extended range of tonalities and an enrichment of the textures. There are three impressions of this state: AIC (possibly the "maculature" cited as no. 69 in the Atelier sale, although it lacks a stamp), BN, and Clark (Rouart). In contrast to the BN's cleanly wiped impression with a number of highlights, the Clark's impression retains a film of ink on the awning and figures; only the gas globes have been left relatively free of ink to glow in the smoky, nocturnal atmosphere.

A unique, unevenly inked impression of the fourth state is probably that described also under no. 69 of the Atelier sale as a "half-erased" impression. It exhibits broad, etched lines that widen the tree trunk, thus decreasing the triangular area of the awning. A patch of lines darkens the space between the principal singer's skirt and her right arm. There are also fine lines of shading under her left arm and beside the profile of the seated woman at left. Etched "brushstrokes" are imposed on the globes, to suggest leafy foliage. Accidental biting is visible on the awning. The only known impression is Albertina (Atelier).

In the fifth and final state a coarse-grained aquatint was applied to unify the dark areas of the background and the tree trunk. The partially burnished figures of the performers are now paler than before, and the profile of the seated figure is amended. By altering the light effects, Degas has reversed the tonal relationships of the figures and their settings; the glow of the footlights sets off the singers from the murky background, an effect that is particularly noticeable in the clean-wiped impression from the National Gallery of Canada. It is interesting to note that when Degas reworked the third state with pastels in 1885, he approximated the balance of light and dark of the fifth state and included a heavyset woman in an armchair who more closely follows the initial monotype model.

Note

1. Janis 1968, checklist no. 31; and Cachin 1973, no. 7.

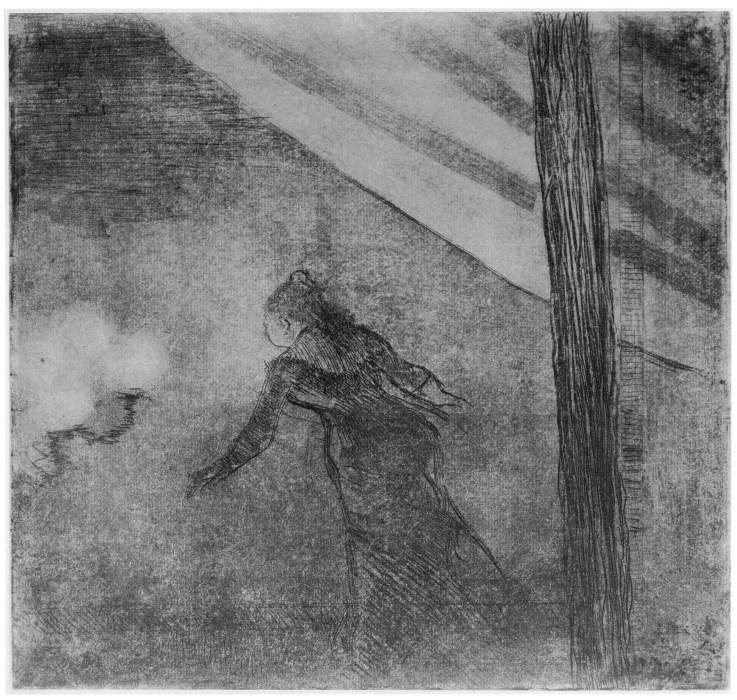

49 second state

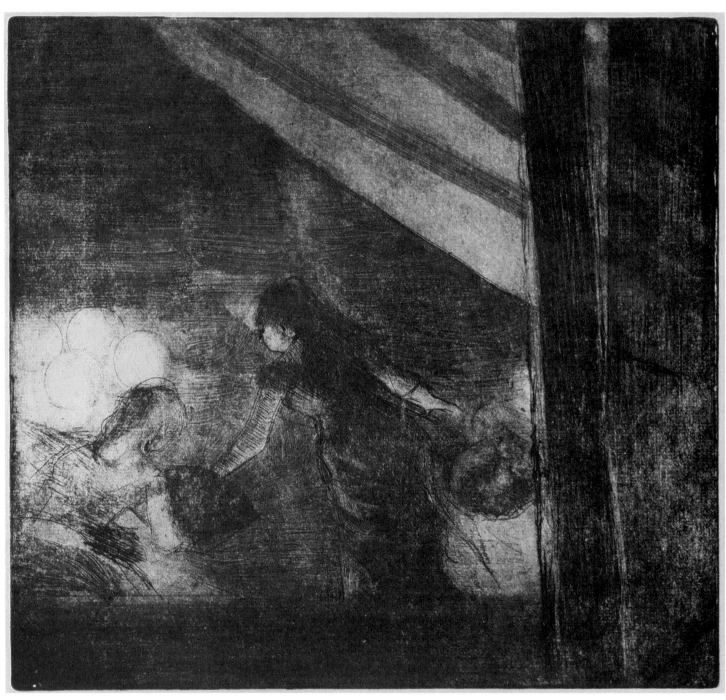

49 third state

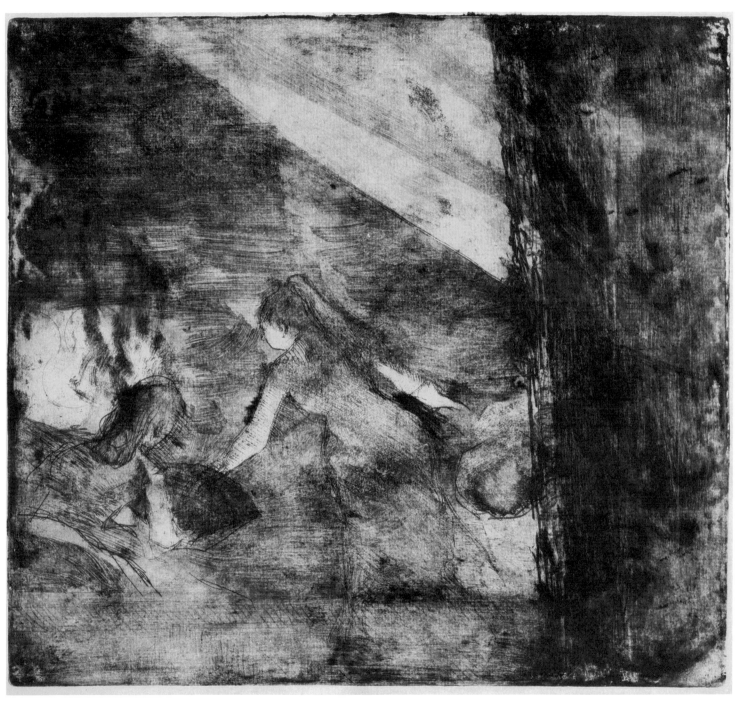

49 fourth state

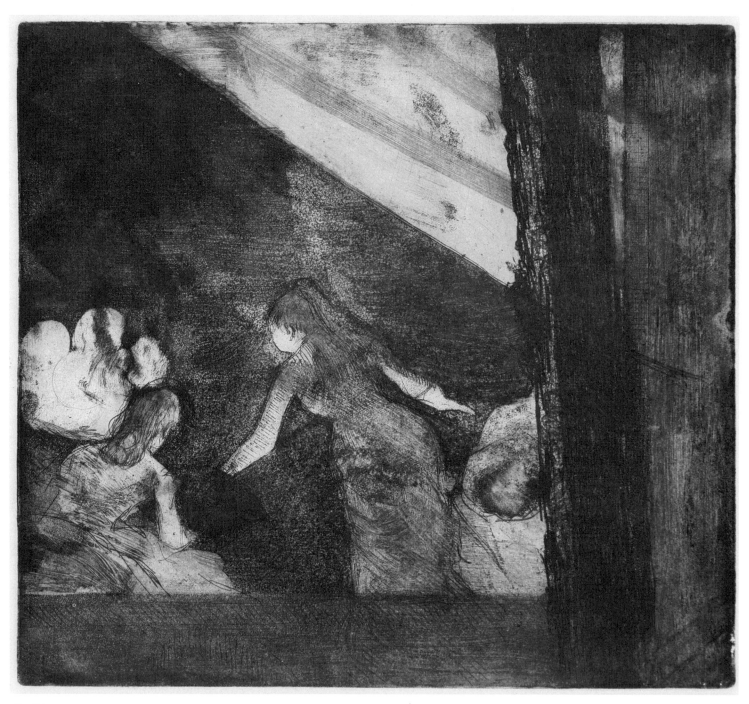

49 fifth state

50

Actresses in Their Dressing Rooms 1879-80

Etching and aquatint. Five states
Delteil 28 (about 1875); Adhémar 31 (about 1879-80)
161 x 213 mm. platemark

I first state

Off-white, thick, smooth, wove paper
193 x 260 mm. sheet
Coll.: Roger Marx
Kunsthalle, Bremen

II second state

Cream, moderately thick, smooth, wove paper
278 x 360 mm. sheet
Atelier stamp
*The Art Institute of Chicago. Albert H. Wolf Memorial Collection
1935.185*

III third state

Off-white, medium weight, slightly textured, wove paper
235 x 263 mm. sheet
Coll.: Rouart
Bibliothèque Nationale, Paris
Exhibited in London

IV fourth state

White, thick, smooth, wove paper
225 x 310 mm. sheet
Coll.: Atelier; H. Whittemore
National Gallery of Art. Rosenwald Collection, 1949

V fifth state

White, thick, smooth, wove paper
170 x 245 mm. sheet
Atelier stamp
*Stanford University Museum of Art. Gift of Marion E. Fitzhugh and
Dr. William M. Fitzhugh in memory of their mother, Mary*

Va fifth state

Pastel over etching
165 x 229 mm. sheet
Signed upper right: *Degas*
Private collection
Exhibited in Boston

In this striking print of two mature actresses preparing for their
performance in adjoining dressing rooms, Degas depicts a subject
not commonly undertaken in his paintings or pastels. The sense of
intimacy and voyeurism as well as the treatment of these voluptu-
ous figures probably derive from the monotypes of brothel sub-
jects that Degas began to execute as early as 1876.[1] The composi-
tion of *Actresses in Their Dressing Rooms* relates to that of a

number of the monotypes Degas made to illustrate Ludovic
Halévy's *La Famille Cardinal*, two novellas about the fictional Cardi-
nal daughters, Pauline and Virginie, who were ingenue ballet danc-
ers at the Paris Opéra. Degas's handling of the complex spatial
arrangement in this print, with a division into vertical panels, is
much the same as that in the *Cardinal* monotypes, in which back-
stage corridors and dressing-room doorways are depicted (see
Cachin 66, 67, 69, and 70). Moreover, for this etching and for
these monotypes Degas used daguerreotype plates of the same
dimensions.

The print is unique in its exploration of the unusual effects
created by artificial light in an interior space rather than on an
outdoor stage. There is a remarkable interplay between cast
shadows and the brightly illuminated parts of the figures that are
nearest the sources of artificial light. The dressing room print is an
interior counterpart to the outdoor settings so carefully studied in
the café-concert lithographs (cat. nos. 25 and 26).

Delteil's descriptions of the state changes are unclear; given
below are the characteristics of each state based on an examina-
tion of fourteen surviving impressions.

In the first state Degas broadly established the composition
in four vertical zones. Using several tones of liquid aquatint that
cover the plate, he suggested some forms including the cast
shadow that would dominate the center of the print. Etched lines
imply the figures of the two women. There are two known impres-
sions of the first state: Bremen (Roger Marx) and Gérald Cramer,
Geneva, cat. 11, 1958, lot 45, cited as a first state (Atelier).

In the second state Degas more fully described the figure of
the actress at left and augmented her long, thick hair. She is now
seated on a curved-back chair. The figure at right is better defined,
and her legs are completed; her dressing room is more detailed.
Degas burnished areas of aquatint to indicate sources of artificial
light and their reflections on both figures. There are etched stria-
tions added to the wall panels and to the large cast shadow.
Degas used single and multipointed tools to create this variety of
lines and tonal areas. Only one impression is known: AIC (Atelier).

Another grain of aquatint was added in the third state and is
especially to be noted on the now legible open door of the farther
dressing room. A decorative pattern of aquatint appears on the
walls at right and left. The small chair, burnished and redrawn, is in
a new position with its shadow visible. Degas also defined the top
surface of the dressing table with burnishing. This unique impres-
sion was imperfectly printed, and white paper fibers appear on the
surface of the sheet; nevertheless, Degas gave it to his friend A.
H. Rouart (BN).

New aquatint was bitten in the fourth state to enlarge the
shadow above the mirror at left and to create a patterned shape at
the lower left that may be read as an armchair or as a costume
cast aside. Almost all traces of the curved-back chair have been
erased, althought its shadow remains. Two impressions have been
located: MMA and NGA (Atelier).

In the fifth and final state a new dark and coarser aquatint
pattern was added to the wall panels, masking over the remains of

50 first state

the small chair. With a few strongly etched lines Degas added a wall at left, defined the ceiling, and suggested an open door, thus creating a box-like interior space. With touches of burnishing and an etched line he clarified the top of the dressing-room doorway across the corridor. These judiciously placed lines dramatically altered the definition of space, moving away from the flatness of the screen-like panels of the previous states. The clarification of the open door accounts more logically for the bold, cast shadow of the seated woman. Severe but localized pitting occurred in this state. One should also note that there are significant variations in the printing of the plate, depending on the amount of ink selectively wiped from the highlighted areas of and around the figures.

Despite the accidental biting, Degas appears to have been satisfied with the resolution of the image and printed at least eight impressions: Albertina, BAA (signed), Bergquist, BM (Atelier), Clark (Atelier), Kornfeld (Atelier), private collection, Germany, Stanford (Atelier).

An impression of the fifth state fully worked over by Degas with pastel, probably in 1885, was sold at auction in the United States in 1909.[2] The pastel work extends slightly beyond the platemark and corrects the spatial ambiguities still found in the fifth state. Degas eliminated reference to the ceiling and clarified the central panel as an open door. The seated actress, brightly lit, is depicted on a larger scale and occupies a more rational space in

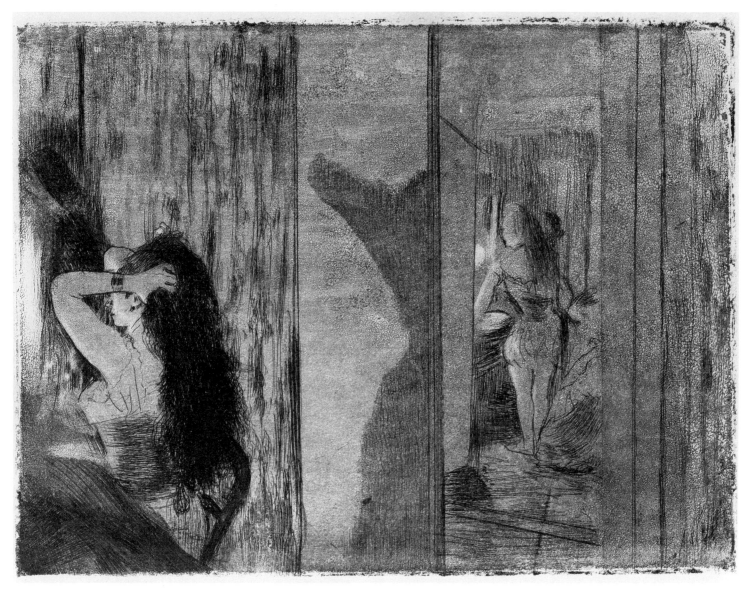

50 second state

the foreground. Her costume skirt hangs from the wall above and covers the corner of the room. Degas has made revisions to the view through the doorway, improving the perspective and increasing the sense of distance. The etched work of the standing figure in her dressing room is still clearly legible under a thin layer of pastel. The bright colors of the pastels heighten the sense of backstage drama that is merely implied in the black and white etchings.

Notes

1. See Cachin 83-123 for illustrations of all known brothel subjects.

2. American Art Galleries, New York, James Inglis sale, 11-12 March 1909, lot 18; and subsequently at the same gallery, 18-20 Jan. 1916, lot 44.

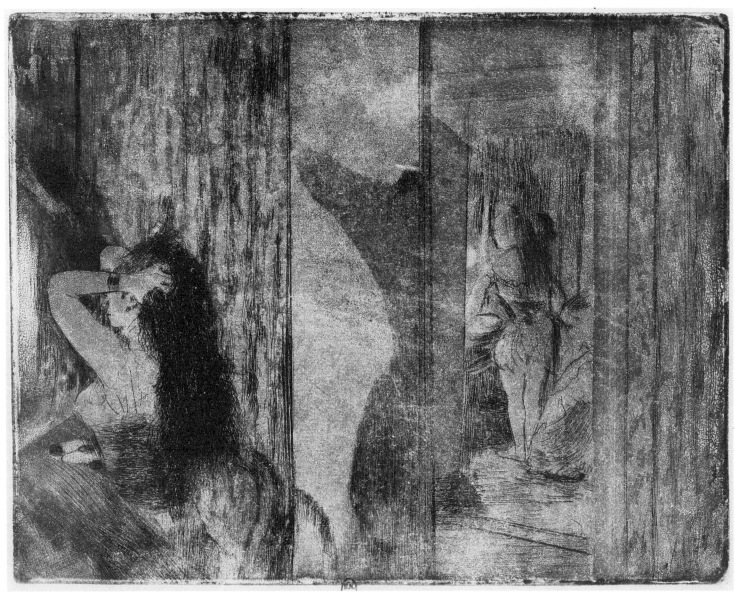

50 third state

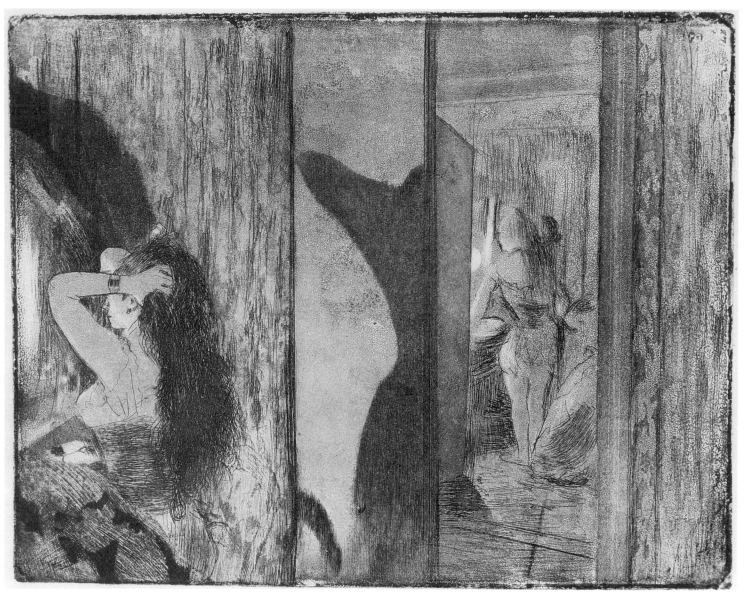

50 fourth state

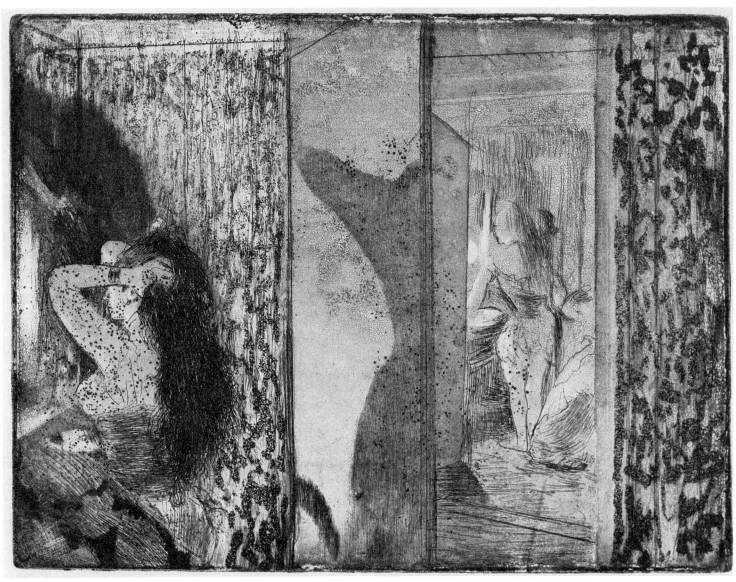

50 fifth state

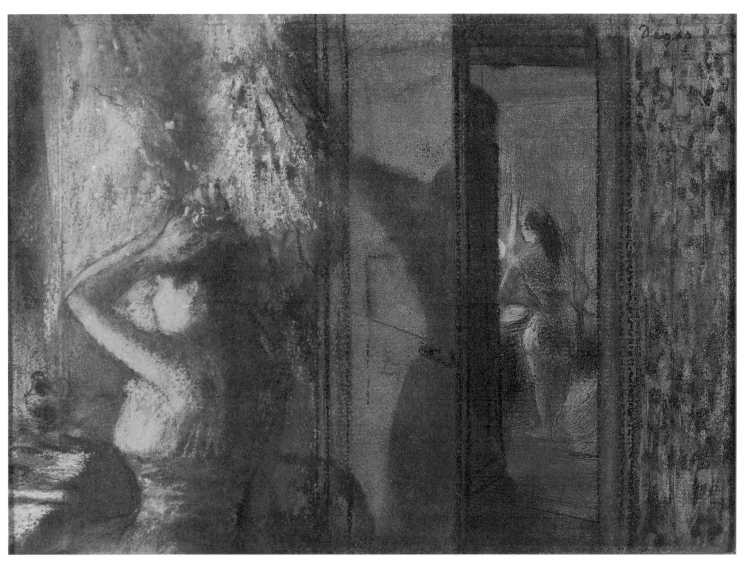

50a fifth state, reworked with pastel

51

Mary Cassatt at the Louvre:

The Etruscan Gallery 1879-80

Softground etching, drypoint, aquatint, and etching. Nine states
Delteil 30 (1876?); Adhémar 53 (1879-80)
267 x 232 mm. platemark

51a

Study for Mary Cassatt at the Louvre
Recto: graphite
Verso: softground adhering to traced lines
Off-white, thin, smooth, wove paper
323 x 245 mm. sheet
Atelier and Degas signature stamps
Mr. and Mrs. Paul Mellon, Upperville, Virginia
Not in exhibition

51b

At the Louvre: The Etruscan Sarcophagus
Graphite
Off-white, wove paper
108 x 163 mm. sheet
Degas signature stamp
Sterling and Francine Clark Art Institute, Williamstown, Massachusetts

I first state

Cream, moderately thick, moderately textured, laid paper
430 x 303 mm. sheet
Watermark: fragment of ARCHES
Atelier stamp
Mr. and Mrs. Paul Mellon, Upperville, Virginia
Not in exhibition

II second state

Buff, medium weight, moderately textured, laid paper
428 x 308 mm. sheet
Watermark: fragment of ARCHES
Atelier stamp
Private collection

III third state

Cream, moderately thick, moderately textured, laid paper
415 x 292 mm. sheet
Atelier stamp
Milwaukee Art Museum. Purchase, Milwaukee Journal Company Funds

IV fourth state

Cream, medium weight, moderately textured, laid paper
Bibliothèque d'Art et d'Archéologie, Fondation Jacques Doucet, Paris
Not in exhibition

V fifth state

Cream, moderately thick, moderately textured, laid paper
432 x 302 mm. sheet
Watermark: fragment of ARCHES
Coll.: Atelier stamp; purple circular stamp with frontal eagle (not identified)
The Toledo Museum of Art. Frederick B. Shoemaker Fund

VI sixth state

Cream, moderately thick, moderately textured, laid paper
430 x 306 mm. sheet
Watermark: fragment of ARCHES
Atelier stamp
The Cleveland Museum of Art. The Charles W. Harkness Endowment Fund

VII seventh state

Cream, moderately thick, moderately textured, laid paper
420 x 310 mm. sheet
Watermark: fragment of ARCHES
Coll.: Rouart
Museum of Fine Arts, Boston. Katherine Eliot Bullard Fund in memory of Francis Bullard and proceeds from the sale of duplicate prints

VIII eighth state

Cream, moderately thick, moderately textured, laid paper
427 x 307 mm. sheet
Watermark: fragment of ARCHES
Atelier stamp
The Brooklyn Museum

IX ninth state

Cream, thin, smooth, oriental paper
359 x 270 mm. sheet
Atelier sale
Josefowitz Collection, Switzerland

At the close of the fourth Impressionist exhibition (10 April-11 May 1879), discussions were already underway for Degas's proposed journal of original prints, *Le Jour et la nuit* (*Day and Night*). The financial success of the exhibition encouraged Degas to enlist the participation of his friends. In a diary entry, 16 May 1879, the novelist Ludovic Halévy wrote: "Visit to Degas. I met him in the company of *l'indépendante* Miss Cassatt, one of the exhibitors of the rue de la Paix. They are very excited. Each has a profit of 440 francs from their exhibition. They are thinking of launching a journal; I ask to write for it."[1]

At the same time, letters from Degas implore Félix Bracquemond, master of the etching medium, to join his venture and to give advice on the intricate technical skills desired by Degas for the execution of these special prints for a wide audience. A well-

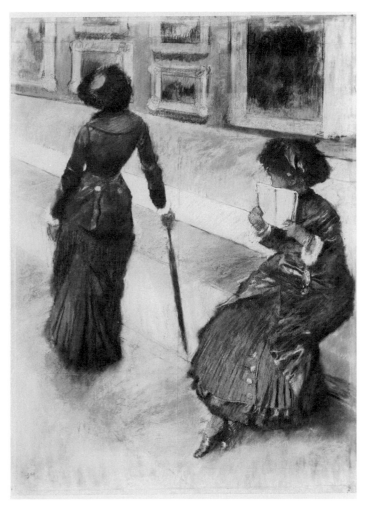

51. Fig. 1.
At the Louvre (Miss Cassatt). Pastel on joined paper. Photo: Sotheby Parke-Bernet, New York.

known letter to Pissarro transmits much of this experimental information and confirms Degas's wish for a great success: "remember that you must make your début with one or two very, very beautiful plates of your own work."[2] Along with Pissarro, Mary Cassatt, Jean-François Raffaëlli, and Marcellin Desboutin, Degas prepared prints from the fall of 1879 through the early months of 1880. At the fifth Impressionist exhibition (1-30 April 1880) works executed for the journal were in fact exhibited by Cassatt: both the first and fifth states of *In the Opera Box (No. 3)* ("Femme au théâtre. Eau-forte. Premier état, dernier état"); by Pissarro: four states of *Wooded Landscape at L'Hermitage, Pontoise*, mounted with yellow mats in a single violet frame ("Un cadre: Quatre états du paysage faisant partie de la première livraison de la publication 'le Jour et la nuit' "); and Degas's *Mary Cassatt at the Louvre: The Etruscan Gallery* was almost certainly included on this unique

occasion among his exhibited prints ("Eaux-fortes. Essais et états de planches").

In each case, the artists made etchings of related format after pre-existing models: Degas adapted a pastel (fig. 1), while Cassatt and Pissarro translated in black and white etchings the light effects and colorations of painted prototypes: respectively, *Young Woman in a Loge*, exhibited in the fourth Impressionist exhibition, 1879, and *Wooded Landscape, L'Hermitage, Pontoise*, dated 1878.[3] Moreover, each artist can be associated with a group of prints related in size and experimental technique, all executed during the same period and under the supervision of Degas. Since it would not have been practical to produce only one etching at a time, it can be assumed that much of this body of work was intended eventually for the journal of original prints.

A number of notations convey Degas's profound commitment to the project and the inventive ideas he had in mind for it (see Reff *Notebook* 30, pp. 208-202, used in reverse order): "For the journal – Crop a great deal – do a dancer's arms or the legs, or the back. . . . Do all kinds of objects in use, placed, associated in such a way that they take on the *life* of the man or woman. . . . Series on instruments and instrumentalists . . . do in aquatint a series on *mourning* (different blacks). . . . On smoke. . . . On evening – Infinite subjects – In the cafés the different values of the lamps reflected in the mirrors. On bakeries, *Bread*." Although none of the etchings for the journal (cat. nos. 47-52) can be associated in subject matter with these comments, they reflect Degas's sophisticated interest in the workings of light and shade.

Through a reading of Cassatt family correspondence a chronology can be worked out for these collaborative efforts. On 1 September 1879, Mary Cassatt's father wrote to his son: "She [Mary] has been fretting over the fact that for three months she has not been doing any *serious* work etc. – and the next Annual Exposition is already staring her in the face."[4] But by 15 October, he related "Mame is just now very much occupied in 'eaux-fortes.' "[5] Finally, it is Mary Cassatt's mother who determinedly sets the record straight and reveals Degas's difficulty in completing a project: "Mary had the success last year, but [in] this one she has very few pictures and is in the background. Degas who is the leader undertook to get up a journal of etchings and got them all to work for it so that Mary had no time for paintings and as usual with Degas when the time arrived to appear, he wasn't ready – so that 'Le Jour et la nuit' (the name of the publication) which might have been a great success has not yet appeared. Degas never is ready for anything – this time he has thrown away an excellent chance for all of them."[6] No issue of a journal of prints ever appeared. Since Pissarro's and Raffaëlli's etchings were printed in an edition of fifty, one can assume that the same number of impressions was made for Degas's.

The identities of the two museum visitors in Degas's print have often been discussed; however, many of the artist's contemporaries recognized in one of them the distinctive bearing and costume of Mary Cassatt. P.-A. Lemoisne wrote in 1912, during Degas's lifetime: "In 1880, M. Degas made several etchings for *Le Jour et la nuit*, an artistic publication that he had organized with

several comrades. . . . It was there that appeared, among others, that well-known [print], of which there exist several variants, representing standing, from the back, leaning on her umbrella, Miss Cassatt, his pupil, looking at paintings in the Louvre."[7] It is generally accepted that the standing figure is Mary Cassatt and the seated figure holding a guidebook may be her sister, Lydia.

The intaglio prints *Mary Cassatt at the Louvre: The Etruscan Gallery* and *Mary Cassatt at the Louvre: The Paintings Gallery* (cat. no. 52) were based on an existing pastel (Lemoisne 581; fig. 1).[8] Rather than acting as an intermediate step between the two etchings, this highly finished work served as the initial model. The pastel, composed of a number of joined sheets, reveals Degas's preoccupation with the placement of the figures. This concern was likewise extended to each print, where he varied the format and the relationship of the two museum visitors, as well as altering the setting.

A pencil drawing (cat. no. 51a) played a vital part in the development of both etchings. Degas reproduced from the pastel the silhouettes of the two women and details of their costumes; they were drawn facing in the same direction and on a reduced scale. The standing figure in the drawing is larger in proportion than its counterpart in the pastel; in turn, the figures in the drawing are exactly the same size as those in the prints. (See the essay "Degas and the Printed Image" for a discussion of the use of photographs and tracings as an intermediate step.) Degas laid a grid of ruled lines over each figure to assist in placing the two for the print. He folded the drawing sheet over the plate coated with softground and traced the contours of the seated figure; he then moved the sheet lower and traced the contours of the standing figure, bringing her more into the foreground. The verso of the sheet reveals the traced lines in softground that adhered to the paper and positively confirms the role of this sheet in the transfer of the two women as they appear in the first state of *The Etruscan Gallery*. Using the grid lines as a guide, Degas also employed this drawing as an aid in the subsequent rearrangement of the figures in *The Paintings Gallery* (cat. no. 52).

In the first state, the museum visitors are set against a blank background. Their fine softground contours match the lines on the verso of the drawing sheet. The entire costume of the standing woman and parts of the seated figure have been darkened with patches of drypoint executed with a carbon rod. Degas repositioned in drypoint the umbrella originally indicated with softground lines. This unique impression (Mellon) was in the Atelier sale.

In the second state the artist used additional drypoint to shade the seated woman and to further darken the standing one. He began to suggest the setting by outlining a bench and indicating a shadow beneath the skirt of the seated figure. Degas took advantage of the tonalities possible with his varied drypoint tools, as may be seen in the range of values from the pale face and gloves to the dark patches in the jackets and hats. Three impressions of the second state are known: AIC (Rouart, signed), East Berlin (Roger Marx), private collection (Atelier).

Degas decided to place the pair of museum goers in one of the Louvre's galleries of antiquities, studying an Etruscan sarcoph-

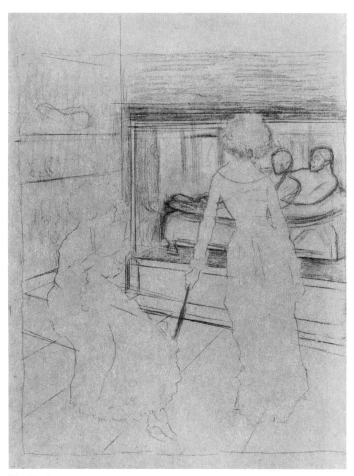

51. Fig. 2.
Study for The Etruscan Gallery (recto). Pencil on white paper. Formerly private collection, London.

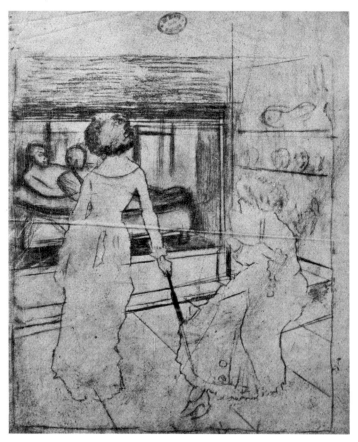

51. Fig. 3.
Study for The Etruscan Gallery (verso). Pencil. Atelier sale IV, no. 249b. Present location unknown.

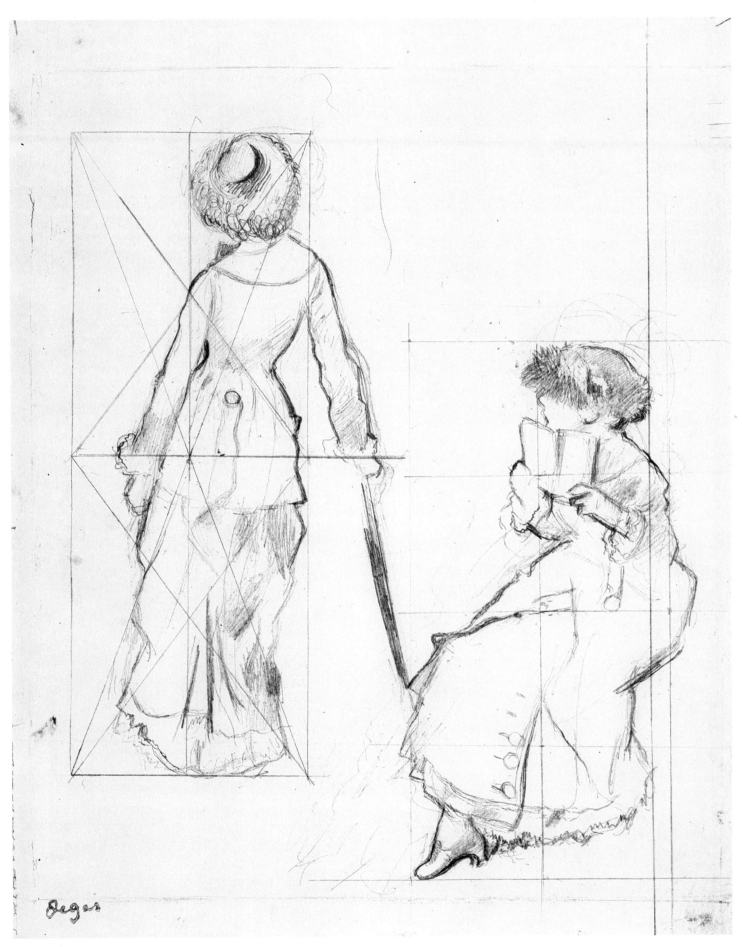

Degas

51a (recto)

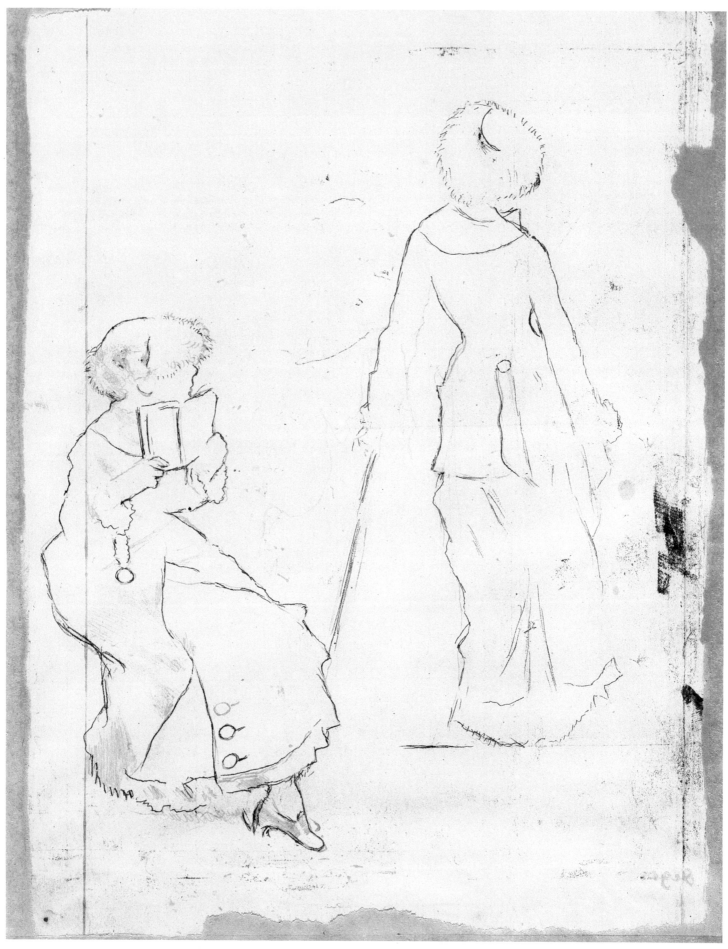

51a (verso)

172

51b

agus, rather than in the Grande Galerie of paintings depicted in the pastel. One can only speculate about the reasons for this decision. Perhaps it was made because the format of the plate lent itself to a horizontal setting; or perhaps Degas thought that the complex patterns of light reflected on the glass display case evoked the title of his projected journal, *Le Jour et la nuit* (*Day and Night*). Finally, he may have wanted to include this wonderful yet curious ancient object for its appeal to potential buyers of his etchings.

A small sketchbook page (cat. no. 51b) records Degas's careful observations of the terra-cotta sarcophagus with its life-sized husband and wife reclining on a couch. He has paid close attention to the structure of the glass case and the windows of the gallery and to the light and reflections in each. Degas utilized this study in another drawing where he reversed and enlarged the sarcophagus and set it into the larger context of a gallery space. This compositional drawing, known only from photographs, appears to be on thin tracing paper and may be read in equal strength from both sides (recto, fig. 2, and verso, fig. 3).[9] It shows the outline of the plate edge and the figures, traced from an impression of the second state where their contours are the same. The Etruscan sarcophagus and setting of the gallery were then drawn on the recto of the sheet, around the silhouetted figures. Degas turned the sheet over and laid it on the grounded etching plate. He redrew some parts of the background in order to transfer them; multiple

lines may be noted particularly on the sarcophagus and its case. The manner of the transfer process is uncertain because of the extensive additions of aquatint in the third state that mask the character of these lines. It is difficult to ascertain whether the linework was executed in etching, softground etching, or drypoint.

In the third state of the print at least two tones of aquatint were applied to color the women's costumes and the bench. More important, the aquatint provides a tonal description of the gallery setting, including the antique sculpture and the objects on shelves in a wall case at left. Degas depended upon both the detailed study of the sarcophagus and the tracing paper drawing in order to translate the intricate reflections into aquatint. He seemed satisfied with the setting as it was first printed, and only minor adjustments were made to it in the succeeding states. There were a number of small changes to the figures. Two impressions of the third state are known: MMA (Atelier) and Milwaukee (Atelier).

After the third state, there are enough changes to the plate by means of burnishing and linework to persuade the present authors that the number of states should be increased from six, as cited by Delteil, to nine.

The only known impression of the fourth state is in the Bibliothèque d'Art et d'Archéologie. On the jacket below the collar of the standing woman, Degas added small dots in drypoint to supplement the overall aquatint tone. These specks of drypoint fill

in the three white patches or highlights seen in the previous state.

In the fifth state there are added patches of drypoint shading on the floor and on the molding of the case. Two new lines were etched in the light part of the upper window. The standing woman's jacket displays delicate, scribbled lines that give it a texture and consistent tonality, while her skirt is further shaded with fine crosshatching. Slight burnishing appears on the heads of the sculptured figures. Two impressions of this state are Boymans Museum (Rouart) and Toledo (Atelier); another (Atelier) impression, with a few minor additional touches of burnishing on the jacket and skirt, belongs to N. G. Stogdon.

In the unique impression of the sixth state (Cleveland/Atelier) there are a number of small adjustments in drypoint and burnishing evident throughout the image. More patches of drypoint shade the floor under the bench and touching the seated woman's feet. Two vertical lines define the lower left edge of the display case. Degas burnished much of the work off the jacket, leaving a film of ink to even the tonality. He also attempted to remove the short horizontal line in the upper window.

In the seventh state vertical lines shade the left side of the book. A newly applied aquatint grain gives an even tone to the jacket of the standing woman. Some of the drypoint lines added in the previous two states are fainter here, particularly the work on the floor. The areas of burnishing behind the heads of the sculpture now read as three light vertical stripes instead of the previous four. The impressions in the MFA (Rouart) and NGA (Atelier) are representative of the seventh state; an impression in the Clark (Atelier) shows a few strokes of burnishing on the standing woman's jacket.

In the eighth state Degas burnished the back and sleeves of the jacket, creating folds and highlights to model the fashionable figure of Mary Cassatt. Again, he directed his attention to the lower left edge of the case to clarify its definition with burnishing. He further lightened the reflections behind the heads of the sculptured figures. There are two impressions of this state: Albertina and Brooklyn (Atelier).

Vertical hatching appears on both sides of the book in the ninth (Delteil's sixth) state. Degas authorized the professional printer Salmon to print this final state in an edition of fifty for the proposed journal. We have documented more than twenty impressions in American and European public and private collections. For the most part, these were printed on a thin oriental (japan) paper, although a few impressions can be found on an off-white, thick, wove paper; one impression on cream, medium weight, laid paper was given by the printer Porcaboeuf (son-in-law of Salmon) to the Bibliothèque Nationale, Paris, in 1898. The Rijksmuseum, Amsterdam, has an impression on japan signed in black chalk by Degas. The impression at the Art Institute of Chicago bears touches of red chalk on the jacket of Mary Cassatt, who was well known for her distinctive russet costumes and her striking hats.

In the course of the development of the image, the fresh and strong drypoint in the second state is, for the most part, scraped away or overlaid with aquatint. This dramatic change observed in the third state suggests that intervening work on the plate must have been executed and not recorded. The paler drypoint in the final state blends in with the moderate aquatint tones to give a soft, gray appearance to the editioned print.

Notes

1. Ludovic Halévy, "Carnets," *Revue des deux mondes*, 15 Dec. 1937, p. 826. Translated in Edinburgh, *Degas* 1979, p. 76.

2. Degas, *Letters* 1947, no. 34; Degas, *Lettres* 1945, no. 25. We believe that this letter can be dated early fall 1879 after Mary Cassatt's return from her summer travels. At that time Degas wrote: "My dear Pissarro, I congratulate you on your enthusiasm. I hurried to Miss Cassatt's with your parcel" (see note 4 below).

3. Reproduced along with the prints in Isaacson 1980, pp. 80-83 and pp. 150-53, respectively. Information on Degas's project as well as a discussion and listing of the fourth and fifth Impressionist exhibitions have been brought together in this useful catalogue.

4. Mathews 1984, p. 147. Mathews indicates (p. 145) that after the close of the 1879 Impressionist exhibition, Cassatt traveled for the summer, stopping first in England.

5. Reprinted in Isaacson 1980, p. 82.

6. Ibid.

7. Lemoisne 1912, p. 90.

8. Sold at Sotheby's, New York, May 15, 1984, lot 8, illus. (color).

9. We have noted that the recto of this drawing bears both the Degas signature stamp at lower left and the oval Atelier stamp pale and upside down in the upper center. The verso shows the oval Atelier stamp upside down and reversed but in the same position on the sheet. The wrinkles and creases on the verso photographed in 1918 are not visible in the recto first published in Degas, *Lettres* 1947, pl. 19; conservation may account for the removal of the wrinkles and the paleness of the Atelier stamp.

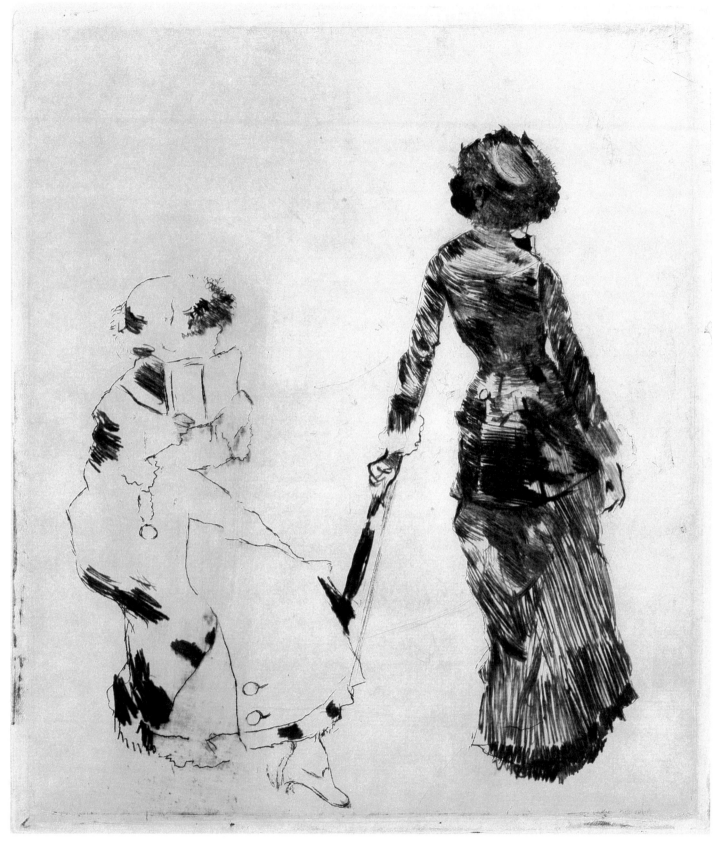

51 first state

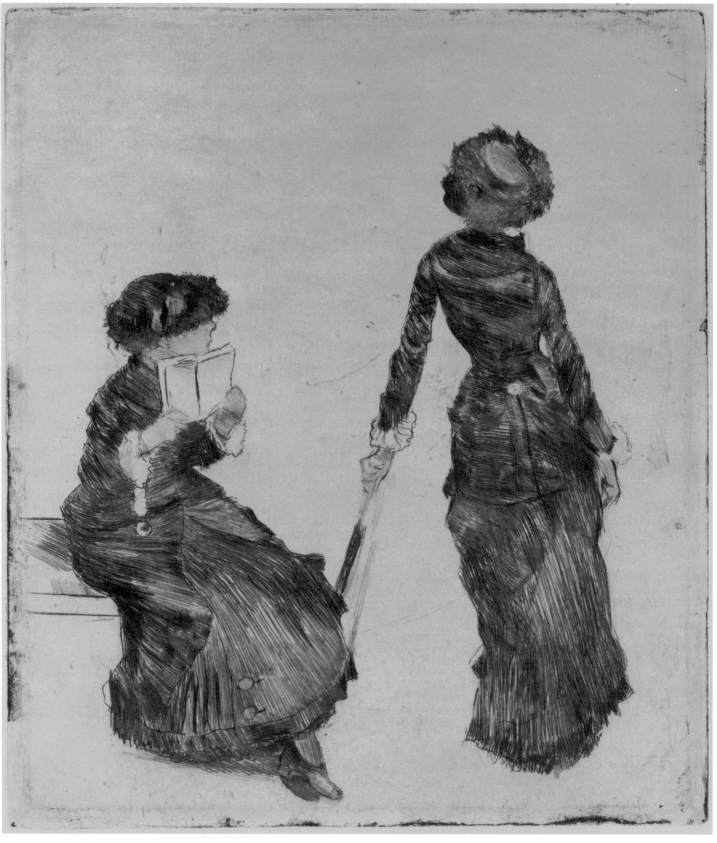

51 second state

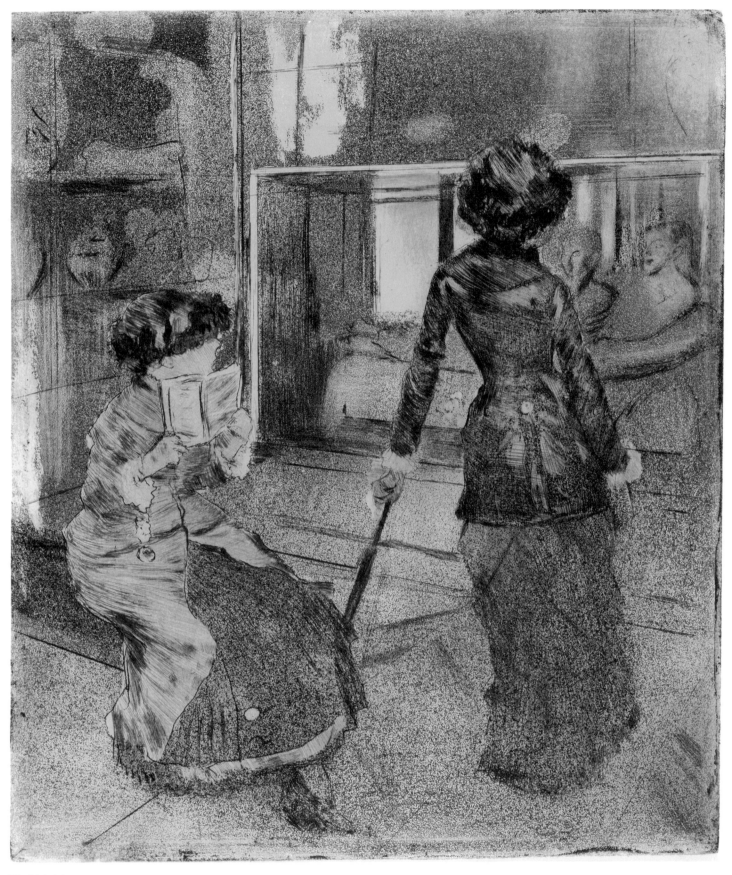

51 third state

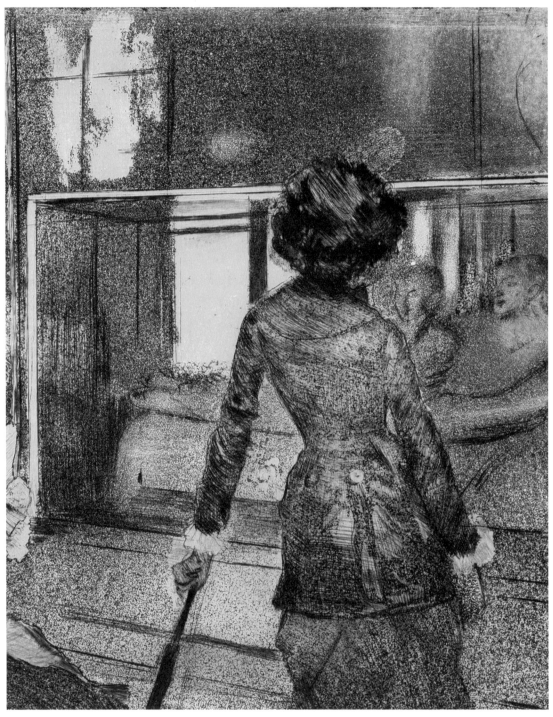

51 fourth state (detail)

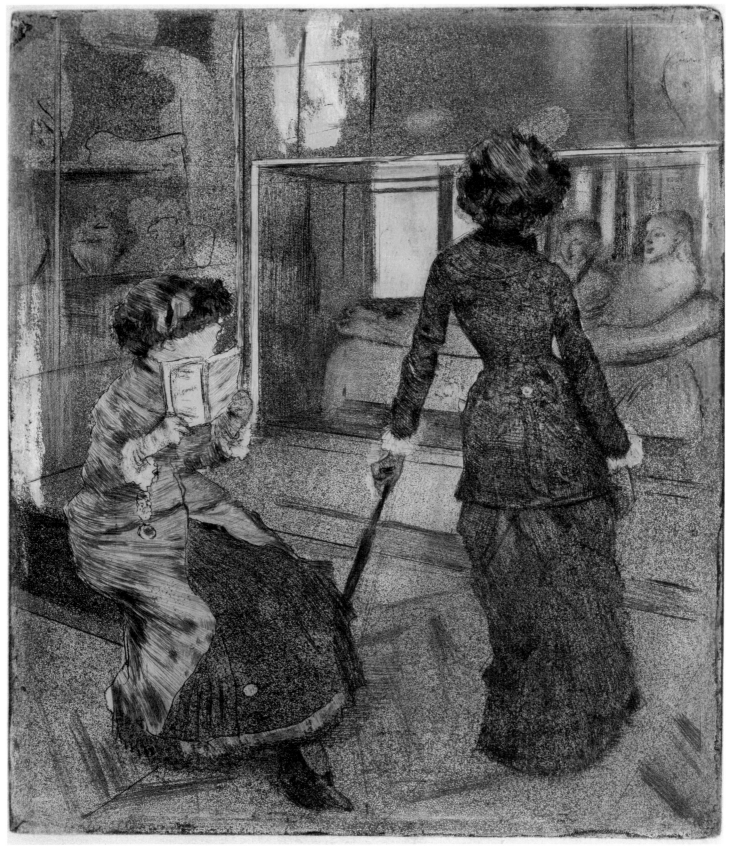

51 fifth state

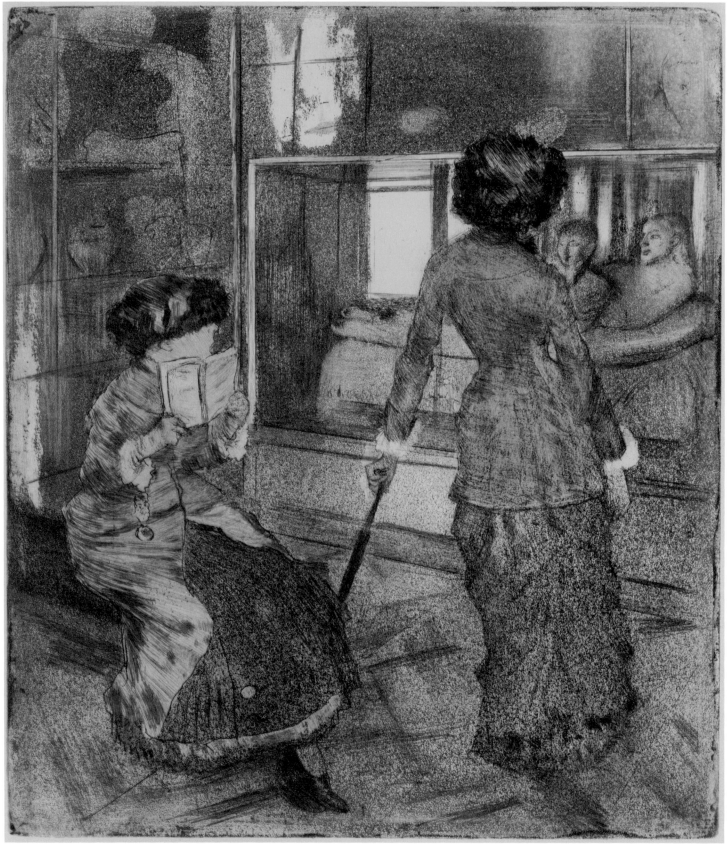

51 sixth state

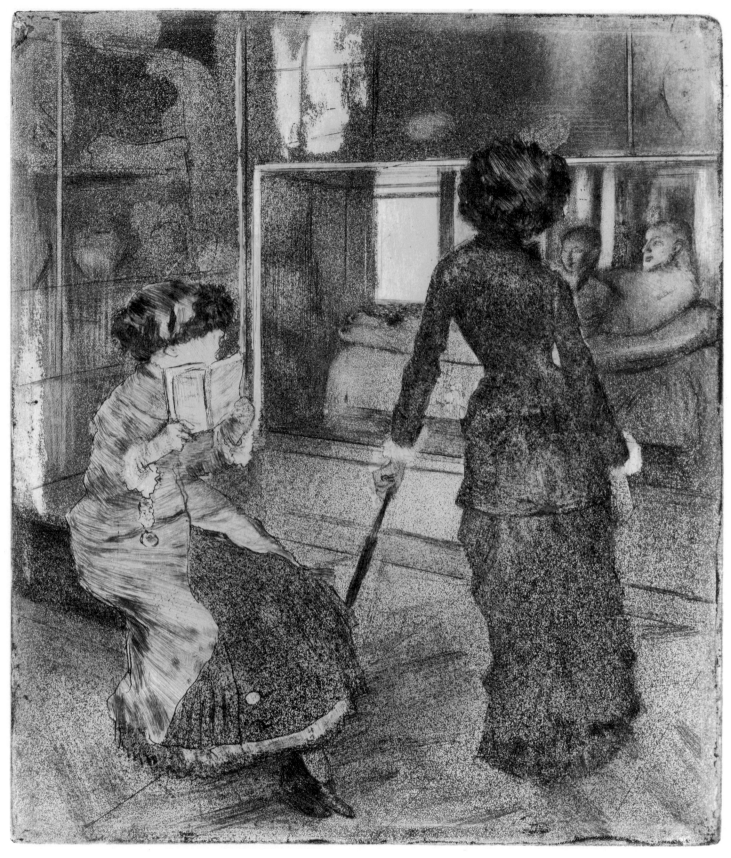

51 seventh state

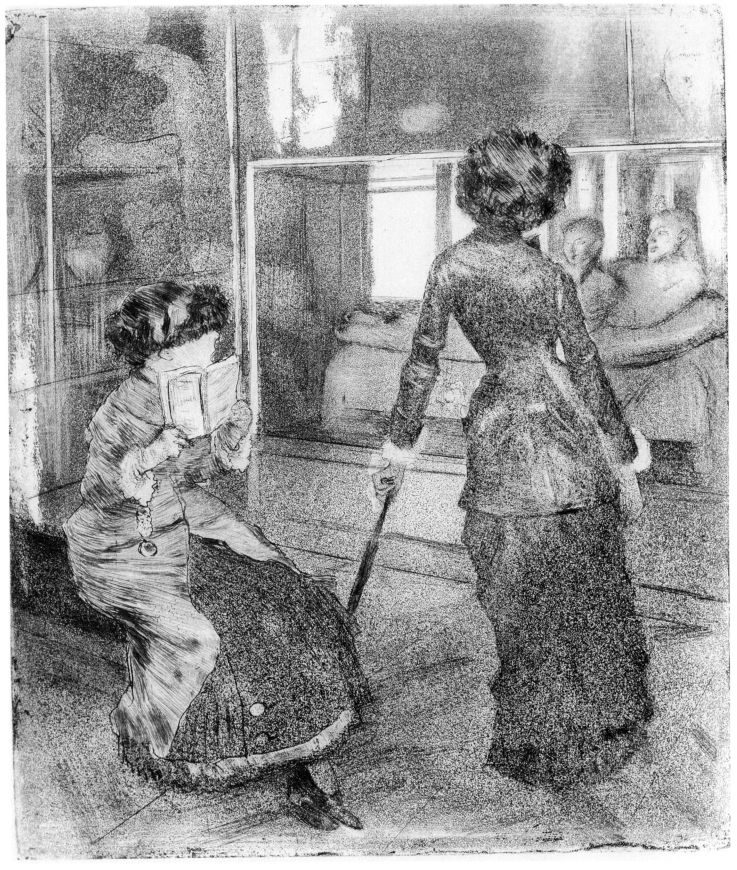

51 eighth state

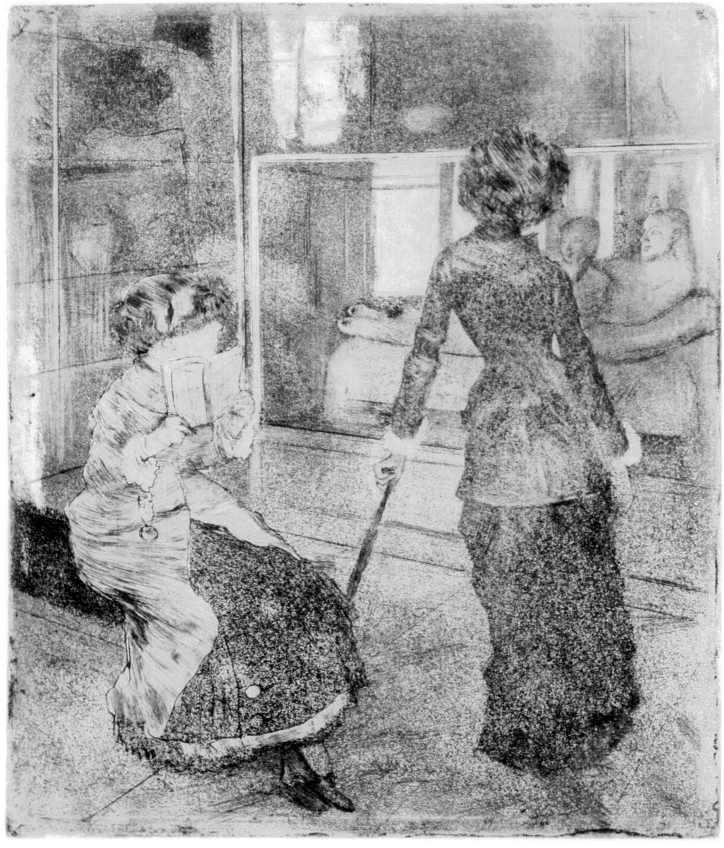

51 ninth state

52

Mary Cassatt at the Louvre: The Paintings
Gallery 1879-80

Etching, softground etching, aquatint, and drypoint. Twenty states
Delteil 29 (1876?); Adhémar 54 (about 1879-80)
305 x 126 mm. platemark

I first state

Buff, medium weight, moderately textured, laid paper
410 x 248 mm. sheet
Coll.: Rouart
Bibliothèque Nationale, Paris
Exhibited in Boston

II second state

Buff, medium weight, moderately textured, laid paper
410 x 240 mm. sheet
Coll.: Rouart
Bibliothèque Nationale, Paris
Exhibited in Philadelphia

III third state

Cream, medium weight, moderately textured, laid paper
361 x 265 mm. sheet
Watermark: top portion of large crowned shield
Coll.: Atelier; Eddy; Whittemore
Yale University Art Gallery. University purchase, 1949

IV fourth state

Off-white, medium weight, moderately textured, laid paper
363 x 262 mm. sheet
Watermark: FRERES
Atelier stamp
Mr. and Mrs. O. G. Bunting

V fifth state

Cream, moderately thick, moderately textured, laid paper
360 x 228 mm. sheet
Watermark: HALLINES and fragment of shield
Atelier stamp
Museum of Fine Arts, Boston. Katherine E. Bullard Fund in memory of Francis Bullard and proceeds from sale of duplicate prints

VI sixth state

Not located

VII seventh state

Cream, moderately thick, moderately textured, laid paper
363 x 266 mm. sheet
Watermark: FRERES
Atelier stamp
The Cleveland Museum of Art. Gift of Leonard C. Hanna, Jr.

VIII eighth state

Off-white, very thick, wove paper
415 x 211 mm. sheet
Atelier stamp
The Minneapolis Institute of Arts. Putnam Dana McMillan Fund, 1982

IX ninth state

Grayish white, medium weight, smooth, oriental-type paper
340 x 170 mm. sheet
Atelier stamp
Anonymous loan

X tenth state

Cream, thin, smooth, Japanese paper
392 x 277 mm. sheet
Atelier stamp
Mr. and Mrs. John W. Warrington

XI eleventh state

Grayish off-white, thick, smooth, wove paper
430 x 233 mm. sheet (irregular)
Atelier stamp
Baltimore Museum of Art. Print Purchase Fund, 1951

XII twelfth state

Buff, moderately thick, smooth, wove paper
370 x 216 mm. sheet
Watermark: fragment of BLACONS
Atelier stamp
The University of Iowa Museum of Art. Gift of Owen and Leone Elliott, 1966

XII-XIII intermediate state

Buff, medium weight, smooth, wove paper
370 x 225 mm. sheet
Coll.: Atelier; Hartshorne
National Gallery of Art. Rosenwald Collection, 1946

XII-XIIIa

Pastel over etching
Buff, wove paper
313 x 137 mm. sheet
Signed and dated in black chalk, lower left: *Degas/85*
The Art Institute of Chicago. Bequest of Kate L. Brewster 1949.515

XIII thirteenth state

Buff, moderately thick, smooth, wove paper
362 x 208 mm. sheet
Watermark: fragment of BLACONS

Atelier stamp
Philadelphia Museum of Art. John D. McIlhenny Fund

XIV fourteenth state

Not located

XV fifteenth state

Buff, moderately thick, smooth, wove paper
368 x 223 mm. sheet
Watermark: fragment of BLACONS
Atelier stamp
The Cleveland Museum of Art. The Charles W. Harkness Endowment Fund

XV-XVI intermediate state

Gray-white, thin, smooth, china paper
343 x 217 mm. sheet
Atelier stamp
Private collection

XVI sixteenth state

Gray-white, thin, smooth, china paper
337 x 170 mm. sheet
Coll.: Atelier; Walter S. Brewster
The Art Institute of Chicago. Walter S. Brewster Collection 1951.323

XVII seventeenth state

Not located

XVIII eighteenth state

Buff, medium weight, smooth, laid paper
365 x 324 mm. sheet
Watermark: fragment of BLACONS
Atelier stamp
Museum Boymans-van Beuningen, Rotterdam

XIX ninteenth state

Buff, moderately thick, smooth, laid paper
365 x 236 mm. sheet
Watermark: fragment of BLACONS; countermark 6 or 9
Coll.: Rouart
Samuel P. Avery Fund, The New York Public Library, Astor, Lenox and Tilden Foundations

XX twentieth state

Cream, medium weight, moderately textured, laid paper
425 x 315 mm. sheet (irregular)
Watermark: fragment of ARCHES
Coll.: Rouart
Library of Congress. Pennell Fund, 1943

The tall, narrow shape of this print distinctly resembles the Japanese woodcuts of "pillar" format so widely admired in France at the time. Since Degas owned a number of Japanese prints and must have been familiar with this type of format, it is understandable that he would choose such an attractive and unusual compositional solution.

It is commonly believed that there are more than the twenty states of this print cited by Delteil in his catalogue raisonné. He knew forty-four impressions. We have examined thirty-two, and it is on the basis of this number of impressions that we accept and can justify Delteil's state descriptions. Two minor variations relating to the thirteenth and fifteenth states have been identified. Nevertheless, it seemed preferable in this instance to maintain Delteil's sequence of states.

The composition of the print was firmly established in the first state. As the plate progressed, Degas focused on and further developed various elements of the figures and setting. Substantial work was added by means of aquatint or subtracted by burnishing as Degas concentrated on perfecting the relationship of shape, pattern, and tone. The hat of Mary Cassatt (the standing figure) appears in four different shapes, and the doorjamb assumes seven different marbleized patterns. In addition, the floor and picture wall undergo a number of tonal adjustments.

From the first to the twelfth states Degas used linear means to describe the dark silhouettes of the two visitors, who are situated amidst a variety of marble and wood textures. The strong contrasts of black and white create a decorative effect, which causes the image to be read as a flat pattern. For the last eight states Degas experimented with tonal techniques to simplify or mask the specific textures. Although the museum goers are still silhouettes in the final state of the print, they are depicted in a subdued light, and the space around them is more logically realized.

It is important to note that the drawing of the two figures (cat. no. 51a), most obviously related to the print *Mary Cassatt at the Louvre: The Etruscan Gallery*, was used a second time for the preparation of this print. The ruled grid lines on the recto probably assisted Degas in the rearrangement of the figures for this vertical format. The verso of the drawing bears indications that the seated figure and the side of the doorjamb were traced from this sheet onto the plate. This reuse of the drawing provides evidence in establishing that the vertical print was the second to be conceived. Furthermore, in contrast to the numerous impressions of the final state of *The Etruscan Gallery*, only six impressions of the twentieth and final state of *The Paintings Gallery* are known. In all likelihood the two prints were being worked on in Degas's studio at the same time; however, given the relatively square formats of Mary Cassatt's *In the Opera Box (No. 3)* and Camille Pissarro's *Wooded Landscape, L'Hermitage, Pontoise*, Degas's *The Etruscan Gallery* would certainly have been the print selected for the proposed journal *Le Jour et la nuit*.

Another study, a pastel, of the single figure of Mary Cassatt (Lemoisne 582, Henry P. McIlhenny Collection) probably served as a guide for the change in shape of the hat in the seventh state of

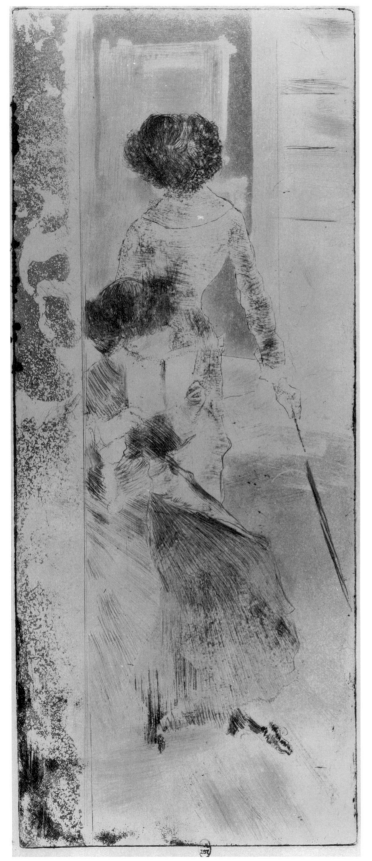

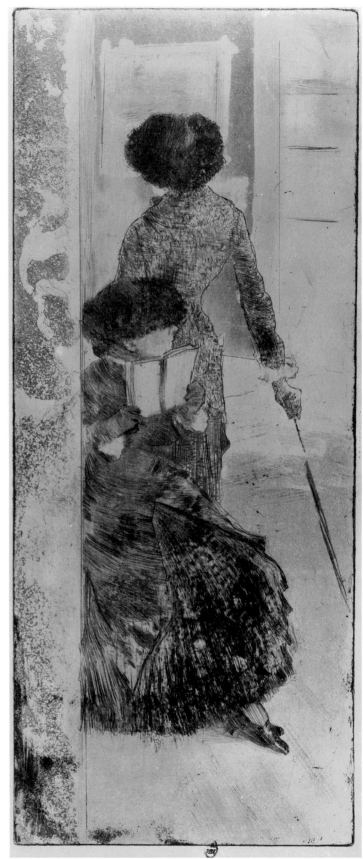

52 first state

52 second state

The Paintings Gallery and for the modeling and highlights of the jacket.

The following state descriptions have been written with more attention paid to alterations made to the figures and setting than to technique. This is one of Degas's most complex prints in its combination of media, and it is often difficult to separate precisely the work in etching, softground etching, drypoint, and aquatint.

In the first state the composition has been completely established, and the overall aspect of the print is light in tonality. The picture wall is not continuous, and an open doorway is seen at right. The doorjamb at left that will widen in subsequent states is narrow. Degas executed the outlines of the figures in softground etching and probably used a carbon rod to shade with drypoint. A fine-grained aquatint describes the gallery, and a coarse grain suggests the marble pattern on the doorjamb. The unique impressions of the first and second states, now in the BN, were given by Degas to his friend Alexis H. Rouart.

The second state reveals new work in drypoint that further shades the costumes, hats, and gloves.

It is possible that a fragmentary drawing known only from reproduction (Atelier sale IV, no. 249a, 29 x 27 cm.) was used between the second and third states to trace softground lines that enrich the costume of the seated figure.[1] This work is almost entirely masked by the etched lines of the third state.

In the third state the doorjamb assumes the aspect of marble with further work in aquatint, light drypoint, and etched lines created with a multipronged tool. The hat of the standing woman now has a deep brim, and etched lines darken the costumes of both figures. The parquet floor is indicated with one strong oblique line and is shaded with hatching. The background is substantially changed: the wall is extended and contains three paintings, and a dado is indicated. Two impressions of this state are known: Copenhagen (Atelier) and Yale (Atelier).

Additional lines were added in the fourth state to the marble pattern on the doorjamb. There are signs of burnishing on the collar of Mary Cassatt's jacket and further etched work on the clothing. A second oblique line divides the floor, and a few fine drypoint verticals shade the dado at lower right. Only one impression of this state is known: Bunting (Atelier).

There were few changes made in the fifth state. Touches of drypoint reinforce the aquatint pattern on the upper part of the doorjamb. A horizontal drypoint line defines the baseboard of the dado, with shading above. Two impressions record this work: MFA (Atelier) and on loan to Ulm (Atelier).

The sixth state has not been located. Delteil notes new work on the costumes and hats of the figures, including a better definition of the button on the skirt. Also, the second oblique line on the floor was accentuated. These changes may be seen in the seventh state.

In the seventh state the doorjamb was widened so that the seated woman is more abruptly cropped. The remnants of her costume were scraped and burnished from the door, and patches of lines were added to create a new marbleized pattern. The standing woman's hat was altered for a second time, and its shape is more angular. The bold linework on the dresses in the fifth state was replaced by fine crosshatching. A thin wedge that will become the uplifted left arm of the standing woman appears. Fine lines shade the dado and the wall between the picture frames. The second oblique line in the parquet floor, described by Delteil in the sixth state, is observed. One impression is known: Cleveland (Atelier).

Additional fine lines in the eighth state simulate marble veins on the doorjamb. Drypoint flicks shade the right half of the book; nine drypoint diagonal lines were added to the floor at the right of the hand that rests on the parasol, and five at the left. One impression has been located: Minneapolis (Atelier).

In the ninth state fine drypoint work enriches the clothes and clarifies the shape of Mary Cassatt's hat. The right side of the book is shaded with horizontal lines. An impression in a private collection (Atelier) records this work.

In the tenth state, many of the lines on the doorjamb have been removed and replaced by widely spaced patches of aquatint that suggest a totally new marble pattern. Aquatint also appears on the face and book of the seated woman, as well as on the floor and in the painting at the upper right. Two impressions are known: private collection (Rouart) and Warrington (Atelier).

There is additional aquatint patterning on the doorjamb in the eleventh state. The hat is smaller and has begun to take on the rounder appearance that will be maintained throughout the remaining states. Erasures are evident on the hats and clothing of both women, most noticeably across the shoulders of the standing figure. Aquatint was added to the clothing, and a small spot appears by the right hip of Mary Cassatt. Impressions located are Baltimore (Atelier) and Prouté (Atelier).

In the twelfth state, aquatint, added to the clothing of both figures, masks the lower of the two buttons on the skirt. It also completely covers the floor between the doorjamb and the foot of the seated woman. The setting remains essentially the same as in the eleventh state. Only one impression of this state has been located: Iowa (Atelier).

An intermediary state (XII-XIII) has all the aquatint additions and tonal changes noted in the thirteenth state but lacks the one etched line that defines another section of the parquet floor. One impression of this state is in the NGA (Atelier), and a second, heightened with pastel, is in the AIC. When Degas worked on the latter in 1885, he maintained the same general palette used in the large pastel prototype (cat. no. 51, fig. 1): red-browns for the standing figure and cool greens for the seated visitor, who holds a salmon-colored guidebook common to both works. The only real change in the colored etching is to the seated woman's hat, which has been made a pale lavender. Degas retained the sense of linear ornamentation present in the etched base and did not attempt to duplicate the even tones of the twentieth state that suggest a subdued light and a more enclosed space.

In the thirteenth state extensive new aquatint on the doorjamb established another, more muted pattern, characterized by a number of small round spots at the lower left corner. The wedge

at the left shoulder of the standing figure is now being reshaped to read eventually as a sleeve, and to her right a strong etched line divides the parquet near her wrist. Further aquatint appears on parts of the floor, creating alternating bands of dark and light, and is also visible on the dado and on the wall between some of the paintings. One impression has been located: PMA (Atelier).

According to Delteil, the third line of the parquet floor that appeared in the preceding state is erased and only a trace remains in the fourteenth state. No impression exactly corresponding to this description has been located.

In the fifteenth state much of the aquatint was erased from the doorjamb, which now exhibits a scribbled line on the lower part. There is burnishing throughout the plate, particularly to make highlights across the shoulders, to round the hat, and to lighten the guidebook. Additional lines as well as burnishing correct the aquatint patch by the hip of the standing figure; the left sleeve has taken its final form. The Cleveland impression (Atelier) is the only one located.

In the intermediate state (XV-XVI) the plate is in the same condition as in the fifteenth except for new drypoint lines that cross the shoulders of the standing woman and fill in the previously burnished highlight. Two impressions record this slight change: BN (Rouart) and private collection (Atelier).

The doorjamb in the sixteenth state is covered with a tracery of jagged drypoint lines. The rest of the image remains the same. Only one impression is known: AIC (Atelier).

Delteil notes the appearance of aquatint touches on the doorjamb and on the parquet in the right foreground of the seventeenth state. No impression corresponding to this description has been located.

In the eighteenth state the doorjamb is almost completely covered with a tone of aquatint that also darkens the light sections of the floor and the dado. There are now fine oblique lines of shading on the jacket collar. The one impression known (Rotterdam, Atelier) anticipates the final appearance of the print.

In the nineteenth state a number of strong vertical lines extend the full length of the doorjamb and suggest a prominent molding that frames in part the opening to the gallery. Throughout the image many areas were refined with delicate lines or hatching, including the hat and collar of the standing figure and the seated woman's left hand, cuff, and skirt; the white button of the skirt is now shaded with parallel lines. There is additional fine linework on the dado and on the picture frames. The ornamentation in the corner of the large frame closely resembles that recorded by Degas in a notebook (Reff *Notebook* 33, p. 1). It is identified by Reff as the frame of a Rubens painting that once hung in the Grande Galerie of the Louvre.[2] Three impressions record these changes: Amsterdam (Atelier), Carnegie (Atelier), and NYPL (Rouart).

For the twentieth state a new grain of aquatint was used to fill in and even out the tonality of the door frame, the dado, and the parquet floor; it also shades parts of the paintings, their frames, and the wall behind. A limited number of white accents remain on the figures and picture wall. At least six impressions of the final state have been located: BAA, BPL (Atelier), Bremen, Brooklyn (Atelier), LC (Rouart), and PMA (Atelier).

Notes

1. This drawing is illustrated in Giese 1978, p. 47, fig. 8; other images of Mary Cassatt are illustrated in this article.

2. Reff 1976, p. 133.

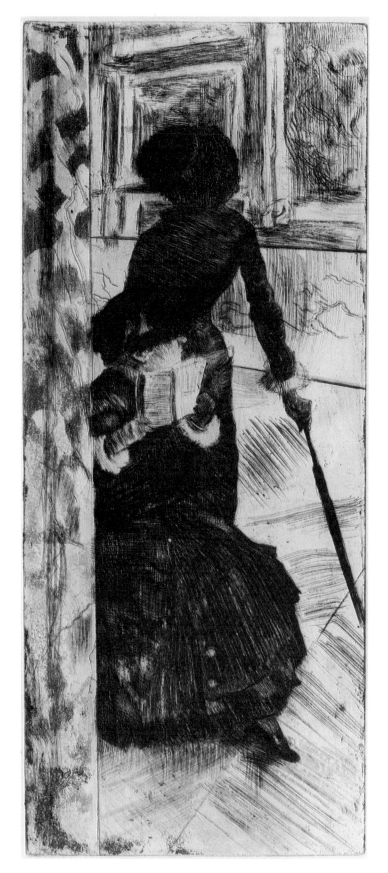

52 third state

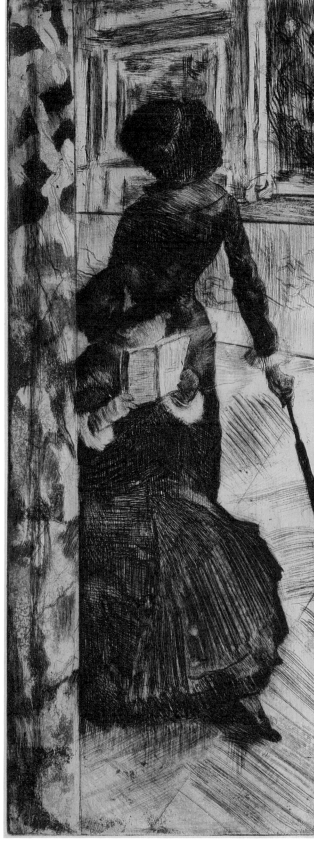

52 fourth state

189

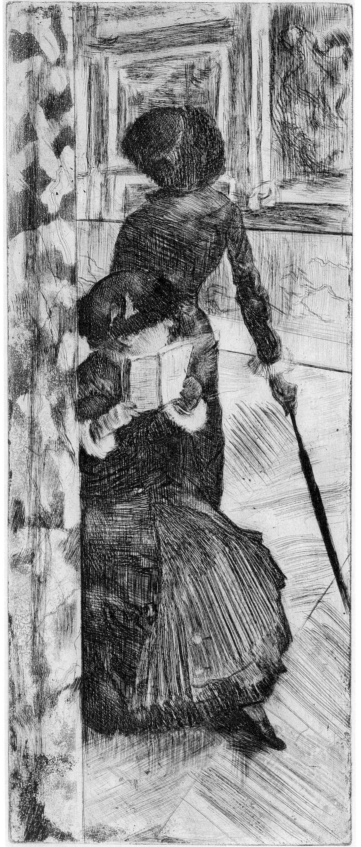

52 fifth state

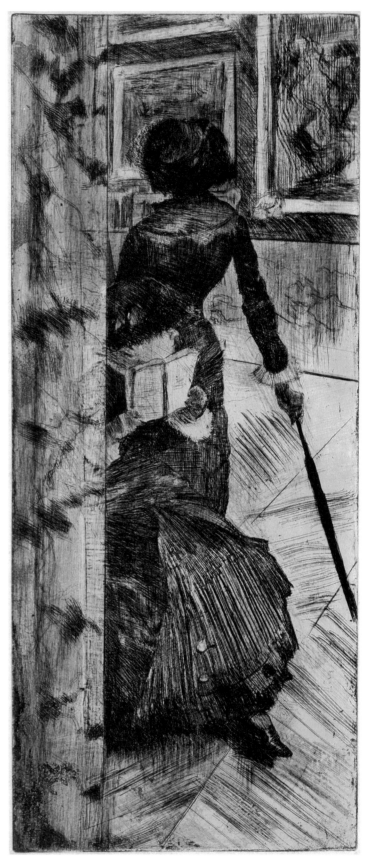

52 seventh state

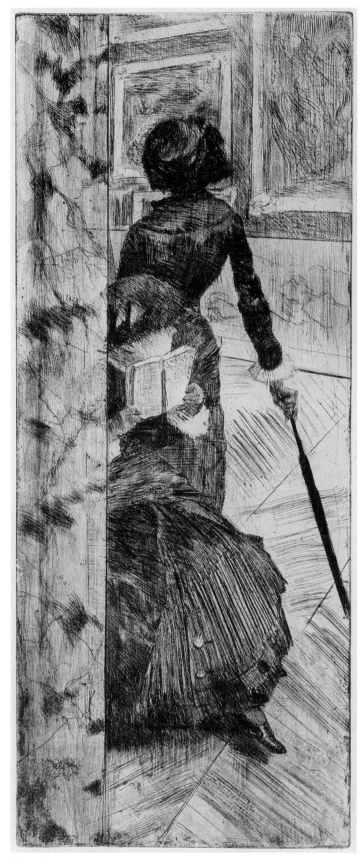

52 eighth state

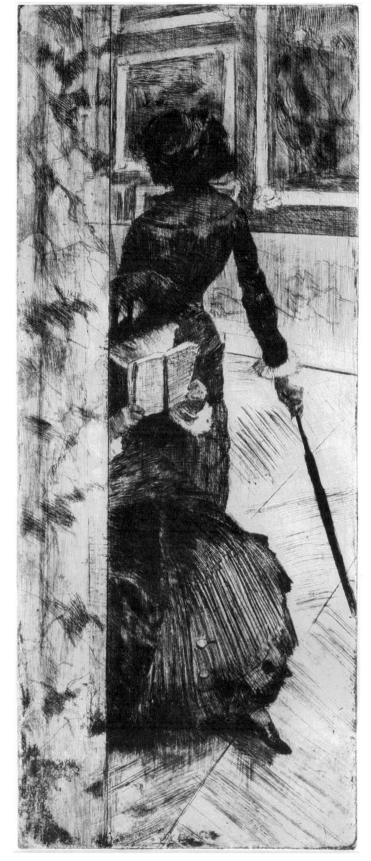

52 ninth state

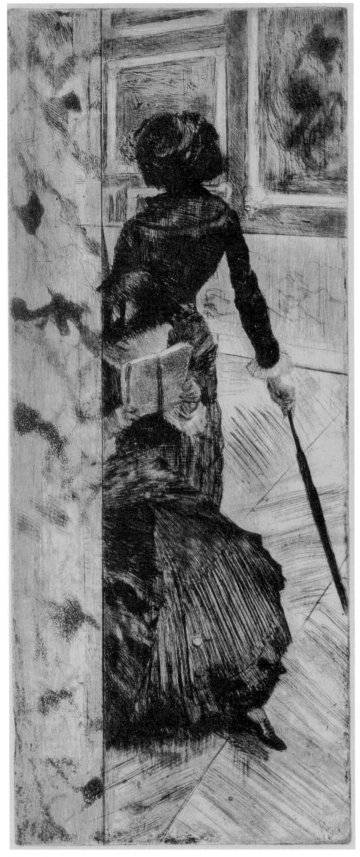

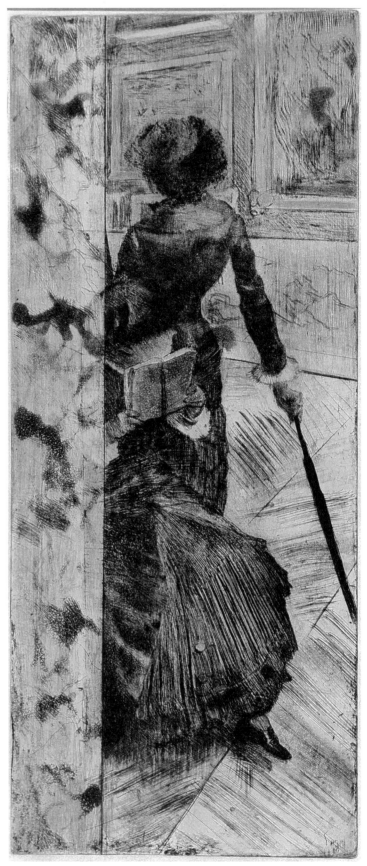

52 tenth state

52 eleventh state

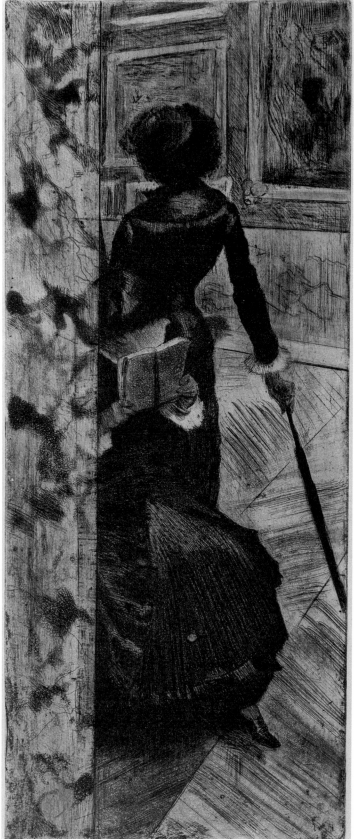

52 twelfth state

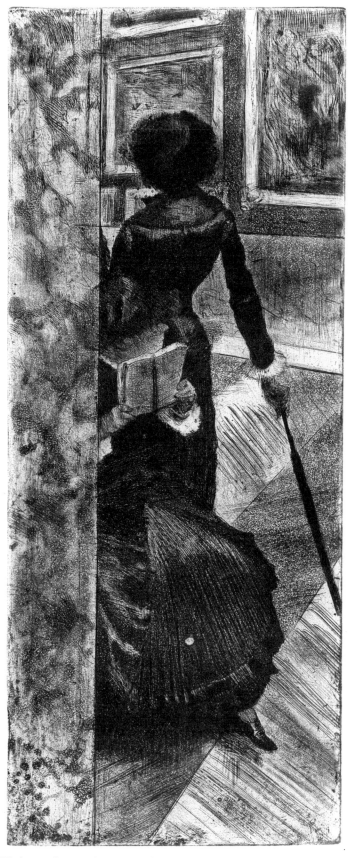

52 intermediate state between twelfth and thirteenth states

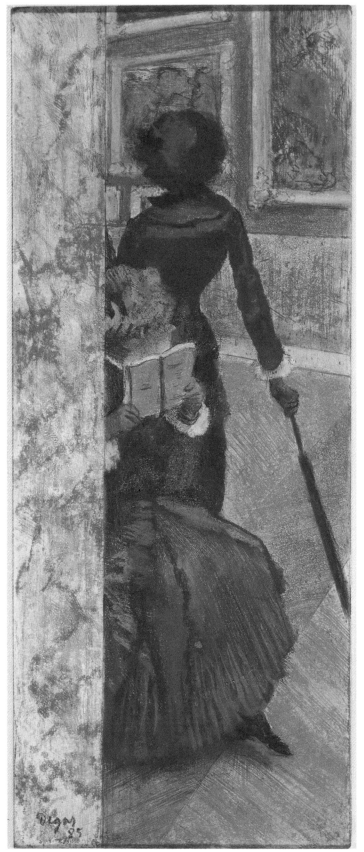

52 intermediate state between twelfth and thirteenth states, reworked with pastel

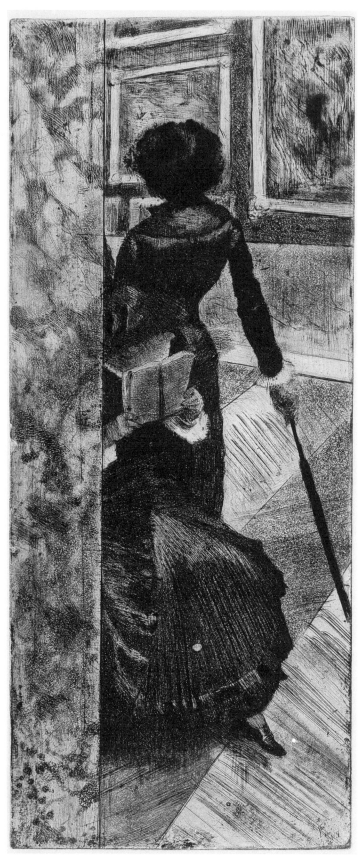

52 thirteenth state

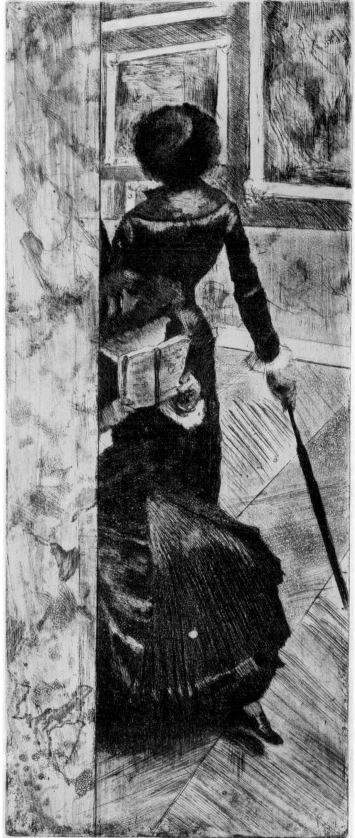

52 fifteenth state

52 intermediate state between fifteenth and sixteenth states

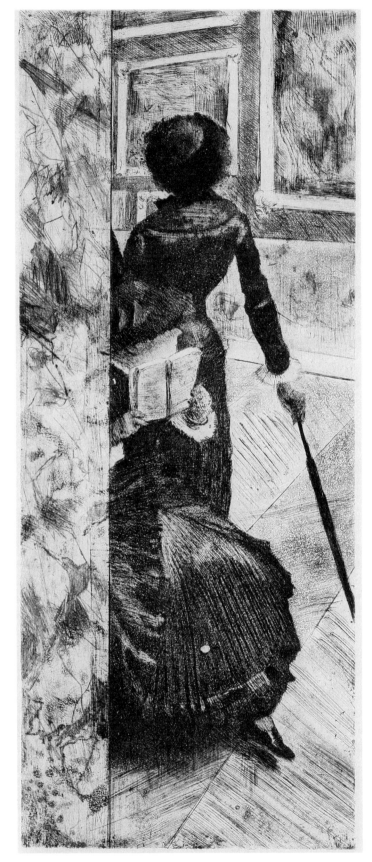

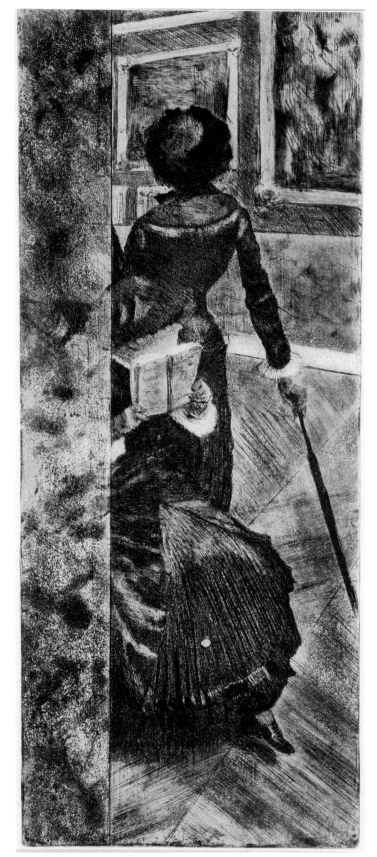

52 sixteenth state

52 eighteenth state

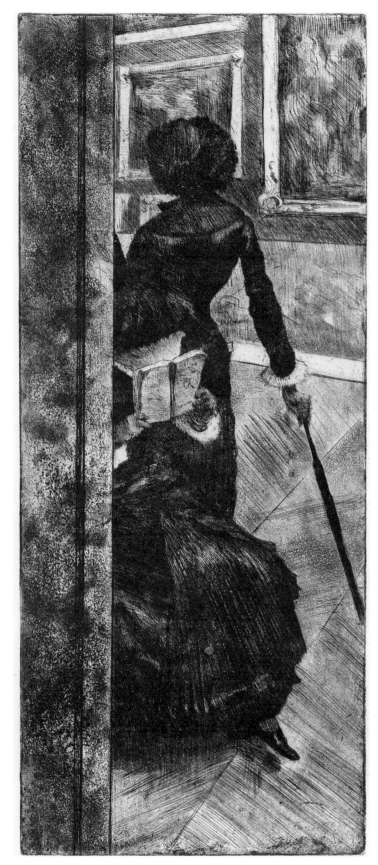

52 nineteenth state

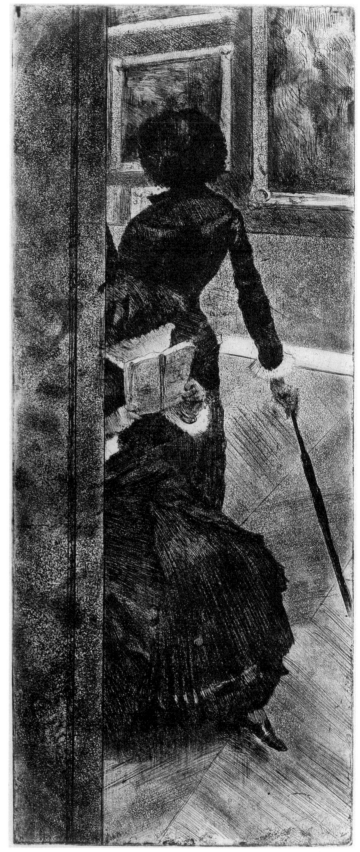

52 twentieth state

53

Study for a Program for an Artistic Evening

1884

Softground etching and drypoint. Four states
Delteil 40 (1884); Adhémar 55 (1884)
250 x 320 mm. platemark (including bevel)

I first state

Formerly Guérin Collection
Not located

II second state

White, thick, slightly textured, wove paper
Sheet trimmed to platemark
Coll.: Rouart
Bibliothèque Nationale, Paris
Exhibited in Boston

III third state

Off-white, thick, smooth, wove paper
390 x 565 mm. sheet
Atelier stamp
E. W. Kornfeld, Bern

IV fourth state

White, thick, smooth, wove paper
288 x 400 mm. sheet
Museum of Fine Arts, Boston. Lee M. Friedman Fund

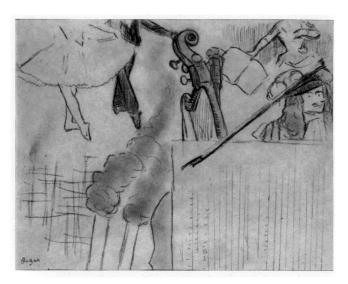

53-54. Fig. 1.
Drawing Study for a Program I, 1884. Black chalk. Isabella Stewart Gardner
Museum, Boston.

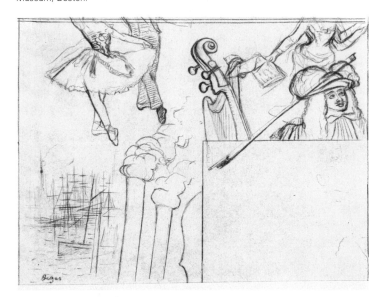

53-54. Fig. 2.
Drawing Study for a Program II, 1884. Black chalk. Isabella Stewart Gardner
Museum, Boston.

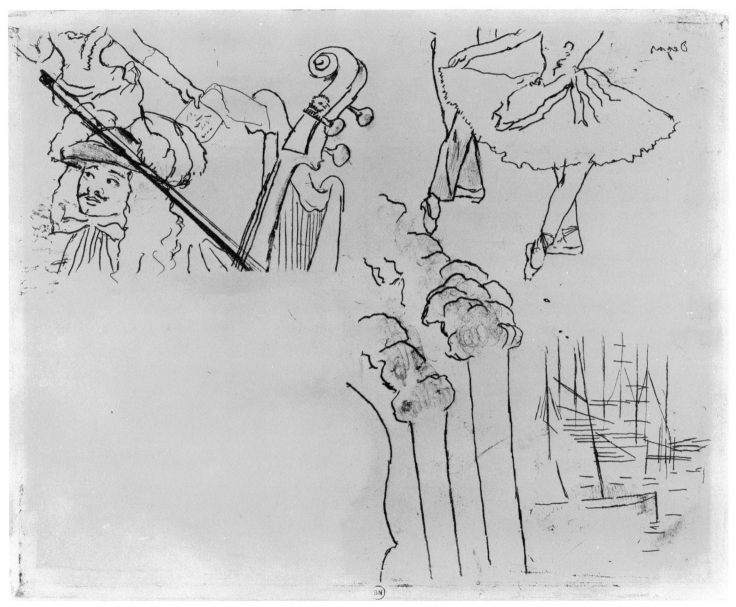

53 second state

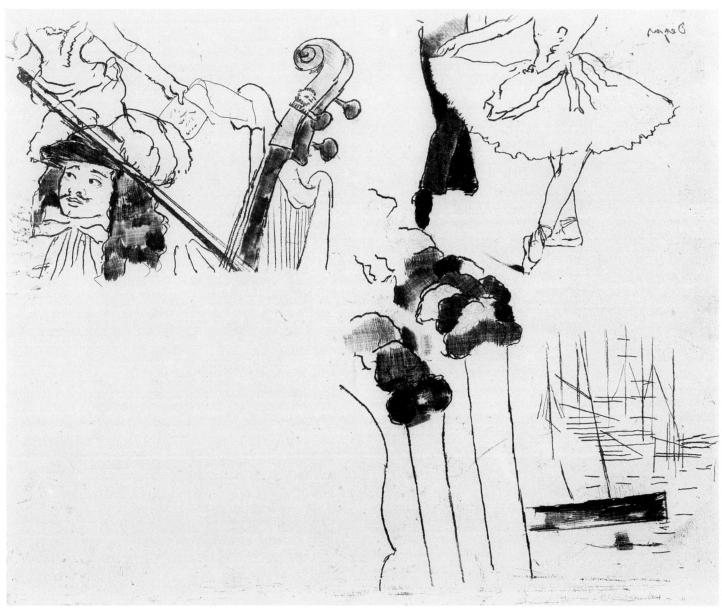

53 third state

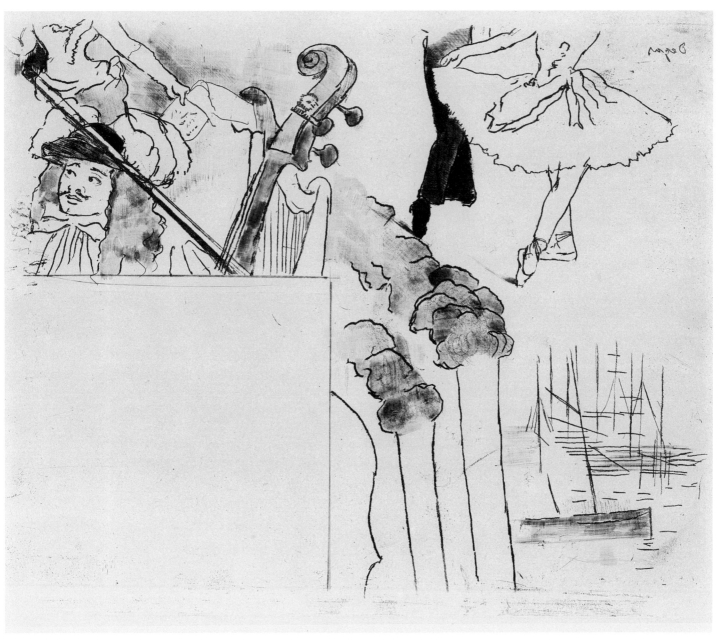

53 fourth state

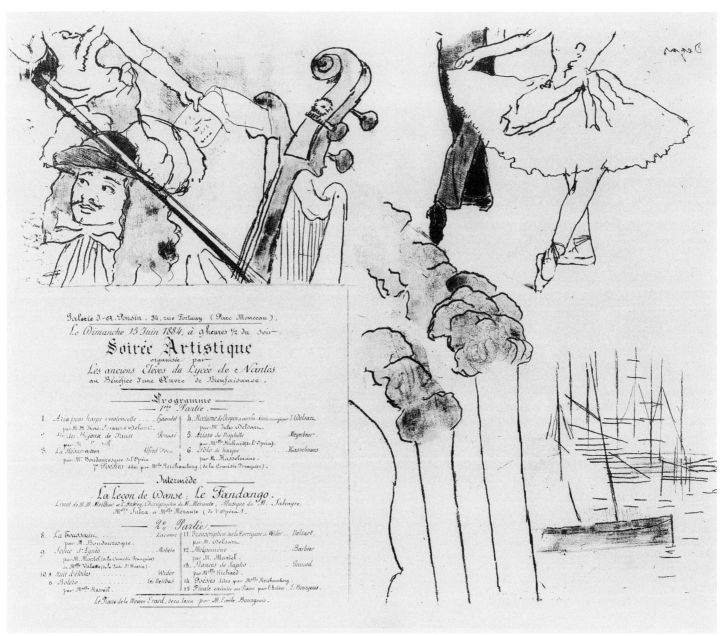

54

Program for the Soirée Artistique 1884

Transfer lithograph. One state
Delteil 58 (1884); Adhémar 56 (1884)
250 x 320 mm. image
Cream, moderately thick, smooth, wove paper
277 x 386 mm. sheet
Museum of Fine Arts, Boston. Lee M. Friedman Fund

This is one of the rare instances in Degas's work of a commissioned print. Like others destined for a wider audience, it involved an elaborate preparatory process (see cat. nos. 23-25 and 51-52). The entire project comprised four black chalk drawings, a preliminary softground etching in four states (cat. no. 53), and a final lithographic print that served as the program for a benefit concert organized by the former pupils of the Lycée de Nantes for June 15, 1884.

Two of the drawings, now in the Isabella Stewart Gardner Museum, Boston, were originally encased together in a white frame and were acquired directly from the studio sale (Atelier sale IV, 258a and b; figs. 1 and 2). The pair are the most fully resolved of the four and vividly demonstrate Degas's working methods. One of the drawings (fig. 2), which closely parallels in design and configuration the subsequent print, is on a thin, tissue-like paper and reveals graphite lines laid over the chalk strokes. The dancers, the singer, and the musical instruments are simply rendered, almost caricatural, with only a minimum attempt to shade the forms. The drawing was used to transfer the image to the copper plate prepared with softground.[1]

The first state, unknown to Delteil, was catalogued as "before the signature and the music sheets," by Marcel Guérin. He was presumably referring to the papers held by the female performer at the upper left.[2]

In the second state the composition is fully drawn in softground lines. Softground sketchily shades some parts of the image such as the male dancer's trousers, the hat of the playwright Molière, and the smoke. The additions mentioned by Guérin that were lacking in the first state are here included, drawn with a fine point. This unique impression of the second state (BN/Rouart) was wiped clean along the bevel and on the empty square at the lower left.

In the impression of the third state, also unique (Kornfeld/Atelier), a spiked roulette wheel was used as a drypoint tool to shade in the head of Molière, the neck of the double bass, the dancer's trousers and shoes, the smoke, and one sailboat.

In the fourth and final state of the etching the square for text is outlined, and additional roulette work shades the background at the upper left, the singer's skirt, the head of the harp, and the crown of Molière's hat. The smoke is extended to the left as far as the harp. This is the only known impression of the fourth state (MFA). This state was illustrated in Atelier sale IV, p. 311, no. 385a, but incorrectly listed as a first state.

It was probably another freshly inked impression of this last state that was transferred to a lithographic stone, permitting the image and handwritten calligraphic text to be printed in a large edition. The linework of the finished print is more characteristic of softground etching and does not reflect the textural characteristics of a lithograph.

The print that served as the program (cat. no. 54) is a montage of images, some of which relate to earlier paintings and pastels (see, for example, Lemoisne 690 for a large pastel entitled *Mlle Salle in Costume of the Fandango and Studies of Arms and Legs*). The form of the double bass relies on a drawing of about 1869 in Reff *Notebook* 25, p. 29, the same sketchbook that once contained the drawing of M. Gouffé (cat. no. 22a). All the images of the program are visual allusions to the musical selections performed, with the exception of the boats and the smokestacks, which symbolize the city of Nantes, a port at the mouth of the Loire River and the location of the Lycée. This sheet not only refers back to earlier visual sources but also reflects Degas's notes on subject matter and cropping made in connection with *Le Jour et la nuit*, the projected journal of prints (see cat. no. 51).

The performers depicted were professionals, widely known in the cultural world of Paris. They were most likely friends of Degas, and one of them must have persuaded the artist to prepare the program for the Lycée. Delteil mentions that at least five impressions of the lithograph were to be found in public and private collections, five more were sold at various auctions between 1906 and 1914, and five were in the same sale as the Gardner Museum drawings (Atelier sale IV, nos. 385b-390). Not one of the lithographs appeared in the Degas Atelier print sale. At the present time, eight impressions have been located: BAA; BN (Rouart); private collection, Boston; private collection, Milwaukee (Beurdeley); NGA; NYPL; St. Louis; and Smith.

Degas sent a note to Monsieur Bouvenne, a printer and historian of prints, on a visiting card, incorrectly dated by Guérin to 1891: "If the stone of my little programme has not been effaced, please be good enough to have ten copies printed."[3] This note should be dated close to the project of 1884. Evidently the lithograph was pleasing to Degas, who was interested enough to request more impressions. He was still concerned with the concert program seven years later when an exhibition of the history of lithography was held at the Ecole des Beaux-Arts, April 26 – May 24, 1891. An impression of the program from Bouvenne's collection was exhibited without the permission of Degas, who wrote in irritation:

Monsieur Bouvenne,

So you are the exhibitor of this little program of the concert at the Quai Malaquais. It was with surprise and anger that I read your name in the catalogue. So you did not think that you lacked my consent. You were not, I very much fear, at the concert and it is not from there that you received the proof. It is more probable that, over and above the copies ordered and paid for by M. Clemenceau who directed the fête, you had your copy printed. It was an excellent reason to keep it in a box, or only take it out with my consent. I should not have given it to you, and the idea of being represented in this survey of lithography by this sole piece would have seemed like a joke to me.

I insist on all occasions to appear, as far as possible, in the form and with the accessories that I like. I can scarcely compliment you on your curious offhandedness.

My friend M. Alexis Rouart, who is, I think, on the committee, did not think that he could exhibit an attempt by Mlle Cassatt without writing to her. She replied that she would permit it. You did not show the same consideration.

Be good enough to have the six lithographic stones, that the maison Lemercier lent me some years ago for some attempts, fetched from 37 rue Victor-Massé. Very fortunately there is nothing at all on them.

I have the honor, Monsieur, to salute you.

Degas[4]

Another collector was not as enamored of the print and referred to it as an "abominable sketch." On the verso of the New York Public Library's impression, which almost certainly belonged to Philippe Burty, is written: "Degas avait fait cet abominable croquis pour une soirée de Nantes."

Notes

1. This drawing is mounted down, and the verso is not available for examination. For a discussion of the project, see B. Shapiro 1978, pp. 14-21.

2. Guérin, *Additions,* no. 40, "avant la signature *et* le cahier de musique," in typescript. Adhémar, no. 55, says "*sur*" (*on* the sheet), not "*et*" (*and* the sheet).

3. Degas, *Letters* 1947, no. 174; Degas, *Lettres* 1945, no. 161.

4. Degas, *Letters* 1947, no. 173, with changes in translation; Degas, *Lettres* 1945, no. 160.

55

Dancer Putting on Her Shoe about 1888

Etching. Two states
Delteil 36 (about 1890); Adhémar 60 (about 1892)
178 x 117 mm. platemark

I first state

White, very thick, smooth, wove paper
250 x 170 mm. sheet
Coll.: Rouart
The Art Institute of Chicago. Joseph Brooks Fair Collection 1932.1334

II second state

Cream, medium weight, moderately textured, laid paper
275 x 183 mm. sheet
Watermark: fragment of ARCHES
Atelier stamp
The Brooklyn Museum

In an article on the prints of the Impressionist painter Berthe Morisot, Janine Bailly-Herzberg discusses some proposed illustrations to a group of Stéphane Mallarmé's prose poems entitled *Le Tiroir de laque* (*The Lacquered Drawer*). In 1887 the poet approached his painter friends, including Morisot, Renoir, Monet, John Lewis Brown, and Degas, from whom he requested a ballet dancer subject. Degas was dilatory, as Mallarmé commented in a letter of August 1888 and others that follow.[1] Adhémar (no. 60) suggested this print as a likely candidate for Degas's contribution. Indeed, it was executed on a professionally beveled plate as if intended for publication. Perhaps the unfinished aspect of the plate reflects Degas's abandonment of the project.

The delicately worked image of a dancer bending to adjust a ballet slipper is a subject treated a number of times in various media, including a lithograph (cat. no. 59). Unlike Degas's more complex etchings of the late 1870s, this is a simple linear image with little suggestion of setting and no modeling. Degas probably used a double-pointed steel pen to cut through the etching ground, producing distinctive dual contour lines. A few trial strokes appear at the lower left.

Delteil cites six impressions without cataloguing a state difference. The present authors have recognized that there are two states of this etching. The Rouart impression in the Art Institute of Chicago is a first state and probably unique. Three further impressions of the second state have been found: BAA, Brooklyn (Atelier), and SCMA (Atelier).

In the final state Degas redrew the contours of the back and both arms. He elongated the left arm to the point of distortion. There are small changes throughout the image, most noticeably the addition of a second bench leg. The double contour and the visible corrections of the etching correspond to the repeated lines of the lithograph (cat. no. 59). Degas's handling of the lines in both prints resembles that found in some of his charcoal drawings of the late 1880s and early 1890s.

55 first state

Note

1. Janine Bailly-Herzberg, ''Les Estampes de Berthe Morisot,'' *Gazette des beaux-arts*, 93 (1979), pp. 215-27.

55 second state

56

Horses in the Meadow 1891-92

Softground etching, aquatint, and drypoint. Three states
Delteil 66 (pièce douteuse); Adhémar 57 (about 1891-92)
130 x 147 mm. platemark

I first state

Not located

II second state

Cream-buff, moderately thick, moderately rough, laid paper
220 x 302 mm. sheet
Coll.: Gerstenberg
*The Metropolitan Museum of Art. The Elisha Whittelsey Collection.
The Elisha Whittelsey Fund, 1950*

III third state

Cream, medium weight, moderately textured, laid paper
200 x 260 mm. sheet
Watermark: fragment of Arches countermark
Detroit Institute of Arts. Gift of John S. Newberry

III third state, as published in Georges Lecomte, *L'Art
impressionniste d'après la collection privée de M. Durand-Ruel*
(Paris, 1892). Copy containing 33 etchings and drypoints by
Auguste M. Lauzet, two softground etchings by Degas, *Horses in
the Meadow* and *Dancer on Stage*, and one heliogravure. Text on
smooth, wove paper; prints on laid Arches paper.
James A. Bergquist, Boston
Not illustrated

56a

Auguste M. Lauzet (1865-1898)
Horses in the Meadow, after Degas
Etching and drypoint
125 x 155 mm. platemark
Published in Georges Lecomte, *L'Art impressionniste d'après la
collection privée de M. Durand-Ruel* (Paris, 1892). Copy containing
35 etchings and drypoints by Lauzet and one heliogravure. Text on
smooth, wove paper; prints on laid Arches paper
Museum of Fine Arts, Boston. Gift of William A. Sargent

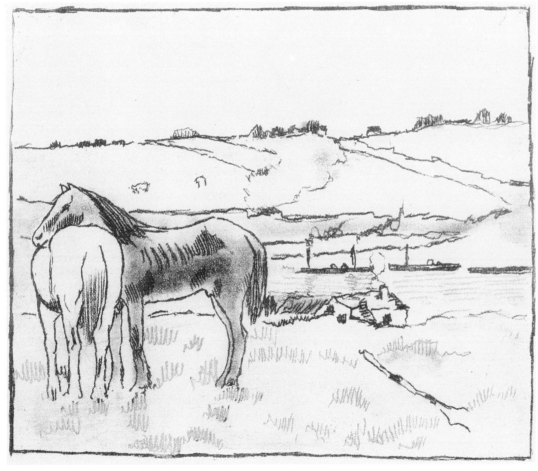

56 second state

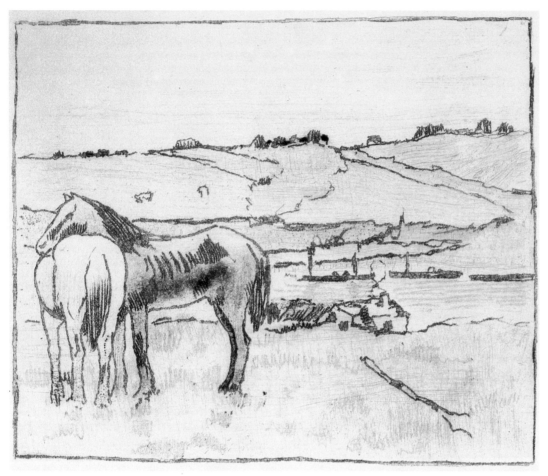

56 third state (Detroit)

In his catalogue raisonné (1919) Delteil did not consider this print, *Horses in the Meadow*, or the following, *Dancer on Stage*, to be by Degas, although he later accepted them.[1] These two prints reproduce a painting and a pastel by Degas in the private collection of his dealer Paul Durand-Ruel. The collection was published in 1892, with descriptive texts by Georges Lecomte and etchings and drypoints by A.M. Lauzet after works by Impressionist artists. Guérin records that Degas was dissatisfied with Lauzet's prints and made two of his own.[2] Apparently he did not complete the project, for two other prints by Lauzet that reproduce Degas's paintings, *Avant la course* and *Ballet de Don Juan*, were included in the book. Lauzet's conventional renditions of *Horses in the Meadow* and *Dancer on Stage* are in the same direction as their prototypes, while Degas's etchings, more advanced in style, are in reverse.

It is generally thought that Degas's prints appeared in this publication only in a deluxe edition of fifty. Yet the copies of the book with his prints that have been examined are identical to those containing Lauzet's versions. Although the colophon indi-

cates that there were to be twenty-five copies with text and etchings on japan and twenty-five copies with text on Holland paper and etchings on japan, most of the impressions of the prints thus far found are on laid paper, often bearing the Arches name or countermark. In both copies of the book cited here, the texts are printed on wove paper and the prints on laid paper. There are two exceptions. The Durand-Ruel family owns copy number 1 of *L'Art impressionniste* in which the text and the etchings, including the two Degas prints, are on Japanese vellum, designated in the colophon as "papier des impériales du Japon." A single impression of *Horses in the Meadow* in the published state in the National Gallery of Art, Washington, is also on Japanese vellum. M. Charles Durand-Ruel has kindly brought to our attention information from the stock books of Durand-Ruel, New York, for 1891-93 and 1893-94. It is apparent that at least sixty copies of the "Lecomte-Lauzet" books were given to clients and friends. These were listed as being on Japanese, wove, and Holland papers.

The first state of *Horses in the Meadow* was described by Marcel Guérin as pure softground. He must have seen the impres-

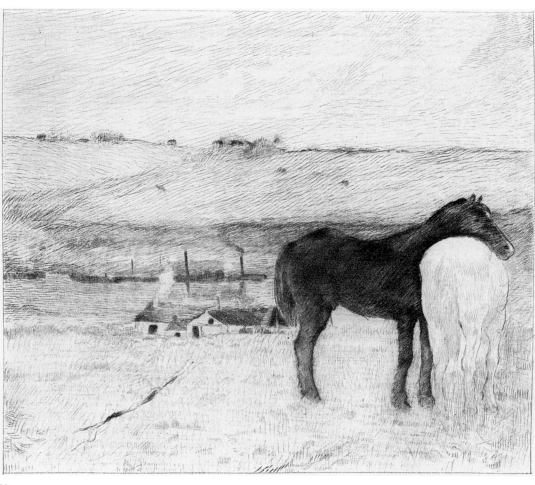

56a

sion sold in 1925 and described by Delteil as a "very beautiful impression of the first state, *before* some work, of a plate incorrectly given as doubtful."[3]

The second state has additional work in aquatint that darkens one horse and shades the distant hillside. This unique impression, on a large sheet of paper, is a proof before publication (MMA/Gerstenberg). The plate edges are not beveled and show a shadow of ink.

In the third state, fine horizontal drypoint lines give a tone to most of the image. They cover the sky and the meadow, where in the foreground along with vertical lines they form a crosshatched pattern. Small flicks of drypoint color the legs of the white horse and appear on the darker band of the hillside. This is the final state as published in the book.

In comparison with Lauzet's drypoint, Degas's print is summarily drawn and appears to be made by tracing Lauzet's image. The medium of softground would lend itself to this procedure. The myriad short drypoint lines that color Lauzet's print replicate more closely the 1871 painting (Lemoisne 289) and are not found in

Degas's boldly outlined image. One can only speculate why Degas desired to change two of Lauzet's illustrations after his own works and why he permitted his images to stand in reverse of the originals.

Notes

1. In 1924 M. Cailac, who collaborated with Loys Delteil, found a letter in the files of the Durand-Ruel Galleries in which Degas asks Paul Durand-Ruel if he was satisfied with these two illustrations for *L'Art impressionniste*. Although the letter has not since been located, this information was apparently given to Delteil, who included both prints in first states in a public sale at the Hôtel Drouot, 9 December 1925, lots 73 and 74.

2. Guérin, *Additions*, no. 66.

3. This is lot 74 as cited in note 1, above: "Très belle épreuve du 1er état, *avant* quelques travaux, d'une planche donnée à tort comme douteuse."

57

Dancer on Stage 1891-92

Softground etching, aquatint, and drypoint. Three states
Not in Delteil; Adhémar 58 (1891-92)
168 x 119 mm. platemark

I first state

Reproduced from plate 382 in Loys Delteil, *Complément du manuel de l'amateur d'estampes des XIXe et XXe siècles*, vol. 2 (Paris, 1926).
Not in exhibition

II second state

Cream, medium weight, moderately textured, laid paper
306 x 221 mm. sheet
Watermark: fragment of ARCHES
James A. Bergquist, Boston

III third state

Cream, laid paper
268 x 200 mm. sheet
Watermark: fragment of Arches countermark
Dallas Museum of Fine Arts. Gift of Mr. and Mrs. Alfred L. Bromberg

This is the second of two prints made to illustrate Georges Lecomte's book on Impressionist works in the Durand-Ruel collection. For a discussion of this project, see cat. no. 56. The main contours of this etching, like those of *Horses in the Meadow*, appear to be traced from Lauzet's drypoint (fig. 1). However, Degas used a slightly wider format and made alterations to the image primarily in the addition of the dancer's raised foot. The ambiguous form in the lower left foreground of Degas's print reads clearly in the Durand-Ruel pastel (Lemoisne 591, dated to 1880) as the skirt of a second dancer.

57 first state

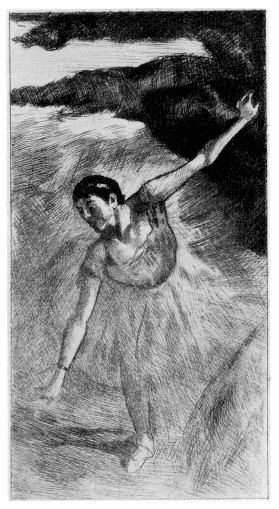

57. Fig. 1.
Auguste M. Lauzet. *Dancer on Stage*. Drypoint. In Georges Lecomte, *L'Art impressionniste* (Paris, 1892). Museum of Fine Arts, Boston.

The boldly outlined, flattened forms of Degas's etching suggest the decorative style of posters and book illustrations of the 1890s and are more effectively modern than Lauzet's bland reproductions made in a traditional manner.

The first state, executed in softground outline, is known only in reproduction. It was included in the Hôtel Drouot sale of 9 December 1925, lot 73, where it was described by Delteil: "Very beautiful impression of the first state, *before* the aquatint, of a piece *not described*."[1]

In the second state, aquatint bitten in two tones was applied over most of the image. Drypoint lines have been added, most noticeably to the back of the dancer's skirt and on the stage floor behind her. In this impression, the only one known of the second state, the plate edges are not beveled and retain ink.

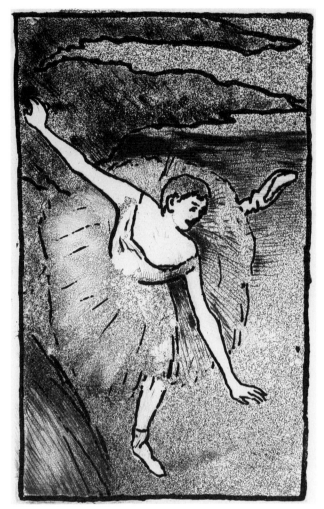

57 second state

57 third state

In the third and published state Degas has further developed the plate. He removed most of the aquatint and drypoint work from the dancer's dress and replaced it with a fine-grained aquatint tone. Both the dancer and the setting have been extensively shaded with etched hatching. Degas scraped to lighten the skirt at the lower left, which now resembles in tonality the skirt of the featured dancer.

Note

1. "Très belle épreuve du 1er état, *avant* l'aquatinte, d'une pièce *non décrite.*"

58

Degas and Pierre-Georges Jeanniot (1848-1924)

Trees 1890-92

Liftground aquatint and aquatint. Two states
Not in Delteil; Adhémar 59 (about 1892)
149 x 150 mm. platemark

I first state

Buff, medium weight, moderately textured, laid paper
310 x 220 mm. sheet
In pencil lower left: *Eau forte faite/par Degas dans mon atelier/en 18[··]*
Bibliothèque Nationale, Paris
Exhibited in London

II second state

Cream, medium thin, slightly textured, laid paper
315 x 233 mm. sheet
In pencil lower left: *Jeanniot;* lower right: *tirage 25 ep. No. 18/ 2e Etat;* in lower margin: *Eau forte dont le ler Etat a été fait par Degas – et le 2e sous sa direction par moi/G. Jeanniot*
Bibliothèque Nationale, Paris
Exhibited in London

Georges Jeanniot was a prolific printmaker of uneven talent who was nonetheless admired by Impressionist artists including Degas and Pissarro. Degas met Jeanniot in 1881, and it was in October 1890 at the latter's studio in Diénay, Burgundy (Côte d'Or), that Degas produced the first of his oil color landscape monotypes. Jeanniot published a memoir in 1933 that chronicled his long-term association with Degas.[1]

Since it is known that Degas utilized Jeanniot's studio and maintained a friendship with him, one should probably consider this print of leafless trees in a winter landscape as a joint technical experiment. The theme of landscape was not one pursued by Degas in printmaking after his very early efforts (cat. nos. 1 and 2), which were essentially derivative explorations of basic etching technique. Were it not that several impressions of *Trees* are inscribed with notes regarding the collaboration, it would be difficult to recognize Degas's hand at all.[2]

The trees in the first state were executed in the medium of liftground aquatint with broad, painterly strokes. It is likely that Jeanniot participated in this process, in which a variety of types of aquatint grains were tried.

The work added in the second state – dark, aquatinted sky, additional tree branches, and small plants and grasses – may be credited to Jeanniot alone. The many small forms alter and weaken the stark black and white image of the first state, which is more evocative of Degas's landscape monotypes of the 1890s.

The authors believe that a comparison can be made between the first state of *Trees* and the first state of Pissarro's *Wooded Landscape, L'Hermitage, Pontoise* (Delteil 16; fig. 1), the unique impression of which was owned by Degas. Although Pissarro's print is much earlier in date, it shows a similarity to *Trees* both in subject matter and in technique. It should be remembered

58. Fig. 1.
Camille Pissarro. *Wooded Landscape, L'Hermitage, Pontoise.* Softground etching and aquatint, 1879. First state. Museum of Fine Arts, Boston. Lee M. Friedman Fund.

that Degas had advised Pissarro about unusual methods of printmaking during their collaboration in 1879 for *Le Jour et la nuit*.

Notes

1. Georges Jeanniot, ''Souvenirs sur Degas,'' *La Revue universelle*, 15 Oct. 1933, pp. 152-74; 1 Nov. 1933, pp. 280-304.

2. Besides the works here catalogued, three impressions have been examined. In the BAA a first state is annotated: *épreuve faite sous la direction de Degas;* a second state is inscribed: *épreuve terminée.* In the BN, Paris, a second state is inscribed: *Les Arbres, c. f.* [i.e., cuivre fait] *de Degas terminée par Jeanniot, 2e état, vers 1895.* Melot 1974, p. 98, nos. 212-13, discusses both states, which he considered to be of documentary interest only.

58 first state

58 second state

214

59

Three Nude Dancers at Rest about 1891

Lithograph, from a metal plate. One state
Delteil 41 (about 1890, as a softground etching); Adhémar 61
(about 1891-92)
197 x 270 mm. platemark
Cream, moderately thick, smooth, Japanese vellum
250 x 319 mm. sheet
Coll.: Rouart
N. G. Stogdon

59a

Lithograph, reworked with black chalk and pink pastel
Cream, moderately thick, smooth, Japanese vellum

235 x 323 mm. sheet
Atelier stamp
E. W. Kornfeld, Bern

In a letter to an artist friend, Evariste de Valernes, dated July 6, 1891, Degas wrote that he intended to make a suite of lithographs; the first of nude women at their toilettes, the second of nude dancers.[1] The editor of the letters, Marcel Guérin, indicated in a footnote that only one plate of nude dancers was executed. Guérin erroneously cited this plate as Delteil 31 instead of 41. The touched impression of the print was designated as a lithograph in the Atelier sale (*Eaux-fortes*, no. 148), and although Delteil and

59

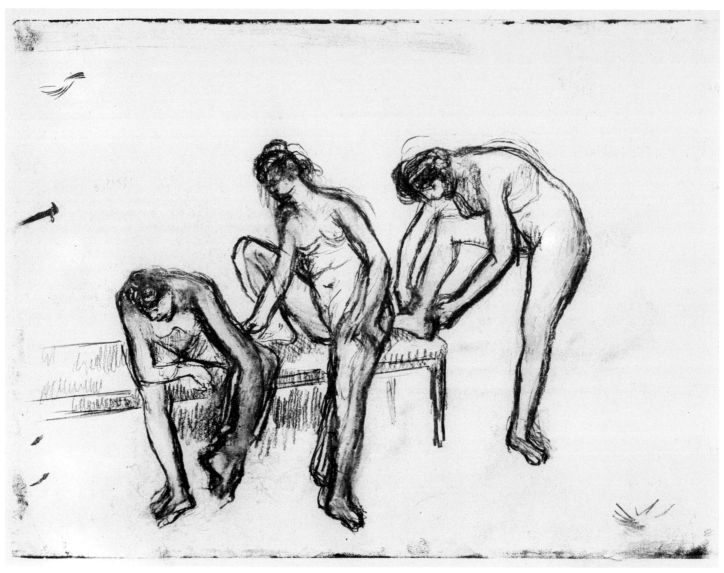

59a

others have subsequently termed it a softground etching, it is indeed a lithograph printed from a plate rather than a stone.

Much of the confusion about the medium of the print is caused by the platemark with heavily inked edges. The unique first state appears to be a study piece, drawn on a prepared lithographic plate (probably zinc) and printed without professional care. Degas tested the crayon in the upper left and wryly sketched a small profile at the the lower edge of the plate, as he had done many years earlier in his portrait of Joseph Tourny (cat. no. 5).

This rare print relates to a group of drawings and pastels that depict three or four dancers in a sequence of poses. The unifying compositional element in each is a long bench. All these works, large in scale, are in reverse of the lithograph. Two charcoal drawings (Atelier sale II, 265, and III, 200) and two pastels (Lemoisne 1294 and 1307, Glasgow Art Gallery) show the closest correspondence to the print.

Stylistically, the lithograph and its variants can be dated in the early 1890s, when Degas favored redundant contour lines that often convey a sense of awkwardness and imprecision. Perhaps this practice was due to difficulties with his eyesight, about which he frequently complained.

The unretouched impression of the lithograph was given by Degas to his friend Alexis Rouart. The only other known impression (59a) was reworked in black chalk and pink pastel, possibly at a later time. It exhibits an even more pronounced clumsiness and distortion of the dancers' limbs. This lithograph on a metal plate was yet another of Degas's experiments in new printmaking techniques.

Note

1. Degas, *Lettres* 1945, no. 159, 6 juillet 1891; Degas, *Letters* 1947, no. 172, 6 Dec. [*sic*] 1891.

60

Maid Combing Hair about 1891

Lithograph, transfer from monotype. Two states
Delteil 62 (about 1890); Adhémar 47 (about 1876-79)
215 x 230 mm. image (approximate)

I first state

Off-white, medium thick, slightly textured, wove paper
251 x 299 mm. sheet (irregular)
Atelier stamp
Bibliothèque Nationale, Paris
Exhibited in Boston

II second state

Cream, thick, smooth, wove paper
405 x 330 mm. sheet
Coll.: *Degas* signature stamp; Guérin
E. W. Kornfeld, Bern

The emphasis on the servant is unique in Degas's prints, although
the subject is treated in the 1890s in his pastels, where maids are
depicted as domestic attendants, bringing cups of tea, holding
bath towels, or combing their mistresses' hair. There are two
charcoal drawings, one a counterproof, that relate closely to the
second state of this lithograph. Both were in the Atelier sales.[1] The
drawings reveal that the servant in the lithograph is combing the
long tresses of a seated woman.

It has been recorded, in a reference to the second state, that
this image was drawn with greasy ink on a sheet of celluloid and
transferred to a lithographic stone.[2] It shares many of the charac-
teristics of the lithographs transferred from monotype impressions,
particularly in the fluid brushwork. The large scale, breadth of
drawing style, unconventional technique, and rarity of this print
made the identification of the medium difficult at the time of the
studio sales. The unique first state was not listed in the 1918
Atelier catalogue but was sold as an additional item, no. 178 *bis*,
as recorded by Delteil in his catalogue raisonné. The unique sec-
ond state appeared in Atelier sale IV, no. 359, under the section
devoted to "Impressions en noir" (Impressions in black), which
included many counterproofs of drawings. It bears the Degas sig-
nature stamp in black that was normally affixed to drawings.

In the first state (BN/Atelier) Degas executed the transfer
image with pointed and broad brushes, later making tonal adjust-
ments with crayon directly on the stone. The charm of the image
is somewhat marred by the unintentional blotches of ink that sug-
gest technical difficulties encountered in the transfer process.

With extensive but judicious scraping and new crayon work
in the second state (Kornfeld/Atelier), Degas refined the drawing
and corrected the inky accidents. The maid's arms are more clearly
defined, and the long hair falls logically between them. He altered
her hairdo and made many amendments to her dress. In this print,
which is devoid of background or setting, Degas has given promi-
nence and monumentality to a single figure, as he did with the
nude bather in the second state of *After the Bath III* (cat. no. 65).

Notes

1. Atelier sale III, no. 177(2), 320 x 300 mm., present location unknown;
and Atelier sale II, no. 317, on tracing paper, 340 x 460 mm., now private
collection; see Adriani 1984, no. 190, illus., dated 1892-95.

2. "Lithographie. Report sur pierre d'un dessin à l'encre grasse sur cellu-
loïd, repris sur la pierre au crayon lithographique et au grattoir. Epreuve du
2e état"; Paris, *Degas* 1924, no. 220 (Guérin collection).

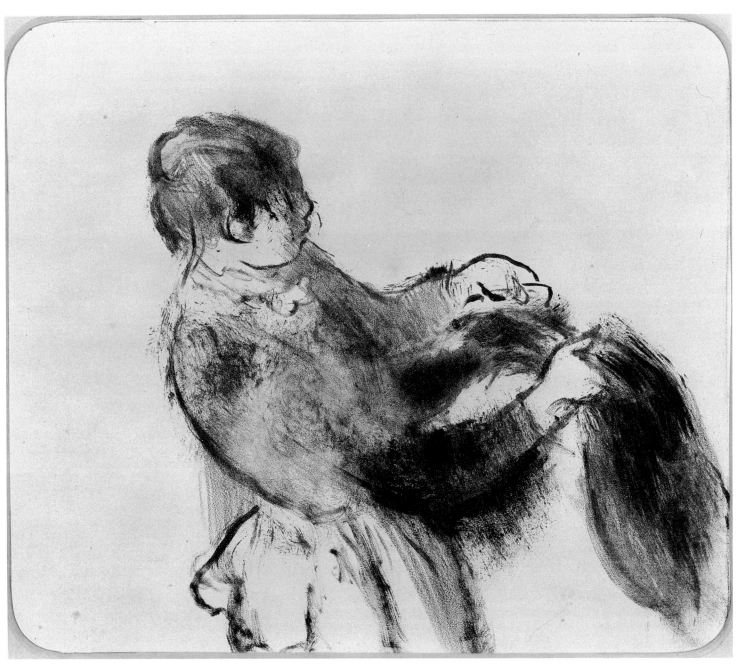

60 first state

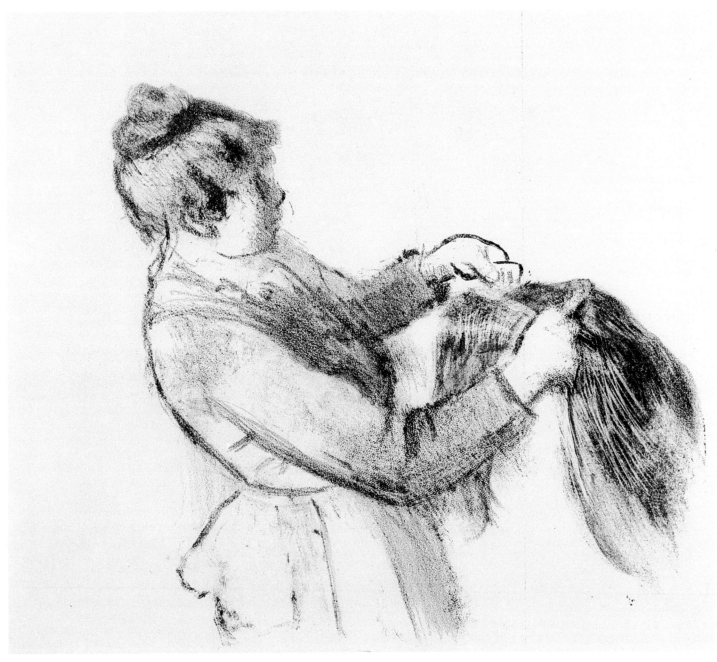

60 second state

61

Nude Woman Standing, Drying Herself 1891-92

Lithograph, transfer from monotype, crayon, tusche, and scraping.
Six states
Delteil 65 (about 1890, four states); Adhémar 63 (about 1890);
Kornfeld (five states)
Image measurements vary with state and are given below

I first state

295 x 195 mm. image
Grayish cream, medium weight, smooth, wove paper
363 x 232 mm. sheet (irregular)
Coll.: Atelier, Gerstenberg
Private collection, Germany

II second state

310 x 195 mm. image
White, medium thick, smooth, wove paper
443 x 304 mm. sheet
Coll.: Atelier, Guérin
The British Museum. Campbell Dodgson Bequest, 1949

III third state

330 x 245 mm. image
White, moderately thick, smooth, wove paper
445 x 304 mm. sheet
Atelier stamp
*Department of Prints and Drawings, The Royal Museum of Fine
Arts, Copenhagen*

IV fourth state

330 x 245 mm. image
Buff, moderately thick, moderately textured, machine-made, laid
paper (wove paper with laid pattern)
455 x 293 mm. sheet
*Museum of Fine Arts, Boston. Katherine E. Bullard Fund in mem-
ory of Francis Bullard and proceeds from sale of duplicate prints*

V fifth state

330 x 245 mm. image
Buff, medium thick, moderately textured, wove paper
375 x 263 mm. sheet
*The Metropolitan Museum of Art. Purchased with funds provided
by Mr. and Mrs. Douglas Dillon, 1972*

VI sixth state

330 x 235 mm. image
Off-white, moderately thick, moderately textured, wove paper
425 x 300 mm. sheet
*Fogg Art Museum, Harvard University. Bequest of Meta and Paul
J. Sachs*

Degas's interest in executing a series of lithographs is confirmed
by two letters. In one, Camille Pissarro wrote to his son Lucien, 25

April 1891: "He [Degas] is making some lithographs, Meyer [*sic*]
would like to have them, it is a rather important deal."[1] And on 6
July 1891 Degas indicated to his artist friend Evariste de Valernes:
"I am hoping to do a suite of lithographs, a first series on nude
women at their toilette and a second on nude dancers."[2]

The bather lithographs (cat. nos. 61-66) were Degas's last
great effort in printmaking. As in the small drypoint of *Leaving the
Bath* (cat. no. 42), Degas has focused here on the back of a model
who performs her private ritual. A decade earlier he made the
single intaglio print, whereas in six separate lithographs he has
explored the same monumental pose and exaggerated gesture of
a standing nude drying herself with a towel. In a number of draw-
ings, most of which are sketched on thin tracing paper, he drew
and redrew this powerful image, directing attention to the bather's
flowing hair, her jutting hip, and the long towel with folds. Using
these studies, especially those rendered on a variety of grainy
transfer papers, Degas captured on stone a sequence of poses
that reveal upon closer examination both visual and technical con-
nections. Degas's friend in later life, Paul Valéry, the critic and
poet, defined his working style: "He is like a writer striving to
attain the utmost precision of form, drafting and redrafting, cancel-
ing, advancing by endless recapitulation, never admitting that his
work has reached its *final* stage: from sheet to sheet, copy to
copy, he continually revises his drawing, deepening, tightening,
closing it up."[3]

With regard to the techniques used to make these six litho-
graphs, there are still unanswered questions. The order of execu-
tion and the state sequences, however, are clearer today than they
have been in the past. Delteil's 1919 catalogue descriptions were
based on a relatively small number of impressions that either were
in private hands or had appeared in the Atelier sales. He did not
know the later states of some of these prints. In the 1950s, E. W.
Kornfeld found a relatively large number of impressions of some of
the bather lithographs (cat. nos. 61 IV and VI, 65 I and II, and 66 V)
in the hands of Maurice Exsteens, who had acquired them from
his father-in-law, the Parisian collector and publisher Gustave Pellet
(1859-1919). Pellet had evidently obtained them sometime
between 1900 and 1910 and is said to have had them signed by
Degas. Kornfeld's 1965 publication on the lithographs has aided in
locating many of the impressions brought together here, and his
information has shed light on the history of the prints unknown to
Delteil.[4]

The visual evidence of the prints themselves leads us to
believe that the state sequences have been securely established.
The interrelationships between the prints and the order of their
execution have been of interest to Douglas Druick and Peter
Zegers (see the essay "Degas and the Printed Image"), and their
observations were most helpful. Uncertainties remain about some
of the techniques, for Degas and his printer employed unusual
combinations of materials and processes: greasy drawings on cel-
luloid, coated transfer papers that produced unexpected granular
patches, photographic transfer, and direct work on the stone. As a
group the bather lithographs vividly illustrate Degas's inventive,
and sometimes unique, working methods.

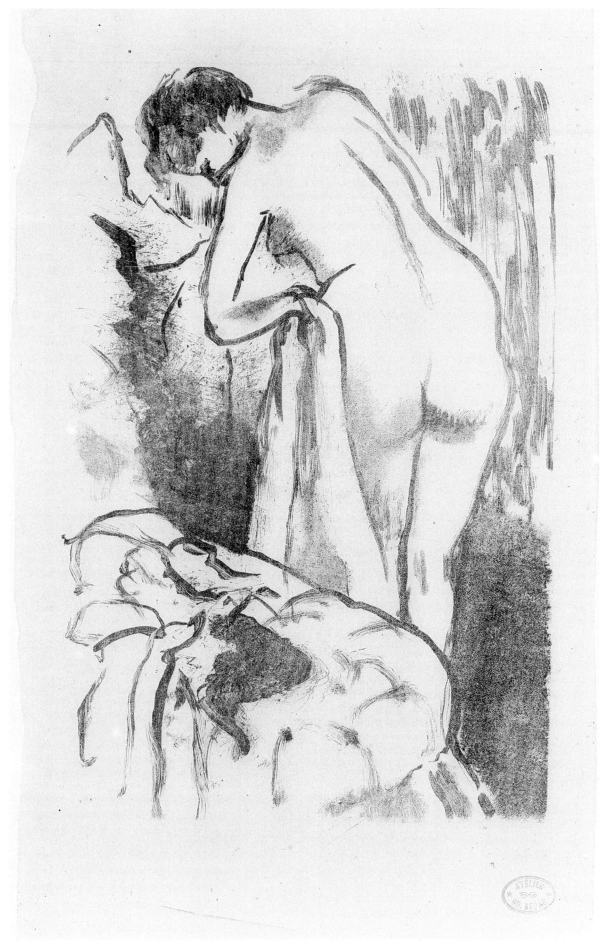

61 first state

Nude Woman Standing, Drying Herself began as a direct transfer to a lithographic stone of a drawing in brush and greasy ink, probably a monotype made on a celluloid plate.[5] The first state resembles other lithographs that were the result of monotype transfer (see cat. no. 30). The nature of the brushwork and the trace of a fingerprint on the bather's right buttock recall the monotype original.

The composition of the figure in its setting is fully established in the first state. This impression (private collection, Germany/Atelier) exhibits a fine, regular texture that reflects the nature of the machine-made, wove paper on which it was printed. The second known impression (BAA) was printed on a smooth-surfaced paper that shows even more clearly the nuances of the transferred monotype image.

In the unique impression of the second state (BM/Atelier and Guérin), Degas removed many of the original brush and lithographic ink contour lines of the body of the bather and replaced them for the most part with crayon lines (as in, for example, the right arm). He further modeled the nude's body with a few crayon strokes and lengthened her hair, partially concealing the broad, irregular brushstroke at the left.

In the third state Degas enlarged the composition with brush and tusche, as well as with crayon, by extending the patterned wall at top and the chaise at left, where a large dark area suggests clothing. There is additional brushwork in the bather's hair as well as on the hairpiece that lies on the chaise. Crayon work and scraping further modeled and shaded the figure; again, the contour of the right arm is changed. Degas scraped away part of the dark background to the left of the bath towel. Delteil cited three impressions, possibly of this state, from the Beurdeley, Fenaille, and Rouart collections that have not been located. There were two Atelier impressions: Copenhagen and another impression, whose present location is unknown.

In the fourth state there is a transformation in the character of the print. The lines look more granular and appear less like those of a lithograph made with brush and ink. Dark areas such as the hair and hairpiece no longer show highlights and read as continuous, unmodulated tones. The top edge at right and upper right corner of the image have been neatly cropped. It has been suggested that the change in the print is due to the sealing and subsequent reopening of the stone at a later time.[6] This process can result in a regularization or coarsening of the printed textures and tonalities. There does not appear to be any intentional rework between the third and fourth states; the spots below the bather's left elbow and on the chaise are accidental. This state may be found printed on two different papers: one is an off-white, moderately thick, smooth, wove paper and the other a buff, medium weight, moderately rough, machine-made, laid paper. In impressions on the buff paper the texture of the laid lines is clearly visible in passages of continuous tone. No impressions of this fourth state (nor of the fifth and sixth) were in the Atelier sale. Some twenty impressions of the fourth state have been located; half of them were inscribed "Degas" in a hard graphite pencil at the lower left.[7]

The fifth state represents a working stage in the reduction of the image. Degas used acid in a painterly manner to erase portions of the chaise and background in order to focus attention on the figure of the bather. He has lightened the hairpiece and has begun to remove the accidental mark near the bather's left elbow. This one impression (MMA) records a procedure that required careful control.

The sixth and final state shows further work with acid in which a large portion of the left side of the print is now bleached out. The size of the image has not been reduced, but elements have been removed, including the entire back of the chaise (see also cat. no. 65 II). Highlights in the bather's hair are once more visible. Degas has emphasized the monumental figure of the bather rather than the setting. As with many of his intaglio plates, Degas did not stop once an image was resolved but continued to experiment with new solutions. At least eight impressions of the sixth state have been located; three bear Degas's name in graphite, as in the fourth state: AIC, Fogg, R. S. Johnson, Kornfeld, NGA, Mr. and Mrs. Michael Pado, N. G. Stogdon, UCLA.[8]

Notes

1. Pissarro, *Lettres* 1950, p. 235. Incorrectly translated in English edition of Pissarro, *Letters* 1972, p. 165. See the essay "Degas and the Printed Image," Part III, n. 36, for the reference to Salvador Mayer.

2. Degas, *Lettres* 1945, no. 159, p. 183; incorrectly dated in English edition, 1947, pp. 174-75. It is interesting to note an excerpt from a letter Mary Cassatt wrote to Samuel P. Avery, 2 March [1893]:

I will try to get you some proofs of Degas, but I cannot promise that I will be successful. He is not an easy man to deal with, he has been talking for some time of doing a series of lithographs but I am afraid it will end in talk. (Mathews 1984, p. 246.)

3. Valéry, p. 39.

4. Kornfeld, 1965. We are grateful to Edith Schmidt for a translation of the introduction. Mr. Kornfeld has seen signatures on impressions of cat. nos. 61 III and IV, 65 I and II, and 66 V. Those we have observed on cat. nos. 61 and 65 are in hard pencil and are not typical of Degas's hand in his later years.

5. In the Paris 1924 Galerie Georges Petit exhibition this lithograph and other bather lithographs (nos. 219-23) were said to have originated as transfers to stone of drawings in greasy ink on celluloid ("Report sur pierre d'un dessin à l'encre grasse sur celluloïd").

6. This suggestion was offered by the lithographer John Brennan, of the School of the Museum of Fine Arts, Boston, who made every effort to unravel the processes that were used for the bather lithographs. One impression of cat. no. 61 IV in the Kornfeld collection (500 x 290 mm. sheet) has the printing characteristics of the earlier states. The image is surrounded by a pale, blotchy tone of ink printed from the stone and may support Mr. Brennan's hypothesis that the stone was sealed and reopened.

7. Kornfeld reported that about twelve impressions of the fourth state came from Gustave Pellet.

8. About twelve impressions are said to have come from Pellet.

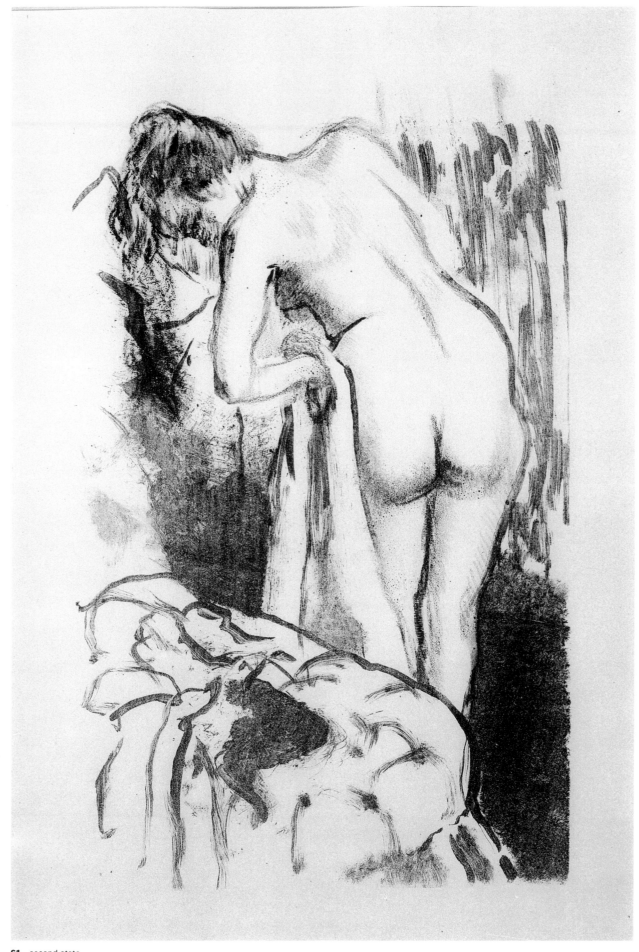

61 second state

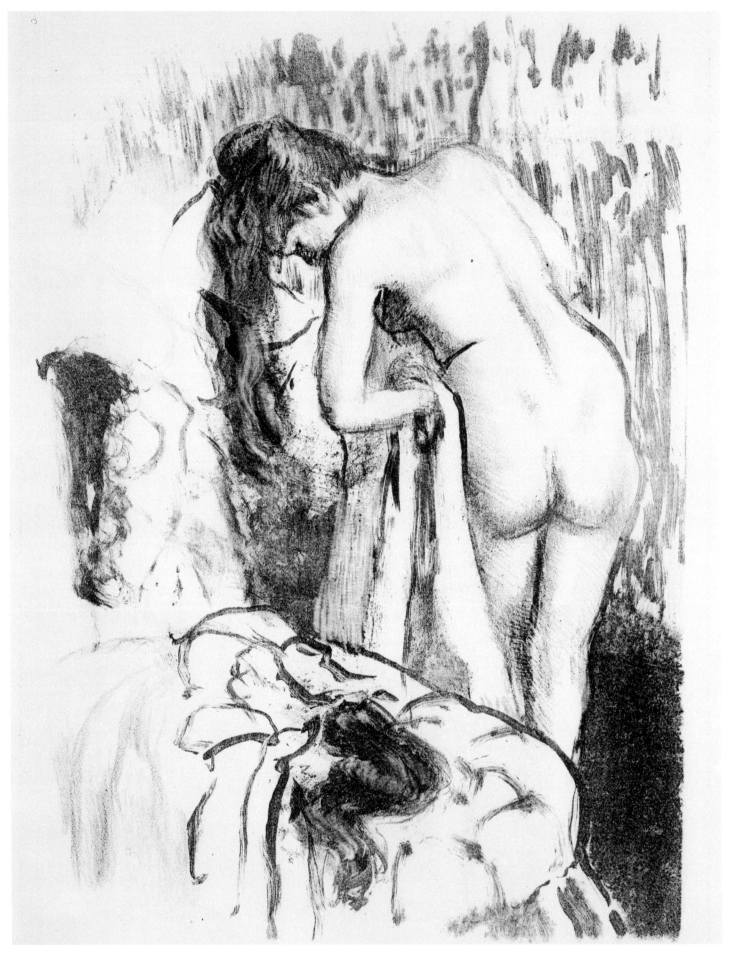

61 third state

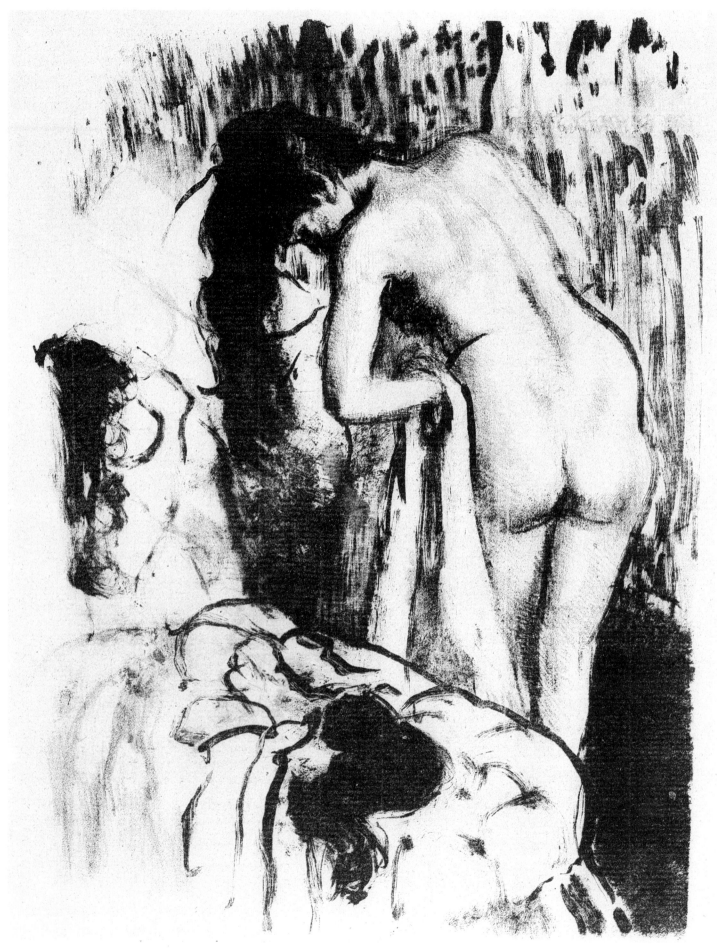

61 fourth state

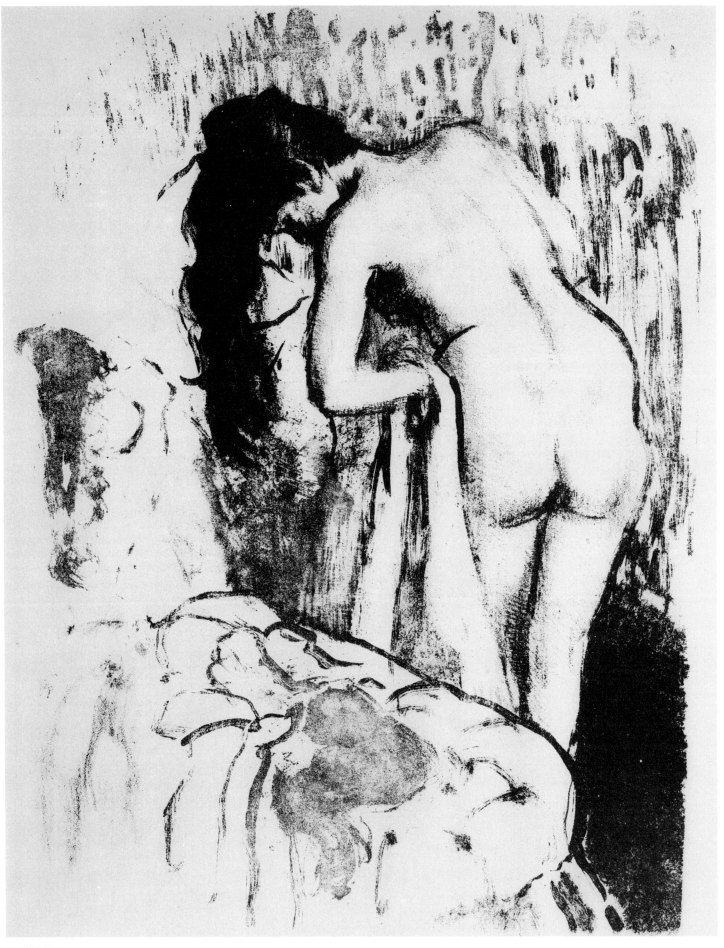

61 fifth state

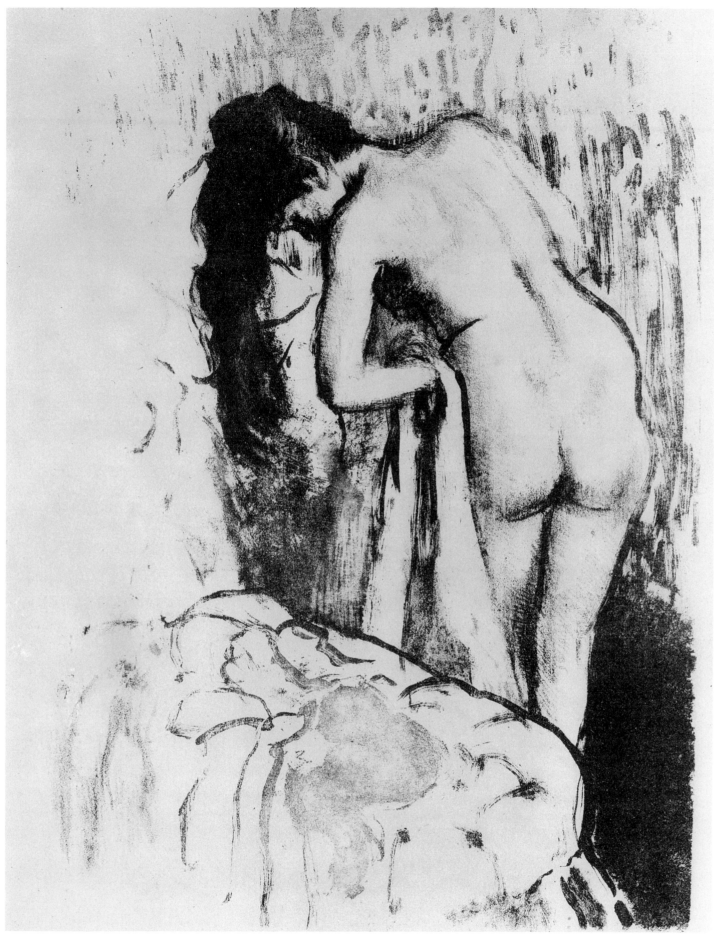

61 sixth state

62

Nude Woman With Towel, Standing 1891-92

Lithograph printed in brown ink. One state
Delteil 57 (about 1880); Adhémar 62 (about 1891)
284 x 152 mm. image
White, moderately thick, smooth, wove paper
370 x 255 mm. sheet
Signed lower right in pencil: *Degas*
*The Cleveland Museum of Art. Mr. and Mrs. Lewis B. Williams
Collection*

62a

Medium uncertain
Delteil 38 (about 1880; essai de lavis au pinceau); Passeron 1970,
p. 71 (etching with brush-drawn wash on zinc)
281 x 198 mm. border line or platemark
Coll.: H. E. Delacroix
Marcel Lecomte, Paris
(Illustrated from Passeron)
Not in exhibition

This image of an isolated bather relates in pose, shape, and pro-
portion to the bather as she appears from the third state onward in
the preceding lithograph (cat. no. 61). This print may be a revision
of that lithograph, possibly through the use of a tracing, as Degas
continued to explore the motif.

A unique work belonging to Marcel Lecomte (cat. no. 62a),
known only through reproduction, is the initial step in the develop-
ment of the lithograph. In his catalogue raisonné Delteil placed it
among the intaglio prints and described it as an experiment in
bitten tone ("essai de lavis au pinceau").[1] He recorded that the
image, taken from a copper plate (278 x 193 mm.), was trans-
ferred to a lithographic stone. In contrast, Marcel Guérin (Addi-
tions, no. 38) called the work a monotype. More recently, Roger
Passeron has claimed that it was "an etching with brush-drawn
wash on zinc."[2] Since it was not possible to examine the Lecomte
work, we cannot confirm the medium, but we are inclined to
believe that it is either the monotype used for transfer or the first
state of the lithograph before any additional work.

There are two impressions known of the lithograph, both
printed in brown ink: BM (Atelier and Guérin) and Cleveland
(signed). Degas used a brush to round the top of the bather's
hairdo and to extend and enlarge the towel.[3] In all other respects
the lithograph corresponds exactly to the Lecomte print, and both
share a somewhat grainy texture that suggests the involvement of
a transfer process. The faint, square-cornered border lines seen in
the two impressions of the lithograph may indicate the edges of a
zinc lithographic plate or the edges of the matrix from which the
original monotype was printed. These lines can be observed as
well in the Lecomte work. In only one other instance did Degas
make a lithograph on zinc (cat. no. 59); there he used a hard
crayon to draw directly on the plate.

Notes

1. We believe that Delteil's use of the term "lavis au pinceau" is probably
inaccurate.

2. As translated in the English edition, Passeron 1974, pp. 214-15. This
print is catalogued as belonging to Marcel Lecomte, who acquired it from
the Palais Galliéra, Paris, 31 March 1962. Passeron gives the measure-
ments as 281 x 198 mm. platemark, including bevels of 5 mm.

3. Instead of tusche he may have used printer's ink, which produced the
drier texture of the brushstrokes.

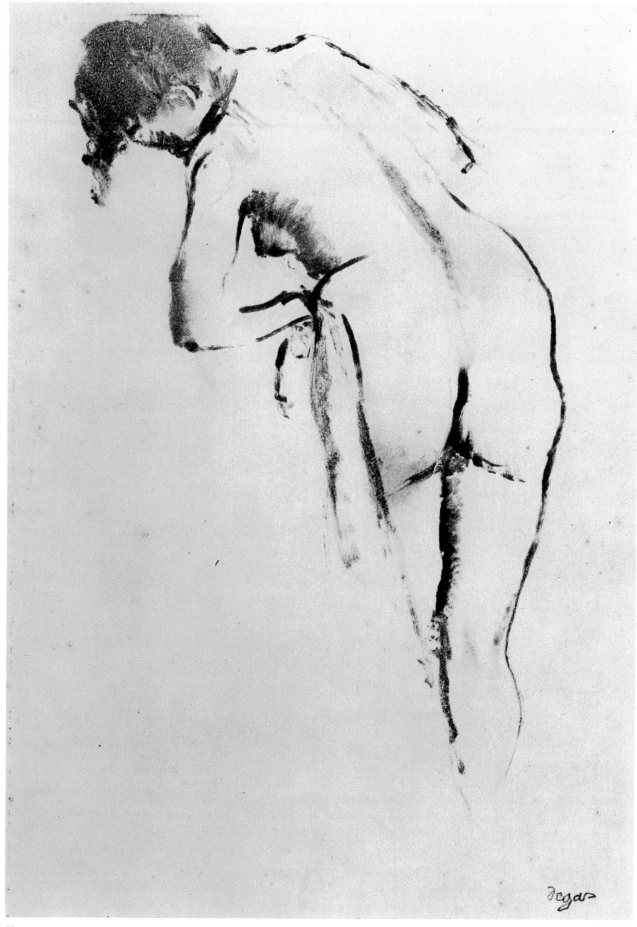

62a

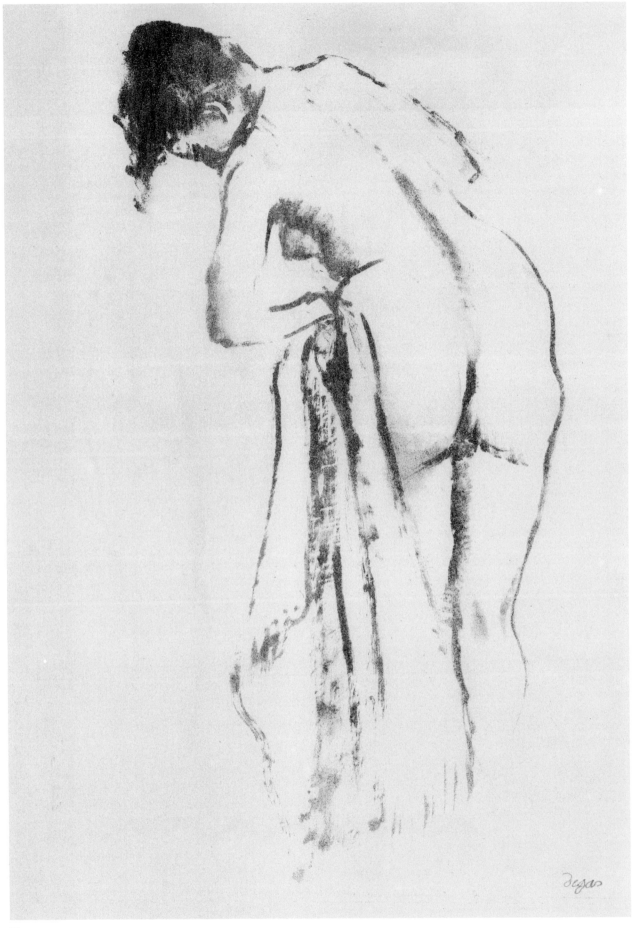

62

63

After the Bath I 1891-92

Lithograph, transfer and crayon. Two states
Delteil 61 (2e planche, about 1885); Adhémar 66 (about 1891)
193 x 147 mm. image

I first state

Off-white, thick, smooth, wove paper
305 x 223 mm. sheet
Coll.: Atelier; Guérin
E. W. Kornfeld, Bern

II second state

Off-white, very thin, smooth, Japanese tissue
272 x 216 mm. sheet (irregular)
Coll.: Eddy; Whittemore
N. G. Stogdon

In contrast to previous cataloguers, we propose that this is the first of a series of three lithographs of a bather drying herself in which the image was transferred to three separate stones. Portions of the composition, such as the unmade bed and its frame seen at the left in cat. nos. 63 and 64 and the tufted chaise in the foreground in cat. nos. 64 and 65, are identical to two of the three stones and provide visual links between all three prints.

The drawing common to the three images must have been that made with greasy ink on celluloid, formerly owned by Michel Manzi and acquired by Guérin from the first Manzi sale in March 1919, no. 128. The sale catalogue cited the inscription on the verso: "Dessin à l'encre grasse sur celluloïd ayant servi pour tirer héliographiquement une contre-épreuve à la presse sur papier humide, par M. Degas" (Drawing [made] with greasy ink on celluloid having served to print photographically a counterproof on damp paper with the press, by M. Degas). The drawing's dimensions were given as 200 x 150 mm., close in size to the lithographic image. While the drawing was in Guérin's collection, it was shown in the 1924 Galerie Georges Petit exhibition of Degas's work as no. 218, along with an impression of *After the Bath I* in the second state. In the catalogue of that exhibition the reference to photography was omitted.[1]

Michel Manzi (1849-1915), a friend of Degas, was a specialist in making reproductive prints. From 1881 he was technical director of the printing studios for Boussod & Valadon. He established a photogravure studio on the rue Forest and also printed illustrations between 1892 and 1896 for a variety of publications including *Le Figaro illustré*. He invented chromotypogravure, a color process.[2] The BAA impression of the second state of *After the Bath I* bears the inscription "Essai chez Manzi" (Experiment made at Manzi's) and is signed by Degas.[3] This confirms the connection between this stone and the documented, though unlocated, drawing on celluloid, as well as the relationship between Degas and Manzi.

The first state of the lithograph is a combination of a photographically transferred brush drawing and crayon applied directly on the stone. The left side and lower edge of the stone picked up

ink and read clearly in most impressions. The photographic passages appear soft, blurred, and somewhat blotchy, and are most noticeable on the bed and the floor. On the bather they are evident in the shadow that separates her legs and on her face and hair. The abundance of small random spots throughout the image is characteristic of photographic processes. Degas subsequently worked with crayon directly on the stone to connect the elements of the figure and setting that had only partially transferred photographically. One impression of the first state has been located: Kornfeld (Atelier, Guérin). A second impression on "chine fixe" was listed in the Atelier sale but has not been found.

The second state exhibits extensive work on the stone in crayon that models the figure more fully and clarifies elements of her surroundings, particularly the chaise in the foreground and the clothing lying on it. With the exception of the bed frame and covers, the areas of photographic transfer are for the most part masked by the direct crayon work.

The pearly surface of the tissue on which the second state catalogued here is printed is particularly well suited to the subject of the nude and contributes to its sensuous quality. Three of the four known impressions of this state were printed on the same gossamer paper that was also used for one impression of the large version of *After the Bath* (cat. no. 66). The four second states are in the BAA, BN (Rouart), AIC (formerly on loan, Beurdeley), and Stogdon (Eddy, Whittemore); the last may be that in the Atelier sale on "japon pelure." Since all the impressions cited by Delteil have been accounted for, it is possible that this impression was not stamped because of the fragile, transparent nature of the paper.

Notes

1. "Dessin à l'encre grasse sur celluloïd, ayant servi à un report sur pierre que Degas a repris ensuite au crayon lithographique sur la pierre" (Drawing with greasy ink on celluloid, having served as a transfer on stone that Degas then reworked with lithographic crayon on the stone). According to Ittmann 1967, no. 12, the drawing on celluloid was sold in a 1951 Hôtel Drouot sale. Its present whereabouts are unknown.

2. See Melot 1974, p. 90; and New York, *Manet* 1983, pp. 86 and 98 under "Provenance."

3. Melot 1974, no. 204, illus. p. 92, with inscription visible.

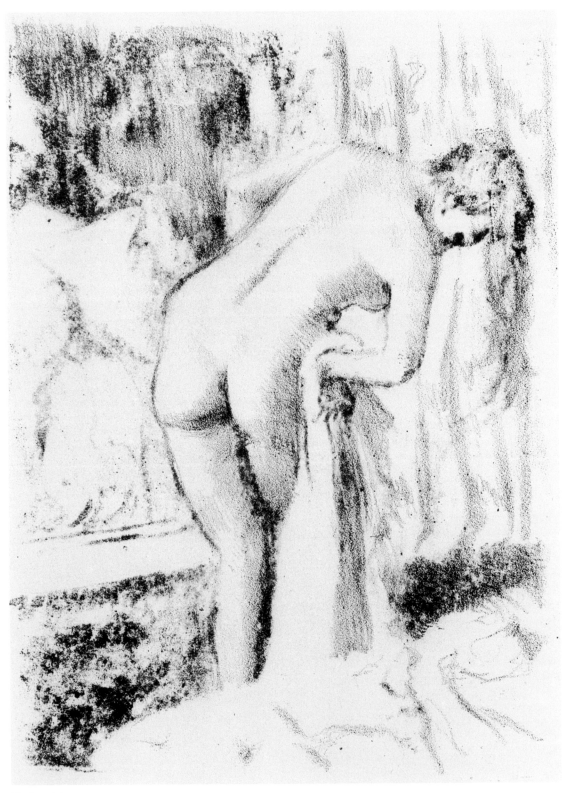

63 first state

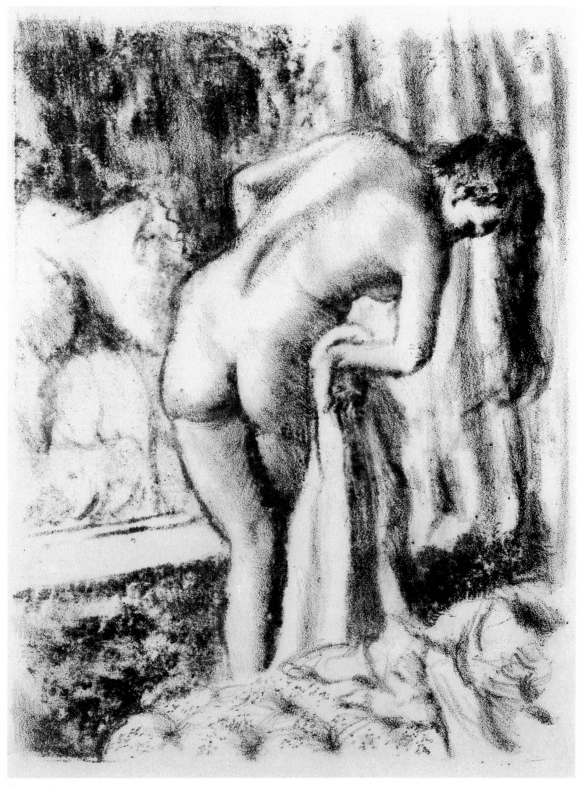

63 second state

64

After the Bath II 1891-92

Lithograph, transfer, crayon, and scraping. Five states
Delteil 60 (about 1885); Adhémar 64 (about 1891)
190 x 147 mm. image (first through fourth states)
210 x 147 mm. image (fifth state)
235 x 187 mm. stonemark

I first state

White, moderately thick, smooth, wove paper
300 x 220 mm. sheet
Coll.: Atelier; Abby Aldrich Rockefeller
*Sterling and Francine Clark Art Institute, Williamstown,
Massachusetts*

Ia first state, variant printing

Off-white, moderately thick, smooth, wove paper
300 x 220 mm. sheet
Atelier stamp
N. G. Stogdon

II second state

Off-white, moderately thick, smooth, wove paper
301 x 221 mm. sheet
Coll.: Atelier; Guérin
The Brooklyn Museum

III third state

Off-white, moderately thick, smooth, wove paper
300 x 219 mm. sheet
Coll.: Atelier; Bliss; Brewster
The Art Institute of Chicago. Gift of Walter S. Brewster, 1954

IV fourth state

White, smooth, wove paper (mounted down)
304 x 218 mm. sheet
Atelier stamp
*British Museum. Presented by the Contemporary Art Society,
1925*
Exhibited in Boston and London

V fifth state

Off-white, moderately thick, smooth, wove paper
303 x 221 mm. sheet
Atelier stamp
Philadelphia Museum of Art. Given by Henry P. McIlhenny

The drawing that served as the basis for *After the Bath I* (cat. no.
63) was transferred photographically to another lithographic stone
with a distinctly different stonemark. The unmade bed and bed
frame are exactly alike in both prints; round imperfections in these
areas continue to appear throughout all the states of no. 64. The
chaise in the foreground of *After the Bath II* was transferred intact
from the initial drawing and may also be seen in the same form in

cat. no. 65. The image as it appears on the stone assumes a flat,
grainy appearance possibly due to the photographic process.

Upon close examination of *After the Bath II* we have con-
cluded that the first and second states cited by Delteil are in fact
variant printings of the first state. Four impressions coming from
the Atelier sale show the same amount of scraping on the bather's
body; however, there are two light impressions and two dark
ones. The variations in printing are not due to additional work but
occurred when the stone rapidly filled in with ink.

In the light printings of the first state it is evident that addi-
tions have been made to the transfer image by means of direct
work on the stone. Degas strengthened the hair and contours of
the bather and delicately scraped the left and right sides of her
body. The crayon additions are darker than the parts transferred.
Delteil characterized these impressions as exhibiting "forts à-
plats" (strong flat tones). Two impressions of this light printing are
known: private collection, Germany (Atelier) and Clark (Atelier). Two
impressions of the dark printing, which Delteil reproduced as his
second state, are known: Albertina (Atelier) and Stogdon (Atelier).

Degas realized that the accumulation of ink on the stone
was obliterating the image. In order to model the bather in the
second state he removed ink by scraping the stone . Extensive
fine, white crosshatching defines her body, especially her left arm,
which now emerges from the darkness. One impression in the
Brooklyn Museum (Atelier, Guérin) records this state.

Although the image remained unclear, Degas did not aban-
don it but tried to retrieve the figure of the bather from the murky
background. In the third state he further scraped the dark areas
with a variety of implements, using these tools in an aggressive
manner to give a lighter aspect to the composition. Only one im-
pression documents this stage of experimental work: AIC (Atelier).

In the fourth state Degas took the crayon and redrew much
of the bather, raising and enlarging her head and left shoulder so
that her proportions have become distorted. He also shaded the
wall and floor in an effort to establish a more convincing space. He
drew ornaments on the curtain and with short strokes added tex-
ture to the rug. One impression records his progress on the stone:
BM (Atelier).

In the fifth and final state Degas shaded the background,
adding a band at the top in an effort to accommodate the scale of
the further enlarged bather. Extensive new scraping including the
use of roulette dramatically altered and broadened her figure.
When the stone was printed, some of the deeply scratched lines
embossed the paper. The towel has been enlarged and obscures
the bather's left calf. The bed, the decorated curtain, and the
patterned rug have essentially disappeared under new shading.
Attention is now focused on the monumental figure of the bather
who pushes against the confines of the darkly shaded background.
Despite the many changes that have taken place, the image of the
tufted chaise, originally transferred photographically, has remained
a constant element throughout the five states of the print. Two
impressions of this state are known: BN (Atelier) and PMA (Ate-
lier). (We have located all the impressions of *After the Bath II* in
the Atelier sale, there entitled *Le Lever*.)

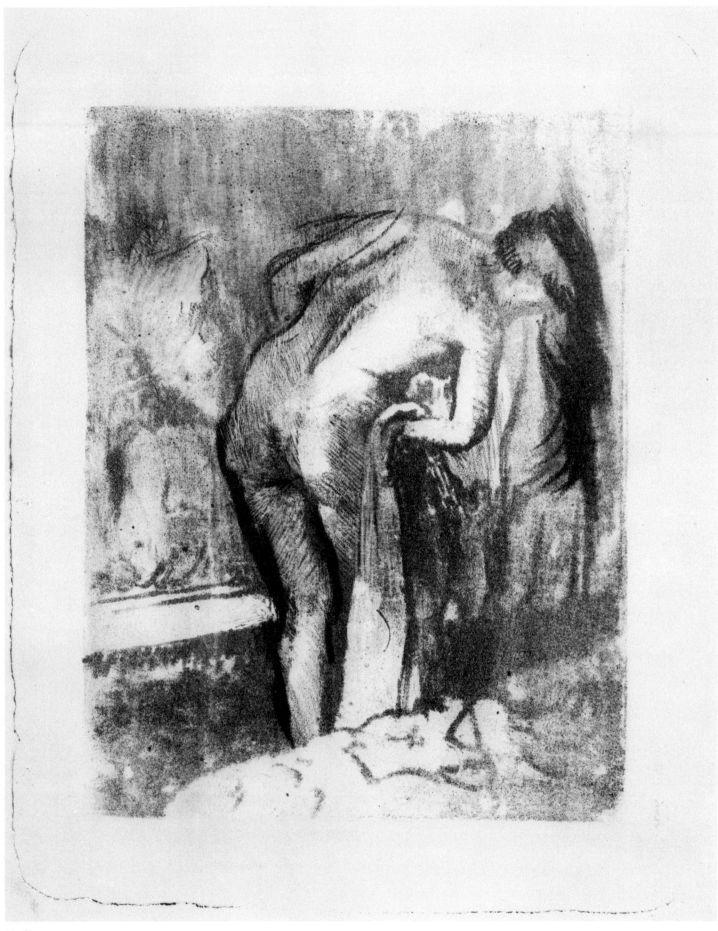

64 first state

235

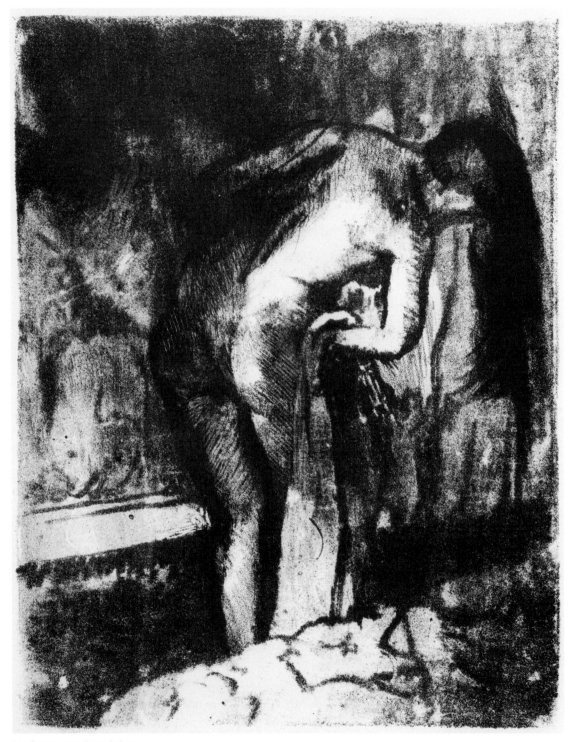

64 first state, variant printing

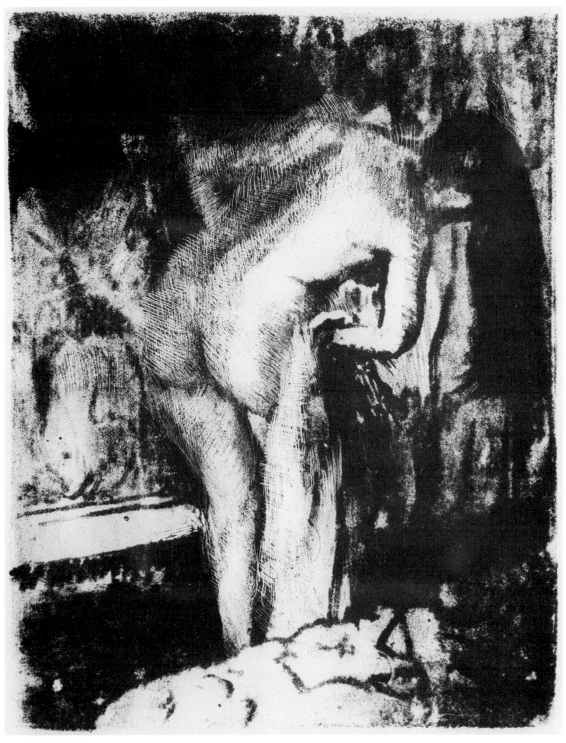

64 second state

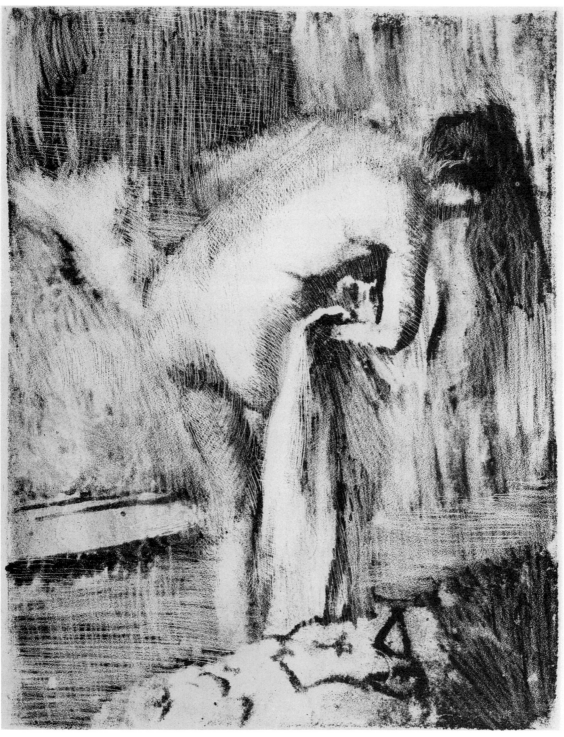

64 third state

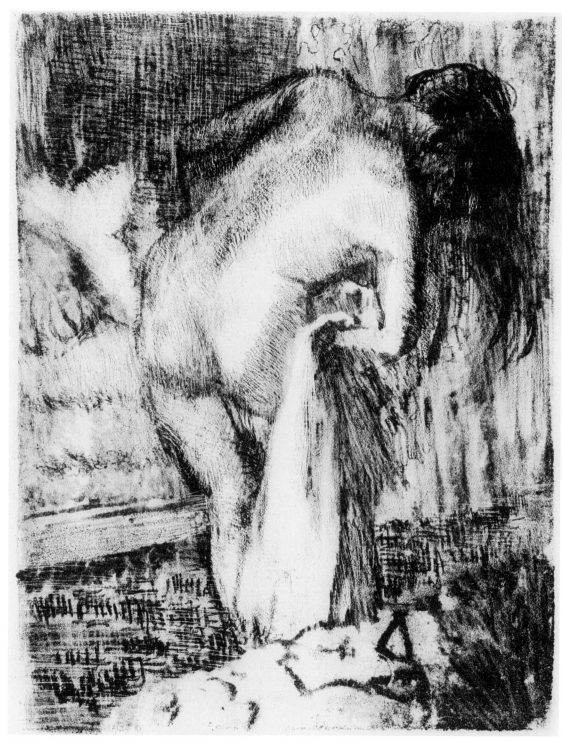

64 fourth state

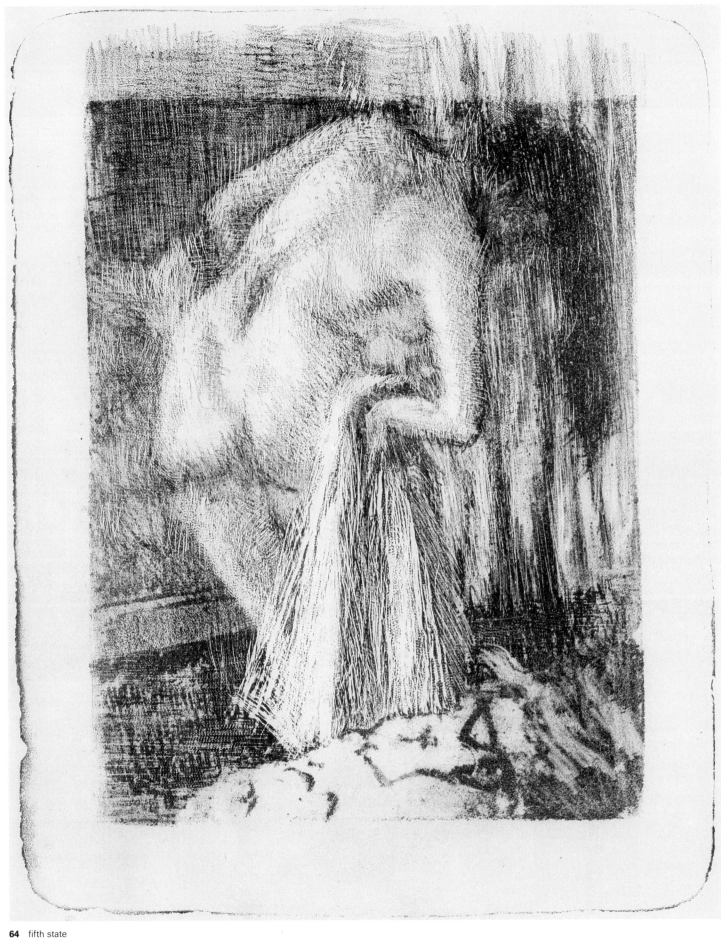

64 fifth state

65

After the Bath III 1891-92

Lithograph, transfer, and crayon. Two states
Delteil 63 (one state, about 1890); Kornfeld 1965, two states;
Adhémar 67 (about 1891)
250 x 230 mm. image
312 x 262 mm. stonemark (first state)
290 x 235 mm. stonemark (second state)

I first state

Cream-buff, moderately thick, moderately textured, wove paper
372 x 315 mm. sheet
In pencil lower right: *Degas*
Museum of Fine Arts, Boston. Lee M. Friedman Fund

II second state

Cream, medium weight, moderately textured, laid paper
375 x 270 mm. sheet
Coll.: Exsteens
National Gallery of Art. Rosenwald Collection, 1964

Degas took an impression of the fifth and last state of *After the Bath II* (cat. no. 64) and transferred it to a new and larger stone. He had deeply scratched the surface of the stone for *After the Bath II*, and it seems likely that the transfer was effected so that he could continue to develop this image. The chaise in the foreground of *After the Bath III* appears exactly as it remained throughout the five states of the previous print. There are also numerous correspondences in the white scratches; for example, the fine, diagonal and curved lines of the falling hair. These were embossed in the fifth state of *After the Bath II* but print flat in the transfer image. Faint traces of the bed frame seen in both the preceding lithographs (cat. nos. 63 and 64) may be detected in the lower left side of the present print, beginning at the edge of the image and crossing the bather's left leg at the knee.

A number of drawings depicting a bather with her maid holding a towel or robe reflect Degas's obsessive pursuit of this particular theme. Two drawings close in scale and composition to *After the Bath III* may have played a role in the revision of the image.[1]

In the first state Degas extended the composition of the transferred fifth state of cat. no. 64 and added the rounded back of the chaise as well as the figure of a servant holding a towel. In addition, he scraped and redrew the towel and the bather, again enlarging her body. He used multipointed tools that made parallel scratches and formed regular patterns. The new scratches in the stone left prominent embossed marks on the paper, most noticeable on the towel and the bather's back. The tonality of the background has been evened out. Some twenty impressions of the first state, many signed, have been located; only one (not signed) was from the Atelier sale (now in the Albertina.)[2]

For the second state Kornfeld indicated that the stone was reduced in size; in fact, however, the image was transferred to a second and smaller stone.[3] A conspicuous variance in the configuration of the stonemarks for the two states provides evidence to support this premise. The maid, the back of the chaise, and most of the background have been erased. The process of transfer to a new stone may have facilitated this removal of a large part of the image. The bather stands isolated against a light field, once more reflecting Degas's preoccupation at this time with a single sculptural figure. Of the three interrelated lithographs (cat. nos. 63-65), this one represents the final statement of an experiment in technique. At least twelve impressions of the second state are at present known; about half were signed. The same number of impressions came from the collection of Gustave Pellet. Recently, one impression of each state has been identified as part of the estate of Auguste Clot, a printer of lithographs (see also cat. no. 66).

Notes

1. Atelier sale III, no. 177 (charcoal, 25 x 30 cm.), and IV, no. 365 ("impression en noir," 30 x 33 cm.).

2. Kornfeld reported that about eighteen impressions came from Gustave Pellet.

3. Kornfeld 1965, referred to as Delteil 63, second state.

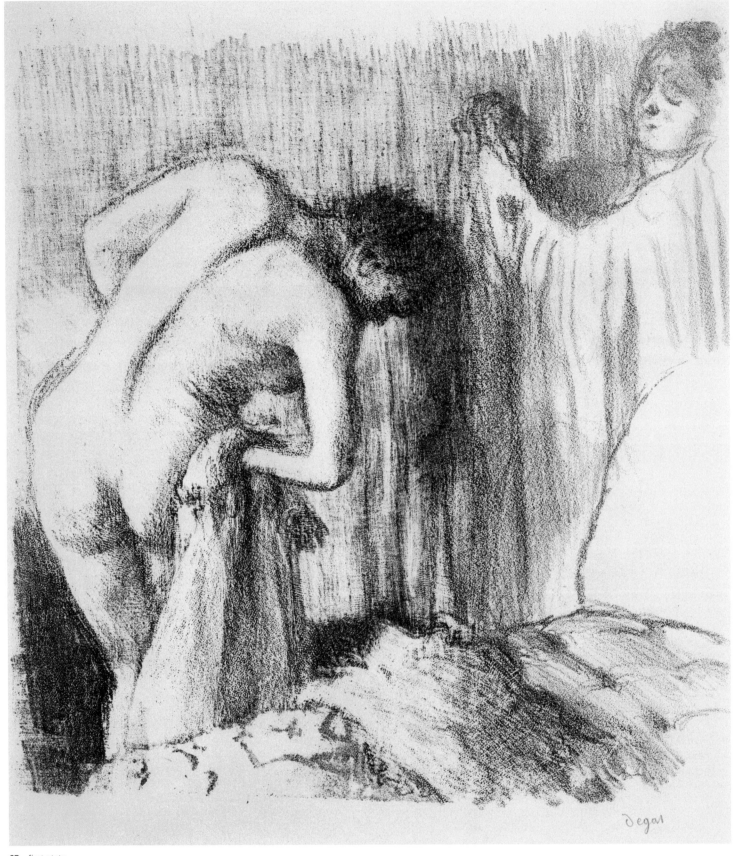

65 first state

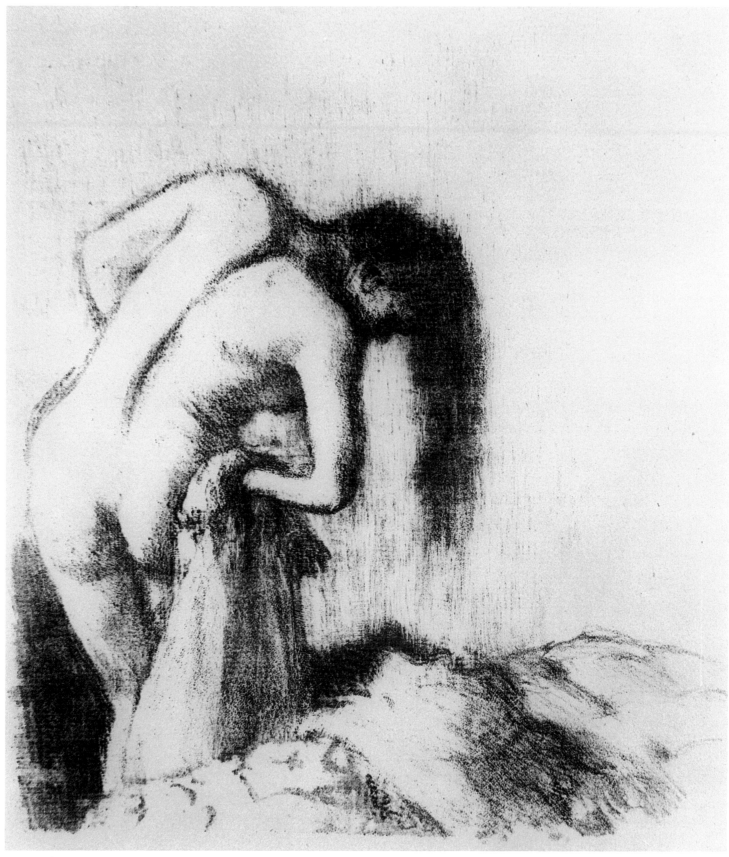

65 second state

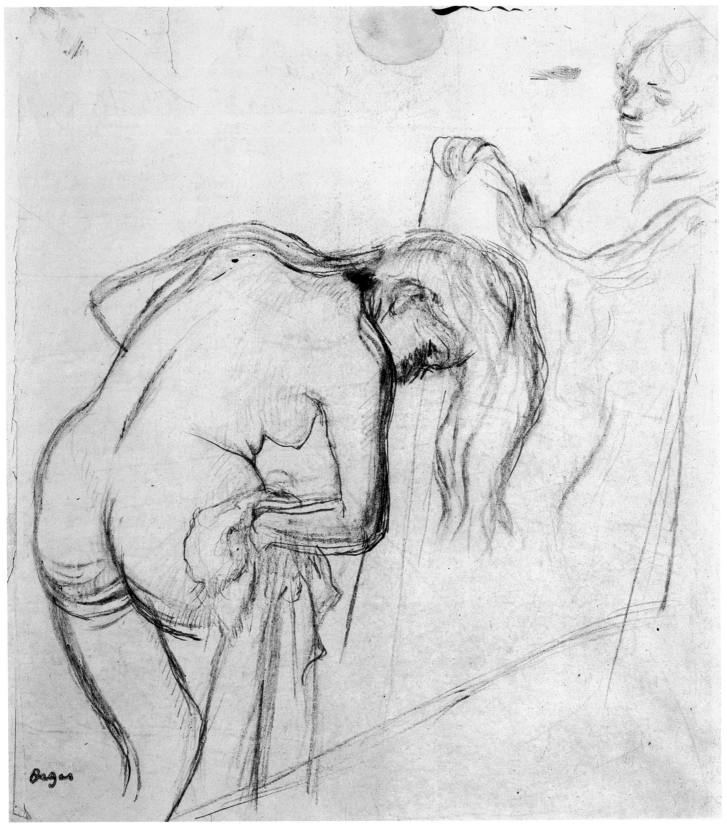

66a

66

After the Bath (large version) 1891-92

Lithograph, transfer, and crayon. Five states
Delteil 64 (about 1890); Adhémar 68 (about 1891)
275 x 313/320 mm. image (third state)
300 x 310 mm. image (fifth state)
300 x 340/360 mm. stonemark (fifth state)

I first state

Not located
Illustrated from Delteil

II second state

Cream, moderately thick, rough, laid paper
266 x 338 mm. sheet
Watermark: PORTFOLIO/MBM
Private collection, Germany

III third state

Off-white, thick, smooth, wove paper
320 x 445 mm. sheet
Atelier stamp
The Art Institute of Chicago. The Clarence Buckingham Collection
1962.80

IV fourth state

Off-white, thick, smooth, wove paper
277 x 360 mm. sheet
Colls.: Atelier; Bliss; Lockhart
Museum of Fine Arts, Boston. Katherine E. Bullard Fund in memory of Francis Bullard and proceeds from sale of duplicate prints

V fifth state

From a second stone
Cream, moderately thick, moderately textured, laid paper
385 x 385 mm. sheet
Coll.: Hartshorne
National Gallery of Art. Rosenwald Collection, 1946

66a After the Bath

Lithographic crayon and graphite with touches of black wash on prepared, thin Japanese paper
350 x 328 mm. sheet
Degas signature stamp in red
The British Museum. Presented by the Contemporary Art Society, 1925
Exhibited in Boston and London

66b After the Bath

Charcoal and pastel
Coated tracing paper, mounted on card
377 x 345 mm. sheet (made up from four separate pieces)
Degas signature stamp
Coll.: René De Gas
Burrell Collection, Glasgow
Not in exhibition

Although it is probable that a brush and ink drawing was transferred to the stone for the initial state of this print, the exact nature of the transfer cannot be determined. The first state is known only through the reproduction in Delteil's catalogue raisonné.

A large number of drawings of bather and servant indicate Degas's persistent exploration of this theme and his quest for an acceptable resolution. Two drawings on the same scale as the print, both in dry media on transfer paper, must have been involved in the preparation of the lithograph. The British Museum sheet (cat. no. 66a, from Atelier sale III, lot 334), drawn in black lithographic crayon and other media on a prepared transfer paper, clearly relates to the first state of the print. The multiple contours of the bather were repeated in lithographic crayon and graphite, which took on a grainy texture as a result of the coating applied to the paper. Although this sheet could have served as an initial study for the print, the configurations of the bather suggest that it played a role in the evolution of the lithographic image from the first to the second state.

The second state, greatly transformed, exhibits considerable work on the stone with crayon and scraper that masks or alters the image as it was first transferred. Degas elevated the left shoulder and the head of the bather, scraping to eliminate the original contour lines. The servant's features, summarily indicated in the first state, were further modeled, and a puffed sleeve was added to her dress. There are vertical lines that shade the background as well as the peignoir held by the servant. In the lower left corner, empty in the first state, Degas has drawn clothing draped over a small chair back. Substantial additional shading models the nude body. New patches of grainy texture visible throughout could have been produced by scraping with a multipointed tool or may have been transferred from crayon work executed on a textured transfer paper. This impression is unique; the image is cropped by the lower edge of the paper.

In the third state Degas further modeled and refined the bather, accentuating the contours of her body. Additional shading on the wall modulates the background between the bather and the servant and creates a darker area at the upper left. The image assumes its most sculptural appearance in this stage of development. Three impressions of this state are known: AIC (Atelier), Copenhagen (Atelier), and BAA (on thin, pearly, Japanese tissue).

In this unique impression of the fourth state (MFA, Atelier), extensive changes were made throughout the composition that suggest a total re-exploration of the image. The figure of the

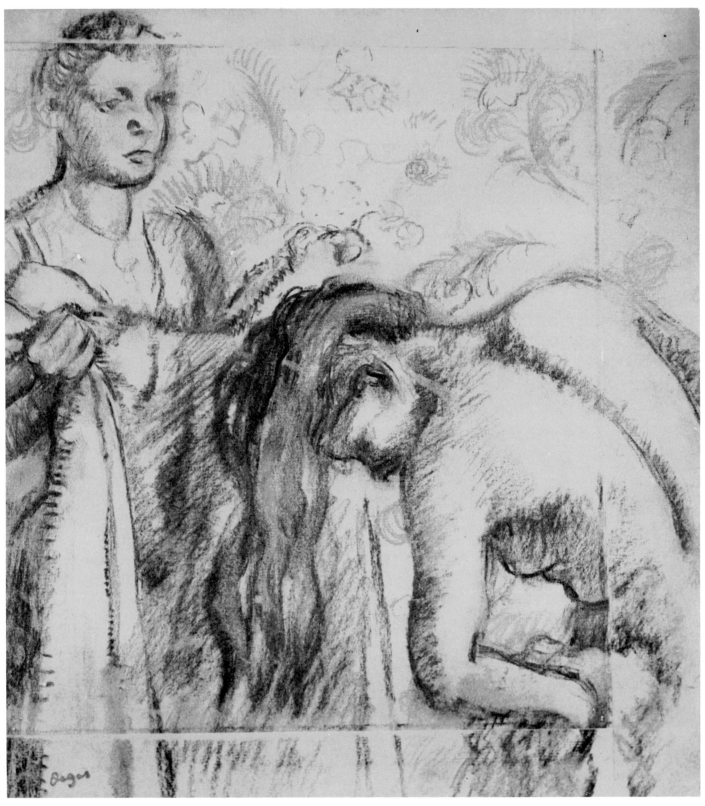

66b

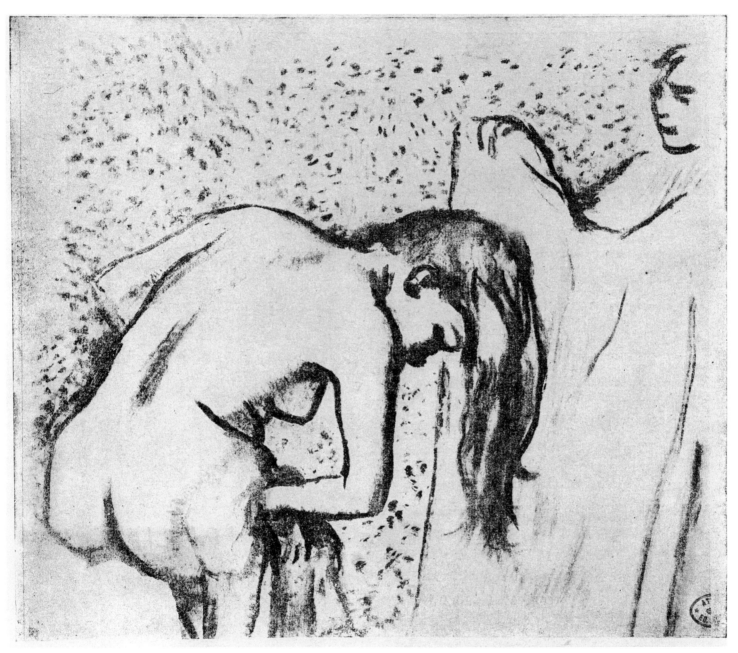

66 first state

bather is somewhat enlarged, the outlines softened, and her body more subtly modeled and shaded, leaving the right arm highlighted. The servant's features have been revised and her fingers elongated so that the tips touch the bather's raised hairdo. The shadowed area of the servant's upper body has been increased. Much of the dotted design of the wallpaper is masked with shading, and a floral pattern, added to the upper part, extends the composition. This trial impression is not uniformly inked.

The grainy texture in parts of the composition suggests that Degas used prepared transfer paper to assist him in the alterations of the image and to transfer passages of tone. Since the stonemarks visible at left in impressions of the third and fourth states match, a complete transferal of the image is not in question. Degas also scraped directly on the stone, making many fine, white lines to lighten the tonality of the print. Because of the originality and complexity of the procedures, one can only speculate about the technical processes employed by the inventive artist and his printer.

There are correspondences in figural shape and background decoration between this state of the lithograph and a pastel drawing in the Burrell Collection, Glasgow (cat. no. 66b, Lemoisne 1085, Atelier sale II, lot 310). The drawing, in charcoal and beige pastel, faces in the opposite direction from the print and is slightly larger in scale. It is on tracing paper with a fine, checkered grain, probably a transfer paper. It may have served a role in the execution of the lithograph before the drawing was enlarged and extensively reworked.[1]

There is no question that the fifth state of this print represents a transfer of an impression of the fourth state to a second, larger stone. Careful comparisons and exact measurements confirm that such a procedure was carried out. Much of the new work was probably executed on grainy lithographic transfer paper. Degas eliminated the chair in the left foreground and removed the servant almost entirely; her hand, still visible, adds a sense of mystery. The body of the bather, greatly enlarged, was lightened in tonality, and the revised composition is dominated by her monumental half-length figure. Degas permitted his indecision about the placement of her lower right arm to remain in the final print. A far narrower range of tonalities than in the previous state was created by judicious scraping of the shadowed areas. There is an overall gray appearance to the fifth state of the lithograph. This impression (NGA) is particularly well printed, with strong intermediate tones in the background and in the hair of the bather and her towel.[2] The sensitive inking of this impression minimizes the unintentional line that runs from the bather's neck through her falling hair. This line, apparent in most impressions of this state, may have resulted from a crease in the transfer paper that occurred during the transfer process.

Only one impression of the fifth state was in the Atelier sale (present whereabouts unknown). More than twenty additional impressions, printed on an identical paper, have been located, representing a larger production than usual for Degas. In the Bibliothèque Nationale an impression given by Atherton Curtis was inscribed upon his request by Auguste Clot and reads on the verso in brown ink: "*Litho inédite de Degas / tirée par moi / A. Clot*" (Unpublished litho[graph] by Degas / printed by me / A. Clot). Other impressions of the fifth state are said to have come from Clot; in the David-Weill sale (Paris, Hôtel Drouot, 25 and 26 May 1971, lot 53) an impression was reportedly from the Clot and Louis Rouart collections. At least fifteen also came from Gustave Pellet. It is possible that a printing of this state was made after 1891 and, as in the case of cat. no. 65, that the impressions remained in the printer's and publisher's hands. Although we have not seen any impressions of the fifth state with Degas's signature, some of those from Pellet are said to be signed.

Notes

1. The entire sheet is made up of four separate pieces and measures 377 x 345 mm. The square inset measures 301 x 292/294 mm., and each corner has multiple pinholes. We are grateful to Margaret MacDonald for her careful examination of this object.

2. This impression is printed on a trimmed sheet of paper commonly used for the fifth state; the average full sheet measurements are 420 x 485 mm.

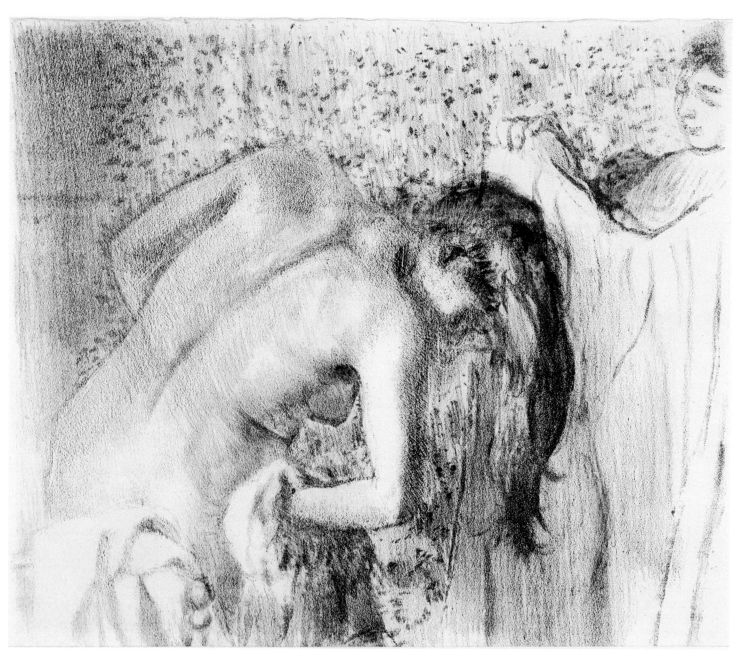

66 second state

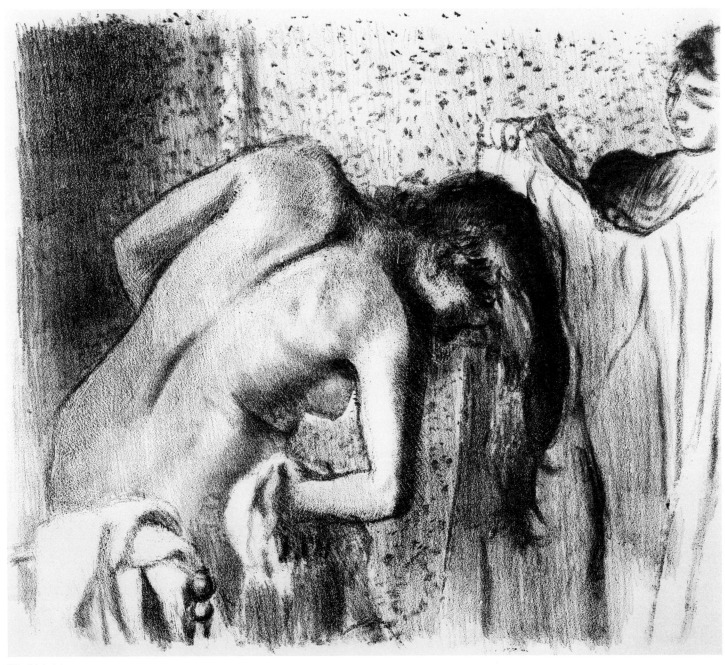

66 third state

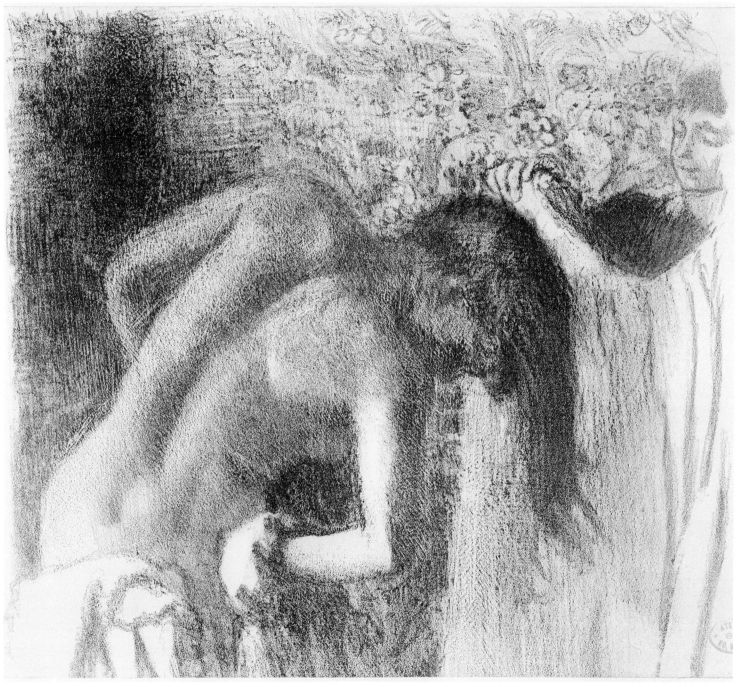

66 fourth state

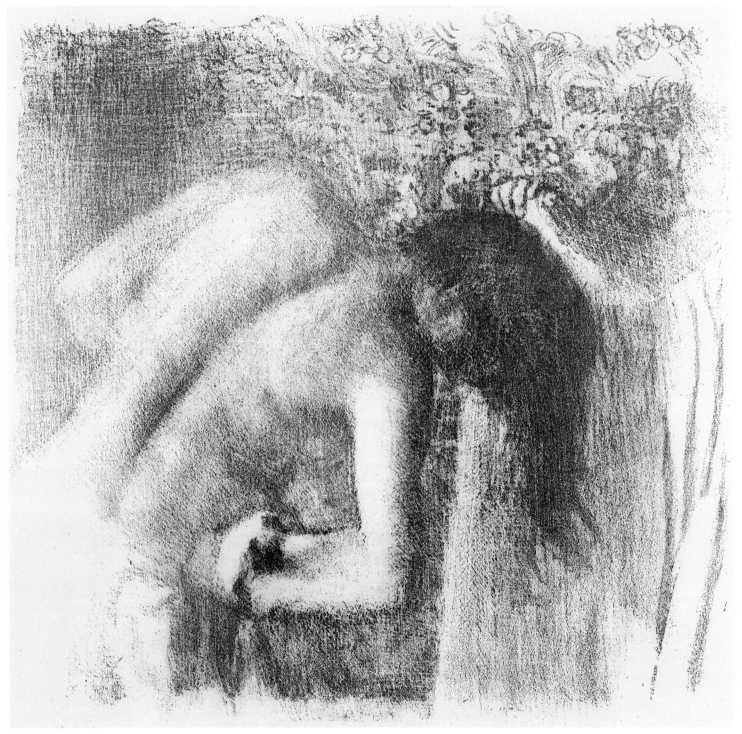

66 fifth state

A (Appendix)

Portrait of Manet

Lithograph
Dimensions unknown
Not located

A printed portrait head of Manet was reproduced as the frontispiece to Marcel Guérin's *L'Oeuvre gravé de Manet* (Paris, 1944). It was part of the author's collection, as indicated by the caption here cited in full: "Manet, by Degas. Transfer on stone of a drawing in lithographic crayon; unpublished and not described by Loys Delteil. Collection Marcel Guérin."[1]

In a written communication Theodore Reff suggested that the lithograph may have been made after a photograph. It is interesting to note the strong resemblance between this print, though reversed, and the photographic portrait by Nadar of about 1865 (reproduced as the frontispiece to the New York *Manet* exhibition catalogue, 1983).

Note

1. "Manet, par Degas. Report sur pierre d'un dessin au crayon lithographique, inédit et non décrit par Loys Delteil. Collection Marcel Guérin." Numerous efforts have been made to track down the print, without success. We are grateful to Judith Pillsbury for assisting in the search. Adhémar, no. 20, claims: "original drawing in pen and lithographic ink in the Fèvre Collection with three transfer proofs. Included in sale of 29 May 1952." We have been unable to corroborate this information.

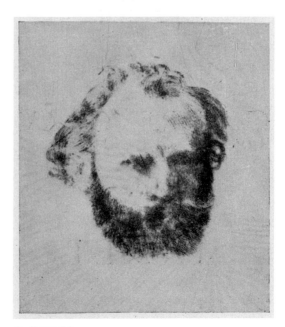

A (Appendix)

B (Appendix)

Woman in a Striped Bodice 1876-77

Monotype
Cachin 49 (Albertina impression); Janis 254 (location unknown);
Delteil 35 (as an aquatint with brush)
162 x 118 mm. platemark

a first pull

Off-white, thin, smooth, oriental paper
140 x 109 mm. sheet (cut within platemark top and right)
Atelier stamp
E. W. Kornfeld, Bern

b second pull

White, medium weight, smooth, wove paper
173 x 130 mm. sheet
Graphische Sammlung, Albertina, Vienna
Not illustrated

This image of a woman in a striped bodice is definitely a monotype, as noted by Janis and Cachin, rather than an aquatint ("essai d'aquatinte au pinceau"), as catalogued by Delteil. The nature of the printing and an oily residue on the verso of the Kornfeld impression confirm the medium. The print relates closely in subject and style to another small monotype illustrated as cat. no. 27a. Both the first and second pulls have been located: Kornfeld (Atelier) and Albertina (purchased 1923 from Sagot-LeGarrec and probably the second Atelier impression).

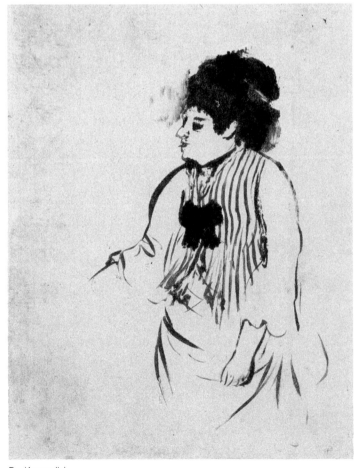

B (Appendix)

254

Degas's Printing Papers

Roy L. Perkinson

When the present catalogue was being planned, it was decided that it would be useful to gather and collate information on Degas's use of printing papers. Neither Degas's own words nor those of his friends offer clues about his preferences or opinions regarding paper, nor do previous catalogues deal with this subject. The scarcity of his prints and their wide geographic distribution, however, made close comparison difficult. Therefore, several identical sets of samples of papers, chiefly of the nineteenth and twentieth centuries, were assembled, with uniform descriptive terminology on color, texture, and thickness. These sets of "standards" enabled each staff member, when examining Degas prints in American and European collections, to make direct comparisons and to collate the information more precisely. Watermarks were recorded whenever possible, and in several instances precise tracings or photographs were provided by colleagues. In addition, for the sake of further comparison, prints by Bracquemond, Cassatt, and Pissarro in the Boston Museum's collection were examined to see if similar papers could be found. In studying Degas's etchings and lithographs, patterns in his use of papers were difficult to discover, partly because he was not prolific (nearly half of his prints exist in no more than four impressions) and partly because he sometimes pulled new proofs of an etching at a later date after making certain changes. Nevertheless, a few general characteristics can be established.

With only one exception, the tan paper of an impression of a fourth state of *Nude Woman, Standing, Drying Herself* (cat. no. 61), Degas never used colored papers for any of his prints and selected from a narrow range of white or grayish white to cream or buff color. This may seem surprising, considering his great abilities as a colorist. In the 1870s and 1880s he frequently employed colored papers for drawing, but parallel examples could not be found in his prints. If he desired to introduce color into a print, he transformed an impression radically by working over the image with pastel (cat. no. 52, Art Institute of Chicago impression).

For approximately the first twenty years of Degas's involvement with printmaking, 1856-75, he used wove or thin white oriental papers nearly twice as often as laid paper. He probably felt that the delicate tonal nuances of his work during these years, particularly evident in his drawings, were best expressed on the white or slightly gray-white, smooth-textured surface of such papers.[1] The subtle, gray, tonal variations of a print such as *Marguerite De Gas* (cat. no. 14) are especially effective on papers of this kind.

Degas frequently printed his etchings on a white or dull gray-white paper called "plate paper." It is soft and absorbent, like blotting paper, and is found in various weights, in general ranging from moderately to very thick. Like most of the wove papers used by Degas, it is machine-made and has no watermark. Plate paper was commonly used by etchers for trial proofs to assess the appearance of a plate at each stage of its development. To print an edition, an artist would usually select a finer paper and one that could provide a consistent appearance from one impression to the next. Sylvester Koehler, in his translation of Maxime Lalanne's treatise on etching, observed that "the heavy Dutch hand-made [laid] papers are still preferred by most people for etchings. . . . The worst, because most inartistic, of all is the plain white plate paper."[2] Degas, however, seldom produced editions of his prints. He would apparently follow customary practice by using plate paper often during the development of an etching and, having reached the final state, would not then take the next step of selecting paper for an edition. It is likely that Degas actually preferred this nondescript, "inartistic" paper because of its effectiveness in rendering the tonal qualities he sought.

From the mid- to late 1870s, coinciding with a period of considerable technical experimentation, Degas began to explore a somewhat greater range of paper. He used laid papers in particular more frequently than before. This increase was at least partly because a few of his prints of this period were intended to be printed in greater numbers for a wider audience. In keeping with common practice, therefore, many of these etchings were printed on hand-made laid paper.[3] All impressions of the last state and most of the preliminary states of *On Stage III* (cat. no. 24) were printed on cream, laid paper. Nearly all impressions of the first eight states of *Mary Cassatt at the Louvre: The Etruscan Gallery* (cat. no. 51) are found on cream or buff, laid paper; the last state, however, is generally on Japanese mulberry paper (discussed later), perhaps because Degas felt that this would produce a richer, more tonal effect than laid paper. Nearly half the impressions of *Dancers in the Wings* (cat. no. 47) were printed on laid paper, although several of the later states are on oriental papers. Following are other etchings in which the majority of impressions are on laid paper: *Profile of a Singer* (cat. no. 29), *Two Dancers in the Wings* (cat. no. 39), *The Actress Ellen Andrée* (cat. no. 40), *The Little Dressing Room* (cat. no. 41), *Leaving the Bath* (cat. no. 42), *At the Café des Ambassadeurs* (cat. no. 49).

Of all the types of laid paper used by Degas, the one most frequently encountered is Arches, identifiable either by the watermark in Roman capitals or by the countermark.

M. Joly of the Arjomari paper company, the present manufacturers of Arches, provided historical information about the countermark. It consists of two intertwined letters, the initials of Morel and Bercioux, who became joint owners of the Arches mill in 1860-61. Although further research on the history of this paper mill would be useful, it appears now that these two initials could not have been used as a watermark prior to that date. Since the mark appears on the following impressions, they must have been printed after 1860-61, even though the plates were begun at an earlier date: The Engraver Joseph Tourny (cat. no. 5), third printing (Kornfeld), third printing (Karlsruhe), fourth printing (Metropolitan Museum), fifth printing (Art Institute of Chicago), fifth printing (Library of Congress); Edgar Degas: Self-portrait (cat. no. 8), third state (Art Institute of Chicago), fourth state (Los Angeles County Museum).

Detailed examination of the specific type of Arches paper used for the last state of Edouard Manet, Bust-Length Portrait (cat. no. 19) indicates that it may have been printed thirty or forty years after the preliminary states. Rather mechanical and uniform in texture, this paper was probably made on a cylinder machine rather than by hand. Under close examination each chain line seems to have been made by two adjacent wires passing alternately over and under the laid lines, giving the appearance of a very closely spaced "double" line. This paper is not found in any other of Degas's prints but is identical to that used for some of the posthumous editions of Pissarro's prints. The last state of the Manet portrait can therefore probably be dated to about 1906 but no later than 1917 since an impression of this state was found in Degas's studio after his death.[4]

Among all the prints surveyed, only a second state of Alphonse Hirsch (cat. no. 21) and an impression of A Cafe-Concert Singer (cat. no. 32) were found to have been printed on paper removed from an old book. The texture and watermarks of these sheets suggest that they might date from the early nineteenth century. Traces of color on three edges, presumably from marbling, and an identical pattern of sewing holes along the fourth not only indicate their source but also confirm that they were both removed from the same book. Many nineteenth-century printmakers, including Whistler and Degas's close friend Pissarro, valued the special qualities of old papers, the rich and varied texture, receptive surface, and subtle patina of age. Seymour Haden asserted that the finest of all printing papers is "old vergé [laid] paper, which can only now be collected sheet by sheet, seldom quire by quire, and very rarely ream by ream, in Holland and Spain."[5] Lalanne observed that "some

artists and amateurs ransack the shops for old paper with brown and dingy edges, which, to certain plates, imparts the appearance of old etchings."[6] Indeed, use of such papers had become common practice among printmakers. Nevertheless, Degas seems to have been immune to this madness, and it is significant that only these two examples can be found in his work. Perhaps his lack of interest can be explained as an expression of his well-known concern that an artist be "modern"; for by printing on old paper one might risk imparting "the appearance of old etchings." He may have felt that the use of old papers was a rejection of the present.

Although Degas used several kinds of oriental papers, they played a less major role in his work than in Whistler's, and he did not seek to exploit their exotic overtones, as did Gauguin. The variety of oriental papers is so great and the applicable terminology is so limited that precise identification is difficult, but four broad types were encountered among Degas's prints. The first is a thin but fairly opaque, short-fibered white or gray-white paper with indistinct wire lines. Occasionally it bears faint brushmarks on one side, the result of having been brushed onto a surface to dry after the sheet was made. This soft, absorbent paper is probably a type of Chinese paper made from bamboo and is therefore sometimes called "china" paper. Impressions of the following prints by Degas were found on this type: Greek Landscape (cat. no. 1), Mountain Landscape (cat. no. 2), The Sportsman Mounting His Horse (cat. no. 3), Marguerite De Gas (cat. no. 14), Three Subjects: The Toilette, Marcellin Desboutin, The Café-Concert (cat. no. 28), At the Theater: Woman with a Fan (cat. no. 37), In the Wings (cat. no. 38), and Mary Cassatt at the Louvre: The Paintings Gallery (cat. no. 52).

Because of their fragility, thin papers were sometimes given additional support by attaching them to thick paper during the printing process. The resulting laminate is called chine collé, a term also used loosely to refer to any kind of thin paper laminated in this manner, regardless of whether it is Chinese. The technique of chine collé was favored in the nineteenth century, particularly by professional printers, but Degas attempted it only four times: in a first state of The Engraver Joseph Tourny (cat. no. 5), Four Heads of Women (cat. no. 27), At the Cirque Fernando (cat. no. 36), and Nude Woman at the Door of Her Room (cat. no. 36). In the Joseph Tourny the thin paper is probably Western, but in the other three it appears to be Chinese.

The second category is the most common type of oriental paper in Degas's work. Although these papers

show variations, they are generally fairly thin, soft, long-fibered, and moderately transparent. They are usually buff or cream color, or possibly of a golden amber hue, but may become lighter after prolonged exposure to light. The chain lines are virtually invisible in some of these papers but quite pronounced in others. All are probably made principally from the mulberry plant (*kozo*), the most common Japanese papermaking material. The elegant texture and subtle color of this paper, as well as its receptivity to ink, make it highly desirable for printing. Degas favored Japanese mulberry paper most frequently during the late 1870s but after 1879-80 never used it again. Almost all impressions of the last state of *Mary Cassatt at the Louvre: The Etruscan Gallery* (cat. no. 51) are on this paper, as are several impressions of the last state and two intermediate states of *Dancers in the Wings* (cat. no. 47). When comparing two impressions of the same state of the latter print, one on laid paper (Museum of Fine Arts, Boston) and the other on Japanese mulberry paper (Baltimore Museum of Art), one can appreciate Lalanne's observation that "Japanese paper, of a warm yellowish tint, silky and transparent, is excellent, especially for plates which need more of mystery than of brilliancy, for heavy and deep tones, and for concentration of effect."[7]

Japanese vellum, the third category of oriental paper, usually ranges in color from buff to a yellowish ivory and is a particularly smooth, dense type of Japanese paper. It is unlike either "china" or mulberry paper in that it is somewhat thicker, varying from medium to moderately thick. It might be mistaken for a Western, machine-made, wove paper, but it is somewhat softer, more absorbent, and has a characteristic soft sheen. Impressions of the following prints were found on this paper: *The Engraver Joseph Tourny* (cat. no. 5), *Edgar Degas: Self-portrait* (cat. no. 8), *René De Gas, the Artist's Brother* (cat. no. 15), *On Stage III* (cat. no. 24), *The Little Dressing Room* (cat. no. 41), *Dancers in the Wings* (cat. no. 47), *The Laundresses* (cat. no. 48), *Program for an Artistic Evening* (cat. no. 54), *Three Nude Dancers at Rest* (cat. no. 59).

The fourth oriental paper is an extraordinary example of the papermaker's art and is quite unusual in Degas's work, only four instances of its use having been found. In the catalogue for the sale of prints from Degas's studio, this paper is called *japon pelure* (Japanese onionskin), an appropriate term. Unlike mulberry paper it has a very lustrous surface, is fairly white, and is extremely thin and transparent like tracing paper. Probably made from *gampi*, the rarest of Japanese papermaking fibers, it is quite beautiful but has a pronounced tendency to become cockled and wrinkled in response to moisture or humidity. Degas used it for two lithographs: three impressions of the last state of *After the Bath I* (cat. no. 63) and a third state of *After the Bath (large version)* (cat. no. 66).

Generally, Degas did not use the same kind of paper for both etching and lithography. One of the few exceptions is the lithograph *Three Nude Dancers at Rest* (cat. no. 59), which is printed on Japanese vellum very similar to that used for three impressions of the last printing stage of the etching *Joseph Tourny* (cat. no. 5). Since the two printing processes are fundamentally different, they naturally have somewhat dissimilar requirements for paper. Etching paper must be soft enough to be forced into the etched lines on the metal plate; otherwise, incomplete or uneven transfer of ink will occur. Therefore, paper with little or no sizing is preferable for intaglio prints.

For lithography, the most desirable paper is one that is smooth enough to ensure good contact with the flat printing surface and has sufficient sizing and cohesiveness to resist having its fibers pulled up by the sticky lithographic ink when the sheet is lifted from the stone. Consequently, many of the papers used for Degas's lithographs are moderately well sized, smooth, machine-made, wove papers, although several smooth oriental papers were also used. The machine-made papers are for the most part quite similar, having few distinguishing characteristics and no watermarks. When seen separately, one sheet may look very much like the next. When sheets are compared closely, however, small differences can be discerned in thickness and in the quantity of impurities within the pulp. It was found that most of the impressions of *Mlle Bécat at the Café des Ambassadeurs* (cat. no. 31) are on identical sheets of off-white or slightly cream, moderately thick, machine-made, wove paper. Examination of a number of impressions revealed that this paper is not of the highest quality and gradually darkens after prolonged exposure to light.

There are three exceptions to Degas's use of wove paper for lithographs. Impressions of the two states of *After the Bath III* (cat. no. 65) are found on laid as well as wove paper. An impression of the second state (fig. 1) provides a good example of an effect that may occur when printing a lithograph on laid paper. Since the surface irregularities of the paper do not permit intimate, uniform contact with the lithographic stone, a series of light, closely spaced horizontal lines appear in the image. The visual result is not unlike a charcoal drawing on laid paper, an effect Degas might have found pleasing. The last state of *After the Bath (large version)* (cat. no. 66) is typically found on laid paper, but the

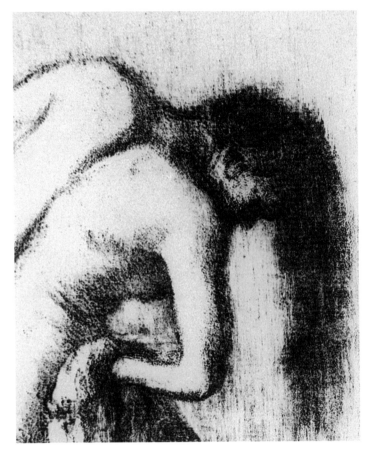

Fig. 1.
After the Bath III, 1891-92 (detail). Lithograph, transfer, and crayon, second state. National Gallery of Art, Washington D.C.

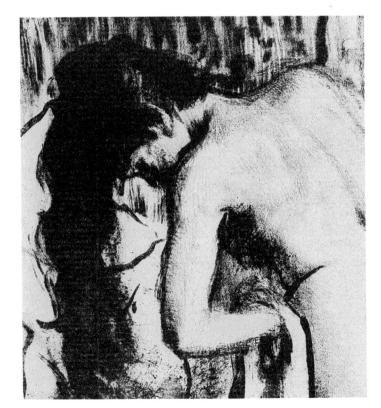

Fig. 2.
Nude Woman Standing, Drying Herself, 1891-92 (detail). Lithograph, transferred from monotype and tusche on stone, fourth state. Museum of Fine Arts, Boston.

texture of this paper is much less prominent than in the previous example and has little effect on the final image. This paper appears to be handmade, is moderately thick, gray-beige in color, and has indistinct wire lines. It was used only for this lithograph. Most of the impressions of *Nude Woman Standing, Drying Herself* (cat. no. 61) are on wove paper, but several are on a rather hard-surfaced, machine-made, laid paper, and in the fourth state, for example (fig. 2), the effect of its texture is quite evident, perhaps a little too obvious.

An interesting aspect of Degas's use of paper is that he was often quite casual in placing an image on the sheet; sometimes it is placed off-center or tilted with respect to the margins. Also, a number of the prints are on sheets of paper whose decidedly irregular edges suggest that they may have been scraps found in the studio. Apparently Degas regarded these prints as keepsakes or personal records of his exploration of a pictorial idea. An impression of his very first print, *Greek Landscape* (cat. no. 1), and three impressions of *Mountain Landscape* (cat. no. 2) are found pasted into his notebooks. Reff observed that Degas "scrupulously preserved every sheet or page of any artistic or sentimental interest."[8] Perhaps casual placement of an image on the sheet and the use of scraps of paper could be regarded as manifestations of Degas's "taste for the eloquent fragment."[9]

Notes

I am grateful to Elizabeth Lunning for her assistance in this project. I would also like to thank the following for their help: David Chandler, Deborah Cornell, Betty Fiske, Shelley Fletcher, Bob Futernick, Michel Joly, Katherine Lochnan, Helen Otis, Denise Thomas, and Judy Walsh.

1. In his notebooks of this period Degas relied increasingly on the finely pointed pencil and smooth white page, recalling the influence of Ingres; see Reff *Notebooks*, vol. 1, p. 15.

2. Maxime Lalanne, *A Treatise on Etching*, trans. S. R. Koehler (Boston, 1885), p. 72.

3. In his treatise on etching Maxime Lalanne asserts that "laid paper is the most suitable for printing etchings; its sparkle produces a marvellous effect; its strength defies time itself"; ibid., p. 59.

4. See B. Shapiro 1973.

5. "Mr. Seymour Haden on Etching," *The Magazine of Art*, 2 (1879), p. 263.

6. Lalanne, p. 59.

7. Ibid., pp. 59-60.

8. Reff *Notebooks*, vol. 1, p. 10.

9. Ibid., p. 23.

Table of Watermarks

Many of the watermarks on Degas's prints are found as fragments. Therefore, it was only after examining many impressions, studying watermarks found on prints by other artists, and referring to the scant literature on nineteenth-century papers that it was possible to identify a particular fragment with reasonable certainty. Rather than provide tracings of endless numbers of these partial watermarks, it was decided that it would be more appropriate and useful to try to prepare as complete a picture as possible of the various types by creating composites of the fragments or by referring to published sources of information. As our knowledge of nineteenth-century papers grows, a more precise record of the minute variations in the design of a particular mark may prove to be valuable. In the table below, each watermark is followed by a brief description of the type of paper on which it was found and a list of the prints for which the paper was used. All watermarks are reduced unless otherwise indicated.

3.
Cool white, medium weight, moderately textured, laid paper. This mark and the following one were found on identical papers, which were obtained from an old book prior to their use by Degas. One impression of cat. no. 32.

4.
Complete tracing unavailable. Cool white, medium weight, moderately textured, laid paper. This mark and the preceding one were found on identical papers. One impression of cat. no. 21.

ARCHES

1a.

1b.
(The countermark consists of the initials *M* and *B* intertwined, referring to Morel and Bercioux, joint owners of the Arches paper mill after 1860-61.) Cream or buff, medium weight, moderately textured, laid paper. Used for more impressions than any other single type of laid paper. (A variant of the Arches watermark in 2 1/2-in.-high italic script capital letters was found in a printing of cat. no. 5 and an impression of cat. no. 6.) Cat. nos. 4, 5, 8, 17, 18, 19, 29, 32, 39, 40, 51, 52.

BLACONS

2.
Found on both wove and laid, cream, moderately thick papers. Cat. nos. 42, 52.

DAMBRICOURT FRERES

5.
Cream, moderately thick, rough-textured, laid paper. Used primarily during 1879-80. Cat. nos. 8, 39, 42, 47, 52.

D & C BLAUW

6.
Buff, moderately thick, moderately textured, laid paper. One impression each of cat. nos. 5 and 8.

7.
Buff, medium weight, slightly textured, laid paper. One impression of cat. no. 24.

8.
Cream, medium weight, moderately smooth, laid paper. One impression of cat. no. 47.

HALLINES

9.
This mark is also found beneath a shield containing the letters HP. Buff, medium weight, moderately textured, laid paper. Paper with this mark was used by Cadart for the first issues of the *Société des Aquafortistes* and for Manet's album *8 Gravures à l'eau-forte*. Also frequently used for the prints of Meryon, Bracquemond, and other artists of the period (see James D. Burke, *Charles Meryon: Prints and Drawings* [New Haven, 1974], p. 25). Cat. nos. 8, 49, 52.

10.
In two prints (one of them the photofacsimile of cat. no. 14) the mark PORTFOLIO is also found on the opposite end of the sheet. Cream, medium weight, moderately textured, laid paper. The initials represent Morel, Bercioux, and Masure, the last having become a partner in the Arches mill in 1879. One impression each of cat. nos. 65 and 66, and one impression of a photofacsimile of cat. no. 14.

ORIGINAL OXFORD MILL

11.
A similar mark was also found with the words ORIGINAL/BASTED MILL/KENT. (For information on this mill prior to 1800, see Kent Mill, no. 35, in Alfred H. Shorter, *Paper Mills and Paper Makers in England 1495-1800* [Hilversum, 1957], p. 196.) Cream, medium weight, laid paper. The "Oxford Mill" variant appears only on cat. no. 42; "Basted Mill" appears on cat. nos. 39, 41, and 42.

12.
Cream to buff, medium weight, moderately textured, laid paper. Used for one impression of cat. no. 47.

13.
Cream to buff, medium weight, moderately rough-textured, laid paper. Used for the edition (fifth state) of cat. no. 24.

14.
Cream to buff, moderately thick, smooth, wove paper. One impression of cat. no. 21. (Porcabeuf, the grandson of Delâtre, was a well-known printer in Paris.)

Van Gelder

15a.

15b.
Cream, medium weight, moderately textured, laid paper. This paper was often used by Pissarro, Cassatt, Bracquemond, and other artists of this period. Cat. nos. 23, 34, 43, 49.

16. (shown actual size)
Buff, medium weight, moderately textured, laid paper. This paper is quite similar to Arches, but no evidence of a definite relationship was found. One impression of cat. no. 42.

Collectors of Degas's Prints

Sue Welsh Reed

The following information is based on some 568 impressions of prints by Degas that we have examined personally or about which we have received information. Many of Degas's etchings and lithographs were discovered in his studio after his death in 1917; 371 impressions were catalogued in the Atelier sale of November 23-24, 1918, devoted exclusively to prints by the artist. We have located 211 of these prints, marked with the oval, red Atelier stamp. During his lifetime, the artist gave or sold some prints, usually to collector friends. To Alexis H. Rouart he offered a number of impressions; we have located fifty-three impressions of forty-six subjects once belonging to Rouart. Other contemporaries of Degas who acquired significant numbers of his prints included Philippe Burty, Alfred Beurdeley, Jacques Doucet, and Roger Marx. To such collectors we have been able to trace 103 impressions of forty-four subjects. The remaining 198 impressions (sixty-nine of which are of the relatively numerous cat. nos. 61 III and IV, 65 I and II, and 66 V) bear no marks of contemporary collectors and therefore have no readily documented early provenance.

The only public collection to have acquired all its Degas prints from one source is the Bibliothèque d'Art et d'Archéologie of the University of Paris; in 1918 Jacques Doucet gave thirty-nine prints by Degas to the library he founded. The Cabinet des Estampes of the Bibliothèque Nationale acquired its sixty-six impressions from a variety of donations and purchases, as have the other sizable collections of Degas's prints.

The names of the collectors listed in alphabetical order below have been drawn from two sources: either from their marks placed on impressions of Degas's prints or from notations in Delteil's catalogue raisonné of 1919. Most of these individuals acquired their Degas prints during his lifetime or from the 1918 Atelier sale. Within the catalogue entries collectors are noted by last name only. The information below enlarges upon these references and gives the pertinent entries in Frits Lugt, *Les Marques de collections de dessins et d'estampes* (Amsterdam, 1921); *Supplément* (The Hague, 1956).

BAA, see **Doucet**

Barrion
G. Alfred Barrion (1842-1903). Pharmacist from Bressuire. Owned over 8,000 prints, mostly nineteenth-century. Sales 1904 and 1913. Lugt 76.

Bartholomé
Paul-Albert Bartholomé (1848-1938). French sculptor. Friend of Degas who inscribed prints and drawings given to him. Not in Lugt.

Beurdeley
Alfred Beurdeley (1847-1919). Parisian antiquarian dealer. Owned about 28,000 modern prints. In his 1920 sale there were twenty-six prints by Degas. Lugt 421.

Bliss
Francis Edward Bliss (1847-1930). American residing in London from 1888 until the early 1920s. Owned many prints by Legros. Sold prints in London at the time he left. Lugt 265.

Bracquemond
Félix Bracquemond (1833-1914). French artist. A prolific printmaker and artistic director for Sèvres porcelain, he was a friend of Degas and advised him on printmaking techniques. His son Pierre must have inherited his print collection, for in 1919 Delteil lists Pierre as the owner of a number of Degas's prints. Neither of the Bracquemonds used a collector's stamp, but when a print was lent for exhibition, *Bd* was written in pen on the verso. Lugt 351.

Burty
Philippe Burty (1830-1890). Parisian writer on art (including prints) and art critic. Active supporter of modern printmakers. Sales 1876, 1878, and 1891. Lugt 413, 2071.

Cassatt
Mary Cassatt (1844-1926). American painter from Philadelphia; worked in Paris. Friend of Degas; made prints during 1879-80 for collaborative project. She owned prints by Degas, some of which she sold to Durand-Ruel. Mrs. H. O. Havemeyer purchased one of these; another was given to her by Mary Cassatt. Cassatt may have encouraged other American print collectors to purchase prints by Degas. See Lugt 604.

Curtis
Atherton Curtis (1863-1943). American living in Paris; writer on prints. Gave duplicates to the Bibliothèque Nationale, among them at least one Degas. Lugt 94; *Supplément* 94, 470c.

René De Gas
René De Gas (1845-1926). Brother of the artist. Inherited works by Degas that were not sold in the Atelier sales (see Succession Ed. Degas). Some of these works were sold in Paris in 1927, but there were no prints. Any owned by him were probably family portraits that were passed down to his heirs. See Lugt *Supplément* 658 bis.

Succession Ed. Degas
A stamp with these words appears on prints that were among the studio contents but were not sold at the Atelier sale in 1918. These remainders, not sufficient for a complete sale, were divided among the heirs, who included Degas's brother René and his niece Jeanne Fèvre. Lugt *Supplément* 658 bis.

H-E Delacroix
Henri-Eugène Delacroix (1845-1930). Painter. Friend of Delteil, who dedicated the 1919 catalogue raisonné of Degas's prints to him. Not in Lugt.

Delteil
Loys Delteil (1869-1927). Parisian art expert, etcher, and writer on art. Author of a series of catalogues raisonnés on nineteenth-century French printmakers including Daumier, Pissarro, and Degas. Catalogued Degas's prints for the Atelier sale. Collection of choice impressions of modern prints sold in 1928. Lugt 773, 1723; *Supplément* 773.

Dodgson
Campbell Dodgson (1867-1948). Curator of prints at the British Museum from 1912. Left it his collection of over 5,300 prints, mostly late nineteenth- and twentieth-century. Lugt 521; *Supplément* 521 bis.

Doucet, BAA
Jacques Doucet (1853-1929). Parisian couturier and art patron. The Bibliothèque d'Art et d'Archéologie of the University of Paris was founded by him and contains his art library and print collection. Thirty-nine prints by Degas were included in his 1918 donation. Not in Lugt.

Eddy
Charles B. Eddy (1872-1951). New York lawyer. Collected old master and modern prints. Sale 1926. Lugt 499.

Fenaille
Maurice Fenaille (1855-1937). Parisian industrialist and art patron. Collected and wrote on the prints of Debucourt (1899); supported work of Rodin and Chéret. With Jacques Doucet promoted the study of French printmaking. See Lugt 655, 1308, 1886.

Fèvre
Jeanne Fèvre was the daughter of Degas's sister Marguerite De Gas Fèvre. Mlle Fèvre inherited family portrait prints after the Atelier sale (see Succession Ed. Degas). Her collection, auctioned in Paris in 1934, included nine prints by Degas. See Lugt *Supplément* 658 bis.

Gerstenberg
Otto Gerstenberg (1848-1935). Owner of Berlin insurance firm. A distinguished collector whose modern prints passed down to his heirs. Lugt 2785.

Guérin
Marcel Guérin (1873-1948). Parisian industrialist and writer on art. Published catalogues raisonnés on prints by Forain, Gauguin, and Manet. Wrote on Degas's prints and edited his letters for publication. Prepared additions and corrections to Delteil's catalogue raisonné. Eight prints by Degas were sold in 1921. Lugt *Supplément* 1872b.

Hartshorne
Robert Hartshorne (died 1945). New Yorker. Small collection of modern prints sold through dealers and in sales 1945-46. Lugt *Supplément* 2215b.

Jacquin
Charles Jacquin. Parisian. Began to collect around 1910. Sales 1939. Lugt *Supplément* 1397a.

Lerolle
Henri Lerolle. Friend and correspondent of Degas. His daughter married Louis, a son of Degas's close friend Henri Rouart. Not in Lugt.

Lockhart
James H. Lockhart, Jr. American. Collected in the 1930s. Exhibition of 100 prints and drawings from his collection held at Carnegie Institute, Pittsburgh, in 1939. Not in Lugt.

Lucas
George Aloysius Lucas (1824-1909). American art agent; lived in Paris. Left his collection of some 20,000 prints to his patron, the Baltimore collector Henry Walters, who, in turn, left it to the Maryland Institute, which has placed the collection on indefinite loan to the Baltimore Museum of Art. Lugt 1671; *Supplément* 1695c.

McVitty
Albert Elliott McVitty (1876-1948). Princeton, New Jersey. Collected prints by Rembrandt, Cassatt, and others. Sale 1949. Lugt *Supplément* 1862c.

Roger Marx
Roger Marx (1859-1913). Art critic and director of French fine arts administration; editor of *L'Estampe originale* and *Gazette des beaux-arts*. Supported innovative printmakers and collected their work. Twenty prints by Degas were in his 1914 sale. Lugt 2229.

Mirault
Marcel Mirault (1860-1929). Collector from Tours. Owned fine impressions of major nineteenth-century prints. Sales 1938, 1939. Lugt *Supplément* 1892a.

Moreau-Nélaton
Etienne Moreau-Nélaton (1859-1927). Parisian painter, writer on art. Published works on Manet, Corot, Delacroix, Jongkind, and others. Made gifts of prints to Bibliothèque Nationale, Paris, although none by Degas were included. See Lugt 1823a.

Ricketts
Charles Ricketts (1866-1931). British painter. In 1919 he gave an impression of *The Laundresses* to the British Museum. See Lugt *Supplément* 2238d.

Rouart
Alexis Hubert Rouart (1839-1911). Parisian industrialist. Close friend and correspondent of Degas. Brother of Henri (1833-1912), who collected paintings by Degas. Degas gave one or two examples of at least forty-three prints to Alexis; fifty-six of these have been located. The prints passed on to the heirs; most are now in public collections. Lugt 2187a.

Soutzo

Grégoire Soutzo (1815-1869). Rumanian prince and artist living in Paris. His extensive collection of prints, including numerous works by Dutch and French seventeenth-century masters, was sold in 1870. He is said to have been a friend of Degas's father and to have introduced Degas to etching. Lugt 2340, 2341.

Stinnes

Heinrich Stinnes (died 1932). Cologne official. Owned 200,000 nineteenth- and twentieth-century prints including works by Pissarro, Kollwitz, Munch, and Toulouse-Lautrec. Sales 1932-38. Lugt *Supplément* 1376a, 2373a, 2861b.

Thomas

Henri-Jean Thomas (1872-after 1952). Parisian stockbroker. Collected old master and modern prints. Sales from 1947-52 included at least three fine prints by Degas. Lugt 1378; *Supplément* 1378.

Vial

Mentioned several times by Delteil and in Viau sale catalogue. We do not know whether he was the inventor of the Vial process discussed in "Degas and the Printed Image."

Viau

Georges Viau. French collector. Three monotypes and nine prints by Degas were sold by his heirs in 1943. Not in Lugt.

Whittemore

Harris G. Whittemore (1865-1927). Naugatuck, Connecticut, manufacturer. Collected prints by Whistler and other nineteenth-century artists. Five prints and one monotype by Degas sold in 1949. Lugt 1384a.

Other collectors mentioned by Delteil in 1919 include Marcel Bing (who left seven drawings by Degas to the Louvre in 1922), Carré (possibly Louis), A. Hébrard (probably Adrien, the foundry owner who cast sculptures for Bartholomé and for Degas), as well as Henraux, A. Martin, Paul Petit, J. Picot, and J. Viaud-Bruant, about whom we have no further information.

Degas's Copper Plates

Barbara Stern Shapiro

Although there is not sufficient evidence to document precisely when Degas's etching plates were canceled, it is possible to collate enough information from various sources to provide a logical itinerary for the canceled plates.

Delteil was the first to refer to the existence of a group of Degas's canceled etching plates in his catalogue raisonné of 1919. Just before the catalogue's publication, he had learned that an edition of 150 impressions had been printed and would appear in a deluxe version of a book on Degas being prepared by Ambroise Vollard.[1] Apparently Vollard, the Parisian art dealer and publisher of prints and illustrated books, had acquired the plates, possibly about 1910, with the intention of using them to illustrate a biography of the artist.[2] Given Degas's known concern for the exhibition and disposition of his prints, it is likely that he saw to their cancellation before turning the plates over to Vollard. In a letter of 1 March 1984, M. Charles Durand-Ruel kindly confirmed that there was no mention of any copper plates in the inventory list of Degas's studio. One may assume that Vollard indeed obtained them before Degas's death.[3]

More recently, Una Johnson in her catalogue on Ambroise Vollard mentions that the dealer acquired at least twenty plates by Degas, which were printed for him about 1919-20 on japan paper of uniform size (323 x 250 mm.). A set of prints from these canceled plates is in the Vollard archives at the Kunstmuseum in Winterthur, donated by Lucien Vollard, the brother of Ambroise. Twenty-one etchings were released in an unspecified edition without a cover or title page.[4]

Most commonly seen in collections and generally accepted as part of the Vollard printing are the impressions on cream, heavy weight, heavily textured, wove paper of the same measurements as those in Winterthur. When the dimensions of the etching exceeded the sheet size, the image was cropped or printed without any margins. Significantly, a group of twenty-five canceled impressions acquired in 1949 by the Kunstmuseum in Basel includes impressions printed on both Japanese vellum and heavy wove paper. The Basel set is probably one of the most representative examples of the impressions printed for Vollard from the canceled plates; the use of two papers of the same size indicates the possibility of varied editions for his illustrated book.

One impression of *At the Café des Ambassadeurs* (cat. no. 49), on wove paper, bears a black Degas signature stamp in the lower margin; this impression was

Fig. 1.
On Stage III (enlarged detail): rework of cancellation lines.

acquired by the present owner directly from Vollard. Other prints on sheets with this distinctive stamp have been examined. The Vollard impressions from the canceled plates are generally considered to be the best printed. Although somewhat dryly inked, the plates were still in relatively good condition.

Upon Vollard's death in 1939, the plates were evidently obtained by the Parisian dealer Henri Petiet from his estate. It is possible that some impressions may have been printed during Petiet's ownership, although none have been identified as such.

In 1955, twenty-three canceled plates were purchased from A. Martinez in Cannes. Subsequently they were acquired by the art dealer Frank Perls, who had a small edition of them (including three additional plates) printed by Lacourière in Paris on japan paper deckled on two edges. Each etching has in the lower right-hand corner a blind stamp, "Frank Perls edition 1959." It was Perls's intention to take only as many impressions as he believed to be satisfactory, and the editions range from one impression of *Marguerite De Gas, the Artist's Sister* (cat. no. 14) to seventeen of cat. nos. 47 and 50. At least six plates were probably not printed: cat. nos. 6, 22, 32, 33, 34, 49.[5]

With a few exceptions, Perls sold the plates as a group to the art dealer Heinz Berggruen. The present loca-

tions of the following copper plates can be accounted for:

> Edgar Degas: Self-portrait (cat. no. 8), LACM purchase in 1960
>
> Manet Seated, Turned to the Right (cat. no. 18), San Diego Museum of Art
>
> Edouard Manet, Bust-Length Portrait (cat. no. 19), presented by Frank Perls to the Musée du Louvre
>
> At the Café des Ambassadeurs (cat. no. 49), LACM bequest 1984
>
> Mary Cassatt at the Louvre: The Etruscan Gallery (cat. no. 51), Mr. and Mrs. Paul Mellon
>
> Mary Cassatt at the Louvre: The Paintings Gallery (cat. no. 52), Mrs. Sidney F. Brody

Sixteen plates are at present in the Josefowitz Collection, Switzerland (cat. nos. 1, 3, 5, 6, 11, 14, 20, 22, 34, 41, 42, 46, 47, 50, 53, 59), including one plate (cat. no. 39) apparently not owned by Perls. The uncanceled plate for the portrait of Alphonse Hirsch (cat. no. 21) is in the Rosenwald Collection of the National Gallery of Art, Washington.

Before their last destination, some of the plates were given a thin gold-plating for protection and presentation, and many were steel-faced. In some instances, an attempt was made to soften or obscure the cancellation lines. Much of the work on the recto and verso of the plates has become illegible; on two plates, however, it is possible to read the manufacturers' names. The verso of the plate for the softground etching of Study for a Program for an Artistic Evening (cat. no. 53) bears the name "H. Godard/Rue de la Huchette 27/Paris"; and for Dancer Putting on Her Shoe (cat. no. 55) can be read "Bridault" and, below, three axe heads around a V in a circle above an illegible name.

According to Juliet Wilson Bareau, plates from these manufacturers were also used by Manet, and she has recorded their chronology.[6] One of the most important plate suppliers was H. Godard, planisher of copper and steel for printmaking ("planeur en cuivre et en acier pour la gravure"). From 1870 until 1874 his name was associated with that of "Paul Valant, successeur." From 1875 to 1878, the name of Godard appeared alone, then in 1879 it was associated with that of "E. Bridault successeur." In 1883, the name of Bridault figured at the top with the mention of "successeur of H. Godard and of Dupuis." Evidence based on our dating of the prints suggests that Degas made his respective etchings several years after he had obtained these copper plates.

Attention must be drawn to impressions from canceled plates in which the effacing lines have been skillfully masked on the sheet. An examination in a strong, raking light proves that certain impressions printed on papers different from those used by Degas during his lifetime have been tampered with to mislead the viewer. An impression of On Stage III, for example, reveals the manipulation of inked cancellation lines (fig. 1).

Notes

1. Delteil records at the end of his Introduction (unpaged): "Nous apprenons au dernier moment qu'un tirage à 150 épreuves a été effectué sur les cuivres biffés de Degas; ces épreuves doivent figurer dans les exemplaires de luxe d'un livre que prépare M. Ambroise Vollard, sur Degas. Nous devions faire au moins mention de ce tirage, sans songer toutefois à indiquer ce tirage comme un nouvel état."

2. We are indebted to William Weston, who so generously shared the information he had learned in conversation with M. Henri Petiet.

3. In a later publication, Delteil mentions that the plates were canceled after Degas's death but does not give any support for this change of information; Manuel, vol. 1, p. 290: "Presque toujours chaque épreuve constitue un nouvel état la rendant d'autant plus précieuse que la plus grande partie des cuivres de Degas ont été biffés après le décès du maître."

4. Una E. Johnson, Ambroise Vollard, Editeur (New York, 1977), pp. 30 and 131.

5. The plates and prints were exhibited in 1959. See exhibition catalogue: Twenty-six Original Copperplates Engraved by Degas, Frank Perls Gallery, Beverly Hills, California, November 9 to December 5, 1959. We are grateful to Joan Q. Hazlitt, who provided the accurate facts concerning the Perls edition. Mr. Perls was concerned about the condition of the plates and about making a posthumous edition. According to Mrs. Hazlitt, the edition was not twenty-five to fifty impressions of each plate, as is frequently cited, but varies from print to print.

6. Juliet Wilson, Manet: Dessins, aquarelles, eaux-fortes, lithographies, correspondance. Exhibition catalogue (Paris, 1978), unpaged; see section on "Cuivres" (copper plates).

Glossary of Technical Terms

An *impression* is any single print from an intaglio plate or lithographic stone. A *state* is any stage in the development of a print at which impressions are taken. States change only with the addition or removal of lines on the plate or stone. Differences in the paper used for printing or variations in the manner of inking do not constitute a change in state.

Intaglio Prints

Intaglio printing processes are those in which the image is incised with a sharp-pointed tool or bitten with acid into a metal plate, usually copper or zinc. When the plate is inked, the ink is held in the incisions, or grooves, and then forced out onto the paper as the plate passes through the press. If in addition to the ink in the grooves, a thin film of ink is left on the surface of the plate, this will print as a gray tone called *plate tone*. Because considerable force is used to press the paper against the metal plate during printing, an embossment of the paper called the *plate mark* is produced.

Etching

To make an *etching* the metal plate is first covered with an acid-resistant coating, or *ground*. In traditional practice the image is then delineated with an *etching needle*, which scratches away the ground and bares the metal. Degas also created unusual, multilinear effects by using a *double-pointed pen* or a *stiff wire brush* to scratch through the ground. When the plate is exposed to acid, grooves are bitten into the bare metal. To produce a *softground etching*, the plate is coated with a soft, sticky ground. After laying a sheet of paper on top, the artist then draws an image on it. When the paper is pulled away, part of the ground sticks to the back of the paper wherever the drawing was done and is removed. These areas then bite irregularly when the plate is placed in acid, and will print as characteristically soft granular lines resembling those produced by a pencil or a piece of chalk.

Drypoint

If lines are incised directly into the plate with a sharp point, the technique is called *drypoint* ("dry" because an acid bath is not required). As it cuts into the metal plate the traditional *drypoint needle* not only creates furrows but also raises a thin, ragged ridge of metal called a *burr* along the edge of the incised groove. When the plate is inked, the burr will catch and hold ink and will print as a rich, velvety line. The burr is fragile, however, and is soon worn away under the repeated pressure of printing. Degas also explored the effects of unconventional implements such as a *carbon-arc rod* from an electric arc lamp or an *emery* (carborundum) pencil. These abrasive tools produce multiple fine scratches on the plate, which print as grayish tonal areas.

When printing an etching or drypoint, most of the ink on the plate is transferred to the paper, but a small amount of ink is usually left in the grooves. To clean the plate, one or two proofs are sometimes taken without reinking; the resulting impression is called a *maculature*.

Aquatint

Aquatint is used to achieve broad areas of continuous tone. Traditionally, powdered resin is dusted onto the plate and made to adhere by heating the plate. The droplets of melted resin protect the plate irregularly, and when placed in the acid bath, the metal that remains exposed is bitten. The irregular network of minute pits thus created will hold ink and print as a fairly uniform tone. The intensity of the tone, which can range from black to pale gray, is determined by the length of time the plate is bitten. Within this tone a grainy pattern is sometimes visible, depending on whether the grains of powdered resin were fine or coarse. In *liquid aquatint* the resin is applied to the plate in liquid form in a solution of alcohol. To reserve certain areas within the tone as a pure white, a protective coating of *stopout varnish* can be brushed on locally before the acid bath.

Monotype

A *monotype* is made by painting an image in greasy ink on a smooth, unworked surface such as a metal plate and then printing it as one would an etching. Combining both painting and printing, this hybrid process offers the artist considerable freedom of execution but has the basic limitation that only one strong impression can be made. By pressing a fresh monotype against a lithographic stone, a *monotype transfer* is produced, transposing the painterly qualities of a monotype image into the medium of lithography. After the image has been transferred, further work may be done directly on the stone.

Lithography

Lithography is based on the fact that grease and water do not mix. An image is drawn with greasy crayon or lithographic ink (*tusche*) on a specially prepared surface, traditionally a smooth block of limestone, although grained zinc plates also came into use in the late nineteenth century. The surface of the stone or plate is then treated to make the areas touched by the crayon or tusche receptive to the greasy printer's ink, while the areas left blank are kept wet to repel the ink during printing.

Rather than drawing directly on the stone, an artist can draw on a special lithographic *transfer paper*. Such papers have a coated surface that readily accepts lithographic crayon and tusche but releases its image onto the stone when the sheet is dampened and passed through the press. Transfer paper has the dual advantage that it is more portable than a lithographic stone and permits the artist to produce a print without having to make allowances for the reversal of image that occurs when drawing directly on the stone.

After the image has been drawn on the stone, and at any time between printings, parts of the image can be removed or modified by *scraping* into the soft limestone with any moderately

sharp tool. Degas sometimes employed a *roulette*, a spiked wheel mounted on a handle, to score the image on the stone. Additions to the drawing can also be made, but the stone must first be chemically treated to make it receptive once again to crayon or tusche. Alternatively, a freshly printed lithograph may be laid onto a new stone and passed through the press, transferring the image. Further drawing could then be done on the stone without the necessity of additional treatment.

The *stonemark* is a slightly embossed mark on the paper, caused by the pressure of printing and corresponding to the outer edge of the lithographic stone.

Paper Terminology

Laid paper, when viewed in transmitted light, shows a regular pattern of closely spaced, parallel, straight lines, crisscrossed every inch or so by a single, heavier line. This pattern results from the wires on the paper mold. *Chain lines* are the widely spaced lines in laid paper; *laid lines* are those which are closely spaced. *Wove paper* has no distinct pattern of lines such as is found in laid paper but sometimes has a fine twill-like pattern resembling window screen.

Sizing is any material incorporated in or applied to paper to decrease its porosity or absorbency. Blotting paper is an example of an *unsized* paper.

Selected Bibliography

Adhémar
Adhémar, Jean, and Cachin, Françoise. *Degas: The Complete Etchings, Lithographs and Monotypes*. Translated by Jane Brenton. New York, 1974. Originally published as *Edgar Degas: Gravures et monotypes*. Paris, 1973.

Adriani 1984
Adriani, Götz. *Edgar Degas: Pastelle, Ölskizzen, Zeichnungen*. Cologne, 1984.

Alexandre 1918
Alexandre, Arsène. "Degas: Graveur et lithographe." *Les Arts*, no. 171 (1918), pp. 11-19.

Atelier sale I-IV
Catalogue des tableaux, pastels et dessins par Edgar Degas et provenant de son atelier. Sales catalogues. Galerie Georges Petit, Paris. I, 6-8 May 1918; II, 11-13 December 1918; III, 7-9 April 1919; IV, 2-4 July 1919.

Atelier sale Estampes
Catalogue de collection Edgar Degas: Estampes, anciennes et modernes. Sale catalogue. Hôtel Drouot, Paris. 6-7 November 1918.

Atelier sale Eaux-fortes
Catalogue des eaux-fortes . . . par Edgar Degas. Sale catalogue. Galerie Manzi-Joyant, Paris. 22-23 November 1918.

Artemis Group
Artemis Group. *Edgar Degas*. Exhibition catalogue by Ronald Pickvance. London, 1983.

Bailly-Herzberg 1972
Bailly-Herzberg, Janine. *L'Eau-forte de peintre au dix-neuvième siècle: La Société des aquafortistes 1862-1867*. Paris, 1972.

Bartsch
Bartsch, Adam. *Catalogue raisonné de toutes les estampes qui forment l'oeuvre de Rembrandt. . . .* 2 vols. Vienna, 1797.

Béraldi
Béraldi, Henri. *Les Gravures du XIXe siècle*. 12 vols. Paris, 1885-1892. Vol. 5: *Degas*.

Boggs 1962
Boggs, Jean Sutherland. *Portraits by Degas*. Berkeley, 1962.

Boggs 1966
Boggs, Jean Sutherland. *Drawings by Degas*. Exhibition catalogue, City Art Museum of St. Louis. St. Louis, 1966.

Browse 1949
Browse, Lillian. *Degas's Dancers*. London, 1949.

Buerger and B. Shapiro 1981
Buerger, Janet, and Shapiro, Barbara Stern. "A Note on Degas' Use of Daguerreotype Plates." *The Print Collector's Newsletter*, 12, no. 4 (1981), pp. 103-6.

Cabanne 1958
Cabanne, Pierre. *Edgar Degas*. Translated by Michel Lee Landra. New York, 1958.

Cachin
See Adhémar

Chicago, *Degas* 1984
Brettell, Richard R., and McCullagh, Suzanne Folds. *Degas in the Art Institute of Chicago*. Exhibition catalogue. Chicago and New York, 1984.

Copenhagen, *Degas* 1948
Ny Carlsberg Glyptotek, Copenhagen. *Edgar Degas, 1834-1917, Skulpturer og monotypier, tegninger og malerier*. Exhibition catalogue. Copenhagen, 1948.

Degas, *Letters* 1947
Degas Letters. Edited by Marcel Guérin. Translated by Marguerite Kay. Oxford, 1947.

Degas, *Lettres* 1945
Lettres de Degas. Edited by Marcel Guérin. Paris, 1945.

Delteil
Delteil, Loys. *Le Peintre-Graveur illustré*. 31 vols. Paris, 1906-1926. Vol. 9: *Degas*; vol. 17: *Pissarro*; vols. 20-29: *Daumier*.

Delteil, *Manuel*
Delteil, Loys. *Manuel de l'amateur d'estampes des XIXe et XXe siècles*. Vol. 1. Paris, 1925; *Complément* (Illustrations). Vol. 2. Paris, 1926.

Druick and Zegers 1981
Druick, Douglas, and Zegers, Peter. *La Pierre parle: Lithography in France 1848-1900*. Text panels and labels of an exhibition, National Gallery of Canada. Ottawa, 1981.

Dunlop 1979
Dunlop, Ian. *Degas*. London, 1979.

Duranty 1876
Duranty, Edmond. *La Nouvelle Peinture*. 1876. Reprint. Paris, 1946.

Edinburgh, *Degas* 1979
National Gallery of Scotland, Edinburgh. *Degas 1879: Paintings, Pastels, Prints and Sculpture from Around 100 Years Ago in the Context of His Earlier and Later Works*. Exhibition catalogue by Ronald Pickvance. Edinburgh, 1979.

Fèvre 1949
Fèvre, Jeanne. *Mon Oncle Degas*. Geneva, 1949.

Finsen 1983
Finsen, Hanne. *Degas og familien Bellelli (Degas et la famille Bellelli)*. Exhibition catalogue, Ordrupgaard. Copenhagen, 1983.

Gammell
Gammell, Robert Hale Ives. *The Shop-Talk of Edgar Degas*. Boston, 1961.

Gerstein 1982
Gerstein, Marc. "Degas's Fans." *The Art Bulletin*, 64 (March 1982), pp. 105-18.

Giese 1978
Giese, Lucretia H. "A Visit to the Museum." *Bulletin of the Museum of Fine Arts, Boston*, 76 (1978), pp. 42-53.

Guérin 1924
Guérin, Marcel. "Notes sur les monotypes de Degas." *L'Amour de l'art*, 5 (Mar. 1924), pp. 77-80.

Guérin, Additions
Guérin, Marcel. "Additions et rectifications au catalogue par L. Delteil de gravures de Degas." Manuscript in Bibliothèque Nationale, Cabinet des Estampes, Paris.

Halévy
Halévy, Daniel. *My Friend Degas*. Translated by Mina Curtiss. Middletown, Conn., 1964.

Isaacson 1980
Isaacson, Joel. *The Crisis of Impressionism 1878-1882*. Exhibition catalogue, The University of Michigan Museum of Art. Ann Arbor, 1980.

Ittmann 1967
Ittmann, William M., Jr. *Lithography by Edgar Degas*. Exhibition catalogue, Washington University. St. Louis, 1967.

Ives 1974
Ives, Colta. *The Great Wave: The Influence of Japanese Woodcuts on French Prints*. New York, 1974.

Janis
Janis, Eugenia Parry. *Degas Monotypes*. Exhibition catalogue, Fogg Art Museum, Harvard University. Cambridge, Mass., 1968.

Janis 1967, I and II
Janis, Eugenia Parry. "The Role of the Monotype in the Working Method of Degas," pts. I and II. *Burlington Magazine*, 109 (Jan.-Feb. 1967), pp. 20-27; 71-81.

Janis 1972
Janis, Eugenia Parry. "Degas and the 'Master of Chiaroscuro.'" *The Art Institute of Chicago Museum Studies*, 7 (1972), pp. 52-71.

Johnson 1981
Johnson, Deborah. "The Discovery of a 'Lost' Print by Degas." *Bulletin of the Rhode Island School of Design: Museum Notes*, 68 (Oct. 1981), pp. 28-31.

Kornfeld 1965
Kornfeld, Eberhard. *Edgar Degas: Beilage zum Verzeichnis des graphischen Werkes von Loys Delteil*. Bern, 1965.

Lafond 1918-19
Lafond, Paul. *Degas*. 2 vols. Paris, 1918-19.

Lemoisne
Lemoisne, Paul-André. *Degas et son oeuvre*. 4 vols. Paris, 1946-49.

Lemoisne 1912
Lemoisne, Paul-André. *Degas: L'Art de notre temps*. Paris [1912].

Lemoisne 1931
Lemoisne, Paul-André. "A propos des Degas de la collection de M. Guérin." *L'Amour de l'art*, no. 7 (July 1931), pp. 283-91.

Lemoisne and Guérin 1931
Lemoisne, Paul-André, and Guérin, Marcel. *Dix-neuf portraits de Degas par lui-même*. Paris, 1931.

Lipton 1980a
Lipton, Eunice. "Degas's Bathers: The Case for Realism." *Arts Magazine*, 54 (May 1980), pp. 94-97.

Lipton 1980b
Lipton, Eunice. "The Laundress in Late Nineteenth-Century French Culture: Imagery, Ideology and Edgar Degas." *Art History*, 3 (Sept. 1980), pp. 295-313.

Los Angeles 1958
Los Angeles County Museum of Art. *Exhibition of Works by Edgar Hilaire Germain Degas*. Exhibition catalogue by Jean Sutherland Boggs. Los Angeles, 1958.

Lugt
Lugt, Frits. *Les Marques de collections de dessins et d'estampes*. Amsterdam, 1921.

Lugt *Supplément*
Lugt, Frits. *Les Marques de collections de dessins et d'estampes. Supplément*. The Hague, 1936.

Mathews 1984
Mathews, Nancy Mowll. *Cassatt and Her Circle: Selected Letters*. New York, 1984.

Meier-Graefe 1923
Meier-Graefe, Julius. *Degas*. Translated by J. Holroyd-Reece. London, 1923.

Melot 1974
Melot, Michel. *L'Estampe impressionniste*. Exhibition catalogue, Bibliothèque Nationale. Paris, 1974.

Millard 1976
Millard, Charles. *The Sculpture of Edgar Degas*. Princeton, 1976.

Moore 1918
Moore, George. "Memories of Degas." *Burlington Magazine*, 32 (Jan.-Feb. 1918), pp. 22-29; 63-65.

Moses 1964
Moses, Paul. *An Exhibition of Etchings by Edgar Degas*. Chicago, 1964.

New Orleans 1965
Isaac Delgado Museum of Art, New Orleans. *Edgar Degas: His Family and Friends in New Orleans. . . . On the Occasion of an Exhibition of Degas's New Orleans Work*. Essays by John Rewald, James B. Byrnes, and Jean Sutherland Boggs. New Orleans, 1965.

New York 1977
The Metropolitan Museum of Art, New York. *Degas in the Metropolitan*. Checklist compiled by Charles S. Moffett. New York, 1977.

New York, *Manet* 1983
The Metropolitan Museum of Art, New York. *Manet 1832-1883*. Exhibition catalogue. New York, 1983.

Nochlin 1966
Nochlin, Linda. *Impressionism and Post-Impressionism, 1874-1904: Sources and Documents*. Englewood Cliffs, N.J., 1966.

Paris 1924
Galerie Georges Petit, Paris. *Exposition Degas: Au Profit de la Ligue Franco-Anglo-Américaine Contre le Cancer*. Paris, 1924.

Paris 1931
Musée de l'Orangerie, Paris. *Degas, portraitiste, sculpteur*. Exhibition catalogue. Preface by Paul Jamot, essay by Paul Vitry. Paris, 1931.

Paris 1969
Musée de l'Orangerie, Paris. *Degas: Oeuvres du Musée du Louvre: Peintures, pastels, dessins, sculptures*. Exhibition catalogue. Preface by Hélène Adhémar. Paris, 1969.

Passeron 1974
Passeron, Roger. *Impressionist Prints*. New York, 1974.

Philadelphia 1936
Pennsylvania Museum of Art, Philadelphia. *Degas*. Exhibition catalogue. Introduction by Agnes Mongan. 1936.

Pickvance 1963
Pickvance, Ronald. "Degas's Dancers: 1872-6." *Burlington Magazine*, 105 (June 1963), pp. 256-66.

Pissarro, *Correspondance* 1980
Correspondance de Camille Pissarro, 1865-1885. Edited by Janine Bailly-Herzberg. Paris, 1980.

Pissarro, *Letters* 1972
Camille Pissarro, Letters to His Son Lucien. Edited with the assistance of Lucien Pissarro by John Rewald. 3rd ed., rev. Mamaroneck, N.Y., 1972.

Pissarro, *Lettres* 1950
Camille Pissarro, Lettres à son fils Lucien. Edited with the assistance of Lucien Pissarro by John Rewald. Paris, 1950.

Reff 1963
Reff, Theodore. "Degas's Copies of Older Art." *Burlington Magazine*, 105 (June 1963), pp. 241-51.

Reff 1964
Reff, Theodore. "New Light on Degas's Copies." *Burlington Magazine*, 106 (June 1964), pp. 250-59.

Reff 1968
Reff, Theodore. "Some Unpublished Letters of Degas." *Art Bulletin*, 50 (March 1968), pp. 87-94.

Reff 1971
Reff, Theodore. "The Technical Aspects of Degas's Art." *The Metropolitan Museum of Art Journal*, 4 (1971), pp. 141-66.

Reff 1976
Reff, Theodore. *Degas: The Artist's Mind*. New York, 1976.

Reff, *Manet* 1982
Reff, Theodore. *Manet and Modern Paris*. Exhibition catalogue, National Gallery of Art. Washington, D.C., 1982.

Reff *Notebook(s)*
Reff, Theodore. *The Notebooks of Edgar Degas*. 2 vols. Oxford, 1976.

Rewald 1973
Rewald, John. *History of Impressionism*. 4th ed., rev. New York, 1973.

Rewald GBA
Rewald, John. "Theo Van Gogh, Goupil and the Impressionists." *Gazette des beaux-arts*, 81 (Feb. 1973), pp. 65-108.

Rivière 1935
Rivière, Georges. *M. Degas, bourgeois de Paris*. Paris, 1935.

Rouart 1945
Rouart, Denis. *Degas à la recherche de sa technique*. Paris, 1945.

Scharf 1968
Scharf, Aaron. *Art and Photography*. London, 1968.

B. Shapiro 1973
Shapiro, Barbara S. *Camille Pissarro: The Impressionist Printmaker*. Exhibition catalogue, Museum of Fine Arts, Boston. Boston, 1973.

B. Shapiro 1974
Shapiro, Barbara Stern. *Edgar Degas, The Reluctant Impressionist*. Exhibition catalogue, Museum of Fine Arts, Boston. Boston, 1974.

B. Shapiro 1978
Shapiro, Barbara Stern. "A Note on Two Degas Drawings." *Fenway Court*. Isabella Stewart Gardner Museum, Boston, 1978, pp. 14-21.

M. Shapiro 1980
Shapiro, Michael Edward. "Degas and the Siamese Twins of the Café-Concert: The Ambassadors and the Alcazar d'Eté." *Gazette des beaux-arts*, 95 (April 1980), pp. 153-64.

Ten Doesschate Chu 1974
Ten Doesschate Chu, Petra. *French Realism and the Dutch Masters*. Utrecht, 1974.

Terrasse 1983
Terrasse, Antoine. *Degas et la photographie*. Paris, 1983.

Valéry
Valéry, Paul. *Degas, Manet, Morisot*. Translated by David Paul. Bollingen Series, vol. 12. New York, 1960.

Vollard 1924
Vollard, Ambroise. *Degas*. Paris, 1924.

Concordance

Delteil	Title	Adhémar	Reed and Shapiro
1	Edgar Degas, par lui-même	13	8
2	Auguste De Gas, père de l'artiste	6	4
3	René De Gas (frère de l'artiste)	21	15
4	Le Graveur Joseph Tourny	7, 8	5
5	Edgar Degas, par lui-même	10	7
6	Dame agée	12	10
7	Mlle Nathalie Wolkonska (1e planche)	14	11
8	Mlle N. Wolkonska (2e planche)	15	12
9	Le Sportsman montant à cheval	3	3
10	La Rade (Paysage de Grèce)	1	1
11	Dante et Béatrice	9	9
12	L'Infante Isabelle, d'après Velásquèz	16	16
13	Jeune homme assis et réfléchissant (d'après Rembrandt van Rijn)	11	6
14	Manet en buste	17	19
15	Manet assis, tourné à gauche	18	17
16	Manet assis, tourné à droite	19	18
17	Marguerite Degas, soeur de l'artiste	23	14
18	Une Danseuse	38	20
19	Alphonse Hirsch	24	21
20	Ellen Andrée	52	40
21	Derrière le rideau de fer	29	32
22	Les deux danseuses	37	33
23	Deux danseuses dans la coulisse	36	39
24	Profil de chanteuse	40	29
25	Une Chanteuse	39	34
26	Danseuses dans la coulisse	28	47
27	Aux Ambassadeurs	30	49
28	Loges d'actrices	31	50
29	Au Louvre: La Peinture (Mary Cassatt)	54	52
30	Au Louvre: Musée des antiques	53	51
31	Sur la scène (1e planche)	25	23
32	Sur la scène (2e planche)	26	24
33	Sur la scène (3e planche)	27	22
34	Le Petit Cabinet de toilette	48	41
35	Femme à mi-corps	—	Appendix B
36	Danseuse mettant son chausson	60	55
37	Les Blanchisseuses (Le Repassage)	32	48
38	Femme nue debout à sa toilette	62	61
39	La Sortie du bain	49	42
40	Projet de programme	55	53
41	Les Trois Danseuses nues mettant leurs chaussons	61	59
42	Buste de femme	50	43
43	Femme à la mantille	51	46
44	Les Amoureux	4	45
45	Buste de femme	5	44
46	Planche à double sujet (Au Cirque Médrano)	45	36
47	Planche à double sujet (Femme nue à la porte de sa chambre)	45	36
48	La Chanson du chien	41	25
49	Aux Ambassadeurs: Mlle Bécat	42	31
50	Aux Ambassadeurs: Mlle Bécat	43	30
51	La Planche à double sujet (Divette de café-concert)	—	35
52	La Planche à double sujet (Ebat matinal)	—	35
53	Chanteuse de café-concert	33	26
54	Quatre têtes de femmes	44	27
55	Planche aux trois sujets (La Toilette – Desboutin – Café-Concert)	46	28
56	Loge d'avant scène (Femme à l'éventail)	34	37
57	Femme nue debout à sa toilette	62	62
58	Programme de la Soirée des anciens élèves du Lycée de Nantes	56	54
59	Dans la coulisse	35	38
60	Après le bain (1e planche)	64, 65	64
61	Après le bain (2e planche)	66	63
62	La Suivante demêlant des cheveux	47	60
63	La Sortie du bain (petite planche)	67	65
64	La Sortie du bain (grande planche)	68	66
65	Femme nue debout, à sa toilette	63	61
66	Chevaux dans la prairie	57	56

(Not in Delteil)
Adhémar

20	Manet		Appendix A
22	La Dame au bonnet (Mme Hertel ?)		13
58	Danseuse sur scène, saluant		57
59	Les Arbres		58

Errata and Addenda

Page 6 (cat no. **3**)	read caption under illustration as fifth state, from the canceled plate
Pages 80-81 (cat. no. **26**)	reverse captions under illustrations for first and second states
Page 95 (cat. no **31**)	read caption under illustration as 31a
Page 97 (cat. no. **31**)	read caption under illustration as 31
Page 156 (cat. no **49**)	There are five known impressions of the fifth state: BAA (signed), East Berlin, NGA (Rouart), NGC, private collection, Germany (Gerstenberg).
Page 174 (cat. no. **51**)	for Porcaboeuf read Porcabeuf
Page 203 (cat. no. **54**)	There are nine known impressions of the lithograph: add MFA.